M000290484

ANATOMY OF A NATION

Also by Dominic Selwood

Knights of the Cloister
Spies, Sadists and Sorcerers
The Sword of Moses
The Apocalypse Fire
Punctuation Without Tears
The Voivod (short story)
Suffer the Children (short story)

ANATOMY OF A NATION

*A History of British Identity
in 50 Documents*

DOMINIC SELWOOD

CONSTABLE

CONSTABLE

First published in Great Britain in 2021 by Constable
1 3 5 7 9 10 8 6 4 2

Copyright © Dominic Selwood, 2021

The moral right of the author has been asserted.

All rights reserved.
No part of this publication may be reproduced, stored in a retrieval system, or transmitted, in
any form or by any means, without the prior permission in writing of the publisher, nor be
otherwise circulated in any form of binding or cover other than that in which it is published and
without a similar condition including this condition being imposed on the subsequent purchaser.

A CIP catalogue record for this book
is available from the British Library.

Hardback ISBN 978-1-47213-189-8

Typeset in Adobe Garamond by Hewer Text UK Ltd, Edinburgh
Printed and bound in Great Britain by Clays Ltd, Elcograf S.p.A.

Papers used by Constable are from well-managed forests and other responsible sources.

Constable
An imprint of
Little, Brown Book Group
Carmelite House
50 Victoria Embankment
London EC4Y 0DZ

An Hachette UK Company
www.hachette.co.uk

www.littlebrown.co.uk

document, *n.*
Something written, inscribed, etc.,
which furnishes evidence or
information upon any subject, as a
manuscript, title-deed, tomb-stone,
coin, picture, etc.

Oxford English Dictionary

Contents

PART III: EARLY MODERN

PART IV: MODERN

Prelude

Voices from the Past

On Christmas Day 1066, aged almost 40, William the Conqueror processed into Westminster Abbey to be crowned king of England. His plan was to envelop himself in the solemnity and splendour of Anglo-Saxon royal tradition like an archbishop wreathed in sanctifying incense. But the day brought no such dignity. At the climax of the ceremony, when the crowd's acclamation filled the abbey with a cacophony of languages, William's guards posted outside thought a riot had erupted. Anxious to contain it, they set fire to the surrounding wooden houses, sparking a day of opportunistic burning and looting.

William's anarchic coronation did not inspire confidence in his new regime, which – after the torching of Southwark two months earlier – was quickly gaining a reputation for viciousness and terror. Among those most alarmed at the violent lawlessness – and concerned about their personal fate – was a group of influential Anglo-Saxon nobles who had, until recently, held out against their new king a mile and a half to the north-east of Westminster in the ancient, wealthy, walled city of Lundenburgh. William was a warlord, descended from Vikings, and his instinctive response to those who resisted him was retaliation with biblical levels of violence, as during his genocidal scorched-earth campaigns against the north of England. On this occasion, however, he did something startlingly different.

William negotiated the peaceful surrender of Lundenburgh. Then, instead of meting out gruesome reprisals on those who had defied him, he offered

them a small piece of scraped animal hide no bigger than a dagger blade. On it, in neat black ink, he greeted Londoners in English, reassured them he came *freondlice* (friendlily), promised he would enforce their laws as in the days of King Edward 'the Confessor', and guaranteed them his protection. He even concluded by wishing them a cheery *god eop gehealde* (God keep you).[1]

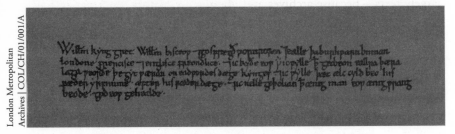

London Metropolitan Archives | COL/CH/01/001/A

William the Conqueror, Charter to Lundenburgh (1067)

Behind the astutely chosen promises and amiable sentiments, this narrow strip of vellum eloquently reveals William's keen political instincts. In the few months since the Battle of Hastings he had understood two important differences between his lands north and south of the Channel. The first was that the people of his new realm valued its long, gnarled historical roots, and identified proudly with its vivid, poetic language, culture and laws, all forged by waves of Anglo-Saxon and Viking warriors from over the North Sea. The other was that it was a land where writing was venerated and celebrated – the home of *Cædmon's Hymn*, *Beowulf*, the *Dream of the Rood* and the *Battle of Maldon* – where a thoughtfully composed text could, on the right occasion, outshine the sharpest steel.

Almost 1,000 years later, the City of London's archives still hold William's vibrant message of reassurance, goodwill and hope. For anyone interested in eleventh-century England, it is a jewel. But for a historian who tells stories, it is even more valuable, as it shows with vivid immediacy why documents – more than anything else the centuries bequeath – open wide windows into the past. Fortresses like the Tower of London remind posterity how William took control of the country militarily, but the proclamation to Londoners is a vivid journey into his inner thoughts. A real man emerges in his unusual choice to use English, his political jockeying to affirm himself as successor to Edward the Confessor, and his gamble to extend the hand of mercy and friendship. Reading this small, delicate fragment of skin tattooed with such a powerful message offers, even a millennium later, an immediate intimacy with William's personality and world.

The title of this book uses the word 'anatomy': the art of dissecting the inner workings of structures by peeling away their outer layers. It is exactly what this book does by slicing open the bodies of myth, legend and tales that surround the identities Britain has had in different ages, cutting them back to expose what lies beneath. To achieve this, it explicitly uses documents – largely texts – because archives and libraries are history's mortuaries, where lifting away the layers uncovers stories that reveal the workings of the past.

The word document derives from the Latin *docere*, to teach, which is also the root of doctor (teacher), doctrine (what is taught) and docile (easily taught). Humans are hoarders, and today, with archivists and librarians preserving cabinets and shelves that overflow with materials from the centuries, there is an immense wealth to choose from. To be representative, this book focuses on documents in their broadest sense: carvings, letters, chronicles, charters, stories, songs, poems, paintings, embroideries, death warrants, graffiti, diary entries, log books, newspapers, telegrams, police reports, record sleeve art, menus, books, and many more besides. History leaves other flotsam and jetsam in its wake, like buildings, artefacts, populations, borders, ideas, and myriad memories, but documents are the richest, most detailed, complete, revealing and evocative relics of the past. And the most nuanced of all, offering the fullest insights and intimacy, are texts, with their plain meanings and subtexts, with what they say and what they omit, and with their rich personal contexts in time and place. Some caution, though. All documents are genuine voices from their age, but what they convey is only as reliable as their authors' intention, knowledge or ability. The contents may be meticulously accurate, but can equally be carelessly erroneous, artfully misleading or even comprehensively untruthful. Medieval monks were just as capable of spinning badly researched or entirely fabricated yarns about what was happening in the country as people are today of posting fake news and conspiracy theories on the internet. Nevertheless, even documents of half-truths or outright fabrications are valuable and reveal opinions or intentions. There is always a tale behind why people present things the way they do, and these stories are what make up history.

The past is of course infinitely layered, although until fairly recently it was often presented as simple, with a monarch's dates and the results of a few battles sufficient to give a good account of an era. But now – thanks to historians specialising in an ever-wider variety of exciting new fields – Britain has many pasts, each of which can be understood from a range of historical, ideological and cultural traditions. This is because social,

economic, military, and many other specialist historians approach the same periods in strikingly contrasting ways, as do those from different backgrounds. The intriguing result is that there will never again be consensus on any history, because individual groups experience events uniquely, so each – and each person – has their own history. The Argentinian Britophile Jorge Luis Borges ponders this in his atmospheric short story 'The Witness', in which he describes the quiet death of the last Saxon in England to have seen the old pagan rites before the country was Christianised. With just this one death, Borges muses, the world lost its last living connection to a piece of the past.[2] History, Borges affirms, is profoundly personal.

In charting Britain's past, therefore, this book does something that is hopefully timely. It divides the nation's history into 50 segments, and illustrates each with a central document. This allows individual voices to speak for their period, conjure its mood, and bring the reader face-to-face with the people of the age. As William the Conqueror's proclamation illustrates so colourfully, documents introduce unparalleled richness of detail, while bringing out the uniquely personal.

A cursory flick through this book will reveal that one constant of Britain's history is change. And what comes across consistently is just how quickly changes occur. Another reason, therefore, for this fresh look at British identity is that the dramatic alterations Britain has undergone since World War Two have so fundamentally shifted its social and cultural tectonic plates that they have transformed it into a different country. An account of these tumultuous shifts needs to be rendered so their far-reaching consequences can be explored.

For instance, the events of January 1965 now seem a world away in so many ways. It was a bitterly cold month, and on its last Saturday Big Ben struck the third quarter chimes at 9.45 a.m., then fell silent until the following day. Below, at street level, mournful drums began, and a phalanx of white-capped Royal Navy sailors stepped off in slow time out of the Palace of Westminster, sombrely pulling a large, four-wheeled gun carriage. Flanked by a subdued escort of bearskinned guardsmen, they wheeled right and headed for ancient Whitehall, where King Charles I had been executed on an equally chilly winter morning 316 years earlier to the day.

Mounted on the gleaming metal of the gun carriage was a solitary coffin draped in a Union Jack and surmounted with a black cushion bearing a gold collar of the Order of the Garter. Inside was Winston Churchill: the Prime Minister who defeated Hitler, the orator, the historian who won the Nobel Prize in Literature and, to many people, the hero who embodied

Britain's national spirit. *The Times* covered the funeral in luxuriant detail, basking in its 'moving tapestry of history', soaking up the strong sense of affection that emanated from the million lining the processional route. 'There were Londoners, countrymen, Scotsmen and Irishmen, Jamaicans and Chinese,' it observed with pride, 'even a Frenchman showing his credentials to the police and declaring that he was an "ancient combatant"; solid members of society wedged between spivs, wideboys and tramps.'[3]

While waiting for the funeral cortège to arrive at St Paul's Cathedral, *The Times'* correspondent revelled in spotting royalty and leaders from every corner of the globe, singling out the crown prince of Ethiopia and Prince Taufa'ahan of Tonga for special mention. Everyone, the newspaper enthused, was 'bound together, not only by a sense of history but by a shared intimacy in personal memories of this great and lovable man. It was as if they were taking their own father to his burial.'[4] No reader of *The Times* that day was in any doubt: this was an international celebration of a colossus who had commanded a grateful and adoring British Empire.

Fast-forward to 2020, and protestors at a Black Lives Matter demonstration in central London passed down Whitehall and put a flame to the Union Jack on the Cenotaph. In neighbouring Parliament Square they graffitied the bronze effigy of Churchill which watches over the gate where his funeral procession left the Palace 55 years earlier. Venting anger and frustration, one protestor sprayed a firm black line through the single word on the statue's plinth – CHURCHILL – and aerosoled the stark words 'was a racist' underneath.

It was not the first time Churchill's statue had been targeted. In fact, defacing it during demonstrations has become something of a tradition after the anti-capitalist march on May Day 2000, when a former Royal Marine artfully arranged a strip of turf on Churchill's head to give him a green Mohican, sprayed red paint around his mouth as if it was dripping blood, and was rewarded with a fine and 30 days in prison. He explained to the court that he thought Churchill was 'an often irrational, sometimes vainglorious leader whose impetuosity, egotism and bigotry on occasion cost many lives unnecessarily and caused much suffering that was needless and unjustified'.[5]

Views will differ on the marine's appraisal of Churchill, but the protestors' allegation of racism is not open to a spectrum of interpretations. In speaking of the 'Red Indians of America' and the 'black people of Australia' Churchill observed, 'I do not admit that a wrong has been done to those people by the fact that a stronger race, a higher-grade race, or, at any rate, a more worldly wise race, to put it that way, has come in and taken their

place.' His racial views extended to other people, too. 'I hate Indians . . . they are beastly people with a beastly religion.' Palestinians did not rank much better: 'barbaric hordes who ate little but camel dung'.[6] It is, of course, true that others of his generation shared similar opinions, yet, taking the plain meaning of the word, he was a racist by the standards of his day and today. All this does not mean *The Times* was not telling the truth in its assessment of the mood at Churchill's funeral. It just means that the newspaper was offering its version of the truth: a version shared by millions, but a stark demonstration that there is no universal historical truth.

In 1965 it would have been difficult for a book to have made observations like these about Churchill without attracting criticism, even outrage. But time has brought freer speech and a broader range of viewpoints to a country that is now very different to the one Churchill left behind. Even though he died only just over half a century ago – within the lifetime of 30 per cent of today's population – opinions in some sections of society have altered so drastically that a statesman who had been loved for embodying all that was best in the nation is now reviled as shameful.[7]

The explanations for these striking shifts in cultural and historical thinking are complex, and include post-imperialism, internationalism, multiculturalism, globalisation, political and economic failure, growing inequalities, new priorities around social and racial justice, the information revolution, and social media. They are also fuelled, somewhat unexpectedly, by Britain discovering a new and vibrant interest in its past. This is surprising given that in-depth history is an endangered species in many school classrooms and university lecture halls, where history modules and courses covering anything other than a small selection of topics continue to be axed. Yet somehow, despite history being squeezed out of many people's education, it is now firmly part of popular debates, prompting confrontation, questioning, and challenges to the past and present as never before. And, from this process, widely divergent views of Britain's history and identities have continued to emerge.

These shifts in ideas about history have also created tensions in some sensitive areas, including heated national debates about statues of men like Hans Sloane, Edward Colston and Cecil Rhodes and artefacts like the Elgin Marbles and Benin Bronzes, with acute questions around what roles they should play in twenty-first-century British life. On the one hand it is exhilarating that history can mobilise armies of passionate enthusiasts on all sides. On the other, cautionary alarms sound whenever debates are simplified and only a limited range of narratives become acceptable, and when politicians,

professors, and public figures weigh in to insist that specific topics are retained or removed from teaching curriculums and public debates. These disagreements about how to view the country's past have now grown so acrimonious that the media refers to them as culture wars.[8]

From out of all this, there needs to emerge an understanding of how to approach sensitive issues like the history of empire, slavery, racism, inequality, cultural identity, and other subjects that increasingly erupt across the front pages and on the streets. This book takes the view that history happened, and it should be confronted and discussed vigorously rather than denied or locked away, as there can only be limited understanding of why things occurred if they are not thoroughly researched and debated. All sides in the battle for the nation's history need to remain mindful that if they approach the past with modern priorities and wish lists, they are engaged in political and not historical judgements.

This book is not about the current culture wars – which may prove ephemeral or may endure – but the subjects chosen and interpretations put forward in it inevitably say something about the way I see British history. Much of the approach is traditional, and there is a fair amount of 'drums and trumpets' because Britain has had a noticeably violent past that has been instrumental in shaping its destiny. The book is also traditional in other ways, like calling paramilitaries in late-twentieth-century Northern Ireland terrorists, because that is what they were. It also retains the name 'Anglo-Saxon'. Although it is the subject of growing controversy because of its use among some white supremacist groups, it remains the most widely understood term for one of the early medieval peoples of England who used the name to describe themselves, and choosing anything else would be artificial. By contrast, the book contains some more contemporary approaches, for instance the inclusion of many women who are often ignored by history. It also departs from those who want to see everything as unfailingly glorious, and candidly appraises the less laudable episodes, such as the bloody rapacity and callousness of the East India Company and its leaders like Clive. Or the catastrophic and arrogant incompetence that led to the Zulu Wars. Or even Tony Blair's lies to Parliament and the country over the presence of weapons of mass destruction in Iraq. None of these interpretations – or any other in the book – is taking a position in the history culture wars: it is just history the way this author, using documents, sees events.

A final reason for telling the history of Britain's identity now is that the 2016 referendum to leave the European Union raised fundamental and

profoundly contentious questions around Britain's perception of itself and its role in a post-imperial world. There can be no understanding of the cultural impact of the 'Brexit' secession without tracing Britain's long relationship with Europe back through the days of empire to the medieval world in which Britain and the countries of Europe were forged and began to define themselves as nations.

One apology up front. The subtitle references Britain, but this book focuses more on England than Wales, Scotland and Ireland. It mentions every king and queen of England since Æthelstan, but would need to be many times its current length to do the same for the rulers of the other parts of the British Isles. This does not reflect any cultural value judgement. It is merely one of those unsatisfactory compromises. That confessed, there are several chapters dedicated wholly to the other parts of the United Kingdom, and mention is made of Wales, Scotland and Ireland throughout.

This book, therefore, offers a new appraisal of Britain's identity down the centuries. It uses a treasure chest of documents to bring each era to life with authentic material and voices of the past. It abandons the cosy conservatism of many histories, and appraises Britain's past in a way that makes sense today, jettisoning traditional reverence to those like Churchill and assessing them more honestly and robustly. And finally, it puts Britain's long history into the context of the intimate but fractious relationship with its European neighbours. Through all this, it tells Britain's story, bringing it to life with the words – like those of William Conqueror, whose uncharacteristic mercy to Londoners changed the course of that city's history – art and music of people from down the ages. Some of the 50 documents are well known, while others are published for the first time, but all eloquently reveal something important about these islands' unique march from the Stone Age to the present, and the differing senses of its peoples' identity that have blossomed in each era.

PART I: PREHISTORY AND ROMAN

1

Hunters and Henges – Nomads Arrive

Stonehenge
Carvings of Axe Heads and Daggers
1750–1500 BC

May AD 43 is the most important month in British history, marking the moment Emperor Claudius's legions landed on the south coast of England and unleashed the dogs of war. Along with conquest, bloodlust, fire, elephants and fish paste, they brought something that would change Britain for ever. Writing.[1]

The arrival of writing marks the moment a society's history begins. By definition, everything before is prehistoric. British history therefore officially starts with the arrival of the Romans, although – as so often – reality turns out to be messier, as British druids already used the Greek alphabet for their records, and some coins struck in Britain already bore Latin inscriptions.[2] Nevertheless, the incorporation of Britain into the Roman Empire is usually seen as the event ending the immensely long period of the islands' prehistory, when its human populations lived through the Stone, Bronze and Iron Ages. To give some time perspective, if all human life in Britain were squeezed into a day, the period of 'history' following the Roman conquest would fill only its final three and a half minutes.

Before beginning the story of Britain, a word on its name. In the sixth century BC a Greek mariner put to sea from Marseilles, which was then a new, edge-of-the-empire Greek city: the first in France. As the prow of his

ship carved through the cerulean waters, the sails filled, and the oarsmen dug in their gleaming blades. They sailed south-west across the Gulf of the Lion, eventually arriving at the great Pillars of Hercules where Gibraltar kisses Morocco. Later Roman writers said the towering, rocky gateway bore the ominous, carved words 'NE PLUS ULTRA', nothing further beyond. The sailor may have gazed up at the jagged sentinels and steeled his nerve.

Once through the liminal waters of the strait, the Greek ship left the warm Mediterranean and ploughed into the squalls of the wild Atlantic. Setting a course north, the sailor hugged the coasts of Portugal and Spain, before turning into the Bay of Biscay. He was now far beyond anything the poets had sung of. The Greeks had spread around the Mediterranean basin, but knew of no world beyond it. They lived at the centre of a flat disk encircled by a foamy ring of hostile waters, home only to barbarians and sea-monsters. This, at least, was the wisdom passed down by Homer. But the Greek sailor was a man of reason. He was not satisfied by epic flights of fantasy, so as he adventured into the beyond, he recorded his observations in a periplus – a type of maritime travel journal – noting where he went, what he found, and the things he learned when putting in to shore.

After travelling the length of the Bay of Biscay, the sailor rounded the Finisterre headland and met the complex system of currents where the Channel rushes into the Atlantic. Looking about in a great clockwise arc from south to east, there was nothing before him but grey water and empty horizon. He had come to the corner of the world, and was on its edge. At this point he entered a brief note in his periplus that he may have thought of marginal importance. He recorded that to the north, two days' sailing away, lay two islands: Albion and Sacred Isle.[3] With this simple log entry, the Greek mariner became the first person in history, as far as records show, to chronicle the existence of the British Isles. In that simple, pared-down diary note, he had put Britain and Ireland on the map.

Unfortunately, the Greek sailor and his periplus are only a theory. His existence is hypothesised because a sixth-century BC periplus starting at Marseilles, heading up to the Channel and noting the existence of Britain (Albion) and Ireland (Sacred Isle) is what seems to be left after peeling back the layers of information embedded into all known ancient Greek and Roman travel texts. For them to make sense, the sailor and his periplus must once have existed.

What is certain, though, is that the earliest name the Greeks used for Britain was Albion. Centuries later, after the Roman invasion, Pliny noted

tantalisingly that it was the name the people of Britain used themselves, but neither he nor any other classical writer offered an explanation for its origin.[4] The most likely etymology is that it derives from a Celtic word meaning 'white', and the reason is probably as obvious as it seems. On a clear day, anyone standing on the cliffs of Calais and gazing across the Channel can see the White Cliffs of Dover towering and gleaming across the strait. And what could be more instinctive than to call that island the White Land?

Humans are not indigenous to the British Isles. The first people to venture to Britain were migrants: nomad hunters who trekked from modern-day Denmark, Germany and the Netherlands following herds of wild game. Britain was not then an island, but a long peninsula jutting from continental Europe into the Atlantic. The land they found turned out to be good for the hunters, who were initially interested in large animals. But in time they also came to benefit from its coastal waters heated by the Caribbean currents of the Gulf Stream making them unusually warm for the latitude. These waters were also relatively shallow, thanks to the wide, northern European Continental Shelf, and the combination of warm and shallow made fish plentiful and easy to catch, creating a bountiful ecosystem of bird and animal life to predate. It was something of an Eden. Unfortunately for the first settlers, however, after discovering such promising new hunting grounds, the British weather sent them packing.

The planet was, and is, slowly cycling through oscillations of temperature extremes in the form of glacial and interglacial periods. Over hundreds of millennia these have seen Britain bask in tropical weather then lie buried under continental ice sheets up to three miles thick. Each time temperatures have plummeted, food has become scarce, and humans have abandoned Britain for warmer climes.

Archaeologists know when the first nomad hunters came to Britain because the wanderers left their footprints in the sands. Literally. In 2013 scientists studying the low-tide seashore at Happisburgh on the Norfolk coast discovered extraordinary imprints of Stone Age feet. Analysis provided a date of 950,000 to 850,000 BC, and an assessment that the tracks had been left by a mixed group of five adults and children, who all seemed to be scampering towards Great Yarmouth.[5] There was international fascination and wonder at the discovery, with the ancient indentations quickly identified as the earliest recorded human footprints on the planet outside Africa. Sadly, the elation evaporated when the sea washed them all away within a fortnight.

No human bones have been found in Britain from this earliest period. The oldest human body parts – in other words, the oldest Briton – date from far later, around 500,000 BC. There is not much to them: just a shin bone and two incisor teeth from a man or woman who stood around five foot nine inches tall. They were found at Boxgrove near Chichester, along with well-crafted flint tools including hand axes. Beside them were bones of horses and rhinos scarred by the tell-tale nicks and gouges of having been butchered with tools, along with the remains of bears, hyenas, lions, water voles and wolves. The first Britons, it seems, were committed meat eaters.

At this stage of prehistory, many different species of human roamed the planet, and the earliest settlers in Britain reflect this species diversity. The oldest human bone found anywhere in the world was unearthed in 2015 in Ethiopia. It is a partial jaw belonging to the first species that was human rather than ape, and dates from 2.8 million BC.[6] The old theory that humans evolved sequentially and progressed from one species to another is long dead. Instead, a wide variety of human species appeared and disappeared in a chaotic evolutionary game of snakes and ladders. Some lived side by side for hundreds of thousands of years. Others were extinct by the time variant species emerged. The oldest bone fragment – the one from Ethiopia – is so small no one can tell whether the person was *Homo habilis* (skilful man) or *Homo rudolfensis* (Rudolf man), but both species were probably evolutionary dead ends. The human line that would go on to thrive probably derived from *Homo ergaster* (working man) and *Homo erectus* (upright man), although it is possible the two are actually the same species. In Britain, the humans who left their footsteps at Happisburgh were probably *Homo antecessor* (pioneer man), while the person who flayed and cooked large animals at Boxgrove was *Homo heidelbergensis* (Heidelberg man).[7]

Today's humans – *Homo sapiens* (wise man) – evolved very late in the overall human story, around 300,000 BC. They shared the planet with other human species, and took a special shine to *Homo neanderthalensis* (Neanderthal man). Although the Neanderthals had notably larger and stockier physiques, the two species managed to interbreed – maybe consensually, maybe not – with just enough vigour for today's Eurasian *Homo sapiens* to retain 1.8 to 2.6 per cent Neanderthal DNA.[8] *Homo sapiens* is not the physically strongest human ever to have lived, or the one with the biggest brain, but it eventually won the evolutionary battle of the hominins. All other human species were extinct by 40,000 BC and, when the

Neanderthals died out around 37,000 BC, *Homo sapiens* was left as the sole human inheritor of the earth.

Until now, *Homo sapiens* had showed little interest in Britain. But it was around this time that they probably first ventured up onto the British peninsula, coming and going as the climate fluctuated.[9] A group of them known as the Creswellians arrived in 12,700 BC. but were gone by the time the dark-skinned Maglemosians arrived around 10,000 BC to begin the permanent settlement of Britain. The next glacial period is expected to reach its maximum in 100,000 years' time – although global warming may yet have an effect on the cycles – and the freeze will almost certainly see *Homo sapiens*, if there are any left, abandon Britain and head south again in search of sunshine, as they always have.

The reason *Homo sapiens* returned to Britain around 10,000 BC is that the Devensian glacial period was ending, and northern Europe was warming up into the Flandrian interglacial – which the planet is still in – making Britain habitable again. Shortly after, around 6200 BC, as the ice sheets shrouding the British peninsula melted and ran off into the sea, something seismic happened that would dramatically change the physical geography of Britain. The water that had been trapped as ice in the glaciers poured into the oceans raising global sea levels by 120 metres.[10] Then, deep in the clear waters north of Norway, around 720 cubic miles of continental shelf snapped off and plummeted into the depths, causing a vast inland Norwegian lake to rupture, fuelling possibly the largest tsunami the planet has ever seen. The monster tidal wave hit Britain so hard that a 14-metre wall of water bulldozed its way up to 25 miles inland. The change in the structure of the oceans caused the southern and eastern regions of the British peninsula to flood expansively, and the fertile wetlands where the Thames and Rhine met in a vast bowl were completely drowned under billions of tons of water. This whole area – Doggerland – disappeared beneath a much-enlarged North Sea, and at the same time a new strip of water buried the south of the peninsula under the English Channel, cutting Britain off as an island. Before long, the Irish Sea also rushed in, separating Britain and Ireland into two, giving the British Isles the unique geography that would fundamentally shape their history.

Humans have always been inherently creative, and archaeology offers a spectacular glimpse inside the prehistoric British mind and soul at around this time. For centuries, Britain was believed to have no prehistoric art like that at Lascaux in France or Altamira in Spain. Then, in 2003, a team

studying caves at Creswell Crags on the Nottinghamshire–Derbyshire border unexpectedly found that their walls and ceilings were festooned with a dozen engravings, including a bovid – probably an aurochs – a deer, a partial horse, and shapes which are either birds or stylised women or parts of women.[11] The carvings are immediate, intense and dynamic, but nothing about them is known except that they were created around 12,700 to 11,000 BC. They may have been conceived by religious figures as part of some sacred space. Or they may be the result of families and children beautifying their homes. Or, conceivably, they may just be the labour of an early Briton who agreed with Nietzsche that existence is ugly and people need art to avoid being crushed by reality.[12] All that is certain is that, as with prehistoric cave art from elsewhere, the pictures radiate a deep, primal bond between the human and animal worlds.

Today, the British are known for their love of animals, and the Creswell Crags engravings suggest this fascination goes back millennia. They are, in fact, not the only evidence that animals played a significant role in prehistoric British culture. At Star Carr in Yorkshire's Vale of Pickering, haunting ceremonial headdresses crafted from red deer skulls and antlers suggest that their prehistoric owners performed animal spirit rituals around 9000 to 8000 BC.[13] And, at Uffington in Oxfordshire, the mystical, 111-metre-long, flowing, galloping horse carved into the chalky hillside between 1200 and 800 BC spectacularly prefigures modernism in its exuberant evocation of raw animal energy.[14]

Throughout history, humans have engineered technological upheavals that have radically altered their experience of living. These have included the print, industrial and information revolutions, but the most momentous of all – so far – began around 10,000 BC in Syria and Iraq, reaching Britain 6,000 years later. Although there was no flick-of-the-switch moment when nomadic life became sedentary, over a period of time, seasonally at first, Britain's hunters gradually settled in farmsteads and hamlets, where they grew crops and tended livestock, bending the natural world to their will, commanding it and dominating it for their convenience. Domestic British life then became recognisably modern. People built houses, usually out of wood, although at Skara Brae in Orkney they only had stone, and a handful of dwellings there from 3180 to 2500 BC have survived the millennia to reveal a strikingly familiar layout, with hearths, beds, seating areas, and even dressers for displaying treasured objects. This seems to have been a standard model, as traces of identically proportioned wattle and daub houses have been found in England.[15]

One of the places in the country with the earliest intermittent human habitation is the sprawling, grassy downlands of Wiltshire's Salisbury Plain. At Blick Mead on the western edge of Amesbury animal remains in pits reveal that its inhabitants were feasting on aurochs, boar and deer as long ago as 8820 BC.[16] The pits also contain frog bones, but it is not clear whether these were enjoyed as a delicacy or were simply unfortunate passers-by. However, what makes the site even more significant is that just over a mile away is something the people of the Plain left that the whole world still marvels at. Stonehenge.[17]

Prehistoric circular monuments are not rare in the British Isles: there are over a thousand.[18] But the sheer, vaulting ambition of the stone structure three miles north-west of Amesbury is unique among them in many ways. At a time when most of England was wooded, the vast, geometric rings of stone on the cleared chalk downland would have been – as they still are – breathtaking in their scale.[19]

The Stonehenge visible today is the product of multiple phases of building. A piece of charcoal has been found on the site dating from around 7000 BC, but the main monument was built in five stages between 3000 and 1600 BC, beginning with pits and posts, and culminating in an intricate complex of concentric stone and earth circles.[20] The scale of what the builders achieved is extraordinary given that the largest upright stone is nine metres high (including 2.4 metres underground) and weighs 28.1 tons. The skills and manpower needed to quarry, dress, transport and install stones of this size are also stupendous, as was demonstrated in 2000 when a millennium project to honour the original journey of the Welsh bluestones from Preseli in Pembrokeshire to Wiltshire proved just how extraordinary an achievement Stonehenge is. A thousand-strong crew of volunteers failed to move one stone from the quarry to the nearby river without having to call in a mechanical crane, and a replica prehistoric barge built to transport the menhir by sea quickly sank off Milford Haven taking the doomed stone to the deep. Experts now believe the bluestones were dragged overland.

The identity of the Plain people who undertook all this building remains an intriguing question. Dark-skinned Maglemosians had settled in Britain permanently in 10,000 BC replacing the earlier Creswellians, but there were then two further, immense population events. The first came at the time of the farming revolution around 4000 BC – before major work started at Stonehenge – when an influx of continental farmers replaced the existing population.[21] The second came during the third stage of Stonehenge, when

another wave of farmers arrived. They are known as the Bell Beaker people from the shape of their drinking vessels and, within 1,000 years of arrival, their DNA replaced 90 per cent of that previously extant in Britain.[22] Whatever they made of Stonehenge, they carried on with the building works.

The effort required to construct Stonehenge was immense. During the second stage of construction, from 2620 to 2480 BC, the workers' settlement at nearby Durrington Walls had around 1,000 houses, with its women and children also involved in the monument's construction.[23] Cremated bones found in its earliest pits are predominantly those of women – a find consistent with cremations around the country in the period – perhaps because the slump in population of the period led to a high status for women and their fertility.[24] Tantalisingly, most of these bones belonged to people from Wales, but there is no ready explanation for this yet.[25]

Stonehenge's purpose remains an enigma, with the most recent theory being that it was a place to honour ancestors, and an extraordinary recent discovery of a ring of large holes at Waun Mawn in the Preseli Hills – where Stonehenge's bluestones came from – may indicate that the stones had first been set up as a circle in west Wales, meaning that Stonehenge has a direct link to Welsh ancestors.[26] How the monument was used in ancestor celebration is not clear, but excavations show that the site itself was kept clean, with the pits of bones from seasonal feasts dug well away from the monument itself.

Eventually, Stonehenge began to crumble and was fenced off with a palisade wall. Society moved on, and the monument became obsolete. No one was able to recall what it had been used for, and few cared. Numerous of its stones were taken away to be incorporated into new buildings like Durrington Church and Amesbury Abbey. The first scholar to investigate Stonehenge in a dedicated manner was the seventeenth-century antiquary, folklorist, biographer and proto-archaeologist John Aubrey, who originated the theory that it was a druid temple. He was wrong, as it predates the druids by millennia. But, in the following century, enquiring Enlightenment savants began taking a scientific interest in the monument as part of Britain's heritage. It baffled them until 1740, when the antiquarian William Stukeley spotted that the avenue, circles and inner horseshoe all align with the solar cycle.[27] He published his findings to widespread excitement and talk of majestic pagan rites, sparking a trend that sees neo-pagans and neo-druids descend on Stonehenge at midsummer to celebrate the misty Wiltshire sunrise.

Despite the international fame of Stonehenge's summer solstice festival, recent discoveries have put it into doubt. Tooth analysis from the nearby remnants of prehistoric feasts and revels shows that the animals – some possibly from Wales – were not slaughtered in summer, but in autumn and winter. Furthermore, while looking north-east from Stonehenge up the Avenue leads the eye to the midsummer sunrise, looking south-west down the Avenue and into Stonehenge precisely frames the midwinter sunset, and the dressing of the sarsens only enhances their appearance when observing them in this wintery direction. The revivalist neo-pagans are therefore out by six months, as Stonehenge was predominantly for winter ancestor rites, when the solar year turns at the solstice and the days begin imperceptibly to lengthen, the dark and barrenness of winter start to recede, and hope for the spring, fertility and nature's creative powers returns.[28]

Another surprising discovery about Stonehenge is that it was not solely for the residents of Salisbury Plain. There is a historical myth that before the age of railways people had little knowledge of life a few miles from their birthplace, but humans have always been travellers. The discovery of the Amesbury Archer – interred on Salisbury Plain around 2480 to 2290 BC – offers striking proof. He was of high social status, having been buried with arrow heads, metalworking tools and the oldest gold found in Britain. His teeth, however, are even more remarkable, because the oxygen isotopes locked into their enamel reveal that he grew up in central Europe. And he is not alone as a foreigner on Salisbury Plain. The Boscombe Bowmen interred nearby with arrow heads and other grave artefacts around 2580 to 2220 BC are also far from local, as their tooth enamel reveals an origin possibly in west Wales but more likely Brittany or northern France.[29] The wonder of all this prehistoric travel is that, without maps or compasses, people were capable of navigating to a monument on Salisbury Plain from all over the country, and as far away as central Europe.

While much of Stonehenge – and the wider area on Salisbury Plain – remains a mystery, the site continues to give up ever more information about the complexity of the Stone and Bronze Age cultures that lived there. In 2020 archaeologists uncovered a ring of immense shafts 10 metres wide and 5 metres deep in a circle whose diameter is a gargantuan 1.2 miles and is centred at Durrington Walls two miles north-east of Stonehenge.[30] It is yet another intriguing piece in the baffling puzzle that may one day reveal what early Britons believed, and how they celebrated with rituals. For now, the leading theory is that Stonehenge was a place for commemorating and

celebrating the ancestors, while Durrington Walls and its monuments were for celebrating the living.[31]

The discovery of the Durrington Walls circle came only eight years after another unexpected revelation of a much more immediate and human kind, when experts found that four of Stonehenge's megaliths have a total of 115 axe heads and three daggers carved onto them.[32] Although a few of them had been identified in the 1950s, and others have been found at Badbury in Wiltshire and at Kilmartin Glen in the west of Scotland, it came as a surprise that there were so many carved on Stonehenge, unexpectedly revealed during a laser scanning project. There is, of course, a significant amount of graffiti on the stones from the last few centuries – including a signature thought to be Sir Christopher Wren's – but the axe heads and daggers are without question prehistoric, and date from 1750 to 1500 BC.[33] They are the first document in this book: an enigma left to posterity by the people of the Plain.

Esther Smith/Alamy Stock Photo

Stonehenge, Carvings of Axe Heads and Daggers (1750–1500 BC)

Intriguingly, the menacing, curved blades of the axe heads all point resolutely skywards, while the stiletto-sharp tips of the daggers are aimed firmly at the earth. There is clearly a pattern to their arrangement, and almost certainly a meaning, but the significance has been lost along with the people that carved them. The blades may have had a symbolic funerary connotation as, by the time they were carved, Stonehenge was at the centre of the

largest collection of round funeral barrows in western Europe. But all that is really clear is that there is a celestial alignment, with most of the axes facing east to the rising sun, while the daggers face the southern major moonrise. They may additionally have referenced something ceremonial, acted to propitiate deities, or even warned visitors that the people of the Plain knew their way around sharp, bladed objects. The meaning, however, is gone. Whatever the axes and daggers' purpose, Stonehenge is one of the earliest documents in Britain depicting weapons. As this book will show, Britons have been notably attached to them down the centuries, and proved consistently efficient at using them.

2

Chariots and Woad – A Patchwork of Celtic Tribes

Julius Caesar
The Gallic War
c. 50 BC

Wetwang is a small village of just under 800 people in the East Riding of Yorkshire. It appears in the *Domesday Book* as 'Wetuuangha', and its battle-mented medieval church of St Nicholas dates from not long after.[1] In 2001 building contractors surveying one of its many paddocks stumbled across a significant-looking earthwork. They called in English Heritage and the British Museum and, as the teams delicately lifted off successive layers of soil, they realised they were opening a 2,250-year-old grave. After carefully digging deeper, they eventually uncovered – undisturbed by the millennia – a well-preserved skeleton. And a chariot.

As the contents of the grave emerged into daylight, the chariot and other artefacts proved to be richly decorated with metalwork, glass and coral, indicating that the individual was of exceptionally high status. There was an intricate coral brooch, an ornate iron mirror, and a fur-lined bag with a drawstring of glass beads. All these confirmed the remarkable sophistication of British Bronze and Iron Age society in the thousand years before the Roman conquest, but what surprised the experts most was that the bones, once washed and assembled, turned out to belong to a tall woman.[2]

Warriors across the ancient world hurtled into battle on two wheels, and the Celts of Britain were internationally renowned for their combat skill with vehicles.[3] Burying warriors together with their chariots was relatively rare, but did occur for periods in parts of China, Cyprus, France, Germany, India, Russia, and east Yorkshire.

Anyone who has stood beside the Palace of Westminster, next to the outsize bronze statue of Boudicca thundering through the capital in her scythed chariot, will be familiar with Celtic warrior women. The difference is that Thomas Thornycroft's dungeons-and-dragons effigy in Westminster is a work of imagination – high, imperial Victoriana with rearing horses and Boudicca's semi-nude daughters – while the Wetwang skeleton is a real Iron Age woman and her chariot.

In life, the Wetwang chariot woman evidently enjoyed wealth, status and power, quite probably as a queen. Her world was part of a complex tribal network that emerged across late prehistoric Britain, splitting the country into competing kingdoms. The Parisi – who buried her around 250 to 200 BC – ruled east Yorkshire.[4] The Iceni controlled Norfolk, Suffolk and Cambridgeshire. The Dumnonii governed Somerset, Devon and Cornwall. The Silures reigned in south Wales. The list runs to dozens of tribes, all guarding and fighting over their respective territories in a patchwork of independent kingdoms. This tribal mosaic was replicated over much of northern Europe, and even Asia as far as Anatolia, with some tribes split over multiple territories.[5] The Belgae and Atrebates of southern England, for instance, also had territory in France. And for a period in the first century BC, a ruler named Diviciacus was the most powerful in France, presiding over a realm that stretched either side of the Channel a thousand years before William the Conqueror's Anglo-Norman kingdom.[6]

Each of these rival tribes had a ruler, capital and identity. Because all the tribes spoke related languages and, to a degree, produced objects in similar styles, they have all come to be known as Celts, although those in Britain did not use the name. However, the term only indicates loose linguistic and cultural bonds. The tribes did not necessarily share DNA or identity, and nor did they see themselves as one culture or people.

Further south, in the entirely different world clustered around the Mediterranean basin, written accounts of day-to-day life – and even of heroic exploits – reach back as far as Homer's *Iliad* and *Odyssey* composed around 900 to 700 BC.[7] Britain has no equivalent written accounts of life from this period to give a flavour of the people's priorities and

preoccupations, but an ancient celebrity as famous as Homer did visit Britain a while later, and he left a colourful and intensely detailed description of what he found.

In 58 BC Julius Caesar ruled Rome as part of an informal triumvirate bringing together politics, the military and money. Hungry for greater personal power, he needed glory and wealth to propel him higher still. Rome already controlled the south of France (Gallia transalpina), so he set his eyes on the rest. Wrapped in his blood-red battle cloak, he headed into barbarian country, and hurled his legions against the Celts of central and northern France. The result was an eight-year campaign of total destruction. The Roman author Plutarch, one of Caesar's earliest biographers, estimated that the would-be dictator sucked three million Gauls into battle, left one million dead, and took another million prisoner.[8]

As his Gallic campaign progressed, Caesar learned that bands of Britons were fighting alongside the Gauls, and that Gaulish warriors were periodically slipping through his net to safety across the Channel. After consulting advisers and spies, he learned to his interest that Britain had significant natural resources. To a military commander and politician looking to extend his *imperium*, both were strong reasons to investigate an island that was barely more than a myth. Some ancient writers even maintained it did not exist and that the world ended at the Channel with the realm of the mighty, watery god Oceanus.[9] Keenly aware that mastery of such a dangerous waterway could only boost his reputation for valour, Caesar made preparations for a Channel crossing and, in late summer 55 BC and again in 54 BC, braved the waves with thousands of cavalry and infantry. To his frustration and disappointment, the visits achieved little apart from the discovery, on both occasions, that storms wreck ships left moored off the coast of Kent.[10]

In Rome, Caesar's enemies were by now openly fomenting rumours that his Gallic war was fuelled by vainglory and ambition. As so many politicians before and since, he decided to control the damage by ensuring that his version of events became the best known. So he set about writing a cut-and-thrust tale explaining to the person in the streets of Rome – in plain Latin, not the Greek of the Roman intelligentsia – that he was merely a loyal Roman soldier doing no more than his job for the good of Rome and its people.[11] The result was the *Gallic War* (*De bello gallico*) which, despite the self-serving political messaging, is unambiguously one of the most fascinating and important documents in British history, and the only surviving eyewitness account of life in Iron Age Britain.[12]

Bibliothèque Nationale de France | MS Lat 5763, fol. 1r

INCIPIVNT LIBRI IVLII CAESARIS

BELLI GALLICI IVLIANI DE NAR

RATIONE TEMPORVM

GALLIA EST omnis diuisa inpartes tres; quarum unam incolunt belgae. aliam aquitani. tertiam qui ipsorum lingua celtae. Nra galli appellantur hi omnes lingua institutis legibus intersese differunt. Gallos abaquitanis. garunna flumen abelgis matrona & sequana diuidit horum omnium fortissimi sunt belgae propterea qd acultu atq; humanitate prouinciae longissime absunt minimeque adeos mercatores saepe comeant atq; eaquae adeffeminandos a mos pertinent inportant proximique sunt germanis qui trans rhenum incolunt quib; cum continenter bellum gerunt quadecausa heluetii quoq; reliquos gallos uirtute precedunt quod fere cotidianis praelus cumgermanis contendunt. Cum aut suis finib; eos prohi bent aut ipsi ineorum finib; bellum gerunt eorum una pars qua gallos optinere dictum est. initium capit aflumine rhodano. con tinetur garunna flumine. oceanum finis belgarum attingit tur absequanis & heluetus. flumen renum uergit adseptentri ones belgae abextremis galliae finib; oriuntur. pertinent adinfe riorem partem fluminis reni spectant insententrionem & orientem aquitania agarunna flumine adpyreneos montes & eam partem oceani quaest adhispaniam pertinet spectat inter occasum solis

5703.

Julius Caesar, The Gallic War (c. 50 BC, this manuscript AD 800–825)

The *Gallic War* was a hit in Rome and the wider ancient world, and it remained popular into the medieval period when it was frequently recopied by monastic scribes for an eager audience of clerics and literate laypeople, becoming one of the earliest books to be mass produced in the late 1400s once printing presses were set up in Rome. Its bald, direct prose has made it staple Latin teaching material for centuries, and its opening sentence continues to reverberate around classrooms across the world: *Gallia est omnis divisa in partes tres* (All Gaul is divided into three parts).[13]

Always on the lookout to showcase his bravery and astuteness, Caesar was eager in the *Gallic War* to include accounts detailing his audacious crossing of Oceanus into the unknown. Gauls, including traders who regularly plied the Channel, had refused to tell him much about Britain, so once he had landed on the east coast he sent his men out into the southern regions to discover what they could about the strange land. The people, Caesar learned, were called Britons.[14] The Greeks had long since dropped the name Albion for the island and switched to *Prettanike*, which probably came from a Celtic word meaning painted or tattooed people. It evolved into Britannia, and stuck as the country's name.[15]

On arrival, Caesar's first priority was to understand exactly who its inhabitants were, and how they lived.

> The inland part of Britain is inhabited by people traditionally believed to be indigenous to the island, the coastal part by people who immigrated from the land of the Belgae for plunder and war (almost all bear the names of the communities they came from) and, having waged war, settled there and began to farm the lands. The population is beyond counting, and the buildings are crammed together, built like those of the Gauls.

His view that the coastal tribes came from the continent was not shared by everyone. Diodorus of Sicily, one of Caesar's contemporaries, stated that the people of Britain were all indigenous.[16] Meanwhile, Tacitus weighed in with a theory connecting the people of Scotland with Germany, Wales with Spain, and southern England with France, but concluded that no one really knew, which was normal with barbarians.[17] Modern historians and archaeologists remain equally at odds on the question. No one is sure whether, before Caesar, Britain was invaded by one or more major waves of European Celts. Whether small groups of them came and settled sporadically. Whether

the indigenous Britons simply adopted mainstream Celtic language and culture through trade and kinship. Or whether there was some combination of all three.[18] A popular modern view is that there was no 'coming of the Celts' in a large-scale, violent displacement of people, but that multiple small pockets of European Celts settled in Britain through war and trade, while indigenous Britons simultaneously assimilated into broader northern European Celtic culture. There had certainly been millennia of very close contact and movement across the Channel. The oldest intact seagoing vessel in the world – dating from 1500 BC – was found in Dover and, even further back, the Amesbury Archer had made it to Wiltshire from central Europe two thousand years earlier.[19]

Caesar was aware that the Greeks believed the Britons were painted or tattooed, and he quickly understood why.

Truly, all the Britons dye themselves with woad, which gives them a blue colour, and accordingly a more terrible appearance in combat.

As well as verifying the Britons' cabbage-based body art, he observed that the men had a distinctive style of grooming.

And they have long hair, and they shave their entire bodies except the head and top lip.

Caesar was inquisitive, and moved around the south of Britain, meeting different tribes. The most civilised, he concluded, were the people of Kent, whose way of life he found was very similar to that he had seen in Gaul.[20] His interest extended to all aspects of life in the country, including family and domestic arrangements.

Ten to 12 men share wives among themselves communally, particularly brothers with brothers, and fathers with sons; but whoever are born out of this are considered the children of the man who first seduced the virgin.

Caesar was, of course, composing propaganda to burnish his reputation as the crusher of barbarians and torchbearer of civilisation. There is, therefore, no way to know whether this description was true or simply invented. He was definitely interested in domestic arrangements generally. In another passage he described to his amazement how in Gaul husbands were required

to match their wives' dowries, then the couple managed the wealth together with the survivor inheriting all. This was in stark contrast to Roman culture, in which women had few rights. He even went on to note, perhaps to redress the balance, that at least British men had the power of death over their wives and children.[21]

The general Roman view of the Celts was that they were drinkers and fighters. Diodorus of Sicily wrote that the Gauls were so addicted to wine they drank it unmixed and fell into a stupor or a state of madness. So keen on wine were they, he continued, that Italian merchants visiting Gaul could exchange an amphora of wine for a slave.[22] With regard to the Celtic fighting tradition, the Romans had first-hand experience of meeting Celts in battle, and scars by which to remember the encounters. In 390 BC a Gaulish army wiped out a Roman one at the Battle of the Allia, then occupied Rome for several months. It was the only time Rome fell before its ultimate decline, and a defeat the Romans never forgot. Nor how Brennus, the Gaulish leader, when upbraided by a conquered Roman for using rigged scales to measure out the gold tribute he demanded before leaving, answered with the blunt *Vae victis!* (woe to the conquered!).[23] The Celts' reputation as warriors was widely known, and they hired themselves out as mercenaries around the world, including to Rome, and even to specialist units like Pharaoh Cleopatra of Egypt's bodyguard.[24] The Romans were, therefore, keenly aware the Celts took fighting seriously, and even seemed to quite enjoy it. At the battle of Telemon in 225 BC, the Gaesatae, a Gaulish tribe from the Alps, 'owing to their proud confidence in themselves' stripped off and fought naked against the Romans. Sadly, however, their ebullience did not carry the day for them.[25] Of all the Celtic warriors, Tacitus singled out the Britons as especially fierce, while noting that the Gauls had been formidable, but were now grown lazy and ineffectual at warfare.[26]

Caesar had therefore expected strong military resistance to his arrival, but was nevertheless dumbfounded on seeing hordes of heavily armed Britons wheeling about in chariots: a vehicle that had long been obsolete in the Mediterranean world. The sight left his army 'terrified', and his commanders and men readily admitted they were 'wholly inexperienced in this sort of fighting'.[27] He watched closely, and left a detailed account of their tactics.

> This is the way in which they fight with chariots. They start by charging about in all directions and throwing their spears, and they break [the enemy's] ranks through fear of their horses and noise of their wheels, and

once they have worked their way among [the enemy's] cavalry, they leap from their chariots and attack on foot.

Caesar saw British charioteers in action several times. In addition to skirmishes around the Roman beachheads, he watched Cassivellaunus bring 4,000 charioteers to confront him at the Thames.[28] And after observing their manoeuvres, Caesar assessed them to be a well-drilled and skilled military force, noting with interest that they never fought in close order, but always spread out in groups with fresh warriors taking the place of the tired.[29]

And by daily practice and exercise they become so skilled they can gallop their horses at full tilt down the steepest slopes without losing control, and check and turn them instantly, and run along the pole and stand on the yoke and then, in the blink of an eye, dart back into the chariot.

Caesar wanted to know his enemy thoroughly, and was also interested in how wider British society functioned. He knew from Gaul that the two dominant groups were the druids and the knights, and his account of druids is the earliest description of their way of life. He explained that they oversaw sacred activities, conducted public and private sacrifices, interpreted questions of religion, determined legal disputes, were exempted from military service, and did not pay taxes. They were organised under an elected chief druid, and gathered every year in the land of the Carnutes around Chartres and Orléans.[30] He also revealed druidry's rather surprising home.

It is believed the [druids'] teachings were discovered in Britain, and then spread to Gaul, and now anyone who wants to deepen their knowledge of the subject generally travels there [to Britain] to learn more.

Caesar was understandably intrigued by the druids, and learned that their training could take up to 20 years and involved committing a vast corpus of poetry to memory. However, he was unable to uncover many details, as the druids explicitly forbade anyone from writing down the content of their religion.[31] Despite this secrecy, Caesar managed to establish that they assiduously followed the movements of the celestial bodies, and taught that 'souls do not die, but pass from one body to another after death'.[32] Tacitus added that the druids performed grisly human sacrifices for

divining the future in the entrails of the dying, and Caesar reported that they conducted human sacrifices to propitiate the gods using what would later be termed 'wicker men'.

> Others have human effigies of enormous size, with limbs woven from branches, filled with living men, which are set ablaze, engulfing the men in flames and killing them. They believe sacrificing those guilty of theft or robbery or other crimes is more pleasing to the immortal gods; but when a plentiful supply of them is absent, they turn to sacrificing even the innocent.

As with his account of the Britons' incestuous polygamy, it is impossible to know whether this account is fact or propaganda.

Caesar was also curious about the Britons' food and diet, which constituted key intelligence for a military commander.

> The number of cattle is large . . . Most people living inland do not sow corn, but live off milk and meat and dress in animal skins.

Although the Britons were strongly carnivorous, he noted that not all animals were prepared for the table. Some were kept as pets.

> They believe it is improper to eat hare, hen, and goose; however, they rear these for enjoyment and pleasure.

Caesar did not get to plunder the natural resources he had been told of, but established that Britain was self-sufficient in tin and iron, although it imported bronze.[33] The resulting economy, he noted, was sophisticated, with established systems of exchange.

> For currency, they use bronze, or gold coins, or iron bars with specific weights.

Many coins have been found from the period, with the most extensive collection being the Hallaton Treasure of 5,292 gold and silver coins dating from around the time of the Roman invasion. Like other hoards, it includes coins from elsewhere in the country, and even from Rome, demonstrating the vibrancy and reach of established national and international trade.[34]

After investigating the country and its barbarous inhabitants, Caesar concluded that he did not have the resources for conquest, so – once his intelligence gathering was complete – decided it was time to weigh anchor. As his ships sailed away, Britain entered its last century of prehistory: a thriving period that was to bring two important changes. The first was that Britain – so long a mythical realm at the edge of the world beyond the waters of Oceanus – was now firmly on Rome's radar, not least because of Caesar's bestselling war memoirs. The second was Caesar's conquest of Gaul, which placed the mercantile communities of southern and eastern Britain in close and frequent contact with the wealthy Roman Republic and, from 27 BC, the Roman Empire. The centuries-old cross-Channel trade routes with France (Gaul), Brittany (Armorica) and Spain (Iberia) now connected Britain directly with the wide market of the Roman world, bringing an unprecedented intensity of exports and imports of luxury and exotic goods, yielding strong economic benefits for the south and east of England.

It was not only the Romans who had views on the Britons. The compliment was returned. 'Plunder, massacre, rape: these they misname empire; and where they make a desert, they call it peace', a Scottish chieftain proclaimed of the Roman Empire.[35] Almost a century after Caesar sailed back off across the Channel, Claudius's four legions plus auxiliaries mustered at Boulogne for the AD 43 invasion of Britain, well aware they faced warriors with a long history and proud traditions. The Celtic tribes of Britain – descendants of the builders of Stonehenge and the Wetwang chariot woman – had deep roots in their White Land, and would not cede control without a fight. What the legions did not know, however, was, once conquered, quite how difficult it would be to impose effective military rule over the misty island on the edge of the known world.

3

Togas and Trade – The Edge of Empire

Claudia Severa
Birthday Invitation to Sulpicia Lepidina
c. AD **100**

In AD 208 the Libyan-born Roman Emperor Septimus Severus travelled to Britain to unleash war on the skirmishing tribes of lowland Scotland. The statesman and historian Cassius Dio relates that once the armies engaged the Scots ran rings round the Romans, and the battle ended in a treaty. At the signing ceremony Empress Julia Domna – Severus's wife, a Syrian by birth – joked with the wife of a Caledonian chief that the women of Scotland were unashamedly promiscuous. The wife, whose name is lost, did not hold back in her reproach. 'We fulfil the demands of nature in a much better way than do you Roman women; for we consort openly with the best men, whereas you let yourselves be debauched in secret by the vilest.'[1]

Dio did not comment on which of the two he sympathised with, but he was generally disapproving of the Scots, who lived in tents 'naked and without shoes' and – echoing Caesar's earlier observation about the Britons in the *Gallic War* – 'possess their women in common, and rear all their offspring communally'.[2] Even if Dio was inventing this incident and description of the Scots, the fact he had a ready audience for his tales of British barbarism reinforces the sense that, after a century and a half of Roman presence in Britain, the cultural chasm between occupiers and natives was still wide.

When Claudius's legions had finally landed in southern England in AD 43, it was almost a century since Caesar had sailed away. In that time, the conquest of Britain had not been high on any emperor's agenda. Augustus had thought about it, but other regions pulled his attention elsewhere. Tiberius was similarly distracted with other campaigns, principally in Germany and eastern Europe. The insane Caligula came as far as forming up his legions on the French side of the Channel, but then ordered them to collect seashells. In the end it was the unlikely Claudius – partly deaf, with a limp, and passed over until his surprise elevation to the purple – who finally loosed the most feared army in the ancient world on Britain, and afterwards took the title *Britannicus*: conqueror of Britain.[3]

Rome's newest territory joined the empire as Provincia britannia, bringing the extreme north-west corner of the known world into a military and trading bloc that extended from the north of England to sub-Saharan Africa, and from the west of Spain to Syria. In time, Rome personified the new province as a young warrior goddess – Britannia – arrayed for battle with trident, shield and helmet. Sometimes she was shown dominating Oceanus: a theme to be taken up a millennium and a half later when Britain had its own empire. Britannia became Britain's national logo, and Emperor Hadrian minted the first coins bearing her image, armed and confident. Although she disappeared when Roman Britain disintegrated, Britannia returned on coins in the reign of King Charles II, and has remained on them ever since.

After the conquest Rome imposed its will on Britain through political appointees backed by the military, bribery, and the threat of the legions returning in anger. There was initial hostility to the occupiers but, as the decades passed, increasing numbers of the Celtic-British elite embraced aspects of Roman life for business and social advancement. They learned Latin to ingratiate themselves, wore togas, built villas, and imported wine and olives to oil their aspirations.[4]

The period AD 43 to 410 is known as Roman Britain and, perhaps misleadingly, implies that the British Isles became a North Sea version of Italy. In fact, just as Roman France, Roman Greece and Roman Syria-Palestine all developed their own unique hybrid identities, so did Roman Britain.[5] For a start, the Romans only focused their attention on certain parts of Britain, ignoring others entirely as their goal had never been to overrun the whole of the British Isles at all costs. Caesar's reconnaissance had revealed that the south and Midlands had wealth, and by the time of the invasion had

developed extensive trading links with the empire and were of most interest to the Romans. Elsewhere, the occupation was lighter and sporadic, especially in Wales, the west and the north. In Scotland the legions never held territory for long, and they did not venture to Ireland at all. 'Partly Roman Britain (Sometimes)' would be a more accurate description.

For many Britons life under the Romans remained largely unchanged from before. The general population continued to live in traditional round houses, and – unless they were involved in day-to-day trade and administration with Romans – carried on speaking Celtic languages. However, at times they could be rebellious, and Rome planned for periodic violence. In Gaul, successive emperors had come to fear the power of the druids to unite the disparate tribes in rebellion, so outlawed them.[6] They had similar anxieties about the British druids, but went a stage further. The showdown came in AD 60, when the Roman Governor marched on the last British druid stronghold, on the island of Anglesey in north Wales.

Aware it would be a fight to the death, the two sides drew up on either bank of the narrow Menai Strait. The druids 'poured out dreadful prayers with their hands held up to heaven' and terrified the Roman army, as did the British 'women dressed in black with their hair all dishevelled, brandishing torches and running between the ranks like the Furies'. Steeling themselves, the Romans waded across the water and attacked. It was no contest, and the Romans burned the druids together with their 'groves devoted to inhuman superstitions' in such a crushing victory that British druidry never returned.[7] However, while the Roman army's focus was on the druids in north Wales, East Anglia had erupted, unleashing a whirlwind rebellion that rapidly escalated to threaten Rome's very hold on Britain.

In general, kings and chiefs of British tribes were permitted to rule and govern more or less as they had before the conquest, but on the understanding that they held their power from Rome. Some did immensely well out of this arrangement, as the lavishness of the villa of the king of the Atrebates at Fishbourne near Chichester shows. But this understanding broke down in East Anglia when King Prasutagus of the Iceni died leaving a will decreeing that half his kingdom was to go to the Emperor Nero and, controversially, the other half to his two daughters. The local Roman *procurator* was incensed, and marched in immediately to reassert full imperial authority. In a brute show of strength, his forces seized Prasutagus's widow, flogged her, raped their two daughters, then stripped the Iceni's nobles of all their possessions.[8]

Cassius Dio described the widow as very tall, terrifying looking with a fierce eye and harsh voice, and a great mass of tawny hair falling to her hips. She wore a tunic of many colours, a thick mantle fastened with a large brooch, and a chunky gold necklace.[9] Her name was Boudicca – a Celtic form of Victoria – and she was so volcanically outraged at the Romans' sadism that she rallied the neighbouring tribe of the Trinovantes to join her Iceni, then unleashed them both on the Roman capital of Britain at Colchester, which she wiped out before annihilating the infantry of *Legio IX Hispana* which had been dispatched to intercept her. She then turned her fury on the newly founded Roman trading city of London, which she burned to the ground, slaughtering its pro-Roman inhabitants with 'beatings, burnings and crucifixions'.[10] Not done, she moved on to the Roman settlement at St Albans, whose inhabitants met the same grisly fate.

When the Romans realised the existential danger to their rule, they rapidly deployed a combined force of *Legio XIV Gemina*, *Legio XX Valeria* and auxiliaries, and met Boudicca at the Battle of Watling Street somewhere in the Midlands.[11] In the moments before the fight, Boudicca rode up and down the lines of her men, her daughters in the chariot beside her – the scene captured in Thornycroft's statue on Westminster Bridge – exhorting her tribesmen to victory, reminding them that women had led Britons to war in the past.[12] The Britons heavily outnumbered the Romans, but the legions had picked the site well and swiftly exterminated Boudicca's forces, who proved no match for a heavily armed and professional army fighting in the open. Tacitus says the Britons lost 80,000 to the Romans 400.[13] Boudicca made it off the battlefield but was dead soon after, probably from suicide.[14] The Britons gave her a lavish burial, but the grave site is long lost. The tradition that she lies under platforms 9 and 10 at London's King's Cross railway station is a modern fabrication.[15]

Key to Roman power in Britain was military force, which resided in garrisons of heavily armed troops stationed in forts all over Britain.[16] The individual soldiers were drawn from across the empire and included British auxiliaries, who gained Roman citizenship for themselves and their descendants after 25 years in uniform, after which they could retire with attractive economic benefits and social privileges. However, following the disaster of the AD 69 to 70 Batavian revolt in Germany, Rome altered its policy and sent auxiliaries to foreign countries rather than letting them police their own. The garrisons in Britain were located strategically around the country, including at Carlisle, York, Chester, Lincoln, Wroxeter, Caerleon and

Colchester. To connect them, and to move troops about the country, the legions built a network of interconnecting roads. In the north, one of the most important was the Stanegate, which ran from the Solway Firth in the west to the Tyne Estuary in the east. For a long time, it served as the northernmost communication route in the empire.

There are few detailed records of life in early Roman Britain, but one notable exception relates to the career of a general named Agricola, who was Governor of Britain from AD 77 to 85. His daughter was married to the orator and historian Tacitus, who honoured his father-in-law by composing a full account of his exploits, with a keen focus on his time in Britain. The resulting book, *On the Life and Character of Julius Agricola* (*De vita et moribus iulii agricolae*), is one of the few pools of light in an otherwise foggy British century.

Agricola had probably fought as a tribune in the showdown with Boudicca at Watling Street. Once Governor, he focused on military matters, completing the conquest of Wales, before turning his forces onto Scotland, pushing deep into the Highlands and, in AD 84, winning the celebrated Battle of Mons Graupius somewhere in the Grampian mountains.[17] Calgacus, the Caledonian confederacy's defeated chief, told him that he had succeeded in conquering the edge of the world, as 'there are no people beyond us, nothing but tides and rocks'.[18] Agricola had finally taken Scotland, but the country's wild geography meant holding and garrisoning it demanded manpower the Romans could not spare as the legions were required elsewhere, notably around the Rhine and Danube. Reluctantly, but acknowledging the reality, the Romans withdrew from Scotland in the late AD 80s and instead built a network of forts along the Stanegate to mark the northern edge of their world.

One notable fort on this boundary was Vindolanda, probably meaning White Plain. Although the empire's border eventually crept a few miles further north, and was then fixed at Hadrian's Wall in AD 122 to celebrate the emperor's visit to Britain, Vindolanda remained a vital northern garrison, halfway between Carlisle and Corbridge, maintained by the excellent connections of the Stanegate and the nearby clay pit and coal, iron and lead mines.[19]

In the 1970s archaeologists working at Vindolanda unexpectedly unearthed a collection of slim, postcard-sized slivers of birch and alder dating from the first and second centuries AD. To their amazement, they found that the wooden postcards were covered in ink script, making them the earliest examples of ink writing in the entire Roman Empire. Over the

years, more than 1,000 have been discovered, and more continue to be unearthed. Among the first to be translated was a note accompanying a care package of sandals, socks and underpants. Others quickly revealed a pictur-esque cast of characters: Atrectus the brewer – probably a Belgian – Vitalis the pharmacist, Virilis the vet, slaves doing deals among themselves, and a host of others.[20] One of the most famous postcards is from Claudia Severa, who was preparing for her birthday party. She was the wife of Aelius Brocchus, a Roman commander stationed nearby, and the card is an invita-tion to a friend at Vindolanda, Sulpicia Lepidina, wife of Flavius Cerialis, Prefect of the Ninth Cohort of Batavians at the fort.

© The Trustees of the British Museum 1 986,1001.64

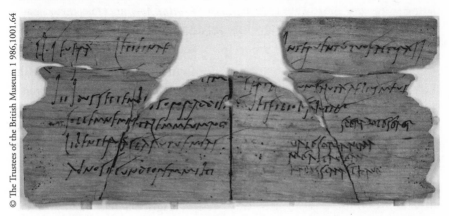

Claudia Severa, Birthday Invitation to Sulpicia Lepidina (c. AD 100)

On the front:
Claudia Severa, to her Lepidina, greetings. On 11 September, sister, for the celebration of my birthday, I give you an eager invitation to come to us, if you can be present, to make the day more enjoyable for me by your arrival. Give my greetings to your Cerialis. My Aelius and my little son send him their greetings. I shall expect you, sister. Farewell, sister, my dearest soul, as I hope to prosper, and hail.

On the back:
To Sulpicia Lepidina, wife of Cerialis, from Severa.

The postcard was written for Claudia by a scribe, except for the greeting at the end, 'I shall expect you . . .', which is in Claudia's own cramped hand, making it the earliest-known writing by a woman in Britain, and in the entire Roman world.

Claudia and her friends living in Roman army camps in Britain were an international group. Her husband, Aelius Brocchus, is known from an altar he dedicated while serving in Pannonia in modern Hungary, while Flavius Cerialis and his Batavians were from today's Netherlands.[21] This internationalism in the Roman military is borne out by many of the other postcards, with hundreds of individuals having roots all around the empire. Britain, they show, had opened up to a wider world.

Until recently, the postcards from Vindolanda were the oldest writing known in Britain. Then, in 2010, excavations in London for the new Bloomberg building beside Bank tube station unearthed 405 writing tablets dating from very shortly after the conquest in AD 43. They are a mixed bag of correspondence, including the probably unwelcome but ageless piece of advice to dress less shabbily if the recipient wanted to be taken seriously in the forum.[22]

Across Britain, the second and third centuries continued much like the first, with demonstrations of Roman strength required to put down periodic insurrections. In an attempt to make the territory more manageable, around AD 212 the country was split into two provinces: Britannia superior (upper Britain) in the south with its capital at London, and Britannia inferior (lower Britain) in the north with a capital at York.[23] That same year, the Edict of Caracalla famously extended Roman citizenship to all free men in the empire, and gave women the same rights as women in Rome. This profoundly changed the status of the free people of Britain, not least by making them liable for additional Roman taxation, which was one of the principal reasons for the pronouncement.[24]

London was completely rebuilt after Boudicca's revolt, and it grew into a thriving trading centre that took over from Colchester as the principal town in the country. It covered an area roughly equivalent to the modern Square Mile, with its forum where Leadenhall Market stands today, bordered by an administrative basilica that was the largest covered building in northern Europe. In honour of its status, the city dropped the name Londinium in favour of the far grander Augusta.[25]

By the third and fourth centuries, the tide finally began to turn. The country became increasingly prosperous and significant within the empire, with its voice heard loudly in Rome. It was even now a major power base for the politically ambitious, with the Britannic legions proclaiming a raft of emperors, including Clodius Albinus, Caracalla and Geta, Postumus, Carausius, Allectus, Magnus Maximus and Constantine III.[26] Most of these

power grabs failed, but some succeeded, including that of AD 306, when one of the most famous Romans of all time – Constantine the Great – was proclaimed emperor by the legions in York. He succeeded in taking power, and went on to become the first Roman emperor to embrace Christianity, the first to demand toleration of religious minorities, the first to convene a universal meeting of the Church, at Nicaea, and the founder of the capital of the eastern Roman Empire at Constantinople.[27]

Despite Britain's historically volatile relationship with Rome, the end of Roman Britain came not with another rebellion, but because Rome itself had run out of steam. Over time all systems become chaotic, and by the late AD 300s the empire was succumbing to this second law of thermo-dynamics and collapsing from the inside, fracturing into two halves with western and eastern capitals.[28] The Romans continued to view it as one empire but, in reality, it had splintered. In the East it found new life as the Byzantine Empire, which survived until it fell temporarily to the crusad-ers in 1204 to 1261, before being destroyed by Sultan Mehmed II in 1453. In the West Diocletian abandoned Rome as his capital in favour of Milan in AD 286, and the emperors stayed there until Honorius moved his capital to Ravenna in AD 402.[29] In this time, the once luminous city of Rome was left to rot. In AD 410 it was sacked by Alaric the Visigoth, and in AD 455 it fell to Gaiseric the Vandal. The exact date the western empire died is a matter of opinion as there was no hard stop, but AD 476 is a popular choice, being the year the last Roman emperor in the West, Romulus Augustulus, was deposed by Odoacer, a Germanic barbarian chieftain. The western empire had died slowly by a thousand cuts, with Germanic tribal leaders carving out mini Roman kingdoms in their regions. However, it lived on culturally, giving birth to medieval Europe, which guarded many aspects of *romanitas*, or Romanness, nurturing the heritage for centuries.

As imperial authority had weakened in the late AD 300s and early 400s, the emperor's power over Britain inevitably declined.[30] Around AD 400 the legions pulled out of the north and west of England to take on barbarians in Italy, and more were recalled to the continent from Britain in AD 407.[31] The increasing military vacuum in Britain meant attacks from neighbours increased, with serious threats coming from the Picts in Scotland, the Scots in Ireland, and the Saxons from over the water. A sign of things to come arrived in AD 367, when all three launched a coordinated assault that one contemporary historian bewailed as a *barbarica conspiratio*.[32]

When barbarians finally overran Roman Gaul in AD 406 to 407, they cut Britain's main supply line to the empire, leaving the country isolated. The end of Roman Britain came swiftly, and is usually placed at AD 410, when a letter known as the Rescript of Honorius arrived in England. The Britons had written to Emperor Honorius requesting legions to defend them against so many invaders, but Honorius's reply was that Britain could expect no help from Rome.[33] With this simple shrug of the shoulders, Britannia was over. As if to prove the point, by the mid-AD 400s the once great Roman city of Augusta lay entirely abandoned.

Although Rome left little trace in Britain in terms of genetic DNA in the British population, its legacy was profound and enduring. London/Augusta did not stay wasted for long, and re-emerged as England's capital and the largest city in the British Isles. Culturally, Romanness lingered until the Reformation and beyond, tying Britain to the family of former Roman territories that all maintained their sense of *romanitas* with debts to Roman systems of government, law, military science and, above all, religion. In the immediate aftermath of the end of Roman Britain, this legacy was perpetuated by the Romano-British Celts, who emerged again as the last Romans sailed away. They had been used to a world in which the emperor had all the answers but, when they found themselves alone in Britain, it was to face a world of uncertainty, chaos and crisis.

PART II: MEDIEVAL

4

Warriors in the Mist – The Age of Arthur

Anonymous
The History of the Britons
AD **829/830**

The small, medieval market town of Glastonbury lies in the rural Somerset Levels. The area has been inhabited since prehistoric times, and a Neolithic timber trackway snaking across it dates from 3838 BC, making it the second oldest in the country.[1] In the Middle Ages the region was home to Glastonbury Abbey, one of the most affluent and important monasteries in Britain. Along with its material wealth the monastery was also rich in legends, like the tale that Joseph of Arimathea brought the Holy Grail to England, where he buried it by Glastonbury Tor at the entrance to the underworld. Then, having climbed Wearyall Hill, he rested and planted his staff into the earth, where it took root as Glastonbury's famous holy thorn, which flowers at both Easter and Christmas.[2]

According to the medieval priest and fine storyteller Gerald of Wales, King Henry II told the monks at Glastonbury that 'an elderly British bard' had confided to him that King Arthur was buried in the abbey grounds between two old pyramids.[3] With feverish excitement the monks set about digging, and soon unearthed a hollowed-out tree trunk containing a large skeleton, a smaller skeleton with a tress of blond hair, and a lead cross bearing the inscription 'Here in the Isle of Avalon lies buried the renowned King Arthur with Winneveria his second wife'.[4]

The discovery of such fabled bones was seen by some as a miracle. To others it was a crude stunt perpetrated by the monks to attract tourists and pay for repairs to the abbey after a fire some years earlier. Whatever the truth, the monks had hit on a first-class public attraction because, in the twelfth century, King Arthur was an A-list historical celebrity.

The main account of Arthur's life had appeared around 55 years earlier in the *History of the Kings of Britain* (*Historia regum britannie*) by another Welsh priest, Geoffrey of Monmouth. As well as introducing the world to the tragic story of King Leir and his three daughters – Gonorilla, Regau and Cordeilla – Geoffrey regaled his readers with the glittering tale of King Arthur and Merlin the wizard.[5] He explained that he had found this old British history in 'a certain very ancient book in the Brittonic language' that his friend Walter of Oxford had given him.[6] Unfortunately, no such book has ever been identified, making it far more likely that Geoffrey cobbled together the idea of a dusty old history book to deflect attention from the fact that his 'history' sprang largely from his very lively imagination. Wherever it came from, Geoffrey's audience could not get enough of Arthur, and other writers quickly obliged by providing chests full of stories about Arthur, Guinevere, Merlin, the knights of the Round Table, their adventures, and their iconic quest for the Holy Grail. These Arthur stories grew into such an important literary cycle that they acquired a grandiose name: The Matter of Britain.[7]

The Arthur of the Arthurian cycle – a chivalrous, courtly, mystical, questing warrior-king – was an outright literary invention of the High and Late Middle Ages, beginning with Geoffrey sometime shortly before 1139 and reaching its English apogee with the appearance of Sir Thomas Malory's *The Death of Arthur* (*Le Morte Darthur*) in 1485. The genre drew on many strands, bringing together themes as diverse as Celtic magic and the crusades, weaving them into a shimmering tapestry of mystical medieval Christian fantasy. In no time this heroic Arthur completely eclipsed the real Arthur, who had lived in the wreckage of post-Roman Britain and led his warriors not on a quest for the Holy Grail, but in a fight for the survival of the nation.

Long before the disintegration of Roman Britain in AD 410, invaders and raiders from Scotland, Ireland and the continent had been storming Britain's borders and coasts in search of spoils.[8] Saxon incursions had started as early as AD 250, and fending off their raids had become a key priority in later Roman Britain. The senior Roman commander in southern England held

the title 'Count of the Saxon Shore', underscoring the frequency and seriousness of the attacks.[9]

In the *Gallic War*, Caesar had described two separate families of European tribes: Celts and Germans. Although they probably sprang from a common root in the mists of the Bronze Age, by Caesar's day they were distinct in language, culture and religion. The Germanic tribes had settled in Germany, Scandinavia, the Baltic and Switzerland. They clashed with the Romans from as early as the second century BC, when they disastrously tried to invade France and Italy. Centuries later, when Rome's military power in the West began evaporating, the Germanic tribes grew bolder and stronger, probing for new lands. France was one target. Italy was another, where the Visigoths and Vandals successfully sacked Rome in AD 410 and AD 455. Meanwhile, another Germanic tribe, the Saxons, turned its attention to Britain.

It was a time of upheaval and instability across Europe as the continent settled into new, post-Roman patterns of power. Accounts of what happened are rare, but the dramatic events in Britain are preserved in the writing of one, lone historian. Gildas was an obscure British churchman, probably a monk, and like a prophet from the Old Testament he groaned at the bloodshed and destruction all around. Sometime between AD 530 and 545 he composed an open letter describing and lamenting it all, urging his countrymen to stop sinning so God's grace would come again and destruction could be averted.[10]

The story Gildas relates is that in Britain a 'proud tyrant' – whom later writers name as Vortigern – was urgently in need of military assistance to help repulse attacks by Picts and Scots (the Irish).[11] He therefore hired a group of Germanic mercenaries who duly arrived under the leadership of two brothers, Hengist and Horsa: Stallion and Horse.[12] However, the arrangement soon broke down and the mercenaries turned on their hosts, slaughtering the Britons' nobility, then inviting large populations of Germanic settlers to join them in Britain.[13]

There is no way of verifying whether Vortigern, Hengist or Horsa really existed – the story has all the features of a creation myth – but it is clear that in the AD 400s and 500s Celtic England was gradually overrun by Germanic settlers.[14] The process was bloody and drawn out, with the Britons putting up fierce resistance in many areas. Although these conflicts were over territory, resources and power, they also had another dimension that was to become a refrain in many of Britain's most acrimonious conflicts. Religion.

When Claudius and his legions had conquered Britain centuries earlier, they brought their pantheon of Roman gods and goddesses with them. As

elsewhere, they tolerated local deities and embraced some of them.[15] At Bath, for instance, they took on Celtic Sulis – goddess of the hot springs, mother figure, and implementor of curses – seeing her as an incarnation of Minerva, and building the shrine of Sulis-Minerva to be used by Britons and Romans.[16] When Rome abandoned polytheism in favour of Nicene Christianity in AD 380, Roman Britain and its population officially became Christian, and remained so after the Romans left. Therefore, as Vortigern and the Britons faced the invading Germanic tribes, the conflict was also between gods, with the Britons ranged under the banners of Christianity, while the invaders attacked in the names of Woden, Thunor, Frig and the other Germanic deities.

Although Gildas was the lone Briton recording events in Latin, there were a handful of British poets writing in their native Brythonic Celtic dialects.[17] One of the most notable was Aneirin, who composed a poem detailing a dramatic battle he fought at.[18] In it, he tells of Mynyddawg Mwynfawr, Prince of the Gododdin, a British tribe whose capital was at Din Eidyn, now Edinburgh. Mynyddawg feasted his trusty retainers with mead-fuelled banquets for a year, before they took up arms and headed south, where they came face to face with an Anglo-Saxon army at Catraeth, probably Catterick in North Yorkshire, and were slaughtered.[19] Alone among the defeated, Aneirin made it off the battlefield. To honour the fallen, his 'three hundred gold-torqued, warlike, wonderful' companions, he sang of the noble spirit by which they had repaid Mynyddawg's generosity with their loyalty and steadfastness in the face of the Anglo-Saxons' 'blood-red blades'. At the poem's dramatic conclusion, Aneirin turned to the feats of his fearless companion Gwawrddur, who thrust boldly beyond 300 men, cutting down those in the centre and on the wings. He was worthy, a leader of noble men, and the bulwark of the front line. He was, though, Aneirin hastened to clarify, 'no Arthur'.[20]

For all his bold feats, Gwawrddur is long forgotten, but the poem's fleeting reference to Arthur has kept Aneirin's memory alive. The poem is known as *The Gododdin* (*Y Gododdin*) and, if the two lines stating that it was sung by Aneirin are true – and they may well be – then it dates from AD 575 to 600, and its reference to Arthur is the earliest known in history.[21] From Aneirin's throwaway comment, it seems Arthur needed no introduction to a sixth-century audience. Arthur, the poem confirms, was a unique hero, head and shoulders in deeds above even giants of the day like Gwawrddur.

The next reference to Arthur comes from Gwynedd two and a half

centuries later, around AD 829/830, in the chronicle the *History of the Britons* (*Historia brittonum*), whose author is uncertain, but may have been the monk Nennius.[22] The text opens with a claim that Britain was founded by the grandson of Aeneas, Brutus of Troy – hence the name Britain – and gives an account of the country's history up to the late AD 600s. In one detail-rich section, it tells of Arthur and his deeds.

L'Apostrophe-Médiathèque de Chartres, Photo IRHT | MS 98, fol. 2v

Ms Chartres 98. Fol. 2v°

Anonymous, The History of the Britons (AD 829/830,
this manuscript AD 900–1100)

Then Arthur fought against them [the Anglo-Saxons] in those days with the kings of the Britons, and he was leader of the battles.

The first battle was at the mouth of the river which is called the Glein.

The second, third, fourth and fifth were at another river which is called the Dubglas, in the region of Linnuis.

The sixth battle was at the river which is called the Bassas.

The seventh battle was in the forest of Celidon, that is, Cat Coit Celidon.

The eighth battle was at Guinnion Castle, where Arthur carried an image of Saint Mary ever Virgin on his shoulders, and on that day the pagans were put to flight, and there was great slaughter by the power of Our Lord Jesus Christ and by the power of Saint Mary the Virgin, his mother.

The ninth battle was fought in the city of the legion.

The tenth battle was fought on the bank of the river which is called the Tribruit.

The eleventh battle was held at the mount which is called Agned.

The twelfth battle was at Mount Badon where, in one day, Arthur felled 960 men in a single charge, and no one felled them except him, and he was victor in all the battles.

Arthur, then, was not a king, but a military commander, 'leader of the battles' (*dux bellorum*), and a formidable strategist and warrior. In Old Welsh *cad* is both battle and army, so its Latinisation may mean he was 'leader of the armies'. As he carried an image of the Virgin Mary into battle, he was also a pious Christian. One of the most interesting features of this passage – known as Arthur's Battle List – is that although the details are imprecise and the archaeology is scanty, around half of the place names are identifiable.[23]

Mount Badon, the twelfth battle, is by far the most famous, and was a decisive victory for the Britons, bringing peace for decades.[24] The earliest date for it comes from the ever-mournful Gildas, who states that he was born in the year it was fought. There have been many attempts to locate the site, with the Iron Age hillfort at Badbury Rings near Wimborne Minster in Dorset a popular choice.

In addition to Arthur's Battle List, the *History of the Britons* contains two more passages relating to Arthur. The first is a story about Cabal, his dog.

There is another wonder in the region of Buelt. There is a mound of stones there, and on top of the pile is one stone impressed with a dog's pawprint. Cabal, Arthur the soldier's dog, impressed his pawprint into the stone when he was hunting Troynt the boar, and after that Arthur piled up the mound of stones under the stone with his dog's pawprint, and it is called the Carn Cabal. And men come and carry the stone in their hands for a whole day and night, and the next day it is found at the top of the pile again.

The passage talks of wonders and reads like the miracle stories that weave in and out of medieval accounts of saints' lives, placing Arthur in the same category as those possessing wondrous, divine powers that could even bless animals and inanimate rocks.

The other reference concerns Anir, his son.

There is another wonder in the region of Ergyng. They have a grave there by a spring which is called Licat Anir, and the name of the man buried in the mound is Anir, who was the son of Arthur the soldier, who killed him there and buried him. And men come to measure the grave, which is sometimes six feet long, sometimes nine, twelve or fifteen. No matter how you measure it, you will never get the same measurements twice, and I have personally tested this.

This is another classic medieval miracle story, demonstrating that Arthur's powers were so strong they were able to transfer magical properties to a grave. Maddeningly, after introducing Anir into history, it gives no details of how or why Arthur killed him.

These three passages about Arthur in the *History of the Britons* comprise almost everything known about him, apart from one further scrap of information in another chronicle. In the tenth century, King Hywel Dda's famous throne in Dyfed passed to his son, Owain ap Hywel Dda. During Owain's reign, around AD 950, scribes at St David's produced the oldest surviving manuscript of the *Annals of Wales* (*Annales cambriae*) – which are themselves older – and it contains two brief references to Arthur.[25] The first is an entry for AD 516 recording that at the Battle of Badon 'Arthur carried

the cross of Our Lord Jesus Christ on his shoulders for three days and nights, and the Britons were the victors'.[26] This is reminiscent of the similar passage in the *History of the Britons* relating that Arthur bore an image of the Virgin Mary on his shoulders at the Battle of Guinnion Castle. Neither would have been practical in battle, and both are probably the result of a scribe's translation error, as the Old Welsh for shoulder is *yscuid*, while shield is the similar-looking *yscuit*.[27] Carrying a shield emblazoned with Christian sacred imagery – like Emperor Constantine had at the Battle of the Milvian Bridge – makes far more sense.

The second mention of Arthur in the *Annals of Wales* simply records for AD 537 'The Battle of Camlann, at which Arthur and Medraut fell'.[28] This is the earliest-known mention of the famous Battle of Camlann – and also of Medraut, who became Mordred in later Arthurian stories – although there is no hint of the later literary tradition that Mordred was the child of Arthur's unknowingly incestuous relationship with Morgause, or that the Battle of Camlann was the final, fatal showdown between battle-weary father and traitorous son.[29]

Outside these three early documents – *The Gododdin*, the *History of the Britons* and the *Annals of Wales* – there is no meaningful information about the historic Arthur. Even his name reveals little. Artorius is a semi-obscure Latin name that appears across the Roman Empire with no special links to Britain. If Arthur was born in Britain, his name suggests only that his family had a sufficiently strong connection to the Romans to choose a Latin rather than a British name. It reveals little else.

When all the evidence is considered, the historical Arthur appears in the written records as transiently as smoke. Some scholars have therefore concluded that he never existed, and that earlier, lost copies of the documents mentioning him were falsified by scribes to give the later, literary Arthur a credible historical pedigree.[30] Others believe he is a figure of folklore, perhaps conflated with Ambrosius Aurelianus, Lucius Artorius Castus, Riothamus, or some other military figure from the age. However, all personalities from this period of British history – even Vortigern and Gildas – are shadows, and the fact that only a slender sheaf of laconic records survives from this turbulent time cannot, by itself, determine whether or not Arthur lived.

The early accounts of the warrior Arthur, 'leader of battles/armies' and hero of Mount Badon, come from a different world to the later medieval king of chivalry with his tourneys, loves and quests.[31] The historic Arthur

who emerges from the early post-Roman chronicles, annals and poems is a far more formidable figure, battling invaders who would eventually change the complexion of Britain for ever. In a period that can only be glimpsed through a glass darkly, there is no compelling reason to dismiss the existence of a figure who appears in multiple texts. There is enough of Arthur in the surviving records to believe he really was a warrior in post-Roman Britain but, whoever he was, he was not the last Briton standing, merely one of the last in the twilight of the British Isles as Celtic islands. The durability and longevity of the stories about him, historical and fantastical, are testament to the power this period of cataclysmic change has exerted on all subsequent ages.

5

Game of Thegns – Angle-Land Emerges

Anonymous
The *Seafarer*
AD **650–950**

On the east coast of England, around 150 miles south of the grave of the Wetwang chariot woman, is another extraordinary burial. It also belonged to a powerful leader interred with a vehicle, but in this case a 27-metre, 40-oar, seagoing ship, sunk into the top of a hill, then covered with an oval, earthen mound.

The centre of the ship had been fitted with an elaborate wooden chamber, richly hung with textiles and filled with precious objects from as far afield as Egypt and Byzantium. They included silver drinking horns, bowls and spoons, a gold and garnet purse of gold coins, shoulder clasps decorated with mesmerising animal motifs, and even a lyre. There were also the instruments of war: a shield and spears, along with a gold and jewelled sword, scabbard, belt and buckle. However, by far the most striking object was a tinned copper, gold and silver *grimhelm* battle helmet complete with a full face mask, and cheek and neck guards.[1] On it, the individual panels had been breathtakingly decorated with bas-relief scenes of warriors and animals, and the mask's two-tone gold and silver mouth, moustache, nose and eyebrows fashioned so that together they form a garnet-eyed dragon, wings spread in flight across the wearer's face.[2] It is one of the wonders of the Middle Ages.

The lavishness and location of the burial at Sutton Hoo – eight miles from Ipswich – suggest the grave's occupant was a chieftain or even a king of the East Anglians. If he was royalty, the dates could fit King Rædwald, King Eorpwald, King – later Saint – Sigebert or King Ecric. However, the warrior-sailor's identity is long lost. The only certainty is that he was an ultra-high-status Angle, from the tribe which gave its name to an entire country: *Engla-londe*. England.[3]

The Angles were one of the many seafaring peoples who arrived in flotillas over many generations, primarily from Denmark, Germany and the Netherlands. They were mainly Angles, Franks, Frisians, Jutes and Saxons, but the native Britons simply called them Saxons, which had become a generic term for pirates.[4] Eventually the name settled as Anglo-Saxons, and was used on the continent and in papal circles to distinguish the Germanic-speaking people of Britain from those on the continent. The most famous Anglo-Saxon of all, King Ælfred 'the Great' of Wessex, was one of the first to use the name in Britain, in his royal title 'King of the Anglosaxons' (*angulsaxonum rex*).[5]

In the same century that the warrior and ship went into the ground at Sutton Hoo, further north, in Sunderland, a seven-year-old boy named Bæda was handed over to St Peter's Abbey in Wearmouth to be educated by its monks. He eventually moved six miles north-west to the twinned abbey at St Paul's in Jarrow, where he was ordained deacon at the age of 19 and priest at 30. He turned out to love rummaging in the abbey's library and, in his late fifties around AD 731, he wrote one of medieval Britain's most famous books: the *Ecclesiastical History of the English People* (*Historia ecclesiastica gentis anglorum*). It is the first detailed account of Anglo-Saxon England by an Anglo-Saxon.

Bede, as he is better known, described the arrival of the Germanic invaders, and where in England each of the different tribes carved out a territory. Although adventurers, they soon settled, and their various chieftains became kings. Later medieval writers firmed up Bede's map into the seven kingdoms of the Heptarchy: the three giant realms of Northumbria (north of the Humber), Mercia (the Midlands) and Wessex (the south-west), along with the four smaller kingdoms of East Anglia, Essex, Sussex and Kent. Northumbria was first to rise to prominence, consolidating smaller northern kingdoms and even taking parts of north Wales. It was followed by Mercia, which flourished under King Penda (died AD 655) and reached unprecedented dominance under King Offa (died AD 796), famous for his vast earthwork – up to 20 metres wide and 2.5 metres high – running the

length of the Welsh Marches. Finally, Wessex expanded to become the dominant kingdom under King Ælfred (died AD 899).

Ælfred was the most impressive person ever to wear a crown in Britain. He united intelligence, perception, curiosity, scholarship, legal subtlety, military skill and political vision in a way no other British ruler has. He was also the father of England, laying the foundations of a united country by marrying his remarkable daughter, Æthelflæd, to King Æthelred of Mercia.[6] Once widowed, she ruled as Lady of the Mercians (*Myrcna Hlœfdige*), openly honoured by some as their king.[7] She knew that a unified England was now within reach, and led military campaigns up and down the country with her brother, Edward 'the Elder', enabling his son, Æthelstan, to become ruler of all England's kingdoms in AD 927. He was the first to take the title 'king of the English' (*rex anglorum*), after which he secured his new, united kingdom by beating off a challenge from a combined army of Vikings from Dublin and Scots and Britons from Scotland at the Battle of Brunanburh. As the dust of the battlefield settled, the royal house of Wessex had created England.

The story of the creation of England was also a religious one. Centuries earlier, when the Anglo-Saxons first arrived, the native Britons had been aghast at their pagan barbarism. Gildas's religious world was built around the legacy of the classical Mediterranean and the bishopric of Rome. His experience as a churchman was to be part of an international community of scholars who studied sacred texts and expounded theology across Christendom. In the Anglo-Saxons he saw only crude pagans with no civility or intellectual subtlety: 'fierce and impious' he concluded, 'a race hateful both to God and men'.[8]

In fact, the pantheon of Germanic gods he detested was old and sophisticated, developed by the peoples that had lived beyond the borders of the Roman Empire in modern day Germany and Scandinavia. At its head was Odin the All-Father, the seeker of wisdom, who blinded himself in one eye and hung himself for three days – as a sacrifice to himself – on Yggdrasil, the vast ash tree connecting the nine realms. Beneath him were two groups of gods – the Æsir and Vanir – who feuded and schemed their way through adventures with each other, beasts, dwarves, elves and mortals, and crossed from their realm in Asgard to the human world of Midgard across Bifrost, the burning rainbow bridge. Among the best-known was Thor, the thunder god, who protected gods and humans with Mjolnir, a hammer so powerful it could flatten mountains. Magical creatures also played key roles, like Fafnir, the great gold-hoarding *wyrm* or dragon, and the Valkyrie, flying

psychopomps who selected those to fall in battle, then led them to Odin's great mead-hall at Valhalla. As with classical Greek and Roman religion, the gods played, fought, interfered, pranked, loved and destroyed rather than offering a route to salvation, and there was no eternal bliss for the dead. Instead, all nine realms looked to the same fate at Ragnarok, the Doom of the Gods, when the sun would turn black, the stars fade, the earth disappear into the sea, and almost everyone perish in the final apocalypse except the just, who would live on in a mead hall thatched with gold.

The Germanic gods' names varied across northern Europe. Woden in England was Oðinn in Old Norse and Wotan in High German, but he was the same All-Father with his two talking ravens – Huginn and Muninn – who flew out from Asgard to bring him back news. His wife and most famous son were Frig and Thunor in England, Frigg and Thor in Old Norse, Frija and Donar in Old German. However, exactly what the first Anglo-Saxons believed is unknown, as the earliest written accounts of the Germanic gods and their world are from thirteenth-century Iceland, from Snorri Sturluson's *Prose Edda* and the anonymous *Poetic Edda*. There are other references in sagas and chronicles, in the poems of the *skalds*, and in images and dedications carved into stones or set into weapons or jewellery, but there is no way of knowing how far the stories and cults of Woden, Thunor, Frig, Tiw and the other gods worshipped in Anglo-Saxon England resembled the detailed picture compiled in Iceland almost a thousand years later.

In England, the Doom of the Gods came early. Bede relates in the *Ecclesiastical History* that Pope Gregory I 'the Great' – before his coronation – stumbled across a merchant selling two beautiful, fair boys in Rome's forum. On enquiry, he was told they were Angles (*angli*), and replied that he thought they were angels (*angeli*).[9] Mindful of them, once pope he sent a monk named Augustine to England with 40 missionaries and orders to convert the Anglo-Saxons to Christianity. Augustine arrived in AD 597 and was warmly received by King Æthelberht of Kent, whose wife, Bertha, was a Frankish princess and already a Christian. Æthelberht duly converted to Christianity, and Augustine set up his mission headquarters at a cathedral he founded in Canterbury.

One by one the kings of the Heptarchy converted, with the death of the mighty Penda of Mercia at the Battle of the Winwæd in AD 655 marking the fall of the last great pagan king in England. Gregory's original plan was for archbishops in London and York to lead the country's clergy, but Augustine did not manage to move from Kent to London, and his successors have

remained in Canterbury ever since. Not long after becoming the first Christian king in England, Æthelberht proclaimed the first English laws, which are the earliest dateable document in Old English. In part he was seeking to protect the property recently donated to the new church at Canterbury, but he also wanted to cast himself in the same mould as great Christian rulers and lawmakers like Constantine.[10]

Once they had become Christian, the Anglo-Saxons grew fervent in their new faith, producing some of the leading churchmen, thinkers and writers of the Early Middle Ages like the scholar and poet Aldhelm of Malmesbury, the polymath Alcuin of York, whom Emperor Charlemagne lured over to Aachen to assist with his imperial school, and the prolific scholar and writer Ælfric of Eynsham. King Ælfred – the country's only fully fledged scholar-warrior-king – published his own translations from Latin into Old English to guide his people, and made the spreading of learning a duty.[11] Even the gospels were translated into Old English to help the people's understanding of Christianity, 600 years before the Tudor scholars of the Reformation pretended they were doing it for the first time. Bede was reportedly translating St John's Gospel when he died. The earliest surviving translation is by a scribe who wrote the Old English words under the Latin text in the *Lindisfarne Gospels* around AD 950 to 960, and free-standing versions of the gospels in Old English were soon produced and circulated widely.[12]

In this period, saints were proclaimed by local communities rather than by the formal papal process that would come later. The Anglo-Saxons' enthusiasm for Christianity saw them embrace the process, creating around 240 saints, a third of whom were women.[13] Some of these cults became internationally successful, especially as a result of the Anglo-Saxons undertaking missions to the pagans of the Frankish Empire in today's France, the Low Countries and Germany. The most famous Anglo-Saxon missionary was St Boniface, originally from Exeter, who evangelised important areas in Germany with fellow Devonians St Walburga – who gave her name to *Walpurgisnacht*, when German witches meet on the Brocken – and her brothers Saints Winnebald and Willibald.

Despite Christianisation, the old gods did not disappear from England, but remained in place names like Wensleydale (the dale of Woden's glade), Thunderfield (Thunor's plain), Tysoe (Tiw's hill-spur), and dozens of others.[14] They also survived in the days of the week: Tiw's Day (Tuesday), Woden's Day (Wednesday), Thunor's Day (Thursday) and Frig's Day (Friday). One even made it into the new English Church, Bede claimed,

pointing out that the Christians' most important annual festival is named after the Germanic goddess Eostre.[15]

Notwithstanding England's conversion, Christianity did not kill off the old ways completely. In 1817, in the countryside north of Carlisle, a man digging a fence post unearthed a heavy gold finger ring engraved with 30 unfamiliar characters. Their stick-like shapes were carefully stained with black niello so they stood out prominently, spelling FRᚫRINᚹᛏᚫRINRIᛒFᛏXᛁFᚹᛏFᛚFᛏ ᛏFᛁ.[16] Once examined by experts, the ring was declared to date from AD 700 to 1000 and to be engraved with a magical charm.[17]

The charm's jagged letters are runes, from a family of Germanic alphabets in which each glyph is not only an individual letter, but – as explored in the ancient Anglo-Saxon, Norse and Icelandic rune poems – enshrines a specific magical property, giving writing a supernatural power beyond the mere meaning of its words.[18] The Anglo-Saxon runic alphabet is called Futhorc, and is a system of 31 runes named after the first six: ᚹ(f) ᚾ(u) ᚦ(th) ᚠ(o) R(r) ᚲ(c).[19] Each glyph is formed of strong, simple lines because they were not designed to be written with a nib on vellum, but scored with a blade into wood, bone or other hard materials – a characteristic preserved in the fact that the modern English verb 'to write' derives from Old English *writan*, meaning 'to carve'. Reading Futhorc, even with a rune dictionary, can require patience, as the inscriptions run randomly from left to right or right to left, and Old Norse runes can also run boustrophedon – like an ox ploughing – with each line in the opposite direction to the preceding one. As a final complication, individual runes can even appear back to front. To appreciate what Futhorc looked like on original Anglo-Saxon objects, there are dazzling examples on St Cuthbert's coffin in Durham Cathedral and on the Franks Casket in the British Museum.[20] Once the Anglo-Saxons converted to Christianity, the Roman alphabet gradually replaced Futhorc to become standard in England once again, enabling the Anglo-Saxons to immerse themselves – as Gildas had done – in international Christian spirituality, intellectual enquiry, and day-to-day interaction with the Church infrastructure 900 miles away in Rome.

The Anglo-Saxons had originally arrived by sea, and the ship burial at Sutton Hoo affirms that the ocean remained strong in their blood. They were seafarers who travelled widely, trading and seeking adventure far afield. King Offa of Mercia minted gold dinars modelled on those of the Abbasid caliph and stamped 'OFFA REX' along with the Arabic script 'THERE IS NO GOD BUT ALLAH ALONE', possibly to facilitate commerce with southern

Europe or the Middle East.[21] The Anglo-Saxon spirit of adventure even led them to hire themselves out as specialist mercenaries in the emperor of Byzantium's elite Varangian Guard, where they fought alongside Danes, Icelanders, Norwegians, Swedes and other 'axe-bearers', in time becoming the unit's predominant ethnic group.[22]

If travel and the sea were one passion, poetry was another, composed by the Anglo-Saxons with hypnotic metrical rhythms and mesmerising alliteration. Like Norse poets, they revelled in kennings, which were figurative expressions like *banhus* (bone-house) for body, *seolbæth* (seal-bath) for the sea, and *heofoncandel* (heaven-candle) for the sun. Around three-quarters of all surviving Anglo-Saxon poetry is contained in just four, bulging medieval manuscripts, which together contain a sparkling kaleidoscope of the Anglo-Saxons' most vivid and intimate observations, impressions, and imaginings.[23] One, the *Exeter Book*, was compiled in AD 950 to 1000 and deposited in Exeter Cathedral's library in 1072, where it has remained for almost a thousand years.[24] It is the fullest of the four books, and includes an untitled and undated poem that has come to be called the *Seafarer*.[25]

The poem is the elegiac lament of an old, wave-whipped sailor, who contrasts his life as a lonely exile on a desolate ocean with the cosy pleasures of the mead hall enjoyed by landlubbers. His ears are assailed by the screams of the eagle, his skin is mortified by the ice-cold billows, his feet bound by frosty fetters and his mind weighed down by the salty toil. But, after setting out his troubles, he comes to see in them a noble sacrifice, and he embraces the ocean's hardships, welcoming them as an ascetic renunciation, as suffering in preparation for eternal rewards. This is an abbreviated version of the poem.

> I can sing this truth-song about myself –
> Of harrowing times and hard travelling,
> Of days of terrible toil. Often I endured
> Bitter heartache on my ship of sorrow,
> In my hall of care, on the heaving waves.
> As we sailed, tossing close to sea-cliffs,
> My feet were pinched by cold, bound by frost,
> Hunger and longing tortured and tore
> My sea-weary mind. No man knows
> Who lives on the land in comfort and joy
> How I endured suffering and sorrow

Exeter Cathedral Library | MS 3501, fol. 81v

Anonymous, The Seafarer (AD 650–950, this manuscript AD 950–1000)

On the ice-cold sea through endless winters
On the exile's road, cut off from kin,
Surrounded by icicles. Hail flew in showers.
There I heard nothing but the roaring sea,
The ice-cold waters, the frozen surf.
Sometimes I listened to the swan's song,
The curlew's cry, the gannet's call –
A seagull singing instead of men laughing,
A mew's music instead of meadhall drinking.
So my thoughts sail out of my unstill mind,
My heart heaves from its breast-board,
Seeking the sea – my spirit soars
Over the whale's home, twists and turns
Over the earth's surfaces, rolls and returns,
Greedy and ravenous. The solitary flier screams,
Rousing the quickened heart on the whale-road
Over the stretch of sea.
For me the joys of the Lord
Are keener than the dead life loaned to us in land –
I can never believe that all this worldly wealth
Will last forever. One of three things
Always threatens a man with uncertainty
Before he travels on his final road –
Illness or old age or the sword's grim edge.
Let us aspire to arrive in eternal bliss,
Where life is attained in the love of the Lord,
Where hope and joy reside in the heavens.
Thanks be to the Holy God, the Lord of Glory,
Who honoured us and made us worthy,
Our glorious Creator, eternal through all time. Amen.

The theme is spiritual, and the notion of withdrawal into hardship is Christian, but the poem is subtle and metaphorical, with hints of an inner pilgrimage.[26] It is not explicitly about Christ, like the *Dream of the Rood* – probably the most famous Anglo-Saxon poem after *Beowulf* – in which the cross of the crucifixion describes how it stood with Christ, was nailed with him, shared his pain, and together they redeemed mankind, the *Seafarer* is far less overtly biblical, instead taking the reader out to sea, to taste the cold

brine of the dolphins' bath and look back to the shore at a seagoing people for whom the icy spray, the gulls' cries and an indomitable faith were all integral parts of life.

Many records relate that the earliest period of Anglo-Saxon invasions and settlement was filled with battles – like the 12 in Arthur's Battle List – but there is no archaeological evidence of ethnic cleansing, mass graves or scorched earth.[27] To escape the settlers, some Britons joined their kin in Wales. Others moved to Brittany, taking their Brythonic language with them, giving Brittany its Celtic culture. Yet others remained, and found that the new law codes categorised them as second-class citizens: the Old English word *wealas* – slaves or foreigners – gave its name to the country of Wales. The animosity between Britons and Anglo-Saxons was, inevitably, mutual. In the Welsh poem the *Great Prophecy of Britain* (*Armes Prydain Fawr*), written in AD 925 to 950, the British poet describes the Anglo-Saxons as 'the shitheads of Thanet'.[28] The only place in England where British life continued was in the far west. Wessex conquered Devon and Cornwall in the AD 800s, but British culture lived on there. The chronicler William of Malmesbury notes that until AD 927 Britons and Anglo-Saxons lived side by side in Devon with equal rights, but that year Æthelstan 'purged' Devon of 'that polluted race' and pushed them beyond the Tamar into Cornwall, which never really joined Anglo-Saxon England, and largely retained its Celtic culture and language throughout the Anglo-Saxon period.[29]

From the extraordinary artistry of the decoration on the Sutton Hoo helmet to the glittering scholarship of the great monasteries and cathedrals, and the vibrant sensitivity of poems like the *Seafarer*, there was nothing dark about the 'dark ages'. The phrase was seventeenth-century Whig propaganda to gild the Reformation with a sense of divine progress, and it distorts and grossly misrepresents an age that shimmered with the beauty of its art and the adventurousness of its ideas.[30] As a backdrop to it all, the sea was a constant. It was the route by which the settlers had arrived as disunited adventurers. It was the whale-road on which they travelled far for commerce and glory. And it was the endless, empty horizon the Vikings crossed when, from AD 789, they came to pillage and invade in an orgy of destruction that was to redraw the map of Anglo-Saxon England, threatening its very existence. By then, the Anglo-Saxons were a confident, established, international, Christian people with developed social, literary, intellectual and mercantile worlds. They were not yet 'the English', but they were on the way. To give them this unified identity, the Vikings would first need to almost destroy it.

6

Rannsaka and *Slahtr* –
Vikings Take the Throne

Anonymous
The Sayings of the High One
c. AD **900**

In AD 867 two Vikings – Ivarr 'the Boneless' and Sigurd 'Snake-in-the-Eye' – captured the Anglo-Saxon King Ælla of Northumbria, who had killed their father, Ragnar 'Shaggy Breeches' Lodbrok, by entombing him in a well of snakes. In retribution, Ivarr hacked open Ælla's back, sheared the ribs off his spine, then dragged his lungs out through the opening to form wings.

This gruesome story was recounted by a *skald* – a medieval Scandinavian poet – and is the earliest written account of the infamous Viking blood-eagle.[1] Later texts provided more victims and details of this ghastly form of execution, including that it was a sacrificial rite dedicated to Odin.[2] Some modern commentators question whether the blood-eagle was real or a literary invention, preferring to see the Vikings as peaceful traders, but its ongoing identification with the Vikings reflects widespread perceptions of them. With or without blood-eagles, Britain's experience of Vikings involved shockingly high levels of violence.

It began in AD 789 with three longships of 'Northmen' landing on the Isle of Portland off Weymouth's Jurassic coast. When the king's reeve rode out to greet the visitors, they murdered him on the spot. The *Anglo-Saxon Chronicle*, written a century later, noted ominously that 'those were the first ships of Danish men

which came to the land of the English.'³ The attackers were actually from Norway, but the Anglo-Saxons at the time called anyone from Scandinavia a Dane. The word Viking was not common and, in any event, has never pinpointed a race or region. In Old Norse to go *viking* was to participate in a raid, so a *vikingr* – plural *vinkingar* – was someone out on a mission for plunder. Its origin is uncertain, possibly from Old Norse *vik* meaning bay or creek, implying the raiders sailed out of Scandinavia's coastal fjords, or from Vik or Viken on the Oslofjord, or from the Old English *wic* meaning a military camp.

The first full-scale Viking attack on England came six years later, in AD 793. According to the *Anglo-Saxon Chronicle*, it was presaged by 'dire portents' across Northumbria: 'immense whirlwinds and flashes of lightning, and fiery dragons were seen flying in the air'.⁴ On 8 June, the Vikings landed on Holy Island off the east coast of England, and 'the ravages of the heathen men miserably destroyed God's church on Lindisfarne, with plunder and slaughter'.⁵ They butchered monks and nuns, smashed up the monastery's sacred relics, looted its valuables, and dragged monks away in chains as slaves. 'The pagans desecrated the sanctuaries of God,' Alcuin of York lamented, 'and poured out the blood of saints around the altar, laid waste the house of our hope, trampled on the bodies of saints in the temple of God like dung in the street.'⁶ They were like 'fierce wolves', according to Simeon of Durham, 'plundering, tearing, and killing'.⁷ England was shattered by the ferocity of the unexpected attack. The isolated island of Lindisfarne had been a haven of peace and saintliness for centuries: the burial place of Saints Aidan and Cuthbert, home to the quiet scriptorium and skilled artists that had produced the *Lindisfarne Gospels* at the start of the century. It had never known violence like this. The Anglo-Saxons had been Christian for two centuries, and the monks were shocked by what they perceived as the bestial savagery of godless heathens. The historical irony is that the Anglo-Saxons had been almost identical Germanic heathen raiders, who worshipped the same pagan gods as the Vikings when they arrived in England centuries earlier. The two groups were close relatives, but the Anglo-Saxons had largely blanked out their ancestral memory.⁸

Any hopes that the sack of Lindisfarne was a unique event were soon dashed. The Vikings returned repeatedly, focusing particularly on wealthy and unprotected coastal monasteries. They hit Jarrow in AD 794 – just 60 years after Bede's death – then Iona in the Inner Hebrides in AD 795, before moving on to attack Ireland. They raided to trade, seizing portable wealth and taking slaves to sell in markets as far afield as Russia and Baghdad. They

became expert at lightning attacks, beginning larger-scale and more destructive raids in AD 835 at sites from Kent to Cornwall, and dispatching bands of marauders ever further inland to major centres like Winchester and London. In AD 850 they grew even more dangerous, shifting strategy and, for the first time, leaving a raiding party to spend the winter in England.

Once organised to meet the threat, the Anglo-Saxons retaliated, and had no qualms responding to Viking violence in kind. The excavation of a mass grave from AD 870 to 1025 at Ridgeway Hill near Weymouth revealed the bodies of 54 Scandinavian men, all but a handful in their teens and early twenties. One had horizontal grooves filed into his teeth – as seen on over a hundred Viking skulls from elsewhere – perhaps then stained with dye or charcoal to make the owner appear wilder. The Anglo-Saxons had shown their prisoners no mercy. The boys and men had been stripped and decapitated, the remains showing catastrophic injuries to the necks, jaws and severed skulls.[9]

Almost 75 years after the raid on Lindisfarne and 15 after the first raiding party stayed for the winter, the Vikings changed tack again, this time far more ominously, assembling a full-scale invasion force in AD 865 and landing in East Anglia. This 'Great Heathen Army' – the *mycel hæthen here* in Old English – was a unified Norwegian-Swedish-Danish warband, and soon made clear that it intended to stay. Its first coup was to take York, followed by all of surrounding Northumbria. It then turned on East Anglia, which it conquered – executing King Edmund, who was soon venerated as a saint for his martyrdom – before going on to crush Mercia. These defeats were a shattering blow for the Anglo-Saxons. England at the time was made up of just four kingdoms, and the Great Heathen Army had rapidly destroyed three of them, leaving just Saxon Wessex to stand alone against the invaders.

A few years earlier, in AD 871, King Æthelred of Wessex had died, leaving his brother Ælfred the Great as king and commander of Wessex. After the Vikings defeated him in numerous skirmishes, Ælfred hid out in Selwood Forest to rebuild his forces with men from Somerset, Wiltshire and Hampshire, before assembling his army at Egbert's Stone in May AD 878 and marching out to take on the Vikings at Edington in Wiltshire.[10] The Great Heathen Army had now spent 13 years in the country – most of which it had conquered – and the future of Anglo-Saxon England hung in the balance. Once battle was joined, Ælfred's forces managed to establish and maintain a dense shield wall 'striving long and bravely', and eventually won the day, routing the invaders.[11] The defeat was so complete that three weeks later Guthrum, the Viking commander, submitted to Ælfred at Aller

in Somerset, where he and 29 of his commanders were baptised. Guthrum took the name Æthelstan, and Ælfred stood as his godfather.

Guthrum and his southern detachment of the Great Heathen Army withdrew to East Anglia, but did not leave the country, and nor did the northern detachments that had settled in Northumbria and Mercia. A decade or so later, around AD 886 to 890 – after another Viking army sailed up the Thames and camped at Fulham before assimilating into the Great Heathen Army – Ælfred and Guthrum concluded a treaty. It scored an imaginary diagonal line across the country from Liverpool to Rochester, declaring that everything west of it belonged to Ælfred and 'the English'.[12] The Old English word that appears in the treaty is *angelcynn* – Angle-kin – and is among the first appearances in Old English of the notion of an English people as a cultural and geographical nation.[13] The treaty did not formally cede the land east of the diagonal line to the Vikings, as it was not Ælfred's to give. However, it was now unambiguously Viking territory. Although it lacked political structures, was fragmented and had fluctuating borders, it was nevertheless a permanent Viking colony in England, covering the north, Midlands and east. It came to be known as the Danelaw: the place where Viking law prevailed.[14]

England was not the Vikings' only focus.[15] They were adventurers and conquerors, and settled in Ireland from the middle of the ninth century, founding Cork, Limerick, Waterford, Wexford and Wicklow. They also settled parts of mainland Scotland, some of the Hebrides, all of the Orkneys, the Shetland Isles, and the Isle of Man. They travelled incessantly, with journeys east taking them to Russia and the Middle East, and voyages west seeing them settle in Iceland, Greenland and Canada, discovering the continent of North America long before John Cabot landed for Henry VII in 1497. Wherever they went, they raided and traded, kidnapped and ransomed, selling stolen goods back to their owners, and hawking slaves internationally. The result was vast wealth. A hoard of silver they buried at Cuerdale near Preston – just one cache among many – comprised 25 pounds of silver coins and 80 pounds of silver bullion.[16]

Given their common Germanic roots, the Vikings revelled in poetry just as much as the Anglo-Saxons.[17] One of their most notable poems is the *Sayings of the High One* (*Hávamál*), which offers a collection of pithy advice from Odin. The manuscript in which it survives, the *King's Book* (*Codex regius*) in Reykjavik, dates from the 1200s, but the poem was composed in Norway around AD 900 or earlier, and was quite likely known in the Danelaw zone of Britain.[18] This is a selection of its verses.

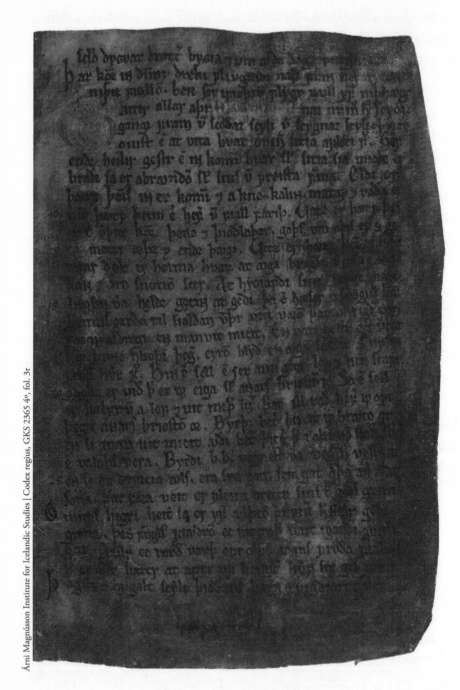

Árni Magnússon Institute for Icelandic Studies | Codex regius, GKS 2365 4°, fol. 3r

Anonymous, The Sayings of the High One
(c. AD 900, this manuscript 1250–1300)

The ale of the sons of men is not as good as they say; for the more a man drinks the less control he has of his wits.

A cowardly man thinks he will live for ever if he takes care to avoid fighting, but old age will give him no quarter though he be spared by spears.

He is a foolish man who lies awake all night and broods over everything. When morning breaks he is weary and all his trouble is the same as it was.

When a senseless man mixes with other people he had better keep silent. No one will know how ignorant he is unless he talks too much. An ignorant man will never know that he is talking too much.

A visitor should depart and not always be in one place. A friend becomes a nuisance if he stays too long in the house of another.

A man should not stint himself in the use of money he has made. Many a time what is meant for friends is being saved up for foes. Things often turn out worse than we anticipate.

Friends should rejoice each other's hearts with gifts of weapons and raiment, that is clear from one's own experience. The friendship lasts longest – if there is a chance of it being a success – in which the friends both give and receive gifts.

A man ought to be a friend to his friend and repay gift with gift. People should meet smiles with smiles and lies with treachery.

One faggot is set light to by another until it is burnt out, one flame is kindled by another. One man is brought out in conversation by another, but becomes moody through being wrapped up in himself.

Cattle die, kinsfolk die, even to us ourselves will death come. One thing I know will never die – the reputation we all leave behind at our death.

Praise no day until evening, no wife until she is burnt, no sword until tested, no maid until given in marriage, no ice until crossed, no ale until it has been drunk.

I advise you Loddfáfnir and you shall take my advice – you will benefit if you lay it to heart – you will prosper if you accept it – know, if you have a friend in whom you have confidence go and see him often, for a path which is never used gets overgrown with bushes and rank grass.

These stoic, fatalistic maxims give a keen sense of the behaviour Vikings valued: especially bravery, honour and friendship. They may also say something of the famed down-to-earth temperament of those descended from Vikings in the English north and Midlands. Their philosophy, too, is clear. Germanic religion foretold that gods and mortals would all perish at Ragnarok. The advice in the *Sayings* is therefore from a religion in which there would be no final reckoning of divine judgement for which souls needed to be prepared. What counted instead was a person's daily conduct and reputation on earth in the eyes of contemporaries and posterity.

The *Sayings* are predominantly concerned with men and warrior loyalty, reflecting the masculine values of Viking society. However, it seems there were quite probably women warriors, too. The Danish chronicler Saxo Grammaticus tells of Ragnar Shaggy Breeches campaigning in Norway with the assistance of a band of women warriors led by Lathgertha, who fought with 'locks flying', and whom he then married.[19] Many of the later sagas and chronicles also tell of women warriors, and Viking-era jewellery depicts them mounted and fully armed. Although the stories may be fiction and the jewellery might represent mythical or divine characters, in 2017 a Viking warrior exhumed in 1889 at Birka in Sweden with a sword, spear, axe, combat knife, arrows, a pair of shields and two horses was discovered to be a woman, prompting archaeologists around Europe to reassess other Viking burials that had simply been assumed, without checking, to be male.[20]

Women certainly held power in the Viking world, more so than in Anglo-Saxon society.[21] The most lavish Viking ship burial known anywhere, at Oseberg in Norway, was a spectacular 30-oar vessel with a tall, spiral-ended prow and stern, and woodwork intricately decorated with carved animal motifs. A woman – possibly a sacrificial slave – was entombed with the ship, along with 15 horses, six dogs, two cows, and a sumptuous catalogue of hundreds of high-end luxury items. However, the most singular aspect of the extravagant naval mausoleum was that alongside the slave was the grave's principal occupant: an exceptionally high-status woman.

In Britain, the treaty of AD 886 to 890 between Ælfred and Guthrum did not curb Viking expansionism. In response, towards the close of the century, Ælfred set about building fortified *burhs* to defend against renewed attack, and the register known as the *Burghal Hidage* lists 33 of them.[22] Some were old towns that had fallen into disrepair or needed expanded fortifications, while others were new, and many, like Bath, Exeter, London, Oxford,

Southampton, Winchester, Warwick and Worcester, went on to number among the most prominent cities in medieval England.

Viking violence continued and, towards the end of the tenth century, their aggression against England reached another peak, with rampaging Scandinavian warbands meeting little resistance wherever they roamed. The drama of one such raid in AD 991 is preserved in the epic Anglo-Saxon poem the *Battle of Maldon*, which recounts how a Norwegian raiding party that arrived on 93 ships pushed inland to Maldon in Essex, where its men shouted across the River Blackwater to Earl Byrhtnoth, demanding that he and his thegns hand over their gold rings as tribute. Byrhtnoth replied, 'Can you hear, seafarer, what these people are saying? They will give you spears as tribute, poisoned points, and ancient swords.'[23] It was the Anglo-Saxon reprise of King Leonidas of Sparta's '*Molon labe!*' – come and get them! – at Thermopylae in response to King Xerxes of Persia's demand that the Spartans throw down their weapons. The Vikings responded to Byrhtnoth's defiance by declaring battle, for which Byrhtnoth and his men assisted the Vikings across the river so the two sides could engage. Unhappily, once the battle commenced, Byrhtnoth was hacked down, and his men were butchered by the Viking *wælwulfas*, slaughter-wolves.[24]

Ultimately, the Vikings were in it for the money. From as early as the arrival of the Great Heathen Army in AD 865, the Anglo-Saxons had paid the raiders off with *gafol* protection money and, after the Battle of Maldon, King Æthelred 'the *Unræd*' – meaning ill-advised, rather than not-ready – made the first payment of what came to be known as Danegeld, in the amount of 10,000 pounds of silver. It was a vast quantity, almost 2.5 million silver pennies, but dwarfed by later payments ranging from 24,000 to 72,000 pounds of silver. Anglo-Saxon coins discovered in Scandinavia show that many were never even in circulation in England, but were minted just to pay off the Vikings.

In 1002 the final act in the Anglo-Saxon and Viking drama opened when King Æthelred, fed up – and at his most ill-advised – ordered that all Danes in England be put to death. It was, he said, a 'just extermination', as the Danes in England had 'sprouted like cockle among the wheat'.[25] In Oxford, the townspeople burned three dozen terrified Danes alive in St Frideswide's church, and charred bones from the period bearing execution injuries were recently unearthed from under the quadrangle of St John's College. These murders – known as the St Brice's Day Massacre – have forever tarnished Æthelred's name, and the extent of the number killed across the country

was never recorded. Viking revenge for the genocidal edict was immediate and sustained, triggering the eventual collapse of Anglo-Saxon England. Reprisals intensified until 1013, when King Swein Haraldsson 'Forkbeard' of Denmark – whose sister may have perished in the burnings at St Frideswide's in Oxford – launched a full-scale invasion. He stormed down through the country to London and then west to Bath where, in the face of his overwhelming forces, 'all the nation regarded him as full king'.[26]

The Anglo-Saxon monarchy of England had lasted just 86 years since Æthelstan had unified the kingdoms in AD 927. Now the throne had fallen entirely to the Vikings. However, Swein did not live to enjoy his new realm. He died within five weeks, leaving Æthelred to take the throne back for a year and a half before also dying. His son Edmund II 'Ironside' then succeeded for just seven months before he, too, died. In the face of sustained Danish pressure, in 1016 England's nobles offered the crown to Swein's son, Cnut 'the Great', who later also became king of Denmark and of Norway. The royal House of Denmark then ruled England as part of a North Sea Anglo-Scandinavian empire until 1042. Although Anglo-Saxon kings briefly returned to power from 1042 to 1066, the Anglo-Saxon era was effectively over.

The Vikings were largely illiterate, so they left no records of their adventures. But the Scandinavian impact on England from the sack of Lindisfarne in AD 793 up to 1066, and on other parts of Britain for several centuries longer, was profound and long-lasting, Although the Anglo-Saxon chroniclers skated with embarrassment over the details of nearly three centuries of Vikings raiding, settling and ruling parts of Britain, they could not airbrush out the Scandinavian legacy.[27]

Across Britain, there are thousands of place names ending in -by, -ness, -thorpe, and other Old Norse suffixes. During the reigns of Kings Swein Haroldsson Forkbeard, Cnut the Great, Harold I 'Harefoot' and Harthacnut, Old Norse was the official language of the English royal court and government administration. Today, there are countless everyday words in English that come directly from the Vikings: anger, awe, axle, ball, berserk, cake, club, die, dirt, egg, fellow, glitter, guest, gun, happy, husband, knife, law, oaf, outlaw, ransack, seat, skill, skirt, sky, slaughter, sledge, steak, troll, trust, ugly, window and wrong, to name a few. One particularly notable loan word is thrall (*thrǽll*) – as in to be in thrall to, or to be enthralled – which was the Old Norse word for a slave: a social group making up around 10 per cent of the population of England in 1066.

Although, on the eve of the Norman conquest, the Anglo-Saxons are traditionally seen as the settled people of England, the final 50 years of Anglo-Saxon England saw such a coming and going of Scandinavian rulers – built on the back of several centuries of Viking presence across much of England – that, by the time the Norman invasion fleet sailed, Britain was no longer an Anglo-Saxon country. The persistence of the Vikings in settling and ruling had made it unambiguously Anglo-Scandinavian.

In 1066 the age of Hengist, Horsa, Penda, Offa, Augustine, Alcuin, Ælfric, Ælfred, Guthrum, Æthelred and Cnut was over. Although the period left fewer records than the High and Late Middle Ages which followed, enough remains to colour in a rich, vibrant, and rapidly changing world. More than the Celtic, Roman, or post-Roman periods which preceded it, the Anglo-Saxon and Viking age in Britain mapped out much of the framework of modern Britain, and its identity.

It was, however, also an era filled with enough blanks for it to have fired the imagination of centuries of British writers. As a child in the early 1900s, J. R. R. Tolkien was captivated by the dramatic battles between the forces of Odin and Christ waged across the English countryside, leading him eventually to become an Oxford professor of Old English and a novelist. His fantasy reimagining of Germanic Midgard as Middle Earth, with its rune-engraved rings, tranquil green valleys set aflame by dark riders, and existential combat against evil tapped into – and continues to evoke – a deep and widespread fascination with a period that kindles a unique cocktail of nostalgia, adventure, and a sense of the forging of a multilingual, multi-religious, multicultural, tribal Britain.

7

A Royal Stitch-Up –
The Bastard's Cross-Channel Empire
The Bayeux Tapestry
1066–77

On 7 January 1943 *Reichsführer-SS* Heinrich Himmler was at his desk in Berlin's Prinz-Albrecht-Straße, gazing with intense pleasure at photographs spread out before him. They were of the Bayeux Tapestry, whose ancient needlework, he pronounced, was a magnificent example of 'our glorious and cultured German history'.[1]

With northern France under Nazi occupation, Himmler had sent a team to examine the tapestry. They were from the Ahnenerbe, a crackpot SS institute for racial history research, and their photographs excited Himmler greatly because they showed William the Conqueror – a Germanic warrior – triumphing over his enemies. Even better, at a time when Britain was foremost among European countries in resisting the onslaught of Nazism, the tapestry reminded its viewers, in bold technicolour, that Britain could be crushed.

In the Reich Ministry for Public Enlightenment and Propaganda, Joseph Goebbels was also an admirer of the tapestry, even making it the centrepiece of one of 'Lord Haw-Haw's notorious and treasonous 'Germany Calling' broadcasts, sparking spirited correspondence in *The Times*.[2] Just over a century earlier, Napoleon had seen similar propaganda value in the tapestry when preparing his invasion of Britain, triumphally exhibiting it in Paris as

a reminder that European commanders had a track record of successful cross-Channel invasions.

Himmler's notion that William was a Germanic ruler was partly right. When 800 longships approached Pevensey in 1066, any English lookout could have been forgiven for assuming it was yet another Viking invasion. The vessels' sharp, high, dragon-headed prows, large, square, painted sails, and sleek, long hulls with shields ranged down the sides were largely identical to Viking invasion ships. The name Normans, like Norsemen, is just a variant of Northmen. A Scandinavian raider named Hrólfr – usually anglicised as Rollo – founded a settlement in northern France around AD 900 but, unusually for Vikings, the colony quickly went native. His followers rapidly adopted Christianity, switched to a dialect of French, embraced feudalism, organised themselves with an aristocracy, and – in a break from Viking and Anglo-Saxon tradition – learned to fight as knights on horseback.

Himmler's father had taught Latin at a local school, and if Heinrich had picked any of the language up from him, or from his Catholic education, he would have read the following story on the tapestry. In the days of King Edward the Confessor, 1042 to 1066, Earl Harold Godwineson of Wessex, the king's brother-in-law, sailed to France. His ship landed just east of Normandy, where Count Guy of Ponthieu took him prisoner, before Duke William of Normandy intervened to secure his release. Harold then accompanied William on a military campaign against one of William's enemies in Brittany, during which Harold heroically saved some of William's men. In gratitude, William presented Harold with arms, after which Harold swore an oath to William on holy relics, and then returned to England. Sometime later, Edward the Confessor died, and Harold was declared king of England. Incensed, William assembled a large invasion fleet and landed it at Pevensey, where he lured Harold into a fight near 'Hestentga'. The two armies clashed, Harold was slain, and the Anglo-Saxons fled.

This account stitched onto the tapestry is recognisably the story of the Norman invasion of England in 1066, but it is missing critical details. Fortunately, a number of them are fleshed out in contemporary Norman chronicles. They add the vital information that, years before, King Edward the Confessor had sent a delegation to William in Normandy to promise that he would be the next king of England. Later, Edward also sent Harold to William to reaffirm the promise, and Harold sealed it by swearing a sacred oath on relics. When Edward went back on his word and nominated Harold as heir, and the *witan* – Anglo-Saxon England's council of nobles

– confirmed Harold as king, William launched an attack to take the crown he had twice been promised.

The first drafts of history are often written by the victors, and the Norman account of the build-up to the invasion – of promises, oaths, betrayal and just war – is how William and his retainers wanted the world to see their actions. It may be an accurate account of Edward and William's arrangement, but could as easily be propaganda to detract from a blatant power grab. No one is sure. It is, though, quite possible that Edward promised William the throne, as he intentionally left many people with the impression they would be his heir as part of his diplomatic and political negotiations. He was also particularly close to the Normans and fond of them. His father, Æthelred the *Unræd*, had married Emma of Normandy, making Edward half-Norman and William a distant cousin. He also knew Normandy well because as a young man he had spent around 25 years in exile in Normandy while Kings Cnut the Great, Harold I Harefoot and Harthacnut ruled England, giving him especially close connections to Normandy and its nobles.[3]

The tapestry does not tell the Norman story of the build-up to Hastings in as much detail as the chronicles, but it has captured imaginations down the ages far more than any of the eye-witness accounts. It is the most vivid source of information about the conquest, and an invaluable visual reference for the period, with detailed depictions of clothes, food, animals, agriculture, weapons, ships, buildings, and hundreds of other sights of the time, including the first representation of Halley's Comet.[4] It was almost certainly stitched by English embroiderers in the decade after the Battle of Hastings, probably in Canterbury at the request of William's half-brother, Bishop Odo of Bayeux, who fought at Hastings and was afterwards made Earl of Kent.[5]

The tapestry – technically an embroidery, as it is stitched not woven – is made of dozens of eight-colour pictorial scenes covering a piece of textile almost 70 metres in length. Along with its arresting images, it also has captions which describe the action and name some of the protagonists. Its characters are all known to history, except for one: a mysterious woman named Ælfgifu – meaning elf-gift – who is given a whole panel to herself in which she is shown being struck or stroked by a priest. In the border beneath the couple is a naked man in the same dramatic pose as the priest, suggesting something sexual, but giving no sense what. Her identity is a mystery, but at least three women named Ælfgifu were associated with the English royal family at the time.[6] One of them was almost certainly involved in a

well-known scandal that the Normans thought bolstered William's claim to the throne.

The following is a complete transcript of the tapestry's captions. The headings in capitals are only for guidance, and do not appear in the tapestry.

HAROLD TRAVELS TO FRANCE AND IS CAPTURED BY GUY OF PONTHIEU
King Edward
Where Duke Harold of the English and his knights ride to Bosham church
Here Harold sailed by sea
And with wind-filled sails came to the land of Count Wido [Guy of Ponthieu]
Harold
Here Wido captured Harold
And led him to Beaurain, and held him there
Where Harold and Wido confer

WILLIAM RESCUES HAROLD AND THEY GO ON CAMPAIGN TOGETHER
Where Duke William's envoys came to Wido
Turold
William's envoys
Here an envoy comes to Duke William
Here Wido led Harold to Duke William of the Normans
Here Duke William comes with Harold to his palace
Where a cleric and Ælfgyfu
Here Duke William and his army came to the Mont-St-Michel
And here they crossed the River Couesnon
Here Duke Harold dragged them from the sand
And they came to Dol, and Conan fled
Rennes
Here Duke William's knights fight the men of Dinan
And Conan handed over the keys

HAROLD SWEARS AN OATH ON HOLY RELICS BEFORE WILLIAM
Here William presented Harold with arms
Here William came to Bayeux
Where Harold swore a sacred oath to Duke William

Here Duke Harold returned to English soil

And came to King Edward

Here the body of King Edward is carried to the church of Saint Peter
the Apostle [Westminster Abbey]

Here King Edward, in bed, speaks to his followers

And here he died

Here they gave the king's crown to Harold

Here sits Harold, king of the English

Archbishop Stigand

These people wonder at the star

Harold

Here an English ship comes to the land of Duke William

WILLIAM'S PREPARATIONS AND INVASION

Here Duke William ordered ships to be built

Here they drag the ships to the sea

These men carry weapons to the ships, and here they drag a cart with
wine and weapons

Here Duke William crossed the sea in a great ship and came to Pevensey

Here horses leave the ships

And here knights have hurried to Hastings to scavenge food

Here is Wadard

Here the meat is cooked, and here the servants have served it

Here they had a meal

Here the bishop blesses the food and drink

Bishop Odo, William, Robert

He ordered a motte to be dug at Hastings castle

Here William was told about Harold

Here a house is set on fire

Here knights have left Hastings and come to the battle against King
Harold

Here Duke William asks Vital if he has seen Harold's army

This man tells King Harold about Duke William's army

Here Duke William exhorts his knights to prepare themselves manfully
and wisely for the battle against the English army

THE BATTLE OF HASTINGS

Here fell Leofwine and Gyrð, King Harold's brothers

Here English and French fell together in the battle

Here Bishop Odo, holding a club, gives courage to the boys

Here is Duke William

Eustace

Here the French fight and have killed those who were with Harold

Here King Harold is killed

And the English have fled

The story's abrupt conclusion was not the original ending. The tapestry was once longer, but the end has been lost, probably destroyed by the cloth having once been mounted on a winding machine. The final scene would likely have shown William's triumphal coronation in Westminster Abbey. But probably not his panicked guards setting fire to the wooden houses of Westminster.

Whoever first had the idea to use pictures to immortalise the invasion had an eye for a story, as the events were unusually dramatic from start to finish. William prepared carefully. He knew that if he won the crown of England, his reign would be simpler if he could demonstrate he was the legitimate king. He therefore first gained approval for military action from the pope on the basis that Harold was a perjurer. The tapestry references this prominently, showing William's ship, the *Mora*, flying a golden-crossed papal banner. Tactically, he timed the Channel crossing immaculately, waiting until Harold had disbanded his men keeping watch on the southern shore and sent them home to tend to the harvest. Luck was on William's side, and when he landed at Pevensey he heard the unexpected good news that Harold had raised a fresh army and marched it to Stamford Bridge in the East Riding of Yorkshire where, on 25 September, he had crushed a major Viking invasion led by King Harald Hardrada of Norway supported by his own rebellious brother, Tostig Godwineson, killing both. This was helpful for William. Harold and his men would be tired.

William built a strong military alliance for the invasion, pulling in troops from neighbouring Flanders and Brittany, and from as far south as Aquitaine and Burgundy. The Shropshire-born Anglo-Norman chronicler Orderic Vitalis noted that morale was high as all of them were 'panting for the spoils of England', whose economy had been growing for over a century, offering rich pickings.[7] To lure Harold south, William sent his knights out to lay

waste Sussex, which had been among Harold's earldoms before he was king and for which he felt a connection. One scene in the tapestry shows William's men torching a house from which a woman and child are forced to flee.

Harold could have delayed until he had rested his forces or raised fresh ones. He could also have made William come to him, forcing the invader to advance up through hostile territory. But he fell for William's provocation, and immediately route-marched his victorious but exhausted army the 280-odd miles south to Hastings.

William was a talented battlefield commander, adept at alliances and conquests. He had learned these skills young, having spent much of his childhood surviving a poisonous civil war in Normandy, at times on the run and hiding out in peasants' cottages. On one occasion an assassin made it into his bedchamber and slit the throat of the guard sleeping near him.[8] He was knighted perhaps as young as 15, and spent his teens and twenties in the saddle, welding together the fractious factions of Normandy with threats and violence. By the Battle of Hastings, he was around 38 years old and a seasoned combat veteran.[9]

Harold was a little older, perhaps 44, and every bit as militarily experienced. His father, Godwine, had been Earl of Wessex, and his mother, Gytha Thorkelsdóttir, was a formidable Danish noble. Godwine had risen to power as a pro-Danish courtier under Cnut, but became even more influential under Edward the Confessor, even giving the king his daughter in marriage. Unfortunately the two men fell out, and Godwine took his family into exile until Harold led an invasion in 1052 and forced Edward to reinstate his father. Once back in England, Harold fought notable campaigns against the Welsh, culminating in the killing of King Gruffudd ap Llywelyn of Gwynedd and of Deheubarth in 1063. He annihilated Harald Hardrada – the most feared warrior in the region – at Stamford Bridge, then arrived to face William leading highly experienced men from the *fyrd* and the elite royal *huskarls*.

On 14 October William marched out to meet Harold, taking him by surprise on Senlac Hill seven miles from Hastings.[10] The two armies were matched in size, but while the Anglo-Saxons fought on foot with axes, the Normans relied on mounted cavalry charges. Harold had his men form a shield wall at the top of the hill, and all day the Normans rode against it, but to no effect, their horses struggling on the steep slope. As dusk fell, with the Normans flagging, William ordered a feigned retreat. The exhausted Anglo-Saxons fell for the ruse, and the shield wall broke as some charged downhill

after the fleeing Normans, allowing a surprise fresh Norman charge from the flanks to break through the weakened wall. The tide had turned. Harold fell soon after, as did his brothers Leofwine and Gyrth. After successfully holding the Normans back all day, it was over quickly.

There is no evidence that Harold was hit in the eye by an arrow. The earliest Norman chronicle appeared in 1066, and two others followed in the next 10 years, one by a priest who was present at the battle. None mention an arrow in the eye, and nor does the *Anglo-Saxon Chronicle*.[11] Had the story been true, it would have been far too good a detail to miss out. The idea did not appear until 14 years later, in 1080, in a chronicle written by an Italian monk who probably added it as a damning allegorical detail, drawing on the biblical authority of blinding as a just punishment for oath breaking.[12] The tapestry does show a man with an arrow in his eye, but it has been altered and repaired numerous times over the centuries, and the arrow is clearly a later addition. The man pulling the arrow from his eye – a medically inadvisable procedure, even in medieval medicine – was originally holding a lance, just as the man one away from him is holding up a lance in the identical pose. Harold is the man to the right of him in the image, in striped blue and terracotta leggings, being charged down by a Norman rider under the words '*interfectus est*' (is killed). Both he and the man with the arrow in the eye are definitely Anglo-Saxons, as they have bushy moustaches, while the Normans are clean shaven. However, the only one dying is the one on the ground.

On Christmas Day 1066 William was crowned in Westminster Abbey, where he made it clear he intended to rule in the tradition of Anglo-Saxon kings. The ceremony was notably religious as he was a genuinely devout Christian, which even Pope Gregory VII – not usually impressed by kings – remarked on. At Hastings, William had gone into battle wearing around his neck the relics Harold had supposedly sworn on and, afterwards, to atone for all the bloodshed, he built an abbey at the site of the battle at Senlac. Once monks were installed at 'Battle Abbey' they were kept busy as the Norman bishops imposed heavy penances on the knights who had killed, maimed or raped during the battle and its long, violent aftermath to pacify the rest of England.[13]

Harold may have been killed, but England did not surrender at Hastings, and the conquest of the country took another six years. The north was particularly hostile to William, and forces under Edgar 'Ætheling' – a son of the Wessex royal line – and Viking armies rose repeatedly in revolt.

William knew only one language with which to impose authority and, with brutal efficiency, unleashed a scorched earth, slaughter and starvation campaign in 1069 to 1070. The objective of his 'harrying of the north' was to burn every single crop and animal north of the Humber so no hostile army could support itself off the land. According to John of Worcester, the campaign was so savage that starving victims resorted to cannibalism.[14] Orderic Vitalis wrote bleakly that more than 100,000 people perished, and observed that although he had often praised William, he could say nothing good about the 'brutal slaughter' in the north, and God would surely punish William for it.[15] Other rebellions also flared, like that led by the outlawed Hereward 'the Wake' around the Isle of Ely. But eventually, by 1072, William was largely in control of his new lands, and after that spent only a fifth of his time north of the Channel. Scotland capitulated without a fight, and Wales held out the longest, with the Normans only finally subduing it in 1094.

Meanwhile, the Vikings had not gone away and, at Christmas 1085, they massed for another attack. As Anglo-Saxon kings had done since the days of the Great Heathen Army, William decided to buy them off. But rather than using his own money or risking minting new coins, he chose to gather information on the *geld*, or tax, he might be able to raise from his new English subjects.[16] He therefore sent commissioners out to make enquiries, and they gathered details from an estimated 62,000 witnesses up and down the land. They were able to present the results of the survey to William at Salisbury the following August, largely because the Anglo-Saxon system of dividing the country into shires and hundreds – or wapentakes in the Danelaw, from the Old Norse *vápnatak*, weapon taking – had bequeathed a local government and tax system of impressive efficiency.[17] The results of the inspections were written up in the *Book of Winchester* (*Liber de wintonia*), soon nicknamed the *Domesday Book*, from the Old English *Domesdei*, Judgement Day, for the tax survey was deemed as unappealable as God's final reckoning.

The *Domesday Book* recorded snapshots of who owned land in 1066 and 1086, what it was worth, and how many peasants it could support.[18] The results revealed that, in the 20 years since Hastings, Norman barons had comprehensively taken control of the country, inserting themselves as great landholders between the king and the old Anglo-Saxon thegns, sitting at the top of England's overall population of 1.7 million people.[19] It also showed a change in naming habits. The Anglo-Saxons used a first name and a

nickname, like Edith 'Swan Neck' or Eadric 'the Wild'. The *Domesday Book* includes the memorable Essex men Roger 'God Save the Ladies' and Humphrey 'Golden Bollocks'. However, by 1086, naming conventions were changing, and the Norman custom of hereditary surnames was becoming more common.[20]

William died a year after the *Domesday Book* was delivered. According to the monk William of Malmesbury, he was overcome by heat from the flames of a French town he was burning and, when his horse stumbled jumping a ditch, he was thrown against the hard pommel of his battle saddle, rupturing his internal organs.[21] In his will, William divided up his lands, giving the family's ancestral possessions in Normandy to his eldest but estranged son, Robert, and leaving the more prestigious throne of England to his younger son. William II 'Rufus' may have been the better choice for England, but not by much. He was a brave and gifted soldier, generous and humorous with his friends, but mainly interested in fashion and notably not bright, regularly surprising audiences with his coarseness and lack of eloquence in public. He was most proud of his long blond hair, and loved the latest short tunics and shoes with tips curled liked scorpions' tails. After a 12-year reign, he died in an accident, shot in the head while hunting in the New Forest.

Rufus's younger brother had, perhaps a little suspiciously, been with him at the fatal hunting party. He immediately rode hard for Winchester, where he secured the royal treasury and had himself crowned as Henry I, outmanoeuvring his older brother Robert, who was on his way back from the capture of Jerusalem in the First Crusade.[22] Cheery, clever and educated – hence his nickname 'Beauclerc' – Henry was the first truly literate king of England since Ælfred. He was the first post-conquest king to have been born in England, possibly in Yorkshire, and was strongly Anglophile, choosing to be buried in England unlike most of his Norman contemporaries. He also went out of his way to marry an English wife from the royal houses of Wessex and Scotland. His fondness for all things English and his local wife did not impress everyone, and Norman courtiers sniggered behind the royal backs, nicknaming the couple Godric and Godgifu: unglamorous Anglo-Saxon bumpkin names. Henry was, however, talented at the ruthless game of medieval kingship and, by deft manoeuvring, took Normandy from Robert, making it a possession of the English crown. Whether or not he murdered Rufus to take the throne, he eliminated any residual threat by imprisoning Robert first in Devizes and then in Cardiff Castle, where he

lived out his life. Henry eventually died in his late sixties while having supper in Normandy before a day's hunting. He disobeyed his doctor's dietary orders and collapsed after eating 'a surfeit of lampreys'.[23] His only legitimate son had been killed in tragic circumstances 15 years earlier, so in 1135 Norman rule ended with Henry.

With the long view of history, 1066 emerges as one of the most significant dates in Britain's past. But at the time not everyone in Anglo-Saxon England thought the Battle of Hastings and William's arrival were especially material. Eight Anglo-Saxon and Viking kings had come and gone in the half century since Æthelstan lost the throne to Swein Haraldsson Forkbeard and, in the process, the genealogies of the royal lines of England and Scandinavia had become tortuously interconnected. Another invasion of longships, another battle and another ruler did not feel epoch changing. A monk at Christ Church Abbey in Canterbury recorded in his annals for 1066 to 1067 merely that Edward the Confessor died and a fire burned his monastery.[24]

Despite William the Conqueror's intention to rule as an Anglo-Saxon king and successor to Edward the Confessor, 69 years of Norman rule fundamentally changed key aspects of Britain's complexion. The top of society altered unrecognisably, the *Domesday Book* revealing that in 1086 a new and limited circle of men now controlled the land. They were all Normans, and largely new to the world of power and influence, meaning they had little experience and a relatively small circle of connections from which to build alliances.

The Church was similarly overhauled. William removed the sitting Anglo-Saxon bishops and installed Normans with continental ideas. He gave the post of archbishop of Canterbury to Lanfranc, a Lombard friend who quickly embarked on a programme of widespread ecclesiastical Normanisation, plotting a course that served both the royal court and the papal curia in an age when tensions between the two were becoming more apparent. Under Lanfranc, bishops like Osmund of Salisbury – William's cousin and Chancellor of England – stamped their character on the new Anglo-Norman church by means including grand architectural projects like the first great cathedral at Salisbury, which Osmund built in the new Romanesque style with rounded arches, vast piers and busily decorated exteriors. This Norman architecture was a novelty in Britain except for Edward the Confessor's Westminster Abbey, which he had completed in the Romanesque style before his death in 1066.[25]

However, the most visible sign of the Norman takeover was the arrival of castles, many of which still dot the countryside. They were a new kind of building that had barely existed in Anglo-Saxon England, and ranged from simple motte and bailey structures to the grandeur of palace-castles like the Tower of London. Somewhere around 1,000 appeared in Britain during the reigns of William I and II, radically altering and heavily militarising the towns and countryside.

Despite all the changes, the majority of innovations had a direct impact on a relatively limited number of people. For instance, after 1066, many fewer claimants to the throne were murdered, bringing a longstanding Anglo-Saxon custom to an end. Most of the changes only really affected the narrow cadre of Norman nobles and their retainers – mostly barons, bishops and their retinues – who settled in Britain to carve out new estates and wealth for themselves. Under their new overlords, after the initial period of violence had calmed, the Anglo-Saxon population carried on without profound disruption.

However, the stage had been set and, before long, Britain would emerge as a major European power, its rulers commanding respect as international figures. Britain had tempted William because it was well organised and promised wealth and prestige. Under the Normans it began turning to the continent immediately to its south rather than eastwards to Scandinavia and, as a direct result, and as the longest-lasting consequence of William's victory at Hastings, Britain and France were to be drawn into a uniquely close relationship that would deeply impact both their histories. The age of Germanic Anglo-Scandinavian identity was over in England. The time of Anglo-French collaboration – and conflict – was beginning.

8

Hƿæt! – The Creation of a Jewelled Language

Anonymous
Beowulf
AD 700–1000

There is no phrase in English that is unquestionably the most famous in the language. However, the opening of the King James Bible – the most widely published text in English – must be a strong contender. 'In the beginning God created the Heauen, and the Earth', it intones. 'And the earth was without forme, and voyd, and darkeneſſe was vpon the face of the deepe: and the Spirit of God mooued vpon the face of the waters. And God said, Let there be light: and there was light.'[1]

One of the reasons for the King James Bible's perennial popularity is a widespread sense that early seventeenth-century English was the high point of the English language: that the written word in the reigns of Queen Elizabeth I and King James I was the moment the language reached its zenith. This impression stems mainly from three larger-than-life works. The first is the *Book of Common Prayer*, in which Archbishop Thomas Cranmer composed all the liturgy the new English church would need to replace the traditional Latin rites of pre-Reformation religion. Cranmer published the first edition in 1549 for the young King Edward VI, before the book underwent three revisions, then settled into its final form in 1662. Because its mellifluous language has lain at the heart of the Church of England's services

for over 470 years, its phrases and cadences have shaped millions of people's experience of English, in Britain and across the English-speaking world.

The second is the King James Bible itself. For centuries it has been the only Bible acceptable to many people. In 2014 it was preferred by 56 per cent of Bible-reading Americans, compared with the next most popular translation at 19 per cent.[2] Its fame, however, does not rest on its novelty, as it was not the first Scripture or Bible to be translated into English. In the AD 600s, Bishop Aldhelm of Sherborne translated the Psalms into Old English and, as mentioned in Chapter 5, Bede was working on a translation of St John's gospel. Around AD 950 to 960 the *Lindisfarne Gospels* had an Old English translation inserted under the Latin text, and shortly afterwards the *Wessex Gospels* and other Old English gospel translations became popular. In AD 813 the Council of Tours explicitly approved translating Scripture into the vernacular to aid people's understanding of God's word, and translations followed in most Christian countries. In England, after the Norman conquest Scripture even existed in the country's three languages, like Eadwine's *Triple Psalter* (*Psalterium triplex*), which offered the Psalms in Latin, Old English and Anglo-Norman.[3] All this translating was no more than a continuation of the tradition started by St Jerome, who translated the whole Bible from Hebrew, Aramaic and Greek into Latin to make it intelligible to the ordinary person in the Roman world, just as earlier translators had translated the Hebrew and Aramaic of the Old Testament into the Greek *Septuagint* to help its spread across the Graeco-Roman world. Translations of the Bible into English increased in the 1500s and early 1600s before the publication of the King James Bible, but its elegant, grandiose, purposefully archaic language proved immensely popular, and has continued to attract devotees in every age.

The third great literary work of the period is not one book, but a collection: the written output of William Shakespeare, which began perhaps in 1582 when he was around 18 years old, and ended in 1613 with his final play, *The Two Noble Kinsmen*. Between these dates, he composed 154 sonnets and 38 plays and, although he is not known to have travelled abroad, his writing has long delighted a global audience, and for many people represents the gold standard of literary English.

These towering works of Elizabethan and Jacobean literature have given the version of English that was spoken and written from around 1550 to 1650 a hallowed status. But language evolves constantly, and Cranmer's and Shakespeare's English are objectively no more pure or beautiful than the

English written or spoken at any other time in the last millennium and a half. The opening words of the King James Bible are, in fact, filled with the historical DNA of English. Words derived from Old English shine through, like 'heaven' (*heofon*), 'earth' (*eorðe*), 'deep' (*deop*), 'water' (*wæter*) and 'light' (*leoht*). Alongside them sit borrowings from Anglo-Norman, like 'form' (*forme*), 'voice' (*voisce*), 'face' (*face*), 'spirit' (*esperit*). There is even the Old Norse 'upon' (*upp á*). Together, these three sentences neatly showcase over a thousand years of the English language's magpie history.

Today, English is spoken on every continent and is the planet's most widespread language. But its survival in the medieval world was not guaranteed, and its existence today is something of a miracle. In the Early Middle Ages, Old Norse dominated large swathes of England for long periods and, after 1066, Old English lost all status when Anglo-Norman and Latin supplanted it as the languages of power at court and in the Church. Where Old English had formerly been a language of poetry and philosophy, law, science and Scripture – far ahead of any other vernacular language in Europe for the sheer quantity and quality of its books – after 1066 it was relegated to the country's third language: the sound of the underclass.

The conquered have frequently taken on the language of their vanquisher, often in a generation. The Jews abandoned Hebrew in favour of Babylonian Aramaic during the sixth-century BC captivity. Celtic Britons in England embraced Old English after the arrival of the Anglo-Saxons. The people of the Maghreb adopted Arabic in the seventh and eighth centuries. The indigenous tribes of South America took on Portuguese and Spanish in the sixteenth century. The list is long. After 1066 the defeated Anglo-Saxons could have jettisoned their historic language and replaced it with that of their conquerors. But English survived, helped in part by marriages between Norman men and English women, who were able to pass their mother tongue to the next generation.

In the British Library, inside an acid-free archive box, nestles a nondescript book of several hundred leaves, each carefully constructed as a frame to hold fragile fragments of eleventh-century parchment.[4] Before the codex – which just means a book with leaves as opposed to a scroll or roll – was given to the British Museum, a notorious fire in Westminster's Ashburnham House damaged many of its edges, but fortunately its spiky, faded, sepia writing remains sharp and clear.

The codex's most famous section starts just over halfway through. 'HWAET!' it commands imperiously in Old English capitals, 'LISTEN!'

And for the next 3,000 lines it tells an ancient, gripping tale. Its hero is a young warrior from Sweden named Beowulf, who hears that late-night drinking sessions at Heorot – the lavish mead hall of King Hrothgar of Denmark – are being plagued by Grendel, a hideous, rampaging monster. Unable to bear the sound of drunken singing, Grendel persistently breaks into Heorot to rip Hrothgar's warriors limb from limb and make the noise stop. After 12 years of Grendel's rampaging, Beowulf offers his services to Hrothgar and, with skill and strength, slays first Grendel then Grendel's grieving mother, who launches attacks on Heorot in revenge for her son's death. Flushed with success, Beowulf returns home to Geatland (probably Gotland) in Sweden, rules as king for 50 years, then battles a dragon which has begun terrorising his people. The fight is vicious and Beowulf is mortally wounded, but not before he and a loyal thane slay the dragon. The story closes with the much-lamented Beowulf being cremated and laid to rest in a grand barrow overlooking the sea.

Beowulf is one of the earliest post-Roman, vernacular epic poems in Europe, and is the oldest long poem in Old English.[5] The events it describes take place in Denmark and Sweden during the sixth century – the age of Arthur – when Anglo-Saxons were settling Britain from Denmark, Germany and the Netherlands. The story was told and retold in mead halls until it was written down centuries later, then copied and recopied. But the centuries are not kind to books, and the text in the British Library is the only version known to have survived.

Beowulf's rhythms are captivating, and devotees of J. R. R. Tolkien will see in them the inspiration for some of the language of Middle Earth. Here are three short sections from different parts of the poem.

Hwaet! We gardena in geardagum theodcyninga thrym gefrunon. Hu tha aethelingas ellen fremedon.

Swa tha drihtguman dreamum lifdon eadiglice, oth thaet an ongan fyrene fremman, feond on helle. Waes se grimma gaest Grendel haten, maere mearcstapa, se the moras heold, fen ond faesten.

'Beowulf is min nama. Wille ic asecgan sunu Healfdenes, maerum theodne, min aerende, aldre thinum, gif he us geunnan wile thaet we hine swa godne gretan moton.'

© British Library Board. All Rights Reserved/Bridgeman Images | Cotton MS Vitellius A XV, fol. 132r

Anonymous, Beowulf (c. AD 700–1000, this manuscript AD 975–1000)

At first glance the language looks nothing like English, but on closer reading many of the words start to appear familiar, especially if read aloud. 'Beowulf is min nama' is not that different to 'Beowulf is my name', and 'feond on helle' is recognisably 'fiend in hell'. The above sections translate as follows:

> Listen! We have heard of the glory of the ancient spear Danes and their kings, and of how they performed courageous deeds.
>
> ***
>
> The lord's men lived joyfully and happily, until a fiend in hell began to commit atrocities. This ghastly demon was called Grendel. He infamously stalked the marshes, prowled the moors, fens, and desolate places.
>
> ***
>
> 'My name is Beowulf. If the son of the famous king, Halfdane, the virtuous one, will allow me to greet him, let me proclaim my errand to him.'

The Old English orthography above is modernised, because one of the most noticeable differences between Old and modern English is the alphabet. A close inspection of the *Beowulf* manuscript shows four letters that are now obsolete:

Upper case	Lower case	Name	Pronunciation
Æ	æ	Ash	'a' in c**a**t
Ð	ð	Eth	'th'
Þ	þ	thorn	'th'[6]
Ƿ	ƿ	wynn	'w' in **w**ay

The pages of *Beowulf* are festooned with these archaic letters. The opening command 'HWAET' is actually 'HƿÆT'. 'Thaet' is 'ðæt'. 'Beowulf' is 'Beoƿulf'. The original text actually looks like this.

> Hƿæt ƿe gardena in gear dagum þeod cyninga þrym ge frunon huða æþelingas ellen fremedon.
>
> ***

Swaða driht guman dreamum lifdon eadig lice oð ðæt an ongan fyrene fremman feond on helle pæs segrimma gæst grendel haten, mære mearc ſtapa, ſeþe moraſ heold fen 7 fæſten.

<div align="center">***</div>

Beopulf is min nama þille ic afecgan ſunu healfdenes mærum þeodne min ærende aldre þinum gif he uſ geunnan þile þæt þe hine þwa godne gretan moton.

The origin of these four letters reflects Britain's history. Ash (æ) was originally a Roman letter, which survived into modern English in words like 'mediæval' and 'dæmon' until it fell out of fashion with the arrival of typewriters, although it remains in a few places, like the trademarked name of the *Encyclopædia Britannica*. Eth (ð) is also a Roman letter, simply a 'd' that has been modified by the addition of a curved ascender and crossbar. The other two characters – thorn (þ) and wynn (p) – have a very different origin. They are survivors from the ancient Anglo-Saxon Futhorc rune alphabet discussed in Chapter 5.

Once the Anglo-Saxons had become Christian and dropped Futhorc to adopt the Roman alphabet, they kept the runes thorn (Þ) and wynn (ᚹ), but slightly reshaped and rounded them into 'þ' and 'p'. Thorn was by far the more successful of the two, even surviving into Middle and Tudor English: Caxton used it in his printed books in the late 1400s, and it appeared in the first printing of the King James Bible in 1611. Thorn's longevity was helped because medieval and early modern English was written and printed using dozens of abbreviations. In these, thorn was commonly used with a small superscript þ̊, þᵗ, or þ̊ to represent 'the', 'that' and 'this', and in many other combinations. Because the blocky, spiky blackletter typefaces of the period made thorn and 'y' look almost identical, Ᵽ printers often just used a 'y' for both. So the 'ye' in high-street names like 'Ye Olde Biscuite Shoppe' is actually 'the': the 'y' is a hurried printer's thorn.

For *Beowulf* to come alive, it has to be spoken. Fortunately, Old English pronunciation is straightforward, and there are no silent letters. Everything is mostly pronounced as in modern English, with only a few exceptions.

Letter	Pronunciation	Example
c before æ, e, i	'ch'	*cild* = child
f between vowels	'v'	*heofan* (heaven) = 'heovan'
g before æ, e, i	'y'	*gear* = year

h middle or end of word	'ch' as in Scottish 'loch'	*dweorh* (dwarf) = 'dweorch'
sc	sh	*scip* = ship
u	'u' as in 'oo'	*sunne* (sun) = 'soonne'
y	'uu' as in the French 'tu'	*cyning* (king) = 'cuuning'

If an Anglo-Saxon was reciting *Beowulf* aloud, each line would break in the middle to highlight alliteration in the stresses of each pair of half-lines. Read with feeling, the rhythms and sound-plays emerge dramatically even after over 1,000 years, giving an idea of the vibrancy and power of Anglo-Saxon poetry.

Original text	**Pronunciation**
Hƿæ þe gardena in gear dagum	Hwat we gardena in year dagum
þeod cyninga þrym ge frunon	theod cuuninga throom ye fruunon.
Huða æþelingas ellen fremedon.	Hootha athelingas ellen fremedon.

It is a sonic adventure.

Grammatically, one of the biggest differences between Old and modern English is that Old English is more complicated and inflected like most Germanic, Romance, Celtic, and many other language groups. This means that its words change or require endings to indicate their grammatical function. This does not happen in modern English, which uses the order of words to dictate a sentence's meaning. For instance, in today's English, 'the dog loves the bird' can only be written in that order to give that exact meaning. Inflected languages work differently. For example, in Old English one word for 'dog' is *docga*, 'loves' is *lufaþ*, 'bird' is *fleogenda* (literally, flyer). If the dog is in love, the sentence is *docga lufaþ fleogendan*, with an 'n' added to *fleogenda* to show it is the object of the verb. This system allows the words to be moved into any order without changing the sentence's meaning. *Fleogendan lufaþ docga* still means the dog loves the bird. Putting *fleogendan* first in the sentence merely emphasises that the dog loves the bird as opposed to anything else. To alter the meaning of the sentence, the endings need to be changed. So 'the bird loves the dog' is *fleogenda lufaþ docgan* or *docgan lufaþ fleogenda*, or *docgan fleogenda lufaþ* or *lufaþ fleogenda docgan* or any other combination of the three words, each bringing a slightly different emphasis. In contrast, modern English has almost completely lost this ability to shuffle words around to create different emphasis.

As well as nouns like *docga* and *fleogenda*, Old English verbs were also inflected. For instance, the verb 'to love', *lufian*, changes its ending depending on who is doing the loving.

I love	*lufie*
You (singular) love	*lufast*
He, **she**, or **it** loves	*lufaþ*
We love	*lufiaþ*
You (plural) love	*lufiaþ*
They love	*lufiaþ*

In Modern English these endings have almost all gone. The word is now 'love' in all examples above except in the third person singular. Here it adds an 's' – she love*s* – which is a direct legacy of the Anglo-Saxon ending, which evolved from 'lufath' to 'loveth' and finally 'loves'.

Old English began to abandon its inflected endings in the Viking period because Old English and Old Norse were closely related, and their different word endings started to blur confusingly. The simplest solution was to drop the endings altogether, and by the time Old English evolved into Middle English after the Norman conquest, the inflected endings had largely gone. Today, just a few survive as a reminder of the ancient system – 'who/whom', 'he/him', 'she/her' – and some irregular verb endings are almost all that remain.

When parts of England became Christian again after St Augustine's mission in AD 597, Old English began to absorb Latin from the Church in words like 'benediction', while keeping its Old English word *bludsian* or *bletsian* – meaning to consecrate with blood – which eventually evolved into 'bless'. After 1066 English also began to absorb Anglo-Norman words from its conquerors. As with the earlier Latin imports, it took them as additions and not replacements, providing the language with an unusually wide vocabulary, offering increased opportunities to express nuance, shade and colour. For instance, English kept its old words like 'ask', 'answer', 'love', 'hate', but added new ones like 'demand', 'respond', 'adore', 'detest'. This was replicated in hundreds of other word pairs, creating an unprecedented palette of lexical richness and precision.

In the fourteenth century, England finally threw off the formal domination of Anglo-Norman and Latin, allowing a revitalised English to re-emerge and flourish. In 1362 English was made the official language of the courts for the first time since 1066, and the following year the Chancellor took the unprecedented step of opening Parliament in English.[7] Not long after, in 1399, Henry IV became the first king of England since Harold Godwineson to make his coronation address in English, while Geoffrey Chaucer's Middle

English *The Canterbury Tales* had been performed at his predecessor's court two years earlier and was now circulating to wide acclaim. English had survived against the odds, and was once again the language of the nation.

One of the most significant changes from Middle English to Early Modern English cannot be seen in most documents as it was a spoken development known as the Great Vowel Shift, which altered certain pronunciations.[8] In old pronunciation date was dart, see was say, shine was sheen, boot was bought, mouse was moose, and so on. The vowel shift saw these vowels, in many dialects, move to the sounds more commonly heard today. The reason for the shift is not clear, but was accompanied by the emergence of London English as the dominant form, and standardised by the arrival of printing and the mass production of texts.

English's ability to absorb words from other languages was not restricted to Latin and Anglo-Norman either side of the Norman conquest. In the 1500s and 1600s English became a sponge again, assimilating a vast number of words of Latin origin that were circulating in scholarly, Renaissance circles. Some, like 'expensive' or 'vacuum', were useful. Others like 'perflate' or 'turbinate' were viewed by many as pompous showing off and disparagingly dubbed 'inkhorn' words. New words also came from other cultures. During the centuries of empire, exposure to a variety of languages brought new vocabulary. Among the additions, Arabic gave 'admiral', 'gazelle', 'jar', 'jumper', 'talisman' and 'tariff'; Hindi-Urdu offered 'Blighty', 'cushy', 'jungle', 'loot', 'shampoo', 'thug'; and Mandarin gave 'chop-chop', 'chow' and 'gung-ho'.

English has, in fact, never stopped acquiring, adapting and evolving. The British Empire left English in many parts of the world as the language of administration, commerce and power. In countries like India – which has hundreds of its own languages – English became the *lingua franca* that connected the disparate parts of the subcontinent. Inevitably, once it had been widely taken up, it remained after the empire ended, and continued to evolve with its own characteristics. The *Oxford English Dictionary* gives its name as 'Hinglish', which it defines as a variety of English that incorporates Hindi vocabulary and constructions. It similarly lists Chinglish (Chinese), Japlish (Japanese), Singlish (Singapore), Spanglish (Spanish) and Yinglish (Yiddish) as regional variants.

Today, English seems unassailable, as globally the last few decades have seen it emerge as the world's main language. This is largely because of the reach of American and British film, television and music, the increasing use

of English as the language of international interaction and business, and the Anglo-American architecture of the internet. Proof of this is that, of today's two billion English speakers, fewer than a sixth are native speakers. One consequence is the emergence of simplified, international forms of English. These can include a tendency to drop the article (she is girl) and omit prepositions (they go the house). The third person singular 's' in 'she loves' is also becoming endangered (she drink, he eat), and the present tense often serves for all tenses (she see him a year ago). These changes are audible every day around the world, but what is not yet clear is whether English is fragmenting into hundreds of separate, simplified dialects, or whether they will all, ultimately, merge into a global Panglish. Either way, the Anglo-Saxon men, women and children who first sat around late-night fires listening to Beowulf's exploits would be astounded to discover that their tribal language was known and spoken in the farthest reaches of the earth, far beyond the whale-roads and seal-baths.

When Christ and His Saints Slept – The Empress, the Usurper and the Anarchy

Anonymous
The Anglo-Saxon Chronicle
1137

Aged eight, Matilda was uprooted from England and packed off to the Holy Roman Empire, where she was drilled in German and the etiquette of her new, foreign home. There is no record of how she felt at leaving her family and moving to the household of the archbishop of Trier. But, just before her twelfth birthday, her life was catapulted forward when she was married to the 28-year-old Henry v, king of the Romans – in other words, Germans – and Holy Roman Emperor.

It was a stratospheric rise for Matilda's family. Her grandfather, William the Conqueror, had been the result of a fling between the Duke of Normandy and a local undertaker or tanner's daughter. All his life, unsympathetic voices jeered, calling him William 'the Bastard'. However, aged just 14, his granddaughter travelled in style to Rome, where – in the ancient grandeur of Emperor Constantine the Great's basilica of Old St Peter's – she was anointed and crowned Holy Roman Empress. Along with her husband, she now presided over the foremost realm in Europe, heir to Charlemagne and all the Caesars back to Augustus.[1]

Although Matilda wore the imperial crown as consort, her title was real, and so was her power. After the coronation, Henry left for business in

Germany, and Matilda – despite her age – stayed on in Italy as his appointed representative to give judgements and administer the business of the imperial court. For England's new, young, aspirational royal family, Matilda's ascendancy was the stuff of dreams.

For four years all was well but, when she was 18, tragedy struck when her father, Henry I of England, was travelling home from Normandy. He embarked onto his longship at Barfleur for a night-time Channel crossing, and disappeared into the darkness. Her younger brother, William 'Ætheling' – an Anglo-Saxon title of nobility, especially for the crown prince – followed on in the next ship, along with the court's younger members, including two of Henry I's illegitimate children: Matilda FitzRoy and Richard of Lincoln.

The youths had been drinking hard and, as they cast off in the sleek new *White Ship* – which the king had declined, but offered to the younger members of his retinue – William ordered its eager master to put the gleaming vessel through its paces and overtake the king's ship. The master was Thomas FitzStephen, son of Stephen FitzAirard, who had captained William the Conqueror's flagship, the *Mora*, in the invasion of 1066. Thomas was, unfortunately, as drunk as his passengers, and as he pushed the 50 oarsmen harder and harder and the vessel sliced through the calm, dark water, the rowdy cheers were suddenly silenced by the crack of the starboard prow splintering on the partially submerged Raz-de-Barfleur reef just beyond the harbour's limit.

William was immediately put into a small lifeboat, but he ordered it to turn back when he heard his half-sister's screams. There had been 300 people on board, and as they grabbed at William's lifeboat, it was overwhelmed and capsized. People in Barfleur heard the shouting across the dark water, but merely assumed the party on the ship was getting into full swing. By the time anyone realised there had been a tragedy, it was too late. Only two survived: a little-known knight and a butcher.[2] King Henry, the chroniclers said, never smiled again. He had been a widower for several years, and swiftly married Adeliza of Louvain – who was a year younger than Matilda – but the match produced no children, and Henry was left to contemplate old age with no male heir.

Five years later, tragedy struck again when Matilda's husband, Holy Roman Emperor Henry V, died leaving her a widow at 23. Her carefully constructed world fell apart, but the circumstances gave her father an idea, and he recalled her from Germany so he could make a special announcement. Accordingly, on 1 January 1127, in Westminster's mighty hall – built by William Rufus 30 years earlier and the largest hall in Europe – Henry assembled his barons and

required them to swear allegiance to Matilda as heir to his kingdom. It was unprecedented. A woman would inherit the throne of England as its absolute ruler in her own right: a queen regnant, not consort.

Shortly before his death on the *White Ship*, William Ætheling had married Matilda of Anjou, as her father's county of Anjou ran from the southern border of Normandy down to the Loire. It was a solid, strategic match to protect and extend the English royal family's interests in France. However, with William dead, Henry I needed another way to cement the alliance, so he arranged for Geoffrey, heir to the county of Anjou, to marry his widowed daughter. Matilda – now aged 26 – was supremely uninspired by her new 14-year-old husband, and not thrilled with trading down her status as Holy Roman Empress for that of countess of a small patch of France. She nevertheless did as she was asked, although she continued to style herself Empress for the rest of her life, and never once Countess. When her father's love of lampreys finally felled him on 1 December 1135, Matilda was in her husband's lands in Anjou. She immediately made preparations to set off for England to inherit, unaware that another member of her family – someone who had kept his head down for a decade – was moving faster.

Stephen of Blois had been with William Ætheling at Barfleur, but had disembarked from the *White Ship* before it sailed, complaining of stomach problems. He was a younger son of Count Stephen of Blois-Chartres – one of the Norman leaders of the First Crusade – and an athletic and physically accomplished knight, widely liked for his affability and easy-going nature. Henry I enjoyed his company, made him Count of Mortain, a small town at the base of the Cherbourg Peninsula, and gave him lands in England, including Lancaster. Most importantly though, Stephen was, like Matilda, a grandchild of William the Conqueror, as his mother was Adela of Normandy, the conqueror's daughter. Unlike Matilda, however, he was a man.

In 1127 Stephen had been the first to swear allegiance to Matilda at Henry's great ceremony in Westminster Hall, but on hearing of the king's death, he made straight for London and then Winchester, where his younger brother, Henry, was bishop. The pair quickly persuaded England's barons and prelates that the king, on his deathbed, had changed his mind about Matilda and nominated Stephen instead. And so, on 22 December, Archbishop William of Canterbury crowned Stephen in Westminster Abbey. It was a shabby coup. Stephen was keenly aware he was breaking his solemn oath, but he also knew that, once he was anointed and crowned, few would challenge his divinely appointed status.

In Anjou, Matilda was left to contemplate the bleak reality that, without castles in England or Normandy, she had no realistic hope of undoing what Stephen had done. She had been comprehensively usurped. So for three years she waited for something – anything – important to change. She appealed to Pope Innocent II, alleging among other things that Stephen was guilty of perjury and oath-breaking. In response, Stephen's representative argued that Matilda was illegitimate because her mother – whom the Normans had mocked as Godgifu – had once been a nun. This was untrue. She had been brought up and educated at nunneries in Wessex, but was never a nun. Unwilling to get involved, the pope adjourned the case and never delivered a ruling, leaving Stephen comfortably on the throne.[3]

In 1138 a doorway of opportunity suddenly opened when Matilda's half-brother, Robert FitzRoy Earl of Gloucester – one of Henry I's 20 illegitimate children – withdrew his lukewarm support for Stephen and transferred his full backing to Matilda. Crucially, he simultaneously offered her use of his castles in Normandy and England as all-important bases from which to mount a campaign for her crown.

Matilda and Robert landed in Sussex in September 1139, and Stephen chivalrously allowed her safe passage to Robert's castle at Bristol, from where she set about skirmishing against royal interests. As the tension rose, in February 1141 the two sides met in open battle at Lincoln, where Matilda's forces trounced the royal army and captured Stephen, who had been gamely wielding a double-headed Norse axe in the melee. Assuming Matilda would imprison the king for life, the barons switched their allegiance to her, and proclaimed her the rightful queen. It was left to Stephen's brother, Bishop Henry of Winchester, to make the formal arrangements. He declared before a specially convened Church council that Stephen had effectively been keeping the throne warm for Matilda, and that she was the rightful 'Lady of the English' (*domina anglorum*). The council endorsed her, and Henry set about preparing the coronation. In anticipation of the momentous day, she headed to Westminster.

In London, however, things were tense. Stephen's wife – also called Matilda – had drawn up an army of mercenaries on the south bank of the Thames, making plain, with the threat of force, who she expected Londoners to back. The *Deeds of Stephen* (*Gesta stephani*), an anti-Empress Matilda chronicle, records that the Empress then made a terrible error by refusing to grant some of the Londoners' requests. 'She, grim eyed, her forehead scrunched into a frown, all womanly gentleness forced from her face, blazed

with unbearable anger.'[4] In response, the Londoners chased her from the city. It was a humiliation.

Matilda had been brought up in Germany to rule an empire. She knew about power, and was comfortable wielding it. In turning down the Londoners, she was acting in the same way as her father, grandfather, uncle, former husband, and all effective medieval monarchs. Had she been a man, no one would have commented on her authoritarian style of leadership. However, in the eyes of the censorious chronicler, a woman – even a monarch – was expected to demonstrate womanly virtues first and foremost. Matilda was finding out the hard way that even though the Germans still loved her and wanted her back, England was not ready for a female ruler.

Matilda regrouped her forces at Oxford, and watched on as Bishop Henry of Winchester changed sides again. To rekindle her fortunes, she massed her allies and marched on Winchester, where she laid siege to Henry's episcopal palace. In response, Stephen's wife Matilda, who still had her army of mercenaries, moved to encircle the Empress at Winchester. In the confusion, Matilda got away, but her half-brother and military commander, Robert of Gloucester, was captured.

Each side had now lost a key leader to the dungeons of the other. Envoys were duly dispatched, and a prisoner exchange was brokered. In early November, Stephen and Robert were both freed and returned to their respective camps. Matilda headed back to her campaign headquarters in Oxford, but by December 1142 found herself in genuine danger from Stephen's siege of the city. With little option, she gambled on a bold escape plan. Disguising herself in a white cloak, she slipped out of Oxford Castle, across the frozen Thames, past the cordon of Stephen's forces, and into the snowy landscape. She made it on foot as far as Abingdon, then rode hard for Devizes.

Matilda remained in the West Country for the next six years. The area had shown her strong support, and she made the North Wessex Downs her base of operations. But it was becoming clear that the deadlock was unlikely to be broken, and then her campaign suffered a major setback when Robert of Gloucester died of a fever in 1147. All hopes of her coronation were slipping away.

Meanwhile, Matilda's son, Henry 'FitzEmpress', was coming of military age, and he brought a band of mercenaries to England to intervene on his mother's behalf. However, he was an inexperienced 14-year-old, and found he could not pay his men. Ever chivalrous, Stephen stepped in, settled the bill, and covered Henry's costs to return home to Anjou. Sensing the

turning of a page, the following year – a decade after landing in England – Matilda passed the baton to Henry and sailed for Normandy, never to return. Meanwhile, Henry headed to Carlisle to be knighted by Matilda's uncle, King David ı of Scotland, then took up the fight, but to win the crown for himself and not for his mother.

The beginning of the end came in August 1153, when Stephen's son, Eustace, died suddenly. With all hope of establishing a dynasty gone, Stephen gave up and agreed terms with Henry. By the Treaty of Winchester, they ended the war by Stephen adopting Henry as his heir. Obligingly, Stephen died within the year, and Henry ascended the throne as Henry ıı, then embarked on one of the most astonishing, accomplished and tragic reigns in British history. As ruler of England, Normandy – which his father, Geoffrey, had seized from Stephen in 1144 – his father's ancestral county of Anjou, and his extremely wealthy wife's extensive lands in Aquitaine, he ruled an empire that stretched almost 1,000 miles, from the Scottish border to the Pyrenees.[5]

Although left out of many histories, the all-consuming struggle between Stephen and Matilda had been a full-scale and catastrophic civil war. The Victorians dubbed it 'the Anarchy', but it was a desolation.[6] One of the most famous descriptions of the state of England in the period comes from the *Anglo-Saxon Chronicle*, which starts with a condemnation of the behaviour of the Normans who controlled the countryside during the war. This account is part of the entry for 1137 although, as it speaks of the full 19 winters of Stephen's reign, a helpful monk evidently updated it later.

They cruelly oppressed the wretched people of the land, forcing them to build castles and, when the castles were built, they filled them with devils and evil men. Then, by night and day, they seized men and women they thought had any wealth, and imprisoned them for their gold and silver, inflicting on them untellable tortures. Never were martyrs tortured as they were . . .

They starved many thousands to death. I do not know how, nor am I able, to tell of the horrors and tortures they inflicted on the wretched people of this land. This lasted the 19 winters Stephen was king, and it always went from bad to worse.

Again and again they levied taxes on the villages and said it was for protection then, when the wretches had no more to give, they robbed them and burned all the villages so you could travel for a whole day and never find anyone sitting in a village, or tilled land. Then corn, meat, cheese, and

butter were immensely expensive, because there was none in the land, and the wretched people starved with hunger. Some who had been rich resorted to living off alms. Some fled the country. There had never been such misery before, and heathen men [the Vikings] never did worse . . .

Where people tilled, the earth bore no corn because the land was destroyed by these actions, and they said openly that Christ and his saints slept.

Bodleian Library | MS Laud Misc 636, fol. 89v

Anonymous, The Anglo-Saxon Chronicle (E, Peterborough)
(1137, this manuscript 1120–1300)

The *Anglo-Saxon Chronicle* is one of the most valuable documents in Britain's archives, as it records the main events of Anglo-Saxon and Norman England. It was started at King Ælfred's court in Winchester around AD 871 to 899 as a record of Anglo-Saxon achievements, covering everything from the arrival of Hengist and Horsa to the fortunes of the Heptarchy, the ravages of the Vikings and the eventual triumph of the West Saxons. As a history fit for the king of Wessex, it inevitably has a West Saxon bias, but only in its first edition.

Ælfred sent copies of the *Anglo-Saxon Chronicle* to monasteries all around the country – probably as part of his wider educational reforms – but these originals are all lost. What has survived are seven versions that are the product of being repeatedly copied and recopied.[7] And, as medieval monks were partial to adding their own views into manuscripts they were quietly duplicating, each version ended up being altered to reflect a range of perspectives. The surviving seven also became living diaries. Monks continued to add entries as each year passed, with the *Peterborough Chronicle* still being updated well into the twelfth century, its last entry made in 1154, the year Stephen died.[8] It is this Peterborough manuscript that the above excerpt is taken from, written in some of the earliest-known Middle English. It still has all the letters of Old English – ash (æ), eth (ð) thorn (þ) and wynn (ƿ) – and like the *Seafarer* and *Beowulf* uses another old letter, the long 's' (ſ), which was to become popular and last until around 1800. (It still survives, slightly disguised, in the German *Eszett* (ß), which is a long 's' linked to a tailed 'z'.) The *Chronicle* also uses the Tironian Et (7) for 'and', which had been a common abbreviation since Roman times. The last line of the *Chronicle* quoted above therefore looks like this in the original manuscript:

þe erthe ne bar nan corn, for þe land ſaſ al fordon mid ſuilce dædes, 7 hi
ſæden openlice ðat xpiſt slep, 7 hiſ halechen.

The spelling of Christ with 'xp' at the start was common in medieval writing, as it is the Greek letters chi (χ) and rho (ρ) from the title χριστος (*Christos*).

The 19 chaotic years of Stephen's reign had been a disaster for England. Armies on both sides had repeatedly laid waste whole regions, strategically incinerating crops and livestock. Profiting from the crisis, the Norman military class grabbed the opportunity to loot and plunder whatever they could, decimating communities in a lawless and sustained free-for-all. With Stephen

focused on Matilda's campaign for the throne, the routines of ordinary government broke down, and Norman landholders avoided the efficient new tax system Henry I had instituted. It revolved around a specially designed counting table fitted with a chequered cloth – hence its name, 'the chessboard' (*scaccarium*), the root of the word 'exchequer' – on which coins were piled and liabilities computed.[9] Amid the chaos, many Anglo-Saxon families deprived of their lands and offices by the arrival of around 8,000 Normans after 1066 took advantage of the mayhem to try and better their positions.[10]

The Anarchy was a bloody hiatus: a chaotic interlude between the end of 69 years of Norman rule and the start of 331 unbroken years of Plantagenet kings. It had a simple cause in Stephen's usurpation of the crown, but it lasted so interminably for a range of reasons. If Stephen had ordered Matilda imprisoned or executed when she first arrived at Arundel in 1139 the war would have been averted. But he did not have the brutality of most medieval monarchs. If Matilda had been less imperious and more like Stephen's wife, Queen Matilda, she may have enjoyed success in forging and holding key alliances, and her coronation in Westminster may not have ended in such an ignominious scramble from the city. But the chemistry of their personalities – his weak, hers strong – fed a protracted stalemate. And overarching it all, no matter how much Matilda had right and law and sacred oaths on her side, the Norman establishment proved itself unwilling to countenance the idea of a woman ruler.

When her son Henry II was crowned in 1154, he inherited a war-wrecked country. His grandfather Henry I had a treasury which yielded £23,000 annually, but after the Anarchy the shattered systems of government could only give Henry II half that.[11] The civil war had eviscerated England, but in the 21-year-old, red-haired, freckled Henry FitzEmpress – as he was known in his lifetime, and he bore the sobriquet with pride – the country had found an energetic, wide-horizoned leader who would turn it into the wealthiest, and one of the most admired, kingdoms in Europe.

10

A House of Devils – Angevin Lords of Rule and Misrule

The Charter of Runnymede (Magna Carta) 1215

Henry II was the king who put England on the map. His vision, intelligence, ability and energy outshone anything any monarch from Æthelstan to Stephen had been able to offer in the two and a quarter centuries since England had been united. He was a whirlwind of enthusiasm and dynamism for building a new country, but he was plagued by a curse. His children.

Richard 'the Lionheart', his third son, knew the family had demons. Rather than suppress this awkward reality, he revelled in it. According to Gerald of Wales, he would tell listeners that one of his ancestors travelled to a distant land, where he met a great beauty and married her. They had four sons, but the man became concerned because his wife always departed holy Mass before the consecration of the host, so one day ordered his knights to prevent her from leaving. When they barred her path out of the church, she seized two of her children, rose into the air, flew out of a high, open window, and was never seen again. This woman, Richard explained, was the fairy-serpent Melusine, and one of the two sons she left behind was ancestor to his family line: the counts of Anjou.[1]

Two years before becoming king, Henry had married Eleanor Duchess of Aquitaine. He was 19 while she was 30 and recently freed from a

moribund marriage to King Louis VII of France. Eleanor was one of the best catches in Europe, and she and Henry would go on to have seven children, of whom five would wear crowns. Richard and John 'Lackland' followed Henry as the first Plantagenet kings of England, but the strong bond they all had to their ancestral county of Anjou in France has also given them the name Angevins. No one used the name Plantagenet until the fifteenth century, when Richard of York – father of Edward IV and Richard III – first adopted it.[2]

After winning his mother's English crown from Stephen, Henry was indefatigable, journeying tirelessly to ensure his cross-Channel domains were managed diligently and efficiently. In England, his priority was to restore order after the Anarchy and lay the groundwork for prosperity. To achieve this he introduced fiscal and administrative reforms and overhauled the legal system, blending established Anglo-Saxon customs with newer precepts of post-1066 royal justice to create a framework for the common law, whose rules and processes were set out in 1187 to 1189 by – or under the authority of – the Chief Justiciar, Ranulf de Glanvill in a *Treatise on the Laws and Customs of the Kingdom of England* (*Tractatus de legibus et consuetudinibus regni anglie*). Henry's efforts at reform bore fruit, and his Anglo-French empire soon became a force to be reckoned with.

Henry's problem was his sons, with the main cause of tension their inheritances and sense of what they were doing with their lives. Henry had tried to give them all something. At 15, his eldest son, also Henry, was crowned co-king of England alongside his father to ensure the succession. At 14, Richard – his mother's favourite – was made Duke of Aquitaine. At 22, Geoffrey was invested Duke of Brittany. With nothing left, John Lackland – his father's favourite – was left to receive hand-me-down territories Henry cut from his other sons' holdings, breeding their deep resentment.

Henry 'the Young King' grew restless at having no real authority while his father was alive, and Richard and Geoffrey resented their father's constant involvement in the management of their domains. In this, Henry's ability to see what needed doing worked against him, as he left his sons feeling untrusted and lacking real authority. When Henry took several castles in France from Henry the Young King to give to John, the three older brothers took the extreme step of declaring war on their father, with the encouragement of the king of France and the support of their mother, who was – among other things – fed up at Henry's indiscreet love affairs. The result was

a civil war in 1173 to 1174, bloodshed across England and France, and the devastation of towns and cities in both countries. Henry eventually put down the family rebellion and his sons reconciled to him, but the real loser was Eleanor, whom Henry punished with imprisonment for the rest of his life.

In 1183 Henry the Young King was still frustrated that, despite being the eldest son, he had no real power. Eager to assert himself, he began attacking Richard's lands in Aquitaine, provoking another civil war which saw Henry II and Richard join forces against him and Geoffrey, its end coming only when the Young King died of dysentery. Ralph of Diceto, dean of St Paul's Cathedral, shed no tears and concluded simply that the world was a far better place without the Young King.

Henry reshuffled the succession to make Richard heir to England, and gave Richard's lands in Aquitaine to John. However, Richard and his mother shared a special bond, and Richard refused to give up her family inheritance to his brother, prompting another war, with Henry, Geoffrey and John ranged against him. The dispute ended in stalemate, before Geoffrey died in Paris, probably from wounds sustained in a jousting accident. He was no more mourned by some chroniclers than Henry the Young King had been. Roger of Howden thought him only 'a son of perdition . . . a son of iniquity'.[3]

However, the biggest sadness for Henry was John: the son for whom he had so antagonised the others. John had been largely loyal to Henry, but in 1189, when Richard allied with King Philip II of France in yet another war against Henry, John – sensing rightly that Richard and Philip would win – joined them. Once the peace treaty was signed and Henry lay on his death-bed, exhausted from fighting his sons for so long, he learned that John had sided with Richard and Philip. The news broke his heart. Gerald of Wales recounted that Henry's final lament was that of all his children – and he had many with mistresses – it was the legitimate ones who had been the real bastards.[4]

On Henry's death, Richard inherited the throne but, unlike his father, showed no interest in England except for the money he could raise from it to fund his crusading ambitions. As king he only visited the country twice, noting on the second occasion that he would have sold London if he found a buyer.[5] Instead, he left the kingdom in the hands of his mother, Eleanor, who was freed from house arrest now Henry was dead. She travelled the length and breadth of the country shoring up alliances, fending off

political coups and keeping the revenues coming in. It is a genuine puzzle that Richard is fêted as England's greatest medieval king, with an equestrian statue of him guarding Parliament, unsheathed sword held aloft. The words that do not appear on his plinth are those of the eminent Victorian historian William Stubbs, whose conclusion was that Richard was 'a bad son, a bad husband, a selfish ruler, and a vicious man ... He was no Englishman.'[6]

Although Henry had loved John as his favourite, John was undoubtedly the most unpleasant of all his and Eleanor's children. When he eventually died, the great observer of thirteenth-century England, Matthew Paris, the sage of St Albans, wrote his own pithy epitaph for him: 'As England has been fouled by John's filth,' he grimaced, 'so John's filth makes filthier the foulness of Hell.'[7]

John's final disloyalty to his father had not been personal. John's only loyalty was to himself. Richard, when king, had given John vast swathes of territory yielding a large income. However, when Richard was captured on his return from crusading, imprisoned by King Leopold of Austria and struggling to raise the ransom, John used his financial resources not to free his brother, but to try and usurp his throne. In the end it was Eleanor who raised the necessary funds. When Richard died five years later at the siege of Châlus, after being shot with a crossbow bolt by a Frenchman he had been applauding for defending himself with a frying pan, contemporaries had no illusions as to what sort of man was about to succeed him.

John did not disappoint. Soon after becoming king he shocked contemporaries by murdering his 16-year-old nephew Arthur – Geoffrey's son – fearing the teenager had a claim to the throne that others might rally to. Rumours even circulated that John had wielded the blade himself 'after dinner, drunk, and possessed by a demon'.[8] This act of vindictive violence was not uncharacteristic. A few years later he drove William of Briouze – a leading baron who knew something of Arthur's death – from office, and imprisoned his wife and one of his sons, then starved them both to death.[9]

Despite John's megalomania, royal power in the period was not absolute, and relied on the support of barons in following and enforcing it. But John's sustained tyrannical behaviour stressed the system to breaking point, losing him the backing of the barons by abusing them financially, overriding them politically and humiliating them sexually. The anonymous chronicler employed by Robert of Béthune recorded that, 'King

John was a most evil man, cruel beyond all men. He was overly covetous of beautiful women, and so brought great shame to the highest men in the land, and for this he was greatly hated.'[10] Robert Fitzwalter certainly complained to the king of France that John tried to seduce his married daughter. And while John's half-brother, William Longspee, was languishing in captivity after the Battle of Bouvines, the 48-year-old John seduced his 23-year-old wife, Ela Countess of Salisbury.[11] None of this endeared the king to his barons.

During the first few years of his reign, John's childhood nickname 'Lackland' took on a far more serious meaning when he lost Normandy, Anjou, and almost all the English crown's other possessions in France. This empire, built from the lands of William the Conqueror, Henry I and II, and Eleanor of Aquitaine, was what gave England its prestige. But John lacked the skills and alliances to hold it together. Faced with his political and military incompetence, the barons gave him a new nickname: 'Soft-Sword' (*mollegladius*).[12]

Many of the barons lived off estates either side of the Channel, and the sudden loss of Normandy and Anjou hit their wealth and status hard. Unable to mount any credible operation to regain these French territories, John chose to make up for his own diminished revenue by hiking taxes on the barons and the wider kingdom to unprecedented levels, and devising new ones to fill his coffers. Examples included large payments from sons wishing to inherit estates, and the auctioning of marriages with heiresses and widows in return for hefty payments.

As well as fundamentally alienating the barons, John also antagonised the Church. Centuries later, King Henry VIII's administration – notably Thomas Cromwell – would rewrite history to cast John as a proto-Protestant trailblazer who took on the papacy. But the reality was far less swashbuckling, and ended in abject humiliation. In 1207 Pope Innocent III appointed Cardinal Stephen Langton archbishop of Canterbury. Langton had been born in Lincolnshire, and had built a stellar reputation as a scholar at the University of Paris. However, John wanted someone else for the job, and prevented Stephen landing in England, while taking the opportunity to plunder Church property. When John refused to back down, Innocent placed England under interdict – in effect locking all churches – and, in November 1209, excommunicated the king. Unrepentant, John continued to seize Church revenues and property, but eventually capitulated and was forced to cede the kingdom of England to the pope and receive it back as a

fief.[13] In effect, he gambled and lost his kingdom. The whole affair was a humiliating disaster, but the principal long-term consequence was a lord–vassal relationship between the pope and the king of England that would later prove important.

Seeing their world collapsing, by 1214 the barons were in open revolt, threatening John with warfare at the hands of their 'Army of God' if he did not rein in his despotic behaviour. When he ignored them, the barons seized the royal castle at Bedford and laid siege to the one at Nottingham. In London, sympathetic townsfolk left the Aldgate open to the Army of God, allowing the barons to march in and take control of the capital.[14] With London in the barons' hands and the prospect of all-out civil war looming, John delayed as long as he could, convinced that the pope – his feudal lord – would ride to the rescue. But when no intervention came, he agreed to meet the barons halfway between his castle at Windsor and their camp at Staines. On 10 June 1215, 'in a meadow called Runnymede', John declared he would agree the demands on the table and no more. The barons accepted, and John's officials attached the king's great seal to the unnamed document, which was simply headed 'These are the articles which the barons seek and the lord king grants'. Today, it is usually called the Articles of the Barons and, extraordinarily, it survives in the British Library, complete with John's great seal.[15] Given the hurried and tense circumstances of its creation, the Articles was not a carefully thought through declaration of legal or political principles, but a list of demands presented to a monarch in a field as part of fractious negotiations.

The most humiliating provision in the Articles for John was the security clause, which stipulated that a panel of 25 barons would monitor every decision he made and, if he failed to observe any of the articles, the barons could attack royal castles and seize royal goods until they had satisfaction. It was nothing short of a *coup d'état*: the barons would now rule the kingdom. Negotiations continued for five days, probably with toing and froing between Runnymede and Windsor, as the two sides tweaked the Articles. Then, on 15 June 1215, John cut short the negotiations and said he would make no further concessions. Over the coming months, scribes in John's royal chancery copied and issued around 40 engrossments of what had been agreed – the Charter of Runnymede – each bearing John's great seal, with one copy sent to every cathedral in the land. Today, four of these original engrossments survive: one each at Salisbury and Lincoln, and two in the British Library. The document opened very traditionally.

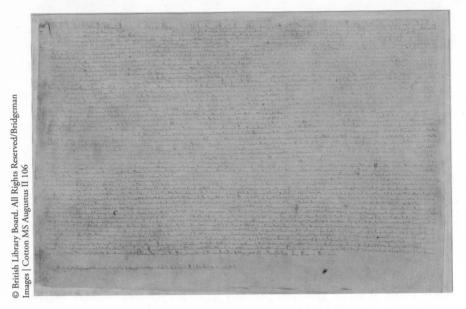

© British Library Board. All Rights Reserved/Bridgeman Images | Cotton MS Augustus II 106

The Charter of Runnymede (Magna Carta, 1215)

John, by the grace of God King of England, Lord of Ireland, Duke of Normandy and Aquitaine, and Count of Anjou, to the archbishops, bishops, abbots, earls, barons, justiciars, foresters, sheriffs, stewards, servants, and to all his bailiffs and faithful subjects, greetings.

After a few further formalities, it set out John's first concession.

First, we have granted to God, and by this our present charter confirmed, for us and our heirs in perpetuity, that the English Church shall be free, and shall enjoy her full rights and liberties undisturbed.

It was a complete climbdown from his earlier dispute with Pope Innocent III during the interdict, and an unqualified victory for Rome. Forty-five years earlier, this right for the Church to manage its own affairs without royal interference had been at the heart of the lethal dispute between Henry II and his archbishop of Canterbury, Thomas Becket: a conflict which had ended with Becket hacked to death beside the altar of St Benedict in his cathedral, and shock waves that resounded across Christendom.

The charter then went on to state that the remainder of John's concessions were made 'to all free men of our kingdom'. The promises therefore were not intended to benefit any man who was unfree – which was most

men – or, arguably, any women. Its promises only really benefited barons, knights, churchmen, merchants and other privileged groups, most of them Normans and Angevins who had arrived since 1066. The majority of England's four million people got little from it.[16]

As the stand-off between John and the barons had intensified in the months preceding 10 June 1215, John had hired foreign mercenaries to boost his forces. The barons required them to be sent home straight away.

> And immediately peace is restored, we will banish from the kingdom all the foreign knights, archers, serjeants, and mercenaries who have come with horses and arms to the harm of the kingdom.

Another sensitive issue was hostages. Kings regularly took them to ensure compliant behaviour from barons they distrusted. John's record in looking after them was not good. As recently as 1212, he had hanged 28 boy hostages, the sons of Welsh barons.[17]

> We will immediately return all hostages and charters which were delivered to us by Englishmen as security for peace or for loyal service.

The barons relied heavily on Jewish moneylenders to manage their cash-flows. They therefore used the charter as an opportunity to improve the repayment terms of their debts.

> If anyone has borrowed to any extent from the Jews, whether a large or a small amount, and dies before the debt is repaid, the debt will not carry interest while the heir is under age.

In the build-up to Runnymede – and especially in the capture of London – the barons had engaged with the country's merchants to cement a broad alliance against John. There were therefore concessions specifically to reward the merchants.

> There will be one measure of wine throughout our whole kingdom; and one measure of beer, and one measure of corn, namely the London quarter, and one width of dyed, russet or halberget cloth, namely two ells within the selvages; moreover for weights let it be as for measures.

Famously, the charter also dealt with fish-weirs – traps or kiddles of nets hung on posts in the water – which hindered river traffic, so their removal benefited merchants by opening up major waterways for trade.

> Henceforth all fish-weirs shall be removed from the Thames, the Medway, and throughout England, except from the sea shores.

As the kingdom's leading mercantile centres, London and the other cities were given privileges.

> And the city of London shall enjoy all its ancient liberties and free customs on land and water. Furthermore, we wish and grant that all other cities, boroughs, towns, and ports shall enjoy all their liberties and free customs.

There was also a direct response to John's lucrative sideline selling off widows and heiresses to the highest bidder.

> No widow shall be compelled to marry while she wishes to live without a husband.

However, in terms of their legal status, the lesser position of women was confirmed.

> No one shall be arrested or imprisoned on the word of a woman for the death of anyone except her husband.

There was nothing approaching democratic representation in the early thirteenth century, and the charter did not have a clause providing for 'no taxation without representation', as the expression originated in the United States during the late 1700s. The closest it came to dealing with the legitimacy of taxation was a requirement that scutage – a tax payable by knights in lieu of military service – and aid could only be levied by 'the common counsel of the kingdom'.[18]

The charter's provisions on criminal justice were largely aimed at stopping John from opportunistically seizing wealthy barons and fining them.

> Earls and barons shall only be fined by their peers, and only according to the nature of the offense.

In the charter's most famous clause, this protection was extended to all free men. Although it has come to be seen as John's most iconic concession, it was not a new principle, but a simple restatement of existing law.

> No free man shall be arrested or imprisoned or disseised or outlawed or exiled, or in any other way ruined, nor will we proceed against him or send anyone against him, except by the lawful judgment of his peers or by the law of the land. We will not sell to anyone, and we will not deny or delay for anyone, right or justice.

Ultimately, however, although 40 engrossments of the charter were sent out to the cathedrals, John had no intention of implementing its provisions, and asked the pope to quash it. Both sides were spoiling for a fight, and within around nine weeks the charter was abandoned and the two sides were at war. In August, Pope Innocent III eventually intervened to declare the charter invalid and to excommunicate anyone who observed its provisions for rising against an anointed king.[19] Now beyond caring, the barons swore loyalty to Prince Louis of France, who duly arrived in England as their newly chosen ruler.

John died of dysentery in October the following year, still at war with the barons. As he went into the ground, so did the animosity of the barons towards the crown. Their complaints had been personal, against him. His nine-year-old son was quickly crowned King Henry III, and to reassure the barons that the new king would not be a tyrant, his officials reissued the charter in 1216, but with critical sections omitted, including the humiliating 25-baron security clause, thereby placing the king back in control. As a strategy to build trust with the barons, the reissue worked, and the barons fell into line behind the new king. Pleased with the result, Henry III's court issued the charter again in 1217.[20] This time, though, it was split into two separate documents. Everything related to royal forests was collected into one document, soon known as the Charter of the Forests, while the main elements concerning all the royal concessions were put into another, which eventually came to be known as the Great Charter (*magna carta*). In 1225 Henry felt another airing was in order, and issued it again with further amendments. As this was granted in return for a tax, consensually by all sides, it became the definitive version and the one used for the statute book. For the remainder of the thirteenth century, successive kings reissued Magna Carta and the Charter of the Forests to demonstrate their good intentions.

In reality, as with most political messaging, kings were happier to make the declarations than implement or live up to them. In large part, life returned to normal, and – after the Angevins – imprisonment, torture, execution without trial and many of the other staples of medieval kingship continued largely uninterrupted.

In the following centuries, Magna Carta fell into obscurity, as few people were interested in an old, failed peace treaty that changed little. It was only in the 1600s that lawyers looking to curb the absolute power of King Charles I found Magna Carta and hagiographised it as an ancient statement of English constitutional principle. At the time of the Boston Tea Party in 1773, lawyers in the United States also seized on it as proof that the powers of the English crown had limits, and the modern political veneration of Magna Carta was born. The original medieval charter, though, had made no claim to be a declaratory statement of democratic principle. Those who agreed it at Runnymede were not democrats, and would be mystified by its modern status as a bulwark of democratic principles across the English-speaking world. Its revered status today is largely a reaffirmation that politicians and historians are dazzlingly inventive in seeing origins and significance where there is little except the disjointed flotsam and jetsam of the ages.

Born in Blood – Forging a United Kingdom

Anonymous
The Owl and the Nightingale
1189–1216

King John's death in 1216 may have befouled hell in Matthew Paris's opinion, but it left England free of a major cause of the chaos and violence of the First Barons' War. The nobles were soon mollified by the new regime of nine-year-old Henry III, who grew to be *rex pacificus*, overseeing a period of relative peace for almost 50 years.[1] He liked calm and a quiet life of comfort, but the barons were trained warriors who grew easily bored by the absence of conflict and, in 1264, they fomented another civil war. Unlike the first time around, the Second Barons' War had a clear leader in the charismatic Simon de Montfort Earl of Leicester: a profoundly pious French baron, Henry III's brother-in-law and one of his closest friends. Propelled by ambition and an agenda of radical reform, de Montfort declared war and scored an early, decisive victory at the Battle of Lewes, taking Henry and his son Edward captive.

Edward was 24 years old, and already an accomplished soldier. While de Montfort installed himself as the country's ruler and set about administrative and political reforms, Edward escaped from Hereford Castle and regrouped the royal forces. The following year he sought out de Montfort and convincingly defeated him at the Battle of Evesham, then had the earl's head and genitals hacked off as trophies. De Montfort's rebellion crumbled away, and the country learned that the heir to the throne was a forceful and

talented military commander in the mould of William the Conqueror and Richard I.

Henry hung on as king for another seven years, but overall left few appreciable legacies from 56 years on the throne, except Westminster Abbey, which he modernised in the new Gothic style to replace Edward I's pre-conquest Romanesque cathedral. In this, he was inspired by a strong personal attachment to Edward, who had been canonised by Pope Alexander III in the reign of Henry II, gaining the sobriquet 'the Confessor'. This honour made him, along with Edward the Martyr – murdered by an assassin at Corfe Castle in AD 978 – one of only two English kings to be honoured as saints by the medieval Church. Henry adopted Edward the Confessor as his patron saint, and piously gave the name to his eldest son. Edward 'Longshanks' was six foot two inches tall, athletic, and not a saint but a warrior. Although he bore the Confessor's name, he did not speak his language. Like all heirs to the English throne from the time of the Norman conquest to the late 1400s, his mother tongue was French.[2] Around him, however, English – the language of the people – was refusing to die.

The Anglo-Saxons' love of poetry had survived the conquest and, at some point in the reign of Richard I or perhaps John, a long, humorous, rhyming poem had begun circulating.[3] Unlike Latin or Anglo-Norman poetry of the period, which was squarely aimed at churchmen and the occasionally literate noble or merchant, this poem was unapologetically written in Middle English for a far wider, popular audience. The text survives in just two manuscripts, in one of which the scribe has added a Latin title: 'An Argument between an Owl and a Nightingale'.[4] Modern commentators simply call it the *Owl and the Nightingale*.

The poem records a spirited and heated debate in which the two birds squabble and bicker over their relative merits, faults, intelligence, appearance, singing ability, lifestyle, personal hygiene, usefulness, and role in the lives and loves of humans. It is simple entertainment rather than moral instruction, and belongs to the popular genre of debate poetry – like the famous dispute between water and wine – in which objects, substances or animals take each other on in an adversarial discussion as if at a disputation in the divinity schools or a trial in the law courts.[5]

The *Owl and the Nightingale* gives no explicit information about its author, but on several occasions mentions Master Nicholas of Guildford ('Maister Nichole of Guldeforde') living at Portesham near Dorchester. It notes no one ever paid him properly, suggesting perhaps that he was the author,

© British Library Board. All Rights Reserved | Cotton MS Caligula A IX, fol. 233r

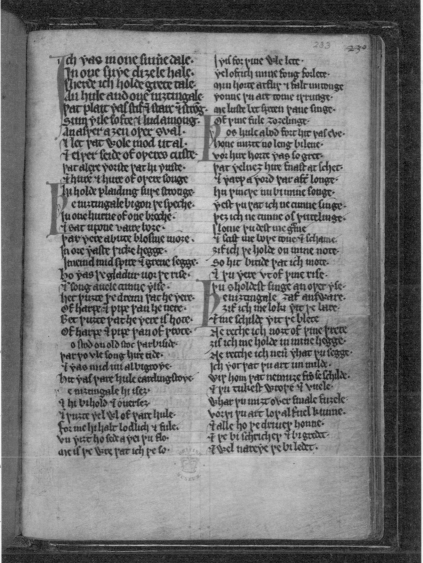

Anonymous, The Owl and the Nightingale (1189–1216, this manuscript 1250–1300)

although he has not been identified as a historical person.[6] The author could, though, have been a man or a woman, as Mary of France, an abbess, was one of the most prolific writers of French poetry in England at the time.[7]

The *Owl and the Nightingale* pits each bird's qualities against the other, and the characters of the two emerge quickly and vividly. The owl is sober, diligent, dutiful and constant, while the nightingale is impulsive, sensual, joyous and seasonal. They share a mutual disdain for each other's attributes, which they attack while robustly advocating their own virtues. The discussion strays broadly, dealing with how they serve and inspire mankind, while reflecting on a wide range of experiences, from overdoing good things to the meaning of life, and from domestic tidiness to bedhopping. Commentators have tried to see in its arguments everything from a thinly disguised account of the fatal rivalry between Henry II and Thomas Becket to a comparison between the traditional, solid, old religion of the cathedrals and abbeys, and the more vibrant celebrations of emerging, popular religious groups like the Franciscans. Ultimately, all these analyses are doomed. The *Owl and the Nightingale* is a medieval allegory of opposites that can be interpreted as symbolic of almost any duality. The following paragraphs are selected from throughout the poem's 1,794 lines to give a flavour of the rancorous dispute:

I was in a valley in summertime; in a very secluded corner, I heard an owl and a nightingale holding a great debate. Their argument was fierce, passionate, and vehement, sometimes *sotto voce*, sometimes loud; and each of them swelled with rage against the other, and let out all her anger, and said the very worst she could think of about the other's character, and especially they argued vehemently against each other's song.

The nightingale began the argument in the corner of a clearing, and perched on a beautiful branch – there was plenty of blossom around it – in an impenetrable thick hedge, with reeds and green sedge growing through it. She was all the happier because of the branch, and sang in many different ways; the music sounded as if it came from a harp or a pipe rather than from a living throat. Nearby there stood an old stump where the owl sang her hours, and which was all overgrown with ivy; this was where the owl lived.

NIGHTINGALE: 'You nasty creature!', she said, 'fly away! The sight of you makes me sick. Certainly I often have to stop singing because of your ugly face.'

OWL: The owl waited until it was evening . . . and finally she spoke: 'How does my song seem to you now? Do you think that I can't sing just because I can't twitter? You often insult me and say things to upset and embarrass me.

You're called a nightingale, but you could better be described as a chatterbox because you talk too much. Give your tongue a rest!

You raise another point against me, and accuse me of not being able to sing, saying that my only song is a dirge, and distressing to listen to. That isn't true – I sing harmoniously, with full melody and a resonant voice. You think that all songs sound terrible if they're not like your piping. My voice is confident, not diffident; it's like a great horn, and yours is like a whistle made from a spindly half-grown weed. I sing better than you do; you gabble like an Irish priest.'

NIGHTINGALE: 'My one skill is better than all of yours; one song from my mouth is better than everything your kind was ever able to do. And listen! I'll tell you why: do you know why man was born? For the bliss of the kingdom of heaven . . . I give people a preview of the future for their good, to give them comfort, and encourage them to pursue the song which is eternal.'

OWL: 'You're no good for anything apart from knowing how to warble, because you're small and weak and your coat of feathers is scanty . . . But I can do very good service, because I can look after human dwellings; and my services are excellent, because I help with people's food supply. I can catch mice in a barn, and also at church in the dark, because I like to visit Christ's house to clear it of filthy mice, and no vermin will enter it if I can catch them.'

NIGHTINGALE: 'Owl', she said, 'tell me the truth; why do you do what evil creatures do? You sing by night and not by day, and your whole song is "Woe! Woe!" . . . It seems to everyone, clever or stupid, that you're wailing rather than singing. You fly by night and not by day; I wonder about that, and well I may, because every creature that avoids doing right loves darkness and hates light; and every creature attracted by wrongdoing likes the cover of darkness for what it does.'

OWL: 'When you sit on your branch, you entice those people who are willing to listen to your songs to the joys of the flesh . . . Everything you sing is about lechery.'

NIGHTINGALE: 'A woman can have a good time in bed in whichever way she chooses, licitly or illicitly, and she can act out my song in whichever way she chooses, properly or improperly . . . For gold and silver are good, and nevertheless you can buy adultery and injustice with them; weapons are good for keeping the peace, but nevertheless people are killed by them illegally in many countries when thieves carry them. So it is with my song: although it's good, it can be misused. Nor should any man loudly condemn a woman and reproach her for physical desires; he may blame such a woman for lechery while sinning worse himself through pride. I teach them by my song that love of this kind doesn't last long; because my song lasts only a little while . . . The girl realises, when I fall silent, that love is like my songs: for it is only a little breath, which comes quickly and goes quickly.

It's only when you're hit or shot that you become useful, as you're hung on a stick, and with your stinking carcase and your ugly neck, you guard people's corn against birds.'

OWL: 'I am useful to them through my death . . . People can set me up on a little stake in the depths of the wood, and so lure and catch small birds; and so through me they can get good roast meat to eat. But you've never been of good service to man, alive or dead. I don't know what you raise your brood for; it does no good, alive or dead.'

NIGHTINGALE: 'What do you know about stars apart from looking at them from a distance? A monkey can look at a book, and turn over the leaves, and close it again, but he can't make head or tail of it, or pick up any more scholarship as a result.

The wise Master Nicholas should judge between us.'

OWL: 'Let's go and visit him, because our judgement is ready and waiting there.'

With these words they set off, without any kind of army, till they came to Portesham; but I can't tell you any more about how they succeeded with their judgement. This is the end of the story.

This excerpt is a free translation of the Middle English, but gives an overall sense of the nature of the debate, and of the birds' observations on the human world. The spelling is modernised, and so is the alphabet. By the

time the poem was written, the Old English eth (ð) and wynn (ƿ) had disappeared, but a new letter had come into use – the yogh (ȝ) – which was used for 'y' or 'gh', as in ȝet/yet, niȝt/night, and therefore niȝtingale. This alphabet was becoming standardised, but it was not yet universal. Shortly before the *Owl and the Nightingale* appeared, a monk from Lincolnshire named Orm compiled a collection of Middle English homilies in a work called the *Ormulum*, and he specifically used additional letters for phonetic precision because he was concerned people were not pronouncing English properly.[8]

This is the opening verse of the *Owl and the Nightingale* in its original spelling, with a literal translation.

Ich ƿas in one ſumere dale;
I was in a summer valley;

In one suþe diȝele hale
In a very hidden nook

Iherde ich holde grete tale
Heard I hold great debate

An hule and one niȝtingale.
An owl and a nightingale.

Many people's experience of Middle English comes from Chaucer and, at first glance, the *Owl and the Nightingale* looks less accessible. For instance, this is the opening of one of the oldest manuscripts of *The Canterbury Tales*.[9]

Whan that aprill with hise schoures soote
When that April with his showers sweet

The droghte of march hath perced to þe roote
The drought of March has pierced to the root

And bathed euery veyne in swich licour
And bathed every vein in such sap

Of which vertu engendred is the flour
Of which power created is the flower

The reason that Chaucer is easier to read is because he was writing 200 years later, first presenting *The Canterbury Tales* at Richard II's court in

1397. The *Owl and the Nightingale* is in much earlier Middle English, but is nevertheless noticeably simpler than the inflected Old English of the Anglo-Saxons. The vocabulary, too, is markedly more modern, with most words recognisable, especially if read aloud. To get a sense of its readability, this is a section dealing with the 'mad rush' of sexual desire felt by rustic folk in the summer and how quickly, for men, it is often over. It shows clearly that the word order is now recognisably developing into the pattern of modern English.[10]

Vor pane he haueþ ido hiſ dede
For when he has done his deed

Ifallen is al his boldhede;
Fallen away is all his boldness;

Habbe he iſtunge under gore
Once he has stung under dress

Ne laſt hiſ luue no leng more.
No last his love not long more

The poem briefly mentions 'þe king Henri – Iesus his soule do merci!' but overall its focus is resolutely on country people, and a reminder that, regardless of the poisonous rivalries at court, for most people life went on, with the seasons coming and going, and generations unfolding as they always had. The poet has no interest in politics, but revels in a sense of the human connection with nature – in its beauty and harshness – and how it is lived intimately by people and animals throughout the changing year, far from the struggles and vanities of kings and princes. What emerges most vividly is that people lived out the big questions behind the purpose of life, love and death in very familiar ways, and that despite the rigours of medieval existence – and the austere morality of the Church's preaching – people's fundamental view of life was that it was for living.

Edward Longshanks certainly believed in seizing the moment. At 31, before his coronation, he became the first English royal crusader since Richard I, sailing for Acre to lead the ninth and final crusade. He won several key battles against Baibars, the Mamluk sultan of Egypt and Syria, before the crusade fizzled out in 1272 with all sides agreeing a truce to last for 10 years, 10 months, 10 days and 10 hours. The moment of highest

drama for Edward came a few months before he was due to sail home.[11] One of his spies – a Muslim who had converted to Christianity – asked to enter the royal bedchamber but, once admitted, attacked the prince. Edward punched the intruder to the floor and stabbed him in the head, killing him, but not before receiving a wound to his hip from the assassin's poisoned blade, which quickly turned necrotic and required an English physician to cut away the dead flesh. Edward's unusually strong relationship with his wife, Eleanor of Castile, was widely known and, before long, the story was circulating – first put about by Bartholomew of Lucca, a friend of St Thomas Aquinas's – that she had saved his life by sucking the poison out of the wound herself.[12]

Henry III died while Edward was on his way home from the crusade. However, no sooner had Edward been anointed and crowned than it became clear he had a very different vision to his father and wanted to use his reign explicitly to unite England, Wales and Scotland to be ruled as a united kingdom. To achieve this, he first set his sights on Prince Llywelyn ap Gruffudd and, by 1282, had the Welsh ruler's head spiked over the gateway to the Tower of London. He then passed the Statute of Rhuddlan to bring Wales under English authority, before consolidating his military control of the region with a chain of the most formidable castles yet built in Britain, dominating strategic sites like Beaumaris, Caernarfon, Conwy, Harlech and Rhuddlan. With Wales conquered, Edward turned his sights to Scotland, but first needed money to fund his campaigning there. In a decision that would have far-reaching consequences, he turned to one of the country's most vulnerable groups.

England's Jewish community had become established in the wake of the Norman conquest, with some of its members building highly successful financial businesses as the Church's restrictions on money lending did not apply to them. Society at the time was broadly conceived of as three orders – clergy, warriors and workers – a classification that originated with King Ælfred as *gebedmen*, *fyrdmen* and *weorcmen*, but settled into the more familiar Latin phrase *oratores*, *bellatores* and *laboratores*.[13] Each had its fixed place in the Christian theory of society, but Jews did not fit neatly into this framework. Instead, because of their importance – and especially the large sums they paid in tax – the crown extended them direct protection as the king's servants, with specific laws and courts for their affairs.

Although England had avoided the anti-Jewish pogroms that erupted across Europe when knights and peoples' armies departed on the various

crusades, over time life for England's Jews became less secure, especially after 1144, when the murder of a 12-year-old boy in Norwich prompted a widespread rumour that the city's Jews had slain him in a gruesome religious ritual. The boy was soon venerated as St William of Norwich, and the affair – for which no one was ever tried – gave the world the 'blood libel': a fictitious and hysterical tale of Jewish sacrificial blood rites that has persisted ever since.[14]

Anti-Jewish feeling was also increasing on the continent, culminating when King Philip II of France expelled all Jews from his royal domain in 1182 and seized their wealth for himself. Soon after, in Rome, the Fourth Lateran Council of 1215 decreed that Jews and Muslims throughout western Christendom must wear a distinguishing mark, which for England's Jews was to be a yellow felt badge depicting the two tables of Mosaic law. In England, anti-Jewish sentiment grew strongly and, in 1290, Edward followed Philip's example and issued an edict of expulsion.[15] This brought him two immediate benefits. It stopped his barons trading in Jewish land-backed debt instruments to increase their landholdings and therefore their power, and it instantly refilled the royal coffers with confiscated Jewish wealth for Edward's planned war with Scotland.

Now fully funded, Edward marched his armies northwards and sacked Berwick-upon-Tweed, where he massacred the men 'like leaves from trees in autumn'.[16] Pressing on into Scotland, he seized the sacred Stone of Scone on which the country's kings had been crowned for centuries. To symbolise the conquest, he sent it back to London for incorporation into the coronation throne in Westminster Abbey, where it remained until John Major dispatched it to Edinburgh Castle in 1996 with the right to recall it to Westminster for future coronations. Ultimately, however, Edward's campaigns in Scotland were inconclusive. He deposed John Balliol in 1296, then had the rebel leader William Wallace hanged, drawn and quartered at Smithfield in 1305, but neither event proved decisive. He spent his last years fighting Robert Bruce, and died in 1307 heading north on yet another expedition. He was 68, still a campaigning warlord, and the first king of England to have got close to forging a united kingdom of England, Wales and Scotland.

Edward and Eleanor had been a genuine love match with 15 children, but she had died in 1290 at the age of 49. Bereft, Edward immortalised his grief by setting up 12 stone Eleanor Crosses between Lincoln and London at the places where her funeral cortège rested on its procession to Westminster

Abbey. Three of them remain: at Geddington, Hardingstone and Waltham Cross. The monument at Charing – now London's Charing Cross railway station – is a Victorian replica in the wrong place. Charing's original Eleanor Cross was just south of today's Trafalgar Square where there is now an equestrian statue of King Charles I with a plaque marking Eleanor's Cross. Cartographically, it is the absolute centre of London: the point from which all map distances are measured.

Constitutionally, the most significant development in Edward's reign was the establishment of Parliament as a permanent counterweight to the feudal nobility. The English monarch traditionally relied on the King's Court (*curia regis*), which conducted the daily business of government and administration. The Normans added the Great Council (*magnum concilium*) of earls, barons and senior clerics to create a body that would come to be known as the House of Lords. Edward's father, Henry III, had been the first king to use the word 'Parliament' for the Great Council.[17] In the late 1200s it expanded to include non-nobles when Simon de Montfort was running the country for a short period, as the Parliament he summoned in 1265 demanded, for the first time, the presence of shire knights and town burgesses. These new delegates were increasingly part of subsequent Parliaments, eventually evolving into the House of Commons. Edward I liked this expanded Parliament with noble and non-noble houses, as it helped him raise taxes to fund wars. During his reign he summoned Parliament 46 times, and consolidated its bicameral composition of Lords and Commons, although the name 'Commons' only appeared in 1332. More than any other ruler, Edward deserves the title of Father of Parliament.

Years earlier, in 1284, when Edward's son was born at Caernarfon Castle, Edward had given him Llewelyn ap Gruffudd's old title, 'Prince of Wales'. This became a tradition, with the crown prince of England bearing it in every subsequent century. On Edward's death in 1307 the 24-year-old Prince of Wales duly succeeded him as Edward II, but the new king's priorities were soon seen to be very different to those of his father. Edward emptied his court of knights and weapons, filling it instead with minstrels and tumblers, and his first act was not to continue the onslaught on Scotland, but to summon his best friend Piers Gaveston, whom Edward I had exiled as a negative influence on his son.

Fourteenth-century chroniclers were not short of views on Edward and Gaveston's relationship, which they described as founded on an affection

that was 'immoderate' and 'beyond measure'. 'I do not remember', the author of the *Life of Edward* II (*Vita edwardi secundi*) wrote, 'to have heard that one man so loved another.' The Westminster monk Robert of Reading went further, referring to their 'illicit' and 'sinful unions'. Gaveston made no effort to deflect all the attention, but revelled in it, appearing at Edward's coronation feast in Westminster Hall resplendent in royal purple and pearls 'shining like the god Mars'. For his part, Edward took no steps to hide his infatuation with Gaveston, choosing to enjoy the evening's festivities from Gaveston's couch rather than that of his wife, Isabella of France, whom he had married a month earlier.[18]

The barons – more used to Edward I's martial style of leadership – were no fans of Gaveston, and repeatedly warned Edward to drop him. When he refused, they took direct action themselves, beheading the royal favourite. Edward was now universally seen as weak and, two years later, in 1314, attempted to rescue the deepening crisis of his reign by continuing his father's conquest of Scotland. However, he had nothing of Edward I's military skill, and his army was routed at the Battle of Bannockburn, with Edward only narrowly escaping off the battlefield.

By now, most of the barons were implacably hostile to Edward, and he moved to develop a degree of functional independence from them and shore up his finances by seeking new backers. He found them in the wealthy Despenser clan, who proved more than happy to take control of the machinery of government in return for bankrolling the crown. However, as the Despensers moved in, observers were not slow to note that Edward and Hugh Despenser the Younger seemed particularly friendly. The new arrangement did nothing to heal the rift with the barons, who grew more alienated and hostile, to which Edward responded with increasingly despotic behaviour, including the rigged trial and execution of the Earl of Lancaster, his cousin, for having orchestrated Gaveston's execution. Meanwhile, the Despensers were consolidating their hold on the court, raiding the barons' assets and attacking their enemies with impunity.

Edward's relationship with Hugh Despenser the Younger eventually alienated his wife, Isabella, who took the rebel baron Roger Mortimer as her lover in reprisal. With her oldest son – also Edward – now in his early teens, she calculated that he would be a better bet than her husband to guarantee her continued power. She and Mortimer therefore took matters into their own hands and declared war on the king, eventually capturing him and Hugh Despenser the Younger fleeing together into the Welsh mountains.

Isabella and Mortimer then nakedly usurped the throne in the name of her son and, with Magna Carta long forgotten, dragged Hugh Despenser the Younger to Hereford where, after a rapid show trial, they publicly hanged him, cut him down alive, castrated and disembowelled him, then beheaded and mutilated the corpse. It was an intentionally hideous death for the person Isabella blamed for coming between her and her husband.

Isabella and Mortimer then swiftly arranged for Parliament to depose her husband officially and hand the crown to her son, the young Edward III. Behind the scenes, they moved the grieving Edward II from dungeon to dungeon, before finally incarcerating him in Berkeley Castle, after which he was never seen again. One popular tradition holds that they inserted a cow's horn funnel into him, then ran a red-hot poker through it to burn out his bowels. Another tradition – almost certainly invented to reassure the young Edward III, sent to him in a letter by Manuele Fieschi, a papal notary – reported that the deposed king had been allowed to flee to the continent where, after much wandering, he settled in Lombardy to live out his days as a hermit.[19] The multiple problems of what to do with a deposed king makes the murder story – however it was carried out – far more likely, and earned Isabella the nickname 'the She-Wolf of France'.[20] Nevertheless, with Edward out of the way, Isabella and Mortimer began settling into their new role as the real power behind the throne of 14-year-old Edward III, thinking they had won themselves a kingdom now at peace. Unknown to everyone, however, England was about to experience the most apocalyptic number of deaths in recorded history.

12

Neumes and Tunes – The Glory of Medieval Music

Anonymous
Sumer Is Icumen In
1240

In 1914 a prominent music critic described Britain as 'the land with no music'.[1] But a visitor to Anglo-Saxon Winchester's Old Minster in the late AD 900s very definitely heard music. He was assailed by blasts from the cathedral's new organ, and remarked on its phenomenal power. 'Audible at five miles,' he noted, 'offensive at two, and lethal at one'.[2] Wulfstan, a monk at the Old Minster, filled in more details, explaining that the organ had 12 bellows, took 70 perspiring men to operate, was mounted with 400 pipes, and 'battered the ears with iron tones like thunder'.[3] It was not, of course, the first instrument to sound in Britain – there had been music for millennia, at least since the arrival of humans – but it was definitely among the most impressive of the country's medieval instruments.

No evidence of music-making survives from Stone Age Britain, but discoveries in other parts of the world show that prehistoric *Homo sapiens* enjoyed making melodies. In 2008 archaeologists digging in the hills around Ulm in southern Germany found carved griffon vulture bone and ivory flutes with finger holes dating from as long ago as 35,000 BC, making them the world's earliest-known manmade musical instruments.[4]

With the arrival of the Bronze Age, it became possible to make metal instruments. The Gundestrup Cauldon – a large, silver bowl decorated

between 150 BC and AD 1 – depicts three men blowing carnyx horns: slender trumpets, each taller than a person, rising vertically and opening into a forward-facing animal's head with gaping mouth. These imposing horns were designed as battle trumpets, able to send great blasts high over the roar of combat. They are known from all across Europe, and one of the best surviving examples, with a dramatic wild boar's head, was found in Banffshire, Scotland.[5]

When the Romans came ashore in Britain, they brought their own musical traditions, including lyres, trumpets, pipes, panpipes, organs, drums, rattles, castanets and cymbals. They had no system for writing music down, so their melodies and compositions are lost, but at least one famous Roman noted that he did not think much of indigenous British music. When Caesar visited Kent in 55 and 54 BC, Cicero wrote to a friend that, among the Britons Caesar might seize as slaves, he anticipated few would have any musical or literary education.[6]

After Roman Britain disintegrated, Celtic music returned, used by bards for accompaniment to their sung poetry. As the Celts were now literate, some poems were written down. Aneirin's great battle epic *The Gododdin* (*Y Gododdin*) – mentioned in Chapter 4 as containing the earliest reference to King Arthur – opens with the line 'This is the Gododdin, Aneirin sang it'.[7] Celtic instruments were added to in the tumult of the fifth century when the incoming Anglo-Saxon settlers brought Germanic musical traditions to England. Their *scopas* (poets) and *hearperas* (harpers) entertained crowds with verse and epics, while in the Danelaw and other areas they occupied, the Vikings enjoyed the poetry and music of their *skalds*. Singing was an especially prized social grace. Bede told the story of Cædmon, a shy seventh-century cowherd at Whitby Abbey, so terrified of after-dinner singing he would leave the room if he spotted a harp being brought out to be passed round. One night, however, a wondrous poem came to him in a dream and, when he recited it, listeners were astounded by its beauty. The experience gave him confidence, and – according to Bede – Cædmon became the greatest poet in the land. Whether or not the story is true, his dream poem, *Cædmon's Hymn*, is the earliest poem in Old English.[8]

In this period, the variety of instruments and technology for making them took significant steps forward. Stringed instruments included lyres, harps, rebecs and crwths. Wind came to be represented by an array of trumpets, horns and flutes. Percussion encompassed drums, cymbals and bells. And more complex and specialised instruments became popular, like the organistrum: an early type of hurdy-gurdy to be played simultaneously by two people.

Cædmon composed his hymn soon after Anglo-Saxon England had been Christianised. As the Church became influential in daily life, music split more starkly into secular and sacred. Kings and nobles continued to enjoy entertainment in their halls and palaces, and – like David in the Bible, who played on his harp to soothe King Saul – magnates cultivated skill in music as an accomplishment of their social rank, like the warlord buried at Sutton Hoo, who went to the afterlife with his six-stringed lyre beside him.[9]

In church, music was predominantly sung. Hymns were performed to the accompaniment of wind, strings or organs, while chant was always unaccompanied. Chant, or plainchant – literally 'level singing' (*cantus planus*) – was a descendant of ancient Roman music that emerged from the third century as the Church's preferred way to adorn and beautify the sacred words of the liturgy.[10] Just as Latin evolved across Europe into French, Italian, Spanish, and other Romance languages, so identifiably separate schools of chant with different regional features developed across western Christendom: Old Roman in Rome, Ambrosian in Milan, variants in Ravenna and Benevento, Gallican in France, Mozarabic in Spain, and numerous Celtic traditions in the non-Anglo-Saxon parts of the British Isles.[11] Gregory I the Great, pope from AD 590 to 604, is traditionally credited with overhauling these disparate chants and introducing a common standard repertoire, although there is no historical evidence for his involvement. Nevertheless, by the ninth and tenth centuries, 'Gregorian' chant – which was derived from Old Roman chant – supplanted the earlier formats to become the Church's standard.

Gregorian chant had a single melody line, sung by one or many voices, no harmonies and no musical accompaniment. Singers memorised its undulating melodies, but in the ninth century the Church began developing ways to write music down.[12] This musical notation – the oldest in the West – began with simple up and down marks called neumes placed above the words to indicate whether the singers' pitch should rise or fall. This was based on the ancient Graeco-Roman rhetorical system of an *acutus* accent (/) to signal that the voice should rise, and a *gravis* accent (\\) that it should fall.[13] In time, these evolved into the *virga* (/, rod) and *punctus* (•, dot) delineating the melody in more detail. The next, and most important, breakthrough came when they were set onto a four-line staff – traditionally attributed to Guy of Arezzo in the early eleventh century – enabling the notation to indicate exact intervals between notes: in other words, the tune.[14]

The main custodians of Gregorian chant were the cathedrals, collegiate churches, monasteries, friaries, nunneries and other religious houses whose

priests, clerks, monks and nuns chanted the daily cycle of eight offices. For these they would assemble in the chapel or church for matins before sunrise, lauds at sunrise, prime at the first hour, terce at the third hour, sext at the sixth hour, none at the ninth hour, vespers at sunset and compline before bed.[15] As each day was divided up using the ancient Roman model, splitting the period between sunup and sundown into 12 equal portions, time was elastic, the length of each 'hour' varying with the seasons.

In Britain, geographical distance from Rome meant that local traditions of liturgy and chant were not completely supplanted by Gregorian chant. Some, like the Sarum Use – developed in Salisbury before the Norman conquest as a variant of the Old Roman rite – became widely established, with elements surviving the medieval period and being incorporated into the first liturgies of the post-Reformation Church of England.

Chant was the Church's soundtrack to the Early, High and Late Middle Ages, and inevitably evolved over the centuries as musicians experimented with new ideas. Before the AD 700s boys' voices were added to thicken the sound by doubling the melody an octave higher. But the real innovation came with the advent of harmony when, in the ninth century, other adult voices began to mirror the melody on the fourth and fifth notes of the scale. This way of composing came to be known as *organum* because the result sounded like the chords played on an organ, and the oldest manuscript in the world with these *organum* harmonies is an Anglo-Saxon codex, the *Winchester Troper*, compiled around 1020.[16]

The next major innovation came in the late 1100s in Paris, when Pérotin and Léonin pushed theory and singers even further, breaking individual voices free from the main melody and allowing them independent and separate melodic lines, creating infinite, interweaving kaleidoscopes of melody and harmony. Although the main medieval collection of this music – the *Great Book of Organum* (*Magnus liber organi*) – was compiled in Paris, it contained significant compositions by a Scot from St Andrews.[17]

One of the final steps came in the 1300s, when composers added the third note of the scale to their palette, opening up major and minor modes and triads, giving music unprecedented options for richness, tension and resolution. In France and Italy these developments culminated in the 'new art' (*ars nova*), which strove for unprecedented heights of compositional sophistication. Although it was primarily a continental movement, the *Four Principles of Music* (*Quatuor principalia musicae*), probably written in Oxford around 1351, outlined specifically English

theories of melodic colouration that proved deeply influential on the evolving *ars nova*.[18]

With a growing and notable focus on melody, England was soon producing ground-breaking pieces like the motet *Sub arturo plebs*, probably written in 1358 for an Order of the Garter ceremony celebrating the Battle of Poitiers.[19] Melodic complexity continued to develop with increasing experimentation but, despite persistent legends, the famous 'Devil's interval' tritone was never forbidden on pain of excommunication, and the phrase *diabolus in musica* is not medieval.

By the early 1400s England's reputation for choral music was firmly established, and composers like John Dunstable, Walter Frye, John Hothby and Leonel Power were the mainstay of the celebrated *Contenance Angloise* (English Manner) built around ornamented melodies based on thirds and sixths.[20] By the early sixteenth century rare collections to survive the Reformation like the *Eton Choirbook* show the continued development of English polyphony, which culminated later in the century in the soaring Renaissance glories of Thomas Tallis and William Byrd.[21]

Although sacred and secular music were conceptually distinct, there was inevitably crossover, and some were quick to exploit the shared musical vocabularies. Popular tunes were taken up by Church composers, and secular works came to incorporate elements of Church music. As early as the seventh century, Aldhelm, abbot of Malmesbury and bishop of Sherborne, regularly took his lyre to the bridge at Malmesbury, where he entertained the crowds by slipping snippets of Scripture into popular songs of the day.[22]

Before the Early Modern era, the ability to read and write was predominantly a Church skill, so while some sacred medieval music was written down and has survived, medieval secular music died with the world that created it. But not completely. The British Library owns a manuscript codex dating from 1261 to 1265 that is filled with a jumble of music, poetry, racy Goliard verses, advice on hawking, medicine, and the *Fables* and *Lays* of Mary of France. With its light and entertaining contents, the volume was probably compiled for a monk as a personal scrapbook, and it was likely made in Oxford for the colourful William of Winchester – whose name appears in the codex – a keen musician with disciplinary issues. In 1272, for instance, he was hauled up in front of the bishop of Hereford for repeatedly breaking his vows of chastity, especially with Agnes of Avenbury, a nun from Limebrook Priory.[23]

In manuscript books the front of a folio is the recto and the back is the verso. In the British Library codex, the verso of folio 11 has a piece of music

written out boldly in black, blue, and red inks. Despite being over 750 years old, many people will know the tune laid out in medieval neumes. They will also recognise the words.

Original text	**Translation**
Sumer iſ icumen in	Summer has come in
✠ Lhude ſing cuccu	✠ Sing loudly, cuckoo
Groweþ ſed and bloweþ med	Seed grows and meadow blooms
and ſpringþ þe wde nu	and the wood springs new
Sing cuccu	Sing, cuckoo
Awe bleteþ after lomb	Ewe bleats after lamb
Lhouþ after calue cu	Cow lows after calf
Bulluc ſterteþ, bucke uerteþ	Bullock stirs, stag farts
Murie ſing cuccu	Sing merrily, cuckoo
Cuccu, cuccu, wel ſingeſ þu cuccu	Cuckoo, cuckoo, sing you well, cuckoo
Ne ſwik þu nauer nu	Don't you ever stop now

There are then two further lines that repeat throughout underneath the melody forming a 'ground', or an *ostinato* in modern terms. The word in the manuscript is the Latin *pes*, meaning foot.

Original text	**Translation**
Line one:	*Line one:*
Sing cuccu nu	Sing, cuckoo, now,
Sing cuccu	sing, cuckoo
Line two:	*Line two:*
Sing cuccu	Sing, cuckoo
Sing cuccu nu	Sing, cuckoo, now

The song's words are laid out attractively on a spacious six-line staff, with the Middle English lyric under the relevant neumes in the style of modern music. One of the many singularities of the song is that it has precise rules for how to sing it, and the scribe has helpfully added several break-out boxes with instructions for performance.

Four singers can sing this round. However, it should be sung by no less than three, or at the very least two, on top of those who hold the *pes*. It is sung like this. One begins along with those who sing the *pes* while the others remain silent. When he gets to the first note after the cross, another begins, and the others do the same. Each one pauses for the space of one long note where a rest is written, but not elsewhere.

For the *pes*:
One repeats this for the length of the work, making a rest at the end.
The other sings this, pausing in the middle and not at the end, immediately repeating the beginning.

This guidance reveals that it is a four-voice canon sung over a two-voice round. In other words, the two voices of the *pes* – each repeating one of the *pes*'s lines – provide a continual backwash, while the four-voice melody soars over the top, with each of the principal singers beginning as the previous voice arrives at the red cross before 'Sing loudly, cuckoo'. Cleverly – and also because vellum was expensive – there is a second lyric, in Latin, on the same folio. It is written in red ink under the words of *Sumer Is Icumen In*, and was performed identically, as a canon, to the same tune, providing a solemn religious song with no *ostinato* for more formal occasions. It may even be that the two, together, offered a cheeky moral framework, with the religious poem acting as a counterweight to the earthier cuckoo song, as spring and cuckoos were associated with sex and infidelity, the word cuckold deriving from cuckoo in this period.

Sumer Is Icumen In is essentially a simple, joyous spring song. But it also has historic significance. It is not only the sole Middle English song in the codex, but the oldest Middle English song known from anywhere. It is also the oldest six-part harmony, the oldest canon, and the oldest song to have an *ostinato*. It is, in fact, probably the earliest non-Latin 'folk' song in Europe, although the manuscript's alternative secular and sacred words highlight just how close the musical worlds of the cloister and village green were. This proximity touched many aspects of life, and was also reflected in another prominent medieval English musical activity in which Christianity's most fundamental stories were retold in great popular pageants of verse and song.

These spectacles did not evolve until the later Middle Ages because the early Church had a complex attitude towards religious drama. At the end of the second century the Tunisian theologian Tertullian condemned public entertainment in his treatise *On Shows* (*De spectaculis*), but eventually a distinction emerged between sacrilegious dramatic festivals like the Feast of the Fools and worthy dramas that promoted Christian values.[24] As a result, mystery and miracle plays began to flourish as a form of popular and improving entertainment. In late 1300s England, when the proto-Puritan Lollards emerged and condemned public religious drama, the English Church viewed this hostility as one of the Lollards' many heresies and gave

the public plays their full support, allowing them to thrive until the Reformation, when a more puritanical climate again banned them.[25]

In time, the mystery and miracle plays developed into full-blown civic affairs, with guilds in major cities vying to outdo each other in the lavishness of their productions, stages and floats. Of the surviving great cycles from York, Wakefield, Coventry and Chester, the York corpus is the grandest, with 48 plays to be performed on the Feast of Corpus Christi by actors and musicians on wagons pulled around the city.[26] The carefully choreographed drama started early in the morning with Adam and Eve, and ran throughout the day, ending late at night with the Last Judgement performed at the city's place of executions. Like secular songs, these mystery and miracle plays were in the people's everyday language rather than Latin, but this was not always English. There are five surviving plays in Cornish dramatising the lives of Saints Meriasek and Keo, the origin of the world, the passion of Christ, and the resurrection.[27]

When the opportunities arose, singing and music inevitably also included dancing. The history of English dance is complex, but in 1448 there is the first mention of a group of 'moryssh daunsers', who were paid for a performance in London before the Company of Goldsmiths.[28] Acrobats were also popular throughout the Middle Ages. At the turn of the 1300s in the reign of Edward I, one of the most famous was Matilda Makejoy, a tumbler and vaulter who performed several times for the king and the Prince of Wales.[29]

For all its joyful frivolity, *Sumer Is Icumen In* is a landmark in English music. It was not true in 1914 that Britain was a land without music. The comment was pointedly aimed at the modest British contribution to eighteenth- and nineteenth-century classical music composition compared with Germany and France. However, it overlooks other traditions, especially old, longstanding ones. England may not have had a Beethoven or a Wagner in recent centuries, but it had flourished musically in the medieval and early modern periods, and nineteenth-century composers like Arthur Sullivan produced accomplished works, including the comic operas he wrote with William Gilbert, which proved internationally popular and entertaining in their uniquely English way. Britain has always enjoyed a wealth of musical excellence, and there has been no period in which it has not had a vibrant musical culture, as true in Wales – with its long choral tradition – Scotland, and Ireland as in England. This musicality would, quite unexpectedly, take centre stage in the twentieth century, when Britain would become one of the two epicentres of modern music, and the place where the term 'pop' was coined.

13

King Death – Pestilence, Apocalypse and Rebirth

Anonymous
Plague Graffiti
1350/1361

The village of Ashwell lies halfway between London and Peterborough, some 15 miles south-west of Cambridge. It dates back to Anglo-Saxon times, and is first mentioned as Æscewelle in a 1066 charter of King Edward the Confessor.[1] A century and a half later – around the time of Magna Carta – it was thriving, and the Abbot of Westminster paid two palfreys to have its weekly market moved from Saturdays to Sundays.[2] It is a typical, sleepy English village, set in the bright green countryside of the Cambridgeshire–Hertfordshire border.[3] It seems highly improbable that such a place could have any connection to an ancient port city overlooking the deep blue waters of the Black Sea. And yet, events in the fourteenth-century Crimea would dramatically change Ashwell for ever.

In 1346 Jani Beg, the Mongol Khan, was besieging Caffa: a Genoese-owned trading town later generations would rename Feodosiya. According to the Italian chronicler Gabriel of Mussis, Jani Beg's Mongol forces suddenly began dying in large numbers, succumbing to a virulent illness that had originated in the steppes of Asia. The attacking army was soon so depleted that Beg could no longer maintain the siege. In desperation, he gave orders for batches of his men's disease-riddled corpses to be loaded onto siege catapults

and fired over the walls into Caffa in the hope the stench of the cadavers and their ruptured boils would hasten the city's surrender.[4] To his surprise, the effect of the corpse ballistics turned out to be far more dramatic than he had hoped. The Genoese residents of Caffa immediately began falling ill with the same fatal illness as his men, and rapidly took to their ships and headed home to Italy. Unknown to the fleeing colonists, however, when their vessels docked in Sicily, they unleashed the disease upon Europe, bringing to western Christendom the most destructive pandemic the world has ever seen. Within a few short years, up to 50 per cent of the continent lay dead from the virulent mystery disease. Centuries later, writers christened it the Black Death.

In Ashwell, opposite the Bushel and Strike public house, the parish church of St Mary the Virgin looms over the road. It is a remarkable building, large for the size of the village, with an imposing, tall tower. Unusually, much of the building is original, and dates back to its construction in the 1300s. Even more unusually, columns in the nave still bear scratched phrases of medieval wisdom from people perhaps idling away the time during a less engaging part of the Mass. 'The archdeacon is unholy', reads one. 'Drunkenness breaks whatever wisdom touches' advises another.[5]

The church's tower rises an impressive 54 metres, with walls in places up to 2.5 metres thick. On its inside north wall are several large, jagged lines of medieval Latin graffiti, still clearly visible. In English, they read:

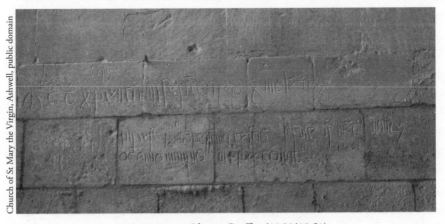

Church of St Mary the Virgin, Ashwell, public domain

Anonymous, Plague Graffiti (1350/1361)

plague 1350 pitiable savage violent
the dregs of the people survive to witness and at the end a great wind
thunders throughout the world in this year 1361 on the feast of St Maurus

The bleak words were scratched into the wall by a survivor of the Black Death, memorialising the vicious destruction that had torn through the community, leaving it ravaged by 1350. The second part of the inscription records its recurrence in 1361, and its final disappearance on St Maurus's Day. A little later, another line was added higher up the wall to clarify:

the first plague was in 1349

The word the despairing writer used for the disease was *pestilencia* – pestilence or plague – the normal medieval description of the fatal illness. Later commentators concluded that it was not just a plague, but the plague – *Yersinia pestis* – a bacterium that has culled humans for millennia, with evidence of its lethal existence reaching back to 6000 BC.[6]

Yersinia pestis is primarily spread by *Rattus rattus*, the black rat, which transmits the bacillus by passing it to its blood-sucking fleas. Once infected, the fleas develop blocked guts from the plague bacteria lodging in their upper digestive tracts. This prevents them from swallowing food, so they become abnormally hungry. When the rat dies of the disease, the fleas find other hosts, including humans. By now starving, they bite ravenously, and simultaneously vomit *Yersinia pestis* into the bite wounds. Once the bacterium has been introduced into the human host, it travels to the lymphatic system, where it causes swelling of the nearest large lymph nodes. If bitten on the legs, the swellings are usually in the groin. If the abdomen, the armpits. And if the head, the swellings develop in the neck, behind the ears. Medieval doctors called these chicken's-egg sized swellings 'buboes' – from the Greek word for groin or swelling in the groin – leading to the name bubonic plague. In the days before antibiotics, the disease killed up to 90 per cent of those infected.

Bubonic plague could also transform into other even more lethal diseases. In some victims it moved from the lymphatic system into the bloodstream, where it caused septicaemic plague. This could be transmitted to other humans through blood-to-blood contact, including via human fleas. Bubonic plague could also travel to the victim's lungs, or be inhaled directly in flea faeces, where it developed into pneumonic plague. This was the disease's most virulent form, with coughing and sneezing transmitting the plague through moisture droplets in the same way as the common cold. Contact with fluids from infected cadavers could also transmit the disease, as happened with the catapulted corpses in Caffa.[7] Septicaemic and

pneumonic plague were far more aggressive than bubonic plague, with death following in one to three days in almost 100 per cent of cases. Since the general availability of antibiotics in the 1940s, they have provided an effective treatment for individual cases of plague, but mass outbreaks remain difficult to control, placing plague high on the list of bio-terror agents. Japan released it among Chinese populations in World War Two – with outbreaks recurring subsequently in the infected areas for years – and it was industrially stockpiled by Russia during the Cold War.[8]

Some have suggested that the medieval Black Death may not have been *Yersinia pestis* at all, or that it may have been a cocktail of *Yersinia pestis* and other diseases.[9] However, academic consensus is that the medieval global pandemic was plague, and skeletons found in a variety of plague pits – like the 48 men, women and children exhumed from Thornton Abbey in Lincolnshire in 2016 – have *Yersinia pestis* in their tooth pulp, confirming the cause of their death.

Caffa may not have been the only place on the Black Sea from which the Genoese fled, but it is known that their plague ships' first landfall in Europe was Messina in Sicily, from where the disease spread rapidly, at times obliterating entire communities. The extent of the pandemic was unprecedented, and people struggled to understand what was happening. Many assumed that God was visiting apocalyptic destruction on humanity for its sins in the same way, according to the book of Exodus, he had unleashed the 10 plagues on Egypt.[10] Communities had no experience of death on such a scale. Church graveyards were quickly overwhelmed as whole families and neighbourhoods died in days or weeks. Pits were dug and bodies interred without ceremony. In many places there were soon no priests alive to perform funeral rites, and the pits overflowed. In Florence one observer noted that corpses were layered with thin sheets of earth between them 'just as one makes lasagne with layers of pasta and cheese'.[11]

Although the plague struck indiscriminately, in Avignon Pope Clement VI received astute medical advice from one of the most renowned physicians of the age, Guy of Chauliac, who insisted the pope forbid all visitors and sit in a room with two large, hot fires to cleanse the air of infected miasmas.[12] The remedy worked because the heat probably kept the rats and fleas away, and the pope saw out the period of intense mortality in the overcrowded city that Petrarch, who visited at this time, dubbed 'the Babylon of the West'.[13]

As the mood turned increasingly to why God was punishing Christendom, in France and Germany popular hostility singled out the Jews, who were

assumed to have enraged God with their disbelief in Christ. Predictably, anti-Jewish mob violence erupted, including burnings. More specific allegations then began to circulate, pointing the finger at Jews for trying to exterminate Christians by poisoning wells, triggering yet more violence.[14] In Avignon, Pope Clement condemned the scapegoating, solemnly issuing three bulls against the thuggery and reminding his flock that 'Christian piety receives and sustains and does not allow Jews to be harmed'.[15]

Another extreme response to the carnage saw the arrival of bands of flagellants, who roamed from place to place scourging themselves until their blood flowed freely in expiation of their sins. They advocated a potent brew of millenarianism and anti-Jewish mantras, believing the plague would foreshadow the second coming of Christ and a new age of divine blessedness. Their extensive wandering inevitably spread the disease more widely, and many of the flagellant bands soon degenerated into criminal rabbles. In October 1349 Pope Clement issued a bull banning them, and by the following year the craze had petered out, helping to reduce the spread of the disease.[16]

In the summer of 1348 ships crossing the Channel brought the pandemic to England. The entry point may have been Southampton, Weymouth, Bristol, or all three, and at around the same time it entered Ireland through ports around Dublin.[17] London was infected by the autumn, and by May the following year the disease had reached York. The ensuing devastation to communities and towns left survivors reeling. In Kilkenny, the Franciscan friar John Clyn – seeing doom moving ever closer – signed off his chronicle with the words, 'I leave parchment for the continuation of this work, in case anyone might still be alive in the future and any son of Adam escapes this pestilence and can continue this work.'[18] His original manuscript survives, but he did not, and no one else lived to add to it.

Despite the trauma, Britain did not witness anti-Jewish violence or mass groups of flagellants. England's Jews had been expelled by Edward I in 1290, and one of the rare sightings of flagellants was a group which arrived from the Netherlands in late September 1349. They wore loincloths and hoods painted with red crosses front and back, carried three-stranded whips with embedded needles, and sang penitential calls and responses. They processed around St Paul's Cathedral in London twice a day, and in each procession lay down in the dust three times, taking it in turns to trample each other and whip the people underfoot.[19]

As towns and villages across Britain filled with corpses, people looked everywhere for explanations. Thomas of Malmesbury reached the considered

conclusion that God's ire was the direct result of men's increasingly indecent clothing: immodestly short doublets, tight-fitting cloaks like women's, stripy hose with laces, belts studded with gold and silver, and pointy shoes.[20]

From the summer of 1348 the disease ran wild in Britain for 18 months, before petering out by December 1349 when the archbishop of Canterbury invited all to say prayers of thanksgiving for their survival.[21] They were the lucky ones. Something in the region of half the population – rich and poor – had succumbed.[22] King Edward III and his family all survived, except his 14-year-old daughter, Joan, who died of the plague near Bordeaux en route to meet her betrothed husband Peter of Castile.

Although the intensity of the plague was over by late 1349 it did not disappear, but continued to recur long into the 1600s. As the graffiti in St Mary's Ashwell witnesses, it returned to England in 1361, when it killed an estimated one in five people. The *Grey Friars Chronicle* of Lynn records for 1361, 'This year there was a great pestilence in the south of England, with the death of children and adolescents and the wealthy.'[23] Although the 1361 death toll was lower than in 1348 to 1349, the chroniclers lamented that this second pestilence was especially hard to bear because it disproportionately struck the young at a time when the population remained decimated by the first plague. The *Grey Friars Chronicle* also confirms the graffiti at Ashwell by referring to the great wind on St Maurus's Day. 'On the 15th of January and the following night there was a violent wind which destroyed and took the roofs off bell towers, churches and houses, and uprooted trees.'[24] In Ashwell, at least, this seems to have been the day the second pestilence ended.

But still it was not truly over in Britain. There were notable recurrences in 1369, 1374 to 1379, 1390 to 1393, and then on and off until the infamous Great Plague of 1665, the year before the Great Fire of London. This last outbreak was very unambiguously *Yersinia pestis*, and the uncommonly rapid death of large swathes of Londoners suggests pneumonic plague had taken hold and was being spread unstoppably by lethal coughing and sneezing. Some rudimentary public health measures were attempted, but with little effect. In 1371 Edward III imposed regulations on London's butchers, complaining that they were responsible for 'putrefied blood running in the streets', 'dumping entrails in the river Thames' and 'appalling abominations and stenches'.[25] But it was all to no avail.

Taken together, the outbreaks of plague from the fourteenth to the seventeenth centuries are known as the Second Plague Pandemic. The first had

raged from the sixth to eighth centuries, starting with the Plague of Justinian across the Eastern Roman Empire. Inevitably, with so many recurrences, plague outbreaks eventually became viewed as an unavoidable feature of life. In London there were resurgences every 20 to 30 years, often killing around 20 per cent of the city's population.

The impact of the initial wave of plague on England's population was beyond anything previously experienced. On the eve of the first plague in 1348 England had 4.8 million people. By 1351 there were only 2.6 million, and by 1450 the number had dropped to a mere 1.9 million. The population had been cut by 60.5 per cent, and it remained shrunken for centuries, not reaching its pre-plague level until well into Tudor times.[26] One of the immediate effects of the sudden drop in population was an unprecedented hike in the survivors' earning power. Before the Black Death there had been steady population growth in England and an oversupply of labour. After the first plague, those who survived were able to charge three or four times more for their labour. In an attempt to control this squeeze on landowners, as early as 1349 Edward III passed an ordinance fixing wages at their pre-plague 1346 to 1347 levels 'since a great part of the population, and especially workers and employees, has now died in this pestilence'. However, the measure was unenforceable, and the administration admitted as early as 1351 that it had no way of curbing the rampant wage inflation.[27]

Women, too, were heavily affected. The death of so many men meant that women were drafted into the workforce to fulfil roles they had previously been excluded from, or had never been recognised for filling in the background.[28] Among landholders, widows turned to managing their estates, daughters inherited when all the sons had died, and changes in the legal system made it easier for women to own and manage property. Although some women benefited from opportunities, found work and assumed positions of social responsibility, it was not an emancipation. The fundamental biblical principle that men ruled women continued to prevail for centuries.[29]

As a result of the reduced population some families became newly wealthy and there was significant upward social mobility, both of which unsettled the establishment. As early as 1363 Edward III passed the first sumptuary laws – from the Latin *sumptus*, cost – regulating exactly what clothing different members of society could wear, and imposing strict financial limits on clothing expenditure to curb some people's attempts to appear socially grand.[30]

The human cost of the fourteenth-century plagues altered society profoundly. These changes did not mark the transition from the medieval to the modern world, but they radically altered long-standing features of society, and ended many traditional practices. They spurred advances in the structures of landholding, and the erosion of the manorial system as labourers abandoned their homes and sought employment wherever they would be best paid. The old master–servant relationship collapsed, and new frameworks evolved. In time, these would lead to the Peasants' Revolt of 1381, when those who had been ignored for so long felt for the first time economically and politically empowered to make demands.

The Church was also deeply affected. Its ranks had been decimated, and it began to face serious rumblings of dissent that would lead, in several centuries, to the Reformation. The first major challenge to its authority came at the time of the Peasants' Revolt with the emergence of proto-Protestant Lollards starting calls for reform. At the same time, measures were being taken within the Church to rebuild and renew. One major initiative was conceived of and financed by the bishop of Winchester and twice Chancellor of England, William of Wykeham. In 1379 he founded a new college – New College – at Oxford, the largest college to date, and designed around an innovative quadrangular pattern that would become the model for later Oxford and Cambridge colleges. His idea was to train armies of literate clerks for governmental administrative work – the civil service of its day – and in 1382 he founded a grammar school, Winchester College, to prepare pupils for it.[31]

Spiritually and philosophically, the plague altered the way people thought about living, and ushered in a new fascination with transience and mortality. In 1424 to 1425 an image of the *Danse Macabre* – the Dance of Death – appeared on the cloister arcading of Paris's cemetery of the Holy Innocents, showing 15 rotting, dancing skeletons, each with a living pope or king, knight, money-lender, lawyer, peasant, infant, or other recognisable characters from society. It was accompanied by a darkly humorous poem, a copy of which was painted the following year in St Paul's Churchyard in London with a Middle English translation of the verses.[32] Mass death was now part of life as never before.

Gruesome scenes of death and corruption making merry with the living were soon commonplace. Simultaneously the *memento mori* – remember you have to die – theme spread widely, even influencing the traditionally calm recumbent effigies on the tombs of the affluent. After the Black Death,

'transi' tombs became fashionable depicting the owners rotting away, in contrast to the earlier medieval sculptures of bodies resting in divine grace. In England the transi figures were commonly represented as starkly emaciated and skeletal, while in other parts of Europe they were often hollow skeletons sheltering worms, snakes or frogs.[33]

For all its destruction, the Black Death was not the only material cause of violent death for fourteenth- and fifteenth-century Britons. While the plague raged, warfare was also rife, with a defining conflict that ran from before the plague in 1337 all the way to 1453 as England and France strove on a variety of battlefields for the French crown. It was one of the most significant conflicts in England's history, catalysing the consolidation of England as a distinct political entity, finally pushing the English monarchy to abandon its French manners and heritage and embrace a solidly English identity.

14

Three Lions and the *Fleur-de-Lys* – Coveting the French Crown

Joan of Arc
Letter to King Henry VI of England
1429

With King Edward II dead in Berkeley Castle, his former queen, Isabella, and her lover, Roger Mortimer, assumed power in the name of her 14-year-old son. However, their administration was not popular with the country or the new young king. When Edward III was 17, he raided Mortimer's castle, seized him and took power in his own name. Despite Isabella's strong plea for mercy – 'Good son, good son, have pity on gentle Mortimer' – Edward took decisive revenge for the regicide of his father, and hanged Mortimer without trial.[1]

Like his grandfather Edward I, the young Edward III showed early promise as a military commander.[2] He continued the intermittent conflict with Scotland, but his life's major opportunity opened up when King Charles IV of France died in 1328 taking the ancient Capetian line of French royalty to the grave with him. Edward had a direct connection to the French crown through his mother, Isabella – the She-Wolf, sister of Charles IV and daughter of Philip IV – so sent a delegation to Paris to stake his claim. In the end, the French nobles rejected the teenage king of England in favour of 35-year-old Philip of Valois, whose claim was more distant but flowed through a uniquely male line.

By this date, the English crown's only significant possessions in France were the county of Ponthieu in the north and Bordeaux with its surrounding region of Gascony in the southern duchy of Aquitaine. In 1337 Philip of Valois – now Philip VI of France – moved on both, uneasy that England should possess territories in mainland France. Fast French warships then arrived off Hastings, Portsmouth and Southampton, launching attacks that destroyed significant areas of the towns, to which Edward responded by marching an army to the continent.[3] No one knew it at the time, but these were the early salvos of what would later be called the Hundred Years War, although it was in fact three wars which would take 116 years to run their course.

The first phase – the Edwardian War – opened in earnest in January 1340, when Edward raised the stakes by pronouncing Philip an imposter and declaring himself the legitimate and lawful king of France. To remove any doubts over his seriousness, he updated his royal arms, quartering the three gold lions of England with the gold fleurs-de-lys of France in an unambiguously unified design.[4] Kings of England from William the Conqueror onwards had claimed duchies and counties in France, but Edward was the first openly to claim its throne.

The first significant military engagement in the fight for France took place at the Battle of Sluys off the Dutch coast north-east of Bruges, where Edward destroyed Philip's fleet and secured control of the Channel to scotch any French invasion attempts. The war then moved onto land, opening with a crushing encounter in 1346 at Crécy – a village in the Somme between Dieppe and Le Touquet – where Edward's army broke a French force outnumbering his three to one. As well as being the first land battle of the Hundred Years War, Crécy introduced the world to England's new technology of massed longbow attacks, with each archer able to loose off 10 to 12 armour-piercing arrows a minute, cutting down the French knights before riders and horses could deliver a charge. The battle also saw Edward use small cannons – *pots de fer* or bombards – in the earliest recorded tactical field use of gunpowder in the West.[5] After a brief respite, the following year Edward secured a second critical victory when he seized the strategic coastal port of Calais, providing his commanders with a vital bridgehead for moving troops freely and safely between England and the continent.

In the two centuries since Geoffrey of Monmouth had written the *History of the Kings of Britain*, his tales of King Arthur had been developed and embellished by dozens of other writers, and Edward was one of their

biggest fans, entirely captivated by the adventures.[6] A few years before
Crécy he had announced a new Arthurian knighthood with a round table,
and started building a home for it at Windsor Castle. The project stalled,
largely because funds were needed for his campaigns but, after the triumphs
at Sluys, Crécy and Calais – and inspired to create a permanent memorial
to them – in 1348 he founded the Most Noble Order of the Garter. With
an eye to his wider political ambitions, he chose French royal blue and not
English royal red for the new knighthood's ceremonial robes, with the
motto *honi soit qui mal y pense* – 'shame on him who thinks evil of it' – as
a direct rebuke to those who questioned his self-appointed status as king of
France. The story that the motto was a reprimand to smirking courtiers
when the Countess of Salisbury's garter slipped down her leg is a later
invention: the garter on the order's arms is a sword belt or strap for fasten-
ing armour.

That year, 1348, the ravages of the Black Death struck France and then
England. Despite the apocalyptic death toll, the Edwardian War against
France resumed afterwards, with an army under Edward's son – the 26-year-
old Black Prince – crushing a French force at Poitiers in 1356 and capturing
the French king, John II. However, enthusiasm for the war was waning on
both sides. The string of heavy defeats inflicted by England was deeply
unpopular with France's nobles, and Edward was frustrated that his many
victories had not succeeded in securing him the French throne. With fatigue
mounting all round, in 1360 the two sides sealed the Treaty of Brétigny.
John was released for the vast sum of three million gold crowns, and Edward
renounced his claim to the French throne in return for significant lands in
France, including the Angevins' old territory of Aquitaine that Eleanor had
brought when she married Henry II. The peace, however, was fragile. John
II died and his successor, Charles V, opened the Hundred Years War's second
phase – the Caroline War – which ran for 20 years from 1369 to 1389. In
response, Edward reinstated his claim to the French throne, but hostilities
came to an end with Charles's death, giving both sides the opportunity to
refocus on domestic affairs.

The third and final phase was the Lancastrian War, begun under Henry
V of England, the ambitious eldest son of Henry Bolingbroke, who had
probably starved Richard II to death before taking the throne for himself as
Henry IV. By the time his son, Henry V, inherited the crown in 1413, France
had descended into a messy civil war that bristled with opportunities for
England. The French royal house of Valois, backed by a faction known as

the Armagnacs, was pitted against a Burgundian alliance that was happy to support England's claim to the French throne. Keen to capitalise on this support and the wider chaos, Henry took an army on manoeuvres in France.

The story of what happened next has filled English textbooks for centuries. On 25 October 1415, near a small village in Picardy called Azincourt, Henry's tired, hungry and dysentery-depleted troops met a force comprising the flower of France's nobility that outnumbered them five to one. The French knights' code of chivalry ran deep, and many were keen to prove themselves in battle to win reputations that would be sung of in ballads for generations.

Like Leonidas at Thermopylae, Henry chose the battle site with scrupulous care to even up the odds, luring the French into a narrow, muddy killing funnel where their vastly superior numbers gave them no direct advantage. He deployed his longbowmen out front so that when the French knights began to advance, they were felled en masse by hailstorms of metal-piercing arrows. As ever more French knights charged into the funnel, they filled up the congested space until they could not move, with the men in front crushed by those continuously advancing from behind. The English longbowmen swiftly moved in to pull them from their horses into the mud, before setting about butchering them with mallets and knives. The result was an abattoir.

Henry took several thousand prisoners and held them to the rear by the baggage train, but – fearing they might overpower their guards and open a second front – gave orders for all but the very highest-ranking to be executed. This was an unimaginable command. Knights, if captured, expected to be ransomed. Horrified at Henry's order, the English knights refused to obey, but eventually the longbowmen formed killing squads and moved in, executing the French knights in cold blood. The massacre sent shock waves through Christendom, and was a definitive sign that the long-established code of the knightly class was breaking down. However, in England, a collection of propaganda songs and writings – culminating in Shakespeare's 'We few, we happy few, we band of brothers' – burnished the battle with tales of English heroism.[7] Clever, Henry had been. Heroic, he had not. When night fell, Henry had lost 100 to 400 men, while somewhere between 5,000 and 10,000 French lay lifeless in the mud: a generation of France's nobility slaughtered. News of the dramatic victory travelled back to England swiftly. The earliest written record appears in the account rolls at Winchester College, where an entry notes that John Coudray was paid for 'bringing

news to the college from overseas' of 'a certain battle held at Agincourt in Picardy on the feast of Saints Crispin and Crispinian'.[8]

After the bloodbath at Agincourt, France was beaten, and Henry demanded its crown. After five years of diplomacy, the intermittently insane Charles VI of France – who was convinced he was made of glass and required metal rods to be stitched into his clothing to prevent him shattering – signed the humiliating Treaty of Troyes, disinheriting his children and declaring that, on his death, Henry V of England and his heirs would be the rightful kings of France.

In the event, Henry never wore the French crown as he predeceased Charles by seven weeks. Instead, his son, Henry VI of England – who also came to suffer from bouts of insanity – became king of England at the age of eight months, and king of France on Charles's death the following month. When he was 10 he travelled to Paris to be formally crowned in a lavish ceremony in the cathedral of Notre Dame, making him the first – and only – English king to wear the crowns of both countries.

Although it seemed to everyone that the Hundred Years War was over, it proved not to be. What would turn out to be the final act had, in fact, begun a few years earlier, in 1429, when a 16- or 17-year-old village girl arrived at the Armagnac court in Chinon. Charles of Valois and his supporters had not recognised the Treaty of Troyes, and they deemed Charles – and not Henry VI of England – the legitimate king of France. However, at this stage, neither he nor Henry had been crowned.

The girl who appeared at Chinon was from a devoutly pro-Armagnac region, and had been three years old at the time of the Battle of Agincourt. She explained to Charles that for several years she had been seeing wonderful lights and hearing the voices of Saints Michael, Catherine and Margaret. These divine messengers, she said, told her that God commanded her to lead Charles's armies, see him crowned at Rheims with the ancient, sacred oil from the Holy Ampoule, then expel the English from France.

The girl's name was Jehanne. In the English-speaking world she is known as Joan, with the sobriquet 'of Arc' suggesting her father's surname was Darc or something similar. Charles listened to Joan's story, then sent her to be questioned by theologians at Poitiers. Her interrogators found her sincere, and advised Charles to dispatch her to the city of Orléans, which was under siege by English forces. If she won a victory, then perhaps she was telling the truth. If she failed, nothing would have been lost. Charles agreed, had armour made for her, and presented her with a white silk

banner charged with golden fleurs-de-lys and angels flanking God holding the world. On it he emblazoned the simple words 'JHESUS MARIA'. He then ordered several hundred soldiers north-east to Orléans, and sent her with them.

At Orléans, the English siege army was encamped around the city's periphery, but Joan and the troops managed to slip through the cordon and into the built-up area. By carefully selecting targets, they took three key English fortifications, prompting the English to abandon the siege. Although armed, Joan did no fighting, but placed herself in the front line, where she gave the soldiers continual encouragement and reassurance that God was with them. Back in Chinon, many of Charles's courtiers were sceptical of Joan's visions, and put the success at Orléans down to the commanders' military skill rather than Joan's miracles. Outwardly, however, her dramatic victory boosted the chronically low public and military morale in Charles's camp, as did the three small victories she went on to achieve at Jargeau, Meung-sur-Loire and Beaugency. For the time being at least, she was politically useful.

A few months later, Joan won even more glory. She was accompanying a large Armagnac force when it intercepted an English army near the small village of Patay outside Orléans. Boosted by the element of surprise, the Armagnac soldiers annihilated the English in a battle as famous in France as Agincourt is in England, and as unknown in England as Agincourt is in France. Buoyed up, Joan turned to the second element of her mission and insisted that Charles be crowned at Rheims. The ceremony was duly arranged, and Joan was present, kneeling in her shining armour at Charles's feet, banner in hand, where she affirmed that he was God's chosen ruler and she his faithful servant.

Joan's remaining goal was to expel the English from France, but her luck was beginning to run out. She struggled to repeat her earlier victories, and – now Charles was crowned – his court lost interest in her. She had been valuable in victory, but was now an embarrassment in defeat. When she failed to achieve anything in an attack on Paris, she found herself largely abandoned. The English soldiery jeered at her as the 'Armagnac whore' – what other kind of woman travelled with an army, they asked – but Charles's court merely distanced itself further from her.

Undeterred, in May 1430 Joan took a small force to relieve the Burgundian siege at Compiègne, but was pulled from her horse during a skirmish. Weighed down by her armour, she found herself unable to get up, and was

captured. Charles declined to pay a ransom for her, and she was quickly sold to the English. Keen to demonstrate that Charles's champion was inspired by the Devil and not God, the English handed her over to pro-Anglo-Burgundian clerics for trial. Throughout months of interrogation, Joan defended herself eloquently, avoiding complex theological pitfalls and insisting her voices were real and holy, but she eventually fell ill. The judges concluded she was an unrepentant heretic, and dragged her to a public square in Rouen – former capital of William the Conqueror – where, weakened and fearing execution, she formally accepted that she was a heretic, and requested forgiveness. As penance, the judges sentenced her to imprisonment for the rest of her life.[9]

Once back in her cell, Joan's voices began tormenting her for having denied their divinity. She also resumed wearing men's clothes, which had been listed as one of her heresies. It may be that her jailers forced the clothes onto her, or that she wore them for protection from assault in prison, or equally she may have decided to face the pyre rather than a lifetime of incarceration. When the judges met her again, they certified that she had relapsed into her heresies. In the trial documents, the scribe noted in the margin 'the lethal answer' (*responsio mortifera*) when she explained that the voices were telling her she had damned her soul to save her life. Under canon law she had rejected the saving grace of the Church, and her soul therefore required cleansing with fire.[10] Cardinal Henry Beaufort – senior Plantagenet, bishop of Winchester, former Chancellor of the University of Oxford, and three times Chancellor of England – had been present at her confession six days earlier, and was with the large crowds in Rouen market square on 30 May 1431 when Joan was tied to a high scaffold and burned alive.[11] She was 19 years old.

When Joan had first arrived at Charles's court two years earlier to launch her mission, he had sent her to Poitiers for questioning by theologians. While there, she had dictated a letter to the seven-year-old King Henry VI of England, and it was duly sent in April. It contained an extraordinary message, in Joan's own words: a mission statement and campaign overview offering a unique insight into her innermost thoughts. She was a teenager with no military or diplomatic experience, whom Charles had not appointed to any position. And yet, in a message to the king of England and France, Joan presented herself as spokesperson for Charles with the full force of heaven behind her. 'I am war commander', she thundered. 'Render satisfaction to the King of heaven.'

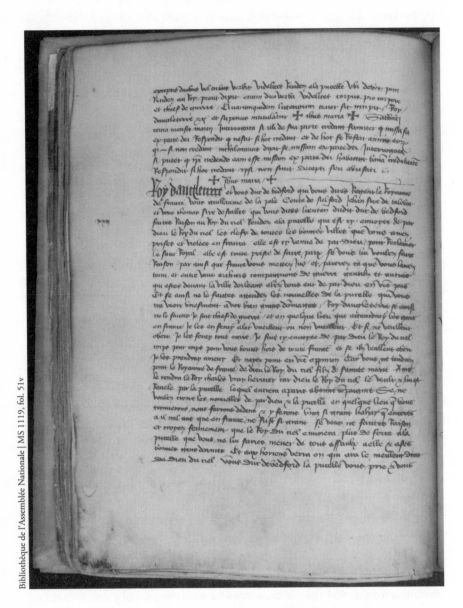

Bibliothèque de l'Assemblée Nationale | MS 1119, fol. 51v

Joan of Arc, Letter to King Henry VI of England (1429)

✠JHESUSMARIA✠

King of England, and you Duke of Bedford, whom you call regent of the kingdom of France, you William de la Pole Count of Suffolk, John Lord Talbot, and you Thomas Lord Scales, whom you call lieutenants of the said Duke of Bedford.

Render satisfaction to the King of heaven. Deliver up to the Maid – who is sent here on behalf of God the King of heaven – the keys of all the good towns you have seized and ravaged in France.

She has come here on behalf of God to reclaim the royal blood. She is fully ready to make peace if you want to render satisfaction to her, By doing this you can do justice to France and repay what you have taken.

And you, archers and companions-at-arms – nobles and others – who are before the town of Orléans, on behalf of God go home to your country. And if you do not, wait for news of the Maid, whom you will soon see to your very great cost.

King of England, if you do not do this. I am war commander, and in whichever place I wait for your men in France, I will force them to leave, willingly or unwillingly. And if they do not wish to obey, I will put them all to death.

I am sent here to drive you out of France, body by body, on behalf of God the King of heaven. But if they wish to obey, I will show them mercy.

And place no faith in your views, as you do not hold the kingdom of France from God the King of heaven, the son of Holy Mary. It is held by king Charles, the true heir, as God the King of heaven wishes it. And he is revealed by the Maid, who will enter Paris with a fine company.

If you do not wish to believe the news on behalf of God and the Maid, and if you do not render satisfaction, in whatever place you find yourselves we will attack you there, and will strike such a blow that there will never be a greater one in a thousand years.

And believe firmly that the King of heaven will send more power to the Maid than you can muster in all your assaults against her or her good men-at-arms. And by blows we will see who has the greater right of God of heaven.

You, Duke of Bedford, the Maid asks and requests that you do not make her destroy you. If you render satisfaction to her you can still come into her company, where the French will perform the most noble feat that was ever done for Christianity.

So deliver a response if you wish to make peace in the city of Orléans. And if you do not do so, you will always remember the immense damage to you.

Written the Tuesday of holy week.

Reading these threats and grandiose claims – even after almost seven centuries – it is clear why many of Charles's courtiers wanted little to do with her. Joan was either genuinely channelling God – who was taking an unusually keen and violent interest in north European dynastic politics – or she was profoundly troubled, and neither made for good statecraft. Piety was one thing – many French and English monarchs and courtiers heard Mass several times a day – but Joan's claim to know the true will of God, revealed uniquely to her, was outside most people's experience. In an age in which kings ruled as God's appointed and anointed representatives, and the Church alone mediated God, there was little room for a peasant girl who claimed to have a better connection with heaven.

To ordinary Armagnac supporters, though, Joan was a heroine. In July 1429, immediately after she led Charles to his triumphant coronation, the French writer Christine of Pisa praised Joan in an epic poem. 'What honour for the female sex!' she wrote, that God had chosen a woman to succeed where 5,000 men had failed.[12] There was even support for Joan in the Church. Two decades after her death, Pope Calixtus III ordered an inquiry into her trial, concluded that she had been divinely inspired, and annulled her condemnation. In the final affirmation, two years after World War One, Pope Benedict xv canonised her as a saint, and she quickly joined St Denis as a patron saint of France.

Although the English were riding high at the time of Joan's execution, the moment marked the beginning of the end of the Hundred Years War. In the following decades the Armagnac and Burgundian factions made peace, and the Burgundians withdrew their support from Henry VI and accepted Charles VII as king. Without French backing, Henry gradually lost almost all England's possessions in France, and the years of conflict drew to a close with the French victory at the Battle of Castillon in 1453. England's fling with the crown of France was over.

The Hundred Years War changed many things. One major and unwelcome consequence was the normalisation of mass civilian casualties in combat. An eyewitness account of the Black Prince's 1355 *grande chevauchée* – a torching and razing expedition – in the Languedoc noted 'there has never been such destruction in a region as in this raid'. The operation destroyed around 500 settlements from the Atlantic to the Mediterranean, and the letter went on to explain that the raid had crippled a region yielding more than half the king of France's revenues for the war.[13] This level of civilian suffering was seen as an acceptable cost in a campaign that, at times,

approached Carl von Clausewitz's nineteenth-century concept of 'absolute war'.[14]

The prolonged war also had a brutalising effect, with suffering inflicted not only in the immediate vicinity of the battlefields. In 1379 Sir John Arundel and a group of English soldiers commandeered a nunnery near Southampton while waiting for a favourable tide to France. Once inside the building, they assaulted and raped the nuns along with the local women and girls taking reading lessons, before carrying them all onto the ships. Local priests ran to the shore and excommunicated the men with bells, books and candles, but the women remained captives. Once at sea, the weather became stormy, and the men threw 60 women overboard to lighten the vessels.[15]

In England, the effect of the war on national identity was also profound. The quasi-permanent combat footing resulted in a perpetually militarised society and, once the war was lost, the wounded pride of the knightly nobility was soon diverted into another conflict that would come to be known as the Wars of the Roses. However, the age of longbows, gunpowder and artillery had reduced the battlefield importance of knights, and their social standing decreased accordingly.

At a national level, the long conflict catalysed a sense of Englishness that was closely linked to hostility against France. Since 1066, kings of England had been, wholly or partly, culturally French or Anglo-French. All spoke French as their first – and in many cases only – language. But a century of conflict with France resulted in a fundamental shift in this identity. A defined sense of Englishness emerged around the English language, which became standard at court, in Parliament and in official documents.

The Hundred Years War did not conclude with a treaty, and did not end hostilities between England and France. Conflicts flared up regularly in the succeeding centuries – all-consumingly during the Napoleonic wars of 1803 to 1815 – while England only formally dropped its claim to the French crown after the French Revolution executed the reigning king and queen. The climate of rivalry between the two countries would not turn a meaningful corner until 1904 with the *Entente Cordiale*. After the Hundred Years War, England ceased to look to France for its territories overseas, and finally abandoned the cross-Channel empire it had ruled since William the Conqueror's day. As a replacement, it would – within 44 years – strike out west and establish another empire in the New World.

15

My Welebeloued Voluntyne – Medieval Romance

Margery Brews
Valentine's Letter
1477

The *Lupercalia* festival of purification and fertility was a very Roman affair, with origins reaching back to prehistoric pastoral times. During the republic and the empire it grew into a major civic festival, celebrated on 15 February each year, initially around the Palatine Hill, but eventually across the Roman world.[1]

The officiating priests, the *luperci*, began each annual celebration by sacrificing goats and a dog. Two young men then approached the altar, where a sword dipped in the animals' blood was touched to their foreheads. They wiped the bloody gouts off with wool soaked in milk, then laughed heartily. The meat was cooked, and the participants enjoyed a meal of the sacrificial animals washed down with plentiful wine before the *luperci* cut the animals' skins into strips and fashioned them into whips known as *februa*. Finally, men ran half-naked around the city using the sacred flails to whip anyone they could find. Young, married women were prominent in coming forward to be struck, believing the whips brought fertility and easy childbirth. The character of the festival eventually changed, with Cicero noting that the day came to include 'rustic style' sex.[2] Eventually, sexual violence also became an element, as seen in a third-century Roman calendar mosaic from El Djem in

Tunisia depicting February as two men holding a woman while a third raises a whip to her. By the fifth century it had degenerated further to involve lewd songs, sexual assaults, flagellation and penance.

Because the *Lupercalia* was originally a festival of purification, 15 February became known as the 'Purified Day' (*dies februatus*), from which the Roman month of February took its name. Participating as one of the runners was a high civic honour, and the festival remained firmly popular even once the empire converted to Christianity. However, as the Church grew more influential and stamped out paganism, in AD 494 – not long after the collapse of the western Roman Empire – Pope Gelasius II finally shut the *Lupercalia* down.[3]

Celebrating romantic love in mid-February on St Valentine's Day was recorded for the first time anywhere in late 1300s England in the poetry of Chaucer, John Gower and Oton of Grandson. The three moved in the same London literary circles and, because much of their work is undated, it is not clear which of them first connected love and Valentine's Day, or possibly even invented the idea.[4] The most famous is *The Parlement of Foules*, in which Chaucer recounts the tale of a group of birds gathering 'On seynt Valentynes day, Whan every foul cometh ther to chese [choose] his make [mate]'.[5]

Valentine was an obscure saint – or perhaps two saints – martyred in Rome during the reign of Claudius II 'Gothicus' between AD 268 and 270. According to the martyrologies, one of the Valentines was a priest in Rome, while the other was bishop of Terni, although they may have been the same person.[6] After martyrdom, one or both were buried on the Via Flaminia linking Rome and Rimini and, by the High Middle Ages, Rome's gateway onto the Via Flaminia – now the Porta del Populo – was known as the Porta San Valentino. The Church cult of St Valentine was known in England from at least Anglo-Saxon times and, during Edward the Confessor's reign, Robert of Jumièges, archbishop of Canterbury, acquired the relic of St Valentine's head, which he presented to the royal New Minster at Winchester.[7]

In the case of some pagan practices – like the late December festivals of *Saturnalia* and *Dies solis invicti*, or the cult of the Celtic goddess Brigit – the Church syncretically absorbed parts of them into its own rites.[8] However, there is no evidence that a similar transfer took place between the *Lupercalia* and the romantic festival celebrated on St Valentine's Day, as the first recorded references to honouring romantic love on 14 February – the day before the *Lupercalia* – appeared in England just under 1,000 years after the *Lupercalia* had been officially suppressed. Nevertheless, it is striking that the two

festivals share the same moment in the year, and it is not impossible that the medieval originators of the romantic Valentine's Day celebration chose the date with the legacy of the *Lupercalia* in mind. Whatever the origin of the connection between romance and St Valentine's Day, it was firmly established in England by the late 1400s, and a unique collection of correspondence from the period shows its importance in the lives of English lovers.

Margery Brews was the daughter of a prominent Norfolk landowner. She was in her late teens or early twenties, and had fallen in love with John Paston, the son of a neighbouring Norfolk family which had strong political and royal connections. John was in his early thirties, had fought in the Wars of the Roses on the Lancastrian side for Henry VI at the Battle of Barnet in 1471, had been pardoned by Edward IV, and fought with him in his French war of 1475. He had been unsuccessfully looking for a wife for some time, but when he met Margery, everything changed. The two fell madly for each other, and talk rapidly turned to marriage. The only fly in the ointment was that Margery's father was not convinced that John was right for her, and John's family was not thrilled with the modest dowry Margery – one of four sisters – would be able to bring. Luckily for the couple, Margery's mother, Elizabeth, had taken a shine to John as a potential son-in-law, and knew a thing or two about the finer points of love and marriage. She also knew how to get her husband on board.

In the second week of February 1477 Elizabeth sent John a letter. 'Fryday is Sent Volentynes Day', she wrote, then paraphrased Chaucer, 'and every brydde chesyth hym a make'. She clearly felt it was auspicious timing, and extended John an invitation to visit them for a long weekend spanning Valentine's Day, from Thursday to Monday. She explained that his visit would enable him to speak to Margery's father, and she trusted that, as a result, all would align 'and I schall prey þat we schall bryng the mater to a conclusyon'.[9]

Elizabeth's matchmaking letter is part of an archive of over a thousand documents known as the Paston Letters, as most are correspondence to or from members of the Paston family, although some are wills, leases, and assorted documents like shopping lists and inventories of books.[10] Together, this incomparable collection traces the minute details of three generations of late medieval daily life at the heart of a family which rose from the peasantry to the aristocracy in just one generation after the Black Death. There are other letters and archives from the period, but none are as rich or wide-ranging as the Paston Letters, which stand in a league of their own as a window into fifteenth-century life.

Among the correspondence is the oldest-known Valentine's letter, which came hot on the heels of Elizabeth's matchmaking invitation to John Paston. It is from Margery to John.

British Library Board. All Rights Reserved/Bridgeman Images | Add MS 43490, fol. 23r

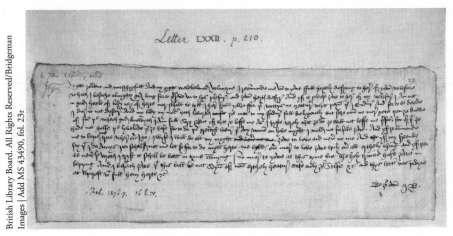

Margery Brews, Valentine's Letter (1477)

Vn-to my ryght welbelouyd Voluntyn John Paston, squyer, be þis bill + delyuered, &c.

Ryght reuerent and wurschypfull and my ryght welebeloued Voluntyne, I recommande me vnto yowe full hertely, desyring to here of yowr wele-fare whech I beseche almyghty god long for to preserve vn-to hys plesure and ʒowr hertys desyre. And yf it please ʒowe to here of my welefare, I am not in good heele [health] of body ner of herte, nor schall be tyll I here from yowe; For þer wottys [there knows] no creature what peyn þat I endure, And for to be deede [dead] I dare it not dyscure [disclose]. And my lady my moder hath labored þe mater to my fadure full delygently, but sche can no more gete þen ʒe knowe of, for þe whech god knowyth I am full sory. But yf that ʒe loffe me, as I tryste verely that ʒe do, ʒe will not leffe me þerfor; for if þat ʒe hade not halfe þe lyvelode [livelihood] þat ʒe hafe, for to do þe grettyst laþure þat any woman on lyve [alive] might, I wold not forsake ʒowe. And yf ʒe commande me to kepe me true wher-euer I go, Iwyse [Indeed] I will do all my myght ʒowe to love and neuer no mo. And yf my freends say þat I do amys [amiss], þei schal not me let [hinder] so for to do, Myn herte me byddys euer more to love ʒowe Truly ouer all erthely thing. And yf þei be neuer so wroth [angry], I tryst it

schall be bettur in tyme commyng. No more to yowe at this tyme but the holy trinité hafe ӡowe in kepyng. And I besech ӡowe that this bill be not seyn of non erthely creature safe only ӡour-selfe, &c. And thys lettur was jndyte [written] at Topcroft wyth full heuy herte, &c.

Be [by] ӡour own M.B.

The letter is beautifully composed. Not only does Margery address John as her 'Voluntyn/e', but she openly entrusts him with her innermost thoughts, and begs that he show it to no one else. She assures him of her love, and entreats him not to pass her over on account of her modest dowry. It is a heartfelt message, balancing the precariousness of her situation with the evident strength of her feelings. Soon after, Margery sent John a second letter, also addressed to her 'welebelovyd Volentyne', again assuring him of her love. This time she signed off as 'ӡowr trewe louer and bedewoman [a woman who prays for another person] duryng my lyfe'.[11] Happily for the couple, the reluctance of Margery's father and John's family soon dissipated, and they were married in the autumn.

Margery was by no means the only letter writer among the Paston women. There is also a collection from Margaret Paston, John's mother, one of which to her husband over 35 years earlier notes that she needs a new 'gyrdyl [belt] . . . for I hadde neuer more nede þer-of þan I haue now, for I ham waxse so fetys [fat] . . .' The reason becomes clear when she concludes saying 'I pre yow þat ye wyl were þe reyng [ring] wyth þe emage of Seynt Margrete þat I sent yow for a rememravnse tyl ye come hom. Ye haue lefte me sweche a rememravnse þat makyth me to thynke vppe-on yow bothe day and nyth wanne I wold sclepe [sleep].'[12] This level of detail regarding the lives of relatively ordinary people – not royalty or the great historical families of the kingdom – is rare in this period, and fascinating. Medieval chronicles usually offer an account of events spiced up with anecdotes illuminating people's characters, while poems like Chaucer's *The Canterbury Tales* – although crammed with vivid glimpses of society – are fiction. Elizabeth and Margery's writing, by contrast, brings out the colours of real lives in fifteenth-century England.

Margery's letters do not reveal what sort of wedding she and John had although, as members of affluent families, it would have been celebrated in church. However, that was not true for everyone. From Anglo-Saxon times, marriage was a simple arrangement between two people, with no requirement for Church involvement. The couple simply affirmed to each other that they considered themselves husband and wife. They did not have to

recite any specific words, and there was no need for a witness or priest. The only requirement was consent, which they could speak wherever they liked: at home, in a field, at the table, on the green, in the tavern, in bed.[13] Consent – technically a contract – created a marriage, and there was no need for any subsequent act such as registration or blessing. There was equally no requirement for consummation, as the marriage of Mary and Joseph had been valid despite her lifelong virginity.[14]

The Church's involvement in marriage evolved gradually with regional variations. In England, the earliest evidence is from York in the AD 700s, where a book of liturgy contains betrothal and marriage blessings to be administered by the bishop. Over time, across the country, this eventually evolved into blessings of the ring, chamber and bed.[15] Meanwhile, in parts of the continent, marriage was being slowly incorporated into the sacrament of the Mass, and this became the norm in the eleventh and twelfth centuries everywhere during the sweeping changes of the Gregorian Reform of Hildebrand of Sovana – elected as pope Gregory VII from 1073 to 1085 – and in the flowering of the 'twelfth-century renaissance'. In this period, the Church developed a whole range of fresh ideas, from transubstantiation and purgatory to priestly celibacy and a definitive list of seven sacraments, which were set out in Gratian's *Decretum* as baptism, confirmation, extreme unction, the eucharist, holy orders, marriage and penance.[16] These sacraments were the Church's most powerful rituals – the ones that imparted divine grace – and the list now included marriage, as theologians had begun to view it as an indissoluble union between a couple reflecting the unbreakable bond between Christ and his Church.

In Britain, from the time of the Norman conquest, the Church acquired jurisdiction over the validity of marriages and marital disputes, although not marital property, which remained with the secular courts.[17] However, even once the Church offered marriage Masses in Britain, the older form of marriage by consent survived. When Pope Innocent III placed England under interdict during his dispute with King John in 1208 to 1214, churches were locked up and the sacraments withheld with very few exceptions. There were no marriage ceremonies, but people continued to marry validly by consent, as consent and not the liturgy was the basis of the sacrament. Although it grew less common, this old style of non-Church marriage survived the Middle Ages until the Church of England eventually brought in a requirement that a priest be present at all marriages, and marriage was finally regulated by Parliament in the Marriage Act 1753 'for the better preventing of clandestine marriage'.[18]

Despite the medieval Church's emerging view that marriage was a holy sacrament binding husband and wife in a sacred and inseparable union, not everyone in medieval Britain shared this new theological stance. Chaucer's Wife of Bath in *The Canterbury Tales* defends having had five husbands since her first marriage aged 12, justifying it with biblical authority by pointing to Abraham and Solomon who, she astutely notes, each had numerous wives.[19] Two centuries earlier, the renowned twelfth-century French scholar and linguist Heloise of Argenteuil – jilted lover of Peter Abelard – challenged the idea that love even needed a formal framework. She wrote passionately in defence of the romantic love she had felt for Abelard before their separation and his castration, and explained that her love was the more real through having been freely offered rather than enforced through a marital tie.[20] 'And if the name of wife is seen as holier or worthier', she wrote, 'sweeter to me always seemed the name of friend or, if you do not resent it, mistress or whore.'[21]

A significant problem with informal marriages outside Church was the lack of independent or documented proof that someone was, or was not, married. To flush out those already married, underage, or closely related, the Church instituted a process of calling the banns at three public announcements of the intended marriage so objections could be raised. Assuming there were no barriers to the union, by the time of Margery and John's wedding the Church's rites began in the porchway of the church – a place for legal commitments – where the couple completed the contractual stage by affirming that they took each other to be husband and wife, with the priest acting as witness. The liturgical elements followed, with the husband placing the ring successively on the thumb, index, middle and ring fingers of the bride's hand while saying in Latin, matching the words to the four fingers (in bold), '*in nomine **patris**, et **filii**, et **spiritus** sancti, **amen**'*. The priest then led the couple into the church to the accompaniment of Psalm 128 ('Your wife will be like a fruitful vine within your house; your children will be like olive shoots around your table . . . May you live to see your children's children'). Next there were prayers at the entrance to the chancel, before the couple entered it to witness the celebration of Mass. Aside from their funerals, this would probably be the only time they ever entered the chancel. After this, they knelt at the altar while four people held a large veil over them, from which they emerged, joined in the eyes of God. When the Church ceremony was complete, the priest often attended the wedding meal which followed, then returned with the couple to their home, where he blessed the bed and the newly wedded couple in it.

Many elements of medieval marriage have changed down the centuries. The ceremony eventually moved into the body of the church, accompanied by a more celebratory liturgy. Medieval husbands did not wear wedding rings, but modern men have come to do so over time. Women traditionally wore the ring on their right hand, but this was switched to the left hand in Tudor times, when Thomas Cranmer, Henry VIII's archbishop of Canterbury, decided that newly Protestant England should mark its break with traditional religion by abolishing former practices. In the first 1549 edition of the *Book of Common Prayer*, he ruled that the approved hand for wedding rings was now the left. Another prominent difference was the bride's wedding dress. One of the earliest letters in the Paston collection is from Agnes Paston to William Paston, the lawyer who founded the Paston dynasty. Unlike Margery's Valentine's letters – which she dictated to a servant – Agnes wrote this one in her own hand 'in hast . . . for defaute of a good secretarye'. The letter is probably from April 1440, and in it Agnes told William that their son, John, was pleased with the wife William had arranged for him. In anticipation of the wedding, Agnes asked if William would buy the bride a wedding dress in 'a godely blew [good blue] or ellys a bryghte sanggueyn [red]'.[22] The tradition of wearing white is more modern, beginning when Queen Victoria wore a white dress to marry Prince Albert of Saxe-Coburg and Gotha in 1840. In previous centuries, brides chose bright, joyful colours.

Margery and John remained married for just short of 20 years until Margery died. In that time, the first fires of love seem to have calmed into a tender relationship. John was a successful man, ending up Sheriff of Norfolk and Suffolk and MP for Norwich, knighted in 1487 on the battlefield at Stoke. His business – and on several occasions war – took him away from home, but Margery continued to write to him. In a letter of 1481 she addressed him as 'myne owyn swete hert', and in another from the same time she wrote, 'Ser, I prey you if ye tary longe at London þat it wil you to send for me, for I thynke longe sen [since] I lay in your armes'.[23]

Picturing the remote past can require an effort to people it with individuals who think and feel in ways that seem familiar. In the case of Margery Brews and John Paston, the surviving letters take readers into their courtship and marriage in the most immediate way, colouring them in as three-dimensional people, collapsing the centuries and revealing lives and concerns demonstrating that the past is very far from being a foreign country. It is intensely familiar, as are the aspirations of romance and the rituals of Valentine's Day, which late medieval England developed and gave to the world.

16

Swords and Sorcery –
The Once and Future King

Thomas Malory
Le Morte Darthur
1485

As Margery Brews and John Paston were living out their romance in Norfolk, England was being torn apart by a shattering 30-year conflict. In 1820 the novelist Sir Walter Scott dubbed it the Wars of the Roses, drawing on the imagery of the red rose of the House of Lancaster and the white rose of the House of York. However, at the time the name would have meant nothing to the combatants, as neither side fought under these emblems. It is also misleading because the conflict was not restricted to the warring branches of the Plantagenet family, but constituted a full-scale, intermittent civil war that engulfed the whole country, pitting the broadly pro-Lancastrian north against the largely pro-Yorkist south.[1]

The Lancastrian branch of the Plantagenets had ruled since 1399, when the soldier-intellectual Henry Bolingbroke deposed – and most likely murdered – the ambitious and self-important Richard II. He took the throne as Henry IV and, after a 13-year reign, was succeeded by his oldest son, Henry V, immortalised by Shakespeare for leading the English at the siege of Harfleur – 'Once more vnto the Breach, Deare friends, once more'

– and then the crushing victory at Agincourt, for which his pre-battle speech is among Shakespeare's most famous passages: 'For he to day that ſheds his blood with me, Shall be my brother: be he ne're so vile, This day ſhall gentle his Condition. And Gentlemen in England, now a bed, Shall thinke themſelues accurſt they were not here; And hold their Manhoods cheape, whiles any ſpeakes, That fought with vs vpon Saint *Criſpines* day'.[2]

The final Lancastrian king was his son, Henry VI, whom Joan of Arc taunted with her threatening letters, and who was the only English king ever to wear the crown of France. Unfortunately for the House of Lancaster, Henry VI was intellectually incapable of engaging with affairs of state, and periodically incapacitated by bouts of acute mental illness. The result was a king-shaped vacuum at court, which gave the rival Yorkist branch of the Plantagenet line an opportunity to strike.

The Wars of the Roses reached its first watershed in 1461 at the Battle of Towton, where, on the open land between York and Leeds, the 18-year-old Edward of York crushed Henry VI's forces. The encounter lasted notably longer than the average medieval battle at a gruelling 10 hours, and the lowest contemporary assessment of deaths was 28,000, making it the blood-iest battle ever fought on British soil. By comparison, in July 1916, the modern British Army suffered the worst day in its history on the first day of the Battle of the Somme losing 19,240, but to industrially produced weap-onry and explosives rather than swords, arrows and axes.[3] Towton was late medieval carnage on an unimaginable scale. A mass grave excavated at the battlefield uncovered 43 individuals packed into a six-by-two-metre pit only half a metre deep, all showing signs of having been executed with fren-zied blade and spike attacks to the face and head, with one skull bearing 13 identifiable blunt trauma and penetrating injuries.[4] This period – the Late Middle Ages – was no more the age of chivalry than the Early or High Middle Ages that preceded it and, in reality, there never was an age of chiv-alry in which warfare was genteel, except in literature, poetry, and the fantasy pageants they inspired. There may have been rules – such as for ransoms – but the battlefield itself was unsparingly brutal.

Edward took the crown as Edward IV but, after nine years in power as the first Yorkist king, lost control of the unstable alliances keeping him on the throne. As a result the Lancastrian Henry VI found himself restored, but his renewed rule, which contemporaries called his 'readeption', was short-lived. He was dead in seven months – murdered by Edward after the Battle of Tewkesbury – allowing Edward to retake the throne unopposed.

At exactly this time, perhaps yearning for a nobler and gentler world, Sir Thomas Malory wrote the greatest epic of chivalry in the English language: *The Hoole Book of Kyng Arthur and of His Noble Knyghtes of the Rounde Table*. He completed it in 1470 and, a decade and a half later, in 1485, William Caxton published the *editio princeps*, the first printed edition. He mistakenly typeset the name of the last chapter, *Le Morte Darthur* – Arthur's Death – as the title of the book, and his error has stuck ever since. The sole complete copy of Caxton's edition is now in the Morgan Library and Museum in New York, but manuscript copies circulated before the printed version, written out by monks or scribes. Of these, only one – discovered at Winchester College in 1934 – survives, and the smudge patterns of printer's ink on it reveal shapes from Caxton's unique typefaces, proving it was on Caxton's bench as he typeset and printed the first edition.[5]

Malory completed *Le Morte Darthur* five months before Edward IV was briefly deposed by – and then murdered – Henry VI. The contrast between the real-world villainy and bloodshed at the heart of Plantagenet government and Malory's idealised Arthurian court of chivalric manners could not have been more stark. Malory's life, too, was filled with contrasts. After climbing the political ladder to become MP for Warwickshire, he mysteriously switched to a life of gang violence and robbery, as a result of which he spent most of his final 20 years in prison. There he began writing his great work, quite possibly using the immense library at the Greyfriars Franciscan house just across the road from Newgate prison.

Le Morte Darthur is the most complete Arthurian epic in English written in the Middle Ages, taking as its foundation the three main French Arthurian prose cycles and the substantial other material in the Matter of Britain. Malory collected all these strands and set them into eight sections, masterfully weaving together Arthur's magical birth and rise to power, his conquest of the Roman Empire, the adventures of his knights, their quests for the Holy Grail, the affair between Lancelot and Guinevere, the calamitous discovery of their infidelity, the resulting destruction of the kingdom, and the deaths of the protagonists. The end product is one of the greatest works of late medieval storytelling.

In 1871 the anthropologist Edward Burnett Tylor observed that, in many cultures, stories of heroes and their deeds follow similar patterns. In modern times Hollywood writers regularly follow the steps of this journey, with heroes usually coming from simple backgrounds before a defining event shakes them out of their torpor and catapults them off on the quest that will

wold for to wynne the swerd / And vpon newe yeersday the
barons lete maake a Iustes and a turnement / that alle knyȝ
tes that wold Iuste or turneye / there myȝt playe / & all this
was ordeyned for to kepe the lordes to gyders & the comyns / for
the Archebisshop trusted / that god wold make hym knowe
that shold wynne the swerd / So vpon newe yeresday whan
the seruyce was done / the barons rode vnto the feld / some to Ius
te / & som to turney / & so it happed that syr Ector that had gre
te lyuelode aboute london rode vnto the Iustes / & with hym ro
de syr kaynus his sone & yong Arthur that was hys nourys
shed broder / & syr kay was made knyȝt at al halowmas afore
So as they rode to ye Iustes ward / sir kay had lost his suerd for
he had lefte it at his faders lodgyng / & so he prayd yong Ar
thur for to ryde for his swerd / I wyll wel said Arthur / & ro
de fast after ye swerd / & whan he cam home / the lady & al were
out to see the Ioustyng / thenne was Arthur wroth & saide to
hym self / I will ryde to the chirckeyard / & take the swerd with
me that stycketh in the stone / for my broder sir kay shal not be
without a swerd this day / so whan he cam to the chirchyard
sir Arthur aliȝt & tayed his hors to the style / & so he wente to
the tent / & found no knyȝtes there / for they were atte Iustyng
& so he handled the swerd by the handels / and liȝtly & fiersly
pulled it out of the stone / & took his hors & rode his way vn
tyll he came to his broder sir kay / & delyuerd hym the swerd / &
as sone as sir kay saw the swerd he wist wel it was the swerd
of the stone / & so he rode to his fader syr Ector / & said / sire / lo
here is the swerd of the stone / wherfor I must be kyng of thys
land / when syr Ector beheld the swerd / he retorned ageyne &
cam to the chirche / & there they aliȝte al thre / & wente in to the
chirche / And anon he made sir kay to swere vpon a book / how
he came to that swerd / Syr said sir kay by my broder Arthur
for he brought it to me / how gate ye this swerd said sir Ector
to Arthur / sir I will telle you whan I cam home for my bro
ders swerd / I fond no body at home to delyuer me his swerd
And so I thought my broder syr kay shold not be swerdles
& so I cam hyder egerly & pulled it out of the stone withoute
ony payn / found ye ony knyȝtes about this swerd seid sir ector
Nay said Arthur / Now said sir Ector to Arthur I vnderstāde

a iiii

Copyright of the University of Manchester | leaf 46

Thomas Malory, Le Morte Darthur (1485)

change their world, and ultimately themselves. Centuries before *The Matrix*, Harry Potter, *Star Wars*, *The Wizard of Oz*, *Jane Eyre* and hundreds of others, Malory followed this plot structure closely.

Here is the scene of Arthur's call, in Caxton's original spelling. Even though it was written only around 70 years after Chaucer's *The Canterbury Tales*, the Middle English is appreciably more modern. Almost all the words are recognisable, and their order is largely the same as today. The alphabet Caxton chose keeps the yogh (3) in words like kny3t/knight, the long 's' (ſ) in words like ſtone/stone, and occasionally uses thorn (þ) for words like þᵉ/the.

Soo in the gretteſt chirch of london whether it were Powlis [St Paul's] or not the Frenſſhe booke maketh no mencyon / alle the eſtates were longe or day in the chirche for to praye / And whan matyns 7 the firſt maſſe was done / there was ſene in the chircheyard, ayēſt [against] the hyhe aulter a grete ſtone four ſquare lyke vnto a marbel ſtone / And in myddes [middle] therof was lyke an Anuylde [anvil] of ſtele a foot on hyghe / 7 theryn ſtack a fayre ſwerd naked by the poynt / and letters there were wryten in gold aboute the ſwerd that ſaiden thus / who ſo pulleth oute this ſwerd of this ſtone and anuyld / is rightwys kynge borne of all Englond / Thenne the peple marueilled [marvelled] & told it to the Archebiſſhop I commande ſaid tharchbiſſhop [the archbishop] that ye kepe yow within your chirche / and pray vnto god ſtill that no man touche the ſwerd tyll the hyhe maſſe be all done / So whan all maſſes were done all the lordes wente to beholde the ſtone and the ſwerd / And whan they ſawe the ſcripture / ſom aſſayed [tried] ſuche as wold haue ben kyng / But none myght ſtere the ſwerd nor meue hit [move it] He is not here ſaid the Archbiſſhop, that ſhall encheue [achieve] the ſwerd but doubte not god will make hym knowen . . .

So vpon newe yereſday [New Years' Day] whan the ſeruyce was done / the barons rode vnto the feld / ſome to Iuſte [joust] / 7 ſom to torney / 7 ſo it happed that ſyre Ector that had grete lyuelode [livelihood] aboute london rode vnto the Iuſtes / 7 with hym rode ſyr kaynus [Sir Kay] his ſone 7 yong Arthur that was hys nouriſſhed broder / 7 ſyr kay was made kny3t [knight] at al halowmas [All Hallowmass] afore So as they rode to þᵉ [the] Iuſtes ward / ſyr kay had loſt his ſwerd, for he had lefte it at his faders lodgyng / 7 ſo he prayd yong Arthur for to ryde for his ſwerd / I wyll wel ſaid Arthur / 7 rode faſt after þᵉ ſwerd / 7 whan he cam home / the lady 7 al were out to ſee the Iouſtyng / thenne was Arthur wroth 7 ſaide to hym ſelf / I will ryde to the chircheyard / 7 take the ſwerd with

me that ſtycketh in the ſtone / for my broder ſir kay ſhal not be without a ſwerd this day / ſo whan he cam to the chircheyard ſir Arthur aliʒt [alighted] 7 tayed his hors to the ſtyle / 7 ſo he wente to the tent / 7 found no knyʒtes there / for they were atte the Iuſtyng 7 ſo he handled the ſwerd by the handels / and liʒtly [lightly] 7 fierſly pulled it out of the ſtone / 7 took his hors 7 rode his way vntyll he came to his broder ſir kay / 7 dely-uerd hym the ſwerd / 7 as ſone as ſir kay ſaw the ſwerd he wiſt [knew] wel it was the ſwerd of the ſtone / 7 ſo he rode to his fader ſyr Ector / 7 ſaid / ſire / loo here is the ſwerd of the ſtone / wherfor I muſt be kyng of thys land / when ſyre Ector beheld the ſwerd / he retorned ageyne 7 cam to the chirche / 7 there they aliʒte al thre / 7 wente in to the chirche / And anon he made ſir kay ſwere vpon a book / how he came to that ſwerd / Syr ſaid ſir kay by my broder Arthur for he brought it to me / how gate ye this ſwerd ſaid ſir Ector to Arthur / ſir I will telle you when I cam home for my broders ſwerd / I fond no body at home to delyuer me his ſwerd And ſo I thought my broder ſir kay ſhold not be ſwerdles & ſo I cam hyder [hither] egerly 7 pulled it out of the ſtone withoute ony payn [any pain] / found ye ony knyʒtes about this ſwerd ſeid ſir ector Nay ſeid Arthur / Now ſaid ſir Ector to Arthur I underſtāde [understand] ye muſt be kynge of this land / wherfore I / ſayd Arthur and for what cauſe / Sire ſaide Ector / for god wille haue hit ſoo for ther ſhold neuer man haue drawen oute this ſwerd / but he that ſhal be rightwys kyng of this land / Now lete me ſee whether ye can putte the ſwerd ther as it was / and pulle hit oute ageyne / that is no mayſtry [mastery] ſaid Arthur / and ſoo he put it in the ſtone / therwith alle Sir Ector aſſayed to pulle oute the ſwerd and faylled.

Now aſſay ſaid Syre Ector vnto Syre kay / And anon he pulled at the ſwerd with alle his myghte / but it wold not be / Now ſhal ye aſſay ſaid Syre Ector to Arthur I wyll wel ſaid Arthur and pulled it out eaſily / And therwith alle Syre Ector knelyd doune to the erthe and Syre Kay / Allas ſaid Arthur myne own dere fader and broder why knele ye to me / Nay kneel my lord Arthur / it is not ſo I was neuer your fader nor of your blood / but I wote [knew] wel ye are of an hyher blood than I wende [supposed] ye were / And thenne Syre Ector told hym all how he was bitaken hym for to nouriſhe hym And by whoos commandement / and by Merlyns delyuerāce [deliverance].

Like so many heroes, Arthur has no idea of his lineage and destiny, but leads an unextraordinary existence before the event occurs that pulls him

over the threshold into another world. It is significant that he specifically pulls a sword from the stone, as in warrior society swords were the ultimate symbol of power and authority, often with generations of tradition and heritage behind them as they were passed from father to son. In Arthur's case the transmission was not human, but from the world of magic into his own, imbuing him with an authority that was otherworldly, and a destiny that was unstoppable. Later, Merlin would lead him to another sword – which would be equally powerful and symbolic – giving him physical abilities from the other world. This second sword was Excalibur, which would rise from the waters in a hand clad in the richest white silk samite, while from the far shore the Lady of the Lake would grant it to him, along with a scabbard that prevented its wearer from losing even a drop of blood from any wound.[6]

The origin of these two Arthurian sword stories is lost in the fog of time, yet both also function on an archetypal level. The sword in the stone may even have a prehistoric metallurgical root, as Bronze Age swords were cast by pouring molten alloy into stone moulds. Once cooled and hardened, the sword was drawn from its stone casing and out into the daylight. Arthur's authority, this implies, went back to time immemorial, and the days of the earliest prehistoric rulers of Britain.

In a similar way, the Lady of the Lake may draw on prehistoric Iron Age rites from a little later. Pre-Christian Celtic and Germanic cultures threw items of value – including weapons and armour – into lakes and rivers as offerings to the spirits. In Norse mythology Odin even hurled one of his own eyes into Mimir's Well at the foot of Yggdrasil for the gift of wisdom. Propitiating water spirits with gifts was a deep-rooted religious act, and archaeology has found hundreds of prehistoric water offering sites in Britain and elsewhere, while echoes of the tradition survive in today's wishing wells and coin fountains. This pagan symbolism comes full circle when Arthur, as he lies dying, instructs Bedevere to take Excalibur back to the lake and cast it in, which he does, and the magical arm rises again from the waters to reclaim it.

Alongside these pagan motifs, Malory's tale is also built around an endoskeleton of resolutely Christian imagery, like explicit references to the knights' spiritual lives, their attendance at Mass and swearing to do God's holy work. Other references are more subtle, couched in symbolism like the Holy Grail, which takes various forms in the different Arthurian traditions, but is at root a eucharistic symbol of Christ's passion and the emerging

miracle of transubstantiation. When Geoffrey of Monmouth wrote the first Arthurian tale in the 1130s, and when Thomas Malory was writing in the 1470s, Britain was a profoundly Christian society. The Church was integral to every aspect of life, and the British Isles were internationally known for the depth of its people's faith. And yet, although the Arthurian stories are deeply rooted in this Christianity, exuberant and overt paganism takes centre stage through the character of Merlin: a sorcerer from the depths of the forests who brings the ancient powers of nature and the wild into the heart of Christian Camelot. Merlin was not a new invention for the Arthurian tales, but had appeared in Welsh literature as far back as the sixth century, where he took the form of two semi-legendary figures: Myrddin the poet, and Myrddin the wild man of the woods who fled into the forests after the Battle of Arfderydd near Carlisle in AD 573, where he grew close to nature, developing the power of prophetic vision.[7] When Geoffrey of Monmouth composed the original Arthur story, he plucked Myrddin from Welsh folklore and turned him into *Merlinus*, rightly concerned that *Merdinus* might sound too similar to the Latin *merda*. He first wrote the *Prophecies of Merlin* (*Prophetiae merlini*), which introduced the wizard as a boy, then reused this material in his great work introducing Arthur, the *History of the Kings of Britain* (discussed in Chapter 4).[8]

Geoffrey's account of Merlin relates that when Vortigern was overwhelmed by Hengist, Horsa and the Anglo-Saxon mercenaries and invaders, he fled to Wales, where he began building a great tower to serve as his refuge, but its foundations repeatedly caved in. Perplexed, his magicians advised him to take a boy with no father, sacrifice him, and sprinkle his blood on the foundation stones. A search was conducted, and a suitable child was found whose parents were a nun of royal blood and a demonic incubus that had ravished her. The child was Merlin and, when he was brought to the place of sacrifice, he told Vortigern that beneath the tower's foundations lay an underground pool that was home to two battling dragons: one red, representing the native Britons, the other white, symbolising the invading Anglo-Saxons. Merlin foretold their struggles, and that a warrior – a 'boar from Cornwall' – would one day come to lead the Britons in the fight for their existence.[9]

According to Geoffrey, Merlin's powers were thereby recognised, and he was spared. Once grown to adulthood, he was sent to Ireland with Uther Pendragon, king of England, where he used his magic to bring the Giants' Dance, a vast ring of stones – now Stonehenge – to Salisbury Plain as a

memorial to mark the burial site of British heroes fallen to the Anglo-Saxons.[10] Merlin's last act in Geoffrey's story was then to be metaphorical midwife to Arthur, by helping Uther when he could neither sleep nor concentrate for lusting after Igraine of Tintagel. Merlin intervened and transformed the king into the likeness of Igraine's husband, allowing Uther to trick his way into her bed for a night of passion, and the child she conceived from the rape was Arthur. In Geoffrey's tale, Merlin then disappeared from history but, over the course of the following two centuries, successive authors wove Merlin more fully into Arthur's adventures, making him companion to the adult Arthur as spell-weaving protector and wise counsellor.[11] Later, Malory's *Le Morte Darthur* definitively confirmed Merlin in this role, creating the template British wizard who would be endlessly called upon and remodelled, in J. R. R. Tolkien's Gandalf, George Lucas's Obi-Wan Kenobi, J. K. Rowling's Dumbledore, and dozens of others.[12]

Among Merlin's most important and abiding contributions to the Matter of Britain was the institution of the Round Table: a perfect circle of fraternal and discipular equality with one place, the Siege Perilous, reserved for the perfect knight, Galahad, who would be the one to find the Holy Grail. Fiction rarely influences government, although Arthur is an exception, as the Order of the Garter is specifically Arthurian, and the enormous round table in Winchester Castle's Great Hall dates from the reign of Edward I, was used for royal pageants, and was eventually redecorated by Henry VIII, with Henry explicitly taking Arthur's place at its head.

Welsh folklore was rich in magic, and Myrddin-Merlin was not the only wizard it produced. Another famous sage from beyond the Severn was Taliesin, whom the *History of the Britons*, written around AD 829/830, recorded as one of the five celebrated British poets of the sixth century.[13] Twelve of his poems survive, and they deal mostly with King Urien of Rheged – probably the area around Carlisle – and Owain, his son. Another 15 poems said to be by Taliesin also still exist, but are attributed to a mythical version of Taliesin who started life as a boy named Gwion Bach.[14] Therefore, like his contemporaries Arthur and Merlin, Taliesin has left two personas: the flesh-and-blood man whose biographical details are largely lost, and a later, mythical character from a world flowing with magic and wonder.

Taliesin crossed the Severn Bridge in Henry VIII's reign, when a soldier from Wales began composing a book that included Taliesin's story in a tale of sorcery, cauldrons, elixirs, strange creatures and shape-shifting, wrapped

in the whole apparatus of magical folklore. The author was Elis Gruffudd, who had formed part of Henry's chivalric retinue for the sumptuous Anglo-French royal pageant-summit at the Field of the Cloth of Gold in 1521. His story of Taliesin was set 'in the beginning of Arthur's time and the Round Table', and recounted how a boy named Gwion Bach was entrusted by the sorceress Ceridwen to keep stirring a cauldron for a year and a day to brew an elixir that would make her ugly son more knowledgeable and popular.[15] Ceridwen forbade Gwion from tasting the bubbling liquor but, when the cauldron overturned and three burning drops fell onto his finger and he instinctively sucked the burnt skin, he was filled with knowledge of everything that was to come. To escape Ceridwen's anger, he turned himself into a hare and fled, but she became a greyhound and pursued him. He dived into a river as a fish, and she transformed into an otter. He mutated into a bird, and she became a hawk. He took the form of a grain of wheat in a large wheat pile, but she morphed into a hen, picked him out and swallowed him whole. Nine months later she gave birth to a boy, wrapped him in a leather bag and put him in the river, from where a man fished him out. As the man carried him home. the boy began to recite amazing poetry, and the man and his wife named him in honour of his radiant brow: *tal iesin*.

This account of how Gwion Bach became Taliesin is a study in symbolic transformation, following an archetypal initiatory structure of death in one world and rebirth into another, not unlike Arthur's transformation from a dogsbody-nobody to saviour-king. It also has clear links with the Irish folk-tale Fenian Cycle of Fionn mac Cumhaill – anglicised as Finn MacCool – in which the young Fionn is instructed to cook, but on no account to eat, a salmon that has gained wondrous knowledge by swallowing hazelnuts from the nine trees around the Well of Wisdom. When Fionn burns his finger on the hot fish and instinctively puts it in his mouth, he tastes a drop of burning fat into which all the salmon's knowledge has condensed, and thereby gains all the fish's wisdom.[16]

The story of Taliesin was eventually translated into English from the Welsh by the irrepressible nineteenth-century linguist Lady Charlotte Guest, who had taught herself Arabic, Hebrew and Persian after learning Latin, Greek and French with her brothers' tutor. When she moved from Lincolnshire to Merthyr Tydfil, she threw herself into Welsh language and culture, and in 1849 published an English translation of Welsh folktales as *The Mabinogion*. It was rapidly translated into a variety of European languages, bringing medieval Welsh tales to a far wider audience.[17] The

story of Taliesin is not strictly part of the classic canon of the medieval Mabinogion – a set of 11 Welsh tales preserved in the *White Book of Rhydderch* and the *Red Book of Hergest* – but Lady Guest included Taliesin's story and a number of other tales alongside the traditional Mabinogion accounts of Branwen, Culhwch and Olwen, Lludd and Llefelys, Manawydan, Math, Pwyll, The Dream of Macsen, The Dream of Rhonabwy, and the three Arthurian tales of Geraint and Enid, Owein (or The Lady of the Fountain), and Peredur.[18] All feature similarly magical and fantastical elements as the tale of Gwion Bach, including shapeshifting animals, a king whose step could span the Irish Sea, and a woman made entirely of flowers.

Taliesin did not have adventures like Arthur, and was never a court wizard like Merlin. He is no longer well-known, as he does not have the benefit of being attached to a perennially popular figure like Arthur, who has proved so adaptable he has been able to become what every age has wanted him to be. In post-Roman Britain he was a warrior leader. In medieval times a Christian philosopher-king. To the Victorians an exemplar of courtly virtues and chivalry. And in the modern world a New Age hero. Throughout all, the stories affirm, he awaits in Avalon, ready to rise if ever Britain needs his sword and company of knights again.

The connections between medieval Welsh and English concepts of wisdom and power embodied in the stories of Arthur, Merlin and Taliesin ran deep, and were soon to become even stronger when the Wars of the Roses came to an end and England's throne was taken by the House of Tudur, whose roots stretched back to Gwynedd in north Wales. English dynasties had ruled Wales for centuries. Now a Welsh one was to rule England.

PART III:
EARLY MODERN

17

Severing Ties – Henry VIII
and the Dream of Dynasty
Thomas Cromwell
Summary of an Execution
1539

Edward IV died in April 1483 and was succeeded by his 12-year-old son. Young Edward V's reign, however, like his life, was to be short, as he simply vanished while in the protective custody of his uncle, Richard of York. Together with his younger brother – who was next in line to the throne – he was one of the two 'Princes in the Tower' who disappeared from history. Richard, who promptly usurped the throne as Richard III, is the only serious suspect in their murder.[1]

Usurpers had murdered for the throne before, but not such senior child royals. Richard had plumbed a new depth, but he did not enjoy the rewards of his crime for long. He reigned for just two years until, aged 32, he was hacked to death west of Leicester at the Battle of Bosworth Field. He was 'fyghting manfully in the thickest presse of his enemyes' according to Polydore Vergil, but was eventually unhorsed and forced to engage hand-to-hand in the melee.[2] Years later, Shakespeare would invent his final, frantic plea: 'A Horfe, a Horfe, my Kingdome for a Horfe', but a killing squad soon found him, and he was executed, stripped, slung naked over a horse, paraded off the battlefield, and swiftly buried at nearby Greyfriars Priory.[3] With his death, 331 years of Plantagenet rule had come to a violent end. His grave

site was largely forgotten until, in 2012, a medieval skeleton was discovered under a car park laid over the ruins of the priory. The DNA evidence linking the bones to Richard was inconclusive but, following intense media coverage, the skeleton was given a formal royal burial in Leicester Cathedral.[4]

The battle's victor was Henry Tudor: a minor Lancastrian of Welsh descent. He was the last king to win England's crown on the battlefield, and the first whose face is known, captured in a bust carved by Pietro Torrigiano, who famously fled Florence after breaking Michelangelo's nose in a fit of artistic jealousy.[5] Contemporary writers were soon celebrating Henry VII's kingly virtues, but his blood claim to the English throne was weak, so instead of fêting him as rightful ruler, they heralded him as a righteous one: a saviour who had rescued the country from the mire of Richard's reign. One author who had full-throatedly praised Richard not long before, extolling him as the embodiment of chivalry, now set his pen to blackening Richard's reputation and burnishing Henry's. He confided that Richard had been a monster who gestated for two years in his mother's womb, and was born with teeth and hair down to his shoulders.[6] However, the most vivid and enduring anti-Richard and pro-Tudor propaganda came several generations later, from Shakespeare, who immortalised Richard as the odious, scheming, malevolent hunchback of popular culture. From everything the historical record reveals, Shakespeare was not far off the mark.

To bolster his shaky claim to the throne and bring the warring houses of Lancaster and York together, Henry married Edward IV's daughter, Elizabeth of York. As a symbol of this important union, he had a combined red and white rose specially devised then stamped onto everything to mark the new dawn. Today, his Tudor rose remains one of the most enduring symbols of England, prominent on the royal arms, on the uniforms of the Yeoman Warders of the Tower of London, and in hundreds of other places.

Henry may not have been born into royal circles, but he knew how to rule, and his crowning achievement as king – a remarkable one in the period – was to engineer 23 years of peace after the violent divisions of the Hundred Years War and Wars of the Roses. Tragically for him, though, his eldest son, Arthur, died as a teenager, so when he succumbed to a recurring illness in 1509 at the age of 52, his second son unexpectedly succeeded as Henry VIII.

At 17, Henry VIII was tall, athletic and soldierly. He was also intelligent, inquisitive, literate and well-educated. For the first time since the dawn of the Renaissance a century earlier, England had a king who was a true Renaissance man, and it was widely hoped his court would become one of

Europe's cultural jewels. In particular it was expected to be a centre of humanism: an emerging intellectual movement sweeping away medieval scholasticism's emphasis on Aristotle, the Church fathers and dogma, and replacing them with inspiration from the wider pagan writings of ancient Greece and Rome. These hopes for Henry's reign were, however, to prove profoundly misplaced, as his unexpected focus on marriages and religion overshadowed everything and was to have – in its own way – as seismic an impact on the country as King Harold Godwineson's decision to march an exhausted army from Stamford Bridge to Pevensey in 1066.

As so often in British history, it would be developments on the continent that started the chain of events. Just eight years into Henry's reign, on 31 October 1517, the German monk Martin Luther nailed his '95 Theses' to the great wooden doors of the Schlosskirche in Wittenberg, firing the starting pistol of what would become the Protestant Reformation. Luther, Huldrych Zwingli and John Calvin would soon set certain parts of Europe aflame with their reform agendas, but Henry's England would not be part of this religious revolution, remaining firmly Catholic while the first wave of Protestantism passed it by. Henry, in fact, on a personal level, was outraged by Luther, and challenged his new theology in a book, the *Defence of the Seven Sacraments* (*Assertio septem sacramentorum*), castigating Luther as a 'pest' and 'most filthy villain' and labelling his ideas 'deadly venom'.[7] In gratitude, Pope Leo x awarded Henry the title 'Defender of the Faith' (*fidei defensor*), which is still used by Britain's monarchs and inscribed on all coins issued by the Royal Mint.[8]

Monarchy is dynasty, and as a royal line the house of Tudor was young. Henry was only the second generation, and profoundly anxious to secure the throne for his children and their descendants. However, by 1527 he had given up all hope that his wife of 18 years, Katherine of Aragon, would bear a son that survived and, in any event, his head had been turned by his mistress Mary Boleyn's younger sister, Anne. When he eventually resolved that he had to marry Anne – not least so she would finally consent to sleep with him – Pope Clement VII refused to annul his marriage to Katherine, partly because Henry had put significant pressure on a previous pope to grant him permission to marry Katherine in the first place, as she was his brother's widow.

Clement's refusal did not deter Henry, who was growing ever more fixated on Anne, and on the succession. Seeing that he had backed himself into a corner, he took a logical – but drastic and unprecedented – step, and

cut the pope out of the process. By a series of acts of Parliament, he forbade anyone from taking a court case to Rome, blocked all payments to Rome, and declared himself the supreme head of the Catholic Church in England, entitled to receive all Church revenues, including a new 10 per cent tax he created for the occasion.[9] Previous kings of England, like Henry II and John, had picked acrimonious fights with the Church, but breaking away from the established infrastructure of western Christendom was unprecedented, and it left Henry's domains in England, Wales and Ireland in unexplored territory. Although Henry remained Catholic in his beliefs, Protestants took the changes to mean he was welcoming their reforms. One of the most acute problems they faced, however, was that, apart from a handful of theologians and several pockets of laypeople in London and the east of England, few of Henry's subjects had any familiarity with Protestantism, and remained firmly and emotionally committed to the religion of their forebears.

In England, as elsewhere on the continent, one of the Church's most important networks lay in the monasteries, nunneries and religious houses dotting the country. Just as Bede, the compilers of the *Anglo-Saxon Chronicle*, Matthew Paris and countless others had done, monks and nuns in Henry's day kept alive much of the country's intellectual heritage, compiling chronicles and accumulating and disseminating learning. Aware that they were educated, organised and well-regarded among their local communities, Henry's administration feared they could become an effective opposition to reform. Therefore, to pre-empt any organised resistance, the government decided to shut them down. A happy by-product of their closure would be that Henry could take control of their lands and wealth for himself and his favourites. As there were around 900 religious houses in the country, it was the single largest land grab and asset seizure in English history after William I's conquest of the realm in 1066.

To formalise the process of gutting the monasteries, Henry passed acts of Parliament in 1535 and 1539 permitting him to close first the smaller, then the larger houses.[10] In the confiscations that followed, the religious houses were razed, and many of their monks executed. At the same time, the great monastic libraries – many of which were the archives of a thousand years of England's intellectual history – were ripped out and their manuscripts thrown onto bonfires. In the words of John Bale, a Catholic turned Protestant priest, the 'lybrarye bokes' were used 'to serve theyr jakes' – that is, for loo paper – 'to scoure theyre candelstyckes', 'to rubbe their bootes', and were 'solde to the grossers and sope sellers'.[11] As with the

Bücherverbrennungen book bonfires in 1930s Germany and Austria, the destruction of the written word was a calculated and explicit measure to obliterate non-official modes of thought: in this case, the evidence of a flourishing pre-Protestant past.

The day-to-day business of eviscerating the monasteries was managed by Henry's leading minister, the lawyer Thomas Cromwell. Despite a revisionist trend to reimagine Cromwell as a thoughtful, sensitive servant of measured methods and calm purpose, the historical record reveals a greedy and thuggish ideologue, masterfully captured in Hans Holbein's menacing, brooding portrait.[12] Changing the country's religion was a gargantuan task and, when it proved impossible to achieve by persuasion, Henry and Cromwell invoked the treason laws, sentencing those who did not agree with the changes, condemning them to be hanged, drawn and quartered. To implement this operation around the country, Cromwell kept detailed records, which are now held in the British Library in a collection known as Cromwell's *Rememberances*.[13] Among them are his instructions for Glastonbury Abbey in Somerset, one of the most famous monasteries in the country.

In the 1530s, Glastonbury Abbey had 54 monks and the largest income of any of England's monasteries, enabling it to feed the poor of the area twice a week.[14] Its abbot was Richard Whiting, a Cambridge graduate who had been appointed by Cardinal Wolsey.[15] He seems to have been a popular man. John Leland, the antiquary and Henry VIII's librarian, noted that he was 'of the highest integrity, and my particular friend'.[16] When Parliament passed the Act of Supremacy in 1534, Whiting and the monks at Glastonbury dutifully swore the required oaths recognising Henry as supreme head of the Church in England.[17] They hoped it would be enough to be left in peace. However, on 25 August 1535 Cromwell's man, Richard Layton, arrived at 'Glassynburie' abbey to ferret out evidence of treason and wrongdoing. After diligent investigation, he wrote to Cromwell that he had been unable to uncover anything incriminating. 'Ther is nothyng notable', he reported, 'the brethren be so straite keppide that they cannot offende'.[18]

Aware the abbey was being targeted by Cromwell, Whiting made him a gift of Church revenues from West Monkton near Taunton in the hope the money would satisfy Cromwell, and in return received Cromwell's personal assurance that the abbey would come to no harm and the king would be its 'shield and defence'.[19] However, despite his reassuring words, Cromwell was preparing meticulously for the community's destruction. To neutralise and

Thomas Cromwell, Summary of an Execution (1539)

© British Library Board. All Rights Reserved | Cotton MS Titus B I, fol. 441r

isolate Whiting, he prohibited the abbot from mixing with his monks, prompting Layton to intervene. Layton wrote to Cromwell that Whiting was a good man, but Cromwell strongly advised him by return not to interfere. Layton duly fell into line, and when he wrote again to Cromwell it was with news Cromwell welcomed, reporting that Whiting did not know God, or his prince, or good Christian religion.[20]

Once Parliament had given permission for the closure of the large monastic houses, Cromwell's men arrived at Glastonbury in the summer of 1539 and started looting the abbey. Along with the property of other monasteries in the west country, the yield was 493 ounces of gold, 16,000 ounces of gilt plate and 28,700 ounces of parcel gilt and silver plate, which they packaged up and delivered to Cromwell in London.[21] This operation was not restricted to the west. Other teams were repeating the process all over the country, while Cromwell amassed all the wealth at the centre of the kleptocracy he was now openly running, sharing the booty with courtiers and henchmen prepared to support the reforms.

The endgame for Glastonbury began on 19 September 1539, when Layton, Thomas Moyle and Richard Pollard arrived at Whiting's residence outside Bath. They interrogated the nearly 80-year-old abbot before taking him under escort to Glastonbury. There they searched his quarters and turned up a book on St Thomas Becket – who had shown such defiance to Henry II – and another with arguments against Henry's divorce from Katherine of Aragon. They wrote to Cromwell that these were not especially incriminating, but reassured him that Whiting nevertheless had a 'cankerd and traiterous heart'. They also found some valuables, which they concluded had been 'secretly laid' before the previous searches. Consequently, they sent Whiting, although 'a very weak man and sickly', to the Tower of London to await personal interrogation by Cromwell.[22]

With Whiting incarcerated in London, Cromwell's men raided Glastonbury Abbey again, turning up 71 ounces of gold with precious stones, 6,387 ounces of silver, and 7,214 ounces of gilt plate.[23] Meanwhile, in London, Cromwell was preparing the climax of the drama, making the following entries in his papers:

Item certayn perſons to be sent to the Towre for the ffurther examenacyon of the abbott of Glaston	*Item, certain persons to be sent to the Tower for the further examination of the abbot of Glastonbury*

With regard to the legal formalities, he recorded:

Item. Confaylurs to gyve evydens ageynſt	*Item. Councillors to give evidence against*
the abbot of Glaſton	*the abbot of Glastonbury*
Rychard Pollard	*Richard Pollard*
Lewis Fforſtew	*Lewis Forstell*
Thomas Moyle	*Thomas Moyle*
Item. To see that the evydens is well sortyd / and the Indytmentte well drawn againſt the ſayd abbotte and theyr complycys	*Item. To see that the evidence is well sorted / and the Indictment well drawn against the said abbot and his accomplices*

Finally, he decided on the outcome:

Item the abbott of Glaſton to tried at Glaſton / and alſo executvd there with	*Item the abbot of Glastonbury to [be] tried at Glastonbury / and also executed there with*
his complycys	*his accomplices*

As a member of the House of Lords, Whiting was entitled to be arraigned and tried in Parliament, but Cromwell wanted him disposed of swiftly, far from anyone in Westminster who might object. It was yet another demonstration that Magna Carta meant nothing. Cromwell – on behalf of Henry – had an unchecked power to murder in the name of the crown. To see the plan through, he arranged for Lord John Russell to assemble a pliable jury in Somerset, with surviving records showing that appropriate bribes were paid to its members.

On 14 November, Whiting and two others – John Thorne, Glastonbury Abbey's treasurer, and Roger James, the abbey's youngest monk – were hauled into the Bishop's Hall at Wells. There was no indication they were about to be judicially murdered, and they were presented to the jury to be tried. When the indictments were read, they were charged not with treason, but with stealing from the abbey. The jury duly found them guilty, and Russell sentenced all three to death. There was no appeal, and the following day, a Saturday, the three were chained to hurdles, dragged by horses through the streets of Glastonbury, past the now deserted abbey, and up to the top of Glastonbury Tor. At its ancient summit, they were subjected to the full brutality of traitors' deaths. They were hanged until almost dead, then cut

down. Their abdomens were sliced open and their entrails drawn out while they were still alive. They were then beheaded and hacked into quarters. Whiting's head was carried down to his former abbey and spiked over its entranceway, while his quarters were tarred and sent to be displayed in Bath, Bridgwater, Ilchester and Wells. Why Whiting and his companions were given the full horror of traitors' deaths and not simply hanged as thieves was never explained. Some – like Charles de Marillac, the French ambassador – made explicit enquiries about this to the government, but Henry's regime remained tight-lipped.[24]

Whiting was by no means Cromwell's only senior monastic victim. The entry in his *Rememberances* immediately before the order to execute Whiting was an identical death sentence for the abbot of Reading Abbey, who had been a firm supporter of Henry and his divorce, but whom Cromwell accused of treason and executed the day before Whiting.[25] Hundreds of others suffered similar fates, and it was not only men. As early as 1534 the 28-year-old nun Elizabeth Barton was executed by Cromwell for her opposition to Henry's remarriage. After being hanged, her body was mutilated, and she became the only woman ever to have her head spiked on London Bridge.[26]

Popular unrest at Cromwell's measures soon resulted in rebellion. In 1536 the north of England rose in the Pilgrimage of Grace to protest the closure of the monasteries, many of which served important community functions like feeding and caring for the poor, treating the sick, teaching literacy, and praying for the souls of the deceased. Over 30,000 protestors succeeded in seizing Lincoln and York, but the uprising was suppressed, and almost 250 of its ringleaders were executed in reprisal. The following decade, in 1549, the country was still not at peace with the religious measures, and the West Country mounted the Prayer Book Rebellion. Many, especially from the far west, resented having the liturgies and practices of Cranmer's official English-language *Book of Common Prayer* imposed on them. In many communities there, before the reforms, the clergy had delivered Church services and Bible readings in Cornish, prompting the rebels to point out angrily that 'certain of us understand no English'.[27] When the rebellion was eventually suppressed, royal forces put 5,500 people to death in reprisal.[28]

It seems unlikely today that the English were ever so fervent about their religion. The country is now manifestly secular, and a recent archbishop of Canterbury noted with melancholy that Britain is now a post-Christian

nation. Based on 2018 data that Sunday attendance at the Church of England is down to 756,000, or 1.4 per cent of the population, he is right.[29] However, it was not always so. Before the Roman conquest, England was the centre of Celtic druidry. From the time of the conversion of the Anglo-Saxons in the sixth century to the reign of Henry VIII, England was famed for its religious fervour, producing hundreds of saints and theologians. It was even nicknamed 'Mary's Dowry' for its marked devotion to the Virgin Mary.[30] In the century after the Reformation, England remained fervently religious, but with the faithful spread across a wider range of beliefs: both Catholic and Protestant. Some groups – like the Puritan Pilgrim Fathers – even fled to America to found a new world where they could build an entire society in conformity with their driving religious convictions. In one of history's ironies, Protestant theologians and laypeople had migrated to England from the continent only a few generations earlier in the hope of finding a similar home for their beliefs.

The aftershocks of Henry's actions continued to reverberate for centuries. Not long after the Pilgrim Fathers set sail in the *Mayflower*, Puritan forces in England fomented the Civil War of 1642 to 1651, and Oliver Cromwell imposed an austere religious Commonwealth from 1649 to 1660. Both of these were clear demonstrations of the ongoing vigour of religious sentiment in England, merely expressing itself in new formats. However, before England could descend into this religious civil war, Henry's three children would all impose religious reforms of their own, driving ever deeper divisions into the country.

Smashing the Altars – Bloody Tudors

Edmund Campion
To the Privy Council
1580

As Henry VIII lay dying, his chaotic and violent love life left three legitimate children: Mary by Katherine of Aragon, Elizabeth by Anne Boleyn, and Edward by Jane Seymour. Eager to include them all in the succession, Henry willed the throne to the youngest, Edward, with Mary and Elizabeth second and third in line.

On Henry's death in January 1547 Edward succeeded as Edward VI but, at only nine years old, was an immediate hostage to ambitious factions at court. He had been brought up staunchly Protestant, so elements that felt Henry's religious reforms had not been far-reaching enough gravitated to the young king, keen to press for more radical change to church services in particular. Henry had confiscated the monasteries' wealth and broken from Rome, but had remained personally faithful to Catholic sacramental and liturgical practices, and made few alterations to the experience of attending church.[1] Now Henry was dead, committed Protestants at court saw their chance and, under the guiding hands of Edward Seymour and then John Dudley, ordered the wholesale junking of traditional religion and enforced mandatory weekly attendance at reformed church services for the whole country.[2]

Edward's reign, more than any other, saw the obliteration of the country's religious past, most visible in his edict to remove all traces of the cult of

saints. In 1547 he ordered all priests to 'take awai, utterly extincte, and deftroye all fhrines, coveryng of fhrines, all tables, candleftickes, tryndilles or rolles of waxe, pictures, paintynges, and all other monumentes of fained miracles, pilgrimages, Idolatry, and fuperfticion; fo that there remain, no memory of the fame, in walles, glaffes, windows, or elsewhere, within their churches or houfes'.[3] The words 'no memory of' were chosen carefully and carried out efficiently. The result was the destruction of centuries of English art, sculpture and glasswork, hammered into dust and shards, with parallels in the fervour with which Da'esh effaced imagery they deemed idolatrous in Syria and Iraq between 2014 and 2017.

For 1,000 years, English parish churches had been focal points in their communities, where dead loved ones were memorialised in the parish regis-ters, church decorations and regular rounds of prayers for the departed. Ripping up the liturgies – and grinding up the tombs and painted windows – destroyed memories as much as the physical objects.[4] In 2012, when Ahmad al-Faqi al-Mahdi of the west African Ansar ad-Din Islamist group directed his forces to destroy religious and historic buildings in Timbuktu, he committed an act for which the International Criminal Court convicted him as a war criminal because the destruction of cultural property is now understood as a traumatic act that effaces communal identity.[5]

To the disappointment of those courtiers who ran Edward's administra-tion, he fell ill of tuberculosis only five years into his reign, prompting a succession crisis. The next in line – his older sister Mary – had been brought up Catholic by her Spanish mother, and Edward's court knew and feared she would strip them of power. To preserve their positions, Dudley moved swiftly to have Mary and Elizabeth declared bastards and disinherited, unequivocally shutting them out of the succession. To fill the void, he selected his daughter-in-law, Lady Jane Grey, a formidably educated and intelligent 15-year-old with a solid royal pedigree. When Edward then died, Jane was informed. She fainted, and – against her will – was declared queen.

Jane's accession suited those at court who had acquired power, wealth and land from the dismantled monasteries and broken-up Church, and they relied on her to be trusted with continuing Edward's work. The citizens of London, however, resented the last-minute alteration to Henry VIII's will, and rallied in support of Mary. Taken by surprise, the court sensed a loom-ing crisis and swiftly abandoned Jane. Emboldened, Mary marched on London and, after just nine days as queen, Jane gratefully relinquished the crown before being imprisoned for treason. Mary duly pardoned the

teenager – aware she had been a puppet of ambitious factions – but when Jane's father participated in Wyatt's anti-Mary rebellion the following January, Jane was identified as a potential figurehead for future rebellions and swiftly executed.[6]

Mary was crowned in Westminster Abbey on 1 October 1553. Swathed in purple velvet, ermine and gold, she processed out of the abbey to the acclamation of the crowds as England's first queen regnant. Four centuries after Empress Matilda had come so close – only to be rejected by the people of London – the country had finally anointed its first queen exercising supreme power in her own right.

Mary was well prepared for the task. She had received a comprehensive humanist education and was a linguist, fluent in English, Spanish, French, Italian, and written and spoken Latin, with a solid understanding of the classical canon of wisdom for rulers. In foreign affairs, the most pressing issue facing her was the conflict between France, Spain and the Low Countries, and she aimed for neutrality. Although her initial diplomacy focusing on peace-making was successful, she eventually found herself sucked into the war and, in January 1558, suffered a humiliating defeat when the French seized Calais. The port had been England's last possession in France, and its loss marked the definitive end of the cross-Channel empire begun under William the Conqueror almost five centuries earlier.

In contrast to Empress Matilda in the 1200s, Mary's sex did not threaten her authority as monarch. However, her choice of husband did. She accepted a proposal from the most eligible man of his generation, the Hapsburg Philip of Spain, calculating that the heir to the throne of Spain – a far more powerful country than England – and eldest son of the Holy Roman Emperor, Charles v, would elevate her kingdom's status far beyond anything even the grandest English nobleman could offer. In the club of monarchs, Philip was top drawer. Ahead of the wedding, in order to give Philip immediate royal status, his father gave him the crown of Naples and his claim to the kingdom of Jerusalem. However, Mary had miscalculated badly. At court, in Parliament and in the country, there was widespread hostility towards Philip and the prospect of foreign involvement in England's affairs. Although English kings had married queens from continental royal houses for centuries – with many wielding significant power in England while their husbands were away on diplomatic missions or military campaigns – Mary's sex worked against her, raising fears she would be dominated by a foreign husband whose real interests lay outside England.

Mary weathered the criticisms, but her simultaneous move to re-establish Catholicism proved a lethal combination. The majority of the country was happy to have the old faith restored after Edward's shift to more radical Protestantism and, across her domains, missals, rosaries and statues of saints reappeared from under floorboards. But there were influential Protestant factions in the church and at court whose incomes and status depended on the church remaining a Protestant possession of the monarch, and they mounted sustained opposition.[7]

On the continent, the Catholic Church had been undergoing a period of modernisation, beginning in 1545 with reforms passed at the first session of the Council of Trent. This Counter-Reformation meant that the clergy Mary brought over the Channel – many of them, like Cardinal Pole, English churchmen who had left the country under Henry VIII and Edward VI – returned with an overhauled theology that was markedly more modern than the medieval Church Edward had suppressed. If Mary's reign had been longer, and if she had left an heir, it is likely a re-established Catholic Church would have been her permanent legacy. But the marriage to Philip did not succeed in producing an heir and, after five years on the throne, her health failed. She died in November 1558 aged 42, leaving her younger half-sister, Elizabeth, next in line.

Mary and Elizabeth had a strained relationship. Mary resented that Elizabeth's mother, Anne Boleyn, had caused the downfall of her own mother, Katherine of Aragon. And Mary was profoundly wary of Elizabeth's Protestantism, along with the plots and coups to place Elizabeth on the throne, the most serious of which, Wyatt's Rebellion, had earned Elizabeth two months in the Tower. Whether through mercy or political strategy, Mary had refused to have Elizabeth executed, and so, as she lay dying, she followed her father's will and proclaimed Elizabeth her heir.

Elizabeth acceded to the throne at the age of 25: astute and lucky enough to have survived the troubled reigns of both her siblings. Like Mary, she had a keen mind, and was an equally accomplished linguist, fluent in French, Italian, Latin and Greek. Once in power, her priority was to tackle the divisive legacy of the various religious reforms imposed by her father, brother and sister, which had collectively left the court and country irretrievably split. The south-east, which had contact with reformed areas on the continent, possessed notable pockets of Protestants, while the more isolated north and west remained largely attached to Catholicism. It was a map of division that strongly resembled the Romanisation of the country over a

millennium earlier, with the south and east more impacted by contact with continental Europe.

Elizabeth began her religious reforms in April 1559 by passing two key pieces of legislation. An Act of Supremacy again broke England from Rome but, in a delicate fudge because of Elizabeth's sex, it proclaimed her 'Supreme Governor' rather than 'Supreme Head' of the English church. When all but one of the English bishops Mary had installed refused to acknowledge Elizabeth as a substitute for the pope, the entire episcopacy of England and Wales with the exception of Bishop Kitchen of Llandaff was removed from office and replaced wholesale. To change the liturgy, Parliament then passed the Act of Uniformity, which was only approved by a majority of three votes after Elizabeth had two lords arrested to prevent them participating in the vote. The act established a revised *Book of Common Prayer*, and a fine of 12 pence for anyone not attending compulsory church services.[8]

Now England was officially Protestant once more, the country's Catholics faced a stark choice: convert to Protestantism, resist or dissemble. The wealthy – especially the aristocracy in the north – chose resistance, remaining Catholic and paying the fines for skipping Church of England services. They became known as 'recusants', from the Latin *recusare*, to refuse. The less affluent who did not wish to convert lived as 'crypto-Catholics', dutifully attending Elizabeth's church services but secretly participating in illegal Catholic worship. The ping-ponging between Protestantism and Catholicism had left the country angrily divided, with tensions permeating everything and everywhere, including Elizabeth's own family. Her younger cousin, Mary, ruled Scotland – also in her own right as queen regnant – making Britain unique in Europe, where the hereditary monarchs were all male.[9] However, after Mary had reigned for 24 years, the Scottish nobility deposed her and, in 1567, she fled south to seek refuge with Elizabeth. Although it was not part of Mary's plan, she was quickly taken up by England's Catholics as a preferable alternative to Elizabeth, triggering a series of threats to Elizabeth's throne that would lead to harsh persecution of her Catholic subjects.

When Elizabeth came to the throne in 1558 she had been happy not to pry into people's personal faith. In Sir Francis Bacon's words, she had no desire to 'open windows into men's souls' and all she required was physical attendance at state church services. However, the arrival of Mary Queen of Scots changed this calculation. In November 1569 Catholic nobles across the north rose in a coup to put Mary on the throne. When the rebellion

failed, Elizabeth was uncompromising in her response, ordering 700 executions in reprisal and hardening her attitude to her cousin.[10]

The following February – largely in support of the northern rebels – Pope Pius v issued the bull *Regnans in excelsis*, excommunicating Elizabeth and freeing the English from all oaths made to her.[11] He was the third pope since Elizabeth had broken from Rome, but the first to declare a sentence of excommunication against her. Coming so soon after the rebellion, Elizabeth took it as a declaration of war, and began considering her Catholic subjects to be agents of a hostile foreign power. Most English Catholics ignored the bull, but the following year a plot to assassinate Elizabeth – masterminded by the Florentine banker Roberto Ridolfi – strengthened her growing sense that all Catholics were in league to destroy her.

In Rome, England's renewed Protestantism was not the only obstacle to Pius's vision of a Catholic Europe. An existential threat was massing to the east, and the same year he issued *Regnans in excelsis*, he assembled the Holy League – which did not include England – to defend Europe from an Islamic invasion. On 7 October 1571 the League's fleet engaged with the Ottomans off Lepanto, now Nafpaktos in Greece, in history's last great galley battle, with the League's victory definitively halting Islam's march west.

Among European countries, England was not the only one struggling with violence born of the Reformation. Germany had seen the Peasants' War in the first half of the century, in which 100,000 peasants seeking Protestant and agrarian reforms were massacred with the encouragement of Martin Luther, who urged the aristocracy to 'dash to pieces, strangle, stab' the peasants 'in secret and in public, as one must batter a mad dog to death'.[12] France was also riven by religious tensions and, in Paris late on 23 August 1572 – the eve of St Bartholomew's Day – Catherine de' Medici and her son King Charles ix sanctioned the murder of a group of leading Protestant Huguenots. In the early hours of the following morning the city's bells for matins combined with a confused alarm that the Protestants were rising, and – following the example of the Duc de Guise – the citizenry of Paris seized arms and slaughtered any Protestant they could find.[13] Up to 3,000 were butchered, followed by another 7,000 in copycat pogroms across the country.[14] Elizabeth's ambassador to the French court, Sir Francis Walsingham, had been in Paris for the slaughter and, on returning to England, was charged by Elizabeth with keeping tabs on England's Catholics to ensure nothing similar happened in her realm.

The combined effect of the presence of Mary Queen of Scots – who had been imprisoned by Elizabeth almost immediately on her arrival in England – the Northern Rising, *Regnans in excelsis*, the Ridolfi plot and the St Bartholomew's Day Massacre, was to convince Elizabeth that any Catholic in England was an enemy within, and she increasingly moved against them. In 1581 she raised the recusancy fine from 12 pence to a crippling £20 per month, and declared it treason to convert to Catholicism, punishable by hanging, drawing and quartering. Despite these measures, she suffered a further blow in 1584 when William of Orange was assassinated in the Netherlands, leaving her the sole Protestant monarch in Europe. Feeling isolated, and with a further increased sense of vulnerability, she moved the following year to shut down English Catholicism completely by requiring all Catholic priests to leave the country within 40 days, after which any of them on English soil would immediately be executed for treason. She also ordered that anyone giving a priest support would be imprisoned or similarly executed.

The outlawing of English Catholic priests prompted a lethal game of cat-and-mouse. Hundreds of Englishmen slipped abroad clandestinely to be ordained into the Catholic Church, many at the first English seminary to have been opened abroad some years earlier, at Douai in the Spanish Netherlands. Once ordained, these priests returned to England covertly, moving around the country in secret, hiding in 'priest holes' and celebrating the sacraments in private, often in the country homes of the recusant Catholic nobility and gentry.

One such priest was Edmund Campion, whom Elizabeth had met in 1566 when he was in his mid-twenties and chosen by the University of Oxford to give a speech of welcome on her royal visit to the city.[15] After struggling with Protestant theology, he eventually travelled to Douai and, in 1578, was ordained a Catholic priest. He then headed to Rome, met Pope Gregory XIII – famous for reforming Europe's calendar two years later – and joined the Jesuits, before travelling to England and entering the country disguised as a jewel salesman.

Campion's eloquence and learning had made him a well-known and well-liked figure while he was a fellow at Oxford, and Elizabeth's administration – aware of Campion's popularity with the Catholic underground – spread the rumour that he and other Jesuits in the country were there on a mission to topple her. To counter this, one evening in Hoxton Campion drew up a letter setting out his religious convictions and an affirmation that

the Jesuit mission was to minister to the country's Catholics. Addressed to the Privy Council, it was rapidly copied and widely circulated.[16] The authorities moved to discredit it by labelling it his 'Challenge' or 'Brag', but did not succeed in preventing it becoming an influential statement of Elizabethan Catholicism. Campion concluded the letter with a famous flourish.

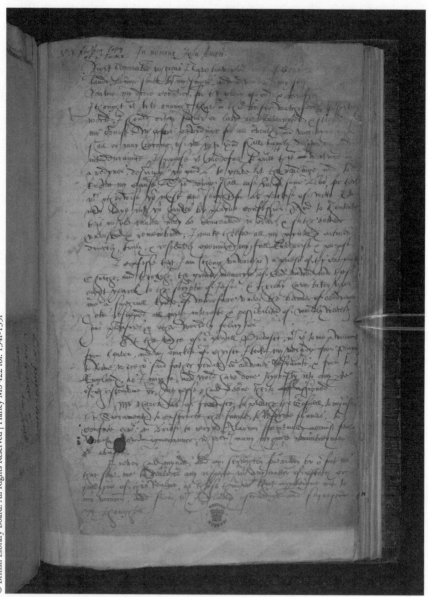

© British Library Board. All Rights Reserved | Harley MS 422 fol. 134r–135r

Edmund Campion, To the Right Honourable Lords of Her Majesties Privy Council (1580, this manuscript 1580–81)

And touchinge our focyetie, be it knowen unto yow that we have made a
league, all the Jefuytes in the worlde, whose fucceffion and multytude
muft over reach all the practizyf of England, cherefullie to carrye the
croffe that yowe fhall laye uppon us, and never to difpair your recoverie,
while we have a man lefte to enjoye your Tybourn or to be racked with
your torments, or to be confumed with your prifons. The expence is
reconed, the enterpryfe is begunne, it is of God. It may not be withftode.
So the faithe was planted, so it muft be reftored.

After being in England just over a year, Campion was betrayed by an
informer and captured. He was imprisoned, then hanged, drawn and quar-
tered at Tyburn with two fellow priests on 1 December 1581. He is one of
the more famous victims of Elizabeth's religious persecution, though in all
Elizabeth executed 133 Catholic priests and 63 Catholic lay men and
women explicitly by reason of their faith, not including the 700 executed
after the rising in the north. In the end, however, it was not sustainable, and
the brutality of the policy proved counterproductive, hardening the resolve
of England's Catholics, and did not survive beyond Elizabeth's reign.[17]

In 1586 Walsingham uncovered yet another conspiracy – the Babington
Plot – this time for a Spanish invasion that would murder Elizabeth, put
Mary Queen of Scots on the throne and restore Catholicism to the land.
Isolated by her 17-year imprisonment, Mary was found to have sent and
received coded correspondence in furtherance of the plot, which was suffi-
cient evidence of treason for Elizabeth finally to sign her cousin's death
warrant. Mary was duly executed at Fotheringhay Castle on 8 February
1587, an inept axeman taking three strikes to sever her neck.

Over in Spain, Philip II had never ceased being interested in English
affairs, even though his wife, Mary I, had died 20 years earlier taking his
title of King of England to her grave. He had been involved in the Ridolfi
Plot and the Babington Plot, and now he took Mary's execution as a pretext
for war. His clear aim was, as ever, to restore England to Catholicism, but
also to punish Elizabeth for supporting Dutch rebels against his rule in the
Spanish Netherlands, and for the piracy she sponsored – through men like
Francis Drake – against Spanish shipping in the Caribbean. Philip therefore
assembled an invasion 'armada invencible' of 130 ships commanded by the
Duke of Medina Sidonia. Once ready, it set sail first from Lisbon in May
1588, then from Corunna on 21 July, carrying some 19,000 infantry with
orders to rendezvous in Flanders with the Duke of Parma and his 30,000

infantry, which would form the bulk of the invasion force. Spies alerted England the invasion was coming and, on 29 July, Cornish lookouts spotted the armada in a crescent-shaped formation approaching Lizard Point. An interception fleet of around 100 ships was scrambled, and it sailed out under Charles Howard. Francis Drake, whom tradition says finished his game of bowls before embarking, was his second-in-command.

The two fleets could not have been more different. The armada was made up of slow, heavy ships, loaded with infantry trained in boarding enemy vessels. In contrast, the English put their faith in fast, light ships fitted with reloadable guns. The two sides eventually met, but initial skirmishes off Plymouth, Portland Bill and the Isle of Wight proved inconclusive, before the Spanish moored off Calais while the Duke of Parma loaded his infantry into the invasion transports. With the armada sitting vulnerable at anchor, Drake spotted his chance and, on the evening of 7 August, launched eight fireships into the Spanish fleet, spreading panic, forcing them to break formation and head out to sea. The English then gave chase and engaged off Gravelines, where their heavy guns dominated history's first major naval artillery encounter.

Boudicca, Empress Matilda, and King Stephen's wife Queen Matilda had all led Englishmen to war, but Elizabeth was not a battlefield commander. Tradition records that she delivered a pre-battle morale speech to her troops mustered at Tilbury, appearing on a white charger, clad in ceremonial armour, where she spoke the famous line, 'I know I have yᵉ body butt of a weak and feble woman, butt I have yᵉ harte and stomack of a kinge, and of a kynge of England too.'[18] Disappointingly, there is no contemporary record of a royal visit to Tilbury at the time, or of any speech. The incident was almost certainly invented years later.[19]

In the Channel, bad weather intervened. Strong winds pushed the armada out into the North Sea, where the Spanish ships broke rank and scattered. The wind then forced them north, offering their captains no option but to sail round Scotland and down the west coast of Ireland, where many were wrecked, leaving only 60 ships to limp back to Spain. In England, Elizabeth was fêted as a hero, whom God – with his windy pro-Protestant intervention – was smiling on, while smiting the outdated Catholics.

Although riding high politically, on a personal and dynastic level Elizabeth's lack of husband and heir were a constant problem. Mary had married a year into her reign, keenly aware of the royal imperative to leave an heir. By contrast, Elizabeth was wary of tying herself to any man

and losing her ability to rule independently. She also did not have good experiences of men. Her first had been as a young teenager, while growing up in the dowager Queen Katherine Parr's household. Parr's husband, Thomas Seymour – then 38 years old – took a shine to the 13-year-old Elizabeth, and it was noted how much she blushed whenever his name was mentioned. Seymour made no secret of his interest, openly romping with Elizabeth, including in her bedchamber, and on one occasion the pair were found in the garden, where Seymour had cut Elizabeth's dress into a hundred pieces while Katherine held her.[20] It all came to an end, though, when Katherine found them embracing, and Elizabeth was sent away. Shortly after, Seymour was caught plotting against Edward VI, and executed. The experience was formative for Elizabeth, teaching her that male interest in her was as likely to be about power and ambition as it was about her.

Once queen in her mid-twenties, Elizabeth fell in love with Robert Dudley.[21] He was a year older and had been imprisoned in the Tower with her after Wyatt's Rebellion, but was married. The Spanish ambassador noted that they spent day and night together, often in Dudley's chamber. When Dudley's wife was found with a suspiciously broken neck, William Cecil – Elizabeth's leading courtier – confided in the Spanish ambassador that he believed the death was the work of Dudley and Elizabeth.[22] The coroner officially recorded a verdict of death by misadventure, but rumours of Dudley's hand in his wife's death led Elizabeth to turn down his proposal of marriage for fear of the scandal.

The third romance in Elizabeth's life came in 1578 when she was 45 and fell in love with the 23-year-old man she called her 'Frog': Duke Francis of Alençon and Anjou. Elizabeth seemed not to mind that he was a Catholic and wanted to take the relationship further, but it provoked strong opposition at court. She was deeply frustrated by those against the match, and even had the right hands of the author and the distributor of a book against the union struck off with a cleaver and mallet.[23] The Privy Council voted against the marriage, and so Elizabeth let it drop, but several years later, when Anjou returned to England, she publicly kissed him on the mouth, gave him a ring, and said she would marry him. For whatever reason, two days later she took it all back, no doubt aware she had gone too far.[24] When Anjou died soon after, Elizabeth confided in his mother, Catherine de' Medici – who, interestingly, had been one of the instigators of the St Bartholomew's Day Massacre – 'I find no consolation except death, which

I hope will soon reunite us, Madame, if you were able to see an image of my heart you would see the portrait of a body without a soul.'[25]

Elizabeth did have reasons for not marrying. Under her church's laws her husband would be her master, but she wanted no fetters on her power to rule independently, exactly as she wished. She had also seen problems caused by the wrong marriage, not least her mother's execution and the unpopularity of Mary's union with Philip of Spain. Finally, she was keenly aware of the physical dangers of motherhood, with a large number of her relatives dead from childbirth. Conscious her lack of husband and heir was a problem, her propagandists worked to turn it into a virtue, likening her to the Virgin Mary, celebrating her as the Virgin Queen married only to her realm and her subjects.[26]

Beyond the gilded world of the court, Elizabeth's country was changing. The population grew dramatically in the sixteenth century: there were 2.3 million people in England and Wales in 1520, but 4.2 million by 1600, and London quadrupled in size to 200,000 in the same period. Around her, England was thriving. Ships sailed to the New World bringing back tobacco and other riches. Francis Drake was knighted for circumnavigating the planet. Writers and poets like Jonson, Marlowe, Shakespeare, Sidney and Spenser flourished, all born in the space of two decades. Printing in English boomed – with over 70 women printers listed between 1553 and 1640 – and literacy increased from a tenth to a quarter of men, and one to four per cent of women.[27] Domestically, many more houses expanded above one storey, were now heated throughout by chimneys, increasingly lit by glass windows and made from affordable bricks. Elizabeth's lack of foreign wars allowed the economy to prosper without the punishing drain of heavy military spending, and the results were palpable. On her deathbed though, she – like her sister Mary – ended her life having failed to produce an heir. Their father, Henry VIII, had changed the country's religion to secure future generations of Tudor rule, but – after 44 years on the throne – Elizabeth took the Tudor crown to the grave with her.

Regardless of Mary and Elizabeth's lack of children, the sisters had both proved themselves skilled rulers, adept at diplomacy and government. Mary's five-year reign was every bit as accomplished and promising as Elizabeth's first half decade, but her religious views put her the wrong side of later history.[28] Writers like John Knox, in his 1558 *The First Blast of the Trumpet against the Monstrous Regiment of Women*, and John Foxe, in his 1563 *Book of Martyrs*, portrayed her as a tyrant – 'Bloody Mary' – although

she executed around 300 Protestants compared to Elizabeth's execution of 896 Catholics.[29] Meanwhile, in 1590 Edmund Spenser's *The Faerie Queene* cast Elizabeth as 'Gloriana', adding to the praise that would see her placed among the greatest of England's monarchs. The characterisations of her and Mary were, ultimately, both spin from Elizabeth's admirers, but the portrayals stuck, feeding into later Whig historians' thesis that English history has been a march of progress from barbarity to Protestant enlightenment. On this journey, Elizabeth and her England became the bedrock of Early Modern English greatness, while Mary – with her medieval dogmas – was a throwback to the dark ages of unreason.

The Tudor monarchs were all intelligent, educated and shrewd. But, unlike earlier monarchs who required the cooperation of their barons to rule, Henry, Mary and Elizabeth all ruled by personal diktat, force, fear, and the liberal use of purposefully horrific executions. Despite the traditional perception that political freedom emerged as the medieval ages ended, the Tudors – who were children of the Renaissance and not medieval – were by far and away the most tyrannical dynasty ever to have ruled England.

The Devil's Votaries – Witches in the Air

Thomas Potts
*The Wonderfull Discoverie of
Witches in the Countie of Lancaster*
1613

The first execution of a witch in Britain occurred in Elizabeth I's reign. It took place in 1566 at Chelmsford, where the justices hanged Agnes Waterhouse of Hatfield Peverel for killing people and animals with the help of her familiar, a black cat named Satan.[1]

The details of her crimes were unusual. Satan the cat transformed himself variously into a toad and a dog, talked, and carried a knife in his mouth as he helped in the diabolical murders. Much of the evidence came from a 12-year-old girl, Agnes Browne, and Waterhouse confessed to it all, even admitting to saying her prayers in Latin, which horrified the judges as 'it was set out by publike aucthoritie and according to goddes worde that all men shoulde pray in the englyshe & mother toung'.[2] It is an indication just how divided the country still was that, only 17 years after Edward VI brought in Cranmer's *Book of Common Prayer*, a 62-year-old woman – born before Henry VIII took the throne – was deemed devilish for saying her prayers in the language she had known them in for the first 45 years of her life.

Agnes's fate also shows that England was changing. Execution for witchcraft could not have happened in the days of King Ælfred, Richard the

Lionheart or Edward Longshanks because theologians did not accept that witchcraft existed. This had been set out in the *Episcopi* canon, which was thought to originate at an early Church council in AD 314, but was probably from around AD 850. It recounted that 'some wicked women . . . seduced by illusions and phantasms of demons' and under the influence of 'Diana goddess of pagans' claimed 'to ride on certain beasts in the silence of the dead of night to traverse great spaces of earth'. After describing these legionaries of Diana transvecting to secret gatherings, the canon ruled that the women were delusional, confusing dreams with reality because magic was not real and to believe otherwise was heresy.[3] There were other proclamations in the same vein. As early as AD 643 the Lombard Code ruled, 'Let nobody presume to kill a foreign serving maid or female servant as a witch – whom people call a *masca* – for it is not to be believed by Christians.'[4] And this was still true in 1080 when Pope Gregory VII told King Harald the Soft of Denmark not to punish women for extreme weather conditions.[5] But the *Episcopi* canon gained the widest audience and, around 1140, was included in one of the most important legal texts of the Middle Ages – Gratian of Bologna's *Decretum* – which remained a key source of Church canon law until 1917.

To deny the existence of magic was an interesting theological stance for the medieval Church to take. It simultaneously required Christians to believe that Christ had supernatural powers over the visible and invisible worlds, and that humans could share in them by following particular rituals and intoning specific words of power to bring about what the Bible describes as *dunameis*, or powerful deeds. Christians call them miracles. Non-Christians might use the more generic word magic. On one level this might seem inconsistent. The reason the medieval Church adopted this position, however, has a logic. Despite the Bible mentioning magic dozens of times – for example the magical powers of the Witch of Endor or Simon Magus – the Church acknowledged no force on earth capable of altering the laws of nature except through the mediation of the Holy Trinity. Non-Christian sorcery was therefore, by definition, charlatanism.[6]

Accordingly, the medieval Church did not have a programme of witch burning, and the trope in fiction and films that the Inquisition was set up to persecute witches is an error. The bishops' Inquisition was established by Pope Lucius III in the 1184 bull *Ad abolendam* to uncover heresy, which meant non-mainstream or deviant Christian beliefs, like those of the

Cathars of southern Europe who followed a dualist form of Christianity, or the Waldensians around Lyons who rejected some of the seven sacraments. The bishops' Inquisition set out to bring these people back to the 'true' faith, and therefore had no involvement with non-Christians like Jews or Muslims. Its manuals specifically noted that the Inquisition had no jurisdiction over witchcraft, which it deemed outside its legal sphere of competence unless the magic was being deployed in a heretical Christian activity.[7] However, the bishops' Inquisition proved patchy and inconsistent, so it was refounded by Pope Gregory IX in 1227 as the papal Inquisition, but its stance on witchcraft did not alter, and papal inquisitors continued to avoid involvement in allegations of *maleficia* and *sortilegia*. The third Inquisition – the Spanish Inquisition – was founded in 1478 by King Ferdinand and Queen Isabella, not the Church, to root out heresy in their lands among converted Jews and Muslims. Again, its focus was not on witchcraft, although – given its late date – it did preside over a number of witchcraft trials, with a reputation for notably brutal tortures. Because of the peculiarities of the English legal system and its use of juries rather than judicial torture, none of the Church Inquisitions ever operated in England, except briefly but unsuccessfully during the trial of the Knights Templar in 1307 to 1312.[8]

Despite denying the existence of magic for centuries, around 1400, after the trauma of the Black Death, some theologians began to change their minds. The first notable work to put forward a new vision was the German theologian Johannes Nider's *Anthill* (*Formicarius*) of 1435 to 1438, which was followed by the Spanish Bishop Alphonso de Espina's *Fortress of Faith* (*Fortalitium fidei*), written in 1458 to 1460.[9] Others picked up and developed their themes, which gradually built a picture of a new kind of witch. Traditionally, sorcery had been thought of as the domain of educated people, often men, who dealt in charms, spells, healing and occasionally blighting, as set out in learned grimoires and books on angelology and the heavenly bodies. However, the emerging vision of late medieval witchcraft was that it was practised by the uneducated – often countryfolk – and became ever more closely aligned to the idea that witches received their powers by entering pacts with the Devil. Before long, witchcraft was being seen as a diabolical compact in which people, mainly women, flew to great Satanic gatherings where the Devil appeared to them, and they worshipped him by slaughtering babies, holding orgies and submitting to dark rites.

These ideas took root especially strongly in Germany, where they were adopted enthusiastically by the Dominican friar and inquisitor Heinrich Kramer. For reasons that are still not clear, in 1484 he persuaded Pope Innocent VIII to issue him a bull – *Summis desiderantes affectibus* – confirming that witches were real and that they served the Devil.[10] Armed with this papal endorsement, Kramer set about using his position as an inquisitor to launch witch trials. The local bishop in Innsbruck, where Kramer was based, wanted none of it, and threw him out of the province. Not wanting to give up, Kramer decided to write a detailed manual on what he had learned about witches, and specifically how to identify and interrogate them. If guilty, he had no doubt that the correct course was to follow God's clear advice to Moses: 'Thou shalt not suffer a witch to live'.[11] Kramer entitled his witch-hunting manual the *Hammer of the Witches* (*Malleus maleficarum*) and, to give it credibility, somehow persuaded Jakob Sprenger, dean of the theology faculty at the University of Cologne, to add his name to the book. The pair then published it together with a document claiming that the theologians of the University of Cologne had endorsed it.

Kramer and Sprenger were living in their own bubble. There are no records of any enthusiasm for the *Hammer* in the Church, and it was never adopted as a manual by the Inquisition.[12] Its popularity came, unexpectedly, from outside the Church. Johannes Gutenberg had recently begun mass-producing printed books, and the *Hammer* became an unlikely favourite with the public, running to 30 editions between 1486 and 1669.[13] A principal reason for this was the evolving theology of the Reformation in which guiding minds like Martin Luther's came to frame the individual Christian life as a permanent battle against the wiles of the Devil. Kramer's conviction that witches were those who had succumbed to temptation, trading virtue for diabolical rewards, began to resonate with this new theology and, as a consequence, the areas of Germany and Switzerland in which witch hunting became most intense were those that embraced more austere branches of reformed theology. Although there had been witch trials in the medieval period, the 'witch craze' flared at the start of the Early Modern era, between 1550 and 1650, while Europe adjusted to the break in medieval religious uniformity. As a kaleidoscope of new sects vied for adherents, the threat of the Devil's wanton votaries lying in wait to trap God-fearing Christians became an increasingly powerful recruiting tool.[14]

Britain joined the witch craze relatively late. There had been cases of witchcraft in England before the Reformation, but not many, and none

involving the notion of Satanic sorcery. The most notorious occurred in 1441, when the Duchess of Gloucester, an Oxford don, a canon of Westminster and a potion-maker from Ebury were all convicted of treason, necromancy and sorcery for casting the horoscope of Henry VI and concluding that he might soon die. The case caused a sensation, not least because the Duchess of Gloucester's husband was known to have his eyes on the throne.

Witchcraft only arrived as an offence on the statute book in the reign of Henry VIII after the break from Rome, when he passed an Act against Conjurations, Witchcrafts, Sorcery and Enchantments in 1542, making sorcery a criminal – not a religious – offence.[15] It was to be tried in the king's courts as a secular crime alongside murder, assault and other forms of physical harm. It followed that anyone found guilty would be hanged as a criminal, not burned as a relapsed heretic. The act was repealed when Edward VI cleared off a raft of old legislation, and he did not enact a replacement. Nor did Mary. It was only brought back, with some modifications, under Elizabeth I in 1563.[16] In her witchcraft act, the penalties were altered, with death by hanging restricted to second offences or cases where the witchcraft actually killed someone, as with Agnes Waterhouse, who was the first person convicted under it.

In Scotland, witch-hunting began after James VI became convinced his kingdom was rife with diabolical plots to dethrone him.[17] He was so certain of it that he wrote a book, *Dæmonologie*, to warn his subjects and foreign readers that witches were both real and dangerous.[18] In 1603, when he became James I of England, he brought this morbid fear of witches south to his new realm, and updated Elizabeth's witchcraft laws in a new act of 1604.[19] Ever attentive to the pulse at court, and with an eye to royal favour, Shakespeare wasted little time penning *Macbeth* in 1606 to 1607 featuring the Three Witches (later called Weird Sisters) whose foul magic plotted the regicide of a Scottish king.

During James's reign, one of the most notorious witch trials in English history took place following events that occurred in Lancashire's Forest of Pendle. A villager, Alizon Device, boasted that she had used magic to lame a pedlar. The local magistrate, Robert Nowell, hauled her in along with her mother, Squinting Lizzie, and her grandmother, Old Demdike, only to discover that all three were witches. Alizon then surprised Nowell by telling him there was another rival family of witches nearby under the matriarch Old Chattox, and that this family had murdered Alizon's father by

witchcraft. Nowell promptly pulled in Old Chattox, and she, too, swiftly confessed.

Nowell might have concluded it was all an over-imaginative family feud and found something better to do, but Squinting Lizzie then threw a party on Good Friday. Tongues inevitably started to wag, wondering what sort of heathens partied on the most solemn day of the year, when God-fearing folk mourned, read the Bible and contemplated Christ's suffering. Whether Nowell actually believed it, or whether he saw an opportunity to find favour with a king who saw witches everywhere, he concluded that Squinting Lizzie's Good Friday party had been a full-blown Sabbath – a hellish gathering of witches and demons in the presence of the Devil – and committed all the women to be tried for witchcraft at the assizes.

There are very few detailed records of the cut and thrust of Early Modern witch trials, but the case of the Pendle witches is a remarkable exception. The court clerk, Thomas Potts, collaborated with the assize judges afterwards to produce an account of what happened in court. Published quickly as *The Wonderfull Discoverie of Witches in the Countie of Lancaster*, it became an instant bestseller, offering a unique insight into the way the legal system wanted to portray its handling of witches. The proceedings were not a modern trial with prosecution and defence. They merely involved the presentation of statements previously given to the magistrate, along with the defendants' confessions. Some evidence was heard live, but there were no defence lawyers, so the witnesses' evidence went unchallenged.

The Wonderfull Discoverie opens with numerous statements describing witchcraft, using language like 'most barberous and damnable Practises, Murthers, wicked and diuelish Conspiracies', which sets the tone for the rest of the book. Similar language is used for the defendants.

> This *Anne Whittle*, alias *Chattox*, was a very old withered spent and decreped creature, her sight almost gone: A dangerous Witch, of very long continuance; always opposite to old *Demdike*: For whom the one fauoured, the other hated deadly: and how they enuie and accuse one another, in their Examinations, may appeare. In her Witchcraft, always more ready to doe mischiefe to mens goods, then themselues. Her lippes euer chattering and walking: but no man knew what.

Of key importance to the court were the diabolical spirits that the women served. In Alizon Device's case:

Mary Evans Picture Library

THE
WONDERFVLL
DISCOVERIE OF
WITCHES IN THE COVN-
TIE OF LAN-
CASTER.

With the Arraignement and Triall of
Nineteene notorious WITCHES, at the Affizes and
generall Gaole deliuerie, holden at the Caftle of
LANCASTER, *vpon Munday, the fe-*
uenteenth of Auguft laft,
1612.

Before Sir IAMES ALTHAM, and
Sir EDWARD BROMLEY, Knights; BARONS of his
Maiefties Court of EXCHEQVER: And Iuftices
of Afsize, Oyer *and* Terminor, *and generall*
Gaole deliuerie in the circuit of the
North Parts.

Together with the Arraignement and Triall of IENNET
PRESTON, *at the Afsizes holden at the Caftle of Yorke,*
the feuen and twentieth day of Iulie laft paft,
with her Execution for the murther
of Mafter LISTER
by Witchcraft.

Publifhed and fet forth by commandement of his Maiefties
Iuftices of Affize in the North Parts.

By THOMAS POTTS *Efquier.*

LONDON,
Printed by *W. Stansby* for *John Barnes,* dwelling neare
Holborne Conduit. 1613.

*Thomas Potts, The Wonderfull Discoverie of Witches
in the Countie of Lancaster (1613)*

There appeared vnto her a thing like vnto a Blacke Dogge: speaking vnto her, this Examinate, and desiring her to giue him her Soule, and he would giue her power to doe any thing shee would: whereupon this Examinate being therewithall inticed, and setting her downe; the said Blacke-Dogge did with his mouth (as this Examinate then thought) sucke at her breast, a little below her Paps, which place did remain blew halfe a yeare next after.

As important as their familiars were, the witches' spells and curses were also key for the court. Squinting Lizzie taught her son to say '*Crucifixus hoc signum vitam eternam. Amen*' when he wanted a good drink to come into the house. It is a garbled, gibberish memory of Church Latin – 'crucified this sign eternal life amen' – and reinforces the fact that liturgical Latin was coming to be seen as a language of dark powers. Other spells were equally nonsensical, even in English. Old Chattox recited one that she deployed to unbewitch a drink that had been cursed.

Three Biters hast thou bitten,
 The Hart, ill Eye, ill Tonge:
Three bitter shall be thy Boote,
 Father, Sonne, and Holy Ghost
 a Gods name,
Fiue Pater-nosters, fiue Auies,
 and a Creede,
In worship of fiue wounds
 of our Lord.

Again, the references to pre-Reformation religion are striking. The *Pater Noster* and *Ave Maria* were a staple of the old devotions, and the cult of the five wounds of Christ had been widely popular, even appearing on the banner of the northern rebels who rose against Elizabeth I's religious reforms in 1569.[20]

The court was also very interested in the witches' methods of killing people, which could be quite elaborate. Likenesses of the intended victim were often used, as Old Demdike explained.

The speediest way to take a mans life away by Witchcraft, is to make a Picture of Clay, like vnto the shape of the person whom they meane to

kill, & dry it thorowly: and when they would haue them to be ill in any one place more then an other; then take a Thorne or Pinne, and pricke it in that part of the Picture you would so haue to be ill: and when you would haue any part of the Body to consume away, then take that part of the Picture, and burne it. And when they would haue the whole body to consume away, then take the remnant of the sayd Picture, and burne it: and so therevpon by that meanes, the body shall die.

Old Chattox was even more inventive in her magical paraphernalia.

Twelue yeares agoe, the said *Anne Chattox* at a Buriall at the new Church in Pendle, did take three scalpes of people, which had been buried, and then cast out of a graue . . . and tooke eight teeth out of the said Scalpes, whereof she kept foure to her selfe, and gaue other foure to the said *Demdike* . . . which said teeth haue euer since beene kept, vntill now . . . at the West-end of [her] house, and there buried in the earth, and a Picture of Clay there likewise found by them, about halfe a yard ouer in the earth, where the said teeth lay, which said picture so found was almost withered away, and was the Picture of *Anne, Anthony Nutters* daughter.

Much of it, ultimately, was unprovable, like the havoc wrought by Old Chattox's familiar, named Fancie.

And thereupon this Examinate called for her Deuill *Fancie*, and bad him goe bite a browne Cow of the said Moores by the head, and make the Cow goe madde: and the Deuill then, in the likenesse of a browne Dogge, went to the said Cow, and bit her: which Cow went madde accordingly, and died within six weekes next after, or thereabouts.

Regarding the more recent offences, the most dramatic moment in the trial came when Jennet Device – the nine-year-old daughter of Squinting Lizzie and sister of Alizon – gave evidence against her mother. There were no objections to the unchallenged testimony of a child as King James had noted in *Dæmonologie* that 'barnes or wiues [wives], or neuer fo diffamed perfons . . . fuch witneffes may be fufficient in matters of high treafon againft God'.[21] Jennet was therefore given the floor.

The said *Iennet Deuice*, being a yong Maide, about the age of nine yeares, and commanded to stand vp to giue euidence against her Mother, Prisoner at the Barre: Her Mother, according to her accustomed manner, outragiously cursing, cryed out against the child in such fearefull manner, as all the Court did not a little wonder at her, and so amazed the child, as with weeping teares shee cryed out vnto my Lord the Iudge, and told him, shee was not able to speake in the presence of her Mother.

This odious Witch was branded with a preposterous marke in Nature, euen from her birth, which was her left eye, standing lower than the other; the one looking downe, the other looking vp, so strangely deformed, as the best that were present in that Honorable assembly, and great Audience, did affirme, they had not often seene the like . . .

In the end, when no meanes would serue, his Lordship commanded the Prisoner to be taken away, and the Maide to be set vpon the Table in the presence of the whole Court, who deliuered her euidence in that Honorable assembly, to the Gentlemen of the Iurie of life and death, as followeth. *viz.*

Iennet Deuice . . . confesseth and saith, that her said Mother is a Witch, and that this shee knoweth to be true; for, that shee had seene her Spirit sundrie times come vnto her said Mother in her owne house, called *Malking-Tower*, in the likenesse of a browne Dogge, which shee called *Ball*; and at one time amongst others, the said *Ball* did aske this Examinates Mother what she would haue him to do: and this Examinates Mother answered, that she would haue the said *Ball* to helpe her to kill *Iohn Robinson* of *Barley*, alias *Swyer*: by helpe of which said *Ball*, the said *Swyer* was killed by witch-craft accordingly . . .

The judges were clearly very taken with Jennet, who also gave evidence against her brother, James.

Although she were but very yong, yet it was wonderfull to the Court, in so great a Presence and Audience, with what modestie, gouernement, and vnderstanding, shee deliuered this Euidence against the Prisoner at the Barre, being her owne naturall brother, which he himselfe could not deny, but there acknowledged in euery particular to be iust and true.

In the end, 10 of the defendants were found guilty and sentenced to death. Jennet's evidence had been so persuasive that she condemned her

mother Squinting Lizzie, her sister Alizon and her brother James to the gallows. Her grandmother, Old Demdike, had already died in prison. On 20 August 1612 the convicted witches were led up Gallows Hill and hanged. The affair remains a shining example of intolerance, ambition and hysteria.

Across the country, those executed for witchcraft were predominantly, but not exclusively, ordinary people, typically country folk. Among the educated and affluent, magical beliefs were less likely to be fatal, as in the case of the Renaissance scholar Dr John Dee, who held various appointments to Edward VI, Mary I and Elizabeth I as astrologer, mathematician, philosopher and cartographer. He was arrested for conjuring, but nothing came of it, and Elizabeth's court later commissioned him to cast horoscopes to identify the most propitious date for her coronation. He ended up obsessed with the occult, summoning spirits, scrying, conversing with angels and even personally lecturing Queen Elizabeth on his profoundly magical text the *Hieroglyphic Monad* (*Monas hieroglyphica*). Objectively, he was guilty of the 'Conjuracons and Invocacons' forbidden by Elizabeth's legislation, but he nevertheless lived a successful and prominent life in royal circles.

Witch trials continued across Britain throughout the first half of the seventeenth century, the most ferocious period in England coming at the end of Charles I's reign, in 1645 to 1647, when Puritans were about to seize the government and Matthew Hopkins – the self-appointed 'Witchfinder General' – presided over more than 100 executions across Essex, Norfolk and Suffolk.[22] The witch craze was also global, with England exporting witch-hunting to its colonies. In 1692 to 1693 a new Congregationalist pastor, Englishman Samuel Parris, arrived in Salem Village – now Danvers in Massachusetts – setting off the notorious Salem witch trials, which resulted in the arrest of over 200 people from half a dozen surrounding villages. When the mania subsided, 19 had been hanged as witches and five had died in custody.

The last execution for witchcraft in England was likely Alice Molland in Devon in 1685.[23] By 1700 the witch craze was effectively over in Britain, and the emergence of experimental science as a branch of natural philosophy saw reason supplant magic as a tool for explaining the unknown. The last witch executed in Scotland was Janet Horne in 1727.[24] However, it was a gradual transition. Figures like Sir Isaac Newton – active in the decades around the turn of the century – played an essential role in remoulding the

magic of polymaths like Dr John Dee into science. The end came during the reign of George II, when Parliament under Robert Walpole finally passed the Witchcraft Act 1735 which rejected the existence of witchcraft and laid out laws to punish people who fraudulently held themselves out as possessing supernatural powers.[25]

By the close of the 1700s fear of Satan's legions on earth had largely evaporated, and magic no longer held the power to terrify. Instead, it began to entertain as, across Europe, the terrors of the darkest reaches of the mind were explored as frisson-inducing stories. In the English-speaking world, diabolical and magical plots surfaced in books like Walpole's 1764 *The Castle of Otranto*, Lewis's 1796 *The Monk* and Shelley's 1818 *Frankenstein, or the Modern Prometheus*. In Germany, Jacob and Wilhelm Grimm collected gruesome and frequently magical tales from the remote corners of the countryside, publishing them in 1812 to 1815 as *Children's and Household Tales* (*Kinder- und Hausmärchen*), better known in English as *Grimm's Fairy Tales*. All these paved the way the following century for even more shocking supernatural entertainment, like Stoker's 1897 *Dracula*, the ghostly stories of Le Fanu and, in the early twentieth century, the antiquarian horror stories of M. R. James.

Alongside the emergence of magic and devilry as entertainment in literature, the late nineteenth century also brought a fashion in society witchcraft, which had definitively moved from the woods and huts of the countryside into the salons and drawing rooms of the wealthy. Spiritism became popular and, in 1887, the Hermetic Order of the Golden Dawn opened in London to cater for those with a penchant for the rituals of high magic. Cambridge drop-out Aleister Crowley – who later founded his own magical religion, Thelema – joined for a while, where he learned spells alongside fellow members Constance Wilde and the Nobel prize-winning poet W. B. Yeats, who noted laconically that Crowley was a 'mad person . . . of unspeakable life'.[26]

Once the twentieth century dawned, witchcraft was a memory in Britain, unlike in parts of Africa, the Middle East and Asia. However, at the height of World War Two, Helen Duncan and Jane Yorke were both prosecuted at the Old Bailey under the Witchcraft Act 1735 for running sham séances to summon the dead, preying on the grief of the war bereaved. Both were convicted, and Duncan was sentenced to nine months in Holloway prison. In No. 10 Downing Street, Winston Churchill was not amused, berating the Home Secretary for the Act's 'obsolete tomfoolery'. Not long after, in

1951, it was repealed, bringing to an end Parliament's 409-year flirtation with witchcraft legislation.

Once the offence of phoney witchcraft was gone, a former colonial civil servant named Gerald Gardner began to speak openly about having been initiated into a witches' coven in Highcliffe on the edge of Dorset's New Forest. He asserted that he was part of a tradition that had survived the witch craze to carry the torch of Europe's ancient magical-pagan religion into the modern world. This was wishful thinking, but the witch religion Gardner 'revealed' – or rather, invented – is now practised worldwide as Wicca, and is the only fully formed, recognised world religion created in England. It is a vibrant mainstay of modern neo-paganism, alongside reinvented forms of druidry, Germanic and Norse heathenism, and a range of other re-imaginings of ancient belief systems. Many now have legal status in parts of the world and, in a case that would have horrified the justices who hanged Agnes Waterhouse in 1566 and the Pendle witches in 1612, in 2004 a Royal Navy technician on board HMS *Cumberland* was lawfully permitted to register his religion as Satanism.[27]

Estimates of the death toll during the witch craze vary as records are patchy and incomplete. A conservative view is that perhaps 40,000 to 60,000 people were executed across Europe, around 80 per cent of them women.[28] In England, the number is usually reckoned to be around 500, with an upper limit of 1,000.[29] In Scotland – where post-Reformation religious splintering was more stark and sectarian – the number is significantly higher, at 2,500.[30] Ireland did not experience a similar religious fissure, and the figure is far lower. The overall numbers, however, remain shocking, and make the witch craze one of the most disquieting features of the sixteenth and seventeenth centuries. The McCarthy purges of the 1940s and 1950s in the United States, and the Satanic child abuse hysteria that gripped the United States, Britain, Europe, and countries as far afield as Australia in the 1980s and 1990s, all offer a reminder of how easily an irrational, persecuting frenzy can take hold. Yet it remains largely incomprehensible that, for two centuries, secular and religious authorities in the Old and New Worlds collectively lost their reason and became so sure of the Devil's agency in the lives of ordinary people that they hanged 'witches' in their tens of thousands. Far from being a medieval problem, the mass execution of ordinary people in Britain for being in league with the Devil was a defining feature of post-Reformation Tudor and Stuart society.

20

Bombing Parliament – Homegrown Terrorism
Gunpowder Plotter
Letter to Lord Monteagle
1605

As Elizabeth I's reign came to an end with no heir to the House of Tudor, the Privy Council offered the thrones of England and Ireland to James VI of Scotland. Accordingly, in March 1603 James rode south from Dunfermline Palace with crowds excitedly cheering him on his long journey to Westminster. The mood was buoyant and optimistic but, when a recurrence of plague broke out, it turned sombre. Some saw it as an ominous portent.

As the first ruler of all three of Britain's kingdoms, among the larger challenges facing James was how to manage the expectations of the countries' widely divergent religious groups. Scotland was a mix predominantly of Calvinists and Catholics. Ireland remained overwhelmingly Catholic, with the exception of the Protestant colonists 'planted' to break up the Catholic hegemony. While England operated under Elizabeth's uneasy episcopalian Church of England settlement of 1558 with a large disenfranchised Catholic population.

England's Catholics hoped that James would show them more tolerance than the Tudors had. One Catholic in particular, Thomas Percy – cousin of the Earl of Northumberland – had even secretly visited James in Scotland three times before the coronation, coming away with the distinct impression that English Catholics would be allowed to practise their faith in

peace.[1] They reassured themselves that James had been baptised a Catholic before becoming a Calvinist, that his mother, Mary Queen of Scots, had been a prominent Catholic, and his wife, Anne of Denmark, was widely rumoured to be a secret Catholic.[2] Accordingly, many anticipated that the new king would usher in a climate of quiet tolerance.

As an individual, James was intelligent, bookish and shrewd, understanding well the value of allowing everyone who pleaded their case to him to think he was sympathetic to their cause. At first he did lift the pressure on England's Catholics, stopped the recusancy fines, and told Parliament that the Catholic Church was the mother church of the nation.[3] But his support was shallow and did not last. After vociferous and sustained complaints from leading Protestant voices, he recognised the depth of the country's divisions and realised he would have a quieter life if he did not work against his courtiers. 'Na Na, gud fayth,' he concluded, 'wee's not need the papists now!'[4] He then swiftly reimposed the recusancy fines and banished all Catholic priests as Elizabeth had done. After so much hope, it dawned on England's Catholics that there would be nothing but disappointment under James, and their optimism turned to resentment and hostility. Those with connections tried to see what could be done. One group went so far as to approach Philip III of Spain and requested him to come and take the English throne. However, he had other plans, and signed the Treaty of London with James, restoring peace between the two realms with no mention of the condition of England's Catholics.[5] Desperate, others looked to more direct methods.

Robert Catesby was from an openly Catholic Northamptonshire family which paid the swingeing recusancy fines.[6] He attended Gloucester Hall at Oxford, was blessed with notable charisma, but was a religious zealot.[7] In May 1604 he met up with his cousin, the soldier Thomas Winter of Worcestershire – a member of the group that had visited Philip III in Spain – and told him and a Yorkshireman, John Wright, that he intended to take matters into his own hands.[8] His plan was to detonate explosives at the Houses of Parliament during the state opening with the intention of killing the king, the queen, the Prince of Wales, and all the country's senior courtiers, judges, bishops and nobles. In one decisive act, he would wipe out the entire leadership of the realm. He was aware many Catholic peers would die in the carnage, but had concluded it was a price worth paying as their collaboration with James signified that they were no better than 'atheistes fooles and cowards'.[9] Parliament was also a symbolic target, he pointed out,

as 'in that place have they done us all the mischeif, and perchance God hath desined that place for their punishment'.[10]

Winter and Wright liked Catesby's plan and brought in Thomas Percy, the cousin of the Earl of Northumberland who had visited James VI in Scotland to seek assurances on his plans for England's Catholics. A recent Catholic with all the ardour of the new convert, Percy had studied at Peterhouse Cambridge and was married to Wright's sister. Winter also brought in Guy Fawkes, an English soldier he had met at Ostend and Dunkirk, who had also been part of the mission to Philip III of Spain. Together, the five set about implementing Catesby's plan.

Fawkes was from the Stonegate district of York. His devoutly Protestant father had died when Fawkes was around 12 years old and, after his mother married a prominent recusant, Fawkes became attracted to Catholicism and converted. He became ardent in his new faith, and by the age of 22 was fighting as a mercenary in Belgium in the ranks of the Spanish army, where he quickly won praise and favour for his skill at arms, loyalty, integrity, piety and good humour.

Catesby's operation required stealth, and it began in earnest in May 1604. Fortunately for the plotters, Percy had been appointed a Gentleman Pensioner – one of the king's bodyguards – by his cousin the Earl of Northumberland, and was therefore able to lease a house in Westminster adjacent to Parliament. Because of his long service abroad, Fawkes was unknown in London, so was able to take up residence in Percy's house as his servant 'John Johnson'. There, behind closed doors, he set about digging a tunnel under Parliament with a view to filling it with explosives to be detonated at the state opening.

So far the plan had worked smoothly, but now things started to go awry. An outbreak of plague caused Parliament to be prorogued, so the plotters left Westminster to hide out in the countryside, only returning at the start of the Michaelmas law term. Then a group of Scottish negotiators working on the proposed union between England and Scotland took over Percy's house for a period, but eventually Fawkes was able to come back to Westminster a fortnight before Christmas to resume digging. Meanwhile, he had secured 18 hundredweight of gunpowder from the surplus circulating in London after the end of the Anglo-Spanish war, and he hid it at Catesby's house in Lambeth, where it was guarded by a new conspirator, Robert Keyes.

Fawkes's tunnelling work was heavy going, digging out an underground shaft and securing it with timber. All the plotters helped him, and to sustain

themselves took supplies of 'bakt meats' into the tunnel to avoid leaving the house. When they eventually hit Parliament's subterranean foundation walls and realised their formidable size, they recruited three fresh men to help with the backbreaking work: Robert Winter (Thomas's older brother), Christopher Wright (John's younger brother) and John Grant (Winter's brother-in-law). They then ferried the gunpowder over from Catesby's house in Lambeth to keep all the danger and risk in one place.

The digging remained arduous but, by a stroke of fortune, they learned that a ground-floor vault directly below the House of Lords had become available. So Percy immediately took a lease on it. With no need to do anything except stack the barrels there when the time came, they abandoned the digging and Catesby rode north to arrange an equally important element of the plan. He organised the Catholic gentry of the Midlands to meet immediately after the attack on Parliament in the guise of a hunting party, then seize Princess Elizabeth – James I's nine-year-old daughter – from her home at Combe Abbey near Coventry. As the king and the Prince of Wales would be dead, they would place Elizabeth on the throne as their puppet.[11] While in the Midlands attending to these preparations, Catesby also filled his home at Ashby St Ledgers with weapons and armour, and brought in three new financial backers to ease the considerable strain on his personal funds: Francis Tresham of Northamptonshire – one of the prime movers behind the mission to Philip III of Spain – Ambrose Rookwood of Suffolk, and Sir Everard Digby of Rutland.

A new date was announced for the state opening of Parliament – 5 November 1605 – so the plotters dispersed for the summer in anticipation. Fawkes went to Flanders, where he told a man named Hugh Owen about the plan so Owen could explain to the continental courts what had happened once the attack had succeeded. Then the conspirators returned to Westminster in the autumn to prepare for 5 November. So far their plan had remained a tightly kept secret, but on Sunday 27 October a servant of William Parker Lord Monteagle hurried to Thomas Winter with alarming news. Monteagle was a prominent Catholic who had been involved in plans for a Spanish invasion in Elizabeth's day as well as the mission to Philip III. However, the servant breathlessly told Winter that Monteagle had just received an anonymous letter at his home in Hoxton warning him to stay away from the state opening of Parliament. The original letter is now in the National Archives, and remains as clear as the day it was written.

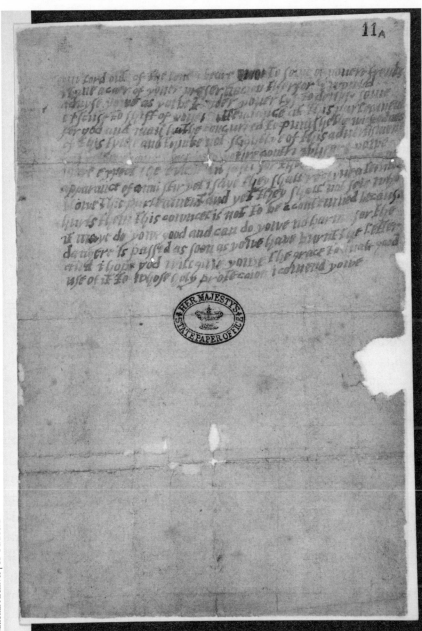

Gunpowder Plotter, Letter to Lord Monteagle (1605)

National Archives | SP 14/216/2

My lord, out of the love I beare to some of youere frends, I have a care of youre preservacion, therefore I would aduyse you as you tender your life to devise some excuse to shift youer attendance at this parliament, for God and man hath concurred to punishe the wickedness of this tyme, and thinke not slightly of this advertisement, but retire yourself into your country, where you may expect the event in safety, for though there be no apparance of anni stir, yet I saye they shall receive a terrible blow this parliament and yet they shall not seie who hurts them this cowncel is not to be contemned because it may do yowe good and can do yowe no harme for the dangere is passed as soon as yowe have burnt the letter and i hope God will give yowe the grace to mak good use of it to whose holy proteccion i comend yowe.

Highly disturbed by the letter's content, Monteagle immediately rode to court, where he put it before Robert Cecil, James's Chief Intelligencer, Secretary of State and Lord Privy Seal. Cecil swiftly showed it to James, aware of the king's sixth sense for self-preservation. James's mother had been executed, his father had been murdered, and he had survived a major plot in Scotland. When he saw the letter, he ordered immediate action to be taken.

The letter was unsigned, but Catesby and Winter immediately suspected Monteagle's brother-in-law, Francis Tresham who, although recently brought into the plot, had never seemed fully reconciled to it, and had even tried to pay Catesby to abandon it. Catesby and Winter confronted him, but he denied any knowledge of the letter.

Once aware that Monteagle had shown the message around court, Fawkes visited the cellar under Parliament to verify if the gunpowder had been discovered, but was able to report back to the others that it was undisturbed, prompting Catesby to confirm that the mission was still on. As a final safeguard to make sure the plot was not revealed, on the evening of 4 November Percy went to dinner at Syon House with his cousin, the Earl of Northumberland. He heard no mention of any suspicions at court so, that night, Fawkes slipped into the cellar with a slow match and a watch, and waited.

The letter had, unsurprisingly, created a major stir at court, but Cecil did not want to move immediately, preferring to wait and catch the plotters in the act. As a precaution, the Lord Chamberlain swept the building unobtrusively and, while doing the rounds, he and Monteagle found 'John

Johnson' with a vast pile of firewood in the vaults. However, they moved on when he explained that the wood belonged to his master, Thomas Percy, one of the king's Gentleman Pensioners.

Once back at court, Monteagle mentioned that Percy was a Catholic, which spurred James into ordering a more thorough search, this time under the pretence of trying to find some hangings lost from the stores. And so, just after midnight on the morning of 5 November, a search party led by Sir Thomas Knyvett – a magistrate and gentleman of the Privy Chamber – went down to the vaults, where they spotted John Johnson leaving. Seeing him booted with spurs, they became suspicious and seized him. They then cleared away the firewood to discover 32 barrels and two hogsheads of gunpowder. All present knew the destructive power of that quantity of explosives. Not only would it completely destroy the entire building above, it would also toxify the air to such an extent it would suffocate any survivors.

James ordered bonfires to be lit all over London to celebrate his deliverance from the papist plot. Fawkes was meanwhile dragged off for interrogation, during which he remained doggedly silent, only giving Percy's name as the registered owner of the vault. He was good humoured, explaining in answer to questions about his recent trip to Flanders that he had gone 'to see the country and to pass away the time'. Tradition also says that when asked why he had so much gunpowder, he replied 'to blow you Scotch beggars back to your native mountains'.[12] He resisted questioning, and did not admit his real name until 7 November, when the interrogators found it on a letter in his pocket. Meanwhile, Catesby, Percy and Wright had ridden north to start the rising. They collected pistols and met up with the hunting party that was to seize Princess Elizabeth. However, when the gentry of the Midlands heard that events in Westminster had not gone according to plan, their enthusiasm for the coup dried up, and they returned to their homes.

Catesby and the remaining plotters tried to resuscitate zeal for a general rebellion but struggled, and by the evening of 7 November were holed up in Holbeach House in Staffordshire, pursued by the authorities. As the noose around them tightened, they prepared to make a last stand, but found their powder was damp. Without Fawkes's expertise in soldiering they were at a loss, and tried drying it before the house's open fire, resulting in severe injuries when it ignited. Until now Catesby had been certain God was smiling on his project. But, as he and his men lay injured, alone, having achieved nothing, he realised they had failed. By mid-morning on 8 November the

house was surrounded by the Sheriff of Worcestershire and his men. With little option, Catesby and his band resolved to fight to the death and, having no powder, drew their swords. They burst out of the front door, blades flashing in the sunlight, but were instantly gunned down. Percy and Catesby had emerged back-to-back, and were shot with a single musket ball which passed through them both.[13] Percy died instantly, while Catesby managed to crawl back into the house, where he died clutching an icon of the Virgin Mary. Thomas Winter was captured and dragged off to London.

Meanwhile, Fawkes's interrogators had learned little from him, as he had few details of the wider plan and Midlands uprising. James questioned him personally, then authorised torture. Fawkes's signatures on his two confessions – one weak and incomplete – evidence his physical deterioration after the application of the instruments.[14] Cecil discovered most of the information about the plot from Winter, who gave full details.[15] Others were also brought in for questioning, as the element that troubled Cecil most was how the plotters hoped to succeed without a leading nobleman to be the power behind Princess Elizabeth. Fawkes and Winter both said the question had been left for after the attack when it would be clear who remained alive, but Cecil felt sure they must already have such a leader. Edward Coke, the Attorney General, suspected Sir Walter Ralegh, but since he was languishing in the Tower he had an alibi. Cecil's chief suspect was the Earl of Northumberland, but no amount of questioning in the Tower for 15 years was able to prove him 'clere as the day, or darke as the night'.[16] With no further information to be extracted, the trial of the eight surviving plotters opened in Westminster Hall on 27 January 1606, with tickets for the public gallery changing hands at high prices. The prosecution was efficiently led by Coke, and the trial was over in a day with all men convicted.

A scaffold was swiftly erected in St Paul's Churchyard, where four of the plotters were hanged, drawn and quartered on 30 January. A second scaffold was put up in Westminster's Old Palace Yard, and the next day Robert Keyes, Ambrose Rookwood, Thomas Winter and Guy Fawkes were similarly executed. Once on the scaffold, Fawkes jumped to his death – or perhaps the rope broke – sparing him the full horror of partial hanging, castration, and having his entrails pulled out while he was alive.[17]

The following 5 November, James encouraged Londoners to celebrate the anniversary of his miraculous escape from death. Meanwhile, the government was widely publicising a narrative of England being specially blessed by God for its Protestantism. The nation had been delivered from

the papist tyranny of Bloody Mary by the virtuous Elizabeth I, before God's holy winds had then scattered the popish armada. And now, God had definitively delivered James from a papist plot of monstrous proportions. It was a rousing and patriotic tale, and the government even hurriedly brought out *The King's Book*, giving an account of how divine providence had enabled Catesby's devilish scheme to be foiled.[18] It was now beyond question that the country was specially blessed by heaven.

England has continued to remember the date of the peril and the deliverance. From the time of the first anniversary to 1859, 'Gunpowder Sermons' were a pillar of the Church of England's 5 November liturgy. Annual bonfires became popular in the 1630s when there were concerns that Charles I's court was drifting back towards Catholicism, and this was underlined in a 1644 sermon to the House of Commons which warned that, as the MPs sat listening, papists were tunnelling 'from Oxford, Rome, Hell, to Westminster'.[19] From the 1650s fireworks were introduced, and in 1673, after the future James II had converted to Catholicism, London's apprentices burned the first effigy on the day: a Whore of Babylon in papal regalia. In 1688, when William of Orange landed at Torbay on 5 November to deliver England from James II, the date assumed an almost mystical significance. Just over a hundred years later, by 1790, the day returned to its roots, and burning effigies of Guy Fawkes became a mainstay of the annual celebrations.

James had survived the most serious assassination attempt of his reign. But the affair had again highlighted the severity of the religious tensions in the country, and James did little to heal them. Catesby's plot, had it succeeded, would have been the bloodiest act of terrorism on British soil in history, eviscerating the entire apparatus of government. What remains speculation is whether, had the king and court been murdered, Princess Elizabeth would have become a puppet, and whether the events would have had any impact on the country's religion. It is conceivable that it may have brought forward the civil war that was to come 37 years later, or even that Parliament may have remained in ruins – a historical memory – defunct like so many similar assemblies on the continent which monarchs had shut down as medieval relics. What is sure, though, is that had the plot succeeded, it would have changed Britain's history more abruptly and significantly than any other single event in the seventeenth century.

21

Monarchists and Regicides – The Uncivil War

The High Court of Parliament
Death Warrant of King Charles I
1649

With the accession of James I, the Tudor dynasty gave way to the Stuarts, and all Britain had just one ruler. The kingdoms' three crowns were distinct – England and Wales, Scotland and Ireland would not be legally united until 1707 and 1801 – but James was nevertheless the first monarch to fulfil Edward I's dream and rule over the British Isles.

The Stuarts had originated as the Stewarts in eleventh-century Brittany and, after a spell in England, rose to prominence in Scotland, taking the throne by marriage in 1371. Later, when the five-year-old Mary Stewart Queen of Scots moved to France as the betrothed of the future Francis II, the French struggled to pronounce the 'w' in her name, so she altered its spelling to Steuart or Stuart. Sixteenth- and seventeenth-century spelling was erratic, but modern practice is to spell it Stuart from the reign of her son James VI and I onwards.

Mary had been the belle of the French court: tall and beautiful with red-gold hair. She was clever, skilled at hunting, an accomplished and witty conversationalist and an even better dancer. Her son, however, inherited none of her charms or gifts. James wore his clothes until they fell off and 'was naturally of a timerous difposition . . . His eyes large, ever rowling . . .

his beard was very thin; his tongue too large for his mouth . . . hee never waſht his hands, only rub'd his fingers ends ſleightly with the wet end of a Naptkin, his legs were very weak . . . that weakneſſe made him ever leaning on other mens ſhoulders, his walke was ever circular, his fingers ever in that walke fidling about his codpiece.'[1]

Elizabeth I had focused her energies on projecting the power and influence of the English court nationally and internationally. By contrast, James was more interested in himself and pleasure-seeking, spending his evenings drinking and carousing. Although his marriage to Anne of Denmark was happy and produced seven children, he was also a serial philanderer with an eye for athletic and polished young courtiers. The most famous of his conquests was the initially obscure George Villiers, whose uncommonly good looks and charm were even remarked upon by seasoned ambassadors in their dispatches. James showered Villiers with titles – viscount, earl, marquess – before finally making him the Duke of Buckingham. It was a meteoric rise – duke was the highest title in the land after the monarch – and understood by all to be the reward for his intimacy with the king. This was gossip even in Paris, where a popular offensive rhyme noted that King Elizabeth who trounced the Spanish had been succeeded by Queen James.[2] The French poet and dramatist Théophile de Viau was even more direct in a poem in praise of same-sex love in which he listed famous couples and used a four-letter description for James's activities with Buckingham.[3]

The divided country James inherited from Elizabeth was not only split between Catholics and Protestants. The new Church of England was equally riven with factions jostling for control, dividing broadly into quasi-Catholic groups promoting bishops and tradition on the one side, and more reformist and anti-hierarchical Puritan elements on the other. To try and hold them together in one church, James convened a church conference at Hampton Court early in his reign in January 1604. Although he had been brought up Calvinist, James was alarmed by the Puritans' call to dismantle the church's hierarchy and do away with the episcopate. 'No bishop, no king', he firmly opined during the debate, keenly aware that the history and legitimacy of the monarchy was intimately intertwined with the infrastructure of the church.[4] He sat in on the conference and enjoyed the theological to and fro, participating fully, castigating both sides equally, and memorably exclaiming 'A turd for the argument!' when the Puritan bishop of Peterborough suggested baptism could be valid if performed with sand.[5]

Disappointingly for the participants, despite the wide-ranging debates, the conference resolved little of significance. However, one concrete legacy was the Puritans' request for a new Bible, as Tyndale's Bible, the Great Bible, the Geneva Bible used by Shakespeare and the Pilgrim Fathers, and the Bishops' Bible with its memorable 'Lay thy bread upon wet faces', all had problems and vocal critics. The Puritans had not gained much at the conference, so hoped to salvage something by obtaining a fresh Bible that might promote their reformed theology more fully. James was keen on the idea as he was an avid translator himself, having personally translated the Book of Psalms three years earlier.

Bible translation was highly sensitive work theologically. As discussed in Chapter 8, translations of Scripture had appeared in Old and Middle English, as they had in medieval French, Spanish, German, Italian, and many other languages. In England, tensions around translation had not arisen until the late 1300s, when John Wyclif, leader of the reformist Lollards, published a Middle English Bible and was condemned for heresy. A century and a half later, in the early 1520s and 1530s, the Protestant scholar William Tyndale similarly published English versions of the New Testament and half the Old Testament, and was likewise condemned. The reason for the condemnations was not that the texts were in English – in the language of the ploughboy, as Tyndale evocatively put it – but that they were not approved translations. Thomas Arundel, archbishop of Canterbury, had spelled this out clearly in 1409, ruling that Scripture in English was fine, but only if it went through a proper validation process. The underlying sensitivity he was seeking to address was that choices made by translators were becoming ideological battlegrounds. For instance, Tyndale preferred to translate *presbyterus* as 'senior' rather than 'priest' and *ecclesia* as 'congregation' rather than 'church', which – quite intentionally – opened up questions about the Church's sacrament of holy orders and its hierarchy of bishops and priests.[6] With the advent of the Reformation, the words of the Bible had become a war zone between Protestants and Catholics, and translators were the battle's commanders.

For James's new Bible, the day-to-day work of translation was entrusted to 54 scholars organised into six companies: two at each of Oxford, Cambridge and Westminster.[7] Among them were the country's most accomplished linguists, philologists and theologians, some of whom were highly colourful characters. Richard 'Dutch' Thomson, for instance, was a gifted philologist who was reported by one contemporary never to have gone to

bed sober, and who was simultaneously working on an edition of the noto-
riously filthy epigrams of Martial.[8]

Seven years after the Hampton Court Conference, the result of all the
translating was unveiled in the new King James Bible or Authorised Version
of 1611. It was a masterpiece of delicate compromises, free of the explana-
tory marginal notes that had proved so inflammatory in previous Bibles. In
devising the texts, the scholars had not started from scratch, but taken exist-
ing translations as inspiration, borrowing most heavily from Tyndale's Bible,
which provided 75.8 per cent of its Old Testament and 84 per cent of its
New Testament.[9] While drawing heavily on Tyndale's language, the new
Bible did not – to the disappointment of the Puritans – incorporate Tyndale's
more overt Protestantism. What it did capture, though, was a pleasing sense
of archaism. Tyndale had been writing in the 1520s, and his recycled phrases
gave the King James Bible a reassuringly old-fashioned feel, as did signifi-
cant borrowings from the Catholic Douai-Rheims Bible, with its weightier
language and more traditional theology. The result was a largely conserva-
tive Bible expressed in timeless-sounding language. The compilers also had
an ear for literary merit, and filled it with vivid phrases, bringing the text to
life with melodious new images in Tudor and Jacobean English. Despite
some printing errors in its early days – including the Wicked Bible of 1631
which omitted the 'not' in 'Thou shalt not commit adultery' – the King
James Bible has remained the most popular Bible of all time.

James took no part in translating or writing the Bible that bore his name
but, unusually for a British monarch, genuinely enjoyed writing and shar-
ing his views with readers. After publishing *Dæmonologie* in 1597 to warn
his subjects of the scourge of witches, his concerns moved on and, by 1604,
the thing making him most anxious was tobacco. He dutifully composed *A
Counterblaste to Tobacco* in the hope of convincing the country to extinguish
its pipes. However, despite the force and colour of his language, which
condemned smoking as 'a cuſtome lothſome to the eye, hatefull to the Noſe,
harmefull to the braine, dangerous to the Lungs, and in the blacke ſtinking
fume thereof, neereſt reſembling the horrible Stigian ſmoke of the pit that is
bottomeleſſe', his pleas had little effect on the nation's puffing.[10]

Two other legacies of James's reign were a new Banqueting House for
Whitehall Palace, which he commissioned in classical, continental style
from the London architect and theatre designer Inigo Jones, and the British
flag, in which the existing red-on-white St George's cross of England was
combined with the white-on-blue St Andrew's saltire cross of Scotland.

(Almost two centuries later, in 1801, around the time of the union with Ireland, the red-on-white St Patrick's saltire cross of Ireland would be added to create the modern flag.) In James's day it was called the Union Flag, but over the centuries it has had many names, including the Britain and the King's Jack. One of its most popular names is the Union Jack, which has been in use since at least Charles II's day. A possible etymology of 'Jack' is that it derives from James himself, as Jack is the familiar form of James from the Latin *Jacobus*. Another possibility is that it takes its name from the jack or small flag flown on the bows of English warships. For instance, contemporary records of the English fleet that engaged the Spanish Armada two decades before the Union Jack was invented describe the vessels flying small St George's cross flags on their bowsprits.[11] The notion that the name Union Jack can only be used when the flag is flown at sea has no basis. Today, both Union Jack and Union Flag are correct in all circumstances.[12]

Unlike his immediate Tudor predecessors, James's succession was secure, and everyone predicted a glittering future for his first-born, Henry Frederick. But, aged 18, just as he was maturing into his role as Prince of Wales, Henry quite unexpectedly died of typhoid. In his place, his shy, stammering, studious, five-foot-four-inch younger brother became heir to the throne and, on James's death, was crowned Charles I at the age of 24.

The key lesson Charles had learned from the Tudors and his father was that kings ruled by the grace of God alone, and that no one, and no group, had the right to stand in the way of the king's will. This was a more extreme position than medieval kings of England had advocated, as they could only rule effectively with the consent and cooperation of their barons, and eventually Parliament. By contrast, James and Charles – along with an increasing number of monarchs in Europe – saw themselves as divinely mandated to rule autonomously, answerable only to God. This absolutism drew Charles into a series of standoffs with Parliament, which he expected simply to accept and fund his various policies. Parliament, on the other hand, saw its responsibility as reining in royal spending, particularly the expensive and disastrous military expeditions of the Duke of Buckingham, who had deftly transformed himself from James's favourite lover into Charles's most trusted adviser. As time went on, however, Buckingham proved increasingly incompetent and self-important, with ill-thought-out policies and advice that fatally damaged Charles's reputation in Parliament and the country.

The antagonism between Charles and Parliament was further aggravated by friction over religion. Although Charles was the first king of England to

have been brought up as a member of the Church of England, he identified strongly with its traditional quasi-Catholic wing, was married to the staunchly Catholic Henrietta Maria of France, and even welcomed an Italian cardinal as papal nuncio to his court. In contrast, Parliament was predominantly Puritan, and suspicious of what it viewed as Charles's flirtations with popery.

These sustained tensions between Charles and Parliament developed into a tense, combustible and dangerous conflict, but Charles felt it his duty to remain firm and drew support from Henrietta Maria, who came from the even more absolutist French monarchy. When Parliament proved intransigent, Charles sensed he had no other choice and demonstrated his authority by shutting Parliament down. The first session he dissolved was the Useless Parliament of 1625 which was refusing to fund a proposed war with Spain, and which – after Henrietta Maria appeared in London with a retinue of Catholic priests – feared the country's penal laws against Catholics would be relaxed. Charles followed this by dissolving the second Parliament of his reign in 1626 for threatening to impeach the Duke of Buckingham. He then imposed taxes without Parliament's involvement, before calling a third Parliament in 1628 but dissolving it in 1629, incensed by its inflexibility and blaming it for the murder of the Duke of Buckingham on 23 August the previous year. Before being closed down, however, Parliament had won a significant concession by forcing Charles to sign the Petition of Right, in which the lawyer Sir Edward Coke had resurrected Magna Carta from obscurity to set out restrictions on the royal prerogative.

With Parliament closed again, Charles elected to rule without it, and succeeded in governing alone for the next 11 years. It proved a happy period for him. His court was alive with masques and entertainments. He patronised artists like Van Dyck, had Rubens paint the ceiling of the Banqueting House built by his father, and ran the court and country the way he wanted. Behind the scenes, though, his swingeing taxes and lavish spending were sowing ever-deeper resentments. This period of personal rule came to an abrupt end in 1640, when Charles suddenly found himself urgently in need of significant finance after his failed attempt to impose Anglicanism on Scotland had triggered the Bishops' Wars. He therefore recalled Parliament but, in the face of renewed non-cooperation, dissolved it again just three weeks later, for which reason it was named the Short Parliament. Still desperate for money, he recalled Parliament six months later, but this time it sat for the next 20 years in various forms, becoming the Long Parliament.

The cumulative effect of these fractious convenings and dissolutions was a chaos of allegiances and profound animosity between Parliament and the king. Most painfully for Charles, at the behest of John Pym, Parliament condemned to death one of his leading advisers and friends, Lord Strafford, and forced Charles to sign the death warrant. The act would haunt Charles for the rest of his life, and he never reconciled himself to it.

As the enmity between the two sides hardened, on 1 December 1641 Parliament presented Charles with a Grand Remonstrance of 204 demands and complaints, including a request that all bishops be expelled from Parliament. Charles viewed the demands as an attack on him and his church and, in response, on 4 January 1642, entered Parliament with an armed guard to seek and arrest Pym and four other MPs he believed responsible. To his dismay, the five had fled, and the Speaker refused to give up their whereabouts.

The ensuing hair-trigger standoff came to a head in March. England had no permanent army, and only the king could raise militias, known as trained bands or trainbands. Notwithstanding this long-settled principle, Pym passed a vote in Parliament empowering it to direct the Lord Lieutenant of each county to raise militias for Parliament. When Charles refused to give the bill his royal assent, Pym, quite unconstitutionally, declared the Militia 'Ordinance' to be nonetheless valid law. Suspicious of Pym's motives in raising an army, Charles issued equally unconstitutional medieval Commissions of Array appointing representatives in each county to raise Royalist militias.[13] Both sides now had access to armed forces and, with Parliament continuing to demand that Charles rule through them, Charles decided to defend his honour and the church. On 22 August 1642, he raised his standard at Nottingham and set up a new capital at Oxford. Parliament likewise raised forces and began what is oddly called the First Civil War, as there had been many in the previous centuries including the Anarchy, the wars of Henry II and his sons, the First and Second Barons' Wars, and the Wars of the Roses.

As recreated in hundreds of re-enactment pageants every year, the two sides could not have provided a starker tribal contrast. The Parliamentarians were plainly and soberly dressed in dark colours, and nicknamed Roundheads after their severe, close-cropped hairstyles. In contrast, the Royalist forces of mounted Cavaliers wore luxuriously long wigs, jewellery, and expensive, colourful fabrics in an open celebration of proto-dandyism.

After preliminary skirmishes, the first major military engagement came at Edgehill in Warwickshire on 23 October 1642. Charles's forces were

commanded by his nephew, Prince Rupert of the Rhine Duke of Cumberland, who – at only 22 years old – was already a respected veteran of the continental Thirty Years War, and had routed Parliamentary forces at Powick Bridge a month earlier. Despite an initial Royalist advantage, the encounter ended in stalemate. But the advantage was with Charles, for whom the road to London now lay open. If he had seized the moment and marched south, there is every chance he could have taken it and the war could have been over. But he chose against an attack on the capital, missed the opportunity, and instead went on to make gains in the north before, on 20 November 1643, the two sides met again at Newbury. After an opening day with no victor, Charles withdrew against the advice of his commanders and lost a key opportunity to inflict heavy casualties on Parliament. It was a bad mistake, and a turning point.

The next key encounter – the largest of the First Civil War – was fought on 2 July 1644 on Yorkshire's Marston Moor. A relatively unknown colonel named Oliver Cromwell and his hand-picked 'Ironsides' surprised Prince Rupert after the battle was assumed to be over by attacking a second time from behind, crushing the unprepared Royalists and opening up the north for Parliament. York soon capitulated, and the final major encounter – which turned out to be the war's decisive battle – was fought on 14 June 1645 at Naseby in Northamptonshire. By now Cromwell had recruited and trained his own force – the New Model Army – which fought across the country rather than locally, and was bonded by firm Puritan faith and rigid discipline. Facing Prince Rupert of the Rhine again, Cromwell inflicted a punishing defeat that finished Charles's chances and captured the royal baggage train. Its contents – including overtures to Catholic countries for help – were soon made public, winning more support for Parliament. The First Civil War was over, and on 5 May 1646 at Newark Charles surrendered to the Scots, who sold him to Parliament for £400,000.[14] Flushed with victory, Cromwell and senior Parliamentarians turned their energies to reinstating Charles on the throne, but with severely curtailed powers.

Many of Charles's senior commanders left the country in defeat. Prince Rupert was banished, but it turned out to be a temporary low point in a long and spectacular career. He reinvented himself as a naval commander, harassing Parliamentary shipping, and eventually returned to England under Charles II, when he was sworn in as a Privy Counsellor, commanded naval vessels in the Anglo-Dutch wars, became the first Governor of the Hudson Bay Company, was a founder member of the Royal Society, and

became the country's first mezzotint print artist, inventing important technical steps in the process.[15]

With Charles I in Parliamentary captivity, the New Model Army began to be influenced by a republican movement nicknamed the Levellers which demanded electoral reforms and that all men should have the vote. This generated tensions and, in October 1647, a wide-ranging debate between factions of the New Model Army and the Levellers took place at Putney.[16] Cromwell, who was in the chair, found himself pulled in multiple directions but, fortunately for him, Charles briefly escaped from Hampton Court Palace, allowing the debate to be called off so the king could be hunted down. Charles fled to the Isle of Wight, where he was almost immediately taken prisoner by the island's Governor. Meanwhile, Parliament continued its efforts to develop a framework for effective sharing of power between the king and Parliament. Charles, however, showed no interest in compromising his view that he was not accountable to any authority except God, and his intransigence would prove disastrous.

In early 1648 Charles's supporters rallied, and – together with forces from Scotland – recommenced hostilities against Parliament. This Second Civil War changed nothing militarily, and ended with a crushing Parliamentary victory at Preston between 17 and 19 August 1648. What had changed, though, was that to many in the New Model Army and Parliament, Charles was now – in a biblical phrase they adopted – a 'man of blood'. In their view God had demonstrated the superiority of Parliament and Puritanism in the First Civil War, so Charles was solely responsible for the bloodshed of the unnecessary Second. In this climate of recrimination the Levellers began to call openly for the king's execution. The New Model Army – which resented the losses it had suffered in the Second Civil War – increasingly agreed. Cromwell vacillated, but eventually sided with the army, and threw his whole-hearted support behind the demand for retribution.

As the clamour for action against Charles grew stronger, one unit within the New Model Army staged a military *coup d'état*. On 6 December 1648 Colonel Thomas Pride deployed a detachment of soldiers to Parliament, where they arrested 45 MPs and turned another 186 away from the building's entrance. Unwilling to be part of what was to follow, 86 of the remaining MPs withdrew of their own accord, leaving a hard core of some 200 MPs intent on punishing Charles. On 6 January 1649 this Rump Parliament passed a measure establishing a court of 159 judges to try Charles for treason, with Cromwell and Pride among them.

The trial opened on 20 January 1649 in Westminster Hall, where Guy Fawkes had been tried 43 years earlier for plotting to murder the royal family. Charles was accused of treason and of having used power for his own personal good and not that of England.[17] The atmosphere was febrile and dangerous. Even the Lord President of the court – an obscure judge named John Bradshaw – wore armour under his scarlet robes for the occasion and lined his velvet-draped beaver hat with bulletproof steel plates.[18] For three days Charles refused to acknowledge Parliament's jurisdiction to try a king and did not enter a plea, instead informing the court that the travesty of justice was all the country could expect from this 'fraction of a Parliament'. Bradshaw had no good answers, and many of his fellow judges slipped quietly away. When the trial eventually concluded with a guilty verdict, Bradshaw – entirely out of his depth – refused Charles the right to speak. More judges melted away. Of the original 159, only 59 appeared on 29 January to sign Charles's death warrant. Bradshaw signed, as did Pride and Cromwell, who was jovial, playfully flicking ink at the other signatories.[19] The death warrant is still preserved in the House of Lords archives.

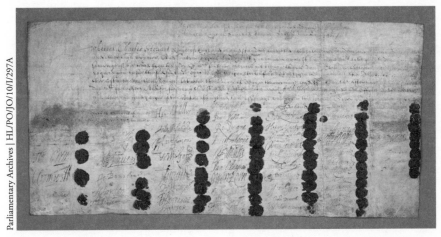

Parliamentary Archives | HL/PO/JO/10/1/297A

The High Court of Parliament, Death Warrant of King Charles I (1649)

At the high Court of Justice for the tryinge and judginge of Charles Steuart Kinge of England January xxixth Anno Domini 1648.

Whereas Charles Steuart Kinge of England is and standeth convicted attaynted and condemned of High Treason and other high Crymes, And sentence uppon Saturday last was pronounced against him by this Court

to be putt to death by the severinge of his head from his body Of which sentence execucion yet remayneth to be done, These are therefore to will and require you to see the said sentence executed In the open Streete before Whitehall uppon the morrowe being the Thirtieth day of this instante moneth of January betweene the houres of Tenn in the morninge and Five in the afternoone of the same day with full effect And for soe doing this shall be your sufficient warrant And these are to require All Officers and Souldiers and other the good people of this Nation of England to be assistinge unto you in this service Given under our hands and Seales

To Colonell Francis Hacker, Colonell Huncks Har. Waller Hen. Smyth A. Garland Symon Mayne Tho. Wogan and Lieutenant Colonell Phayre and to every of them.

• Har. Waller • Hen. Smyth •A. Garland • Symon Mayne • Tho. Wogan • John Blakiston • Per. Pelham • Edm. Ludlowe • Tho. Horton • John Venn • M. Livesey • J. Hutchinson • Ri. Deane • Henry Marten • J. Jones • Gregory Clement • Jo. Bradshawe • John Okey • Willi. Goff • Robert Tichborne • Vinct. Potter • John Moore • Jo. Downes • Tho. Grey • J. Danvers • Tho. Pride • H. Edwardes • Wm. Constable • Gilbt. Millington •.Tho. Wayte • O. Cromwell • Jo. Bourchier • Pe. Temple • Daniel Blagrave • Rich. Ingoldesby • G. Fleetwood • Tho. Scot • Edw. Whalley • H. Ireton • T. Harrison • Owen Rowe • Willi. Cawley • J. Alured • Jo. Carew • Tho. Mauleverer • J. Hewson • Willm. Purefoy • Jo. Barkstead • Robt. Lilburne • Miles Corbet • Ad. Scrope • Isaa. Ewer • Will. Say • James Temple • John Dixwell • Anth. Stapley • Valentine Wauton • Greg. Norton • Tho Challoner

The following day, 30 January 1649, Charles dressed in two shirts in case he shivered from the cold and the trembling was mistaken for fear. He put his favourite large gold and pearl drop earring in his left ear, ate some morsels of bread, drank a small glass of claret, and headed to the place of execution.

The crowds – including a 15-year-old Samuel Pepys – stretched all along Whitehall down to Charing Cross. Charles walked into the Banqueting House, under the spectacular ceiling Rubens had painted there for him, then out of a hole freshly cut into the wall and onto the black-draped

scaffold where the block and masked axeman were waiting. Charles smiled at the metal hoops and ropes sunk into the floor in case he needed to be restrained, but laid his head voluntarily on the block. When he was ready, he raised his arms, and the axeman struck his head off in one blow.

It was over.

For the first time in England's history, the people had slain their king: a shocking fact, still memorialised in the public conscience in the countless King's Head pubs around the country. The Rump Parliament then legislated to abolish the monarchy and House of Lords, and pronounced Britain to be a republic, commonwealth and free state.

22

Religious Dictatorship –
King Cromwell and his Saints

Margaret Cavendish Lady Newcastle
A Lady Drest by Youth
1653

Margaret Lucas was 19 years old when the First Civil War erupted across the country. She knew what side she was on, and immediately moved from her family home near Colchester to Oxford, hoping to find a position at Charles I's new court and headquarters. She was successful, and within the year was a lady in waiting to Queen Henrietta Maria, whom she accompanied to France in 1644. In Paris, she met William Cavendish Marquess of Newcastle upon Tyne, who had been one of Charles's key Cavalier commanders at Marston Moor. Although he was 30 years her senior, they fell in love, were married, moved to Rotterdam, then set up home in Antwerp in a house owned by Rubens.

In 1651, two years after Charles's execution, Margaret – now Margaret Cavendish Marchioness of Newcastle upon Tyne – returned to republican England, where Parliament's Sequestration Committee had confiscated her husband's lands along with the property of other leading Royalists. Parliament did, though, invite the dispossessed owners to buy their assets back – at huge cost – so one of the reasons Margaret was in England was to petition the Committee for Compounding for their return.

In the four years since the end of the monarchy, England had been run by Cromwell and the New Model Army as a military dictatorship. Their policies were firmly Puritan, with Parliament regulating everything it deemed at odds with the ideal Christian society. Theatres – including the Globe – were demolished. Ale house doors were barred. Dancing was curtailed. Church choirs were disbanded and music was banned in church. Swearing was punishable with fines. Leisure activities, including walking or knitting, were forbidden on Sundays. All social celebrations were cancelled at Easter and Christmas, which were to be spent in Bible study. Adultery was made a capital offence. A bill was even introduced against the vice of women painting their faces, wearing black beauty patches, or going about in immodest dresses, although it proved a step too far for most MPs, and failed to pass.[1]

On Charles I's execution in 1649 his 18-year-old son, Charles, immediately inherited the crowns of Scotland and Ireland, which Cromwell had no power to prevent. The young Charles had been commanding Royalist troops from the age of 14, and – now keen to take back the English throne – led Scottish and Irish forces in the Third Civil War from 1649 to 1651. However, his hastily assembled men proved no match for Cromwell's and, after being defeated at Dunbar and Worcester, he went on the run, famously hiding from the New Model Army up an oak tree at Boscobel in Shropshire, before escaping into exile across the Channel. Once in France, he moved into the Louvre Palace, but struggled financially and to find purpose, instead gaining a reputation for idleness and romantic liaisons with English women hanging around his court-in-exile. He moved to Cologne for a period, then settled in Bruges in the Spanish Netherlands. He had not, however, forgotten about England, and maintained active contact with English Royalists through the clandestine Sealed Knott network.[2]

In England, Cromwell's rule was factional and inexperienced. He was a stranger to the inner workings of high governmental circles, having been born into a family of brewers descended from the sister of Henry VIII's Chief Minister, Thomas Cromwell, a relationship which had enriched his family from lands and assets Thomas Cromwell seized from the monasteries. Cromwell spent just over a year at Sidney Sussex College Cambridge, before leaving at 18 on the death of his father to care for his mother and seven unmarried sisters. His first, tentative foray into politics was not successful. He sat as MP in the 1628 Parliament, but made no impact and became unwell, quite possibly suffering a breakdown from which he emerged reborn into the light of Puritanism. When Parliament closed for

11 years he moved to St Ives in Cambridgeshire, where he lived as a yeoman farmer. He contemplated moving to the Puritan colonies in the New World, but in 1613 an uncle died leaving him a fortune, which changed his life, giving him financial stability. At the same time, his religious journey evolved with equal drama and, by 1639, at the age of 40, he was – if largely obscure – a wealthy, radical Puritan.

The next phase of Cromwell's life began in 1640, when he was returned to the Short and Long Parliaments as MP for Cambridge, and threw himself into Westminster life, sitting on over a dozen committees. A contemporary described him as wearing a plain cloth suit and linen shirt with bloodstains on the collar, suggesting that he shaved himself, inexpertly. His early speeches were fervent, but he made fewer once it became clear he had neither the subtlety nor the patience needed for high politics. Instead, it would turn out to be the military where he shone, with his first experience coming in August 1642 when he was sent to prevent Royalists taking possession of silver plate donated to Charles's cause by Cambridge colleges. Cromwell rode to the university city with a force of 200 men, and was successful in the operation. The experience affected him profoundly, when he found that the command of soldiers came naturally, and his fervour to do God's work – which had held him back in the corridors of Parliament – was perfectly suited to leading troops. By October he was part of the Earl of Essex's forces, and present at the final stages of the Battle of Edgehill.

Cromwell's rise in the military was then meteoric. By February the following year he was a colonel and, within 17 months – by the time of the crushing Parliamentary victory at Marston Moor on 2 July 1644 – he had been appointed Lieutenant General of Horse in command of Parliament's left wing. The success he won there catapulted him into the public eye and earned him the nickname 'Ironside', which was soon applied to his troops. All the while, religion was central to his mission. 'God made them as stubble to our swords', he reflected on the battle in a letter to a father who lost a son, reassuring him that 'the Lord tooke him into the happinesse wee all pant after, and live for. There is your precious child, full of glory, to know sinn nor sorrow any more.'[3] This war, for Cromwell, was God's war, and what he had been born for. In time, he would see himself as the new Gideon – the farmer whom Yahweh chose to lead the Israelites against the Midianites – and the Bible would become a highly personal channel through which God miraculously revealed to him his secret destiny as a soldier in the heavenly army.

Cromwell, the Levellers, and factions within the New Model Army had all urged the execution of Charles I as a 'man of blood', but ultimately it is Cromwell whom history remembers for biblical levels of bloodshed, most notably in the Irish campaign he departed for in the autumn after Charles's execution. Although aiming to punish the participants in a recent rebellion alongside those who had supported Charles, Cromwell saw himself as part of a divine Puritan plan. On arrival he gave the Irish a stark warning: 'You are a part of Anti-Christ, whose Kingdom the Scripture so expressly speaks should be "laid in blood"; yea, "in the blood of the Saints". You have shed great store of that already:— and ere it be long you must all of you have "blood to drink"; "even the dregs of the cup of the fury and the wrath of God, which will be poured out unto you!" '[4] The wholesale butchery he then unleashed remains notorious, as does his observation afterwards that the slaughter had been a 'righteous judgment of God upon these barbarous wretches'.[5] Most infamously, at Drogheda his troops killed around 3,000 in the heat of battle and afterwards in the cold-blooded executions of surrendered soldiers, civilians and clergy, while at Wexford the number was perhaps 2,000, with a higher proportion of civilians.[6] To neutralise the possibility of further Irish revolts or hostility, Cromwell then shipped boatloads of peasants and the intelligentsia to the Caribbean as slaves and indentured servants. By 1655 around 12,000 had been forcibly deported with the loss of their freedom.[7] For understandable reasons, Cromwell has few fans in Ireland.

The instrument of Cromwell's overwhelming military successes had been born in 1645 when Parliament's forces were performing less well than those of Charles, prompting a decision to reorganise the Roundhead troops. Among the key problems was that many peers – like the Earls of Essex and Manchester – were entitled to military commands, but either had Royalist sympathies or lacked experience in soldiering. To address this, on 3 April 1645 Parliament passed the Self-Denying Ordinance stripping all lords and MPs of military commands to remove them from the military chain of command. Parliament nevertheless made an exception for Cromwell, who was permitted to remain an MP and military commander. The main reform, though, to Parliament's forces was to reorganise the mosaic of regional militias into a national resource – the New Model Army – under Thomas Fairfax, with Cromwell as second-in-command. This new force was built around Cromwell's Ironsides, and chose its officers on talent rather than ancestry and wealth. It was welded together with discipline, demanding of its men unshakeable Puritan faith and strict morals. These were rigidly

enforced. Any soldier caught swearing had a hole bored through his tongue with a red-hot iron spike.[8]

The New Model Army was England's first standing army, and was answerable to Parliament rather than individual local commanders. It was also the first English army to adopt a uniform of red coats, chosen because Venetian red dye was among the cheapest available. Its most significant legacy, though, lay in its record of overwhelming success. It took control of the whole country in a short space of time, dominating the battlefields of England, Ireland and Scotland and, most famously, orchestrated a *coup d'état*, arranged the execution of the king, and established a military dictatorship.[9]

Once the Commonwealth was inaugurated with Cromwell in charge, he soon found – as had Charles I – that Parliament did not always cooperate. Cromwell wanted more radical religious legislation, but Parliament was wary of the power of the New Model Army and began frustrating his plans with delays. In a rage, Cromwell marched into Parliament on 20 April 1653 with soldiers – as Charles I had done – but went further, and dismissed the Rump. His colourful and lengthy speech to MPs is often quoted. 'Ye are a pack of mercenary wretches, and would, like Esau, sell your country for a mess of pottage and, like Judas, betray your God for a few pieces of money.' He berated them at length, then commanded 'In the name of God, Go!' Unfortunately, there is no contemporary transcript of this speech, and it is probably a later invention. However, Bulstrode Whitelocke, who was an MP in the chamber at the time, confirmed that Cromwell had declared 'they had sate long enough . . . That some of them were Whoremasters . . . That others of them were Drunkards . . .' before 'He bid one of his Soldiers to take away that fools bable, the Mace.' Finally, 'he stayed himself to see all the Members out of the House, himself the last of them, and then caused the doors of the House to be shut up.'[10]

With Parliament closed, as it had been so often in Charles's day, Cromwell wielded power through the Council of State, which was effectively the New Model Army. Based on a suggestion from millenarians within the Army that England needed a Jewish-style sanhedrin to welcome the second coming of Christ, Cromwell summoned a Parliament of Saints, also known as the Barebones Parliament after one of its more excitable members, Praisegod Barebone. The MPs in this Parliament were not elected but, in a totalitarian act, handpicked by Cromwell and the army for their religious fervour. Once assembled, however, they quickly fell into factionalism, and Parliament dissolved in chaos in just five months.

After four years, the Commonwealth ended in abject failure, paralysed and destabilised by religious and ideological divisions. A new system was needed and, four days later, Cromwell was sworn in as Lord Protector for life, now addressed as 'Your Highness', and adopting the signature 'Oliver P' in imitation of monarchs who signed an 'R' after their name for *rex* or *regina*. In case there was any doubt of his new status, he permitted his daughters to style themselves 'Princess'.

That year, 1653, Margaret Cavendish was still waiting for a decision from the Committee for Compounding on her husband's lands. But instead of spending her days in society pursuits to fill the time, she did something highly unusual for a seventeenth-century Englishwoman, and particularly for one living in Puritan England. She published a book. And it was not just any book. Unlike most authors of the interregnum she did not write to extol the virtues of a Puritan lifestyle or to castigate the ungodly. Instead, she published a collection of poetry and essays.[11]

In *Poems and Fancies*, Cavendish mainly tackled natural philosophy and metaphysics, questioning the building blocks of life and matter. The first hundred poems are largely about the role and behaviour of the elements, matter and light, with a specific focus on how atoms animate them. Her vitalist views were well thought through and earned her, some years later, the first invitation for a woman to attend scientific experiments at the Royal Society. She took up the offer and, after watching experiments performed by Robert Boyle and Robert Hooke, impressed the gathering with her scientific observations.[12] Other sections of *Poems and Fancies* address more human concerns such as mind and body, joy, laughter, wit, love, beauty, ambition, pride, poverty, the natural world, animals, and even an animal parliament. Some of it is light, in stark contrast to weighty Puritan works like *Paradise Lost* which Milton composed in the same decade.[13] Cavendish was, in reality, wholly out of step with the times, not only for her scientific and literary interests, but also because she revelled in eccentricity, dressing outlandishly, sometimes as a man, flirting prodigiously and swearing liberally. She was as Cavalier as they came. Her poem 'A Lady Drest by Youth' from *Poems and Fancies* shows a sense of exuberance and pleasure that could not have been more ideologically dissident in an austere Roundhead society. It was also dangerously foreign: the 'brall' in the last line being a fashionable dance step and dance from the Catholic French court, similar to a cotillon. Cavendish was challenging contemporaries, writing of an England that had vanished.

© British Library Board. All Rights Reserved

A Lady *dreſt by* Youth.

3 *Maſque*. **H**ER *Haire* was curles of *Pleaſures*, and *Delight*,
 Which through her *skin* did caſt a *glimmering Light*.
 As *Lace*, her *baſhfull Eye-lids* downwards hung,
* *As a* Veile. A *Modeſt Countenance* * over her *Face* was flung.
 Bluſhes, as *Corall Beades* ſhe ſtrung, to weare,
 About her *Neck*, and *Pendants* for each *Eare*.
 Her *Gowne* was by *Proportion* cut, and made,
 With *Veines Imbroydered*, with *Complexion* laid.
 Light *words* with *Ribbons* of *Chaſt Thoughts* up ties,
 And looſe *Behaviour*, which through *errours* flies.
 Rich Jewels of bright *Honour* ſhe did weare,
 By *Noble Actions* plac'd were every where.
 Thus dreſt, to *Fames* great *Court* ſtrait waies ſhe went,
 There danc'd a *Brall* with *Youth*, *Love*, *Mirth*, *Content*.

Margaret Cavendish Lady Newcastle, A Lady Drest by Youth (1653)

After the book's release, Cavendish returned to Antwerp, where she continued to write and publish, her subjects widening to encompass relationships, sex, and equal opportunities for women.

Cromwell's regime, on the other hand, became increasingly moralistic, although he unexpectedly grew convinced of the need for greater religious toleration, and repealed the laws requiring mandatory attendance at Church of England services. In 1655 – against a backdrop of further conversations relating to the necessary preconditions for the second coming of Christ – he also permitted Jews to return to England, ending the 365-year exile first imposed by Edward I in 1290.

By now, Cromwell was king in all but name and, in 1657, Parliament offered to crown him. However, after six weeks' agonising he declined, aware that the army would not support it. Instead, on 26 June he did the next best thing. Parliament changed the basis of the constitution from the Instrument of Government to the Humble Petition and Advice, making the Lord Protector a hereditary position, and giving Cromwell status and powers that were fully royal in everything but the title. At the formal ceremony to mark the occasion, he sat on England's great medieval coronation throne and was venerated in a semi-regal rite complete with items of the royal regalia.

As with the Commonwealth, Cromwell's tenure as a republican monarch was unsuccessful. Personally, he aged rapidly, and withdrew from day-to-day affairs. When his favourite daughter died in August 1658 he finally lost

interest in much of what was going on around him, wearily aware that his vision of a Puritan, Godly Britain was now a fantasy. He had flourished and triumphed spectacularly as a military commander with clear objectives and absolute control, but had floundered as a politician and statesman where ambiguity and compromise were a more valuable currency.

After what was probably a malarial fever that developed into pneumonia, Cromwell died on 3 September 1658. He was not much missed. In the country, where Charles I was already being portrayed by many as a saint, Cromwell was seen as having sold his soul to the Devil. As he had lain dying, an enormous storm – 'Oliver's Wind' – hit the south of England, and rumour went about that it was the Devil come to claim his own. A line of fallen trees in Herefordshire was even reputed to mark the route along which Cromwell had been dragged down to hell.[14] His body was laid out for people to file past, but inadequately embalmed. When it began rotting, a wooden effigy fitted with a wax mask was laid out at Somerset House with crown, orb and sceptre in a ceremony based on that used for James I. Finally, in death, Cromwell appeared as the monarch in full regalia.

Before dying, Cromwell had nominated his oldest surviving son as successor. Richard was a 31-year-old country gentleman who had fought for a year in the army but had no experience of command. He had also sat briefly as an MP, but made no impression. Although a kind and decent man, he was unequipped to head a failing military state in which he did not have the confidence of the generals. As the New Model Army's ruling council and Parliament began to fall out, Richard was caught helplessly in the middle, and resigned his role as Lord Protector after just eight and a half months. With no ruler, the country developed a power vacuum, which a number of groups – military and religious – swiftly vied with each other to fill.

Britain's attempt at being a republic had failed on many levels. The Commonwealth and Protectorate had both been dangerously unstable and unable to find any meaningful consensus or solution to how England, Wales, Scotland and Ireland should be governed. By the time Richard Cromwell resigned – probably under physical duress from the New Model Army – there was a growing sense in many quarters that the only way to achieve stability was to reinstate the monarchy.

Meanwhile, the New Model Army had stepped into the power void and was running the country directly. In Scotland, General George Monck decided enough was enough, and rode south from Coldstream with his own

New Model Army forces. As he approached London, the government's soldiers melted away or joined him and, when Monck arrived at Westminster, he reinstated the Rump Parliament, before overseeing the election of the firmly Royalist Convention Parliament. Its MPs opened formal negotiations with Charles II in exile, making the dissolution of the New Model Army its first priority. Once a deal was in place, Charles pronounced the Declaration of Breda in the Netherlands, promising an amnesty for everything done during the Civil Wars and interregnum, freedom of religion to all, back pay to the army, and full recognition of all land purchases effected in the previous 11 years. This proclamation was then also read out in Parliament, which duly voted that Charles had been lawful king of England since the execution of his father, and invited him to return. Constitutionally, it was an unprecedented step. Parliament was inaugurating a monarchy, and the 30-year-old Charles duly arrived at Dover on 25 May to take his crown.

To dismantle Cromwell's legacy, Parliament manually reset the clock to 1649 by reversing Cromwell's entire legislative programme. In practical terms, it effaced all traces of the Republic as if it had never existed. However, the presence of so many trained soldiers in the country posed a security problem, until an unrelated event suggested a solution. On 6 January 1661 a cooper named Thomas Venner – a member of a radical Puritan sect known as the Fifth Monarchy Men – staged an uprising in London, capturing St Paul's Cathedral to the cry of 'King Jesus!' His 40 men – and at least one armed woman – were eventually cornered by General Monck and his troops and killed or executed for treason. Alarmed by this uprising in the capital, Charles resolved to abandon the traditional practice of raising trainbands for individual wars, and instead decided to establish a permanent peacetime army for the security of the realm. His warrant for standing forces is dated 26 January 1661, and is the birthday of the permanent, modern British Army. To constitute the nation's new forces, he took the best military talent from what was left of Cavalier and New Model Army units and combined them.

It was a bold but successful fusion, and several units he warranted survive today, 350 years later. They include the British Army's most senior regiment – the Life Guards – whose roots lie in Charles's cavalry bodyguard from his days in exile in Bruges in the 1650s. Its sister regiment in today's Household Cavalry – the Blues and Royals – also dates from the period, but draws on a New Model Army pedigree, as do the Coldstream Guards, which is the regiment General Monck brought down from Scotland to restore the

monarchy.[15] These venerable regiments are not, though, the oldest in the modern British Army. That accolade goes to the Honourable Artillery Company, which was founded over a century earlier by Henry VIII.[16]

Charles's amnesty for actions taken in the Civil Wars and interregnum was respected, although there was a proviso regarding the men who had executed his father. On 30 January 1661, exactly 12 years after Charles I was beheaded, Parliament voted to punish the regicides. Thirteen were tried, then hanged, drawn and quartered for treason, and two were hunted down on the continent and executed. The four dead ringleaders – Cromwell, his son-in-law Henry Ireton, Bradshaw and Pride – had all died, but their bodies were dug up, hanged, decapitated, then buried anonymously in a lime pit at Tyburn.[17] Their heads, however, were spiked on the south end of Westminster Hall, and Cromwell's was still there nearly two decades later. Its whereabouts today is unknown, although it is reputed to have been interred under the chapel of Sidney Sussex College Cambridge in 1960.

After Charles's Restoration, Cromwell was largely reviled as an extremist. The Wars of the Three Kingdoms he fought across the British Isles cost an estimated 540,000 lives, making it the bloodiest conflict in Britain's history, and far more costly in lives than the American or French revolutions that followed over a century later. Cromwell's wars claimed 3 per cent of the English population, 6 per cent of the Scottish and 15–20 per cent of the Irish.[18] In contrast, the mechanised horrors of World War One took less than 2 per cent of the British population.

In more recent times, some have tried to promote Cromwell as a torch-bearer for Britain's democracy. From the 1840s – notably with Thomas Carlyle's publication of his letters and speeches – he has garnered admirers, keen to ascribe to him a substantial role in Britain's journey from absolute to parliamentary and constitutional monarchy. There is no doubt he was a key figure in that transition, but it was by accident rather than design. He was not a promoter of Parliament, constitutional monarchy or democracy. He was a religious extremist who sat at the head of a military dictatorship that was even more contemptuous of Parliament than the Stuart monarchs had been. His orchestration of the regicide of Charles I was self-serving, and his record of ideological murder and deportation in Ireland remains notorious to this day. He does, however, have both fans and critics. During World War One Winston Churchill twice tried to name a Royal Navy battleship HMS *Oliver Cromwell* but on both occasions George V – a career naval

officer – blocked it.[19] Hamo Thornycroft's towering 1899 statue of Cromwell captures the three elements of his legacy eloquently. It stands outside Parliament, an institution he oppressed and shut down, but which he is now often seen as having defended. And in his hands he holds the two things that most define him: not symbols of democracy or justice, but a sword and a Bible.

With the Restoration, England threw off 11 years of Puritan austerity and welcomed the dissolute, sybaritic Charles II to Whitehall, with Margaret Cavendish and her husband returning to England shortly afterwards. They regained their lands under the new regime, and Margaret then spent significant time managing Bolsover Castle in Derbyshire and their other estates. All the while, she continued to write, even publishing a proto-science fiction novel, *The Blazing World*.[20] Memories of Cromwell's straitlaced religious regime faded, and people were again free to go for a Sunday afternoon walk, and even dance a brall with 'youth, love, mirth, content'. England had rejected fundamentalism and – after suffering the unprecedented bloodletting of the Wars of the Three Kingdoms and a decade of repression – was ready for the pendulum to swing dramatically the other way.

23

Prignappers in Rumvile – The Restoration's Dark Underbelly

Richard Head
The Canting Academy, or, the Devils Cabinet Opened
1673

Charles II moved into Whitehall Palace – where Cromwell had ruled and died – but what they had in common went no further. Their philosophies did not intersect in any sphere, and they had very different thoughts about politics and religion. As men, Cromwell embodied the English yeoman Protestant, while Charles was French on his mother's side, and married to the Portuguese *infanta*, Catherina of Braganza, so comfortable with Catholicism. Outwardly, the visual contrast was between asceticism and indulgence. Cromwell usually wore the Puritans' modest and simple dress, while Charles and his entourage arrived foppishly swathed in sumptuous fabrics and coiffed with luxuriously long, perfumed wigs.

Charles was no fool when it came to fitting into British society. He had been 18 years old when the New Model Army executed his father, and he had spent the last 11 years in exile on the continent, watching and learning from the rulers of dangerously divided countries. The conclusion he astutely drew from all he had experienced was that strong opinions were what got people killed, so he worked very hard to be seen as not having any, especially in matters of politics and religion. Instead he projected nonchalance and affability, with a disarming informality and openness to all views, including

those expressed by former supporters of Cromwell. However, as the country would soon learn, he found it easy to stay detached from these questions because he was not especially interested in them, or in the practical details of policy and governing.

Five years into his reign, in February 1665, the plague that had ripped across medieval Europe in the mid-fourteenth century and resurfaced many times since hit London again. This time it struck with more virulence than anything seen in 300 years. Charles, his court, Parliament, and the Westminster legal apparatus all decamped to relative safety in Oxford while the plague raged through the capital. The worst week was 19 September 1665, when London's weekly Bill of Mortality showed 7,165 plague deaths, compared to, among others, 134 for consumption, 15 for 'wormes', and three each for 'grief', 'winde' and 'frighted'.[1] Before the year was out, one in five Londoners was dead.[2]

The plague lingered, and had not run its course by the following autumn. In fact, its last case was recorded 14 years later in 1679. But, in the autumn of 1666, London was hit by another disaster when, on 2 September, as the long, hot summer was drawing to an end, Thomas Farriner – who baked for the king, made biscuits for the Navy and supplied bread to the local poor – had an accident at his bakehouse in Pudding Lane. At around 1 a.m., a pile of solid fuel beside his oven caught light and, by the time the family was awake, the blaze was too established to tackle. There was a strong easterly wind gusting that night and, as a result, the fire jumped nimbly among the tinder-dry buildings, devastating everything as it swept rapidly west.

Many of London's overcrowded, jumbled medieval houses were filled with stores of wood, oil, tar and other accelerants, meaning that fires were not uncommon. When Sir Thomas Bludworth, the Lord Mayor, arrived on the scene at around 3 a.m. and overheard officials debating whether to pull down houses to create fire breaks, he answered with a 'pish' that it was nothing and 'a woman might piss it out'.[3] His assessment turned out to be overly optimistic, as the strong wind pushed the fire on relentlessly, creating an inferno. Melted pottery from the ashes indicates that temperatures reached at least 1,700 degrees Celsius: over twice those achieved in the 1945 Allied incendiary firestorm bombing in Dresden which saw people sheltering in air raid shelters melted into liquid.[4]

Sensing the danger, Samuel Pepys – now one of Charles's leading courtiers – buried his prized Parmesan cheese and wine in the garden, then carried his other valuables off to Bethnal Green. There was no fire service, so Londoners

had to ferry water in buckets and pull down houses themselves. In a show of solidarity few kings before him would have considered, Charles left Whitehall Palace and headed to the blaze, where he rode and walked about, helping direct the effort to control the flames, personally passing buckets of water close to the conflagration, spending time with those who had lost their homes, and handing out money.[5] By the third day it was clear they could not pull houses down quickly enough, so they began blowing them up with gunpowder. Finally, by Thursday morning, the fire was out, with 437 acres of London in ruins. Dozens of iconic buildings were gone, including St Paul's Cathedral, Bridewell Palace, the Guildhall, the Royal Exchange, Newgate prison, 87 churches and 52 livery company halls, but ordinary citizens suffered the worst, losing 13,200 homes. A map from three months later shows the total desolation of an area stretching from the Temple in the west to the Tower of London in the east and as far north as Cripplegate, now the Barbican.[6] Astonishingly, although the exact death toll is unknown, it is thought only seven people perished.[7]

A Frenchman, Robert Hubert, soon confessed to having set fire to Farriner's bakehouse as part of a Catholic plot, and was duly hanged at Tyburn, where the mob then tore his body apart. Only later did it transpire that he had not been in the country on the day the fire started, and he was a Protestant.[8] Nevertheless, the story stuck and, in 1681, a sign was affixed to the Monument stating, 'Here by ye Permission of Heaven Hell broke loose upon this Protestant City from the malicious hearts of barbarous Papists, by the hand of their Agent Hubert'.[9]

The project of rebuilding the city took decades, until the heart of London re-emerged in gleaming stone, and what had been an overcrowded, jumbled sprawl was refashioned into a modern European city. Sir Christopher Wren designed 52 new churches for it, including a completely remodelled St Paul's, which gave the skyline a bold, triumphant, English, Anglican, baroque replacement for the venerable, spired, stained-glass-filled medieval cathedral.

With Charles's Restoration, London also resumed its role as a centre of entertainment. The theatres that had been boarded up reopened and quickly boomed. Playwrights like John Dryden, George Etherege and William Wycherley churned out new material, with Comedies of Manners – satires on high society – quickly becoming firm audience favourites.

English theatre had evolved from medieval mystery and miracle plays, with the first purpose-built secular playhouse, the Theatre, opening in Shoreditch in 1576. Female roles had traditionally been taken by men or

boys but, with the new liberality of the Restoration, women were permitted onto the stage for the first time. The novel spectacle of actresses led to an explosion of public interest in the theatre. Many playwrights – including women writers like Aphra Behn – purposefully eroticised women's roles as far as decorum would permit. Couch scenes were especially popular, with the curtain rising on a dishevelled, disarrayed, slumbering woman draped over a couch at the front of stage. Plot lines featuring assaults were also well received as a way to sexualise the action around even the purest female character, with off-stage shrieks followed by the appearance of a partly clad actress. And general titillation was provided nightly by women in 'breeches' roles, squeezed into close-fitting male clothing that displayed their figures. This new cadre of actresses came from a variety of social backgrounds, including the privileged and educated, as literacy was helpful in learning lines. However, many of London's theatres were in Covent Garden, which was also famous for its sex trade. The inevitable result was that actresses facing economic hardship were at times drawn into the surrounding brothels, blurring the line between the stage and prostitution.

The year after the great fire, Charles celebrated his capital's new dawn by starting one of the most famous royal love affairs in history: with an actress. Previous royal mistresses – like Rosamund Clifford or the Boleyn sisters – had been noble women with strong connections to the court. In contrast, Samuel Pepys recorded in his diary that the king's new mistress, Nell Gwyn, said she had grown up in a brothel serving drinks to customers.[10] By the age of 12 she was selling oranges at the King's Theatre, and within a year had made it onto the stage. Pepys saw many of her performances, and described her as 'pretty witty Nell' and 'a mighty pretty creature'. Technically, he judged her to excel at comedy and mad parts, but struggle with serious roles.[11]

Gwyn had survived the plague of 1665 and the fire of 1666 and, in the winter of 1667, she caught the eye of the Duke of Buckingham – son of George Villiers, favourite of James I and Charles I – who selected her as one of the king's new mistresses. Charles took an instant liking to the 16-year-old actress, and she made enough of an impression for Pepys to note in his diary in January that 'the King did send several times for Nelly'.[12] The relationship quickly intensified. By the following year Gwyn was pregnant by the king and living in a house in Lincoln's Inn Fields. She gave her last stage performance a year later, and Charles purchased her a house at the west end of fashionable Pall Mall, close to St James's Palace. Now a regular feature at

court, Gwyn bore Charles a second son and, by the age of 25, was receiving a royal income of £5,000, supplemented by significant tax and lease revenues.

Gwyn's quick wit, cheery manner, directness and lack of pretension were soon famous at court. When one of the queen's dressers called her a whore, Gwyn responded that if anyone else had said it she would not have minded, but it afflicted her to be called one by such a notorious whore from the days before whoring was in fashion.[13] She was not impressed by rank, either. Charles once asked her opinion on how to placate Parliament, whereupon she advised him to 'Hang up the French bitch', meaning Louise de Kérouaille, Duchess of Portsmouth, Charles's other principal mistress at the time.[14] Gwyn was also good with the crowds. When an angry mob surrounded her carriage believing she was de Kérouaille, Gwyn poked her head out of the window and cheerfully reassured them that she was 'the Protestant whore'.[15] In contemporary political satires, Gwyn was gaining a reputation as plain-speaking, patriotic and English. She was also ambitious for her eldest son, and eventually persuaded Charles to ennoble him as a baron, an earl and finally a duke. When Charles died, one account of his last words was the entreaty to his brother, 'Let not poor Nelly starve'. James II did as he was asked, settled her debts and continued to pay her pension.[16] Gwyn died two and a half years later, aged 36, and was buried in St-Martin-in-the-Fields.[17]

With little interest in the details of governing, Charles spent his days in his own intellectual pursuits, outdoor activities, games, drinking and womanising. A circle known as the Merry Gang formed around him, all dedicated to joining in the hedonism. Among its leading lights were Buckingham, Sir Charles Sedley, Charles Sackville Lord Buckhurst (later Earl of Dorset), John Wilmot Earl of Rochester, and the playwrights Etherege and Wycherley. They soon became known as the 'rakes' – short for rakehells: men so immoral one would have to rake through hell to find such a person – and gained infamous reputations.[18]

On one notorious occasion, on 16 June 1663, Sedley, Buckhurst and one other went on a summer afternoon's binge drinking in Covent Garden, after which they stripped naked on the balcony of the Cock Tavern (or Oxford Kate's Tavern) in Bow Street, delivered a sermon of obscenities and blasphemies, then simulated group sex. The gathering crowd's amusement turned to outrage when Sedley washed his private parts in a glass of wine, toasted the king, then drank the glass off. Enraged, the onlookers rioted and smashed in the tavern's windows.[19]

For all the hedonistic bravado, the life of a rake was punishing in its own way. Wilmot, for instance, became the second Earl of Rochester at the age of 10, going up to Wadham College Oxford two years later. At 14, the university awarded him an MA *filius nobilis* and, after travelling with his tutor for three years in Europe, he arrived at Charles II's court on 25 December 1664. One of his first exploits there was to kidnap a wealthy heiress as her carriage was passing Charing Cross, earning him three weeks in the Tower. To rehabilitate himself, he joined the Navy for the Second Anglo-Dutch War, serving on board *Revenge*, then heroically on *Dreadnought*. At 19 he was appointed a gentleman of the king's bedchamber, and at 20 he married the heiress he had kidnapped almost two years earlier, then took his seat in the House of Lords.

Now a full-time courtier, Rochester became the youngest member of the Merry Gang, settling into a life of dandyism, theatre, hard drinking, and debauching actresses while also finding time to compose and translate large quantities of poetry. At Christmas when he was 26 he unexpectedly had to flee court when he was revealed as the author of a verse which coined the soubriquet 'merry monarch' for Charles. The poem was not subtle. 'His Sceptter and his Prick are of a Length, / And she may sway the one, who plays with th'other / And make him little wiser than his Brother. / Restless he roalles about from Whore to Whore / A merry Monarch, scandalous and poor'.[20] It was a blunt but accurate assessment of life at Charles's court.

Although he was only 22, the libertine lifestyle was taking its toll on Rochester, who was already undergoing mercury treatment for syphilis. Alcoholism had also become a problem. At 28 he again had to flee court in disgrace, this time for drunkenly smashing Charles's prized glass sundial, one of the rarest in Europe. By now he was out of funds, partially blind and urinating blood, struggling to make ends meet by masquerading as a doctor, Alexander Bendo, peddling quack remedies around London's suburbs. As the final stages of syphilis set in he went insane, then died in 1680 at 33, just skin and bone.[21] His life had been charmed, promising, and utterly wasted.

When General Monck summoned Charles back to England after the collapse of the Protectorate in 1660 there had been high hopes that a restored Stuart monarchy would reintroduce stability through dynastic continuity. But doubts set in when Catherine of Braganza did not produce an heir, and Charles seemed happy openly consorting with his mistresses and illegitimate children. For some, this climate of pleasure-seeking was all too much. At Easter 1668 mobs attacked London's brothels in what became known as the Bawdy House Riots. The protestors were angry that Charles was clamping down on private,

non-conformist worship, while tolerating the networks of illegal brothels that covered the capital. Modest attacks on bawdy houses on Shrove Tuesday were something of an annual tradition – at least 24 were recorded between 1606 and 1641 – but this time the disorder was on an altogether larger scale, with thousands rioting for five days.[22] One report put the number at 40,000, attacking and pulling down brothels across London, focusing on the most notorious areas of Holborn, Moorfields, Smithfield and Southwark.[23] The government concluded that the agitators were ex-Cromwellian soldiers, pointing to the fact that they were marching under the green banners of the Levellers. When the dust settled, the government took firm action and executed four of the ringleaders for treason. This was partly because Charles understood that, to a degree, the rioters' anger was directed at him and his court. Pepys noted astutely that it was a miracle the protestors were content with the little bawdy houses when they could have focused on 'the great bawdy house at Whitehall'.[24]

The rakes were, on occasion, guilty of serious criminal offences, but their social positions protected them from any meaningful punishment. Beyond Whitehall Palace, however, in the crowded lanes, alleys, byways and courts of London, crimes of a different sort were blossoming, and a sensational dictionary appeared that claimed to reveal the secret language of the 'wicked crew, commonly known by the names of hectors, trapanners, gilts, &c': in other words, street crooks, swindlers, thieves, vagabonds and beggars. This group had been growing throughout the Middle Ages and, a few years before Henry VIII came to the throne, a Venetian ambassador had sent a dispatch warning that, 'There is no country in the world where there are so many robbers as in England; in so much that few venture to go alone in the country excepting in the middle of the day, and fewer still in the towns at night, and least of all in London.'[25] The number of criminals and vagrants had increased over the period for several reasons. Plague deaths had driven up prices, forcing many below the breadline. Silver from the New World had pushed down the value of money and reduced its buying power. Henry VIII and Edward VI additionally debased the currency multiple times. And Henry VIII's suppression of the religious houses had forced many of the ordinary employees of the 900 monasteries – cooks, smiths, labourers, masons, herdsmen, gardeners – into unemployment and destitution, while depriving the local poor of the meals and charity monasteries had traditionally supplied. As a result, by 1594 the Lord Mayor of London estimated there were 12,000 beggars in the city and, in 1615, a survey in Sheffield revealed that 725, or a third of the city's 2,207 inhabitants, were 'begging poor'.[26]

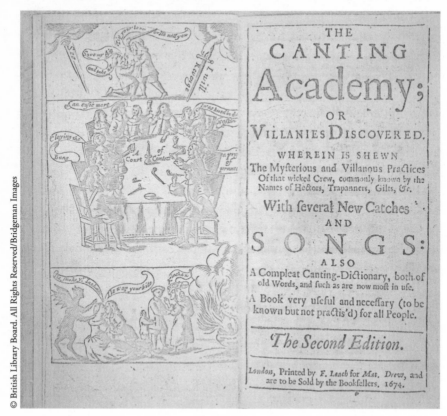

© British Library Board. All Rights Reserved/Bridgeman Images

Richard Head, The Canting Academy (1673, this edition 1674)

The dictionary's author, Richard Head, had left Oxford for lack of funds, then established himself as a London bookseller, before repeatedly losing his businesses to gambling debts. To supplement his volatile income he took up writing. Aware that risqué books would sell, he first published *The English Rogue* in 1665 – a racy, scandalous and scurrilous autobiography of a thief – and promptly fled into hiding when it was immediately condemned as indecent.[27] It was, however, one of the most successful books of the Restoration and, a dozen years later in 1673, he followed it up by turning to the secret jargon of the criminal underworld in a book entitled *The Canting Academy, or the Devils Cabinet Opened*. 'You are not ignorant', he explained in his introduction, 'how little there is extant in Print of a way of speaking, commonly known by the name of Canting, a Speech as confused, as the Professors thereof are disorderly dispos'd; and yet you know how much it is in use among some Persons, I mean, the more debauched and looser sort of people.'[28]

In *The Canting Academy* Head collected a number of texts, songs and poems in Canting including 'The Form of the Oath, with the Articles thereunto annexed, which these Gypsies and other Stroling Canters take, when they are first admitted into this Society'. In this – and other places in his book – he continued a standard confusion between gypsies and criminals. In fact, gypsies did not speak Canting. They had arrived in England from the continent in Tudor times calling themselves Egyptians – hence gypsies – although their ethnicity was Roma, with roots in India.[29] When they first appeared in England in the early 1500s their travelling lifestyle, distinctive clothing and reputation for fortune-telling soon led to widespread accusations of criminality. As a result, as early as 1530 Parliament passed an act for the seizure of all gypsy goods and their imprisonment and, 24 years later, the punishment for being a gypsy was increased to immediate execution.[30] Despite Head's assumption that English gypsies spoke Canting, their language was Romani, which is unrelated. He was, though, by no means alone in making the mistake. The *Winchester Confessional* of 1615 to 1616 has a list of 'such Canting words as the Counterfett Egiptians use amongst themselves as ther Language', but the vocabulary it gives is exclusively Romani, with no Canting.[31] The Roma were simply assumed to be criminals.

The Canting Academy has almost 300 words and phrases in Canting with English translations, then 230 words in English with their Canting equivalents. The following is a selection:

Canting	Translation
Abram	Naked
Abram Cove	A Poor Fellow
Autem	A Church
Autem-Mort	A Married Woman
Betty	An Instrument to break a door
Booz	Drink
Bulk and File	The one jostles you up whilst the other picks your pocket
Cackling Farts	Eggs
Clincher	Crafty fellow

Confeck	Counterfeit
Cove, or Cuffin	A Man
Cracker	An Arse
Croppinken	A Privy or Boghouse
Darkman	Night or Evening
Dell or Doxy	A Wench
Dimber	Pretty
Dommerars	Mad-men
Fencing Cully	A Receiver of stoln goods
Flick	To cut
Flick the Peeter	Cut the Cloak-bag
Fogus	Tobacco
Gentry-Mert	A fine Gentlewoman
Glym Stick	A Candlestick
Gropers	Blind men
Harmanbeck	A Constable
Heaver	A Breast
Lib	To tumble together [a bed is a libbedge]
Lightmans	Day, or Day-break
Maunders	Beggars
Mower	A Cow
Mynt	Gold
Nabgirder	A Bridle
Nazy	Drunken
Nazy-Cove	A Drunkard
Nubbing	Hanging

Nubbing Cove	The Hangman
Ogles	Eyes
Prigg	To Ride
Priggers of Prancers	Horse-stealers
Priggs	All sorts of Thieves
Prig-napper	A Horse-stealer
Queer	Base or roguish
Queer Ken	A Prison
Ratler	Coach
Rum Mort	A Curious wench
Rum pad	The Highway
Rum Padders	The better sort of Highway men
Rumvile	London
Snudge	One that lieth underneath a bed, or in some other covert place to watch an opportunity to rob the house
Trine	To hang: or Tyburn
Toppin Cove	The Hangman
Wap or Jockum cloy	Copulate
As the Prancer drew the Quire Cove at the Cropping of the Rotan through the Rum pads of the Rum vile, and was flog'd by the Nubbing-Cove.	The Rogue was drag'd at Carts-arse, through the chief streets of London, and was soundly whipt by the Hangman.
As Fib the Coves quarrons in the rum ad for the lour in his burg.	Beat the Man on the high-way for the money in his purse
As tip me a gage of Fogus	Give me a pipe of Tobacco
The Mort hath tipt the Bube to the Cully	The wench hath clapt the Fellow
Tout through the Wicker	Look through the Casement
Track up the Dancers	Goes up the Stairs

Lifting the veil on the clandestine language of the expanding criminal underworld had been popular since Elizabethan times, but *The Canting Academy* has by far the longest list of vocabulary. Head was astute to assume it would sell well. The secretive words fascinated a wide group of readers, and spawned considerable interest in subsequent publications like *The Ladies Dictionary* of 1694 – billed as 'general entertainment for the fair sex' – which expressly included Canting words and their definitions.[32]

Inevitably, some words of Canting became mainstream. Booz, cove, fencing and queer all made it into English slang, retaining their original meanings. Canting was also one of the base lexicons for another secretive language, Polari, which developed in the eighteenth century among circus and fair people, Punchmen, sailors and vagrants as a mishmash of Canting, Cockney rhyming slang, Italian, Romani and Yiddish.[33] Because of its links to the world of entertainment, Polari survived in the theatre, where it gained a new lease of life in the early twentieth century among the theatre's gay community, providing a useful clandestine vocabulary with which to avoid the draconian laws against homosexuality. The general public became aware of Polari in 1965 when the BBC began airing the radio show *Round the Horne*, featuring Kenneth Williams and Hugh Paddick swapping lightning-fast spicy innuendoes in Polari.

The Canting Academy reveals a dark side to the streets and alleys of Restoration England which was present, too, in a different way at the Merry Monarch's court. When the Duke of Buckingham put 16-year-old Nell Gwyn into the 37-year-old monarch's bed, it is unlikely she had any choice in the matter, or over whether she wanted to remain his mistress for the rest of her life. There was also violence. Buckhurst spent time in Newgate prison being tried for the manslaughter of an alleged highwayman. When the charge was increased to murder he was only freed after pleading the king's pardon. On one occasion, Rochester, the playwright Etherege and several others got drunk at the Epsom races, then broke down a door in search of a prostitute alleged to be the most beautiful in the country. A fracas developed and the watch was called. Once they broke up the scuffle Rochester set it off again, pulling his sword in a fit of pique. Alarmed he was about to do something he would regret, one of his party restrained him but, in the dark and confusion, the watch attacked the friend, splitting his head open. At this, Rochester and Etherege melted into the night, abandoning the friend to die in the street.[34]

Richard Head's earlier novel – *The English Rogue* – with its cast of free-wheeling, libidinous characters and *The Canting Academy*, with its exposé of

the underworld's vocabulary, were both as much products of the Restoration's iconoclasm as Charles moving an actress into his palace or the rakes stripping off and starting riots in Covent Garden. And to prove to what extent things had changed from the strait-laced days of Oliver Cromwell, Charles on his deathbed did the most dangerous thing an English monarch of the period could do. He changed religion.

24

A Very British Alchemy – The Emergence of Science

Isaac Newton
The Emerald Tablet
1685–95

In antiquity, pagans across the world mapped the skies, eager to unlock the mysteries of the heavens. Christians continued the tradition, developing an ever more detailed understanding of the clockwork movements of the celestial bodies in order to compute liturgical calendars. These researches were observational and systematic, but they were not yet science. That would have to wait for the universities.

The *cursus* at medieval universities was broad, beginning with the seven liberal arts of the undergraduate degree: the *trivium* of logic, grammar and rhetoric, followed by the *quadrivium* of arithmetic, astronomy, geometry and music. Graduates could then go on to specialise in law, medicine or theology. Alongside these disciplines there were lectures in moral philosophy and metaphysics, as well as the forerunner of modern science, then known as natural philosophy. This name lasted for centuries. When Isaac Newton published his ground-breaking theories of physics in 1687, he entitled them *Philosophiæ naturalis principia mathematica*: The Mathematical Principles of Natural Philosophy.

The established way for medieval natural philosophers to develop new understandings of the physical world around them was to propose fresh

interpretations of the writings of established authorities like Galen or Aristotle, but this text-based approach began to change when natural philosophers started to test their theories in reality. One of the earliest to do this was the thirteenth-century Somerset-born friar Roger Bacon, who set up a laboratory to verify his ideas in natural philosophy, in the course of which he became the first European to describe the process for making gunpowder.[1] In the succeeding centuries the idea of learning about the natural world through trial, error and observation caught on more widely, so that by the reign of Elizabeth I philosophical debates about nature had been supplemented by systematic laboratory work and observation. They called this evolving discipline experimental philosophy.

In Britain before the Reformation, intellectual pursuits were based largely in the two universities and the religious houses, but in 1645, at the height of the Civil War, a group of experimental philosophers whose political allegiances were fairly evenly split between King Charles and Parliament began weekly demonstrations of experiments at London's Gresham College.[2] In contemporary letters Robert Boyle wrote that the group called itself the 'Invisible College'.[3] Their sessions continued throughout the Civil War and Cromwellian period until Wednesday 28 November 1660, six months after Charles II's restoration. That afternoon, 12 members met as usual, and they heard a paper delivered by one of their distinguished members, the Gresham Professor of Astronomy Christopher Wren. Once his paper had been debated, the 12 resolved to establish themselves more formally into a 'Colledge for the Promoting of Physico-Mathematicall Experimentall Learning . . . and Experimentall Philosophy' and they adopted a list of a further 41 names to join them as members.[4] Charles II was informed, signalled his approval, and made known his wish to join as well. The necessary preparations were made and, just over a year and a half later, on 15 July 1662, he issued them a royal charter of incorporation and a new name: The Royal Society.[5] Inspired in their researches by the motto *nullius in verba* – take nobody's word for it – the society rapidly became Britain's foremost scientific institution.

A decade later, in 1672, one of the University of Cambridge's most brilliant young stars was elected to the Royal Society.[6] Isaac Newton was 29 years old, and his rise to prominence in mathematics and natural philosophy had been as rapid as his personality was odd. He had entered Trinity College Cambridge 10 years earlier and, in the intervening decade, had taken his BA, been elected a fellow of Trinity, invented infinitesimal

calculus – independently of Gottfried Leibniz, who discovered it simultaneously in Germany – made unprecedented discoveries in the fields of light and optics, and been appointed to the university's Lucasian Chair in Mathematics. In the following decades he would go on to write *Philosophiæ naturalis principia mathematica*, formulate his three laws of motion, and develop the theory of universal gravity.[7] This combined output is the foundation of modern physics.

As a man, Newton was profoundly private. He abhorred the coffee shop science and philosophy debates favoured by his colleagues, never travelled abroad to exchange ideas with foreign scholars, and had no interest in any sort of social life. He also shunned public activities, his only roles being to serve twice as Whig MP for the University of Cambridge, to be President of the Royal Society and finally to act as Master of the Royal Mint. His real joy was simply to cloister himself in his library and the world of his mind, writing thoughts down day and night in notebooks.

At the start of his career, once appointed a fellow of Trinity at the age of 24, college rules required Newton within seven years to take holy orders as a priest in the Church of England. In preparation, he set about studying theology, rapidly mastering the discipline and deciding that orthodox views on the Trinity were misguided, preferring the ancient Arian heresy which maintained that Christ was not one and the same as God. This view, which he held strongly, was fatal to any ambition in the church, but kind supporters intervened to secure an exemption for the holder of the Lucasian Chair in Mathematics from the usual ordination requirements.

Although now released from the traditional obligation to enter the church, Newton had gained a fierce love of Christianity, together with a belief that the Bible held hidden clues to the secrets of the universe. He ceased to follow mechanical philosophers like René Descartes, who posited a notion of the universe as an intricate clockwork mechanism with individual processes that could be separately identified and analysed. He found himself dissatisfied with their idea that God set the universe in motion at creation then took a back seat, preferring instead to believe that God remained active and involved in his plan. He also developed a sense that he had a special role to play in God's vision for humankind, becoming fixated with the Bible's prophetic books of Daniel and Revelation, convinced they contained secrets for him to decipher. Before long he had uncovered one of them, calculating that the apocalypse and Second Coming of Christ would occur in the year 2060.[8]

As part of unlocking the secrets of the Bible, Newton became captivated with the physical properties and dimensions of King Solomon's Temple, whose mathematical ratios he examined exhaustively, convinced they were pregnant with ancient wisdom. In deepening his researches, he increasingly came to believe that he – who had been born on Christmas Day – was one of God's specially chosen savants described in Isaiah 45:3: 'And I will giue thee the treaſures of darkeneſſe, 7 hidden riches of ſecret places, that thou mayeſt know, that I the LORD which call thee by thy name, am the God of Iſrael'.

In addition to his deep love of mathematics, natural philosophy, biblical prophecy and sacred geometry, Newton also had a surprising all-consuming passion with which he remained utterly entranced his entire adult life. Alchemy. The ancient tradition captivated him so much he assembled one of the country's largest alchemical libraries, and set up an alchemical laboratory beside his rooms at Trinity, where he conducted experiments late into the night. After his death, when Thomas Pellett of the Royal Society sorted through the mountains of Newton's personal papers, he found hundreds of booklets of experimental alchemical notes, with a special focus on the work of the American-born alchemist Eirenaeus Philalethes, who had died in the London plague of 1665.[9] Concerned for Newton's reputation, Pellett collected these papers into a bundle and labelled them 'Not Fit To Be Printed'.[10] The public only became aware of them and of Newton's clandestine obsession in 1936, when Sotheby's in London sold 329 lots of these writings containing over five million words of Newton's alchemical research.

Alchemy has a long history, and was already an old discipline by Newton's day. It had begun in the Graeco-Egyptian world of the third century AD as *chemeia*, before passing into the Islamic world, then eventually percolating into Europe.[11] It never became part of the mainstream university curriculum, but it fascinated many natural philosophers, tantalising them with the suggestion that adepts down the ages have unlocked the secrets of the universe. Although quack alchemists made a living duping wealthy patrons into sponsoring them to generate riches by transmuting base metal into gold, or to gain eternal youth by decocting the elixir of life, Newton's alchemical interests were far more serious. His conception of the universe assumed that the foundation blocks of nature were minute particles combined in different ways to create the visible and invisible worlds. He therefore reasoned that if the correct chemical scalpels and glues could be

identified to interact with these particles, matter could be disassembled then reassembled in new configurations. It was therefore logical that if the right reagents could be identified, base metals like lead really could be broken down and reassembled as precious metals.

After mastering centuries of opaque and mysterious alchemical texts, Newton came to see himself as one of the adepts who had been granted the insight to decode the natural world's inner workings via the spiritual and intellectual tradition of *prisca sapientia* – or ancient wisdom – transmitted down the generations for those with eyes to see. In the same way he considered his research on biblical prophecy to be a sign that God had chosen him to decipher the Bible, so he believed that God had raised him up among alchemy's adepts to gain the secrets of manipulating the building blocks of creation. In recognition of this divine power, he even adopted the alchemical pseudonym *Ieova Sanctus Unus*, the One Holy Jehovah, an anagram of *Isaacus Neuutonus*.[12]

According to alchemical lore, the first alchemist was Hermes Trismegistus, a syncretic Hellenic-Egyptian god formed from the Greek Hermes and the Egyptian Thoth. His knowledge was passed to the Zoroastrians, before culminating in the wisdom of Pythagoras and Plato.[13] Hermes synthesised his learning into a text known as the *Emerald Tablet*, which came to be revered as the foundation text of alchemy.[14] It is therefore no surprise to find it, in Latin, along with a careful translation, in one of Newton's alchemical notebooks.[15]

King's College Library Cambridge | Keynes MS 28/ALCH00017, fol. 2rv

Isaac Newton, The Emerald Tablet (1685–95)

Tis true without lying, certain & most true.

That w^ch is below is like that w^ch is above & that w^ch is above is like y^t w^ch is below to do y^e miracles of one only thing.

And as all things have been & arose from one by y^e mediation of one: so all things have their birth from this one thing by adaptation.

The Sun is its father, the moon its mother, the wind hath carried it in its belly, the earth is its nourse. The father of all perfection in y^e whole world is here. Its force or power is entire if it be converted into earth.

Separate thou y^e earth from y^e fire, y^e subtile from the gross sweetly w^th great industry. It ascends from y^e earth to y^e heaven & again it descends to y^e earth & receives y^e force of things superior & inferior.

By this means you shall have y^e glory of y^e whole world & thereby all obscurity shall [deleted word] fly from you.

Its force is above all force. ffor it vanquishes every subtile thing & penetrates every solid thing.

So was y^e world created.

From this are & do come admirable adaptations where of y^e means (or process) is here in this.

Hence I am called Hermes Trismegist, having the three parts of y^e philosophy of y^e whole world

That w^ch I have said of y^e operation of y^e Sun is accomplished & ended.

The subject of the *Emerald Tablet* – the mystery and power of the 'one thing' – is described in typically obscure alchemical language, permitting multiple interpretations. To some it may have been a description of the Philosopher's Stone preparation that effected the transmutations of matter from one form into another. To others it was the wonder element the *quinta essentia* – the quintessence, or fifth element – also known as aether, from which earth, wind, fire and water were created. To the earliest alchemists it was most likely the pure matter that lay at the heart of everything created: the link between earth and heaven.[16]

Although, looking back, alchemy was proto-chemistry – and is the etymological root of the word – it was never a respectable discipline in Europe, and was firmly derided by Newton's day. Over the centuries its hidden wisdom and spiritual exercises seemed ever more cranky to the emerging coldly observational and rational philosophers who would eventually turn laboratory experiments into the modern science of chemistry. As the economist John Maynard Keynes noted after purchasing and examining

large quantities of Newton's alchemical papers, 'Newton was not the first of the age of reason. He was the last of the magicians.'[17]

Newton's deep intellectual obsessions with biblical prophecy, sacred geometry and alchemy all sit uneasily with history's view of him as one of the main founders of rational science, and disclose a side of his personality and mental world that are rarely explored when discussing the prime movers of the scientific revolution. However, in Newton's mind, mathematics, the Bible and alchemy were all simply tools to understand God's plan. The *Principia* turned out to be one of the most important books in the history of science, but he wrote far more about alchemy, and the work that took up his final years, *The Chronology of Ancient Kingdoms* – with its detailed mathematical analyses of the proportions of King Solomon's Temple – was of equal importance to him. He may even have had other, more arcane interests, as he burned a quantity of personal papers shortly before he died, and their contents remain unknown.[18]

In Newton's lifetime, science was in the air. Charles II was fascinated by it all, especially mechanics, engineering, and disciplines with military and naval applications. He had a special interest in navigation and, on 4 March 1675, issued a warrant for a royal observatory and appointed John Flamsteed 'astronomical observer' tasked with establishing longitudes for 'perfecting the art of navigation'. Based on a design by Christopher Wren – recently retired as Savilian Professor of Astronomy at Oxford – Charles's observatory was constructed on high ground just south of the Thames over the ruins of Greenwich Castle.

At this date, people used many different 'prime' meridians as the imaginary line running from the north to south poles marking longitude 00° 00′ 00″. It was vital for navigation and cartography to have such a prime meridian so everywhere on earth could be described as falling on a north–south line a given number of degrees, minutes and seconds to the meridian's east or west. Inevitably, with its royal backing, the meridian running through the Royal Observatory soon came to be the nation's prime meridian, becoming known simply as the Greenwich Meridian.

To standardise the confusion and inefficiency caused by each country having its own prime meridian, in 1884 a 25-nation council met in Washington DC and selected the Greenwich Meridian as the world's prime meridian, making longitude 00° 00′ 00″ for the whole world the meridian that passes through the cross-hairs of the Greenwich Royal Observatory's Airy Transit Circle telescope. These days, astronomers base their measurements on

the centre of the earth's mass rather than surface observations, so the Greenwich Meridian has shifted 102.5 metres east of its original location, which nevertheless remains marked in the ground with a brass strip. As a result, anyone standing astride the strip today imagining they have one foot in each hemisphere may be surprised by the GPS reading they will get on their phone of longitude 00° 00' 05.3".[19]

Longitude is intimately connected to time, and at Greenwich John Flamsteed established a method for converting solar time to local mean time by observing when the sun passed across the Greenwich Meridian. As almanacks published by the Greenwich Observatory became ever more widely used, Greenwich Mean Time (GMT) was increasingly adopted as an unofficial international time reference. Across Britain, however, for day-to-day matters, cities still calculated their own time. Bristol Mean Time, for instance, was 10 minutes behind GMT. When railways began publishing timetables this variety of local times caused profound confusion, so in 1847 the Railway Clearing House adopted GMT as official Railway Time for its timetables and services. The country's public clocks gradually also adopted GMT, and in 1880 GMT became the country's official time nationwide. Beyond Britain GMT was also becoming standard because of the intimate relationship between the prime meridian and time, so when Greenwich was selected as the world's prime meridian in 1884, GMT inevitably became the world's international time reference, too.

Newton had been born the year Charles I raised his standard against Parliament at Nottingham in 1642. He lived through his regicide, the republic, the Wars of the Three Kingdoms, the Anglo-Dutch Wars, the reigns of six further monarchs, the plague and the Great Fire. The political and social turmoil during his lifetime was like no other period in British history, with the aftershocks of the Reformation still cannonading around the bishops' palaces and corridors of power, and Whitehall and Westminster still locked in a fight for the confessional soul of Britain. Although Newton stayed largely out of religious politics, he, like the rest of the country, was no doubt taken aback when Charles II, on his deathbed, summoned the Catholic priest who had helped hide him in 1651 after the Battle of Worcester. The priest heard the king's confession, then received him into the Catholic Church.

If that was not disquieting enough for Parliament and the religious establishment, Charles was succeeded by his younger brother, who took the throne as James II. On paper, James had all the right qualities. He had been

a successful soldier in the French and Spanish armies – in which he had fought the New Model Army at the Battle of the Dunes – and after the Restoration had been Lord High Admiral of the British fleet. He was a warrior-king of the old school. But, to many influential people's alarm, he had converted to Catholicism over a decade earlier and, after all the Parliamentary struggles for Protestantism, an openly Catholic king was a step too far. To make matters worse, he made the mistake of pushing a pro-Catholic agenda, using his prerogative powers to lift Parliament's penal laws against Catholics and other non-Anglicans while overtly Catholicising the court and the Army.

This earned James enemies at home, but there was also a serious threat to him across the Channel. There had been three Anglo-Dutch Wars between 1652 and 1674 in which England attempted to curb the rampant economic success of the Dutch.[20] The first war was a Cromwellian victory. In the second, under Charles, the Dutch sailed up the Medway to Chatham, burned the English fleet and towed away the flagship HMS *Royal Charles*, forcing a humiliated England to sue for peace. And the third, again in Charles's reign, saw England ally with Bourbon France against the Dutch in line with the notorious Treaty of Dover, only to be defeated again.

When James acceded to the throne in 1685 relations between Britain and the Netherlands were fragile. The staunchly Protestant William of Orange ruled most of the Dutch Republic and had a keen interest in British affairs. Although his family hailed originally from the south of France, he had strong British royal blood as his mother was Charles I's eldest daughter and sister to Charles II and James II. To those in Britain unprepared to tolerate a Catholic on the throne, William was an attractive Protestant proposition, particularly because he had married his English cousin, James II's eldest daughter, Mary. As a result, the couple were overflowing with top-grade English royal pedigree.

Pragmatists in Britain were prepared to put up with James because Mary, supported by William, was his heir, so James would leave no Catholic legacy. But when James's Catholic second wife, Maria of Modena, gave birth to a son at St James's Palace everything changed. The infant, also James, was now a Catholic heir, whose claim to the throne trumped Mary's because he was male. In response, British Protestants began a whispering campaign to delegitimise the baby, murmuring that Maria's real child had been stillborn and a substitute had been smuggled into the birthing chamber in a warming pan. This rumour spread so rapidly that James was forced to publish the

sworn testimony of over 70 witnesses to the birth and health of the Prince of Wales, but the story stuck.[21] Nevertheless, the reality was that Britain now had a Catholic monarch and a Catholic heir for the first time since Henry VII and VIII two centuries earlier.[22]

Having observed James's increasing vulnerability and received promises of support from Protestant factions in England, William of Orange resolved to invade. Accordingly, on 5 November 1688, Gunpowder Treason Day, he arrived off the Cornish coast at Brixham with a 500-ship invasion fleet – almost four times the size of the Spanish armada – from which he landed 21,000 invasion troops. He simultaneously published the *Declaration of Reasons for Appearing in Arms in England* to stress that his purpose was merely to assist Parliament and the Church of England to maintain their liberties. He also had a letter from seven English nobles – the 'Immortal Seven' – requesting his assistance, but it fooled none. This was an invasion. The seven aristocrats were not formal representatives of Parliament, and their treason did not make William's armed landing any less an act of war.[23]

William marched on London, ordering all English regiments to stay out of the capital or face the consequences. Then he put Dutch Blue Guards on the capital's streets, occupying it by force. He captured James, escorted him to Rochester, and put him on a ship to France.[24] Mary then joined William in London, where James's abdication was pronounced. With the capital under occupation and little choice in the matter, Parliament ignored the 'warming pan' Prince of Wales and offered the throne jointly to Mary and William.

In a triumph of Whig history writing, the accession of Mary II and William III is usually remembered in Britain as the 'Glorious Revolution' (the school examination syllabus now finally uses inverted commas around the phrase). It is portrayed as the replacement of a religious tyrant with a worthier ruler. The less sectarian reality was that a foreign power had landed a colossal invasion army in England and seized the throne. Later historians have been kinder to James than the Whigs, seeing in him a successful, international soldier and ruler who was looking to emulate the stability and framework of Louis XIV's Bourbon administration in France, but whose religion put him the wrong side of seventeenth-century British history.

The year 1689 was a milestone in Britain's history, as something even more fundamental than a conquest occurred. When James II went into exile and Parliament gave the crown to Mary and William – as it had done to Charles II on the Restoration – it enthroned them at the very high price that

Parliament became the undisputed power in the land, with Mary and William ceding all meaningful monarchical influence and instead assuming limited constitutional roles. James was, therefore, the last of Britain's all-powerful monarchs. With the settlement imposed on Mary and William, Parliament became the undisputed seat of Britain's government. There had been 42 crowned monarchs of England from Æthelstan in AD 927 to James in 1688, but from his exile onwards, the individuals who led Britain would be parliamentarians.

The document which definitively encapsulates this changed relationship between Parliament and the monarchy is the Bill of Rights 1689, which was the charter of this new constitutional settlement.[25] It provided for frequent Parliaments with free elections, free speech in Parliament, and no standing armies or taxation without Parliament's consent. It also provided for a Protestant-only succession, barring Catholics or anyone married to a Catholic from the throne. It is among the most important documents in Parliament's long history, not only setting out the constitutional framework that still prevails, but also inspiring the United States 1789 Bill of Rights, the United Nations 1948 Declaration on Human Rights and the 1953 European Convention on Human Rights.

Once crowned, William led campaigns as a military commander, but he and Mary had only a technical and ceremonial role in the process of government, as would all their successors. Those who want a memorial outside Parliament to the founders of Britain's modern parliamentary democracy should quietly take down Cromwell – who was a despot, fanatic and slaver – move him to a museum, and replace him with the unsung parliamentarians who devised the 1689 settlement. From the accession of Mary and William, the age of kings and queens steering the ship of state was over, and it was the turn of the politicians to rule. But first, intellectuals were offering brand new ideas about individuals and their role in society, ideas that would fundamentally change Britain, and bring it to the threshold of the modern world.

Sapere Aude! – The British Roots of the Enlightenment

Anonymous
The Forme of Giveing the Mason Word
1696

Doneraile Court is a large country house in County Cork. For centuries, it was the home of the Anglo-Irish St Leger family. Around 1710 its occupants were Arthur St Leger Viscount Doneraile and his family, including his daughter, the Honourable Elizabeth St Leger.

One winter afternoon when she was between 17 and 19 years of age, Elizabeth was reading quietly in the library. As the light began to fade, she grew drowsy, and eventually fell asleep in her chair. A while later she woke to the sound of men's voices in the adjoining room. Aware that workmen had removed sections of the partition wall's ornamental wooden panelling to repair the structure behind, she slid out some of the loosened bricks and peered through the gap to see what was happening in the next room. Squinting, she made out her father, her brothers and several other men, dressed unusually, and engaged in some kind of ritual. Several were seated on large chairs arranged around the edge of the room, while others were moving about with choreographed steps. When they spoke, it was in what seemed like formulaic exchanges, occasionally stopping to make odd gestures. Elizabeth watched on, mesmerised, until she realised one of the men was taking bloodcurdling oaths, and she grew afraid of what would

happen if discovered. With rising panic, she hurriedly slotted the bricks back into place and swept out of the library into the hallway. The door to the adjoining room was next to the library door and, as she flew into the hallway, she collided with the family butler, who was dressed similarly to the men in the next room, but guarding its door with a drawn sword. She screamed, and fainted.

Knowing about the condition of the partition wall, the butler understood what had happened and alerted Viscount Doneraile and the men in the adjoining room. Together they carried Elizabeth back into the library and, when she had come around and confessed to watching them, the men retired solemnly to consider what was to be done. Concluding there was only one solution, they returned and suggested it to Elizabeth, who agreed. She was therefore taken into the adjoining room and put through a ritual ceremony. When it was over, she was a freemason.[1]

The 1600s and 1700s offered gentlemen an array of clubs and societies catering for almost every interest, and freemasonry – a particularly British institution – was one of them. Its origins are mysterious, but lie somewhere in the world of the stonemasons who built – or, in the case of the master masons, designed – the medieval cathedrals, churches, castles and palaces across the country.[2] The word freemason itself refers to a mason skilled in carving free stone – quality stone used for sculptural work like capitals, tracery and gargoyles – and appears in Latin as 'sculptors of free stone' shortly before Magna Carta, and in English a century later when 'Nicholas le Freemason' broke out of Newgate prison.[3]

In the Middle Ages most trades and professions were regulated by local guilds, also known as crafts or mysteries. For centuries, stonemasons operated outside this framework as they moved about the country, making municipal or regional organisation difficult. Instead, they regulated their trade in lodges built on construction sites. The first mention of one appears in 1277 at the building of a new Cistercian monastery for Edward I at Vale Royal Abbey in Cheshire.[4] However, stone buildings had been going up across the country for centuries, so it may well not have been the earliest.

Like many medieval groups, religious and secular, stonemasons developed their own traditional history and lore. There is a lengthy poem in Middle English from around 1390 – the time of *The Canterbury Tales* – with an *incipit* in Latin reading 'Here Begin the Constitutions of the Art of Geometry According to Euclid'. The poem was to be read in stonemasons'

lodges, and relates how stonemasonry – which it also calls geometry – was discovered in Egypt by Euclid before finding its way down the centuries to England in the reign of Æthelstan, who summoned a great council of stone-masons to draw up rules for the trade.[5] The poem lists these regulations before returning to Euclid and explaining that he was a master of the seven liberal arts, given as *gramatica*, *dialetica*, *rethorica*, *musica*, *astronomia*, *arsmetica* and *gemetria*. It discusses the merits of each discipline, then coun-sels that the last, geometry, 'can separate truth from falsehood' and concludes, 'These be the sciences seven, who uses them well, he may have heaven.'[6]

The poem's philosophical focus on geometry and celebration of other proto-sciences suggest these were important subjects in the lore of medieval stonemasons, and they are what would eventually prove attractive to non-stonemasons. The focus on geometry made sense to anyone familiar with Plato and the sign over his Athens Academy: 'Let No One Ignorant Of Geometry Enter'.[7] Plato had not invented the idea, as the ancient Greeks understood geometry to be a cardinal tool for decoding the structure of the universe and a key prerequisite to the study of philosophy.[8] In identifying their craft with geometry, medieval stonemasons were therefore, on one level, claiming affinity with this ancient philosophical tradition.

There are few surviving records, and the details are still unclear. But, at some stage in the early 1600s, gentlemen completely unfamiliar with stone, mallets and chisels began joining stonemasons' lodges to participate in phil-osophical rituals the lodges had developed. These seem to have taken the tools of masonry and the act of working rough stones into perfect cubes as a metaphor for applying tools of morality and virtue to fashion individual stonemasons into better men. From an early date the symbolism of one of the Bible's most famous ancient buildings, King Solomon's Temple, also had pride of place in these ceremonies, allowing analogies to be drawn between building the real, sacred temple in Jerusalem and fashioning an inner temple of rectitude inside each stonemason.

The details are again lost, but with the influx of philosophically minded gentlemen, some lodges of working stonemasons gradually evolved into purely philosophical lodges of gentlemen. They had no actual involvement with the craft of stonemasonry, but inherited its history and rituals. The first non-stonemason known to have joined a lodge in England was the Scotsman Sir Robert Moray, who became a member of Edinburgh Lodge while in Newcastle on 20 March 1641 – the year before the outbreak of the First

Civil War – when he was Quartermaster General of the Scottish army occupying the north. Moray was one of the country's leading figures: a career soldier who was well known at both the English and French courts, and a keen experimental philosopher who would later become a member of the Invisible College, one of the founding 12 of the Royal Society, a key mediator between the society and Charles ɪɪ, and the man most responsible for obtaining its royal charter. As a prominent intellectual and courtier, he did not join just any lodge: Edinburgh Lodge has the oldest archive of any lodge in Britain with records dating back to 1599.[9]

The next account of a gentleman joining a lodge came five years later, on 16 October 1646, in the brief hiatus between the First and Second Civil Wars. Elias Ashmole was another prominent Royalist and experimental philosopher, and in his lifetime also a member of the Royal Society, astrologer, alchemist, antiquary – his collection seeded the Ashmolean Museum in Oxford – and Windsor Herald at the College of Arms.[10] His diary entry for the day reads, '4H.30pm I was made a Free-Mason at Warrington in Lancashire', making him the first recorded Englishman to have joined an English lodge.[11]

Perhaps because of its philosophical and Platonic heritage, observers began to connect freemasonry with the esoteric tradition, and especially the new, clandestine fraternity of the Rosy Cross. This group – better known as Rosicrucians – had burst onto the scene in 1614 when it unveiled itself in three mysterious alchemical tracts featuring Christian Rosenkreuz, each purporting to contain the secrets of the adepts.[12] As early as the 1630s observers confused freemasons and Rosicrucians, as in Henry Adamson's 1638 poem *The Muses Threnodie*, in which he wrote, 'For we be Brethren of the Rosie Crosse: We have the Mason word, and second sight'.[13] In time, the fashion for clubs with themes and rituals was inevitably targeted by humorists, as in a 1676 article in *Poor Robin's Intelligence*, a satirical London journal, which published a spoof dinner announcement making fun of them all. 'The Modern Green-ribbon'd Caball,' it declared, 'together with the Ancient Brother-hood of the Rosy-Cross; the Hermetick Adepti and the Company of Accepted Masons, intend all to dine together on the 31st November next, at the Flying-Bull in Windmill-Crown-Street.' It went on to describe the fantastical meal they would feast on, including delicacies such as phoenixes and haunches of unicorns.[14]

The reason men like Moray and Ashmole joined lodges, and nobles like Viscount Doneraile hosted them in their homes, was that the underlying

ethos of philosophical science was attractive to those caught up in the discoveries of experimental philosophy, which increasingly tied into new ideas that were sweeping across Europe bringing fresh and penetrating ways of understanding the world and humanity's place in it. This new intellectual dawn was the Enlightenment, or Age of Reason, and it came swiftly on the back of Europe's two most recent upheavals in ideas and identity. The first was the Renaissance, which began with the competition in 1400 to design the new baptistry doors in Florence, and brought a flood of humanism – intellectual enquiry based on the whole corpus of writings from ancient Greece and Rome – that quickly overturned centuries of medieval thought rooted in the Church fathers. The second came a century later, when the Reformation tore through Europe, sundering the religious unity that had bound the continent together for a millennium. The new streams of thinking that flowed from both the Renaissance and Reformation – and then the Counter-Reformation on the continent – culminated in the scientific and intellectual revolution of the Enlightenment, whose guiding principle was summed up by the Prussian Enlightenment thinker Immanuel Kant: '*Sapere aude*! (Dare to know!) Have courage to make use of your own understanding!'[15]

The Enlightenment was not a centrally controlled movement, but across Europe and the New World each country had its own Enlightenment. The best known of its thinkers are the French *philosophes* and German intellectuals like d'Alembert, Diderot, Frederick the Great, Goethe, Kant, Montesquieu and Voltaire. But three of the movement's most significant members – its earliest architects and prime movers – were English.

The first was the polymath Sir Francis Bacon, who laid the foundations for the intellectual revolution that was to follow. He entered Trinity College Cambridge in 1573 before embarking on a successful legal and political career, eventually being appointed James 1's Lord Chancellor. However, professional work was not enough to satisfy his inquisitive mind, and he read and wrote widely on natural philosophy, notably devising a strict, logical method to arrive at conclusions by experimentation and observation. His method was picked up and became the basis of scientific empiricism, focusing on the importance of building knowledge from experience and not merely arriving at it by abstract thought. Tragicomically, his thirst for empirical knowledge was also his downfall when, on a winter's day, he alighted from a carriage at the bottom of Highgate Hill to pack a dead hen with snow in the hope of seeing if the cold would delay its putrefaction. In

the process of cramming snow into the hen's eviscerated carcass he caught a chill of which he died.[16] Despite his premature demise, Enlightenment philosophers of all traditions cited Bacon as the movement's progenitor.

The second English pillar of the Enlightenment was Sir Isaac Newton, who built on Bacon's empiricism to develop mathematics and take the first steps in physics. He, too, was an empiricist. Even his calculus was profoundly capable of demonstration, and could be observed to work in reckoning areas under curves or volumes of rounded objects. His theories on the physical world were equally based on strict observation, like his infamous experiment conducted while living at home in Woolsthorpe for two years to escape the plague of 1665 as it raged through Cambridge. He wrote that in order to understand how light moves from the eye to the brain, he 'tooke a bodkine & put it betwixt my eye & [the] bone as neare to [the] backside of my eye as I could: & pressing my eye [with the] end of it (soe as to make curvature in my eye) there appeared severall white darke & coloured circles'.[17] For later Enlightenment intellectuals, Newton was the first true exponent of empirical science.

The third English architect of the Enlightenment was John Locke, born six years after Bacon died and 10 years before Newton's birth. His parents were Somerset Puritans, and he attended Westminster School and Christ Church Oxford before taking up a career in medicine. In 1690, just four years after the appearance of Newton's *Principia*, Locke published *An Essay Concerning Humane Understanding* in which he built on a heritage of ideas outlined by Aristotle, Avicenna and Thomas Aquinas to conclude that the human mind was a *tabula rasa*, a blank slate, upon which experiences imprinted themselves to mould the individual.[18] It was a quintessentially empiricist argument, seeing each mind as the accumulation of experiences perceived through the body's senses, and also a message of hope, that people were not born with a predisposition to sin, but were empty books which could be filled in infinite ways. In *An Essay*, Locke did for epistemology – the theory of knowledge – what Newton had done for physics, opening up new, post-medieval avenues of intellectual pursuit. He also wrote on government, toleration and education, inspiring a broad spectrum of thinkers including the Scottish Enlightenment figure Adam Smith. In his 1776 *The Wealth of Nations*, Smith drew on Locke's assertion that governments' primary role was the protection of individual rights, using it to lay the foundations of classical liberal economics, which soon replaced the previous centuries' mercantilist models of state intervention.[19]

Although Bacon, Locke and Newton were all practising Christians in the Church of England, the Enlightenment definitively broke philosophy away from the church – which was also highly influential in the universities – allowing the first secular philosophers to emerge. Voltaire and others were deists who believed in an abstract god as a universal architect, but rejected revealed religion in order to embrace reason and observation, often adopting strongly anti-Catholic and anti-Protestant stances. Others like Diderot went further, advocating atheism, sometimes in scandalous publications. A notorious instance was the appearance of the *Treatise on the Three Imposters* – probably written by Irish satirist John Toland – the first known printing of a blasphemous treatise rumoured to have been in secret circulation since the thirteenth century which systematically annihilated the religious claims made for Moses, Jesus and Muhammad.[20] It provoked a stern rebuke in verse from Voltaire, including the famous aphorism '*Si Dieu n'existoit pas, il faudroit l'inventer*' (If God did not exist, he would have to be invented).[21]

Like many leading figures of the Enlightenment, Voltaire was a freemason, but few lodge records survive from the period, making it difficult to be sure exactly who else was. Locke may have been, but there is no firm evidence.[22] The University of Cambridge's lodge is named Isaac Newton University Lodge, but there is no proof Newton was ever a freemason. Likewise, London's Lodge of Antiquity – possibly once an original stonemasons' lodge – has an antique maul it claims was used by Charles II to lay the foundation stone of St Paul's Cathedral before it was presented to the lodge by member and master Sir Christopher Wren, but again there is no evidence that Wren ever joined freemasonry.[23] What is certain, though, is that large numbers of Enlightenment intellectuals who moved in the same circles as Locke, Newton and Wren were attracted to lodges in the late 1600s and early 1700s, with the fashion spreading across the Channel and Atlantic. Many of the most prominent names of the Enlightenment were freemasons, including Montesquieu, Voltaire, Benjamin Franklin, Frederick the Great, Diderot, d'Alembert, Joseph Haydn, George Washington, Goethe and Mozart.

The details of what exactly took place in the old stonemasons' lodges is only sketchily visible. The oldest record of a stonemasons' ritual is from Edinburgh, and dated 1696.[24] It is a catechism of questions and answers followed by a ritual in which stonemasons exchange 'the mason word'. This is the ritual section, in its original Scots dialect.

National Records of Scotland | RH9/17/14/2

The forme of giveing the mason word

[handwritten manuscript text, largely illegible]

Anonymous, The Forme of Giveing the Mason Word (1696)

THE FORME OF GIVEING THE MASON WORD

Imprimis you are to take the person to take the word upon his knees and after a great many ceremonies to frighten him you make him take up the bible and laying his right hand on it you are to conjure him, to sec[r]ecie, By threatning that if [he] shall break his oath the sun in the firmament will be a witness ag[ain]st him and all the company then present, which will be an occasion of his damnation and that likewise the masons will be sure to murder him, Then after he has promised secrecie They give him the oath a[s] follows

By god himself and you shall answer to god when you shall stand nak[e]d before him, at the great day, you shall not reveal any pairt of what you shall hear or see at this time whither by word nor write nor put it in wryte at any time nor draw it with the point of a sword, or any other instrument upon the snow or sand, nor shall you speak of it but with an entered mason, so help you god.

After he hes taken the oath he is removed out of the company, with the youngest mason, where after he is sufficiently frighted with 1000 ridicolous postures and grimmaces, He is to learn from the s[ai]d mason the manner of makeing his due guard whis is the signe and the postures and words of his entrie which are as follows:

Ffirst when he enters again into the company he must make a ridiculous bow, then the signe and say God bless the honourable company. Then putting off his hat after a very foolish manner only to be demonstrated then (as the rest of the signes are likewise) he sayes the words of his entrie which are as follows

Here come I the youngest and last entered apprentice As I am sworn by God and St John by the Square and compass, and common judge to attend my masters service at the honourable lodge, from munday in the morning till saturday at night and to keep the Keyes thereof, under no less pain then haveing my tongue cut out under my chin and of being buried, within the flood mark where no man shall know, then he makes the sign again and with drawing his hand under his chin alongst his throat which denotes that it be cut out in caise he break his word.

Then all the mason present whisper amongst themselves the word beginning at the youngest till it comes to the master mason who gives the word to the entered apprentice.

This ritual may have been similar to the ceremony Elizabeth St Leger went through, although it cannot be known as the ceremonies were rarely written down and there were significant variations around the country.

Once a freemason, Elizabeth embraced the society wholeheartedly for the rest of her life, becoming well-known and distinguished in the fraternity, often wearing her freemason's regalia in public. Near her place of burial at St Finbarre's Cathedral in Cork is a gleaming brass plaque proclaiming that she was a notable woman freemason. She was, though, not the only one in the period. In France, Marie-Henriette Heiniken Madame de Xaintrailles chose to fight in the Napoleonic wars, and was aide-de-camp to General de Xaintrailles. A contemporary watercolour portrait shows her in the uniform of a cavalry major, and she joined a lodge in Paris not through misadventure like Elizabeth St Leger, but because the lodge's members were enthusiastic for her to join. Although they did not know it, they were starting a movement that would see hundreds of thousands of women join freemasonry over the years, the society being notably popular among the suffragettes.[25]

The ideas that impelled the Enlightenment – especially new understandings of liberty and equality – culminated in the outbreak of the American Revolutionary War in 1775, followed by the French Revolution in 1789. In the United States, the revolution delivered independence from Britain, and its leaders – many of whom were freemasons – explicitly embedded Enlightenment principles into the new country's constitutional framework. Thomas Jefferson even took John Locke's 1689 assertion that 'being all equal . . . no one ought to harm another in his Life, Health, Liberty, or Poſſeſſions' and in the United States Declaration of Independence turned it into 'all men are created equal . . . endowed by their Creator with certain unalienable Rights, that among these are Life, Liberty and the pursuit of Happiness'.[26] In this, and in setting up the state, government, separation of powers, individual rights and overriding ethos, the United States expressly designed itself as an ideal Enlightenment society.

In France, events moved in a sharply different direction. The mechanical bloodshed of the 1793 to 1794 *Terreur* and the slide into dictatorship marked the end of the French Enlightenment. What was said of Voltaire's work – that it was 'a chaos of clear ideas' – ultimately became the epitaph of the French Enlightenment itself in the hands of its revolutionaries who, ironically, brought Voltaire's body back from Champagne to give it a hero's burial in the Panthéon.[27]

Partly because of the French experience, the ideas of the Age of Reason soon grew unfashionable across Europe, and intellectuals – especially writers and artists – began rejecting the empiricism, rationalism and neo-Classicism of the Enlightenment. They turned instead to Romanticism, shifting their gaze to the imaginative, emotional and irrational. But the legacy of the Enlightenment survived, deeply embedded in science and politics, drawing on the dynamic ideas of Bacon, Newton and Locke to drive the start of the modern world.

26

Fortunes for the Taking – Robbery on the Highways and High Seas

Admiral Sir John Norris
The Hunt for Pirate Blackbeard
1718

In the warm, azure waters between the southern tip of Florida and the northern coast of Venezuela, the long islands of Cuba and Hispaniola sit as breakwaters between the Atlantic Ocean and the Caribbean Sea. Along with the small island of Guanahani in the Bahamas, they were the discoveries in the New World that Columbus made on his voyage in 1492.

By the early 1600s, the virtually deserted island of Hispaniola was a stopping point for marauding English, Dutch and French adventurers. To the Dutch they were sea robbers (*zeerovers*), to the French freebooters (*flibustiers*) and to the Spanish corsairs (*corsarios*). To provision themselves for their long sea voyages, they smoked meats using grills known as *boucans* in French, giving them their English name: buccaneers. They were notorious for raiding and plundering Spanish ships transporting riches to Europe from the 'Spanish Main', which was Spain's colonies running in an arc south from Florida, through Central America, down to South America.

English shipping had been active in the region for centuries. The first Tudor king, Henry VII, had sent Giovanni Caboto – remembered in Britain as John Cabot – to explore the seas to the west of Britain and, in 1497, he

became the first European since the Viking Leif Eriksson in the tenth century to set foot in North America. England took possession of numerous Caribbean islands, and formal English colonies on the mainland began when James I chartered Jamestown, Virginia in 1606, after which more English colonies sprang up along the eastern seaboard. By 1732 there were 13: at New Hampshire, New York, Massachusetts, Rhode Island, Connecticut, Pennsylvania, New Jersey, Delaware, Maryland, Virginia, North Carolina, South Carolina and Georgia.

The waters in the region were crowded, and buccaneers were not the only aggressive shipping. Europe's conflicts spilled west into the New World, and warring European governments issued Letters of Marque to private ships off the Americas, permitting them to fly national colours as privateers and capture enemy ships for a share of the prize money.[1] A notable exception to the expedient of hiring private ships in the region to fight European conflicts was Oliver Cromwell's 1655 campaign to seize all Spain's New World territory, for which he dispatched a vast armada directly from Portsmouth. The operation was a debacle, failing to take its first target of Hispaniola and, in the end, only acquiring Jamaica, where most of the English sailors and soldiers died of disease.[2] Throughout the period buccaneers carrying Letters of Marque frequently exceeded the authority of their commissions, blurring the dividing line between buccaneer and privateer. At the same time, pirates – the majority of whom were English – and slave traders also prowled the Caribbean looking for spoils. Many captains and crew moved fluidly between all these categories, as Francis Drake had done in Elizabeth's day when he was a Caribbean privateer, pirate and slaver.

The net result of this maritime anarchy was a nautical wild west, with ships and riches won and lost in the lawless waters of the New World. For those with an aptitude for brigandage, there were real fortunes to be made. An example was Welshman Henry Morgan, who arrived with Cromwell's forces in 1655, then settled down to life as a buccaneer, privateer, pirate and plantation owner, eventually leading an operation that seized and burned Spanish Panama. As Britain had recently concluded a peace treaty with Spain, Morgan was arrested and transported to London, where Charles II unexpectedly decided he rather liked him, knighted him, and sent him back to the Caribbean as Lieutenant Governor of Jamaica. Morgan eventually died there, a titled, wealthy man who is remembered today as the face of a well-known brand of rum.

Piracy in the Caribbean became so endemic that the pirates eventually founded their own capital. Charles Town on New Providence Island had

been named after Charles II of England but, in 1695, was renamed Nassau in honour of William III of England's new royal house of Orange-Nassau. By the early 1700s authority there had broken down, and thousands of pirates took control of the city as their headquarters, declaring it a pirate republic.[3]

Back in England, the bumpy transition from the exiled James II to Mary II and William III had been effected by William's Dutch Blue Guard invasion troops. These were left on the streets of London for the first 18 months of their reign to face down any opposition, which was feared especially from the two-thirds of the British Army's officer corps who wanted James back. Stuart supporters mounted several risings but James, ever the military man, was planning a far more substantial campaign. He first secured French support, then sailed for Ireland to rally the Catholics.

The showdown was not long in coming. On 1 July 1690, 25 miles north of Dublin at a bend in the River Boyne, father- and son-in-law met in battle to decide who would wear the three crowns of Britain. William was at the head of a force of professional soldiers from England, Scotland, Holland, Germany, Denmark and France. James's army was two-thirds the size and largely Irish agricultural labourers supported by some French. William's army had eight times the artillery power, and the outcome was never in question.[4] Defeated, James returned to France, all dreams of being restored to his ancestral thrones lost.

When Mary I had died over a century earlier in 1558, her husband Philip II of Spain immediately lost his entitlement to be king of England. However, when Mary II died in 1694, William retained the throne and ruled on alone. Unhappy Jacobites – those who still supported the deposed James II – continued to foment unrest by means that included spreading rumours that William was having affairs with his courtiers Hans Willem Bentinck and Arnold Joost van Keppel, with whom he had interconnecting bed chambers. But they mounted no major rebellions and William saw out his reign. When he died eight years after Mary, he left little legacy in England, although he retains a heroic reputation among Northern Ireland's Orangemen, who annually celebrate his victory over James and Ireland's Catholics in celebratory parades. As he and Mary left no heir, under the terms of the Bill of Rights 1689 the three British crowns passed not to James's son – the Catholic 'warming pan' Prince of Wales – but to another of his Protestant daughters, Mary's younger sister, Anne Stuart, who came to the throne at 37 with a life of sadness behind her. She had lost her mother

at the age of six, and six siblings and a favourite governess by the age of 12. Before her coronation, she had 17 pregnancies, all but five of which ended in miscarriages or stillbirths. Of the five children born alive, all died in infancy or childhood. She was surrounded by death.

On Anne's accession, England, Scotland and Ireland were still legally distinct kingdoms, each with its own crown and parliament. This had not changed despite all three crowns being worn by the same monarch since James VI of Scotland became James I of England and Ireland in 1603. Under Anne, however, a new constitutional settlement was devised and, on 1 May 1707, England and Scotland formally united to create one combined nation: Great Britain. The union was engineered by England specifically to manage its royal succession planning, as in 1701 it had passed the Act of Settlement stating that if Anne died without an heir, the throne would pass to her nearest Protestant relative. England feared that Scotland – with its attachment to the House of Stuart – might try to undermine this arrangement with regard to the crown of Scotland, perhaps even with the help of the French as in the days of the 'auld alliance'. The English therefore calculated that uniting the crowns of England and Scotland would solve the problem.

There was significant popular opposition in Scotland to the prospect of union, but the merger was sweetened by a valuable free trade agreement with England and its dominions, along with generous gifts to Scotland's parliamentarians.[5] The 'betrayal' of those who voted for the union remains a source of anger among Scottish nationalists, who still cite Robert Burns's lines, 'such a parcel of rogues ... bought and sold for English gold'.[6] Nevertheless, the union went through, and Anne's government succeeded where the Romans and England's medieval kings had all failed. The two countries were now one, with the formal consent of Scotland and no bloodshed. Under the articles of union, Scotland retained its own distinctive legal and judicial system, but both countries extinguished their parliaments and a new body – the Parliament of Great Britain – rose in its place at Westminster with spaces for 45 MPs and 16 peers from Scotland. Anne was highly enthusiastic about the project, and her active support for the union proved to be a considerable factor in its acceptance by both countries.

After England's humiliating failures in Cromwell's 1655 Caribbean operation and the last two Anglo-Dutch Wars, the country's military fortunes now changed dramatically. The newly combined British forces that engaged in the 1701 to 1714 War of the Spanish Succession proved formidable,

winning some of the most celebrated victories in British military history before the Napoleonic campaigns a century later. Under the command of John Churchill Duke of Marlborough, Anne's forces won decisively at Blenheim, Ramillies, Oudenarde and Malplaquet, burnishing the military credentials of the newly united Great Britain.

Behind closed doors, Anne's personal sadnesses continued after her coronation. She had married Prince George of Denmark when she was 18 years old and they remained married until his death five years before hers. History, however, remembers her strong but ultimately unhappy relationship with childhood friend Sarah Jenyns, who married the ambitious soldier John Churchill to become Duchess of Marlborough. Anne lost her heart to Sarah, who responded with affection but not love while the two corresponded intimately as Mrs Morley and Mrs Freeman. Eventually, however, the influence Sarah had acquired over the queen for decades went to her head, her behaviour became increasingly imperious and controlling, and the friendship collapsed in a rancorous and irremediable falling out.[7]

Anne held the throne for 12 years until her death in 1714. She proved a skilled, effective and accomplished constitutional monarch, while her reign marked the critical turning point between the chaos and bloodshed of the 1600s and the stability of the 1700s. However, like every queen regnant of England before her – Mary I, Elizabeth I and Mary II – she left no heir. With her entombment in Westminster Abbey, the Scottish house of Stuart relinquished the thrones of England, Scotland and Ireland for ever. There was, however, a pre-planned solution.

In 1660, at the Restoration, Parliament had invited Charles II back from exile and given him the crown. In the Declaration of Right 1689 it had offered the throne to Mary II and William III. In the Bill of Rights the same year it confirmed Mary and William as monarchs, and declared that if Mary had no children, the throne would pass to her younger sister, Anne, which it did. The direction of travel was therefore clear. Since General Monck's Convention Parliament of 1660, Parliament had the power to choose the monarch, and it did so again now.

On implementing the Act of Settlement 1701 it turned out that virtually all Anne's relatives were Catholic, with the closest Protestant to the throne being Sophia Electress of Brunswick-Lüneburg, a noble of the Holy Roman Empire who was 51st in line to the British throne. In the event, the elderly Electress predeceased Anne by two months, so the British throne passed to her 54-year-old son, who was crowned George I of Great Britain on

20 October 1714. He brought with him the distinction of being the first king in Whitehall for centuries who understood not a word of English.[8]

The British people were not taken with George, and he was not noticeably interested in his new subjects. He was wooden, and even his mother found him uninspiring, confiding that he was 'the most pigheaded, stubborn boy who ever lived, who has round his brains such a thick crust that I defy any man or woman ever to discover what is in them'.[9] He was also widely disliked for the cruelty he meted out to his former wife, Sophia Dorothea. Before his accession, when he discovered she had a paramour, her lover was mysteriously murdered, and George divorced her then locked her up in the castle of Ahlden for the remaining 30 years of her life. He forbade their children – including the future George II – to visit her, while he continued openly consorting with his mistresses, most notably Melusine von der Schulenburg, who became queen consort in all but name.[10]

For Britain, the most significant development in George's reign was a direct result of his lack of engagement with the country. He had minimal interest in government and ceased chairing or even attending meetings of his ministers. Parliament was not slow to spot the opportunity, and the vacuum was quickly filled by Sir Robert Walpole, Chancellor of the Exchequer and First Lord of the Treasury, who took on the responsibility of heading the government. By the 1730s he was being addressed as Prime Minister and, on 22 September 1735, he moved into No. 10 Downing Street, a gift from the king. Ever since then it has traditionally been the Prime Minister's official London residence.

George died in 1727, to be succeeded by his son. George II made perhaps the least impact of any king in British history. He had no intellectual life, spent his days hunting and playing cards, and showed no awareness of the country or his role as its monarch. His reign did, though, bring dynastic stability, as the pro-Stuart Jacobite threat – which had sparked a major rebellion in 1715 under the warming-pan-baby Old Pretender – was definitively seen off in 1745. The Old Pretender's son, the Young Pretender, Bonnie Prince Charlie, staged another rebellion, and the definitive engagement took place on 16 April 1746 at Culloden near Inverness in the Scottish Highlands. There, Prince William Augustus Duke of Cumberland, George II's youngest son, routed the Jacobites in the last pitched battle on British soil and secured the Hanoverian succession.

For all the orderliness at court of Parliament orchestrating the royal succession, on the streets the period from 1650 to 1725 saw significant

lawlessness across Britain, just as it did on the seas of the Caribbean. In 1714, the year George I succeeded, a book appeared entitled *A Complete History of the Lives and Robberies of the Most Notorious Highwaymen, Footpads, Shoplifts, and Cheats of Both Sexes*, written by a Captain Alexander Smith.[11] Nothing is known of the author, except that he had a good sense of what the public wanted to read, for the book was into its third edition in a year incorporating an extra volume of biographies and a Canting diction-ary.[12] Although the title feigned horror at the notoriety of the criminals, its full description made sure to add deliberate titillation: *Wherein Their Most Secret and Barbarous Murders, Unparalleled Robberies, Notorious Thefts, and Unheard-of Cheats Are Set in a True Light and Exposed to Public View, for the Common Benefit of Mankind.*

Britain had no police, and the lonely, windswept roads winding out of its towns and cities and up from its ports had become notorious for robberies. As Smith banked on in writing his book of biographies, the public was fascinated by criminals and gained a deep frisson of excitement from read-ing about highway robbers, who were soon being seen through a lens of romance and glamour. It is a reputation that has persisted, as in Alfred Noyes's twentieth-century *The Highwayman*, a long-time staple of school poetry anthologies with its moody opening: 'The wind was a torrent of darkness among the gusty trees, / The moon was a ghostly galleon tossed upon cloudy seas, / The road was a ribbon of moonlight over the purple moor, / And the highwayman came riding – / Riding – riding – / The high-wayman came riding, up to the old inn-door.'[13] Although highway attacks were usually brutal and frequently fatal, swathes of the public held a certain respect for the audacity of the robbers, who came to enjoy something of Robin Hood's outlaw glamour for liberating riches from the undeserving wealthy and bringing them down a peg or two. The most celebrated road robbers were the highwaymen and women who pulled off their crimes on horseback. Those who plied their trade unmounted were the slightly less glamorous footpads.

The first notorious highwayman in Smith's book was Sir John Falstaff, the robber in Shakespeare's *Henry IV Parts I* and *II*.[14] Shakespeare based the character loosely on the fourteenth- and fifteenth-century rebel Sir John Oldcastle, but fabricated his highwayman activities. Having started with fiction, Smith's biographies went on to blend fact and fantasy, seamlessly chronicling dozens of robbers, swindlers and cheats of all descriptions. Unsurprisingly, the public was particularly scandalised and

fascinated by highwaywomen, and Smith obligingly chronicled a handful of women robbers, including the infamous Moll Cutpurse – real name Mary Frith – who was already the subject of intense interest in pamphlets, books and plays for her cross-dressing, hard drinking, violent robberies and unlicensed lute playing. After her death, the story even emerged that she had once mugged General Fairfax, founder and commander of the New Model Army, on Hounslow Heath.[15] Surprisingly, one notable omission from Smith's book was the Wicked Lady, traditionally identified as the gentlewoman Catherine Ferrers, who married at the age of 13 but was neglected by her husband, and fell into highway robbery for the sheer thrill of it, becoming ever more ruthless until fatally injured in a hold-up.[16]

The most celebrated highwayman of all was Essex-born Dick Turpin, who was active in the 1730s. After a career spent poaching, fencing stolen goods, housebreaking, horse rustling and murdering, his end was anticlimactically banal. He was imprisoned at York Castle for shooting a game cock, and his true identity was only revealed when he sent a letter to his brother, who refused to pay the postage, so it was returned to the post office. There, one of Turpin's former schoolteachers recognised the handwriting, travelled to York and gave evidence at his trial. Turpin was duly convicted, and hanged in a new frock coat he purchased for the occasion, where – as was expected of highwaymen – he put on a good show for the crowds. In death, his legend evolved rapidly, including the invention of his faithful horse, Black Bess, and the yarn that they galloped from London to York to set up an alibi, killing Black Bess from exhaustion.[17]

Highwaymen struck all across the country, even in the heart of the capital, where Hyde Park was notoriously dangerous. William III had hung 300 lamps along the park's *Route du Roi* – now corrupted to Rotten Row – connecting St James's Palace and Kensington Palace, specifically to keep it safe from highwaymen, making it Britain's first lit roadway.[18] Nevertheless, the rest of the park remained hazardous. While travelling through it in 1749, the politician and writer Horace Walpole was injured in the face when a shot was fired through his carriage and he was relieved of his watch and sword, which he had to buy back for 20 guineas.[19] Despite this, he became quite caught up in the romance of the more fashionable highwaymen, although a few years later he wrote to a friend, 'one is forced to travel, even at noon, as if one was going to battle'.[20]

In a similar vein to Captain Smith's *Highwaymen*, in 1724 an author calling himself Captain Charles Johnson published *A General History of the Robberies and Murders of the Most Notorious Pyrates*. Just as Smith delighted in tales of robbery on the roads, so Johnson's book regaled readers with accounts of audacity on the high seas. Like Smith, Johnson was also keen to give accounts of lawless women, and one of his biographies topped anything in Smith's *Highwaymen*. It related the story of the English pirate John 'Calico Jack' Rackam, who sailed with his Irish lover, Anne Bonny, an accomplished pirate in her own right. If this was not singular enough, Rackam's crew was then joined by the Englishwoman Mary Read, who had fought as a soldier in Flanders. Bonny and Read both cross-dressed, and Johnson revelled in recounting the story of their meeting. '[Mary Read's] sex was not so much as suspected by any person on board till Anne Bonny, who was not altogether so reserved in point of chastity, took a particular liking to her. In short, Anne Bonny took her for a handsome young fellow and for some reasons best known to herself, first discovered her sex to Mary Read. Mary Read, knowing what she would be at, and being very sensible of her incapacity that way, was forced to come to a tight understanding with her; and so to the great disappointment of Anne Bonny, she let her know she was a woman also.'[21] The two became firm friends, and were reportedly among the fiercest, hardest-living, profanity-proficient of Rackam's crew. They were both eventually tried and convicted of piracy, but pregnancies spared them the gallows. Read died in prison, but Bonny eventually gained her freedom, married, had a large family, and died a respectable woman aged 84.[22]

In the Caribbean, as the lawlessness grew more endemic around the pirate capital at Nassau, former privateer Woodes Rogers, newly appointed Captain-General and Governor-in-Chief of the Bahamas, arrived in the city with a pardon from George I for any pirate willing to abandon the life of plundering. Most accepted the offer, bringing Nassau back from anarchy, but one who chose to reject the amnesty was Edward Teach, or Thack, usually known as Blackbeard. There is no definitive description of him, but he is traditionally depicted as unusually tall, with a large bushy beard up to his eyes which he adorned with ribbons and slow-burning hemp fuses to wreathe his head in smoke as he waded into combat.[23]

Teach was probably from Bristol, and had sailed as a privateer in the War of the Spanish Succession before turning to piracy when his Letter of Marque expired. He first joined Benjamin Hornigold's crew, then made his

name by capturing the 300-ton French frigate and slave-ship *Concorde*, which he refitted to take 40 cannon and renamed *Queen Anne's Revenge*. While Hornigold took advantage of George 1's amnesty in Nassau, Teach chose to blockade Charlestown, South Carolina, for five days, holding it at his mercy and looting all inbound and outbound shipping with notable brutality using improvised ordnance of mixed shot, bolts, nails, spikes and glass to inflict maximum suffering. He then ran *Queen Anne's Revenge* aground and marooned most of his men on a sandbar while he and a small, hand-picked crew made off with all their plundered treasure. He accepted a pardon, married, and settled in North Carolina's Bath Town, but soon bored of shore life and returned to piracy.

By now Teach was so notorious that the Governor of Virginia put £100 on his head and dispatched Captain George Gordon of the Royal Navy to hunt him down. Gordon tracked Teach to North Carolina's Ocracoke Inlet, where one of his officers, Lieutenant Robert Maynard, hoisted the king's colours on the sloops *Jane* and *Ranger* and, with 54 armed men, entered the sheltered waterway. This is Admiral Sir John Norris's account of what followed on 22 November 1718.

In order to this I shall, very briefly lay before their lordship's all ye steps of that action with Thatch alias Blackbeard. After they were so near, that the compliment past betwixt them of not giving each other quarters, Thatch observing all his men upon deck gave them a broadside; his guns being sufficiently charged with swan shot, partridge shot and others; with his broadside he killed and wounded (most by the swan shot) one and twenty of his men, Mr Maynard finding his men thus exposed, and no shelter ordered his men down to the hold, giving himself unto the cabins avaſt; ordering the midshipman, that was at the helm, or Mr Butler, his pilote to aquaint him with anything that should happen. Thatch, observing his decks clear of men presently concluded the veſsel his own, and then sheers on board Lieutenant Maynard's sloop, enters himself the first man, with a rope in his hand to lash or make fast the two sloops. Mr Butler aquainting Lieutenant Maynard with this, turned his men upon deck, and was himself presently among them: wherein less than six minutes tyme Thatch and five or six of his men were killed; the rest of these rogues jumped in the water where they were demolished, one of them being discovered some dayes after in the reeds by the fowls hovering over him.

National Archives | ADM1/2/1826

Honor.d S.r

Having acquainted you yesterday for their Lord.ps: information Maj.r had reason to finde fault w.th the account Lieu.t Maynard Master of his Maj.ties Pearle under my command made to his Maj.tie in his petition lately layed before him in Counsell.

In order to this I shall, very briefly, lay before their Lord.ps: all y.e Steps of that action with that life takes Blackbeard

After they were so near, that the compliment past betixt them of not giving each other quarters; Thatch observing all his men upon deck gave them a broad Side; his guns being Sufficiently charged with Swan Shott, partridge Shott, and others; with this broad Side he killed and wounded most by the Swan shot, one & twenty of his men, M.r Maynder finding his men thus exposed, and no Shelter order his men down into the hold, going himself into the helm abaft, ordering the midshipman, that was at the helm, or M.r Butler his Mate to acquaint him with any that should happen. Thatch observing his deck clear of men presently concluded the vessel his own, and then Steers on board Lieu.t Maynards Sloop, enters himself the first man, with a rope in his hand to lash or make fast the two Sloops: M.r Butler acquainting Lieu.t Maynard with this, turned his men upon deck, and was himself presently among them: where in less then Six minutes tyme Thatch and five or Six of his men were killed; the rest of these rogues Jumped in the water where they were demolished, one of them being discovered some dayes after in the reeds by the fouls hovering over him: the Sloop in w.ch the Lymes people were in, had the Misfortune to have the three officers that commanded them killed a bord of his Sloop: & another Shot through the body in Thatchs Sloop by one of our men, takeing him, by Mistake for one of the pirates

This S.r is the true and real Steps of that action, given in upon oath at his Maj.ties Court of admir.l: in Virginia, by himself & his people the truth of which if need be Lieu.t Governor Spotswood can justifie & his Cap.t Brand: there being no Such thing given out there boarding Thatch Sword in hand; as he is pleased to tell his

Maynard's ruse in hiding his men below *Jane*'s deck had successfully fooled Teach. Johnson's history, published six years later, added that Maynard and Teach closed on each other with pistols, with Teach sustaining a wound before the pair drew swords and fought at close quarters until Maynard's blade snapped. As the naval officer scrambled to reload his pistol, one of *Jane*'s crew delivered a fatal wound to Teach's throat. Maynard then had Teach's head cut off, and hung it from his bowsprit as he sailed back into Bath Town.[24] Although people have subsequently embellished the story, the core is fact, and in 1996 divers finally discovered the much-hunted wreck of *Queen Anne's Revenge* at nearby Beaufort Inlet, although Teach's treasure has never been located.[25]

The golden age of piracy and highwaymen lasted roughly the 75 years from 1650 to 1725, but such crimes continued for decades afterwards, the last case of robbery by a mounted highwayman in Britain being reported in 1831.[26] Nevertheless, by then the swashbuckling images of pirates and highwaymen were burned into the British imagination, becoming a staple of popular entertainment well into the modern day. The success of Stuart Goddard in the guise of Adam Ant and Johnny Depp as Captain Jack Sparrow have proved the timelessness of the appeal of audacious British adventurers, rewriting a bloody reality and swathing it in a nonchalant, anarchic glamour.

With the final years of George II's undistinguished reign, the Early Modern Age in Britain drew to a close, ending two and a half centuries that had seen the British Isles change beyond recognition. When Henry VII raised the crown at Bosworth Field in 1485, he had seized a medieval kingdom. By the time George III took the throne in 1760 he was invested with two kingdoms – England–Scotland and Ireland – which had been shattered by the Reformation and political struggles between palace and Parliament. Power had definitively moved from the royal court to Westminster and its Prime Minister, and Britain had begun to project its new-found strength, confidence and influence to the Americas and the Indian subcontinent. As the curtain came down on the age of highwaymen and pirates, Britain entered the Modern Age.

PART IV: MODERN

The Sun Never Sets – Losing the Colonies and Gaining an Empire

Robert Clive
Letter to William Pitt on Opportunities in India
1759

On a chilly winter evening in 1773 around 150 British colonists in New England set to work. They first disguised themselves in the clothes and head-dresses of the local Mohawk people, then made for the waterfront. There, off Griffin Wharf, riding at anchor in the deep water, were *Dartmouth*, *Eleanor* and *Beaver*, all laden with cargo from China. The men rushed aboard the three ships and quickly overpowered their crews. With the voices of the thousands who had met at Old South Meeting House earlier that day still ringing in their ears – 'Boston Harbour a teapot tonight!' – they jemmied open the ships' 342 neatly stacked chests of oriental shrub leaves and dumped their contents into the rolling, cold, murky Atlantic. It was 16 December 1773, and the dramatic act of commercial sabotage would go down in history as the Boston Tea Party.[1]

The destroyed shipment of black and green tea had a value of £18,000 and, if it had been landed in Boston, the importers would have been required to pay customs tax to London. The level of duty owing had recently been lowered – making it some of the cheapest tea in Massachusetts – but the colonists' protest was not about the level of duty. Their issue was a funda-mental sense of outrage that London levied tax in the 13 colonies of America at all. To their minds, since they sent no MPs to Westminster's Parliament

they could not see why they should pay taxes imposed by it. After talking had got them nowhere, the nocturnal harbour protest was intended to be an action that Britain would notice.[2]

The tension leading to the Boston Tea Party had begun after the British Prime Minister, William Pitt the Elder, sent troops to fight alongside the American colonists in the recent French and Indian War, which quickly merged into the Seven Years War back in Europe. In Britain, Pitt was a national hero, overseeing a string of military triumphs that culminated in his 1759 *annus mirabilis*, when Horace Walpole noted that, 'Our bells are worn threadbare with ringing for victories.'[3] Pitt had understood the strategic importance of the war in the colonies, and dispatched skilled military commanders like Jeffrey Amherst, John Forbes and James Wolfe to prosecute it. The result was a crushing success and, at the Treaty of Paris in 1763, France ceded Canada to Britain along with everything it owned east of the Mississippi. It also gave Louisiana to Spain, while Spain handed Britain Florida in return for Havana.[4] The result was the almost total loss of French influence in the Americas, while Britain dramatically expanded its territory and influence on the continent.

Britain's military assistance had pleased the colonists, but the campaign left Westminster with a hefty bill, and MPs voted to cover it by increasing the taxes levied across the 13 colonies.[5] The result was an indignant rallying cry among the colonists of 'No taxation without representation', which soon turned into civil disobedience. The mood then grew uglier in the face of growing intransigence on both sides, and the Boston Tea Party marked a material escalation in the dispute. Westminster responded with a package of punitive measures – known in the colonies as the Intolerable Acts – imposing direct rule by London in Massachusetts, closing Boston Harbour until compensation had been paid to the owners of the tea cargo, bringing in onerous obligations for quartering British troops, and allowing royal officials accused of offences to be tried back in Britain rather than the colonies.[6]

Affronted by these measures, 12 of the colonies began to collaborate for the first time, coming together in a new assembly they named the First Continental Congress. It met in Philadelphia, Pennsylvania, from September to October 1774. Samuel Adams – leader of the Boston Tea Party – was present, along with a veteran commander of the French and Indian War named George Washington. The Congress resolved to remain loyal to King George III and his representatives, but no longer to submit to laws passed in Westminster. To demonstrate their resolve, they simultaneously implemented a hard-hitting package of economic sanctions on British trade.[7]

No longer seeing themselves as bound to Westminster's laws, the colonists filled the legislative gap by creating Provincial Congresses for the individual colonies. This act of defiance inevitably stoked tensions with Britain higher, making military confrontation increasingly likely. The standoff finally came to a head on 19 April 1775 on the tranquil green at Lexington, Massachusetts, where 700 British redcoats ran into around 70 'minutemen': colonial militiamen who could be ready for combat in no more than one minute. Neither side's commander gave an order to engage, but the crack of a shot snapped through the air – no one knows from whose musket, or from which side – and the redcoats then loosed off a volley into the minutemen. Almost by accident, the American Revolutionary War had begun.[8]

As the violence spread, political developments moved swiftly in parallel. The 12 colonies that had established the First Continental Congress were joined by Georgia, and then all 13 colonies held a Second Continental Congress. Among the delegates were two men – Thomas Jefferson and Benjamin Franklin – who were both to prove pivotal in what was to follow. Now that armed conflict was under way, the Second Congress voted for full military engagement and to establish a rebel army, which they put under the command of George Washington and armed with weapons covertly supplied by France.

The initial impetus for the colonists' protest had been to secure greater democratic rights within a reformed framework but, as the Second Congress ran into the following year, its mood changed to a demand for independence. The wider body of colonists fell in behind this stance, many of them inspired after reading *Common Sense*, a passionate pamphlet written by Norfolk-born Thomas Paine, who had recently emigrated from Britain to Pennsylvania and enthusiastically taken up the cause of revolutionary independence.[9]

Emboldened, on 4 July 1776 the Congress unilaterally – although with New York abstaining as its representatives could not get permission in time – pronounced the independence of the 13 colonies and adopted a vote they had taken on the subject on 2 July. They made the declaration itself in rich, idealistic terms, written primarily by Thomas Jefferson, radiating the political spirit of the Enlightenment.[10] 'We, therefore, the Representatives of the united States of America, in General Congress, Assembled, appealing to the Supreme Judge of the world for the rectitude of our intentions, do, in the Name, and by Authority of the good People of these Colonies, solemnly publish and declare, That these United Colonies are, and of Right ought to be Free and Independent States; that they are Absolved from all

Allegiance to the British Crown, and that all political connection between them and the State of Great Britain, is and ought to be totally dissolved.'[11]

Away from the Congress chamber, the armed struggle for independence intensified, with both sides digging in for a war of attrition up and down the eastern seaboard. It was, at first, a purely British civil war, but it became international when France, Spain and the Netherlands joined with the rebels against Britain. The pendulum swung indecisively in both directions until the showdown came on 19 October 1781 at Yorktown, Virginia, where colonial and French land and naval units forced the surrender of senior British commander General the Earl Cornwallis.[12] Hostilities continued sporadically for two more years before petering out, and the war formally came to an end at the Treaty of Paris in 1783, in which Britain recognised the independence of the United States of America. It had been just over eight years since hostilities commenced at Lexington, and the rancorous war had left a visceral residue of hostility and enmity between the two nations.

Although the rebellion had been political and constitutional, it had also been profoundly economic, as the colonists were fighting over taxation rights. The conflict also had a wider economic context for the British beyond the taxation revenue, as the tea dumped from the three ships into Boston Harbour did not belong to a group of anonymous merchants forgotten to history. It was the property of one of the world's most powerful organisations, the East India Company, a British commercial corporation with vast global monopolies on international trade. It was wealthier and more powerful than many countries, with headquarters on London's Leadenhall Street on the site now occupied by Richard Rogers's futuristic Lloyd's building.[13]

'The Company', as it was known, was already ancient by the time of the Boston Tea Party, having begun life when Shakespeare was at the height of his career. It received a royal charter from Elizabeth I on 31 December 1600 addressed to 'The Governor and Company of Merchants of London, Trading into the East-Indies', granting it a monopoly on all trade in the enormous area between the Cape of Bona Esperanza (Good Hope) and the Straits of Magellan.[14] Historically, large-scale business ventures had been financed by guilds, wealthy families, their participants, or a combination of all three. In the thirteenth century, royally chartered companies formed for specific projects appeared, granting merchants official monopolies in return for supplying capital to the venture. Monarchs were keen on this arrangement because, in times of financial need, they could call on favours from the grateful merchants. Tradeable shares also appeared in the thirteenth century,

but it took until the end of the Tudor and start of the Jacobean period for a recognisably modern form of company to emerge. This involved disparate groups of investors providing capital in return for a fixed ownership stake that brought with it a right to receive a *pro rata* share of the distributed profits. These ownership stakes were represented by shares that could be freely bought and sold at a price reflecting the market's view of the company's value. The undertaking was called a joint stock company, and it allowed the creation of permanent businesses that did not have to liquidate after each venture and facilitated access to funding on an unprecedented scale. The same fundamental principles of broad ownership, *pro rata* distributed profits, and permanent, tradeable shares priced by market sentiment are still the key characteristics of most forms of western trading company.[15]

Immediately on incorporation in 1600 the Company financed its first voyage to the East as a one-off venture, raising £68,373 (£9.4 million in modern money), at the end of which investors were repaid with profits.[16] These turned out to be very enticing for those who were prepared to wait for the ships to return from their round trips. The Company's tenth voyage, for instance, earned a return of 148 per cent.[17] After a total of 12 expeditions financed this way, the Company moved to a more refined model in 1613, inviting public subscriptions for shares to cover a number of expeditions, which proved to be an even more successful arrangement. Finally, in 1657, the Company reorganised itself into a fully fledged joint stock company with permanent share capital.[18] In so doing, it became one of the world's earliest recognisably modern companies. Although it was not the very first. That was the *Vereenigde Oost-Indische Compagnie*, the Dutch East India Company, which had been formed in 1602.[19] Nor was it the first in England. But it was by far and away the most famous, ambitious, ruthless and successful of the early joint stock companies.

The Company's business objective was summed up in its name. It aimed to acquire spices directly from the East Indies – today's South-East Asia – thereby avoiding the inflated prices of the resellers in the Middle East. At the time, Britain's wealth lay in wool, but the Company soon found that spice traders in the East Indies had no interest in sheep's pelts, and were much more enticed by luxury fabrics and silks. The Company therefore hunted about for a solution, and found it in the Indian subcontinent, where merchants were happy to sell the Company and its 'writers' – as its men were known – as much luxury fabric as their ships could carry. The Company therefore became a specialist in Indian affairs, with Company writers settling permanently in the subcontinent and becoming expert in the intricacies of

the region's micro-economies and politics. In time, the Company grew so committed to its Indian trade that it built three controlling hubs, or Presidencies: at Bombay on the west coast, Madras on the east coast, and Calcutta in the far north-east on the Bay of Bengal.

Eager to return as much profit as possible to shareholders, the Company was always looking for new opportunities. One of the most exciting proved to be mainland China, where it was able to acquire silk, porcelain, and especially tea, which was not grown anywhere else. However, the Chinese displayed little interest in any of the Company's wares aside from silver and, when supplies of that grew low, demanded opium, so the Company set up opium cultivation plants in India, then sold the drug into China to fund its now enormous tea trade.[20]

As the Company's three Indian Presidencies became ever wealthier from this luxury international commerce, amassing and storing the assets and profits of its lucrative trading, it began building up a private army to guarantee security over its interests. In a deliberate policy, it raised these troops locally, beginning military connections and traditions between Britain and the subcontinent – as with the Gurkhas of Nepal – that would long outlive the Company.[21]

Seventeenth- and eighteenth-century India was wealthy beyond any nation in Europe. But the Mughal empire that had held most of the subcontinent together for centuries was beginning to fracture.[22] To observant watchers of its intricate power structures, an opportunity was emerging to exploit the subcontinent's growing vulnerability. And it was an Englishman who would do it. Robert Clive was born in Shropshire in 1725, three years after Samuel Adams in New England. But while Adams was to find his calling in his home town – as a rebel politician bent on throwing off British rule – Clive would discover his vocation thousands of miles from home, laying the foundations of British India.

As a boy, Clive was untalented and disruptive, his main achievements being fighting and acts of daring.[23] When he left school his father secured him a position as a junior with the Company and, in 1744, aged 18, he arrived at Fort St George in Madras. At first he was bored and unhappy, and he soon attempted suicide. However, when the French sacked Madras and he escaped to a nearby Company base which he helped fortify and defend, he discovered his calling, and transferred to the Company's military arm. He was soon spotted as a talent, and offered rapid promotion on the strength of a string of military successes. Within a decade he was a seasoned battlefield commander, with a deep knowledge of India, and especially its exploitable weaknesses.

By 1757 the Company was becoming concerned that hostilities in Europe between Britain and France could spill east into India, so began

heavily fortifying its Indian centres of operation. In Bengal, the local ruler, Nawab Siraj ud-Daulah, became alarmed at the Company's increased militarisation and mounted a pre-emptive strike, seizing the Company's base at Calcutta. Flush with success, he incarcerated 146 captured Europeans in a small lock-up, which accounts reported was only 5.5 by 4.0 metres in size. The next day, it was said, just 23 of the prisoners were still alive. Although the numbers were almost certainly exaggerations, the 'Black Hole' of Calcutta became a cause célèbre in Britain as a demonstration of the cruelty of the Mughal rulers and a justification for what was to follow.

As international tensions rose, Siraj ud-Daulah began talks with France, with which Britain was now on the brink of the Seven Years War. The Company took the Nawab's actions as proof that he was a threat to their security and prosperity, and resolved on replacing him with someone more sensitive to their interests. Sabre rattling escalated on both sides until 23 June, when the armed forces of the Nawab and the Company met at Palashi, often anglicised as Plassey. The Nawab was at the head of 50,000 men, while the Company's forces ranged under Clive numbered around 3,000. It would be a David and Goliath fight.

In the 13 years Clive had been in India, he had grown to be a skilled military tactician and a born intriguer with a deep love for backroom chicanery. Ahead of the showdown, he had made secret plans with one of the Nawab's commanders, Mir Jafar and, at a critical moment in the battle, Jafar and his forces deserted the Nawab. This came after a rainstorm had rendered the Nawab's artillery useless, denying him a major tactical advantage. Disheartened, the Nawab's forces began drifting off, and were swiftly routed by Clive's men.[24] Keen to push through plans for regime change, the Company installed Jafar as puppet nawab, and appointed Clive Governor of Bengal. It was a move that proved to be a turning point.[25] For the first time, a British mercantile company had deployed a private army thousands of miles from home, defeated a foreign ruler, and assumed political control of a wealthy region of another nation. This was a company acting as a country.

Eighteen months later, recognising the Company as a new power in India, the Mughal Emperor offered Clive the *diwani* of Bengal, which brought with it the right to run the region's civil administration and collect and keep its taxes. Sensing the significance of the moment – and the possibilities it opened up for future Company activity in India – Clive wrote to the Prime Minister, William Pitt, to suggest that rather than accept on behalf of the Company, he should agree in the name of the British government.

" To the Right Hon. William Pitt,
" One of His Majesty's Principal Secretaries of
State.

" Sir,

" Suffer an admirer of yours at this distance to congratulate himself on the glory and advantage which are likely to accrue to the nation by your being at its head, and at the same to return his most grateful thanks for the distinguished manner you have been pleased to speak of his successes in these parts, far indeed beyond his deservings.

" The close attention you bestow on the affairs of the British nation in general has induced me to trouble you with a few particulars relative to India, and to lay before you an exact account of the revenues of this country, the genuineness whereof you may depend upon, as it has been faithfully extracted from the Minister's books.

" The great revolution that has been effected here by the success of the English arms, and the vast advantages gained to the Company by a treaty concluded in consequence thereof, have, I observe, in some measure, engaged the public attention; but much more may yet in time be done, if the Company will exert themselves in the manner the importance of their present possessions and future prospects deserves. I have represented to them in the strongest terms the expediency of sending out and keeping up

I 4

The Life of Robert, Lord Clive (1836), public domain

Robert Clive, Letter to William Pitt on Opportunities in India (1759)

Sir,

Suffer an admirer of yours at this distance to congratulate himself on the glory and advantage which are likely to accrue to the nation by your being at its head . . .

The close attention you bestow on the affairs of the British nation in general has induced me to trouble you with a few particulars relative to India, and to lay before you an exact account of the revenues of this country . . .

The great revolution that has been effected here by the success of the English arms, and the vast advantage gained to the Company by a treaty concluded in consequence thereof, have, I observe, in some measure, engaged the public attention; but much more may yet in time be done, if the Company will exert themselves in the manner the importance of their present possessions and future prospects deserve. I have represented to them in the strongest terms the expediency of sending out and keeping up constantly such a force as will enable them to embrace the first opportunity of further aggrandizing themselves; and I dare pronounce, from a thorough knowledge of this country government, and the genius of the people, acquired by two years' application and experience, that such an opportunity will soon offer. The reigning Subah [ruler of a province], whom the victory at Plassey invested with the sovereignty of these provinces, still, it is true, retains his attachment to us, and probably, while he has no other support, will continue to do so; but Musselmans are so little influenced by gratitude, that should he ever think it his interest to break with us, the obligations he owes us would prove no restraint . . . Moreover he is advanced in years; and his son is so cruel . . . So small a body as two thousand Europeans will secure us against any apprehensions from either the one or the other; and, in case of their daring to be troublesome, enable the Company to take the sovereignty upon themselves.

There will be the less difficulty in bringing about such an event, as the natives themselves have no attachment whatever to particular princes; and as, under the present Government, they have no security for their lives or properties, they would rejoice in so happy an exchange as that of a mild for a despotic Government: and there is little room to doubt our easily obtaining the Moghul's sunnud (or grant) in confirmation thereof, provided we agreed to pay him the stipulated allotment out of the revenue, viz. fifty lacs [five million] annually. This has, of late years, been very ill-paid, owing to the distractions in the heart of the Moghul Empire,

which have disabled that court from attending to their concerns in the distant provinces: and the Vizier has actually wrote to me, desiring I would engage the Nabob [Nawab] to make the payments agreeable to the former usage; nay, further: application has been made to me from the Court of Delhi [the Emperor's Court], to take charge of collecting this payment, the person entrusted with which is styled the King's Dewan, and is the next person both in dignity and power to the Subah. But this high office I have been obliged to decline for the present, as I am unwilling to occasion any jealousy of the part of the Subah; especially as I see no likelihood of the Company's providing us with a sufficient force to support properly so considerable an employ, and which would open a way for securing the Subahship to ourselves. That this would be agreeable to the Moghul [the Emperor] can hardly be questioned, as it would be so much to his interest to have these countries under the dominion of a nation famed for their good faith, rather than in the hands of people who, a long experience has convinced him, will never pay him his proportion of the revenues, unless awed into it by the fear of the Imperial army marching to force them thereto.

But so large a sovereignty may possibly be an object too extensive for a mercantile Company; and it is to be feared they are not of themselves able, without the nation's assistance, to maintain so wide a dominion. I have therefore presumed, Sir, to represent this matter to you, and submit it to your consideration, whether the execution of a design, that may hereafter still be carried to greater lengths, be worthy of the Government's taking it into hand. I flatter myself I have made it clear to you, that there will be little or no difficulty in obtaining the absolute possession of these rich kingdoms; and that with the Moghul's own consent, on condition of paying him less than a fifth of the revenues thereof. Now I leave you to judge, whether an income yearly of upwards of two millions sterling [£204 million today], with the possession of three provinces abounding in the most valuable productions of nature and of art, be an object deserving the public attention . . . It is well worth consideration, that this project may be brought about without draining the mother country, as has been too much the case with our possessions in America. A small force from home will be sufficient, as we always make sure of any number we please of black troops, who, being both much better paid and treated by us than by the country powers, will very readily enter into our service . . .

Behind Clive's letter was his fear that the Company simply did not have the resources to run Bengal. However, Pitt was not convinced that Clive's proposals were in his political interests, as he was acutely concerned that a sudden inflow of wealth would make the king less dependent on Parliament at a time when he needed George II to toe the line. Pitt therefore advised Clive that the Company should take on the *diwani* itself.

Clive acceded to Pitt's wishes, but it took several more years to make it a reality and required a further Company military victory at the Battle of Buxar in 1764, where it defeated a coalition including the Mughal Emperor Shah Alam II. In its aftermath Shah Alam finally granted the *diwani* of Bengal to 'the high and mighty, the noblest of exalted nobles, the chief of illustrious warriors, our faithful servants and sincere well-wishers, worthy of our royal favours, the English Company'.[26] The appointment brought immense prestige and wealth to the Company, much of which it was then able to plough back into its own proprietary trading activities. It also irretrievably blurred the line between government and private enterprise.

Now the Company had a taste for political power it wanted more, and gradually acquired control of further swathes of India, ejecting the residual French and Dutch presences to make India an almost exclusively British venture. This was achieved so successfully that, by 1818, the Company controlled two-thirds of the subcontinent. Now the taps were turned on, India's wealth flowed to the Company's treasury and to individual Company officers. After the victory at Palashi, Clive had loaded a flotilla of barges with wealth from the Nawab's treasure store – which Mir Jafar had offered him in grateful thanks – and shipped it to the Company's fort at Calcutta. As the Company took over more territories in India, an increasing amount of the nation's wealth made its way into the Company's treasuries and back to Britain in the pockets of Company officials, who returned flush with new wealth and were soon disparagingly known as *nabobs* or *nobs*. It is no coincidence that, at the same time, the Hindi word *loot* entered the English language.

Almost 30 years of intriguing in India had earned Clive the rank of major general, a title in the Irish peerage as Baron Clive of Plassey, and a personal fortune of £500,000, equivalent to £44 million today.[27] He was Britain's most prominent nabob, and divided public opinion starkly, with a steady roll call of voices accusing him of greed, abuse of power, and lining his pockets. At the age of 48, after decades of ill health, nervous disorders and depression, he eventually took his own life in his Berkeley Square house,

either with a penknife to the throat or an overdose of opium. Although no one saw it at the time, by breaking the hegemony of Mughal rule and blurring British corporate, military and political power, Clive was the man most responsible for the British Raj that would soon follow.

The tide eventually began to turn in the early 1800s when observers in Britain grew increasingly concerned at the Company's power, wealth, and complex web of interests reaching into Parliament and the establishment. Warren Hastings – one of Clive's successors as Governor of Bengal – was even impeached in Parliament for corruption, but was acquitted after a dramatic trial that held the nation spellbound.[28] The end finally came in 1857 when the Company's private army rebelled in what the British called the Indian or Sepoy Mutiny, but in India is the First War of Independence. A rumour had started that new cartridges issued for the recently introduced Pattern 1853 Enfield rifle-musket were greased with cows' and pigs' fat, and that the drill requirement for soldiers to bite the cartridge casing open was a dietary religious insult to Hindus and Muslims. The rumour was untrue, but it captured a growing sense of anger that Britain was riding roughshod over many of India's traditional beliefs and values.

In Westminster the rebellion was seen as the last straw, and the perfect opportunity to cut the Company down to size, so the following year Parliament passed the India Act 1858 to nationalise the Company. As a result, all Company property was passed to the Crown, and overnight Queen Victoria became ruler of the Company's possessions in India. It was a dramatic end to an extraordinary experiment in corporate government, and the start of a new chapter – the Raj – with Victoria ruling as Empress of India. The Company's private army was also nationalised, becoming the British Indian Army, which supplied Britain with 1.4 million soldiers in the First World War and 2.5 million in the Second, and remained a vital part of Britain's armed forces establishment until India gained independence in 1947.[29]

With its Indian power base gone, the Company quickly disintegrated and was wound up, bringing to an end an unparalleled corporate story. An Elizabethan shareholder-backed corporation had risen through trade – including industrial-level opium dealing – to govern a nation which it simultaneously and comprehensively asset-stripped for the benefit of its shareholders thousands of miles away, many of whom were MPs woven into a web of interconnected corporate and political interests that were at times impossible to disentangle.

When Clive died in London in the winter of 1774, news of Samuel Adams and the Boston Tea Party had already reached England. Although William Pitt had not acted on Clive's proposal in 1759 to take on the administration of Bengal, Clive's sense that ultimately the British government should assume control of the Company's activities in India proved prescient, as did his assessment that Bengal was only the start, and that other regions of India would follow. He was also clear-sighted about the fact the Americas were 'draining the mother country' while India would fill it with wealth. Clive was, however, deluded when he imagined that Indians would see Britain as 'a nation famed for their good faith' or that Indians would be happy to swap 'a mild for a despotic Government'. The reality was that while India remained fractured it was possible for the Company, and then the Raj, to exploit its resources and population to deliver wealth and military manpower. But the revolt of 1857 and the declaration of independence in 1947 both clearly demonstrate that India had no appetite for vassalage to Britain. In this, it followed the American colonists closely in their timeline to independence, with 177 years from the chartering of Jamestown to the Treaty of Paris and 182 years from the Company acquiring the *diwani* of Bengal to the Indian Independence Act 1947. In both these ventures, Britain learned that ruling, controlling and taxing people thousands of miles away is, in the long term, doomed.

England's Green and Pleasant Land – The Birth of the Romantics

William Blake
And Did Those Feet in Ancient Time
1804–11

In the south-west corner of the great, calm plaza in front of the British Library, overlooked by the bristling, polychromatic steeples of Gilbert Scott's Midland Grand Hotel, there is a hulking bronze sculpture. It is a seated man, hunched forward over his knees, lost in contemplation. In his left hand he holds a large pair of compasses with which he is fixedly measuring something on the ground in front of his feet.

The statue is *Newton*. It was designed by Eduardo Paolozzi in 1995, but the figure comes directly from a print, ink and watercolour by William Blake created sometime between 1795 and 1805.[1] It is a singular choice for the nation's library, as in Blake's original the Enlightenment scientist is seated on an algae-covered rock on the ocean floor, where he is measuring out a circle within a triangle at his feet. He is oblivious and insensible to the dramatic natural beauty and colour around him, and the image grows progressively darker from left to right as his calculations kill the light. The composition is a vision of Blake's despair at what he saw as narrow, reductive Enlightenment thought, which computes everything and experiences nothing. He had used a similar figure in a previous illuminated manuscript entitled *There is No Natural Religion*, in which he etched an isolated,

kneeling, bearded man using a compass to measure a triangle. Over it he wrote 'He who sees the Infinite in all things sees God. He who sees the Ratio only, sees himself only.'[2]

The giants of the English Enlightenment – Bacon, Newton and Locke – were all educated at school and then Oxford or Cambridge, where they became deeply immersed in university life and natural philosophy. By contrast, like most children of the eighteenth century, Blake had no formal academic education, and learned everything he knew at home.[3] He was then fortunate enough to be taken on as an apprentice to begin his practical training. This was not an uncommon path for bright boys, but what set him quite apart was that from a young age he experienced visions. The first came at around the age of 8 or 10, when he saw 'a tree filled with angels, bright angelic wings bespangling every bough like stars'.[4] It was to be the first of many which came to him throughout his life. Years later, his wife would confide in a friend, 'I have very little of Mr. Blake's company; he is always in Paradise.'[5]

As a boy, Blake set his heart on a career as an artist and, at the age of 14, he began an apprenticeship with the etcher and engraver James Basire, who had a studio at 31 Great Queen Street, Covent Garden. For the next seven years he learned everything about etching, engraving and printing, with a hunger for knowledge that impelled him to read widely. Among Basire's clients were the Society of Antiquaries and the Royal Society, allowing Blake to immerse himself deeply in their publications, gaining insights into history and science from some of the country's foremost experts. From these studies he quickly grew passionate about everything medieval, and revelled in a commission he was given to produce illustrations of all the ancient monuments and wall paintings in Westminster Abbey.

Blake turned out to be unusually talented at etching and engraving. When his apprenticeship was over he started out as a journeyman engraver, immediately finding work. Keen to develop his skills as an artist, he also enrolled in the newly established Royal Academy of Arts to gain more formal instruction in drawing and painting. At 24 he married Catherine, a market gardener's daughter from Battersea, and turned their house into a studio. He taught her to read, write, colour, and carry out many of the processes involved in engraving and printing, making them a lifelong creative team which worked on his prints and books together. It was a profound bond that even survived the grave, as after he had died she would spend much of her days in imaginary conversations with him.

Although no one knew it at the time – or used the word – Blake was a pioneer of Romanticism. The movement's adherents rejected the objective reason and logic of the Enlightenment, and instead embraced all that was personal, emotional, imaginative and supernatural. Blake did not think of it in these terms. In his mind he was simply trying to understand the world, which he did by inventing a pantheon of mythological figures to personify the forces and impulses he saw at work all around him in people's lives and in society. He filled books, largely of poetry, with these characters, and illustrated them with hundreds of images. The most important to him were Albion, who represented psychic wholeness but was disrupted by his four sons Urthona/Los, Urizen, Tharmas and Luvah, who respectively embodied the fundamentals of imagination, reason, the senses/body and emotion/sexuality.[6] For Blake, understanding, exploring and embracing these building blocks of human nature shone infinitely more light on the human condition than all the dry, physical measurements of the Enlightenment's scientists put together.

Blake is now fêted as one of the founders and titans of Romanticism but, during his life, he was widely ridiculed and dismissed. A reviewer of an exhibition he held in 1809 above the family's hosiery shop in Broad Street, Soho, summed up Blake's work as 'the ebullitions of a distempered brain', and wrote Blake off as 'an unfortunate lunatic, whose personal inoffensiveness secures him from confinement'.[7] The vindictiveness of the criticism largely broke Blake, who retreated into himself, continuing to produce his profoundly personal art and poetry, but sharing it with almost no one. His world of poems and images only became known to a wider public several decades after his death, when the barrister turned art critic Alexander Gilchrist assembled a biography of Blake with an accompanying volume of images and poems. He left the work unfinished at his death, but the two volumes were completed by the brothers Dante Gabriel and William Michael Rossetti – founders of the Pre-Raphaelite Brotherhood – and when they published them in 1863 Blake became an overnight sensation among Romantics.

By then, Britain had produced many of the leading Romantics in art, poetry and prose, including Barry, Byron, Coleridge, Constable, Flaxman, Fuseli, Keats, Scott, the Shelleys, Turner and Wordsworth. Unlike the Enlightenment – many of whose ideas Britain imported from France and Germany after the foundational work of Bacon, Newton and Locke – Britain was a cornerstone of the Romantic movement, driving it with a

uniquely British vision in which, for the first time since the Reformation, artists and writers were able to look back and celebrate an idealised version of medieval Britain.[8]

Romanticism is usually placed between the 1770s and 1840s, starting in the age of revolutions and lasting through the reigns of George III, George IV and William IV, and the early years of Victoria. It was not only a profoundly counter-Enlightenment movement, but also a reaction against urbanisation and the Industrial Revolution which swept through Britain in largely the same period from the end of the Seven Years War in 1763 to the Europe-wide revolutions of 1848. The heyday of Romanticism, though, was the long and highly eventful reign of George III, who came to the throne as the most promising of all the Hanoverian kings. The country was fed up with the mentally absent George II, whose eldest son had died young, leaving his grandson next in line. The new, young monarch promised to be a breath of much-needed air. Not only was George III a shift in generations – from a 76-year-old to a 22-year-old – but, for the first time since James II's accession in 1685, he would be a king born in Britain with English as his first language.

Despite the goodwill offered to George III by the nation, the first 10 years of his reign were largely disastrous. He was intelligent and engaged, but lacked the subtlety to find a Prime Minister he could partner with, and his desire to exercise real power rather than be a constitutional figurehead put him directly at odds with Parliament in a throwback to the struggles of the Stuarts. His insistence that the British territories in America should remain part of his dominion – with no flexibility over their demands for tax reform – led many to hold him personally responsible for the American Revolutionary War and the loss of the 13 colonies.

Eventually, however, once he worked out how to collaborate with Parliament, his standing improved and he finally found Prime Ministers like Lord North and William Pitt the Younger with whom he could work effectively. He had also come to be liked for his personal habits, as he was modest in his tastes, unostentatious, devoted to his wife and children, and passionate about agriculture, earning him the nickname 'Farmer George'. He was mentally active, fascinated by science and scientific instruments, and keen on reading, supervising the creation of a royal library numbering over 85,000 books, manuscripts, maps and pamphlets.[9] On his death, the collection was bequeathed to the nation, and it is now displayed as the King's Library in the soaring, six-storey glass tower punched through the heart of the British Library.

George III's heir, George Prince of Wales – nicknamed Prinny – was a profound disappointment to his father. He was a dissolute sybarite, dedicated to drinking, gluttony, gambling, whoring and louche living, with the newspapers noting that he could be relied upon to prefer 'a girl and a bottle to politics'.[10] He was everything George III was not, and the father–son relationship was turbulent.

George III's brothers were also a concern to him, especially when two of them married scandalously. Keen to uphold standards, George brought in the Marriages Act 1772 requiring all descendants of his grandfather, George II – although not the children of princesses who married into foreign families – to obtain royal consent for their proposed unions.[11] Although it was too late in the case of his two brothers who had contracted unsuitable marriages, it successfully invalidated Prinny's secret marriage to a twice-widowed Catholic, and nearly two centuries later it would become relevant again when Elizabeth II's younger sister, Margaret, sought approval to marry the divorced Peter Townsend, and Elizabeth initially withheld consent.

After several decades on the throne, George III was now well liked. He was family focused, buying his wife Buckingham House – now Buckingham Palace – and ever-attentive to his 13 surviving children. In public he was admired for his *sangfroid*, which was notably on display in 1800 when he was shot at in the Theatre Royal, Drury Lane, but remained so unfazed he afterwards fell asleep as usual during the interval.[12] He had become the most popular monarch in centuries but, in 1788, disaster struck dramatically and unexpectedly in the form of an acute bout of insanity, rendering him confused, sleepless, and chattering constantly until he grew hoarse and foamed at the mouth. His physicians diagnosed that a humour in his legs caused by not changing out of wet stockings had moved to his bowels. Unable to find a treatment, the court's medical men eventually resorted to constraining the king in a straitjacket until he exhausted himself. In the twentieth century it was widely thought George was suffering from porphyria – a hereditary condition causing bouts of insanity and purple urine – but more recent research indicates it was a bipolar disorder characterised by acute, then finally chronic, mania.[13] It rendered George so ill that a Bill of Regency was prepared for passing power to Prinny, but the king turned a corner three days before it was to come into force, recovered fully, and ruled again without incident for just over another decade until he suffered relapses in 1801 and 1804. He recovered on both occasions and was able to join in the celebrations of Nelson's victory at Trafalgar in 1805.

However, in 1810 he finally went catastrophically insane and blind, and spent the last 10 years of his life in seclusion while Prinny ruled as his regent. He therefore missed one of the highlights of his reign when Wellington defeated Napoleon in 1815 at Waterloo, concluding 12 years of Napoleon's wars that had torn Europe apart.

Prinny's nine-year regency and 10-year reign as George IV turned out to be the disaster George III had feared they would be. Though he took an interest in the arts – notably overseeing the creation of The Regent's Park and Regent Street in London, and building the Brighton Pavilion – his time on the throne was largely a continuation of his drinking, womanising and gambling, ending in obesity, chronic ill-health, laudanum addiction, and virtual isolation. On his death *The Times* noted that he died unregretted by anyone.[14]

William Blake watched it all, living through the reigns of George II, III and IV, the revolutions in the American colonies and France, the Industrial Revolution and the Napoleonic wars. He was fundamentally a radical in most aspects of his thought – spiritual, political and social – and a devoted republican. At the time of the French revolution he did some work for the liberal bookseller Joseph Johnson, who held gatherings of a radical circle that included Thomas Paine – who had returned from firing up the American revolution and was soon to head off to do the same in France – and the feminist and social reformer Mary Wollstonecraft, whose *Original Stories from Real Life* Blake illustrated.[15] He delighted in the group's free-thinking spirit, and was the only one of them brave enough to wear the *bonnet rouge* of the French revolutionaries, although he took it off for ever on learning of *La Terreur*.[16]

Blake was not, though, an agitator. His only serious brush with authority came when he moved temporarily out of London to the Sussex village of Felpham, where he came home one day in 1803 to find a soldier, John Scholfield, in his garden. Scholfield refused to leave, so after trying verbal persuasion, Blake took him by the elbow and ejected him by force, marching him back to his barracks with the soldier cursing and struggling all the way. Scholfield was unhappy at this treatment and reported Blake for having shouted 'Damn the king!' during the incident. Blake was accordingly tried for sedition, but the jury acquitted him when Scholfield failed to produce anyone who had heard the dangerous words.[17]

Despite the acquittal, Blake's political views were edgy for the period, and it is entirely plausible he did yell 'Damn the king!' His religious views

were also unconventional, and may have come partly from his mother who had, for a while, been a parishioner at the Moravian church in Fetter Lane, where she claimed once to have had a vision at a love feast in which 'Our Saviour was pleased to make me Suck his wounds'.[18] Although Blake requested to be buried with the rites of the Church of England, and he dabbled a little with Swedenborgianism as a young man, he went to no organised services of any church during his adult life, and became virulently opposed to what he described as 'Lies & Priestcraft'.[19] Instead, he designed his own spiritual world, which he constantly enriched and reinvented, taking characters from the Bible, mythology and his own imagination, then imbuing them with significance he invented. In his poem *The Everlasting Gospel* he noted, 'The vision of Christ that thou dost see / Is my vision's greatest enemy . . . Both read the Bible day and night; / But thou read'st black where I read white.'[20] Freed from the constraints of organised religion, his views on sexual freedom were equally forthright. 'Abstinence sows sand all over / The ruddy limbs & flaming hair; / But desire gratified / Plants fruits of life and beauty there'.[21] At one stage he tried to deal with sexual liberation in the epic *Vala*, or *The Four Zoas*, which he illustrated with etchings that would have been deemed explicit, but he gave up the project when it became too complex and overwhelming.[22]

Between 1804 and 1811 Blake composed one of his most ground-breaking works, the vast epic *Milton: A Poem in 2 Books*.[23] It recounts a profoundly personal vision of how the spirit of Milton – one of Blake's heroes – enters Blake's left foot and fills him, before the two embark on a journey to save Albion through the power of imagination. On the front page Blake composed a short lyric poem entitled 'And Did Those Feet in Ancient Time', and it has since become one of the most famous in the English language.

And did those feet in ancient time.
Walk upon Englands mountains green:
And was the holy Lamb of God.
On Englands pleasant pastures seen!

And did the Countenance Divine.
Shine forth upon our clouded hills?
And was Jerusalem builded here,
Among these dark Satanic Mills?

Bring me my Bow of burning gold:
Bring me my Arrows of desire:
Bring me my Spear: O clouds unfold:
Bring me my Chariot of fire!

I will not cease from Mental Fight,
Nor shall my Sword sleep in my hand:
Till we have built Jerusalem,
In Englands green & pleasant Land.

––––––––––

Would to God that all the Lords people
 were Prophets
 Numbers xi. Ch 29 v.

Like much of Blake's poetry, the stirring, evocative phrases do not offer themselves to easy unravelling. The first two stanzas rather grandiosely suggest that Christ visited England: a claim not even the medieval Arthurian and Glastonbury legends made, which were content with the humbler notion that Joseph of Arimathea visited and founded the first church.[24] The remainder of the poem switches to a personal, heroic affirmation that the speaker is readying himself or herself as if for battle, and will not cease or stint until the goal of rebuilding Jerusalem in England is accomplished. As with much of Blake's thought, the writing is symbolic, not literal. It does not mean Christ ever visited or built a holy city in England, but evokes the imagery of the biblical book of Revelation, which prophesies that a second Jerusalem will descend from heaven: 'And I John faw the holy City, new Hierufalem, comming down from God out of heauen, prepared as a bride adorned for her hufband'.[25] This vision in turn draws on Plato and his notion that the heavens contain pristine and perfect forms of all ideas and things, while earth merely holds their imperfect imitations. Blake's theme is therefore that once, in the misty past, England had a faith that was heaven-sent, from a realm of perfection, and that he will fight as a soldier, unsleeping and unceasing, to restore it. The symbolism throughout is redolent of his wider imaginary worldscape. The 'dark Satanic Mills', for example, represent the tyranny of dogmatism grinding away at the light of imagination, while the whole universe with its starry wheels is an evocation of Satan grinding up creation.[26] The poem's beauty comes not only from its sparkling language

– many phrases of which have entered everyday English – but also the complex spiritual and historical ideas that underpin Blake's sense of England.

'And Did Those Feet in Ancient Time' was not much noticed as a poem until 1915, when Robert Bridges, the poet laureate, included it in an anthology.[27] Then, the following year, at the height of World War One, he needed a stirring piece of music for an upcoming meeting of the Fight for Right movement, which aimed to stress the spiritual context of Britain's war effort. He asked the composer Hubert Parry to set Blake's poem to a rousing tune that the audience could take up. Parry undertook the task in just one day and, when he handed it over, he pointed to the climactic moment of the 'O' in 'O clouds unfold' as his favourite moment in the composition. The music was duly performed at the Queen's Hall, Langham Place by a choir of 300 voices.[28] It was an instant hit, but Parry soon had doubts. As a deep lover of German music, he was growing increasingly uncomfortable with the Fight for Right movement's nationalism, and within months, he withdrew his permission for them to use the song. Millicent Fawcett of the suffragettes then approached him to ask if her organisation might have it to support the cause of women's votes, and Parry was delighted to give the composition to her, after which it became the suffragettes' anthem.[29] Eleven years later, when women over 21 obtained equal voting rights to men, Parry's executors passed the song to the Women's Institute, who have sung it ever since as their unofficial anthem.

Parry's setting for organ and voices was simple but striking. However, in 1922 Sir Edward Elgar grandiosely re-orchestrated it for the Leeds Festival, and his bombastic, triumphalist version was soon taken up at grand events, becoming a staple of the Last Night of the Proms in the 1950s. It was also adopted by all three main political parties, with Labour continuing to sing it alongside the Red Flag at the close of every party conference. Despite not being a hymn – which the *Oxford English Dictionary* defines as a song of praise to God – it has also become a perennial at English church services, weddings and funerals, with even the future king, William Duke of Cambridge, having it sung at his wedding in 2011. When George v first heard Elgar's setting he professed to prefer it to 'God Save the King', and from 1927 – the centenary of Blake's death – there have been regular public calls for it to become the national anthem of England. Even without that official status, it is now regularly used by English teams at sporting events, and was played at the opening of the summer 2012 Olympics in London, confirming its place as England's unofficial national song.[30]

Blake was buried in an unmarked grave behind the grounds of the Honourable Artillery Company in what is now Bunhill Fields Burial Ground, Islington, which had been opened in the 1660s as a burial plot for nonconformists. John Bunyan and Daniel Defoe already lay there, and Catherine was buried there when she died four years after Blake. Today the site of his remains are marked with words from his poem *Jerusalem*: 'I give you the end of a golden string / Only wind it into a ball / It will lead you in at Heavens gate / Built in Jerusalems wall'.[31] For Blake the political and religious radical, the republican and creator of his own religious world, who died believing no one liked his work, it would come as something of a shock that his *Newton* adorns Britain's national library, and that one of his more opaque poems is played at royal weddings and governmental gatherings, and in churches and football grounds around the country. Britain, he would have to conclude, is significantly more Romantic than he ever suspected.

29

Full Steam Ahead –
The Age of the Machines

John Constable
Salisbury Cathedral from the Meadows
1831

Walled off serenely in a calm green close, the great medieval cathedral at Salisbury sits as a vast stone time capsule from another age. At 123 metres from ground to tip, its dizzying spire is the tallest in Britain, and the dimensions of its tranquil cloisters and languid close are also British record holders. Perhaps most remarkably, the main building was constructed in just 38 years – beginning within a decade of King John's capitulation at Runnymede – and complete by 1258. Recognising this architectural uniqueness, generations of bishops have avoided the urge to rebuild sections in the latest style, leaving the cathedral a rare and pure example of light and airy Early English Gothic.[1]

The cathedral's chapter house holds the country's best engrossment of The Charter of Runnymede (Magna Carta), but even more rare is a cubic iron frame in the nave nestling against the north wall near the great west doors. It stands around 1.25 metres square and 1 metre deep, housing a sparse array of airily spaced mechanics. There are two drums, each wound with a rope that runs through a pulley on the ceiling and ends in a heavy weight. Around the drums, irregularly spaced, are seven differently sized wheels – five with teeth – all connected by a handful of pinions and rods.

The drum and cogs to the right are the 'going train', from which a double-weighted foliot bar protrudes, clunking metronomically every four seconds as it swings from side to side. The left-hand drum and cogs are the 'striking train', which end in a bar mounted with large paddles protruding from the frame. The whole assembly has been dated to 1386 – the generation following the Black Death – and its sole function is to cause the paddles to strike a large bell once every hour. It is, quite possibly, the oldest working mechanical clock in the world.[2]

Aside from the mechanism's significance in the history of horology, it is a reminder that when the machines came in the 1700s, they did not appear – as is often suggested by Whig historians – because of a specific and unique English national spirit and genius born of the Reformation and Enlightenment. The science of mechanics had long been understood internationally, and clocks and intricate machines across the medieval world were employed in telling the time, calculating astronomical movements, raising water, operating trip hammers, and performing a wide range of other functions.[3] The medieval world had even enjoyed making amusing automata robots designed for entertainment. What occurred in England in the 1700s was an evolution not a revolution in engineering, and had far more complex causes than can be explained by a belief in a singular English soul. The age of the machines has no fixed dates, but falls broadly between 1750 and 1850, with the period from the end of the Seven Years War in 1763 to the year of revolutions in 1848 often cited. Its widely accepted name came a little later, in 1884, when the historian Arnold Toynbee published *Lectures on the Industrial Revolution in England*, bringing the name into common use.[4]

In 1830, towards the end of the Industrial Revolution, the Romantic painter John Constable set up his easel in the Harnham water meadows just across the river Nadder from Salisbury Cathedral, and began to paint. Seven years earlier, in 1823, he had captured the cathedral from a different angle, standing in the bishop's garden to the south.[5] Then he had depicted a vast summer sky over the water meadows, cows in the foreground idling and drinking from the River Avon, trees spreading luscious canopies over sun-dappled grass, the bishop, his wife and daughter as small figures gazing on in awe, and the immense, mellow cathedral filling the backdrop. Constable and his contemporary J. M. W. Turner had largely invented English landscape painting, focusing on nature's moods in idyllic countryside scenes, and his 1823 Salisbury Cathedral is a definitive example of the genre. He

exhibited it at the Royal Academy as the centrepiece of his show that year, and it was an instant hit, becoming and remaining among his most admired paintings.

By contrast, seven years later, when Constable stood in the Harnham water meadows to the north-west of the cathedral, something very different began to appear on his canvas.[6] The sky billows in rolling, angry, stormy greys. The idling cows have disappeared, replaced by three horses pulling hard to drag a cart across the river. There is a crumbling gravestone in the foreground – its sepulchral hue matching the stone of the cathedral in the distance – while a bolt of lightning rips across its spire and trees recoil from the drama, their branches pinned back by the gale. The mood is dark, filled with an unsettling anxiety and tension that is not resolved by the slender, dull rainbow slicing through the storm clouds. Constable exhibited the painting at the Royal Academy in 1831, believing it would be seen as his greatest work.[7] To his intense disappointment, the critics struggled to understand what he was trying to convey, and they declared the scene overly theatrical. No buyer came forward either, and the canvas stayed in Constable's studio, where he continued to retouch it until his death in 1837.

The painting is, in fact, rich in context. Constable's childhood friend and wife, Maria, had died in 1829, and the sombreness of the painting's mood – and the scene's inclusion of the gravestone – capture his personal mourning. The picture is also about change. Constable was profoundly concerned by the recent Roman Catholic Relief Act 1829, assailed by the fear it could spell the demise of the Church of England to which he was so strongly attached. Beyond his personal preoccupations, the painting is also imbued with an unsettling apprehension that puts it firmly into the Gothic genre – the Romantic movement's darker side – which summoned the more powerful and frightening aspects of the imagination's journeys into the physical and spiritual worlds. It began with the publication of Horace Walpole's *The Castle of Otranto* in 1764, and grew fashionable in art and literature. As with Romanticism in general, Britain was at its heart, producing two of its most famous tales – Mary Shelley's *Frankenstein, or the Modern Prometheus* and Bram Stoker's *Dracula* – while it also flourished in Europe and the United States, with Edgar Allan Poe's macabre American masterpieces appearing in the 1830s and 1840s.[8]

Compared with Constable's sunny 1823 cathedral, his 1831 version could be another building in a different country. In terms of composition,

one of the most notable differences is the placing of physical work at the heart of the rural scene in the three harnessed horses tugging the cart. The implication is that languid rural life has changed, and any contemporary observer would instantly have reflected on the storm of industrial transformations that had broken across the country.

There was no single act that started the Industrial Revolution. Instead, a century of myriad changes turned England from a country in which 80 per cent of the population lived in the countryside tending the land into one in which half were in towns and cities, working in the creation or logistics of manufactured objects, turning England, in Disraeli's words, into the 'workshop of the world'.[9]

Before the revolution, people lived as they had for centuries, for the most part travelling little and owning only a small number of locally made possessions. A century later, many lived in towns and cities connected by tens of thousands of miles of roads, railways and canals, in houses filled with mass-produced consumables manufactured hundreds of miles away. It was not just an unrecognisable life. It was a different world.

Unlike the American or French revolutions, the Industrial Revolution was not planned, saw no concerted action or violence to bring about its aims, and was achieved by individual entrepreneurs and not the government. It had no defined starting moment, but gradually emerged as machinery, mining, iron casting, textile manufacture, pottery and transport all developed beyond recognition. If it has to start sometime, one of the most significant early moments came in the iron-making industry in 1709, when Abraham Darby smelted iron ore at his ironworks in Coalbrookdale using coke instead of charcoal. The coke was cheaper, more efficient, allowed furnaces to be larger, and yielded better quality iron. This laid an important part of the bedrock of what was to come by allowing many more objects and tools to be produced relatively cheaply from iron, making railways and bridges possible, along with domestic objects like iron cooking pots instead of expensive brass and copper ones.

Water-powered machines were continuously enhanced and deployed, powering much of the early manufacturing progress. These were, however, soon superseded by steam power. Although steam engines had been around since at least the aeolipiles, or 'Hero's engines', of Roman Egypt, the first successful modern steam engine of the industrial era was Thomas Newcomen's atmospheric engine.[10] Because of its beam action, it was mainly used for pumping water out of mines, the first one being in operation by

1712 at the Coneygree Coalworks near Dudley.[11] It only really came into its own when James Watt added a condenser to Newcomen's engine, making it more heat and cost efficient. In 1781 he enhanced it further with a sun-and-planet gear to turn the piston's up-and-down action into rotary power, allowing the engine to be used as a replacement for the water wheels powering manufacturing machines.[12] This had a major impact, as there were limited locations to site water wheels, but Watt's engines could be installed anywhere, driving a rapid expansion in the use of steam-powered machinery. By 1800 there were 1,000 in operation across England.[13]

The other revolutionary use of steam was in transport. In 1802 the tugboat *Charlotte Dundas* was fitted with a steam engine and successfully pulled two barges 19.5 miles along the Forth and Clyde canal, opening up the age of steamships.[14] On land, railways had existed for decades with horses pulling carts along tracks, as at Ffestiniog. The system was ripe for mechanisation and the first successful steam locomotive was soon built by Robert Trevithick. In 1804 it pulled five wagons, 70 men and 10 tons of iron along 9.5 miles of track near Merthyr Tydfil from Penydarren to Abercynon.[15] Within a couple of decades, father and son George and Robert Stephenson had applied the technology to passenger rail transport and, in 1825, *Locomotion No. 1* hauled passengers on a colliery track between Stockton and Darlington.

With the increasing use of water and steam power, a range of industries quickly took off dramatically. England had grown wealthy from wool, and from the mid-eighteenth century its cotton industry had flourished, making textiles from supplies brought back by the East India Company. Manufacture was initially carried out on hand looms, but when these gave way to water- and then steam-powered looms, it allowed production on a wholly different scale. Although John Kay's flying shuttle of 1733 was a landmark invention, the real advance in textile production came in 1769 with Richard Arkwright's 96-spindle water frame and Samuel Crompton's spinning mule a decade later.[16] Powered by these new machines, by 1800 the industry had boomed to such an extent that all social classes in Britain wore cotton as the fabric of choice.

Other industries went through similarly dramatic changes. High-end crockery and china were traditionally the preserve of the wealthy, but Josiah Wedgwood's technological innovations meant he could mass produce a range of high-quality ceramics for a far wider social group and a hungry export market, so that by 1852 England was sending 84 million pottery

items overseas.[17] Wedgwood was also focused on the logistics of distributing his products around the country, and was a keen advocate of the emerging canals, especially those linking Staffordshire to the ports of Hull and Liverpool. In this he was harnessing the latest technologies, as the speed of canal creation around him was breathtaking. The first had been opened in 1757 at Sankey Brook – now St Helens – in Lancashire. Less than half a century later, by 1800, England had 3,000 miles of working canals connecting manufacturers with the country's three main ports at London, Bristol and Liverpool, which emerged as the hubs for national and international trade.[18]

This first Industrial Revolution closed with a vast demonstration of what had been achieved. On 1 May 1851 a colossal exhibition, the 'Great Exhibition', opened in Hyde Park, displaying over 13,000 objects. It was a showcase of 'machinery, science, and taste', housed in an immense glass building – artificial lighting was not possible on such a scale – four times the size of St Paul's Cathedral.[19] The frame was constructed of 2,300 girders and 3,230 columns, all cast iron, covered in 293,655 individual sheets of glass, topped off with a spectacular barrel vault.[20] When it was being built, *Punch*, then in its heyday as Britain's leading satirical magazine, described its architectural style as 'early English shed' but, once the glazing began, settled on the more flattering 'Crystal Palace'. After the exhibition, when the building was moved to Sydenham Hill in South London, the surrounding area inherited the name.[21]

Inside the exhibition hall, half the space was devoted to objects from Britain, the other half given to international exhibitors from as far afield as China. The items on display ranged from heavy industrial machinery to domestic appliances, painting, sculpture, and even a penknife of Sheffield steel with 1,851 blades.[22] The centrepiece at the building's transept, and the highlight of the opening ceremony, was a crystal fountain 8.5 metres high bubbling with carbonated water. It was supplied by Mr Schweppe, who ran the exhibition's refreshment court, and his company still uses the fountain as its corporate logo.[23] Among the more popular exhibits was Hiram Powers's saccharine nude sculpture *The Greek Slave* in the American section. The most compelling exhibit, though, and the greatest demonstration of the age's industrial skill, was the Crystal Palace itself.[24]

Over six million people visited the exhibition between 1 May and 15 October, with the peak on a single day hitting 109,915 visitors.[25] Many used parish savings schemes and train and accommodation packages to visit

London, some organised by Mr Thomas Cook.[26] The exhibition was a national event, arousing enormous excitement with those like Charles Dickens who found it indescribably dull in the minority.[27] Entire villages visited en masse. Lord Willoughby d'Eresby even hired a townhouse in London for his tenants to stay in as rental accommodation was so scarce.[28] Queen Victoria visited 41 times and marvelled at the country's excitement. 'On the morning of the 12th', she wrote in her diary, 'we saw from the windows 3 whole Parishes, Crowhurst, Litchfield & Longford, from Kent & Surrey, (800 in members) go by, walking in procession, 2 & 2, the men in smockfrocks, with their wives looking so nice. It seems that they subscribed to come up to London, by the advice of the Clergyman, & see the Exhibition.'[29] When it was over, profits from the ticket receipts were used to purchase 87 acres of South Kensington – later dubbed 'Albertopolis' – on which was built a range of cultural buildings including the Royal Albert Hall, the Victoria and Albert Museum and the Science Museum, the latter two both receiving many of the exhibition's items as the core of their collections.

Not everyone was thrilled by the industrial miracle. In 1845 the young German philosopher Friedrich Engels visited Manchester. He had read Moses Hess's *The European Triarchy*, and had become a follower of its theory that England's advanced state of industrialisation would lead English workers to be the first to lead a communist revolution.[30] Engels stayed for two years and wrote *The Condition of the Working Class in England*.[31] 'The revolution must come', he exclaimed, 'it is already too late to bring about a peaceful solution.' His cry was part of an emerging debate that would run and run over whether the Industrial Revolution worsened or improved the lives of the working class.[32] The question had begun the previous decade when the poet laureate, Robert Southey, and the Whig historian, Lord Macaulay, had taken diametrically opposing stances on the question. Southey viewed the Industrial Revolution as an evil, while Macaulay concluded that the working classes grew better off as a result of the changes. A few generations later the issue was still being hotly debated. The philosopher Bertrand Russell thought it had brought unspeakable misery, while the economists Friedrich Hayek and John Keynes both rejected his view as unsupported by the facts. Today there is still no consensus, largely because the data is patchy and there are different ways to analyse it, especially if looking at concepts as nebulous as the standard of living.[33] However, it is clear that overall incomes rose: between 1750 and 1850, average real incomes per head increased between 50 and 100 per cent. Life expectancy

also rose, and infant mortality fell. At a national level, the economy transitioned from showing no or little growth before the Industrial Revolution to demonstrating material and sustained growth. As a result, Britain was Europe's dominant economic power for the following century, its towns and cities flooded with goods to be sold, making it a land of shopkeepers.

There were, however, widespread casualties. Certain industries – like hand loom weaving – disappeared in the onslaught of mechanised production. In response to the loss of traditional crafts, from 1811 to 1816 Luddites or 'Ludds' wrote threatening tracts and letters, donned masks and destroyed factory machinery. 'Ned [Ned Ludd, a fictitious name] will assemble 20000 Menn together in a few Days and will Destroy the town in Spite of the Soldiers – no King', read one threatening letter to the authorities in Nottingham.[34] Children, too, were widely used in factories, although they had always been involved in agriculture, and remained so before, during and after the Industrial Revolution. What urbanisation did eventually achieve was the impetus to remove children from the labour market, and the forum to create unions, friendly societies and related political movements to protect workers.

Overall, the British Industrial Revolution blossomed with such vigour that no other country was able to supplant its dominance. The reasons why it began in England and not elsewhere are complex and defy single-cause explanations, lying instead in the delicate balance between power and individuals. Britain had rejected the French model of absolute monarchy with mercantilist economic policies directed from the centre locating wealth into the hands of a few royal favourites, and instead encouraged entrepreneurship. Britain also had an Enlightenment tradition of respect for property – as John Locke had advocated – which was reflected in patent laws that encouraged and protected innovation for the good of the realm.[35] This was underlined explicitly by the Chief Justice from 1756 to 1786, Lord Mansfield, who observed that the law of merchants and the law of the land were the same.[36] In addition, Britain had a single currency and no internal tariffs, enabling businesses to operate nationally with ease. Recent advances in agriculture – like the Norfolk four crop rotation system – were also able to provide food security for the increasing population, which grew rapidly from 11 million in Great Britain in 1801 to 21 million in 1851.[37] This rise in turn created a deep market of consumers who were in employment and wanted to purchase the myriad objects being manufactured, from footwear and clothing to household wares and decorations.

When Constable had produced his 1823 Salisbury Cathedral, his vision had been of a timeless countryside, indistinguishable from the scene that had greeted medieval visitors, although they would have seen much of the cathedral and its statues brightly painted, rather than the mellow stone of Constable's day.[38] Yet by the time he revisited the cathedral in 1831, he seems to have been shaken by the magnitude of the changes that had swept the country in his lifetime. He had, of course, known no period other than industrialisation, but he was as aware as anyone of the sheer scale of the transformation it had brought in every aspect of English life, and his tense portrait of the embattled cathedral captures something of the sense of instability and uncertainty. What he could not have known was that the first Industrial Revolution would be confined to the years surrounding his generation, making it the century of the most dramatic social and economic change in the history of Britain.

Victorian Salons to Bletchley Park – The Rise of British Programmers

Ada Byron
Code for Charles Babbage's Analytical Engine
1843

In World War Two, in the cold depths of the Atlantic, 'wolfpacks' of U-boats hunted the Allies to devastating effect, torpedoing 14.1 million gross register tons of shipping and over 72,000 people to the sea floor.[1] The German submarines operated with extreme stealth, their movements and targets cloaked in multiple layers of secrecy. They kept communications to a minimum, only breaking silence with messages securely encrypted on specially modified Enigma machines, upgraded from the three-rotor army and air force versions with up to eight encrypting rotor wheels. Although the Allies had the technology to intercept the U-boats' Morse traffic carrying these signals, decoding the content was another matter entirely.

The Enigma machine was state-of-the-art encryption technology invented in 1918 by German engineer Dr Arthur Scherbius. He initially aimed it at the commercial market, but its military potential was rapidly appreciated by the German government, which purchased the units for the state. Cryptographers at the Polish Cipher Bureau eventually cracked the Enigma's encryptions in 1932 but, six years later, the German military added further rotors taking it beyond the Poles' resources, prompting them to hand their work over to Britain and France in the hope they could continue it.[2]

At the outbreak of World War Two, British intelligence assigned the code-name ULTRA to the project of decrypting all German military signals intelligence. This top-secret work was undertaken by the Government Code and Cypher School (GC&CS) in a small village of temporary wooden huts dotting the grounds of a nineteenth-century mansion in rural Buckinghamshire an hour from Oxford and Cambridge. To preserve secrecy, the site was blandly referred to as 'Room 47 Foreign Office' or 'War Room X', but is now generally known by its real name: Bletchley Park.

Each hut at Bletchley focused on a different source of signals intelligence, with the bulk of their efforts directed against messages encoded by Enigma and the formidable 12-wheel Lorenz machines used by Hitler and German army high command. To tap into cutting-edge academic expertise for this highly specialised work the government recruited, among others, 27-year-old Alan Turing, fellow of King's College Cambridge, an expert in mathematical theory and logic.

Turing and his team set to work in Hut 8 which, like the others, was windowless, cramped and spartan, and only meagrely furnished with a scattering of utility tables and chairs. Wreathed in pipe and cigarette smoke, they pored over the components and schematics of the mechanical *bomba kryptologiczna* the Poles had engineered to unscramble the Enigma's rotor settings, and experimented with upgrades to cope with the larger and more complex Enigma. They worked ceaselessly, transforming the Polish bombe into a more advanced machine, and its drums whirred and clunked as they cycled exhaustively through endless programmed routines.

The bombe and its process were conceptually simple. When the team in Hut 8 identified a word or phrase of encrypted Enigma text they believed they understood – usually a greeting, name, place, or something similar – they would launch a 'bombe run' for the machine to work out which Enigma rotor settings would generate that particular result. In doing this, they had the help of agents in German-occupied France who could arrange for unusual events to occur near specific German military bases, so Bletchley could then guess the content of Enigma transmissions they knew would soon follow.

Turing was an eccentric, easily identifiable during the hay fever season as the man cycling to and from work wearing a gas mask. Others at Bletchley were also larger than life. One was Gordon Welchman, a fellow of Sidney Sussex College Cambridge who ran Hut 6 focusing on German army and air force Enigma intercepts. In the course of his work he developed vital systems for extracting traffic information from Enigma messages and used

it to build up maps of German military locations and strengths, in effect inventing metadata analysis. He also improved Turing's bombe by adding an additional board that reduced the operating time of an individual bombe run from days to hours or even minutes.

The work at Bletchley had profound consequences on the course of the war. Churchill later called the GC&CS the geese that laid the golden egg but never cackled. Famously in 1941 Welchman's team pinpointed the German warship *Bismarck* after she had sunk the pride of the Royal Navy, HMS *Hood*, killing all but three of its 1,418 men. When the Navy lost the fleeing *Bismarck*, Hut 6 intercepted a message to Berlin from General Hans Jeschonnek, a senior Luftwaffe officer stationed in Athens, enquiring about *Bismarck*'s wellbeing because one of his staff officer's sons was a midshipman on board. At Bletchley, 18-year-old Jane Fawcett was monitoring the conversation and spotted the reply that *Bismarck* was safe and running for Brest. She passed the message up the chain, triggering an urgent interception operation that culminated in HMS *Ark Royal* finally closing on *Bismarck* around 600 miles off western France and destroying her with a loss of over 2,000 lives. 'Ship unmanageable,' read the captain's final communication, on his 52nd birthday, 'We shall fight to the last shell. Long live the *Führer*.'[3]

From 1939 to 1945 the GC&CS grew from a few dozen people to a force of almost 10,000, with Bletchley and its substations eventually running hundreds of Turing–Welchman bombe machines to decrypt the avalanche of Enigma traffic. Although Turing and the bombe are legendary in the history of computing, the bombe, while ingenious, was not a computer. Rather, it was a mechanical device that undertook one single activity: to reverse-engineer Enigma rotor combinations. To be a computer, it would have needed to be capable of running a range of programmes for a variety of purposes.

Bletchley did in fact have one such machine, and it was the GC&CS's best-kept secret. It was designed and built by Tommy Flowers of the Post Office at Dollis Hill in London, then operated at Bletchley by Max Newman, a mathematician from St John's College Cambridge, who used it to decrypt the Lorenz traffic between Hitler and his generals. The machine was code-named COLOSSUS and, after several upgrades, used 2,400 thermionic valves to analyse 25,000 characters of tickertape text per second.[4] Although it was limited in its programmability because it was customised specifically to decrypt Lorenz traffic, its importance to history is that it was the world's very first working, programmable, electronic, digital computer, and its existence was so confidential it remained classified for decades after the war.

Although the Turing–Welchman bombe was not a computer, Turing was very familiar with the idea of programmable machines. Before the war he had laid the basis of modern computer science by describing the mathematical foundations of 'automatic machines' and investigating what was and was not theoretically capable of being computed.[5] He was fascinated by the human mind and how it worked – an interest largely springing from the sudden and traumatic death of his first love, a boy in the year above him at school – and the mourning process led him to ponder the brain and its inner workings. In turn, this guided him to the mathematical aspects of how closely a machine could emulate the brain's abilities to problem solve. This work was groundbreaking, but he was not the first person to conceive of a machine that could be programmed to act like a human brain and undertake an infinite range of tasks. That work had been done almost a century earlier, at the tail end of the Industrial Revolution, by an indefatigable English scientist.

Born in London in 1791, Charles Babbage spent a promising but eventually disappointing few years studying mathematics at Cambridge. He failed to be awarded honours, and left in disgrace after his defence in a disputation on whether God was a material agent was deemed to be blasphemous. He returned to London, and soon established himself as a polymath, publishing on everything from chess to meteorology, geology, astronomy, statistics, lighthouses, and dozens of other topics. He was elected a fellow of the Royal Society in 1816, and in 1828 returned to Cambridge to take up the Lucasian Chair in Mathematics until 1839. Although part of the establishment, he always saw himself as a plain-speaking outsider, and in 1820 wrote a book despairing at the ineptitude of the British scientific community and castigating the Royal Society as useless.[6]

Of all Babbage's many passions, his favourite was producing mathematical tables, and his detailed work on them led him to conclude that machines might calculate and compile them more accurately than people. To test this hypothesis he designed and partially built a machine he called a Difference Engine, which was the first modern, mechanical calculator. The government was interested enough to fund the work, but eventually Babbage fell out with the engineer and the project collapsed in the 1830s after only one-seventh of the engine had been built. In 1991 – the 200th anniversary of Babbage's birth – London's Science Museum built the full engine to Babbage's second specification, demonstrating that it worked exactly as Babbage had described it would.

When the Difference Engine project imploded, Babbage was already engaged in a more ambitious venture, designing what he called an Analytical Engine. He only ever built a tiny part of it, but his schematics were detailed, providing the full specification for a machine that could be programmed to undertake any sequence of additions, subtractions, multiplications and divisions depending on the instructions it was fed via punch cards like those used in Jacquard looms. It was programmable. It could repeat functions, a process now known as looping or iteration. It could make choices based on its results, which is now called conditional branching. Its 'mill' was a processor, and its 'store' was memory. It even had a printer with which it could print its results in ink and typeset complex tables. Without knowing it, Babbage had designed a modern computer.

In 1840 Babbage visited Turin, where he gave a lecture on the Analytical Engine to a group of enthusiasts. One member of the audience – a military engineer named Luigi Federico Menabrea, who would go on to become Italy's Prime Minister – was so captivated by the Analytical Engine that he wrote an in-depth mathematical analysis of it in the *Bibliothèque Universelle de Génève*.

Just under 20 years earlier, the poet and hellraiser Lord Byron had died fighting in the Greek War of Independence. He left behind a widow and one legitimate child, Augusta Ada, although he had sailed from England when she was four months old and never saw her again. His widow was determined that Ada would not turn out like her father – whom she had concluded was insane – and so she encouraged Ada's fascination with science and numbers, engaging the mathematician Augustus de Morgan and the Scottish polymath Mary Somerville as tutors. Ada was responsive, and revelled in the world of scientific knowledge they opened for her, becoming passionate about mechanical science and even designing a steam-driven flying machine.

When she was 17, Ada was introduced to Babbage, and the pair began a lifelong friendship. She started to mix in his social circle, which included Charles Dickens, and became intrigued by his Difference and Analytical Engines. She and Babbage had complementary minds and, when they discovered a joint love of horses and gambling, even set to devising a range of betting schemes. Two years later she married William King-Noel, and three years after that became the Countess of Lovelace when he was made first Earl of Lovelace. On reading Menabrea's paper about the Analytical Engine, she wanted to translate it into English for a wider audience, and consulted with Babbage. He valued her collaboration and work highly – calling her his 'dear and much admired interpreter' – and was delighted

with her suggestion, recommending that she also add some explanatory notes of her own.[7]

Ada's translation appeared in 1843 along with her explanatory notes, which were over twice as long as Menabrea's original article.[8] They are lettered A to G, and contain some of the most important early observations in the history of computer science. Most significantly, she saw what Babbage had not. 'The Analytical Engine', she wrote, 'weaves algebraical patterns just as the Jacquard-loom weaves flowers and leaves.'[9] In this, she had realised that the engine could use mathematics for non-mathematical purposes. 'Supposing, for instance,' she continued, 'that the fundamental relations of pitched sounds in the science of harmony and of musical composition were susceptible of such expression and adaptations.'[10] The engine could therefore run a program, she imagined, that 'might compose elaborate and scientific pieces of music of any degree of complexity and extent'.[11] Anticipating the debates that would arise in the twentieth century around artificial intelligence, she was nevertheless also aware that the system had limits. 'The Analytical Engine has no pretensions whatever to *originate* anything,' she pointed out, observing that people tended first to overrate new inventions, then dismiss and undervalue them.[12] The sum of her observations is that where Babbage saw a sophisticated calculator, she saw a computer.

Scientific Memoirs (1843)

Ada Byron, Code for Charles Babbage's Analytical Engine (1843)

Ada's notes show a penetrating understanding of the engine's capabilities and potential, but her real claim to fame is that in Note G she wrote a program for it. In 25 itemised steps she set out instructions for the engine to calculate a sequence known as the Bernoulli numbers. Babbage had previously written several short sets of illustrative instructions for the engine, so he was the first to write snippets of computer code, but Ada's 25 steps to generate the Bernoulli numbers required the engine to perform a complex set of steps to achieve a defined result. As such, they constitute the first complete computer program.

Bugs have been the bane of coders' lives since programming began and, fittingly, there is one in Ada's code. It is in Operation 21, where a '3' appears in place of a '4' in the third factor of the denominator. Somehow it slipped through the net, missed by Ada, Babbage and the editor. It is almost certainly a typesetter's loss of concentration, given that the page is littered with complex mathematical equations. Typographical slips were not uncommon in hand-set printing: there is also one in Menabrea's original paper in which *le cas de* (the case of) is typeset as *le cos de* (the cosine of).

Unfortunately, Ada was already seriously unwell when she translated Menabrea's article and was taking laudanum for the pain. As her illness worsened she sought solace in gambling, which became a destructive compulsion, even leading her to pawn the family's jewels. Having finally stopped when the illness became too debilitating, she died of uterine cancer the following year aged 36: the same age at which her father had succumbed to a fever in Missolonghi. Despite her mother's successful efforts to keep Ada away from her father – the two never met after he left England within months of her birth – Ada's last wish was to be buried next to him, which she was, in Hucknall, Nottinghamshire.

Once Bletchley Park was shut down after World War Two, the civilian development of computers began in earnest. Following his work on COLOS-SUS, Newman took over as head of mathematics at the University of Manchester, where he set up the Computing Machine Laboratory, inviting Turing to take the post of Deputy Director. The team duly set to work and, in 1948, unveiled the Manchester Small Scale Experimental Machine. Affectionately known as the Baby, it was the world's first fully programma-ble, digital electronic computer, and paved the way for the Manchester Mark 1 and then the groundbreaking Ferranti Mark 1, which was the first commercially available computer. By now similar developments were taking place in the United States, where the ENIAC and UNIVAC machines

followed quickly after the end of World War Two, with American companies developing many of the landmark early computers.

Ada's work remained obscure until she was mentioned in a 1953 book on computing to which, coincidentally, Turing contributed a chapter entitled 'Digital Computers Applied to Games'.[13] Her reputation as a pioneer then grew steadily among the computing community so that when, in 1979, the United States Department of Defense devised a programming language to unite the disparate languages in use across its systems, they named it Ada after her, and it remains in use today.[14]

On 4 October 1957, once World War Two had given way to the Cold War and the arms race, Russia put Sputnik 1 into orbit. This was the first satellite, and it deeply alarmed President Eisenhower of the United States, who immediately allocated resources to ensure America never again fell behind in technology.[15] The decision changed history, as the ensuing American focus on military communications resulted in the development of an interconnected network, an internet, that would eventually become 'the' internet. Meanwhile, in England, a couple that had been part of the Manchester team working on the Ferranti Mark 1 had a son, Timothy Berners-Lee, who followed his parents into computing. In 1989, while working at CERN in Switzerland to devise a company telephone directory, he developed a system for linking information stored on connected computers.[16] The result was hypertext and hyperlinks that allowed users to jump between sources of information on networked computers. Although starting life as an internal CERN directory, it was soon released on the internet as the World Wide Web, and now has over two billion websites.

Turing's aim in his early research had been to understand the extent to which, using mathematics, computers could emulate human decision-making processes. In this he was one of the fathers of the discipline of artificial intelligence, or AI. Although General AI as depicted in science fiction remains fantasy, Specific AI is increasingly a part of daily life, embedded in autonomous vehicles, farming, finance, logistics, manufacturing, medicine, security, sports, and a host of other areas, as well as being behind many of the largest websites, social media and bots. Given AI's power – which is still in its technological infancy – its future scope is a source of anxiety for some. Stephen Hawking, who held the same Lucasian Chair of Mathematics at Cambridge as Newton and Babbage, even cautioned that General AI could spell the end of the human race. The issue, in his view, was not so much who controlled AI but whether, in the long term, it would be possible to control at all.[17]

Babbage continued to develop the Analytical Engine for the rest of his life, although he paused in 1851 to write a book complaining that he had not been invited to help organise the Great Exhibition.[18] In 1946 GC&CS became the Government Communications Headquarters (GCHQ), the most secretive and by far the largest of the United Kingdom's three intelligence agencies.[19] Turing died in 1951 from cyanide poisoning, either by accidental inhalation of fumes created in a chemistry experiment, or on purpose, maybe struggling to cope with the oestrogen therapy he was required to take following a criminal conviction for homosexuality. Welchman went to work in the United States setting up the National Security Agency but, after publishing his memoirs of Bletchley in *The Hut Six Story*, his security clearance was revoked, his reputation attacked, and he died in 1985 trying to clear his name.[20] The most surprising thing of all their stories is – looking back now from an age in which computers are everywhere and the world is living, daily, through the information revolution – that it all started not in the laboratories of World War Two and the Cold War, but in the febrile creativity of Victorian science. Equally remarkable is that from Babbage and Ada Lovelace to Turing, Welchman, Flowers, Newman and Berners-Lee, the computer revolution was as British as the Industrial Revolution.

31

Immigrants of the World Unite!
– Marx's London Capital

Sergeant W. Reinners
Rejection of Karl Marx's Application for Naturalisation
1874

In August 1849 a thick-set, heavily bearded man arrived in England. Having been chased out of Germany, Belgium and France, he had decided to try his luck in London. Together with his wife, Jenny, and their three children, he settled at 4 Anderson Street off the King's Road in Chelsea. However, his money ran out after six months, forcing them to move into squalid rooms in Soho.

There was nothing unusual about the family's relocation to England. Within a few years an editorial in *The Times* would proudly proclaim: 'Every civilised people on the face of the earth must be fully aware that this country is the asylum of nations, and that it would defend the asylum to the last ounce of its treasure, and the last drop of its blood. There is no point whatever on which we are prouder and more resolute.'[1] And a few years later it returned to the theme: 'It is part of our identity to be the refuge of nations . . . From our ancient fusion of many races and hospitality to many refugees we derive both the precedent and the capacity for sympathizing with all the tribes of humanity'.[2] Europe was aflame with unrest and revolutions, and people were on the move. One more family arriving in Britain from across the Channel was not a matter of note.

The man was an obscure political journalist. He was something of a rising star in his small intellectual circle, but largely unknown to the public. Even

in his home town of Trier few had ever heard of him. But in time they would. As would the world. His friends called him 'the Moor' because of his dark looks. The name on his passport was Karl Marx.

In February the previous year – 1848, the year of failed revolutions across the Austrian Empire, France, Germany, Italy and Sicily – Marx had published a limited-edition German language pamphlet which was to become one of the most famous of the nineteenth century. 'A spectre is haunting Europe', it began, with a hint of Gothic mystery, 'the spectre of communism.' The pamphlet was the *Communist Manifesto* (*Manifest der Kommunistischen Partei*), a clarion call to arms laying out Marx's views on the corrosive forces of exploitation and struggle that he believed animated human existence. 'The history of all hitherto existing society is the history of class struggles,' he declared. 'Freeman and slave, patrician and plebeian, lord and serf, guild-master and journeyman, in a word, oppressor and oppressed.' Despite this voyage into the past, Marx was not writing history. This analysis was background, building the case for his assessment of contemporary society, which was to be the bedrock of his entire belief system. 'The modern bourgeois society that has sprouted from the ruins of feudal society has not done away with class antagonisms. It has but established new classes, new conditions of oppression, new forms of struggle in place of the old ones. Our epoch, the epoch of the bourgeoisie, possesses, however, this distinct feature: it has simplified class antagonisms. Society as a whole is more and more splitting up into two great hostile camps, into two great classes directly facing each other – Bourgeoisie and Proletariat.'[3]

For Marx, human history was a continuum of struggle, antagonism, oppression and exploitation. In the industrial world around him, he saw these in anyone whose labour generated profits for someone else. He was especially thinking of factory and manual workers, craftsmen and labourers, but he did not exclude others, and perceived it as a problem at all levels of society. 'The bourgeoisie has stripped of its halo every occupation hitherto honoured and looked up to with reverent awe,' he continued. 'It has converted the physician, the lawyer, the priest, the poet, the man of science, into its paid wage labourers.' Exploitation was everywhere, Marx concluded, to be found wherever anyone sold someone else's work for profit.

Marx's view of history as an eternal struggle of oppositional forces was not original. It had been a highly fashionable view in German philosophy for decades, originating with Georg Hegel, who delivered lectures at Berlin's Friedrich Wilhelm University throughout the 1820s on the largely unknown

subject of the philosophy of history. In these lectures Hegel explored the past as consisting of repetitive cycles of tension leading to conflict and then resolution, only for fresh tension to break out and the cycle to recommence. A key source of this tension, he observed, was people's sense of alienation, of feeling that things affecting their destinies were beyond their control. His conclusion was that only when people took ownership of the things from which they felt alienated could they become whole, have self-knowledge and be free.[4] This cycle of tension-conflict-resolution became known as Hegel's dialectics, and profoundly influenced the young Marx. As a student in Berlin he became active in the Young Hegelians, soaking up the notion that the true end point of Hegel's dialectics was the actual creation, on earth, of a utopian society of free people. But for Marx it went beyond the lecture hall. He wanted action. As he wrote four years before landing in England, 'Philosophers have hitherto only interpreted the world in various ways; the point is to change it.'[5]

There was, however, a key difference between the thinking of Hegel and Marx. Where Hegel saw the cyclical struggle as internal, taking place in the *Geist* – the mind and spirit of the individual and the group – Marx placed the conflict in people's physical day-to-day struggles for economic survival. He saw the unhappiness of the proletariat welling up in alienation from the full profits of their labour, which was being siphoned off to make the bourgeoisie wealthy. Like Hegel's, his solution prescribed taking control of the source of alienation, but not in the *Geist*. Instead, Marx looked to the emerging communist groups inspired by the French revolutionaries, and concluded that the solution could only come in the physical realm from a full-scale workers' revolution to overthrow capitalism. It was a genuinely radical vision, blending Hegel's German philosophy, French revolutionary Jacobin politics and the economics of English industrial capitalism into a demand for the world's workers to institute a completely new economic and social order.[6]

Marx had visited Britain twice before he finally moved to London in 1848, both times with Friedrich Engels, his communist soulmate, intellectual collaborator, best friend and supporter, and personal financier. Engels's father owned a cotton mill in Manchester, and the two friends visited it together in the summer of 1845.[7] Buoyed up by this shared adventure, they turned to activism, transforming the underground League of the Just into the more open Communist League. In the winter of 1847 they returned to England, this time to attend the second congress of the German Workers Educational Association being held off Shaftesbury Avenue in Soho, where they converted the members to the views of the Communist League. Here

they were commissioned to set out the new agenda in a pamphlet that was to appear the following February: the *Communist Manifesto*.

Once settled with his family in Soho, Marx lived in extreme poverty. His understanding of money was theoretical, not practical, and the family existed on the breadline. He secured an appointment as the London correspondent of the *New York Daily Tribune*, but it paid a pittance and barely staved off destitution. Jenny bore four more children, but their living conditions were so dire that only three of the seven survived. When one died, Jenny had to beg the price of a £2 coffin from a French refugee neighbour. Domestic life was desperate. 'At home a constant state of siege,' Marx wrote to Engels. 'Am annoyed and enraged by streams of tears all night long . . . I'm sorry for my wife. She bears the brunt of the pressure, and *au fond* she is right. In spite of this . . . from time to time I lose my temper.'[8]

For six years the family lived in Soho's Dean Street, allowing Marx to walk every day to the round reading room of the British Museum, where he devoured books. Mentally, however, he had grown despondent after realising that the European revolutions of 1848 were over and were not going to catalyse a workers' revolt in England. In an equally disappointing blow, the German workers' organisations in London had pulled away from him and Engels in a climate of bitterness and recrimination over their failure to foment revolution in England. The police also shut down the Communist League – the organisation in which he felt most at home – leaving him politically isolated and without a sense of direction.

It was a desperate time. Jenny headed to France to secure more funds for the family and, while she was away, Marx added a further complication by sleeping with their housekeeper, who became pregnant with a boy, Frederick. Engels gallantly claimed paternity to spare embarrassment, and Frederick was quietly fostered, eventually becoming a toolmaker and activist in the Amalgamated Engineering Union.[9] After the Russian Revolution it is believed the USSR paid Frederick a significant sum to keep quiet about his true paternity, while Stalin buried all papers relating to him deep in the state archives.[10]

Adrift from active politics, Marx threw himself into intellectual pursuits, focusing on writing a grand, sweeping history and analysis of political economics. When Jenny inherited some money and Engels gave him more, he was able to move to 9 Grafton Terrace in Kentish Town for eight years, then 1 Modena Villas in Haverstock Hill for the following eleven years.

Throughout his life, Marx worked with enormous energy on whatever project was consuming him. However, there was a problem. As a colleague

once noted: 'He never finishes anything; he is always breaking off, and then plunges again into an infinite ocean of books.'[11] In the early 1860s, when the American Civil War killed off his work for the *New York Daily Tribune*, the financial pressure became so acute that he applied for a job as a clerk on the Great Western Railway but, unfortunately, was rejected because his handwriting was incomprehensible. All the while, he was working on the book. In 1851 he told Engels of his progress, 'I am so far advanced that I will have finished the whole economic crap in 5 weeks' time.' It was optimistic. After ever more research, the book finally appeared 16 years later, in 1867, under the less-than-catchy title *Capital. A Critique of Political Economy* (*Das Kapital. Kritik der politischen Oekonomie*).[12] To his intense disappointment and disillusionment, it sank without trace.

Fortunately, Marx's political life had been reignited a few years earlier in 1864, when he attended the inaugural meeting of the International Working Men's Association that had emerged from the trade unions and the breakup of the Chartists. The 'First International' gave Marx a new lease of life, and in 1869 Engels agreed to pay off all Marx's debts and provide an allowance, removing his money worries so he could focus on his work. However, the First International soon became riven by fractious disagreements between Marx's pro-state faction and Mikhail Bakunin's revolutionary anarchist followers, and it disintegrated in acrimony. Bitterly frustrated, Marx ceased active involvement in politics and stopped writing and researching with anything approaching his usual vigour. He had lost the will to continue, but was somewhat consoled by the arrival of Engels, who had settled near him at 122 Regent's Park Road, allowing the pair to meet regularly, even when Marx moved a short way from his previous house to 41 Maitland Park Road.

Throughout his life, Marx suffered from poor health. As a young man he had been excused military service for a weak heart, and by the 1860s he laboured with respiratory problems, neuralgia, liver and gall-bladder complaints, rheumatism, headaches and inflamed eyes. Most unpleasantly for him, he also suffered from painful outbreaks of furuncles and carbuncles – including 'right under the place to which Goethe refers'. He wrote with exasperation about these to Engels, who was also, along with everything else, something of a maternal figure for him.[13]

Marx's physicians recommended seaside breaks and spa holidays, and he took them at Harrogate, Malvern, Ramsgate, the Isle of Wight, Jersey, Algiers and numerous places in Germany. In 1874 he planned to visit a spa in Prussia, but was concerned he would be arrested on arrival. His solution was to apply

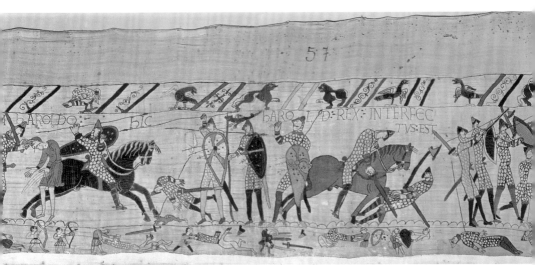

Musée de la Tapisserie, Bayeux, France – Bridgeman Images

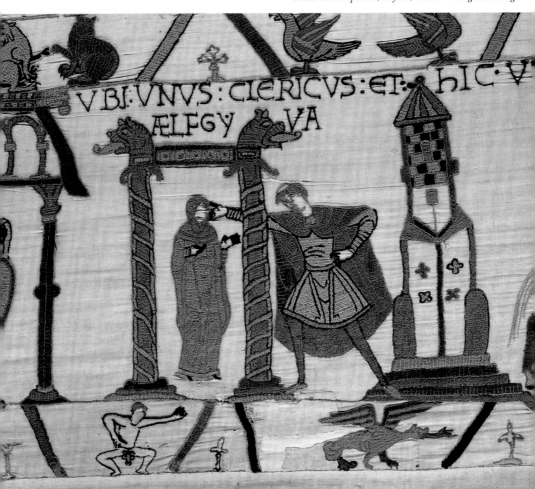

Musée de la Tapisserie, Bayeux, France – © Photo Josse/Bridgeman Images

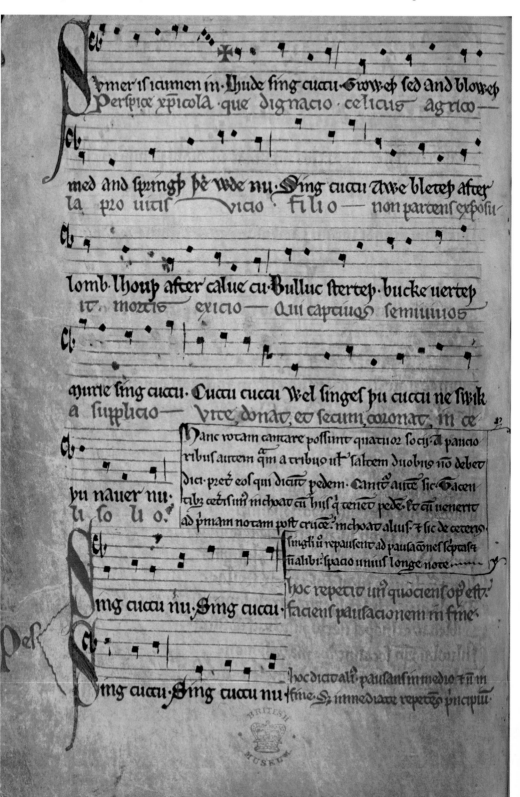

© British Library Board. All Rights Reserved/Bridgeman Images/Harley MS 978, fol. 11v

PREFACE.

The Stolen and Perverted Writings of Homer & Ovid. of Plato & Cicero. which all Men ought to contemn: are set us by artifice against the Sublime of the Bible. but where the New Age is at leisure to Pronounce, all will be set right: & those Grand Works of the more ancient & consciously & professedly Inspired Men will hold their proper rank & the Daughters of Memory shall become the Daughters of Inspiration. Shakspeare & Milton were both curb'd by the general malady & infection from the silly Greek & Latin slaves of the Sword. Rouze up O Young Men of the New Age: set your foreheads against the ignorant Hirelings. For we have Hirelings in the Camp. the Court & the University: who would if they could, for ever deprels Mental & prolong Corporeal War. Painters! on you I call Sculptors! Architects! Suffer not the fashonable fools to depress your powers by the prices they pretend to give for contemptible work. or the expensive advertizing boasts that they make of such works. believe Christ & his Apostles. that there is a Class of Men whose whole delight is in Destroying. We do not want either Greek or Roman Models if we are but just & true to our own Imaginations. those Worlds of Eternity in which we shall live for ever. in Jesus our Lord.

And did those feet in ancient time.
Walk upon Englands mountains green:
And was the holy Lamb of God
On Englands pleasant pastures seen!

And did the Countenance Divine
Shine forth upon our clouded hills?
And was Jerusalem builded here.
Among these dark Satanic Mills?

Bring me my Bow of burning gold!
Bring me my Arrows of desire:
Bring me my Spear: O clouds unfold:
Bring me my Chariot of fire:

I will not cease from Mental Fight
Nor shall my Sword sleep in my hand:
Till we have built Jerusalem.
In Englands green & pleasant Land.

Would to God that all the Lords people
were Prophets
Numbers XI Ch 29.v.

© British Library Board. All Rights Reserved/Bridgeman Images/1859,0625

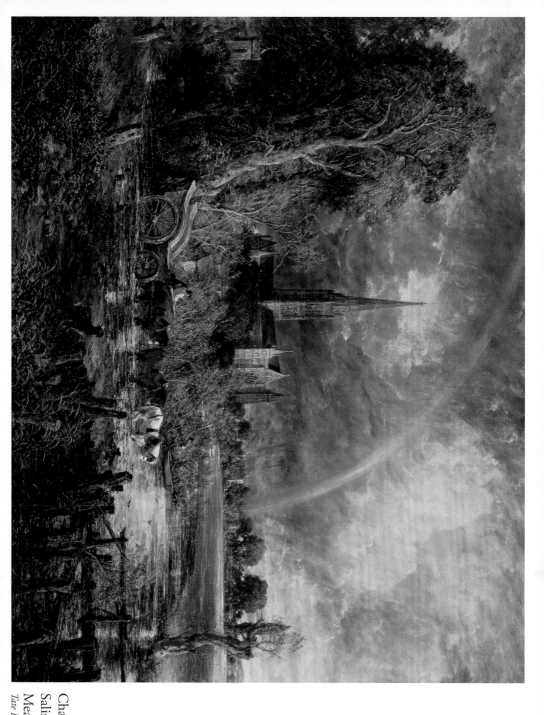

Chapter 29: John Constable,
Salisbury Cathedral from the
Meadows (1831)

Tate Britain/Bridgeman Images /T13896

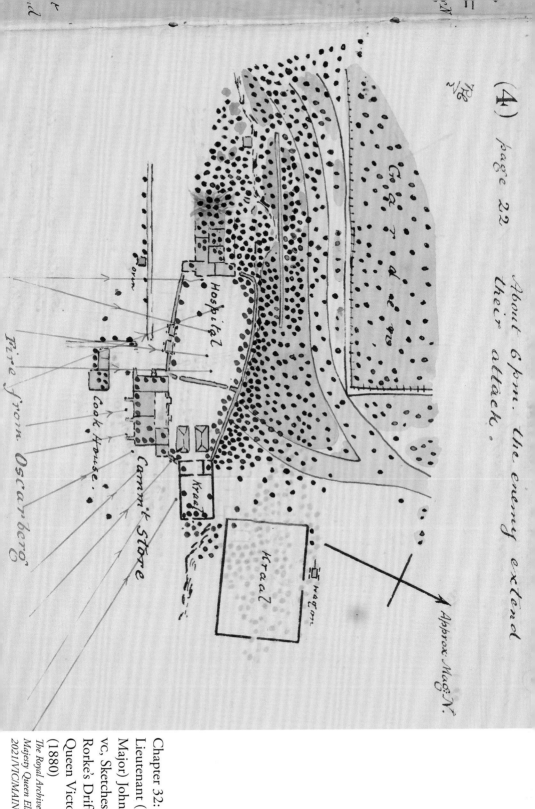

½ R.E.

Approx Mag⁴ N.

Fire from Oscarberg

Cook House.

Comm⁵ Store

Kraal

Kraal

wagon

Hospital

Oven

G. X. 7 a⁵ 9.9

Chapter 32:
Lieutenant (Brevet
Major) John Chard
vc, Sketches of
Rorke's Drift for
Queen Victoria
(1880)
The Royal Archives/© Her
Majesty Queen Elizabeth II
2021/VIC/MAIN/O/46

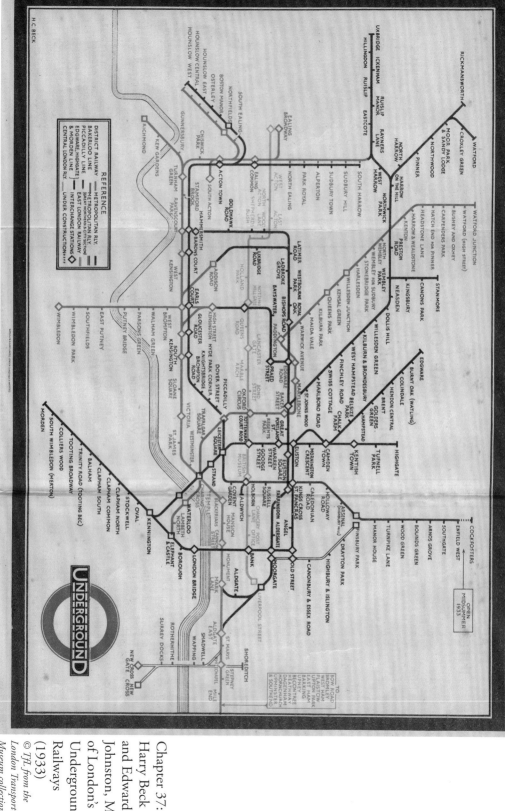

Chapter 37:
Harry Beck
and Edward
Johnston, Map
of London's
Underground
Railways
(1933)
© TfL, from the
London Transport
Museum collection

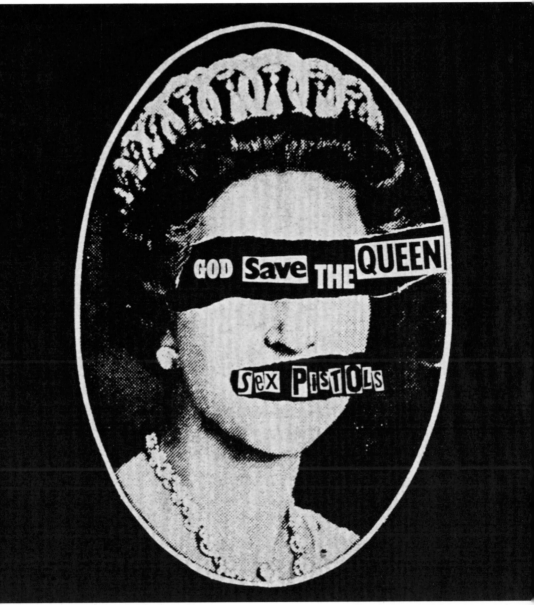

Courtesy of The Advertising Archives

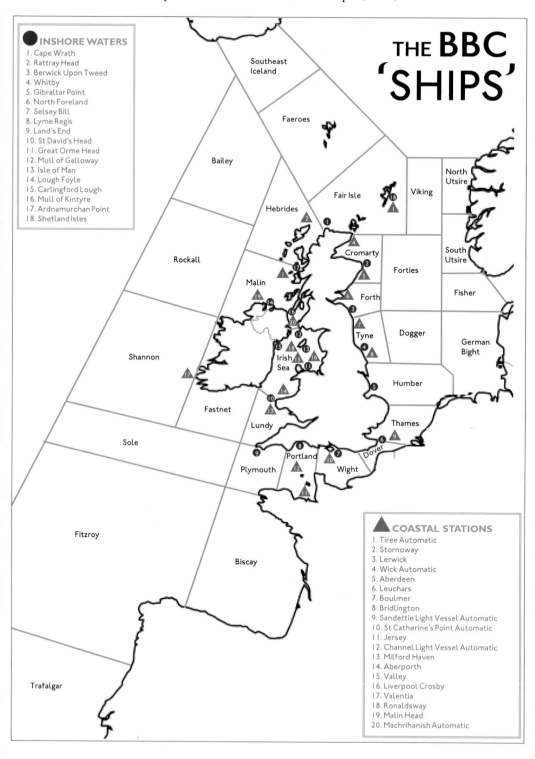

THE BBC 'SHIPS'

● INSHORE WATERS
1. Cape Wrath
2. Rattray Head
3. Berwick Upon Tweed
4. Whitby
5. Gibraltar Point
6. North Foreland
7. Selsey Bill
8. Lyme Regis
9. Land's End
10. St David's Head
11. Great Orme Head
12. Mull of Galloway
13. Isle of Man
14. Lough Foyle
15. Carlingford Lough
16. Mull of Kintyre
17. Ardnamurchan Point
18. Shetland Isles

▲ COASTAL STATIONS
1. Tiree Automatic
2. Stornoway
3. Lerwick
4. Wick Automatic
5. Aberdeen
6. Leuchars
7. Boulmer
8. Bridlington
9. Sandettie Light Vessel Automatic
10. St Catherine's Point Automatic
11. Jersey
12. Channel Light Vessel Automatic
13. Milford Haven
14. Aberporth
15. Valley
16. Liverpool Crosby
17. Valentia
18. Ronaldsway
19. Malin Head
20. Machrihanish Automatic

Southeast Iceland

Faeroes

Bailey

Fair Isle

Viking

North Utsire

Hebrides

South Utsire

Rockall

Cromarty

Forties

Fisher

Malin

Forth

Shannon

Tyne

Dogger

German Bight

Irish Sea

Humber

Fastnet

Lundy

Thames

Sole

Plymouth

Portland

Wight

Dover

Fitzroy

Biscay

Trafalgar

for a British passport in the hope that the British government would protect him from incarceration in Prussia. He therefore submitted an application for naturalisation, anglicising his name to 'Carl' and describing himself as a doctor of philosophy and author. Most requests for naturalisation were passed with little enquiry, but Sergeant W. Reinners of the Metropolitan Police took a special interest in Marx's application, and wrote a report on it.

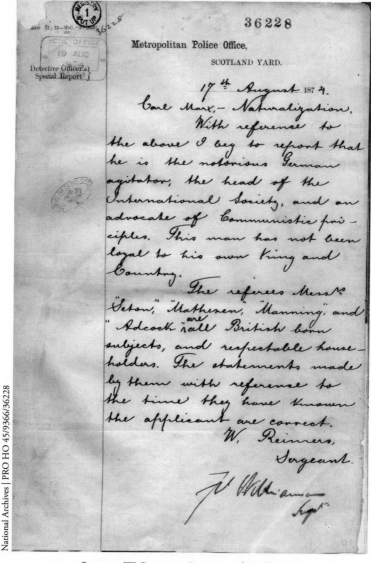

National Archives | PRO HO 45/9366/36228

Sergeant W. Reinners, Rejection of Karl Marx's
Application for Naturalisation (1874)

36228

Detective Officer's
Special Report

Metropolitan Police Office.
SCOTLAND YARD

17th August 1874.

Carl Marx – Naturalization.

With reference to
the above I beg to report that
he is the notorious German
agitator, the head of the
International Society, and an
advocate of Communistic prin-
ciples. This man has not been
loyal to his own King and
country.

The referees Messrs
'Seton,' 'Matheren,' 'Manning,' and
'Adcock' are all British born
subjects, and respectable house-
holders. The statements made
by them, with reference to
the time they have known
the applicant are correct.

W. Reinners
Sergeant.

This put paid to Marx's chances, and the application was rejected. Britain
was not ready to adopt him.

Marx continued to live in London. But Jenny – who had worked stead-
fastly alongside him, participating actively in his various organisations and
transcribing his voluminous notes – died of liver cancer in 1881, and Engels
noted with sadness that the loss broke Marx. A year and a month later his

eldest and favourite daughter, also named Jenny, died of bladder cancer aged 37, and Marx shut down, dying two months later in March 1883 while taking an afternoon rest in an easy chair at home. He was buried in nearby Highgate Cemetery in Jenny's grave. Engels spoke movingly at his graveside. 'As Darwin discovered the law of evolution in organic nature, so Marx discovered the law of evolution in human history . . . that human beings must first of all eat, drink, shelter and clothe themselves before they can turn their attention to politics, science, art and religion'.[14]

At the time of Marx's death, *Capital* was largely unknown in Britain, so his youngest daughter, Eleanor, set about translating it into English. Engels edited the manuscript, and it was published in 1888. Eleanor was committed to the socialist movement and became increasingly active in promoting her father's work, but took her own life 11 years later after discovering that her long-term partner and fellow activist had secretly married a young actress.[15] It was not the only tragedy among Marx's children. Just over a decade later, another daughter, Laura, killed herself in a suicide pact with her husband, having given all they could to the socialist movement and fearing the onset of old age.

While sorting through Marx's papers, Engels found unfinished manuscripts for a further two volumes of *Capital*. The second was well advanced, although the third was more a collection of thoughts and ideas. Ever the friend, he set about completing them, and they appeared in 1885 and 1894 as *Capital* parts two and three, subtitled *The Process of Circulation of Capital* and *The Process of Capitalist Production*.

Britain had rejected Marx's application for naturalisation, and its people also largely rejected his revolutionary ideas. The year before settling in England Marx had declared that 'England seems to be the rock against which the revolutionary waves break'.[16] But it never came. The workers of the Midlands and northern factories did not respond to industrialisation as he and Engels had expected, and the revolution they were confident would detonate in England failed to materialise. Britain's trade unions proved to be protective of their workers' rights rather than militant, while the level of antagonism and resentment between the British proletariat and bourgeoisie never reached the flashpoint levels Marx and Engels assumed were inevitable. Whether this was owing to British equanimity or some other reason, its industrial capitalist society failed to self-destruct. Instead, consumerism increasingly took hold, so that by 1960 a journalist was able to joke that 'Marx and Engels have been supplanted by Marks & Spencer, and the sound

of class war is drowned out by the hum of the spin dryer.'[17] When the first large-scale workers' revolutions did come, they were far from England, in distant Russia and China. In Britain it took until 1920 for a meaningful communist party to emerge from smaller revolutionary groups, but the resulting Communist Party of Great Britain never attracted mainstream support, its membership falling from a peak of 60,000 in 1942 to 761 in 2019.[18]

Far more successful was the Labour Party, founded in London in February 1900 by a coalition of trade unionists and socialists, and housing a broad spectrum of beliefs including Marxism.[19] Its original economic programme was conceptually Marxist, with Clause IV of its first constitution of 1918 explicitly calling for a non-capitalist economy 'to secure for the workers by hand or by brain the full fruits of their industry and the most equitable distribution thereof that may be possible upon the basis of the common ownership of the means of production'.[20] The clause was removed in its entirety by Tony Blair in 1995 before the party swept to a landslide victory and three terms in office.

In the earliest days after 1900 many policies of the Labour and Liberal parties were largely interchangeable, and Labour built its parliamentary presence by the Liberals' agreement to stand aside in certain constituencies to help them. From the 1920s onwards Labour overtook the Liberals, and since then Parliament has been dominated by the Conservatives and Labour in a broadly two-party system. Labour has mainly advocated centre-left policies, a notable exception being the period of Jeremy Corbyn's leadership from 2015 to 2020 when the policies shifted to the left with notably Marxist elements. However, despite Labour's sustained success in being one of the country's two principal parties, its time in government has been limited, providing only 6 of the 30 Prime Ministers in office since it was formed, and occupying No. 10 Downing Street for only 37 of its 120 years' existence.[21]

Karl Marx lived in England from the age of 31 until his death at 64. He never held a British passport, but was undoubtedly one of the most influential figures of nineteenth-century London, although not during his lifetime. No other individual in history has devised a political ideology that so many millions have lived under – although, paradoxically, Marx observed that the thing he detested most was servility. The authoritarian, dictatorial, murderous nature of most of the regimes established in his name would have filled him with abject horror.

By the time Marx died in London, Victoria had been on the throne for 45 years and was Empress of India, presiding over a regime that took British commerce, finance and industry to the subcontinent and beyond. Far from decaying and shrinking, capitalism was expanding. Marx watched all this, and was in London for the technological highlight of her reign – the Great Exhibition of 1851 – which he visited. While many marvelled at what Thomas Hardy called 'a precipice in time', Marx was unimpressed, describing it as an 'emblem of the capitalist fetishism of commodities'.[22]

Whatever twentieth-century regimes may have done in his name, Marx was a gifted and original thinker. Yet regardless of how penetrating some of his insights were, the tide of western history was against him. His analysis of the mechanics of capitalism – of how those with money make yet more off the labour of others – is as arresting now as it was in his day. But he was wrong in his fundamental belief that capitalism's workers were enraged by the system and yearned for class war. It turned out that most of them were happier than those living under regimes that had overturned capitalism, and ultimately his obsession with revolution was an ideological *idée fixe* from the late 1700s, which by the late 1800s was shared by almost no one outside his small circle.

Communist-Marxist regimes have come and now largely gone. In the main, they have demonstrated that communal ownership has not led to utopia but instead to people clashing over other scarce resources like power and status, while the masses remain largely alienated. The sight of East Germans in 1989 smashing down the Berlin Wall and dancing on the rubble to flee a communist system and embrace a capitalist one would have shocked Marx profoundly, as would the lack of intellectual freedom at Berlin's Friedrich Wilhelm University – solidly inside the communist side of the city – where he, Engels and Hegel had formulated so many of the ideas that would dominate their lives. Marx was a visionary Londoner, but his political ideas have never resonated with the majority of British people – who, since throwing off Oliver Cromwell, have shown no significant appetite for revolution.

32

Men of Harlech –
Weaving a Tale in Zululand

Lieutenant (Brevet Major) John Chard VC
Sketches of Rorke's Drift for Queen Victoria
1880

On the eastern coast of South Africa, between the towering Drakensberg mountains and the Indian Ocean, the land is fertile and the climate kind. Shaka – first great Chief of the Zulu – granted a strip of this coastline to British traders in 1824. They built the town of Port Natal there, soon renaming it Durban in honour of General Sir Benjamin d'Urban, British Governor of the powerful Cape colony to the south. Fifteen years later, Boer *voortrekkers* escaping the Cape crossed the Drakensberg and seized Durban, but Britain sent forces to expel them before declaring the surrounding region to be the British colony of Natal.

Around 100 miles north-west of Durban – at a spot that is almost the definition of the middle of nowhere – is the isolated, 215-metre-high, craggy rock of Isandlwana. On 20 January 1879 around 2,000 British soldiers made camp there while on an offensive operation into Zululand. The British High Commissioner in South Africa, the Welshman Sir Bartle Frere, had seen how Britain created a confederation in Canada, and was keen to use the same model to link up his various possessions in South Africa.[1] The principal obstacle to this plan was Zululand in the middle of the country, controlled by King Cetshwayo and 29,000 Zulu warriors.

Disraeli's government in London was firm that Britain had no appetite for a war against Cetshwayo, but Frere's mind was made up, and he was confident he could take Zululand before London would be able to react. Cetshwayo wanted peace – a fact Frere knew well – but to set up a *casus belli* he presented the Zulu king with a list of impossible demands including dismantling the entire Zulu military system. When Cetshwayo failed to meet the conditions, Frere placed the matter into the hands of Lieutenant General Sir Frederic Thesiger Lord Chelmsford to oversee the invasion of Zululand.

On 11 January Chelmsford and 17,929 men of the British Army entered Cetshwayo's territory in five columns, each crossing the border at different points.[2] Morale among the soldiers of the invasion force was high. One wrote home, 'I suppose we will give the natives a dreadful thrashing.' Another mused in a letter, 'Although large and powerful, they have not the pluck and martial spirit of Englishmen.'[3] However, none of the troops knew quite how out of his depth Chelmsford was, how little experience of commanding large field armies he had, and how limited his understanding of Zulu fighting abilities or strategies was.[4] The British were also unaware that Cetshwayo was monitoring Chelmsford's advance closely, and had accurate intelligence on the movements of all the British columns. He had decided to focus his counterattack on Chelmsford and the body of troops with him first, hoping that if he could destroy Chelmsford's largest force while his warriors were fresh, it would then be easier to take on the smaller, remaining columns.

Once firmly in Zulu territory, on 20 January Chelmsford and around 2,000 men of No. 2 and No. 3 Columns and their local levies made temporary camp at the rock of Isandlwana. Some of the soldiery saw the outline of a sphinx in the towering rock's shape, which they took to be a good omen as their cap badge had featured a sphinx since the regiment defeated Napoleon at the Battle of the Nile.[5]

Early in the morning of 22 January, Chelmsford and around half of No. 3 Column rode out in the direction of the Mangeni Gorge where, tricked by fires the Zulus had lit there as a ruse, he thought the main Zulu army was massing. As he left, Chelmsford gave Colonel Durnford of No. 2 Column orders to see to the defence of the camp. However, in breach of regulations, he decided not to issue orders for it to be entrenched and the wagons laagered. Believing that the main Zulu army was converging on Mangeni, and confident that any other Zulu force would be far too

overawed to attack a British camp, he did not consider standard defensive precautions necessary.

In the next phase of the deception plan, the Zulus sent a warband out after Chelmsford. Spotting it, Durnford swallowed the bait and immediately set out in pursuit to protect Chelmsford's rear. What neither Chelmsford nor Durnford knew was that the main Zulu *impi* had already run the 55 miles from their capital at Ulundi and was camped within a stone's throw of Isandlwana. When a small British reconnaissance party accidentally stumbled on the 20,000 Zulus sitting in regimental order, all element of surprise was gone and, with nothing to be gained from delay, the Zulus moved immediately against Isandlwana.

On seeing the advancing Zulus, the British soldiers at Isandlwana were relaxed, confident they posed no threat. A junior officer, Lieutenant Henry Curling, later recalled, 'We congratulated ourselves on the chance of our being attacked, and hoped that our small numbers might induce the Zulus to come on.'[6] Their optimism also came from being heavily armed with field artillery, rockets and new Martini-Henry rifles, and knowing that the Zulus only had a few firearms and were mainly equipped with *assegai* spears – six-foot versions for throwing up to 70 yards, and short broad-bladed ones for stabbing – along with *knobkerrie* clubs for bludgeoning, and man-high cowhide shields for defence and battering.[7] All things considered, the British assumed the engagement was as good as won before it started.

The Zulu field commander was Chief Ntshingwayo. At around 70 years old he was an experienced warrior and still a fit soldier, who had run from Ulundi alongside his men. His strategy of attack was the Zulus' trademark 'horns of the buffalo' pincer manoeuvre in which he sent out two armies to encircle Isandlwana. These 'horns' ran wide either side of the British camp, then closed in behind it from five miles apart, pushing the British back into the main Zulu force, the 'head' of the buffalo, which was supported by a second, reserve army behind it forming its 'loins'.

At first, only half the British soldiers engaged with the approaching Zulus, assuming that their superior firepower would bring the engagement to a swift and decisive end. However, despite the capacity of the Martini-Henry to be reloaded quickly, the British rate of fire was slow and measured, focusing on control and accuracy as mandated in the 1874 *Musketry Instruction Manual* written for the older Snider-Enfield. Against a traditional European enemy this tactic was effective, but it proved completely inadequate against thousands and thousands of fast-moving warriors

running constantly at the firing line. In no time, the Zulus began to over-whelm the British positions by sheer force of numbers.[8] In an almost super-natural intervention, at one stage the battlefield was even plunged into the half-light of a solar eclipse. By then, however, the result was not in doubt. When the last gun fell silent, over 1,329 redcoats and African auxiliaries lay dead – stabbed or clubbed to death – with only 55 British soldiers making it off the battlefield alive.[9] It was a catastrophe the like of which the British Army had never experienced.

While the Zulus were washing their *assegais* in British blood, Chelmsford and his detachment noticed the dust rising from Isandlwana, but as Durnford had not ordered the tents to be struck – which would have been the usual preparation for an engagement – Chelmsford assumed he was watching a minor skirmish. He therefore ordered his picnic to be laid out, and dined and chatted convivially with his officers while the slaughter was under way. By the time he arrived back at Isandlwana there was no one left to greet him, just piles of bodies. Many had been disembowelled, which Chelmsford took to be proof of barbarous savagery, but was in fact the Zulu custom of releasing the soul from the flesh before it became trapped in a ballooning corpse.

The bloodbath at Isandlwana – the result of Frere's unauthorised war-mongering, Chelmsford's arrogance and incompetence, Durnford's lack of experience, and an outdated rifle drill – ranked among the worst catastrophes in the history of the empire. Queen Victoria heard the news on 11 February and recorded it with shock in her diary. 'Directly after breakfast, there came a telegram from Col: Stanley to Gen: Ponsonby telling of a great, & most unfortunate disaster at the Cape, or rather more Natal, the Zulus having defeated our troops with great loss & Ld Chelmsford obliged to retire. How this could happen, we cannot yet imagine, but fear Col: Durnford was enticed away. A Cabinet was to be called at once, & large reinforcements ordered out. 30 Officers 70 non commissioned Officers, & 500 men have fallen. It is fear-ful. The Zulus lost more than 3000.'[10] The numbers she recorded of British and auxiliary dead were a gross underestimate and her number of Zulu dead was a wild exaggeration, but the shock in London was profound, and the public reacted with incomprehension that the men of the modern, experi-enced and heavily armed British Army could have been massacred by Zulu tribesmen with spears. Disraeli and senior officials laid the blame squarely on Chelmsford, but he was a particular favourite of the queen, who stood by him and pressured Disraeli hard not to damage the general's career.

To exonerate Chelmsford, supporters put about the story that there had been 60,000 Zulus and that Durnford – who had died a hero's death leading a group in hand-to-hand combat – had brazenly disobeyed orders, rendering him single-handedly responsible for the carnage. Chelmsford even gave this version of events to Victoria, knowing it to be untrue. To repair his reputation and the dignity of the Army, heroes were sought, and found in Lieutenants Nevill Coghill and Teignmouth Melvill, who were reported to have died bravely defending the Queen's Colours. Their heroism was made known to Victoria, who recorded on 1 March in her diary, 'better news from the Cape . . . By a telegram, we know that the Colours of the 24th Regt were found, but the 2 gallant young officers who defended them, were found killed by their side! Too sad!'[11]

As the scale of the disaster sank in, the recriminations against Chelmsford intensified and Victoria was criticised in both houses of Parliament for her letter sending support, encouragement and condolences to her favourite, criticism which she recorded in her diary as 'most impertinent'. However, now that Britain had been bloodied by the Zulus, Disraeli had no option but to finish what Frere and Chelmsford had so incompetently started. Accordingly, in July, a force of 5,200 men marched directly on Cetshwayo's capital at Ulundi, razed it, and annexed Zululand as a British territory.

Despite the inspiring story of Lieutenants Coghill and Melvill defending the Queen's Colours, criticism of Chelmsford and his bungling refused to die down, and something new was needed to move the focus of newspapers away from his incompetence. Eventually, his supporters alighted on a little-known engagement that had taken place shortly after the slaughter at Isandlwana around 10 miles away at an obscure compound of buildings by a drift, or crossing point, on the Buffalo River.

In 1849 an Irish trader named James Rorke had built a frontier post there, using it to sell everything from beads to guns across the river into Zululand. After he died the land was eventually purchased by Otto Witt, a missionary pastor of the Church of Sweden, who turned the storehouse into a chapel. Zulu speakers knew the place as *kwaJimu*, Jim's Place, while the British called it Rorke's Drift. Before invading Zululand, the British had requisitioned the mission from Witt and placed it under the command of John Chard, a lieutenant in the Royal Engineers, whose instructions were to maintain and protect the ponts over the river so the invasion troops could use them.[12]

When Chelmsford had arrived at Rorke's Drift with No. 3 Column and half of No. 2 Column at the start of the operation, he left 139 British soldiers at the compound. Around 80 of them were from the predominantly Welsh 24th Regiment of Foot – later renamed the South Wales Borderers – under the command of Lieutenant Gonville Bromhead. They converted the main house into a hospital for 35 ill and injured men, and transformed the chapel into a commissariat supply store.[13] After the Battle of Isandlwana, and now flushed with victory, an *impi* of around 4,000 Zulus decided to wipe it out.

At around 3 p.m., a cloud of dust near Rorke's Drift heralded the arrival of two riders who told Chard and Bromhead the shattering news of the massacre at Isandlwana. Then, at 4.30 p.m., lookouts at the isolated depot spotted the 4,000 Zulus closing in.[14] Chard and Bromhead immediately considered their options with Acting Commissary Dalton and Surgeon (equivalent to Captain) Henry Reynolds. Their first thought was to abandon the station, but Dalton – a veteran with years of experience – persuaded them that they would be swiftly slaughtered in the open, weighed down with supplies, baggage and the infirm. The only realistic course of action was to stay and defend Rorke's Drift, so they set about fortifying the compound and preparing defensive positions.[15] They punched loopholes through the walls of the hospital and commissary store, then raised a perimeter of mealie bags and wagons along the north and south edges of the central courtyard to connect the two buildings. As a secondary, inner line of defence, they erected a wall of biscuit tins across the eastern edge of the courtyard. However, before the wall was two tins high, the Zulus charged.

Months later, once Chelmsford's supporters had identified that the Battle of Rorke's Drift had been fought with extreme courage, they made it the story of the campaign in the hope of pushing the massacre at Isandlwana off the front pages. To burnish the gallantry of the soldiers involved, 11 of them were awarded the Victoria Cross: more than for any other single engagement in the history of the British Army. By comparison, the gruelling and bloody D-Day beach landings into German-occupied Normandy on 6 June 1944 resulted in one Victoria Cross.

As the officer commanding Rorke's Drift, Chard was fêted as a hero and promoted to brevet major. His dispatch after the battle was held up as a model of gallantry for praising everyone without mentioning himself. Queen Victoria was captivated and invited him to Balmoral, where she presented him with a gold signet ring and he gave her a personal account of

the battle.[16] After dinner, he retired to the billiard room and gave a blow-by-blow account to a group including Colonel Arthur Pickard VC, Victoria's Private Military Secretary, using books and billiard balls to lay out the scene. In his journal, Pickard noted that Commissary Dalton had been as much behind the defensive strategy as Chard, and that Chard was modest, 'not a genius, and not quick, but a quiet, plodding, dogged sort of fellow who would hold his own in most of the situations in which, as an Engineer officer, his lot may be cast'.[17] Chard returned to see Victoria on a second occasion in February 1880 to present her with a written report of the battle, together with five watercolours he had painted mapping out its phases.[18]

The sketches are rectangular, around 20 x 16.5 centimetres, and delicate. They have the feel of a Victorian children's book, as if depicting an imaginary kingdom like Narnia or Middle Earth. The colours are gentle and calming, and all the main features are clearly labelled with skilful simplicity. The first gives the lie of the land, showing the buildings of Rorke's Drift running in a line west to east. The hospital is to the left, with the commissariat store to the right. Between them is an open courtyard with ovens and a cook house to the south. To the right of the store is a small *kraal* for animals, with a larger one beside it, while to the south of the whole complex lies the Oscarberg mountain. And off to the east is the Buffalo River crossing into Zululand with the ponts Chard was responsible for, all carefully labelled. The first picture carried the explanation:

> This sketch is chiefly from memory, and therefore may not be quite correct – but it will give a fairly accurate impression of the relative positions of the House, Oscarberg, Drift, etc –

Ominously, it shows a thin line of dashes sweeping around the west of the Oscarberg and heading to Rorke's Drift labelled:

> 1st Advance of the Zulus

The second picture is a close-up of the complex with the written description:

> Sketch showing the 1st Check of the Zulus and their 1st Assault. About 4-30 p.m.

The image depicts with remarkable clarity what had been done to fortify the buildings. The courtyard between the hospital and commissary store has walls of mealie bags strung across the north aspect and wagons across the south, both creating defensive lines linking the two buildings. The wall of biscuit tins running north–south across the courtyard is also marked out, cutting off the commissary store and *kraal* to create an inner defensive zone. Under it is a key, with a cluster of red blobs labelled 'British' and a similar group of black blobs labelled 'Zulus'. Around the compound, a ring of red blobs guard the unbroken perimeter running in a large loop around the inside walls of the hospital and commissary store, connected by men manning the mealie bag and wagon walls of the courtyard. Further out, black blobs are massing about the hospital, with two already on its northern veranda.

The third sketch shows an alarming increase in black blobs swarming around the hospital and open ground to the north. There are also lines showing Zulu gunfire down from the Oscarberg mountain onto the buildings. Chard's description reads:

A series of Assaults from about 4-30 pm to 6 pm: the Zulus at last, forcing the end of the hospital.

Sketch four shows graphically that the situation was becoming desperate, with the hospital lost. Its roof is on fire, and the building is filled with black blobs being repelled by just a few red ones. Around them, the compound is being pressed from all sides by hordes of tightly packed black blobs, with the label:

About 6 pm. the enemy extend their attack.

The final painting shows a calamitous development. There are densely packed black blobs covering the whole page, running through the buildings and stretching out far beyond. The hospital has been completely lost, as has the courtyard with mealie bags to the west of the store and the *kraal* to its east. The red blobs are now confined to a small inner perimeter defending the biscuit tin entrenchment and outside wall of the *kraal*. The description notes with dramatic understatement:

Darkness – Completely surrounded.

By now the men defending Rorke's Drift were exhausted. They had repulsed wave after wave of Zulu attacks, and still the enemy kept coming. The outcome of the battle was clear, and it was only a question of time before the compound's last defences fell. However, miraculously, at around 4 a.m., the Zulus unexpectedly withdrew. Not fooled, Chard ordered his fatigued men to refortify the depot in anticipation of renewed attacks, and the Zulus duly returned at around 7 a.m. to recommence the assault. However, before they were able to overrun the final defences, a dust cloud on the horizon signalled the arrival of Chelmsford with a relief column, and the Zulus melted away.[19] Despite the strong tradition – born from the 1964 film *Zulu* – there is no record that the departing Zulus sang a warrior's song of respect to the defenders of Rorke's Drift, or that the Welshmen of the 24th Regiment of Foot offered a lusty rendition of 'Men of Harlech' in response. Instead, the records simply show that 17 British and 351 Zulus lay dead around Rorke's Drift, with inconclusive speculation that up to 500 wounded Zulus may have been put to death by Chelmsford's relief column.[20]

Although the contact at Rorke's Drift achieved nothing material towards Frere and Chelmsford's goal of taking Zululand, the soldiers had defended the compound and themselves with newspaper- and novel-worthy heroism, not yielding despite being outnumbered almost thirty to one. Those singled out for the Victoria Cross were Lieutenants Chard and Bromhead, Surgeon Henry Reynolds, Acting Assistant Commissary James Dalton, Corporals William Allen and Ferdinand Schiess, and Privates Frederick Hitch, Henry Hook – who, after retiring, was eventually put in charge of readers' umbrellas at the British Museum – Robert Jones, William Jones and John Williams.[21] Despite the official celebration of their gallantry, Frere's bungled Zulu War was not popular with the British public, and Disraeli's government fell soon afterwards, partly as a result. Cetshwayo was sent into exile in the Cape but when, surprisingly, he moved to London for six months in 1882, he became something of a celebrity, was granted audiences with Queen Victoria and Gladstone, and attracted large crowds outside his Holland Park house in Kensington.

The attempt by Chelmsford's supporters to make Rorke's Drift the most memorable engagement of the Zulu War was successful. Few British people today have heard of Isandlwana. Fewer still know of the final showdown at Ulundi. But many have heard of Rorke's Drift, not least because of the film *Zulu* – which gave Michael Caine his first major role – and regularly features in lists of the most popular British films. Despite the growing sensitivity

and controversy over Britain's colonial presence in Africa and its legacy, the visceral drama of the Battle of Rorke's Drift has ensured its place in popular memory.

In the aftermath of the civil war that followed the Battle of Ulundi, Zululand was absorbed into the British Empire, before becoming part of independent South Africa in 1931 and emerging from the end of apartheid in 1994 as KwaZulu-Natal. Frere's vision of a British Africa had disappeared into the continent's dust. At the last census in 2011 its population was 87 per cent black, and Zulu was spoken by 78 per cent of its people. On 22 January each year, 10 miles from the small museum at Rorke's Drift, Zulus gather at the massive, sphinx-like rock at Isandlwana and celebrate the heroic victory of their forebears, one of whom noted wistfully, 'Nothing but death conquers the white man.'[22]

33

Slaughter in the Slums –
Poverty and Terror in Whitechapel
'Jack the Ripper'
Letter from Hell
1888

Millbank prison once sat, fortress-like, on the north bank of the Thames at Westminster. With its geometric wheel of six pentagonal wings and towers, it opened in 1816, saw the accessions of George IV, William IV and Victoria, and closed when she was an old woman. It brooded on the riverbank while William Blake wove his mystical mythologies, Constable captured his visions of Salisbury Cathedral, Ada Byron was programming Babbage's Analytical Engine, Marx was sweating over *Capital* and Victoria was blanching at news of Chelmsford's bungling in the Zulu War.

The prison had been open four years when George IV came to the throne, and was already full of convicts as he began his lacklustre reign. Politically, little of note occurred in his time on the throne, save for the Duke of Wellington's Catholic Emancipation Act 1829 allowing English and Irish Catholics into Parliament and other high offices, which George resolutely opposed. As he neared the end of his decade on the throne, he was an obese recluse, bedridden, with his health destroyed. He suffered from gout, arteriosclerosis, an inflamed bladder, breathlessness and spasms that blackened his face and fingertips, and possibly porphyria. He bled himself excessively, and self-medicated daily with prodigious quantities of alcohol and up

to 250 drops of laudanum, although none of this diminished his appetite. The Duke of Wellington observed him one morning at breakfast tucking into a pie filled with three beef steaks and two pigeons, a glass of champagne, another of brandy, two of port, three-quarters of a bottle of Moselle, and all of it topped off with hearty doses of laudanum.[1]

George had one daughter, Princess Charlotte of Wales, but she died at the age of 21 after a 50-hour labour that produced a stillborn son.[2] George was therefore succeeded by his younger brother, who took the throne aged 64 as William IV. His seven-year reign was a progressive and active breath of fresh air, bringing critical change that propelled Britain into a more modern age. The Reform Act 1832 abolished the rotten boroughs that had foisted corrupt candidates on Parliament for so long, doing away with 76 boroughs that each had fewer than 100 voters, with 44 of them having fewer than 50 voters each.[3] The following year Parliament also redrew the rules relating to children in factories, and in foreign policy turned Lord Grenville's prohibition on trading in slaves into an outright ban on owning them anywhere in the British Empire, except in the territories of the East India Company, Sri Lanka and Saint Helena.[4] The year after that, Parliament overhauled the poor laws, updating outmoded social legislation that had been in place since the reign of Elizabeth I.

William IV died in 1837 with no heir still alive, so the throne passed to his niece, the 18-year-old Victoria, daughter of the Duke of Kent and Strathearn. The young queen ascended the throne with enthusiasm, delighted finally to be free of her overbearing mother, who had worked ceaselessly to undermine Victoria's confidence in the hope of retaining influence after her accession. Victoria's reign was to be one of the most famous in British history, known for the empire, the Raj, industrialisation, exploration, scientific advances, literature, and a flowering of the *pax britannica*. She would rule a larger territory than any monarch before her, governing almost a quarter of the world's population. For many in Britain – although not the vast majority of her non-white subjects in the empire – it felt like a golden age. Parliament reverberated to the oratory of Peel, Disraeli, Gladstone and Cecil. The Royal Navy policed the world's seas. People around the globe played cricket, read Dickens, and hummed Gilbert and Sullivan tunes. The classrooms and playing fields of Britain's schools taught a generation how to run an empire. And Victoria sat at the centre of it all, receiving tributes from a realm so vast it spanned from the East where the sun rose to the West where it set. Such was the perspective of those who ran

the empire from Britain. The views of those whose countries were governed and taxed by Westminster were quite different.

Beneath it all, the mechanics of British society were becoming more complex. In part this was down to population. When Henry VIII took the throne in 1509 London had 50,000 inhabitants. By the time James I acceded in 1603 it had jumped to 200,000. Two centuries later, in 1800, once industrialisation was under way, it had a million people, and the growth was now unstoppable. Almost a century later, in 1890, when Millbank prison closed its doors, the capital's population had rocketed to 5.6 million. This rapid explosion in the number of people to be employed, housed and fed inevitably brought with it poverty, which was endemic in the slums and rookeries that sprang up across London, with the East End becoming notorious for hardship, degradation, alcoholism, violence and despair. The American writer Jack London lived there for a while and described what he found in *The People of the Abyss*. 'The obscenities and brute vulgarities of life are rampant. There is no privacy. The bad corrupts the good, and all fester together. Innocent childhood is sweet and beautiful; but in East London innocence is a fleeting thing, and you must catch them before they crawl out of the cradle, or you will find the very babes as unholily wise as you.'[5]

In 1887 Victoria celebrated 50 years on the throne. Church bells pealed in celebration across the country and, in the summer, London filled with endless spectacles. Along with only Henry III and Edward III, Victoria had sat on the throne for half a century. However, just eight months after her jubilee year, on 31 August 1888, the mood in London turned to shock when 43-year-old Mary Ann 'Polly' Nichols was found murdered on the cobbles of Buck's Row in Whitechapel. Murder itself was not uncommon, but the brutality of this one was. The killer had cut Polly's throat, then savagely mutilated her abdomen and genitals.

Hopes it would be a one-off were dashed eight days later when 46- or 47-year-old Annie Chapman was found dead in a yard off 29 Hanbury Street in Spitalfields. The killer had slit her throat, mutilated her corpse, and this time taken away her womb and some of her internal organs as trophies. The frenzy of the butchery sent ripples of terror through the East End, as did the news 22 days later when 44-year-old Elizabeth Stride, a Swede, was found dead at Dutfield's Yard off 40 Berner Street. The killer had cut her throat but left the scene quickly, moving westwards into the Aldgate area of the City of London where he found 46-year-old Catherine Eddowes in

Mitre Square. After slitting her throat, he then mutilated her body before carrying her womb and other internal organs off into the night. While evading the quarter-hourly police patrols, he mysteriously left a piece of her blood-soaked apron in a stairwell at 108–19 Wentworth Model Dwellings, Goulston Street, under a message hastily scrawled on the wall reading 'The Juwes are The men That Will not be Blamed for nothing'.[6] A break of 40 days then gave people hope the horrors were over, but on 9 November he attacked 24- or 25-year-old Mary Jane Kelly, an Irishwoman, killing her in a rented room in Miller's Court off Dorset Street.[7] After cutting her throat he used the seclusion of the doss house to indulge himself. The police surgeon who examined the scene estimated that the killer had spent over two hours mutilating and partially flaying her, then removing her internal organs and arranging them under and around the body.[8] As suddenly as they had started, the killings then stopped.

For some in the East End, economic desperation made occasional or full-time prostitution the quickest way to pay for food and shelter. The Metropolitan Police Commissioner at the time, General Sir Charles Warren, estimated that around 1,200 of the 8,530 homeless people in Whitechapel's lodging houses engaged in prostitution, but acknowledged it was impossible to know the real number.[9] Although it is often assumed that the Whitechapel killer targeted prostitutes, he did not. Of the five victims, only one earned occasional money from sex work.[10] All five just happened to be in the wrong place at the wrong time.

The newspapers covered the murders in salacious, lurid detail, stoking hysteria. The cabinet minister Lord Cranbrook noted, 'More murders at Whitechapel, strange and horrible. The newspapers reek with blood.'[11] The publicity and climate of fear prompted hundreds of letters to the police and press, with a significant number claiming to be from the killer. Some were from cranks, others from journalists keen to keep the story alive. But the police took a handful of them seriously.

On 27 September, after the first two murders, the Central News Agency received a letter from someone claiming to be the killer and promising he would kill again. 'I am down on whores and I shant quit ripping them till I do get buckled', it asserted. 'The next job I do I shall clip the ladys ears off'. At the bottom it was signed 'Yours truly Jack the Ripper'. A few days later, on the morning after the double murder of Stride and Eddowes, the same news agency received a postcard in what seemed to be the same handwriting, again signed 'Jack the Ripper' and postmarked that morning. 'Double

event this time number one squealed a bit couldn't finish straight off'. When Eddowes – the second victim of the night – was found to have significant damage to her ear, the police circulated photographs of the letter and post-card widely, and the name Jack the Ripper caught on.

Two weeks later, George Lusk, President of the Whitechapel Vigilance Committee – which had been set up to patrol the streets – received a box wrapped in brown paper and postmarked 15 October. Inside was half a rotting human kidney and a letter in spiky, angry writing:

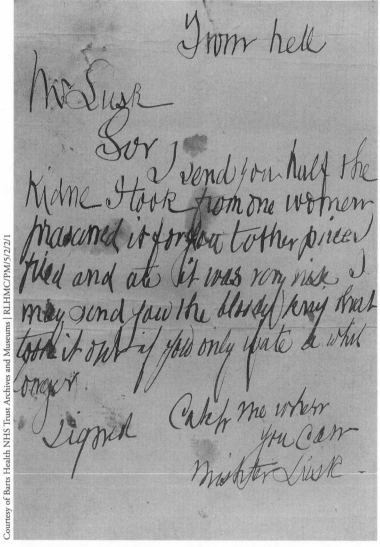

Courtesy of Barts Health NHS Trust Archives and Museums | RLHMC/PM/5/2/1

'Jack the Ripper', Letter from Hell (1888)

From hell

Mr Lusk

 Sor

 I send you half the
kidne I took from one woman
prasarved it for you tother piece I
fried and ate it was very nise I
may send you the bloody knif that
took it out if you only wate a whil
longer.

 Signed Catch me when

 you can

 Mishter Lusk

The authorities faced an uphill task as Victorian policing methods were basic. Fingerprinting and DNA analysis had not been invented and evidence was gathered and recorded haphazardly. By piecing together witness accounts, contemporary newspaper reports and recollections from decades later, it seems that one of Lusk's colleagues then took the box to a local medical practice on the Mile End Road, where a Mr Reed confirmed it contained a human kidney that had been preserved in spirits of wine. It was then examined by Dr Thomas Openshaw of the London Hospital, who was also the curator of its Pathology Museum.[12] He concluded it was part of the left kidney of a heavy-drinking woman around 45 years old, and that it had been removed from a body around the time of the Eddowes murder.[13] However, although witnesses and a newspaper article confirmed this was Openshaw's opinion, an interview he gave directly to the *Star* that day was more tight-lipped and merely noted that it was part of a human left kidney.[14]

According to Acting City of London Police Commissioner Major Sir Henry Smith's recollections in 1910, the box was then passed to a police surgeon, Dr Gordon Brown, who had examined Eddowes at the scene. He inspected the kidney and concluded that it was inflamed with Bright's disease and a good match for the diseased section of left kidney the killer left inside Eddowes. The box was next passed to Mr Sutton, a senior surgeon at London Hospital, who said he would stake his reputation on the fact that the kidney had been put into spirits of wine within hours of death, meaning it was almost certainly not a medical sample as these were normally only harvested after the inquest.[15] No other tests were done, and the box with the

kidney and the 'From hell' letter were eventually lost, along with any opportunity for modern scientific methods to extract any further information from them about the killer or the kidney. However, if Openshaw, Brown and Sutton's views were accurately recorded, it is possible the package was genuinely from the murderer.

Unfortunately the handwriting on the letter cannot be compared with the graffiti reading 'The Juwes are The men That Will not be Blamed for nothing' scrawled on the wall at Goulston Street where the killer left or dropped a bloodstained piece of Eddowes's apron as there are no images of the writing. Commissioner Warren ordered it cleaned off the wall while the police photographer was still en route, anxious that it might further stoke the already high levels of anti-Jewish feeling in the area, as there was a widespread rumour identifying the murderer as Jewish.[16] If, which is not clear, the writing was left by the killer, it might indicate he had read Sir Arthur Conan Doyle's *A Study in Scarlet*, which had introduced Sherlock Holmes to the world the previous Christmas. In the story, the word 'RACHE' is scrawled in blood-red letters on a wall beside a murdered body. While the police assume they are looking for someone called Rachel, Holmes corrects them, observing it is German for 'revenge'.[17]

Queen Victoria knew about the murders, and mentions them in her diary on Thursday 4 October. 'Dreadful murders of unfortunate women of a bad class, in London. There were 6, with horrible mutilations.'[18] She was wrong about the number – only four of the 'canonical five' had been killed by then – but she may have been including two other Whitechapel victims: Emma Smith, a 45-year-old woman stabbed on 3 April in Osborn Street, and 39-year-old Martha Tabram, murdered on 7 August at George Yard Buildings.[19] Smith was definitely not a victim of the Whitechapel killer, as she was murdered in a gang sexual assault. Tabram's murder, on the other hand, did have elements in common with the five, as she was stabbed 39 times and, like all but Stride, was left with her skirts hiked up and her lower body exposed. It is possible she was also his victim.

Queen Victoria was moved to get involved. When she received a petition from 400 to 500 women of East London 'who have lost a firm hold on goodness, and who are living sad and degraded lives', requesting the closure of 'bad houses', she passed it on to the government, asking them to action it.[20] The day after the last victim was discovered she also sent a terse cipher telegram from Balmoral to the Prime Minister, giving instructions. 'All these courts must be lit,' she ordered, 'and our detectives improved. They

are not what they should be.'[21] Three days later she followed up with another, insisting that the police improve and demanding to know if they had properly searched all lodging houses and passenger boats for bloodied clothes.[22] Her interest in the East End was not unusual for those fortunate enough not to live there. People visited the slums for a wide variety of reasons. Some, like Jack London, to understand their conditions. Others, like Charles Dickens, to enjoy their attractions. He frequently went on long walks through the area's winding alleys and enjoyed eating there, noting on one occasion, 'concerning the viands and their cookery, one last remark. I dined at my club in Pall-Mall aforesaid, a few days afterwards, for exactly twelve times the money, and not half as well.'[23]

The Whitechapel killer's state of mind can be surmised up to a point. He does not seem to have gained his main gratification from killing, which occurred quickly, slashing the throat with cuts so forceful that on occasion they almost decapitated the bodies. His pleasure appears to have come from the profound mutilation of their bodies after death. The post-mortems found no trace of sexual intercourse or semen, but the damage to the women's sexual organs, removal of wombs, flaying, and overall level of violence suggest a visceral hatred of the female reproductive system, and the enactment of highly disturbed psychosexual fantasies concerning them.

Once many serial killers have lived out the fantasy in their head by murdering a real person, they cannot control the urge to continue gratifying themselves with further murders. As the pleasure then becomes less novel, they experience the need to push the fantasies further, which is the case in the Whitechapel murders. Each victim was more mutilated than the last, except Elizabeth Stride, the first on the night of the double murder. It is likely this was not intentional, as the killer was probably disturbed after cutting her throat, so quickly found another victim three-quarters of a mile away, this time indeed pushing his fantasies further. PC Watkins described Eddowes's body as having been 'ripped up like a pig in the market'.[24]

Serial killers do not usually stop murdering until they are caught or are no longer physically able to murder. A handful are on record as murdering over 100 people, the most prolific being the English doctor Harold Shipman, who murdered at least 218 people – possibly as many as 250 – over a 23-year period from the 1970s to the 1990s. One of the most puzzling mysteries regarding the Whitechapel killer is therefore why he suddenly stopped after two months and nine days. Even if he'd gone abroad, it is probable he would

have continued his crimes. The most likely explanation is that he became incapacitated or died.

The profile the police formed of the killer was meagre. The cutting angles of his knifework suggest he was right-handed. The murders took place in the small hours of two Fridays, a Saturday and a Sunday, indicating he probably had a job. And the skill with which he moved around inside his victims' abdomens, locating and cleanly detaching organs like kidneys and wombs, working quickly in the dark in most cases, suggests practical skills in surgery, dissection or butchery.

After the first killing the police arrested John Pizer, a Jewish slipper-maker and extortionist nicknamed 'Leather Apron'. He had a record of violence against prostitutes, but it was soon clear he was not the killer and they released him. After the second murder they arrested Charles Ludwig, a German hairdresser, but released him when the third and fourth killings occurred while he was in custody. Other suspects included Jacob Isenschmid, an insane Swiss butcher, Oswald Puckridge, an apothecary recently freed from an asylum, and an array of medical students, including one who had recently gone insane.

Various senior police officers involved with the case had their preferred suspects. One was Montagu Druitt, a Wykehamist, Oxford graduate and barrister, who drowned himself in the Thames shortly after the fifth murder. Another was Severin Klosowski, a Polish Roman Catholic hairdresser who masqueraded as Jewish and had studied surgery before going on to poison three of his partners. A third was Aaron Kosminski, a Polish Jewish hair-dresser who was committed to an asylum a few years later. And the last was Francis Tumblety, an insane American doctor who breached his bail and fled first to France and then to America after being arrested and bailed for gross indecency with men two days before the fifth murder.

Despite the large number of theories about the Whitechapel killer's iden-tity, none of them are compelling. The police had few tools beyond question-ing, and short of someone providing a detailed physical description or catch-ing the killer in the act, there was little the Victorian police could do. And there is even less that can be done now. Much of the evidence the police collected was largely irrelevant, and many of the records have been lost or gone missing from the files over time. Tantalisingly, four Special Branch files contain information relevant to the original police inquiries, but they have never been seen and remain classified, which has served to add fuel to the conspiracy theories.[25] The official explanation for withholding them is that

they contain names and details of informants, and that revealing them may still bring retribution against their families. Taking everything that is known about the Whitechapel killings, the bald reality is that, without new evidence, all theories about the killer's identity are no more than speculation.

The Whitechapel deaths were a significant turning point in a number of areas. The murderer was the first internationally infamous serial killer, a phenomenon that had previously been largely unknown, but which has become a feature of subsequent centuries. The murders were also the first real-life embodiment of the psychological darkness filling the pages of Gothic horror novels that had opened up the world of the gory and macabre in literature. Robert Louis Stevenson's *Strange Case of Dr Jekyll and Mr Hyde*, published just two years earlier, had introduced readers to violent psychological disorders, and interest in the sexual elements of violent behaviour was also gaining increased attention.[26] The German psychiatrist Richard von Krafft-Ebing published *Psychopathia sexualis* (*Psychopathy of Sex*) that same year, analysing paraphilia in depth for the first time, and coining the term masochism.[27]

Today the Whitechapel killer is big business. Tours of the places where the women's bodies were found bring groups of up to 100 walking through the atmospheric streets of the East End as often as five times a night. Mitre Square, where Eddowes was murdered, regularly has half a dozen groups squeezed into it at any one time. The sites are a chilling reminder that for all the perceived splendour and achievements of Victoria's Britain, there was a dark side to the capital of the world's largest empire. A woman may have ruled it all from Buckingham Palace but, for those living in destitution only three miles to the east, her streets were a place of terror.

Chewing Barbed Wire – The End of Empire

12th Battalion Sherwood Foresters
The *Wipers Times*
1916–18

In rural Oxfordshire, the lead effigy of a man stands imperiously atop a towering, fluted Doric pillar a little shorter than Nelson's Column in London, but over a century older. It honours John Churchill Duke of Marlborough who, dressed as Caesar, surveys the grounds gifted to him by Queen Anne in gratitude for his victories against Louis XIV of France. In his direct line of sight, just over half a mile away, is Blenheim, the 187-room house built to celebrate his triumph at Blindheim in Bavaria. It is the only non-royal and non-episcopal palace in Britain, and its grandeur is so striking that when George III visited he muttered admiringly, 'We have nothing equal to this.'[1]

In 1874 the seventh Duke of Marlborough's grandson, Winston Spencer Churchill, was born at Blenheim, and spent much of his childhood absorbing into his blood the palace's celebration of his ancestor's victories, inculcating in him the lesson that history saves its greatest laurels for those who triumph in arms. After boarding school at Harrow, Churchill won a place at the Royal Military College at Sandhurst on his third attempt and, 17 months later, was commissioned into the 4th Queen's Own Hussars. After serving as a junior officer in India, Sudan and South Africa at the age of 25, he entered Parliament in 1900 as Conservative MP for Oldham. Finding his natural political instincts to the left of the Conservative Prime Ministers who

dominated his first years in the house, four years later he crossed the floor and joined the Liberal Party, which he stayed in for 20 years.

Churchill's timing was good. Balfour resigned as Conservative Prime Minister the following year, and Henry Campbell-Bannerman was invited to form a Liberal government, which soon swept to a landslide victory. Churchill's talents had already been noticed, and he was appointed Under-Secretary of State for the Colonial Office. Over the next six years he rose swiftly, serving successively as President of the Board of Trade, Home Secretary, and eventually First Lord of the Admiralty. It was a job he relished, overseeing the world's largest navy and its 133,000 regular officers and men plus reserves.[2]

On the last Sunday in June 1914, just over 1,000 miles from Churchill's office in the Admiralty, a hot-headed Yugoslav nationalist walked past a backstreet coffee shop in Sarajevo and unexpectedly saw the Archduke of Austria and his wife in an open-topped car that had stopped to reverse. The teenager had been part of a team throwing bombs at the royal couple earlier, but they had all missed, so he was dejectedly wandering home. On seeing the archduke and his wife at point blank range, he pulled out a handgun and fired twice, murdering the couple on their fourteenth wedding anniversary.

Austria-Hungary responded by declaring war on Serbia. Germany promptly seized the opportunity to declare war on Russia and France, then mobilised troops into Luxembourg and Belgium as a staging post to invade France. Britain protested that Germany was violating the 1839 Treaty of London guaranteeing Belgian neutrality, but the German Chancellor, Theobald von Bethmann-Hollweg, was unrepentant, ridiculing the idea that Britain would go to war with Germany over 'a scrap of paper'. His confidence was misplaced, and Britain declared war on Germany on 4 August.[3] Montenegro followed by declaring war on Austria-Hungary, which in turn declared war on Russia. Serbia and Montenegro declared war on Germany. France and the United Kingdom declared war on Austria-Hungary. Japan declared war on Germany, then on Austria-Hungary, which in turn declared war on Belgium. In the space of two months, the world was at war.

The conflict raged globally and, in October 1914, the Ottoman Empire entered the war with a raid on Russian shipping at Odessa. By this stage Churchill had been put in charge of the Royal Navy's war effort and the country's air defences, and had quickly become a key figure in Asquith's war cabinet.[4] In that role, he backed a plan to seize the Dardanelles Strait linking the Aegean with the Sea of Marmara, push through to Istanbul, and then cripple the heart of the Ottoman Empire to take it out of the war. Accordingly, in

April 1915 Allied troops landed on the shores of the Dardanelles for the Gallipoli campaign. Unfortunately, the Allied naval barrage hammering the area since mid-February had given the Ottomans two months to mine the beaches and set up machine guns, and the assault troops from Britain, France, Australia and New Zealand walked into a well-prepared killing zone. Even once beachheads were finally established and reinforced with Indian and Gurkha troops, the Allies were unable to advance. The entire operation was eventually abandoned, and the exhausted troops withdrawn. The human cost of the bungled operation had been immense, with almost three-quarters of a million dead or wounded.[5] Recriminations immediately began to fly, and most fingers pointed at Churchill, who had been the campaign's main promoter in the face of vociferous opposition from senior military figures.

Asquith fired Churchill as First Lord of the Admiralty and refused his request to be appointed Governor General of British East Africa. Instead, Churchill set about rehabilitating himself, choosing to join the Grenadier Guards for several weeks of training at Laventie, then taking command of a battalion of Royal Scots Fusiliers in Belgium. He returned to Parliament four months later having seen no action and, in July 1917, David Lloyd George appointed him Minister of Munitions.[6]

In Britain, the public response to the war was initially patriotic. On Easter Sunday 1915 the dean of St Paul's Cathedral even read out a poem, 'The Soldier', one of five sonnets written a few months earlier by 27-year-old Rupert Brooke – a friend of Asquith's children – who had persuaded Churchill to get him a commission in the Royal Naval Division. A profoundly Edwardian poem, it is suffused with romantic and patriotic nostalgia: 'If I should die, think only this of me: / That there's some corner of a foreign field / That is for ever England'. It goes on to cast Brooke's dead body as a quasi-religious relic, 'a dust whom England bore . . . Gave, once, her flowers to love, her ways to roam . . . Washed by the rivers, blest by suns of home.'[7] Brooke's ideal of honourable sacrifice was felt by many who sensed that the conflict offered the chance for glory and a place in the nation's history.

When Brooke died before ever fighting, killed by a septic mosquito bite on his way to Gallipoli, Churchill wrote his obituary in *The Times*. 'The poet-soldier told with all the simple force of genius the sorrow of youth about to die, and the sure triumphant consolations of a sincere and valiant spirit. He expected to die: he was willing to die for the dear England whose beauty and majesty he knew: and he advanced towards the brink in perfect serenity, with absolute conviction of the rightness of his country's cause.'[8]

This praise for Brooke was not without self-interest. Churchill had every incentive to exalt Brooke as the heroic soldier-poet, rather than one of the doomed youths heading for the charnel house of Gallipoli. He was, though, being true to Brooke's vision. 'But, dying, has made us rarer gifts than gold', Brooke wrote in one of his other war sonnets. 'These laid the world away; poured out the red / Sweet wine of youth; gave up the years to be'.[9]

As the war progressed, poets who actually fought in the trenches took a quite different view. Just two years after Brooke's idealistic sonnets were published, 23-year-old Wilfred Owen – who had none of Brooke's social or academic advantages – challenged Brooke's fundamental premise in his nightmarish 'Dulce et decorum est', railing against Horace's sentiment 'it is sweet and proper to die for one's country' and instead deploying the graphic imagery of a man 'guttering, choking, drowning' in the 'thick green light' of a gas attack.[10] Like Brooke, he did not survive the war, falling exactly one week before the Armistice.

The war also unfolded ferociously at sea. A nerve-racking game of cat and mouse was played out in the Atlantic, with a similarly unprecedented death toll. German U-boats at first obeyed established prize rules and surfaced before attacking but, after Britain introduced Q-ships – warships disguised as merchant ships – the U-boats began attacking with no warning from underwater. The wider public became aware of their lethal effectiveness a few months later when SM *U-20* torpedoed the glamorous four-funnelled ocean liner RMS *Lusitania* 11 miles off County Cork with the loss of 1,198 civilian lives.[11] By April 1917 the U-boats had so decimated Britain's ocean supply routes that Lloyd George was on the verge of announcing Britain's surrender, before he was rescued by the United States' entry into the war.

World War One was, on any analysis, a calamitous failure of global politics and diplomacy, and a catastrophe for tens of millions of people. The world had never seen warfare and death on this scale, carnage made more infernal by the industrial production of weapons that could rip bodies apart in hails of boiling bullets, drown them in pungent clouds of gas, and vaporise them with explosions of unprecedented force. The scale of the technological killing was shocking to everyone. For instance, at 3.10 a.m. on 7 June 1917 the British exploded one million pounds of explosives sunk into 19 deep mines under the German lines at Messines killing an estimated 10,000 people. It was the largest blast before the invention of the atom bomb, and the loudest man-made sound produced on earth up to that date. The Prime Minister, David Lloyd George, heard it from his study in No. 10 Downing Street, and it was audible as far away as Dublin.[12]

In the trenches, the regular Army was augmented by territorial reserves and the volunteers of 'Kitchener's Army'. When the three armies all proved insufficient against the far larger forces of the imperial Central Powers ranged against them, Britain imposed conscription in January 1916, drafting most single, able-bodied men between the ages of 18 and 41. Within four months this was expanded to include married men and, finally, in 1918, desperate for more bodies, the upper age limit was extended to 50, or 56 in certain cases.[13] Throughout the war, millions of these men sat in the trenches of Flanders 'chewing barbed wire' – in Churchill's graphic phrase – and a trench culture inevitably began to form. Then, as now, the Army set about the task of soldiering with exacting professionalism, leavened with irreverent humour that targeted anyone suspected of self-aggrandisement and anything that smacked of futile bureaucracy, and there was plenty of both. But life in the trenches was unremittingly grim. Another war poet, Siegfried Sassoon, conjured up the dismal reality. 'I see them in foul dugouts, gnawed by rats, / And in the ruined trenches, lashed with rain.'[14]

The British Army arrived at Ypres in Belgium in October 1914, tasked with preventing the Germans from advancing into France. Unable to pronounce the city's unfamiliar name, the British christened it 'Wipers'. In military terms the area was a salient, meaning it bulged out into enemy territory. The British held it throughout the war, facing the first major use of mustard gas there in the Second Battle of Ypres on 22 August 1915, and later successfully taking more surrounding territory from July to November 1917 in the bloody Third Battle of Ypres, also known as the Battle of Passchendaele. It did not take long for the city to become a ruin but, in February 1916, a party from the 12th Battalion Sherwood Foresters stumbled across a battered printing press in a derelict building. Intrigued, they decided to see if they could get it working and, before long, a small team had come together to print materials for the troops. Captain Fred Roberts MC took the helm as editor, with Lieutenant Jack Pearson MC – who later opened the Foresters Arms pub in Flanders for wounded soldiers – as sub-editor and Corporal George Turner, who had been in the printing trade before the war, taking on the duties of typesetting and operating the press. The format they settled on was a parody of a parish newsletter, the title setting the irreverent tone: the *Wipers Times. Or Salient News*. The first issue of 100 copies rolled off the press on Saturday 12 February 1916 with an explanatory editorial:

> Having managed to pick up a printing outfit (slightly soiled) at a reasonable price, we have decided to produce a paper. There is much that we would like

to say in it, but the shadow of censorship enveloping us causes us to refer to the war, which we hear is taking place in Europe, in a cautious manner.

In reality, the team was anything but cautious. They mocked everything, gently but firmly, especially ineffectual or pompous characters in the chain of command, which they captured in a cartoon of a chinless officer asking himself wistfully, 'Am I as offensive as I might be?'

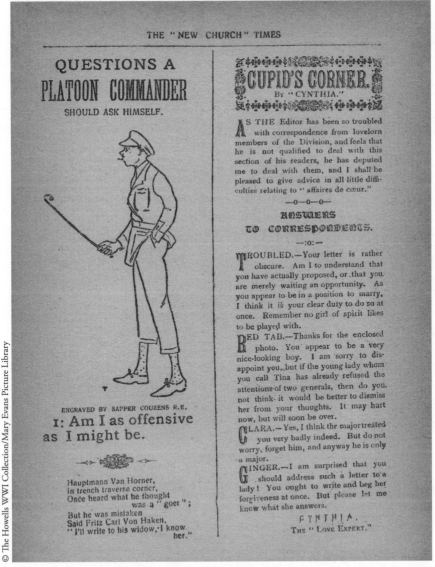

© The Howells WWI Collection/Mary Evans Picture Library

The New Church Times, No. 3, Vol. 1 (22 May 1916)

There were inevitably calls to close the paper down for being impertinent and disrespectful, but a general with the sense to realise that the irreverence and quiet anarchy took men's minds off the senseless reality of the war gave it the green light, and the paper settled into a routine of parody news from the front.

The *Wipers Times* was published in a 12-page format, and professionally laid out despite a shortage of 'e' and 'y' types. The front page, as with traditional newspapers of the day, was given over to advertisements.

Combination Respirator and Mouth Organ. The dulcet tones of the Mouth Organ will brighten even the worst Gas Attack.

IS YOUR FRIEND A SOLDIER?
DO YOU KNOW WHAT HE WANTS?
NO!! WE DO!!!

—o—o—o—

Send him one of our latest
Improved Pattern Combination
UMBRELLA AND WIRE CUTTER

—o—o—o—

These useful appliances can be used
simultaneously. No more colds caught
cutting the wire. He will be delighted
with it and will find a use for it.

PRICES
$\left[\begin{array}{l} \text{Gold Plated 500fr} \\ \text{Silver Plated 30fr} \\ \text{Ordinary 15fr} \end{array}\right.$

o—o—o—

SEND HIM ONE AT ONCE

THE NOUVEAU ART CO., SPITALFIELDS.

Its regular features included 'Things We Want To Know'.

The name of the brunette infantry officer whose man got hold of the carrier pigeons, (sent to this celebrated Company Commander when his communications in the front line had broken down) and cooked them. Also who were his guests?

The price of second-hand Flammenwerfer.

Every issue also featured advertisements for invented cinema and theatre shows. Many made fun of the Germans.

The Three Sisters Hun-y in their little song scena entitled: Star Shells Softly Falling.

Others sent up British generals:

MAUDE ALLENBY
IN HER FAMOUS SERIES OF EASTERN DANCES, INCLUDING THE
GAZA GLIDE
BEERSHEBA BUNNY HUG and the
JERUSALEM JOSTLE

Inevitably, there was an agony column:

DEAREST, I waited two hours on the Menin Road last night, but you didn't come. Can it be a puncture that delayed you? – Write c/o this paper.

And, of course, readers' letters, which featured an ongoing acrimonious dispute about hearing and sighting cuckoos when on patrol or going over the top. Other topics were straightforwardly absurd.

Sir, As the father of a large family, and having two sons serving the Tooting Bec Citizens' Brigade, may I draw your attention to the danger from Zeppelins. Cannot our authorities deal with this measure in a more work-manlike way. My boys, who are well versed in military affairs, suggest a high barbed wire entanglement being erected around the British Isles. Surely something can be done:— PATER FAMILIAS

The zaniness and silliness ran through the whole paper, and even into poetry.

Stop-gap.

—<o>—

Little stacks of sandbags,
Little lumps of clay;
Make our blooming trenches,
In which we work and play.

Merry little whizz-bang,
Jolly little crump;
Make our trench a picture,
Wiggle, woggle, wump.

The paper's biting satire was in a direct line of descent from Hogarth, Gillray, Cruikshank and *Punch*, and would later be taken up by *Private Eye* and the *Daily Mash*. But the *Wipers Times* also had a fresh surreality and zaniness which made it a precocious precursor to the 1950s *Goon Show* and 1970s *Monty Python's Flying Circus*. Twenty-three editions were published, the paper's name changing depending on where the editorial team was deployed. It was variously the *New Church Times* (after the town of Neuve-Église), the *Kemmel Times*, the *Somme Times* and the *B.E.F. Times* (after the British Expeditionary Force). The final two issues appeared after the Armistice, in November and December 1918. Hopeful of a change in their fortunes, the team called it the *Better Times*.

> Though some may be sorry it's over, there is little doubt that the line men are not, as most of us have been cured of any little illusions we may have had about the pomp and glory of war, and know it for the vilest disaster that can befall mankind.

On 12 February 2016, exactly a hundred years after the *Wipers Times* was first published, a twenty-fourth edition appeared in the German newspaper *Die Welt*, itself founded in Hamburg in 1946 by British forces. Entitled the *Fritz Times*, issue number 24 was a remarkably faithful replica of the original,

but sold at 'Price 0 bloody €'. Its surprise appearance was a response to the announcement of the 2016 Brexit referendum, and its editors' request was for Britain not to leave the European Union as 'Life without British humour is possible, but meaningless'.[15] Its articles focused firmly on the uniqueness of British humour and Germany's profound admiration of it.

> Since the Battle of Waterloo there's been occasional ill feeling between the Germans and the British which, to our regret, led to three nasty conflicts in the previous century. Although we meanwhile consider the 1966 conflict resolved – the ball was not over the line. We have to admit responsibility for the first two cases. But . . . without us Germans you Brits would not even have a Royal Family any longer. Nor would you have any reasonable cars. No one to make such great jokes about and no one who loves your scurrilous humour as much as we do . . . One thing is undeniable and we proclaim it loud and clear: We are grateful that the British rescued democracy in Europe in the 20th century. Today we need you for a successful European Union. And that is why we are printing this edition.[16]

The *Fritz Times* would doubtless have brought a smile to the creators of the original, whose 23 editions – many of them lampooning 'Messrs Hun & Co.' – are among the wittiest and most effective works of anti-war literature to come out of World War One, or any war.

When the Armistice was announced on 11 November 1918 the world had become a very different place. In the space of four years, as many empires had disappeared – the Austro-Hungarian, German, Ottoman and Russian – and around 20 million lay dead, with 20 million more wounded. But the Armistice did not stop the deaths. As the war was entering its closing phases, the world was unexpectedly hit by two waves of unusually deadly influenza in the spring and autumn of 1918 and then again by another in the winter of 1919. Healthy adults were disproportionately affected, the pandemic killing far more than the war at an estimated 50 to 100 million people.

In the years before the war, British society had been changing significantly, and it continued to do so during and after the Armistice. Politically, the growing strength of trade unions and the emergence of the Labour Party in 1900 had put socialism firmly on the map. As early as 1895 the future Edward VII had opened a key speech with the observation 'We are all socialists now-a-days'.[17] Women's suffrage was also gaining ground. Queen

Victoria had famously implored, 'The Queen is most anxious to enlist everyone who can speak or write or join in checking this mad, wicked folly of "Woman's Rights" with all its attendant horrors on which her poor feeble sex is bent, forgetting every sense of womanly feeling and propriety . . . Women would become the most hateful, heathen, and disgusting of human beings were she allowed to unsex herself; and where would be the protection which man was supposed to give the weaker sex.'[18] This was mildly absurd coming from a woman who ruled a quarter of the world's population. Churchill, too, in earlier days, had taken a similar view, calling suffragism 'a ridiculous movement'.[19] But the mood was definitively changing, spurred on in large part by millions of women entering the workforce in the munitions and armaments factories that became the heart of the war economy, and filling the void in other sectors left by men who were away in the armed forces.

Notions of class and hierarchy were also beginning to soften, and the proximity within which members of different classes found themselves in the armed forces, factories and hospitals acted to lower previous barriers. In the 1960s the notion emerged that, during the war, the upper classes had let the ordinary fighting men down, and that they were 'lions led by donkeys'. In fact, the phrase had been coined by Karl Marx and Friedrich Engels in relation to the Crimean War, and was unrelated to the trenches of World War One, where officers suffered twice the fatality rate of other ranks, largely because they were expected to lead from the front. As a result, the alumni of public schools and universities died in disproportionately high numbers, the losses being skewed to the youngest. For instance, Oxford lost 24 per cent of its students who fought under the age of 20. But the losses were across the board. Even the most senior officer grades were not immune, with 78 generals killed and double that wounded.[20]

The monarchy – and attitudes to it – had also been evolving since the end of the previous century. Victoria and Albert's eldest son, Edward VII, had to wait until he was 59 before his accession, during which time he struggled to find a role, instead spending his time in philandering and fast living, leaving to posterity his notorious three-person *siège d'amour* in Paris's Le Chabanais brothel. At one stage, Albert – who had been unwell – visited Edward in Cambridge to encourage him to lead a less scandalous life, but the journey exhausted him, and he died soon after. Victoria was distraught and never forgave Edward. 'I never can, or shall, look at him without a shudder,' she confessed. Unrepentant, Edward remained a playboy for the rest of his

tenure as Prince of Wales and for the 10 years of his reign, openly taking lovers including the actresses Lillie Langtry and Sarah Bernhardt, and society *belles* like the American Lady Randolph Spencer-Churchill – Winston Churchill's mother – and Alice Keppel, great-grandmother of Camilla Parker Bowles, Duchess of Cornwall.[21]

George v took over from Edward four years before the outbreak of war and the diminishing role of the monarchy became evident to all when the Edwardian era did not become the Georgian as Britain had decided it no longer measured time by the name of who was on the throne. The monarchy had palpably become less relevant to people's lives, and this was not helped by the name – inherited from Albert – of Edward and George's royal house: Saxe-Coburg and Gotha. With anti-German feeling running high during the war, on 17 July 1917 George relinquished all German titles and adopted the simple English name Windsor.

As a child at Blenheim, Churchill had learned that palaces and victory columns went to those who triumphed in war. But in a sign of how much times had changed, in the years after World War One there were few vanity projects to the glory of the politicians and commanders. Instead, all over the country, memorials appeared on village greens, church lawns and in town centres commemorating the men and women who had fallen, and who had become the focus of a grateful nation: 6.1 million who had served in the armed and allied services – 5,215,162 on the ground, 640,237 at sea, and 291,175 in the new service that fought in the air.[22]

The end of the war was not only the death knell for Victorian and Edwardian monarchy and social divisions. It also ushered in the final chapter of the great country houses like Blenheim. Although they enjoyed a resurgence after 1918 as owners threw their energies into trying to return to normal life, the 1920s and 1930s were the grand houses' last hurrah. When, during a church fête in 1921, the Earl of Powis and 18 of his guests disappeared through the rotten floor of his 1625 manor house at Lymore, it was a sign the long country weekends were coming to an end, and the houses were sliding into gentle decrepitude through a lack of heirs, unavailability of staff, neglect, and tax.[23] By the end of the 1930s they were increasingly obsolete legacies from a bygone age, as were their older inhabitants like Winston Churchill.

35

The Unholy Land –
Britain's Palestine Dilemma

Arthur Balfour
The Balfour Declaration
1917

Chaim Weizmann arrived in Manchester at the age of 29. He had left his home in the western Russian Empire – now the Republic of Belarus – dispirited by the official restrictions on the number of Jews permitted to attend university. Instead, he settled in Darmstadt and then in Berlin, where he studied chemistry before moving to Switzerland for his doctorate. When a contact set him up with a laboratory at the University of Manchester, he made the city his home. He learnt English, became a devout Anglophile, progressed through the ranks to become a senior lecturer, and was eventually naturalised as a British subject.[1] His ambitions as a chemist were to be appointed to a university professorship and to be elected a member of the Royal Society. In the event, he failed at both, because life instead took him down the path of his other passion: the creation of a homeland for the Jewish people.

In the previous decades there had been numerous calls for a Jewish homeland, but the project only gained impetus when the Austrian lawyer and writer Theodor Herzl founded the international Zionist movement. It was a success and, against a backdrop of rising anti-Semitism – including notable pogroms in eastern Europe and Russia – gathered increasing support,

holding the First Zionist Congress in Basel in 1897. Weizmann was a student in Berlin at the time and became active in Zionism, advocating a full Jewish cultural renaissance and the need for a Jewish university. He was eloquent and impassioned, and continued his Zionist activities when he moved to England, where he was elected Vice-President of the English Zionist Federation in 1911.

When Britain entered World War One three years later, the country had a sudden need of large quantities of acetone for manufacturing explosives. Weizmann set his mind to the problem, and eventually perfected a viable technique for synthesising it on an industrial scale. He was therefore relocated to the Ministry of Munitions in London, where he supervised its mass production for the war effort.

As fighting engulfed the globe, Weizmann watched Britain's military and political strategy closely, especially its operations to destabilise the Central Powers by focusing attacks on the Ottoman Empire. British planners viewed this as 'knocking away the props' of the enemy powers, although the Ottoman Empire had been a close ally of Britain in the past and Britain had gone to war to defend it in 1854.[2] Weizmann grew convinced that if the Ottomans were defeated, Britain would assume control of Palestine, keeping it as the western flank of British interests in India to protect the all-important Suez Canal which was vital for moving oil and military forces around the empire.

Even before the war it was clear to Weizmann that the British government was sympathetic to calls for a Jewish homeland. In 1903 Joseph Chamberlain, then Colonial Secretary, had offered Herzl 5,000 square miles of land at Uasin Gishu in today's Kenya for Jews wishing to find a place of safety. Although the Seventh Zionist Congress of 1905 rejected the offer – holding out instead for Palestine – the proposal had demonstrated Britain's willingness to help Europe's Jews.

Weizmann's important contribution to the war effort drew him into a privileged circle, eventually gaining him access to the Prime Minister and Foreign Secretary. He used this access well, bolstered by the knowledge that both Lloyd George and Balfour felt warmly towards Zionism – as did much of the establishment, many of whom had grown up with Disraeli's 1847 novel *Tancred* and George Eliot's 1876 *Daniel Deronda*, both of which included romantic proto-Zionist themes.[3] Weizmann was a natural politician, once describing the art using the German word *Fingerspitzengefühl*, or feeling with the fingertips, meaning a blend of intuition and flair. When

putting forward his ideas he combined natural wit with irony and challenging paradoxes but was always a pragmatist, firmly in the Bismarck camp of the art of the possible, and a devout believer that 70 per cent of something was better than 100 per cent of nothing. He knew Zionism required compromises, but saw in the likely redrawing of the map of the Levant after the war an opportunity that would not come again.

By 1917 Lloyd George concluded that with Russia wrapped up in the Bolshevik revolution and faltering, Britain had to secure America's entry into the war in order to survive. Calculating that he could be helped in this by gaining the support of America's Jewish citizens, he decided to identify a policy he hoped they would view favourably. At the same time he also had his eye on the rest of the world's Jews – especially the many millions loyal to the German and Austro-Hungarian Empires and those thought to be influential in Bolshevik Russia – and was keen to align all of them, to the extent he could, with the Allies' cause.[4]

An obvious policy to choose was one related to Palestine, but he knew the question of the country was profoundly tricky. It had a small population of 689,000 people, which was helpful, but it was culturally divided at 86 per cent Arab and 14 per cent Jewish.[5] Like everyone else who had considered the balance of power in the Levant, he was keenly aware that Palestine had a uniquely complex history with profound significance for Jews, Arabs and Christians. At the same time he was aware that it was – and always had been – of interest to military powers, as it sat on a strategically important corridor that linked Anatolia and Africa and offered starting points for numerous key routes east into Asia.

The Levant's history is one of the richest in the world. The oldest hominid remains in the region are from 1.5 million BC at the start of a succession of hunter-gatherer cultures which flourished throughout the Stone and Bronze Ages. One of the earliest settlements was at Jericho, which was inhabited by 10,000 BC.[6] Eventually the Ghassulians established agriculture in the area and, around 2500 BC, gave way to the Canaanites, before a millennium and a half later the origins of Judaism appeared among Canaanite polytheist Yahwist cults. Although dating is challenging in the absence of written records, archaeologists place the first villages of tribal Israel in Canaan around 1200 to 1000 BC.[7]

The history of Israel then comes from the *Tanakh*, the Jewish sacred scriptures. It is likely that King Solomon's Temple was built in the 900s BC, before large numbers of the Jewish population were deported to southern

Iraq in the early sixth century BC where they were held in the 'Babylonian Captivity'. Some returned in 538 BC after King Cyrus of Persia conquered Babylon, but others remained in Babylon, marking the beginning of the Jewish diaspora.

When Rome rose to be the foremost military power in the Mediterranean, Pompey eventually turned his eyes to the east, sacking Jerusalem and the surrounding area in 63 BC. At first Rome ruled the conquered Levant through local puppets, but that changed in AD 6 when Emperor Augustus renamed it Iudaea, garrisoned it with legions, and imposed direct political and military rule. Never reconciled to Roman occupation, the Jews rebelled in AD 66 prompting an overwhelming Roman military response in which the future Emperor Titus razed Jerusalem to the ground. After the Jews rose again in the Bar Kokhba Revolt of AD 132 to 135, Emperor Hadrian acted decisively to forestall any more violent unrest. He merged the provinces of Iudaea and neighbouring Syria into a new entity, Syria Palaestina, expelled all Jews from Jerusalem and its environs, and rebuilt the city as Colonia Aelia Capitolina for veterans of the legions, dedicating its new temple to Jupiter.[8]

The next main development came in the early seventh century when Islam emerged from the Hejaz region of Saudi Arabia and Muhammad's armies fanned out to conquer and convert, seizing Jerusalem in AD 638 under Caliph Omar and transforming it into a Muslim city. A succession of Islamic dynasties then ruled the region for 1,310 years, culminating in the Ottomans, who took power in 1517 and still held it four centuries later at the start of World War One.

As a result of Lloyd George's aspirations for winning the loyalty of American, German, Austrian and Russian Jews – coupled with Weizmann's persuasive advocacy for Zionism – the British cabinet made an important statement on 2 November 1917. It was in the form of a letter from Balfour, the Foreign Secretary, to Lord Rothschild, one of Britain's most prominent Zionists. This short letter – subsequently known as the Balfour Declaration – was the first public endorsement of Zionism by a major world power. It is also one of the most misunderstood documents in the history of the Middle East, because it is part of a collection of policies that need to be seen together.

In 1915 the experienced diplomat Maurice de Bunsen was Assistant Undersecretary of State at the Foreign Office, where he chaired a committee that reported back in June. Its remit was to formulate British policy in the

© British Library Board. All Rights Reserved/Bridgeman Images

Foreign Office,
November 2nd, 1917.

Dear Lord Rothschild,

I have much pleasure in conveying to you, on behalf of His Majesty's Government, the following declaration of sympathy with Jewish Zionist aspirations which has been submitted to, and approved by, the Cabinet.

"His Majesty's Government view with favour the establishment in Palestine of a national home for the Jewish people, and will use their best endeavours to facilitate the achievement of this object, it being clearly understood that nothing shall be done which may prejudice the civil and religious rights of existing non-Jewish communities in Palestine, or the rights and political status enjoyed by Jews in any other country".

I should be grateful if you would bring this declaration to the knowledge of the Zionist Federation.

Arthur Balfour, The Balfour Declaration (1917)

Middle East, particularly on what to do if the Ottoman Empire collapsed. The committee's conclusion was that the Arab peoples of the Middle East should be granted independence and autonomy for self-determination within a federation. However, it also recognised that the complex relationships and rivalries within the Arab world would make it difficult for this to be achieved without the risk of civil wars, and that Britain should therefore

play a role in temporarily stabilising and protecting while autonomous regions within an Arab federation could emerge.[9]

In furtherance of the policy, from July 1915 to March 1916 Sir Henry McMahon, British High Commissioner in Egypt – a country Britain had conquered in 1882 – exchanged nine letters with Sharif Hussein of Mecca. Hussein wanted to rule Arabia, and McMahon was keen for the Arabs in the Ottoman Empire to fight with the Allies against the Ottomans. In a letter of 24 October, McMahon phrased the British position on the arrangement warmly and reassuringly. 'Great Britain is prepared to recognise and support the independence of the Arabs within the territories included in the limits . . . Great Britain will guarantee the Holy Places against all external aggression and will recognise their inviolability. When the situation admits, Great Britain will give to the Arabs her advice and will assist them to establish what may appear to be the most suitable forms of government in those various territories . . . I am convinced that this declaration will assure you beyond all possible doubt of the sympathy of Great Britain towards the aspirations of her traditional friends the Arabs and will result in a firm and lasting alliance.'[10] McMahon was both cautious and reassuring because he knew Hussein was also in discussions with the Ottomans, and it was by no means clear which side he would choose.

Despite persistent claims that the Balfour Declaration and McMahon–Hussein correspondence are contradictory and demonstrate British duplicity, together they are in fact clear and consistent.[11] Neither is a binding international treaty. Both are statements of intent. In the Balfour Declaration, Britain confirmed that it supported the creation of a Jewish home – it does not use the word 'state' – in Palestine. To Hussein, Britain affirmed the recommendations of the de Bunsen Committee. Britain wanted the assistance of both Jews and Arabs in the war, and had policies which it hoped would achieve the engagement of both, the end goal being a Middle East of autonomous, federated Arab states – a solution which had worked with some success in Canada and South Africa – and a home for the Jews. McMahon's letters offered Hussein sufficient reassurance and, with the help and guidance of an Oxford academic, Captain T. E. Lawrence 'of Arabia' – and two squadrons, an armoured car company, a camel corps company, and Indian and Egyptian units – Hussein's forces joined the war against the Ottomans in June 1916.

Britain was, of course, looking after its own interests, making sure it had functioning diplomatic and trading relations with all actors in the region

after the war. It was also keenly aware that nationalism had been increasingly fashionable since the late 1800s. Zionism was an expression of Jewish nationalism, while in the Arab world nationalism was emerging from the desire to live free of Ottoman control so Arab culture could flourish as it had in Cairo, Damascus and Syria in the caliphates of old that had given the world Aristotle, philosophy, science, astronomy, medicine and so much else.

Sharif Hussein was an important person in the Middle East. He was a Hashemite – of the tribe of the Prophet Muhammad – and therefore a natural challenger to the Ottomans for the prize of ruling the Arab world. But he was not the only regional force. In Arabia, Ibn Saud was a strong challenger, and there were others with local power bases. No one envisaged that one man could rule it all, whatever his lineage and aspirations. But these would be problems for after the war. For the time being, Lloyd George was keen to engage all sides to help defeat the Central Powers.

In 1916, after secret talks, Britain and France signed the Sykes–Picot Agreement drawing areas on the Levantine map of their 'spheres of influence'. This was not a post-war colonial carve-up as fundamentalists like Da'esh insist. It was a sketch of contingency plans for who would stabilise which areas if, in 1915 or 1916, the Ottoman Empire collapsed, and these spheres were intended to be temporary until a proper solution could be found.[12] When the Russian Empire fell, the Bolsheviks publicised the Sykes–Picot Agreement a few weeks after the Balfour Declaration was issued. However, less than a month later, the situation on the ground changed fundamentally when, on 11 December 1917, General Allenby marched into Jerusalem as its conqueror.

Events then moved quickly. There was already a slow stream of Jewish immigration into Palestine, to which the Arabs had not objected. In the summer of 1918, with the war still raging in Europe, Weizmann headed to Jerusalem where he realised one of his dreams and presided over a ceremony to lay the foundation stone of the Hebrew University of Jerusalem. The Armistice came in November and, a few months later, Weizmann met with Sharif Hussein's third son, Faisal. They concluded an agreement in which both sides declared themselves to be 'mindful of the racial kinship and ancient bonds existing between the Arabs and the Jewish people, and realizing that the surest means of working out the consummation of their natural aspirations is through the closest possible collaboration'.[13] The agreement went on to approve the notion of a home for the Jews in Palestine,

although Faisal added a codicil that his people's consent depended on Britain honouring its promise of giving the Arabs independence over the area.

Faisal repeated warm sentiments in a letter drafted for him by T. E. Lawrence and sent to the American Zionist Felix Frankfurter. 'We feel that the Arabs and Jews are cousins in having suffered similar oppressions . . . The Arabs, especially the educated among us, look with the deepest sympathy on the Zionist movement . . . [whose proposals] we regard . . . as moderate and proper . . . we will wish the Jews a most hearty welcome home.'[14] However, when the Zionist delegation – which included Weizmann and Frankfurter – presented the Faisal–Weizmann agreement to the Paris peace conference, they omitted Faisal's codicil.[15] In the end, the question of the Levant was not settled in Paris, and the conference broke up with no solution for the region. On the ground, Hussein had been internationally recognised as king of the Hejaz from 1916 after expelling the Ottomans from the region, and had started styling himself King of the Arab Countries. To the north, Faisal had entered Damascus and was ruling as king of Syria.

In 1920 the Allies regrouped at San Remo to decide the Levant's fate. Weizmann was again present, and the Balfour Declaration was reaffirmed in the conference's formal documentation, which then endorsed a plan visibly related to the report of the de Bunsen Committee, creating new territories that would become Lebanon, Palestine, Syria, Transjordan and Iraq. Under the international oversight of the League of Nations, France was given the mandates over Lebanon and Syria, while Britain was entrusted with the mandates for Palestine, Transjordan and Iraq. Unlike Britain, France was looking for a Levantine colony, and the French promptly ousted Faisal from Syria and ruled it directly until it was lost in World War Two.

Britain meanwhile worked towards autonomy for the Arab states, welcoming Faisal onto the throne of Iraq in 1921 as promised. This arrangement lasted until 1958, when Faisal II, his 23-year-old grandson, was machine-gunned in the revolution that made Iraq a republic. In 1921 the British also helped his brother, Abdullah, onto the throne of Transjordan – which became Jordan in 1946 – where his family still rules. Their father, Hussein, had declared himself caliph on the fall of the Ottomans, but failed to gain support, and his policy towards Britain became aggressive. In 1924 he came under threat from the al-Saud family, was defeated, abdicated as king of the Hejaz, and went into exile. Britain continued to provide supervisory oversight to the regions which required it, but assisted others to

emerge as autonomous states. This was also in line with Britain's general policy of decolonisation, given that the country no longer had the resources to be involved around the globe. Accordingly, Egypt, Iraq, Kuwait, Oman, the Trucial States and Turkey all gained their autonomy.

At San Remo, Palestine – with its troubled and potentially volatile conflicts – was placed under the control of the League of Nations, with British forces on the ground to oversee security. This is what Britain had wanted all along, allowing it to protect the Suez Canal from east and west. However, neither Jews nor Arabs were happy with the arrangements and the British presence in Palestine rapidly found itself in the middle of escalating violence as the largely amicable relationship between Jews and Arabs began to deteriorate into animosity. When the Arabs began mounting armed attacks on Jewish settlements, the Jewish settlers responded by founding the paramilitary Haganah (meaning 'Defence'). The Arabs also turned their anger on the British, who responded harshly, seizing, imprisoning and executing those they considered responsible, escalating an increasingly intractable triangle of hostility and bloodshed.

One of the bloodiest months came in August 1929, when 110 Arabs and 133 Jews were murdered. In the case of the Jewish slain, 67 were civilians from the old Jewish community of Hebron, many of whom were anti-Zionist.[16] In response to incidents like these, some among the settlers thought the Haganah's policy of defence did not go far enough, so in 1931 an element broke away to form an extremist right-wing nationalist faction. They called themselves the Irgun Zvai Leumi (National Military Organization), and began terrorist attacks and assassinations targeting both the Arabs and the British.

By 1936 the situation had deteriorated to such an extent that the Arabs began a general strike which rapidly turned into a revolt. It was initially led by supporters of Sheikh Izz ad-Din al-Qassam, killed by the British in a shootout after his fundamentalist terrorist group had murdered a policeman. Soon, however, the revolt spread to all sectors of Arab society. Britain responded decisively, drafting in 20,000 extra troops.[17] It also summoned the Northern Irishman Sir Charles Tegart, a veteran anti-terrorist specialist in the Indian police, who built a two-metre-high barbed wire wall along the Lebanese and Syrian borders and 50 fortified 'Tegart' police stations across Palestine.[18]

A junior British Army officer, Orde Wingate, was also sent to Palestine, where he was put in charge of training 'Special Night Squads' of combined

British and Zionist troops, training them in techniques of irregular warfare and assassination. Wingate took to the role with gusto, wholeheartedly embracing Zionism and seeing himself as a biblical figure chosen to lead the Jews into an existential battle. After helping to quell the revolt, he went on to become the British Army's youngest major general, founder of Abyssinia's Gideon Force and Burma's legendary Chindits.[19] In Israel today there are countless streets and squares named after Wingate, and he is fêted as a father of the Israeli Defence Force and inspiration behind much of its strategic, operational and tactical capabilities.[20]

The British government was unprepared for the scale of the Arab revolt, which resulted in 5,000 Arab deaths. In response, Parliament established the Peel Commission to review the options for Palestine. It reported back in 1937, concluding that the assumption that Arabs and Jews could live together was misplaced, and suggesting instead that two independent states should be created. Weizmann, Ben-Gurion and other Zionist leaders welcomed Peel's recommendation as a step towards a full Jewish state, while Palestinian Arabs rejected it as the break-up of their country. Weary of the vortex of violence, in 1939 Britain called all sides together for a conference at St James's Palace in London. Weizmann led the Jewish delegation, but no progress was made and the gathering dispersed just over a month later. Britain's attention, however, was now moving closer to home and firmly focused on the build-up to World War Two.

Several months later, the British government had one more push and published a White Paper on Palestine rejecting the Peel Commission's call for two states and affirming that Palestine should be governed by Arabs and Jews as a home to both. However, to keep cordial relations with the Arabs, it set a quota of 25,000 Jewish refugees to be allowed to settle in Palestine immediately, then 10,000 Jewish immigrants a year for the following five years, after which there would be no further Jewish immigration into Palestine without Arab consent.[21]

Four months later, Britain entered World War Two, with Jews and Arabs alike fighting on behalf of the Allies. As the horrors of the Nazis' mass extermination of Jews in Germany and countries under its occupation became apparent, ever more Jews tried to leave Europe for Palestine, but their numbers were limited by Churchill's policy of enforcing the quotas in the White Paper. In 1940, as a result of Zionist anger at the quotas, more radical extremists broke off from the Irgun to found the Lehi (short for 'Fighters for the Freedom of Israel'), a self-proclaimed terrorist group whose mission

was to gain a Jewish homeland by extreme violence. Their leadership aimed for a nationalist and totalitarian state, and twice tried to make an alliance with Nazi Germany against their common enemy: Britain.[22] But they were not the first from the region to approach Hitler. In 1941 Amin al-Husseini, Grand Mufti of Jerusalem, had visited the *Führer* in Berlin to share with him that they had the same enemies – the English, the Jews, and communists – in the hope Hitler would support him in a region-wide revolt against Britain and Jewish communities.[23]

The White Paper's immigration quotas expired in 1944 with 24,000 immigration licences outstanding, so Churchill extended the scheme at a rate of 18,000 a year until all 75,000 places had been taken up.[24] Infuriated by the continuing quotas, in November the Lehi murdered the British minister Lord Moyne in Cairo. The assassination – and that of the United Nations (successor to the League of Nations) negotiator Count Bernadotte in 1948 – was planned by the Lehi leader, Yitzhak Shamir, whose nom de guerre was Michael after the IRA leader Michael Collins, and who would become Prime Minister of Israel from 1983 to 1984 and 1986 to 1992.[25] By the end of World War Two, 11,000 immigration certificates had still not been issued, although on the ground the quota of 75,000 had been far exceeded by unofficial immigration.[26] Simultaneously, the Irgun and the Lehi stepped up their activities, and the Haganah – which until then had condemned terrorism – joined them. On 22 July 1946 the Irgun bombed British headquarters in Jerusalem's King David Hotel, murdering 91 and injuring 46.

In the wake of the San Remo conference a quarter of a century earlier, Chaim Weizmann had been elected head of the World Zionist Congregation, but his Anglophilia and support of many British policies meant he was deselected at the 22nd World Zionist Congress in December 1946 as anti-British sentiment among Zionists mushroomed, bringing further waves of violence. At the congress, Weizmann spoke forcefully against the use of terrorism. 'Assassination, ambush, kidnapping, the murder of innocent men, wanton destruction of life and property, are alien to the spirit of Zionism. Jews came to Palestine to build, not to destroy. When men with such a mission abandon it for barren violence they perform a monstrous distortion of historic truth. Terrorism insults our history; it mocks the ideals for which a Jewish society must stand; it contaminates our banner; it compromises our appeal to the world's liberal conscience . . . For my part I am convinced that terrorist acts, apart from being morally abhorrent, are

also barren of all advantage. They expose our hard-won achievements to the prospect of destruction, and they lead us to a bottomless abyss of nihilism and despair.'[27] It was the last time Weizmann would address the congress.

Weary from almost 30 years of bloodshed in Palestine – and virtually bankrupt after the war and unable to sustain ventures like Palestine, or even India – Britain asked the United Nations to find a solution. Accordingly, on 29 November 1947 the United Nations adopted Resolution 181(II) proposing that Palestine be partitioned into independent Jewish and Arab states with international oversight for Jerusalem. As with the Peel Report a decade earlier, the Jews accepted the proposal but the Arabs rejected it, and a new and vicious civil war broke out. By now the killing by both sides had turned into open massacres. In a joint operation on 9 April 1948 the Irgun and Lehi murdered an unprecedented number of civilians at the village of Deir Yassin a few miles west of Jerusalem. The figures remain disputed, but the Irgun district commander stated at a press conference afterwards that they had killed 240. The Red Cross visited the site and confirmed that civilian men, women and children had been executed.[28] Menachem Begin, Irgun leader and later Prime Minister of Israel from 1977 to 1983 – who had also overseen the King David Hotel bomb, causing Britain to denounce him as a most wanted terrorist and placing a £10,000 dead-or-alive bounty on his head – wrote afterwards that the massacre has been strategically successful in so terrifying the Arabs that enough had fled to enable the State of Israel to be created.[29] In reprisal, the month after Deir Yassin, Arab forces cornered a group of Haganah and civilians who had been defending the kibbutz at Kfar Etzion, and murdered 129 of them. Accounts vary, but it is likely that some, most or all of the victims had surrendered before being murdered. Four months later, the Jews retaliated at the village of al-Dawayima, murdering between 80 and 200. The spiral of violence was unstoppable.

The British finally pulled out of Palestine on 14 May 1948, the day after the Kfar Etzion massacre, leaving the United Nations to oversee the creation of two independent states. However, that afternoon, just hours before the British completed their withdrawal, the Zionists took matters into their own hands. David Ben-Gurion, head of the World Zionist Organisation, declared the State of Israel, and one of his first acts was to appoint Weizmann as the state's first President. Now an official country, the Haganah became the Israel Defence Force and absorbed the Irgun and Lehi. The next day it swiftly mobilised to defend Israel against a coordinated invasion by Egypt, Transjordan, Iraq, Syria and Lebanon, who seized the parts of Palestine that

the United Nations had allocated to the Palestinians, and in addition took east Jerusalem. When the guns ceased firing 10 months later, Israel's fight-back had succeeded, and it had taken the majority of the land earmarked for the Arabs by the United Nations. That remained the geopolitical reality until the Arabs launched the war of 1967 – primarily to retake the Sinai Peninsula – but culminating in Israel gaining control of Sinai, the Gaza Strip and West Bank, the old city of Jerusalem and the Golan Heights. Aside from Sinai, which it returned to Egypt in 1979, Israel remains in occupation of all these territories, although it disputes the accuracy of the term 'occupation'.

Despite Britain being blamed by Zionists for having failed to deliver on the Balfour Declaration, and by the Arabs for having failed to implement what was promised in the McMahon letters, the reality is that the situation was fast-moving, largely unmanageable and highly combustible. Increasing nationalism on both sides – stoked not least by Weizmann and Lawrence – had given rise to the mounting animosity and violence among Jews and Arabs in the Levant.[30] The Balfour Declaration did, however, foreshadow two of the most challenging issues of the region which have remained unsolved. One is that it referred to a 'national home for the Jewish people' rather than a state. While this satisfied Hussein and Faisal, who were ready to welcome Jews to Palestine, it did not satisfy Zionists, who wanted a country. The other is that it mentioned not prejudicing the 'civil and religious rights of existing non-Jewish communities in Palestine', which fell short of protecting the Arabs' political rights, and confirmed a process of alienating the Arabs from the land, defining them merely as 'non-Jewish'. All parties' inability to resolve four tensions – statehood, security, political rights and identity – have remained at the heart of the region's bloody impasse.

There is no doubt that Balfour believed passionately in a Jewish home-land. In a letter to Lord Curzon in 1919 he was starkly honest about his motivations. 'For in Palestine we do not propose even to go through the form of consulting the wishes of the present inhabitants of the country . . . The four great powers are committed to Zionism and Zionism, be it right or wrong, good or bad, is rooted in age-long tradition, in present needs, in future hopes, of far profounder import than the desires and prejudices of the 700,000 Arabs who now inhabit that ancient land. In my opinion that is right . . . In short, so far as Palestine is concerned, the Powers have made no statement of fact which is not admittedly wrong, and no declaration of

policy which, at least in the letter, they have not always intended to violate.'[31] Written before the San Remo conference, this makes plain Balfour's personal commitment to Zionism. However, the settlement that emerged from San Remo followed far more faithfully the ambitions set out in the de Bunsen report of 1915. As for Da'esh's claim that it finally ended Sykes–Picot in 2014 when it bulldozed the border between Syria and Iraq and burned the border guards alive, it was a century out of date. Sykes–Picot had died before World War One ended, having been explicitly repudiated not least because the Russian Empire had fallen in 1917 and so was less of a threat to the post-Ottoman Levant.[32]

As with so much else in the troubled politics of the region, many things are not what they seem. Britain has blood on its hands from numerous self-serving imperial adventures over the centuries, but its involvement with the map of the modern Middle East in the aftermath of World War One was not an occasion for the duplicity and strong-armed colonialism that is often alleged.

Flights of Fancy – The Idyll of the English Countryside

Ralph Vaughan Williams
The Lark Ascending
1914/1920

'Nothing in the world is as beautiful, as admirable, as heart-warming as the English countryside,' Stendhal told his readers in 1830.[1] Coming from one of the most perceptive writers of his generation – and a native of scenic Grenoble – it was high praise.

British writers have also rhapsodised over their native landscape for centuries. In the *Seafarer* (Chapter 5), the Anglo-Saxon mariner yearned for home, picturing in his mind when 'the groves bear blossom . . . the fields become beautiful'.[2] In the fourteenth century Chaucer opened *The Canterbury Tales* with a paean to the flowers of the spring countryside. Two centuries later Shakespeare was often lyrical in remembering rural Warwickshire where he grew up, dotting his writing with country images like the 'banke where the wilde time blowes, Where Oxſlips and the nodding Violet growes, Quite ouer-cannoped with luſcious woodbine, With ſweet muske roſes, and with Eglantine'.[3] In Victorian times Thomas Hardy made the moods of the landscape so central to his Wessex novels that it was a protagonist in all but name. And these writers were not alone. British poetry and literature in praise of the islands' natural beauty fill miles of shelves.

Georgian painters were similarly drawn to the British outdoors. George Lambert, Richard Wilson, Thomas Gainsborough, J. M. W. Turner and

John Constable elevated evocations of the countryside in all its moods to a status once held only by history paintings, establishing a fashion for British landscapes that has rarely waned. Musicians, too, have venerated its magical beauty, including Elgar in his *Enigma Variations*, Delius in *On Hearing the First Cuckoo in Spring*, and Finzi with his *Eclogue*.

Like Picasso, who explained that he painted objects as he thought them not as he saw them, each of the writers, painters and composers who have taken the British countryside as a subject has produced profoundly personal interpretations.[4] Yet they were all working from the same starting point: the complex dance of nature and human toil that has shaped the British landscape since the last ice sheets withdrew and left undulating vistas of mountains, hills, valleys, lakes, streams, meadows, heaths and fens. In parts of it nature has always reigned undisturbed. Elsewhere humanity has taken over, entirely ordering the scene. But, for the most part, nature and people have worked side by side. An example is the great forests, which show at least 1,000 years of human maintenance. Another is the 280,000 miles of hedgerows that snake between fields and around the contours of the landscape. Some of these date from the Parliamentary enclosures of common land that peaked from the 1750s to the 1830s, but an estimated 42 per cent are far more ancient – the work of nature, people or both – going back to the Bronze Age.[5]

The countryside of the Anglo-Saxon mariner, Chaucer, Shakespeare, Stendhal and Hardy was strikingly unchanging. Since at least the Celtic period Britons have parcelled it out into either common or private land, with few movements of major perimeters. Many parish limits have barely changed from Roman or even Iron Age boundaries. Documentary proof can be found in the hundreds of Anglo-Saxon land charters that contain perambulations describing the landmarks seen when walking out the edges of the property. Many can still be walked today with little difference in the location of the woods, hedgerows, barrows, pits, streams, ditches, roads and lanes that acted as lines of demarcation in the Early Middle Ages.[6] Some parishes still 'beat the bounds', continuing a tradition from the world before maps of walking the parish's perimeter to fix its boundary in the minds of successive generations.

As a sign of how little of the countryside has changed, William the Conqueror's *Domesday Book* of 1086 recorded that 65 per cent of the country was arable and pasture, while 36 per cent was woodland, meadows, mountains, heath, moorlands, fens, and other wild areas. In 2020 the Ordnance Survey calculated that for the United Kingdom – which includes Scotland and Northern Ireland, which the Conqueror did not – 57 per cent

was farmland, while 35 per cent was natural or seminatural. It seems that 1,000 years of agricultural and industrial revolutions, of mechanisation, roads, rail and cities, has changed the basic fabric of the landscape very little. The biggest transformation in this period has been population. In Celtic prehistory around 500 BC there were probably 0.5 to 1 million people in Britain. When the Romans left and the Anglo-Saxons arrived the number had risen to around 2 million. At the time of *Domesday Book* in 1086 it was 1.7 million. On the eve of the Black Death in 1348 it was 4.8 million, but by 1450 it had shrunk to 1.9 million. At the time of the Civil War in 1642 it was 5.5 million. But it was the Industrial Revolution and modernity that brought the real explosion, with 10.5 million in 1800, 41.2 million in 1900, 58.9 million in 2000 and 67 million in 2020.[7]

All these people have made their presence known in the landscape, not least by erecting a variety of buildings, from shacks to cathedrals and car parks to skyscrapers. *Domesday Book* did not record the number of buildings extant in 1086, but Ordnance Survey figures from 2020 reveal there are 44.8 million buildings across the United Kingdom, covering 1.4 per cent of the country's total surface.[8] That may seem low, but satellite data from 2017 confirms that just 0.1 per cent of the United Kingdom is continuous urban fabric, in which 80–100 per cent is built on or is gardens or small parks, while 5.3 per cent is discontinuous urban fabric, where 50–80 per cent is built on. None of these numbers is high, a fact corroborated by night-time satellite imagery of the country that reveals vast swathes of darkness.

Against this picture of relative immutability, one element of the countryside has changed almost beyond recognition, and it has happened since 1945 and the arrival of intensive agriculture for the production of ever more and cheaper food. Farmers have saturated the country from top to bottom in industrial pesticides, decimating insect populations, in turn destroying the interdependent ecosystem of wild flowers and nesting birds. The result is that where formerly there was a rainbow of floral colour and a cacophony of buzzing insects and birdsong in the spring and summer countryside, there are now places with featureless acres of crops under largely empty skies and silent trees.[9] The bluebells, cornflowers, poppies, hawthorn, butterflies, lapwings, turtle-doves, and hundreds of other staples of the countryside have been comprehensively culled. The dependable abundance of wildlife that everyone from the Anglo-Saxon mariner to Finzi knew is, in many places, now largely gone.

Insects represent two-thirds of life on the planet. Today car drivers need to stop less frequently to clean their sad remains off windscreens than they

did 30 years ago, and this is borne out by data. In 2017 German scientists reported that in the previous 27 years 76 per cent of insects in the country's nature reserves – 82 per cent in summer – had simply vanished from the system.[10] In England 58 per cent of butterflies disappeared between 2000 and 2009.[11] The impact of this loss on birds has been immediate. In England alone, since 1970 56 per cent of wild farm birds have gone.[12]

There is still, of course, countryside to be enjoyed, but one of the last full-throated odes to the rural world before the indiscriminate deployment of pesticides came from the imagination of the composer Ralph Vaughan Williams, born in Gloucestershire in 1872 and a relative of Charles Darwin and the Wedgwoods. As a schoolboy he showed no promise at music, but his teachers persisted, realising it would 'simply break his heart if he is told that he is too bad to hope to make anything of it'.[13] However, perseverance paid off. He won a place at the Royal College of Music, and then read history and music at Trinity College Cambridge, where he eventually gained a doctorate in music.

After a period studying in Paris with Maurice Ravel – who later noted with pride that Vaughan Williams was the only one of his students who did not emulate his music – Vaughan Williams settled down to life as a composer, becoming moderately successful.[14] Then, on New Year's Eve 1914, at the age of 42, he shocked his friends by volunteering as a private soldier with 2/4 London Field Ambulance of the Royal Army Medical Corps. He served in France and Greece, doing the backbreaking work of stretchering the wounded from battlefields to field hospitals, before transferring in 1917 to a combat role. Commissioned as a second lieutenant in the Royal Field Artillery, he found himself in command of heavy guns at the Somme.[15]

After being demobbed in 1919 Vaughan Williams returned to compos- ing, and to a work he had written on the eve of war for the eminent violinist Marie Hall. The piece was called *The Lark Ascending*, and the public first heard Hall perform it on 15 December 1920, scored simply for violin and piano, before she gave a second performance on 14 June 1921 at the Queen's Hall in London, now accompanied by an orchestra. Vaughan Williams's decision to compose two versions of the piece was not uncommon. Music written for a solo instrument and piano accompaniment was cheaper to stage and people could put on recitals at home, making it common to produce a piano arrangement first, then a full orchestration later.

The inspiration for the piece came from a poem, 'The Lark Ascending', by the once revered but rapidly forgotten novelist and poet George Meredith,

who published it in 1881 when Vaughan Williams was a boy and Thomas Hardy a loyal disciple. In 122 lines it venerated the song-flight of the male skylark, who rises almost vertically up to heights of 300 metres, hovers, then parachutes down, all the while spraying out song for as much as an hour non-stop. 'Renewed in endless notes of glee, / So thirsty of his voice is he, / For all to hear and all to know / That he is joy, awake, aglow, / . . . He sings the sap, the quickened veins, / The wedding song of sun and rains.'[16]

The trench poet Siegfried Sassoon thought Meredith's 'The Lark Ascending' perfection, but time has given the laurels for the decade's most memorable poem of bird flight to the Jesuit Gerard Manley Hopkins and his breathtaking description of a kestrel in the experimental sonnet 'The Windhover'. 'I caught this morning morning's minion, king- / dom of daylight's dauphin, dapple-dawn-drawn Falcon, in his riding / Of the roll-ing level underneath him steady air, and striding / High there, how he rung upon the rein of a wimpling wing / In his ecstasy! then off, off forth on swing, / As a skate's heel sweeps smooth on a bow-bend: . . . No wonder of it: shéer plód makes plough down sillion / Shine, and blue-bleak embers, ah my dear, / Fall, gall themselves, and gash gold-vermilion.'[17]

The original score for Vaughan Williams's interpretation of Meredith's 'The Lark Ascending' is lost. But a copy he wrote for Marie Hall survives. In confident, expressive handwriting, he put her name at the top of the front page, and to the right the detail 'Composed for Miss Marie Hall'. Under the title *The Lark Ascending, Romance for Violin and Orchestra* he set out 16 lines of Meredith's poem.

<u>Marie Hall</u>

Composed for
Miss Marie Hall

The Lark Ascending
Romance for Violin and Orchestra
by
R. Vaughan Williams
(Arrangement for Violin and Pianoforte)

He rises and begins to round,
He drops the silver chain of sound,
Of many links without a break,
In chirrup, whistle, slur and shake,

x x x x x x x x x

© British Library Board. All Rights Reserved | Add MS 52385

Ralph Vaughan Williams, The Lark Ascending (1914/1920)

For singing till his heaven fills,
'Tis love of earth that he instils
And ever winging up and up,
Our valley is his golden cup,
And he the wine which overflows
to lift us with him as he goes;

x x x x x x x x x

> He is, the dance of children, thanks
> Of sowers, shout of primrose banks,
> And eye of violets while they breathe;
> All these the circling song will wreathe . . .
>
> x x x x x x x
>
> Till, lost on his aërial rings
> In light . . . and then the fancy sings.
> George Meredith

The music starts on the second page of the manuscript with the score in two parts: the top line for 'Violin Solo', the other two for the piano, labelled 'Orchestra'.

The piano begins *pianississimo*, as quiet as can be, just three languid, rising chords: D, E and F#. It repeats them unhurriedly, leaving the last ringing out. When the sound eventually stills, the violin starts *pianissimo*, played *sur la touche* with the bow over the fingerboard to produce a softened, warm sound. The melody begins low, an arresting, liquid bubbling that rises hesitantly like a bird taking to the air, swooping and swirling, climbing ever higher. The score labels the violin's line a *cadenza* – a virtuosic solo – so the violinist improvises the timing and feel of the bird, soaring, plummeting and gliding as the mood evolves, subtly mesmerising the audience with improvised *agogio* accents that lengthen notes to build dynamics and tension. As the music takes shape, the violin is the singing lark, climbing ever higher 'as up he wings the spiral stair, / A song of light, and pierces air', while the piano is the countryside below: gentle, undulating, sleepy.

Vaughan Williams called the piece a romance, and its golden flashes of wings and melody over the hills and valleys, woods and fields below are a love song to the English outdoors. The mood belongs to 1914 and the end of the Edwardian era, reminiscent of Rupert Brooke's 'The Soldier' from the same year, with its 'hearts at peace, under an English heaven'.[18] But *The Lark Ascending*'s sense of innocence, yearning and nostalgia is all the more poignant because Vaughan Williams reworked it in 1919 to 1920, after four years in the shattered charnel-house landscapes of Flanders.

The original 1914 violin and piano version has the calm mellowness, intimacy and reflectiveness of an undisturbed summer's day, with the lark and the countryside alone in their solitary dance. When Vaughan Williams orchestrated it in 1919, the piece moved from lyrical and arresting to majestic.[19] In the original, the piano – a percussion instrument of hammers

hitting strings – has one fundamental sound which is either on or off. When Vaughan Williams replaced it with strings, bassoons, horns, an oboe, clarinet, flutes and triangle, the composition transformed from black-and-white into colour, opening a whole spectrum of subtle soundscapes beneath the soaring and diving violin, permitting it to plunge again and again into the orchestra, rising in repeated waves of song-filled flight.

In this and other pieces, Vaughan Williams had discovered a uniquely English musical vocabulary, moving away from centuries of British composers who emulated the most celebrated Germans, and crafting an English voice that drew on everything from Tudor music to English folk songs. He made it his own, before eventually bequeathing it as a unique legacy to William Walton and Benjamin Britten, leaving a body of work that is widely accessible and admired abroad, especially in Europe and the United States. Its melodies and harmonies are rooted in the past and his present, and not yet the avant-garde atonality of what would follow. *The Lark Ascending* does not reach the complexity of his symphonies or opera, but its immediate, romantic, bucolic, yearning nostalgia has made it a piece that regularly tops Britain's polls of the nation's most loved works of classical music.

The subject of *The Lark Ascending* – the small but magisterial skylark – has not fared so well. From at least 1430 an 'exaltation' has been used as a collective noun for larks, revealing the veneration in which the bird has always been held. However, twentieth-century pesticides and the switch to sowing more crops in autumn have combined to decimate the native population. Between 1972 and 1996 the skylark's presence in the countryside dropped by 75 per cent, and its conservation status is now red: the highest category of risk. If the skylark does eventually disappear from Britain's skies, it may be that the 14 or so minutes of Vaughan Williams's violin and orchestra exaltation will be the most enduring hymn of praise for the bird's unique contribution to the land's once musical and colourful countryside.

A Nation of Books and Letters
– The British Type

Harry Beck and Edward Johnston
Map of London's Underground Railways
1933

In his seven decades on earth, Abbot Ceolfrith of the great Northumbrian double monastery at Wearmouth-Jarrow had seen much. Reaching the end of a long life, he reflected that two of his greatest pleasures had been helping Benedict Biscop build the abbey at Jarrow, and taking charge of the young boy, Bede, whom he saw grow into a scholar of repute and a close personal friend. Now weakened by age and having resigned his abbacy to live in Rome, he looked back from the boat at the monks waving, singing and sobbing, and may have put his hand reassuringly on the large bundle beside him. Wrapped tightly in its waterproof skins was a magnificent book his monks had laboured over, sourcing hundreds of goatskins which they soaked, stretched and scraped until soft, thin and perfectly smooth. They then pricked, ruled and filled the vellum folios with the sacred Latin words of St Jerome's Old and New Testaments, before stitching the pages into gatherings and mounting them between heavy, leather-covered boards. The result was an enormous volume, as long as an arm from fingertip to elbow, and almost half as thick. It was one of the most magnificent Bibles of the age, and Ceolfrith was going to present it to the pope in person.

Codex amiatinus, as Ceolfrith's Bible is known, never made it to Rome. Ceolfrith died in Burgundy in AD 716 on his way there and the Bible only

reached Tuscany, where it has remained ever since: the oldest complete Latin Bible in the world.[1] The monks at Wearmouth-Jarrow had in fact made three, all identical, but the two that stayed in England – one at each of the monasteries – were destroyed in the Reformation.[2]

Medieval Britain had an acknowledged skill in book production. The results were admired at home and abroad, and many examples survive. At the time Ceolfrith was being waved off in his boat down the Wear, another group of monks 50 miles north on Holy Island was completing the *Lindisfarne Gospels*.[3] And, by the end of the century, monks on Iona in the Inner Hebrides and perhaps Kells in County Meath were finalising the *Book of Kells*.[4] These two collections of gospels were smaller than *Codex amiatinus* but are lavishly decorated and leading exemplars of British book production in the Early Middle Ages.

The oldest complete, surviving bound book in Europe is the *St Cuthbert Gospel*, made probably at Wearmouth-Jarrow in the early AD 700s.[5] Along with *Codex amiatinus*, the *Lindisfarne Gospels* and the *Book of Kells*, it is written in insular script using readily recognisable uncial and half-uncial letterforms which originally derived from the cursive handwriting of ancient Rome, and survive today in lettering designed to look Celtic. The British monks who laid out, wrote and decorated these books were profoundly in touch with the cultures of the Mediterranean, which is also evident from the influence of Mediterranean art in their decorative work, with the *Book of Kells* even incorporating influences from Coptic Egypt. These cross-Channel connections in the look and feel of British books persisted throughout the Middle Ages, and were renewed again with the arrival of the printing press in the mid-fifteenth century.

The man who brought printing to Britain was William Caxton, a mercer and diplomat from Kent who spent years living and trading in Bruges and Ghent before moving to Germany, where he learnt the basics of the new art of printing from Johann Veldener. In 1471 to 1472, the two printed a popular thirteenth-century Latin encyclopaedia by Bartholomaeus Anglicus, before Caxton returned to Bruges, set up his own press, and in 1473 printed *The Recuyell of the Historyes of Troye*. It was the first book to be printed in English, and he quickly followed it with *The Game and Playe of the Chesse*.[6]

European printing was still in its infancy, but the technology Johannes Gutenberg had invented in the 1450s was spreading rapidly. There were over 1,000 printers in Europe's cities by 1500. The process they used was highly skilled and labour intensive, but the results were impressive and lucrative.

The first stage involved acquiring small pieces of metal type – also called sorts – for the letters of the alphabet and punctuation. These could be purchased, but many printers preferred to engage specialist punch-cutters to make them to order. This involved carving the end of a slim steel rod into the three-dimensional form of a reversed letter. This was the punch, and could be hammered into a block of soft copper to create a matrix, or mould, into which molten metal was poured to cast the sort. To print something, the printer locked the required sorts into a frame called a galley, inked them, then impressed them onto a sheet of paper. The result was a page covered in printed letters. Using this method, once the galley was loaded with the relevant sorts, hundreds of copies of the same page could be produced mechanically far more quickly and cheaply than a scribe could handwrite them. If the sorts eventually wore out, replacements could easily be cast from the matrix, or a fresh matrix could be stamped from the original punch.

Caxton was a merchant, and he had translated *The Recuyell of the Historyes of Troye* and *The Game and Playe of the Chesse* from French into English in the hope they would sell. They did, and in sufficient numbers to persuade him that it was worth opening up an English-language printing business. He therefore moved back to England – which was still in the grip of the Wars of the Roses – and set up a press at Westminster, near the sign of the Red Pale. The first dated item he printed there was an indulgence, issued on 13 December 1476 by Henry, abbot of Abingdon, remitting the sins of a husband and wife who had atoned by donating money to a fleet being sent to attack the Turks in Constantinople.[7]

The first book Caxton produced on English soil was probably Chaucer's *The Canterbury Tales*, likely printed the same year as the indulgence although the edition is undated. His first to carry a date was *The Dictes or Seyengis of the Philosphhres*, printed on 18 November 1477.[8] These books all proved good business, and he went on to produce around 100 more titles, mostly courtly books for his Westminster clientele. On his death he bequeathed his press to Wynkyn de Worde, his assistant and former apprentice to Johann Veldener. De Worde took over the business but reorientated the catalogue towards prayer books and other religious and educational texts. No longer needing to be close to the court at Westminster, he moved his press to the sign of the Sun in Fleet Street, beginning an association between the area and printing that survived into the twentieth century. He then began selling the books at the sign of Our Lady of Pity in St Paul's Churchyard, establishing another tradition that persisted for centuries. De Worde died around the time Henry VIII broke from

Rome, making him the most important and influential Catholic printer and bookseller in pre-Reformation Britain, with a large legacy of liturgical books for lay people that evidences a vibrant culture of literate churchgoers, instructing themselves in ecclesiastical ritual and texts – and often reading along during services – before English was adopted as the language of religion.[9]

Like Gutenberg, Caxton used typefaces that emulated the expensive handwriting of the finest books coming out of the monasteries. At this date these were often in a handwriting style called *textura*, book hand, black letter or Gothic, in which each letter was written carefully and separately in a formal, upright, spiky style similar to that used by Hollywood today for any medieval writing. Gutenberg chose *textura* for his 42-line Bible of 1455 to make it look like a top-end scriptorium product, even having different versions of the same letter sorts cut with variations so the page looked authentically handwritten.

To make his edition of *The Canterbury Tales* appealing to the nobility at court in Westminster, Caxton made a slightly different choice, selecting a style of lettering known as *littera bastarda*, which was less religious and the height of fashion for romances at numerous continental courts. He chose well, as the *bastarda* typefaces remained popular for centuries, later giving rise to the *fraktur* letterforms that became the unofficial typeface of all German printing, and were only discontinued in 1941 when the Nazis issued a directive condemning them as Jewish using stationery with, ironically enough, the name of the Nazi Party emblazoned across the top in large *fraktur* letters.[10]

The typefaces the West uses today emerged separately, in Venice, where the brothers Johann and Wendelin of Speyer introduced printing from Mainz. Instead of emulating the black letter scripts of the monasteries, Venetian printers looked to the humanist handwriting of secular Renaissance scholars who drew inspiration from Rome and the Early Middle Ages. The result was a crisp blend of uppercase letters derived from classical Roman inscriptions and lowercase letters developed from early medieval uncials like the Carolingian minuscule, which became popular around AD 800 under the direction of the energetic English polymath Alcuin of York, a leading light at Charlemagne's court.[11] These early Venetian printers added their own stylistic fingerprint to the new letterforms, formalising them to look more like stonemasons' inscriptions by the addition of small, neat serifs, as if cut by chisels, in place of the grandiose, flowing swashes of contemporary calligraphy. The result was the Roman family of typefaces, which eventually eclipsed black letter to become the preferred typefaces for Latin alphabets, and are the ones still used for most purposes today.

The next major development in letterforms also occurred in Venice, in 1500, when Aldus Manutius – one of the most famous names in the history of printing – published a collection of the letters of St Catherine of Siena. The book included a woodcut of the saint holding in one hand an open book displaying the words '*iefu dolce iefu amore*', and in the other a heart bearing the single word '*iefus*'. These five short words were set in a radical new style created for Manutius by the Bolognese punch-cutter Francesco Griffo, who based the letters on the cursive calligraphy of the writing masters.[12] He had just invented italic letters, and the following year Manutius published an entire book in Griffo's italics, which he thought might catch on as a stand-alone typeface.[13] By 1500, therefore, the two principal components of modern book type – Roman and italic – were both in existence. Coincidentally, it was also the year that ended the period of incunabula – the earliest printed books – which are the most prized and collectable.

In Britain, printers since Caxton and Wynkyn de Worde had been happy to purchase typefaces made abroad, and this remained the norm until John Fell, energetic Vice-Chancellor of the University of Oxford and future bishop of the city, overhauled the university's press in 1667 on Charles II's restoration. He opened a foundry in the city, and sought the best typefaces from the continent, especially Holland. After gaining permission to move the press into Christopher Wren's new Sheldonian Theatre, he flung himself into action, publishing everything from the *Anglo-Saxon Chronicle* to theology, and from music to a prayer book and catechism in Welsh. Keen for a new look, he commissioned the German punch-cutter Peter de Walpergen at the Oxford foundry to carve and cast a new family of letters specifically for the press, and the result in 1672 was the Fell Types. These were quickly and successfully deployed at the press and, largely owing to their wobbly irregularity, turned out texts that added an exuberant and jolly feel to otherwise serious reading matter.[14]

The first heyday of British type began in earnest around 50 years later, when the gun engraver William Caslon turned his hand to letter punches. He received his first commission from the Society for Promoting Christian Knowledge, which requested an Arabic typeface for a Bible and prayer book that missionaries could take east. The letterforms he cut were a success and, sensing a career ahead of him, he threw himself into designing and casting dozens of other new punches. By the time he moved to Ironmonger Row off Old Street in 1734, his specimen sheet offered 14 Roman and italic types, seven titling types, black letter, Gothic, Anglo-Saxon, Arabic, Armenian, Coptic, Greek, Hebrew and Samaritan.[15] His Romans and italics – which took traditional Dutch forms and

garnished them with English baroque – became widely popular, prompting a decline in the import of foreign types and the true start of the British type-founding industry. His letters were widely appreciated, too, in the United States, where Benjamin Franklin – who was also a printer – used them, as did the printers of the 1776 Declaration of Independence.[16]

The first serious challenge to Caslon came not from an engraver but an eccentric writing master, gravestone letter cutter, inventor and entrepreneur named John Baskerville. He had made his fortune with a japanning business, and was a recognisable figure around Birmingham, usually wearing a scarlet waistcoat under a green coat edged with gold lace, and travelling around the city in a highly japanned coach. In the decades after Caslon became established, Baskerville turned to letter cutting and, in October 1752, sent some innovative punches he had designed to a London publisher along with the plea, 'Pray put it in no One's Power to let Mr Caslon see them.'[17]

Baskerville's letterforms were calligraphic, drawing on his years as a writing master. However, as an inventor, his interest went beyond the letters, and he improved his printing press by replacing wooden sections with cast bronze components to increase its accuracy. He also developed a recipe for blacker and shinier ink than the standard fare, along with a process for producing bright white paper that, once printed, he glazed. When put together, all these elements offered an entirely new reading experience, which first appeared in his 1757 edition of Virgil's *Eclogues, Georgics, and Aeneid* (*Bucolica georgica et aeneis*).[18]

The book immediately grabbed attention, and Baskerville was appointed printer to the University of Cambridge, for which he produced prayer books and a folio Bible while on the side bringing out a set of Milton's *Paradise Lost* and *Paradise Regained* for a London publisher.[19] The Milton editions were his most successful project among the 50 or so titles he printed but, as he tried to expand his catalogue further, London booksellers claimed his methods were too laborious and costly, and there were even complaints that his pages hurt some readers' eyes. Wounded, he considered himself the victim of London snobbery and closed down his printing business. Aside from an occasion on which he was stung into producing another book because a competitor claimed his process was better, Baskerville all but abandoned printing.

However, although Britain had not given him the encouragement he hoped for, Baskerville's letterforms were much admired abroad. Macaulay noted that his Virgil 'went forth to astonish all the librarians of Europe'.[20] Voltaire praised his punches highly, as did Benjamin Franklin and type

designer and printer Giambattista Bodoni. In 1776 Pierre-Simon Fournier noted in his influential manual on typography that Baskerville had reached '*la plus haute perfection*' and the very best italics anywhere in England.[21] French printers in general welcomed them warmly, and the French revolutionaries adopted them as the official type for their journal, the *Gazette Nationale*. History has also been kind. For sheer artistry and elegance in letter design and cutting, Baskerville has rarely been rivalled.

The next British innovation in typography came from the indefatigable Enlightenment architect Sir John Soane and his plan for a neo-Classical senate house, which he entered in the 1779 Royal Academy show.[22] In the title of the design he used a striking handwritten uppercase letterform he had recently seen on a temple at Tivoli. It featured solid lines, all of the same thickness, and no serifs or swashes. Without knowing it, he had designed the first modern sans serif letters. He began using this style of lettering on his architectural drawings, and others soon copied him. Printers cut punches of them, and the bold letterforms caught on for signage, advertising, and material which needed to draw readers' attention.[23] During the 1800s these sans typefaces grew blockier and bolder as they vied with one another to gain attention on hoardings and advertising bills.

Sans typefaces were not beautiful, but this would all change with the work of Edward Johnston, who was born to Scottish parents in Uruguay. Once back in Britain his father disappeared for long periods and his mother became an invalid, leaving Johnston to be brought up by a hypochondriac aunt with a morbid fear of draughts who kept Johnston locked up in the house with little formal education or contact with the world. He started to read medicine at the University of Edinburgh, but was forced to leave when his family withdrew him through fear that he was not strong enough. Instead, he turned to art. Since childhood he had filled endless drawing books with copies of medieval manuscripts, so he took his portfolio to London, where the principal of the Central School of Arts and Crafts in Bloomsbury had one look and appointed him to teach a class in lettering.

Johnston quickly established himself as a leading light of the school. Although his passion was the medieval writing of AD 500 to 900, he demonstrated that he could put his hand to almost any style, and proved it with his influential manual *Writing & Illuminating & Lettering*. His big break came in 1913 when Frank Pick of the Underground Electric Railway Company asked him to design new lettering for posters that would capture the 'bold simplicity of the authentic lettering of the finest periods' yet belong

'unmistakably to the twentieth century'. London's walls were plastered in a riot of advertising, and Pick wanted his new Underground posters to stand out cleanly from all the visual noise.

To fulfil the brief, Johnston looked back to antiquity. For the uppercase lettering he started with the text on Trajan's Column in Rome, which for centuries had been considered by many artists the finest in existence, while for the lowercase he turned to fifteenth-century Italian minuscules. Both choices suggested he was envisaging something traditional and bookish, but to address Pick's request for a contemporary design, he stripped the letterforms back to their bare essentials, abandoning thick and thin strokes and redrawing them in a monoline, uniform weight. With a nod to the abstract geometric art that had begun appearing around him, he rendered the 'O' and 'Q' as circular, gave the 'U' a wide semicircular base, and used flowing geometric forms for all other arcs. Finally, in homage to his love of medieval manuscripts, he replaced the usual dots over the lowercase 'i' and 'j' with small diamonds. The result was a striking set of elegant, geometric, modernist, humanist letters, well ahead of their time and prefiguring the Bauhaus. They were a radical break from the clunky sans typefaces of the age, and influenced virtually every sans serif that followed.[24]

Johnston's Railway Type was first used in July 1916 on the Underground's woodblock print posters to entice more people to use the railway to get about London. It was so successful that it was soon adopted as the Underground's lettering for all notices, paperwork and enamel station signs, and for the word UNDERGROUND on the new red, white and blue bullseye logo Johnston also designed. The lettering became the Underground's brand.

At the time, the Underground's map was a confused series of lines and stations overlaid onto a geographical representation of the city. It was messy and hard to read, with the lines meandering haphazardly across the capital. In 1931 a former Underground employee, Harry Beck – who had worked as an electrical draughtsman – presented Frank Pick with a radical new design he had devised in his spare time. He had reimagined the map completely, transforming the network into an abstract, colourful electrical schematic. The stations on each line appeared as components in a circuit diagram, with the only concession to geography being a stylised blue zigzag representing the Thames. At first Pick rejected it outright as lacking geographical information, but when Beck presented it again the following year, Pick had it labelled with Johnston's Railway Type and ordered a few copies to be left at select stations. These were well received, so he printed

700,000 copies as a fold-out pocket guide with the slightly unsure cover text 'A new design for an old map. We should welcome your comments.' The public response was overwhelmingly positive, and the design was adopted as the Underground's official map. The combination of Beck's playful, colourful, abstract lines and Johnston's arresting, warm, geometric letters was soon widely fêted as a twentieth-century design classic, fusing the best of modern art with practical functionality. As the ultimate proof of its success, it quickly set the standard for underground and railway networks around the world, which copied it widely.[25]

Johnston's Railway Type was not the only typeface to become a British design icon in the field of transport. Another came in the 1950s and 1960s when it was realised that vehicle speeds on roads rendered the chaotic clutter of unstandardised regional road signs wholly inadequate and dangerous. The result was a new hyper-legible typeface, trialled on the Preston Bypass in 1959 and deployed across the country in 1964. The designers rejected the rigid, heavy lettering of continental road signs in favour of something more organic, and took elements from the late nineteenth-century German Akzidenz Grotesk – which had already inspired Helvetica in Switzerland and Univers in France – and blended it with aspects of Johnston's Railway Type to create lettering that was so readable in bad light, strong light, headlights, and a range of poor weather conditions that the typeface was taken up around the world, with additional letters for other alphabets. Today, Transport guides motorists to their destinations everywhere from Britain to India, Iceland to the Middle East, Greece to Hong Kong, and many other countries besides.[26]

Edward Johnston and his Railway Type marked the start of the second wave of British typography, and Johnston was quickly followed by the giant of the century, Stanley Morison, who arrived on the scene the following decade. Unlike the quiet Johnston, Morison was in every way the eccentric aesthete: always in austere steel-rimmed spectacles, a plain black suit, white shirt, black tie and small black hat, with a breviary in his pocket. He was unfashionably Roman Catholic, leaned strongly towards communism, had worked on a farm as a conscientious objector during World War One, and had musical tastes that culminated eventually with an interest only in plainchant.[27] After working at several publishers, Morison was appointed typographical consultant to the Monotype company. This had its roots back in 1887 when the American engineer Tolbert Lanston invented a keyboard-controlled machine that used molten metal to cast all the sorts needed for a

book page. When the required copies of that page had been printed, the machine melted the sorts down and cast fresh ones for the next page. It was marketed to printers as the Monotype hot metal machine from business hubs in the United States and London. The quality of its printing was superb and ideally suited for book production, quickly becoming the work-horse of the book industry. Its rival, the Linotype hot metal machine, worked on a similar principle, but cast complete lines of text into a single metal slug, making it more suited to newspapers and magazines. Together, the two machines came to dominate printing.

Morison was taken on by Monotype with a particular responsibility for producing new typefaces.[28] In this he was helped by a simultaneous appointment as advisor to Cambridge University Press, on whose deep typographical resources he was able to draw.[29] As an ardent admirer of historical type, he set about unearthing the most beautiful printed books from the past and creating new versions of their letterforms.

Morison started by going right back to the beginning of Roman type, to Venice, to Aldus Manutius and his punch cutter Francesco Griffo. The first book of theirs he selected was *On Etna* (*De aetna*), a 1495 travelogue by the Venetian intellectual Pietro Bembo: a colourful character who would go on to be Lucrezia Borgia's lover, a Knight Hospitaller and a cardinal. The book had long been admired by bibliophiles, and had an unusual feature in that its uppercase letters were shorter than the lowercase ascenders, making it notably kind on the eye in continuous blocks of text. Around 1538 – once the home of fine typography had moved to France – the punch-cutter Claude Garamont had cut typefaces in homage to *On Etna*, and Morison's first act was to revive them for the Monotype machines as Garamond.[30] Strongly drawn to the look of *On Etna*, Morison returned to it again in 1929 and produced his own version, which he called Bembo after the book's author.[31] Morison also took from Manutius and Griffo's catalogue the 1499 book *Poliphilo's Dream Sex-Battle* (*Hypnerotomachia poliphili*), thought by many to be the most beautiful incunable ever printed, and faithfully reproduced its letters as Poliphilus.

Still in Venice, but looking back to before the time of Manutius, Morison chose an early humanist typeface – a group identifiable by the sloping cross bar on the lowercase 'e' – cut in 1470 by the Frenchman Nicolas Jenson, which Morison released as Centaur.[32] Staying with French cutters, he also produced Fournier to resurrect the elegance of Pierre-Simon Fournier's mid-eighteenth century Parisian baroque typefaces, choosing an example

from 1764.[33] Closer to home, he brought John Baskerville's revolutionary typeface from the 1750s back to life as Baskerville.

Morison was not, though, just a lover of the past. He also had a keen interest in contemporary work, which took him to Eric Gill, a former student and friend of Johnston's who would go down in history for the notoriety of his sexual crimes. When Morison commissioned a sans serif, Gill sent him a barely modified version of Johnston's Railway Type which, since it was privately owned by London Underground, was not available to the public. Gill Sans was a runaway success as a commercial typeface, and rather unfairly took the limelight from Johnston's Railway Type, which was a comprehensively better design. Morison also asked Gill for a modern serif typeface for books, and he delivered the slightly quirky Perpetua.[34]

In scouring the history of the printed word for the most beautiful typefaces of all time, and in making them available for a machine widely used by printers, Morison almost singlehandedly reconnected the look of twentieth-century books with the rich past of 450 years of type design. The result profoundly influenced the public's experience of reading, and of books. Morison's Bembo, Garamond and Baskerville have filled millions of pages of bestsellers, and many of his typefaces remain the workhorses of book printing around the world. Since the advent of home computers, dozens of them have also been bundled with the most commonly used computer software, making his typefaces household and office names.

However, of all Morison's typefaces, the most successful was one he designed himself, bringing his encyclopaedic knowledge of type to the task. It began with his comment that the typeface in *The Times* newspaper was not as good as it could be. In response, *The Times* challenged him to design a better one. Morison accepted, and set about developing something that would be legible in the confined columns of a newspaper and hold its shape well when mass-produced on cheap newsprint. He settled on the Gros Cicero cut in 1569 by the Frenchman Robert Granjon for the Antwerp publisher Christophe Plantin, which Monotype had revived in 1913 as Plantin.[35] After tweaking it for newspaper layouts and trying to free it from 'conscious archaism and conscious art', he delivered it to *The Times*, and the newspaper was printed in it for the first time on 3 October 1932. Since it replaced the existing Roman type used by the newspaper, it was named Times New Roman.[36] With versions cut for books, titling, and a variety of sizes, it rapidly became one of the world's most used typefaces. Today, because everyone sees it dozens of times a day in books, letters, reports, accounts, and in hundreds of other places, Times New Roman has

become invisible and the definition of dull, a non-typeface lacking any elegance. But the fact that it never calls attention to itself, and simply allows the reader to focus on the words and not the letterforms – on reading rather than looking – makes it one of the most successful typefaces in history.[37]

Producing books and letterforms that give deep visual pleasure – before and after printing was invented – has been one of Britain's major contributions to world culture. At the same time, Ceolfrith, Fell, Caslon, Baskerville, Johnston, Morison and the others all proved that the look of British books is an aesthetic that has always been profoundly linked to European history and fashions, yet has always built its own unique identity, drawing on continental currents and traditions, and sending them back across the Channel in an endless interchange of ideas, style and excellence.

Typefaces mentioned in this chapter

GUTENBERG (1455)
Waltz, bad nymph, for quick jigs vex ABFGJMOQSWZ

CAXTON (1476)
Waltz, bad nymph, for quick jigs vex ABFGJMOQS WZ ff1234567890

BEMBO (1495)
Waltz, bad nymph, for quick jigs vex ABFGJMOQSWZ £1234567890
Waltz, bad nymph, for quick jigs vex ABFGJMOQSWZ £1234567890

POLIPHILUS (1499)
Waltz, bad nymph, for quick jigs vex ABFGJMOQSWZ £1234567890

GARAMOND (1538)
Waltz, bad nymph, for quick jigs vex ABFGJMOQSWZ £1234567890
Waltz, bad nymph, for quick jigs vex ABFGJMOQSWZ £1234567890

PLANTIN (1569)
Waltz, bad nymph, for quick jigs vex ABFGJMOQSWZ £1234567890
Waltz, bad nymph, for quick jigs vex ABFGJMOQSWZ £1234567890

FELL (1672)
Waltz, bad nymph, for quick jigs vex ABFGJMOQSWZ £1234567890
Waltz, bad nymph, for quick jigs vex ABFGJMOQSWZ £1234567890

CASLON (1725)
Waltz, bad nymph, for quick jigs vex ABFGJMOQSWZ £1234567890
Waltz, bad nymph, for quick jigs vex ABFGJMOQSWZ £1234567890

BASKERVILLE (1757)
Waltz, bad nymph, for quick jigs vex ABFGJMOQSWZ £1234567890
Waltz, bad nymph, for quick jigs vex ABFGJMOQSWZ £1234567890

FOURNIER (1764)
Waltz, bad nymph, for quick jigs vex ABFGJMOQSWZ £1234567890
Waltz, bad nymph, for quick jigs vex ABFGJMOQSWZ £1234567890

CENTAUR (1914)
Waltz, bad nymph, for quick jigs vex ABFGJMOQSWZ £1234567890
Waltz, bad nymph, for quick jigs vex ABFGJMOQSWZ £1234567890

JOHNSTON'S RAILWAY (1916)
Waltz, bad nymph, for quick jigs vex ABFGJMOQSWZ £1234567890

GILL SANS (1928)
Waltz, bad nymph, for quick jigs vex ABFGJMOQSWZ £1234567890
Waltz, bad nymph, for quick jigs vex ABFGJMOQSWZ £1234567890

PERPETUA (1930)
Waltz, bad nymph, for quick jigs vex ABFGJMOQSWZ £1234567890
Waltz, bad nymph, for quick jigs vex ABFGJMOQSWZ £1234567890

TIMES NEW ROMAN (1932)
Waltz, bad nymph, for quick jigs vex ABFGJMOQSWZ £1234567890
Waltz, bad nymph, for quick jigs vex ABFGJMOQSWZ £1234567890

TRANSPORT (1959)
Waltz, bad nymph, for quick jigs vex ABFGJMOQSWZ £1234567890

38

SS-GB – Hitler's Targets in Britain

Reich Main Security Office
Specially Wanted List G.B.
1940

The playboy Edward VII's eldest son, Albert Victor, inherited his father's hedonism. He enjoyed a life of dissipation, drinking and – according to rumours – homosexual brothels, until he died unexpectedly of influenza aged 28 leaving the throne to his straitlaced brother, George V.

Victoria, Edward VII and Albert Victor had not been remotely Victorian in character. Victoria enjoyed sex, looking at pictures of naked men, modern art, and avoiding her royal duties, while Edward VII's love affairs and scandalous living were the lifeblood of society's salons. His brother George, on the other hand, fulfilled the stereotype of a Victorian – buttoned-up and focused on decorum – traits which he passed to his son, George VI. In a century of wars, the two Georges knuckled down to duty and seeing the nation through hard times, and in the process transmitted their code of conformity and duty to the nation, adding a reserve and formality that endured until the late 1950s in many aspects of British life.

George V, Britain's first non-German speaking monarch since Anne in 1714, was educated from the age of 12 by the Royal Navy – where he was diligent rather than accomplished – and only left in his late twenties on the death of Albert Victor. He was formal, read the Bible every day, and could not tolerate women who wore nail varnish or did not ride side-saddle. He was not

shy of all innovations, though, and made the first monarch's Christmas broad-cast in 1932 with a script written by Rudyard Kipling. Almost immediately after his accession, however, he had to face the catastrophe of Queen Victoria's descendants across Europe tearing the continent apart with World War One. Banned from fighting by the government, he threw himself into boosting morale, making 450 visits to troops, 400 to hospitals, and almost the same number to armaments factories and shipyards.[1]

Around him, Britain's political system was changing profoundly. In 1913 the campaign to end the domination of men at Westminster had taken a dramatic step forward when Emily Davison – who had gained first-class honours in English at Oxford but was not awarded a degree because she was a woman – was killed under the hooves of George's horse at the Epsom Derby, probably while she was trying to attach suffragette colours to its bridle.[2] Within five years Countess Markievicz, the Irish Republican revolu-tionary, became the first female member of Parliament. She was elected MP for Dublin St Patrick's but, in line with Sinn Féin's abstentionist policies – and the fact she was in Holloway prison – did not take her seat, leaving Lady Astor to become the first female MP at Westminster the following year, where she represented Plymouth Sutton for the Conservatives.[3]

Parliament was not only changing its sexual composition, but also how it made decisions. Under the Plantagenets the Normans' Great Council of earls and barons had evolved into the House of Lords, before Simon de Montfort's 1265 Parliament had begun the process of establishing the House of Commons. Over the centuries the struggles between the two chambers for overall power and control had ebbed and flowed, but they finally came to a head in 1911 when the Lords conceded that the Commons could – after a one-month delay in the case of money bills and a two-year delay in the case of all others – force its will through the Lords. It was an immensely significant development. The elected chamber had finally triumphed over the inherited and appointed one.

Inside Buckingham Palace, inheritance still ruled, and in January 1936 George v's eldest son, David, succeeded him as Edward viii. George had little confidence in his eldest son, and predicted, 'After I am dead, the boy will ruin himself in twelve months.' He was proved right, and spectacularly. Edward was having a love affair with American divorcée Wallis Simpson, which posed a constitutional crisis as he was simultaneously the head of the established church with its strict teachings on divorce and remarriage. When it became untenable to keep both his lover and his throne, Edward

chose to abdicate, marry Simpson in France, and live there together. However, his largely isolated life in exile grew into one of intense personal frustration as Buckingham Palace resolutely refused to involve him or Simpson in the public life of the country.

On his abdication, Edward was immediately succeeded by his younger brother, 'Bertie', who took the throne as George VI, making 1936 the third time in history there had been a year of three kings in London. George was 40, a Navy veteran of World War One and painfully shy with a stammer, possibly owing to a childhood dominated by his puritanical and disciplinarian father. He nevertheless exhibited a likeable doggedness born of a desire to overcome.

Across the Channel, clouds were already gathering, and it was clear that Germany under the angry and implausible misfit Adolf Hitler was heading into darkness. The previous year, his government had passed the anti-Jewish Nuremberg Laws requiring racial and sexual segregation. And in the year of George's coronation, Hitler had showcased his militarism by marching infantry into the demilitarised Rhineland, and openly sending troops and aircraft to fight for the Nationalists in the Spanish Civil War. Throughout 1938 tensions mounted as Hitler annexed Austria and then the Sudetenland. The Prime Minister, Neville Chamberlain, infamously returned from Munich declaring Hitler wanted peace, but it soon became clear Germany was gearing up to invade Poland, bringing the prospect of a resumption of war across Europe closer. On 25 August 1939 Britain signed the Anglo-Polish pact promising Poland assistance if Germany invaded, hoping it would discourage Hitler's aggression.

Appeasement, however, had made Hitler confident, and on 1 September 1939 he hurled 1.5 million ground troops across his eastern border, punching hard and fast into Poland. Panzer tanks and an array of armoured vehicles pushed deep into the hinterland, while the Luftwaffe rained down bombs from the sky. This was traditional German manoeuvre warfare updated for the 1930s with heavy armour, motorised infantry and close air support, all advancing at breakneck speed. The Germans never gave it a name, but the rest of the world did: Blitzkrieg. One by one countries fell to it as Hitler's shock troops rolled unstoppably across Denmark, Norway, Belgium, the Netherlands, Luxembourg and France, conquering everything in their paths, driving civilian populations from their homes and scattering non-combatants across the continent.

The speed of the conquests was unprecedented, although, surreally, there was a brief throwback to an older, more traditional style of warfare in Poland,

when an elite Polish mounted unit from the Nowogródek Cavalry Brigade – on horseback and brandishing sabres and lances – successfully overran a detachment of the German 8th Infantry Division which had taken the town of Krasnobród. Showing something of the old Prussian spirit, Germany responded in kind with a horse cavalry counterattack, but it was a spirited anachronism. The new reality was fast and furious machine warfare.

Two days after Hitler marched into Poland, Britain declared war on Germany. The British Expeditionary Force immediately deployed to France, but there was little action until Hitler's forces rolled west the following spring. Together with the Allies, Britain mobilised to repel the Blitzkrieg on France, but failed dismally. Humiliated, they were driven into a pocket six miles from the Belgian border around the Channel port of Dunkirk, where the famous von Rundstedt–Hitler 'Halt Order' to the German panzers gave the Allies enough of a reprieve to launch Operation Dynamo. The Royal Navy dispatched destroyers and troop transports in a rescue mission, accompanied by a determined flotilla of around 850 civilian vessels – everything from fishing boats to pleasure craft – many of which had never been in open water before.[4] Against all expectations, Dynamo successfully evacuated 198,000 British and 140,000 French and Belgian troops, while the RAF kept the Luftwaffe out of the skies over the beaches.

The 'Dunkirk spirit' of those who had dropped everything to sail into harm's way and rescue the troops offered a brief moment of national pride in an otherwise desperate situation. British forces had been convincingly beaten by Hitler and, although the men escaped to safety, they had no option but to abandon almost all their tanks, artillery and armour at Dunkirk. Hitler jubilantly made it plain that, in his view, Britain now had no option but to surrender. When Churchill refused, his defiance swelled British chests with pride. Yet the nation also knew it meant a showdown, and that Hitler's war machine would soon swivel its sights north onto Britain.

In London, the government had been making preparations. Beaches were mined, covered with obstacles, and guarded by gun emplacements and searchlights. Bridges were set with demolition charges in case they had to be brought down, and machinery was on hand to destroy airfields. Even roadside signposts and names of railway stations were removed. Plans were also deployed for any German forces which made it onto the beaches to be doused in industrial quantities of mustard gas, while any who got beyond would run into successive walls of defences.[5] Twenty-eight thousand concrete pillboxes were built across the country in great lines: one of the

longest, the GHQ Lines, ran from Weston-super-Mare on the west coast to the Thames Estuary on the east, dividing off the south of the country. London was even more heavily protected with two strong concentric rings of fortifications around its perimeter.[6] Additionally, concrete anti-tank cubes and pyramids were widely scattered across the countryside alongside freshly dug anti-tank ditches.

The preparations were not just military. The treasures of the country's great museums and libraries were removed from danger to tunnels, quarries and mines. The Bank of England relocated the majority of its staff and operations to the Overton-Whitchurch region of Hampshire, and shipped its entire gold reserves to Canada.[7] The government had plans to move to Dollis Hill if the Cabinet War Rooms were damaged, while Parliament would relocate to Willesden, and George VI would take his wife and two daughters – Elizabeth and Margaret – to Madresfield Court in the Welsh Marches.[8]

To bolster the military, in May 1940 the government instituted the Home Guard – made infamous in the 1970s television comedy *Dad's Army* – and it grew to 1.5 million strong within a month. What it lacked in resources its members made up for with ingenuity, improvising homemade Molotov cocktails, flamethrowers, and bayonets roped onto poles.

Beyond the military and volunteers, the defence of the country relied heavily on the civilian population. Church bells were silenced, with peals only permitted to signify invasion so everyone could ready themselves.[9] All civilians – men and women – were expected to play a part, guided by the Ministry of Information's leaflet *If the Invader Comes. What To Do – And How To Do It*. The instructions gave seven rules for how to cope with invading forces, the last of which read: 'Remember always that the best defence of Great Britain is the courage of her men and women. Here is your seventh rule: (7) THINK BEFORE YOU ACT. BUT THINK ALWAYS OF YOUR COUNTRY BEFORE YOU THINK OF YOURSELF.'[10]

Inevitably, there were also plans for a covert underground. The Secret Intelligence Service (MI6) established a resistance, and the Special Operations Executive – Churchill's brainchild, the 'Ministry of Ungentlemanly Warfare' – trained suitable men and women in guerrilla warfare, sabotage and assassination, aiming to deploy them in the towns and villages under German occupation with orders to wreak bloody mayhem.[11] Churchill even told his wife and daughter-in-law he expected them to use butcher knives from the kitchen if need be, advising them, 'You can always take a Hun with you.'[12] His

assessment of the fighting that would follow an invasion was stark. 'The massacre on both sides would have been grim and great. There would have been neither mercy nor quarter. They would have used terror, and we were prepared to go all lengths.'[13]

The number one fear of military planners was attack from the air, as in World War One all sides had developed aerial bombing capacities. The first strategic aerial raid in history had been conducted in 1914 by the Royal Naval Air Service, targeting Zeppelin sheds in Düsseldorf, and the Kaiser had responded with 451 air raids on Britain – first with Zeppelins and then Gotha bombers – killing 1,414 people, to which, in response, Britain dropped double the amount of explosive on Germany.[14] With the passage of two decades, aerial military technology had improved, and the world had seen what Hitler's bombers could do in the Spanish Civil War, including at Guernica in April 1937 where the Condor Legion killed 1,654 of the town's residents.[15]

To safeguard civilians in Britain, a committee for Air Raid Precautions had been formed in 1924 under Sir John Anderson, who later gave his name to the air raid shelters that sprang up across the country. The committee was sure that any future war would involve massive aerial bombing or gassing, and concluded that the only effective protection would be moving civilians from out of harm's way to preserve life and morale. Accordingly, it drew up extensive plans for evacuations from the cities and ports that were likely to be targeted.

Britain had seen Hitler's attack on Poland coming and, the day before his tanks crossed the border, triggered Operation Pied Piper to start the evacuations. From Friday 1 to Sunday 3 September 1939 the country's railways transported 1.5 million people from danger areas to reception centres in the countryside.[16] When no aerial bombing materialised, around 900,000 of the evacuees drifted back to their homes the following year. But in September, when the 'Blitz' began, a fresh wave of 1.25 million again left the cities for the countryside. In July 1944, when the V1 and later the V2 rockets started hitting Britain, another 308,000 would leave for the countryside under the evacuation scheme, with another 552,000 making their own arrangements for relocation.[17] Those who remained did the best they could. By the end of September as many as 120,000 Londoners were sleeping rough in the Underground's stations, including on the tracks. Yet even there they faced dangers. In March 1943 a stampede at Bethnal Green Underground station killed 173 people.

The evacuees leaving the cities were children, mothers of infants under five, and expectant mothers, but in some areas the entire population was moved. In Kent and East Anglia, for instance, 40 and 50 per cent respectively of the population was relocated.[18] Most evacuees were billeted in private homes, but some went to specially built government camps in the countryside, while others were dispatched abroad – to Australia, Canada, New Zealand, South Africa and the United States – under the aegis of the Children's Overseas Reception Board. This scheme worked well initially, but was scrapped when SS *City of Benares* was sunk by a German torpedo off Canada claiming the lives of many, including 77 evacuees.[19]

Evacuation proved a life-changing experience for many. Some inner-city children were enchanted by the unfamiliar ways of the countryside, while their hosts gained an appreciation of the children's urban worlds. Others had negative experiences – as guests and hosts – with the dislocation and tension proving traumatic. The full legacy of these experiences is still being evaluated, but there is little doubt it profoundly changed the lives of the 3.5 million or so evacuees and their hosts, and for a significant proportion of the British population became the abiding memory of life in World War Two.

The long-anticipated Nazi campaign against Britain was finally inaugurated on 16 July 1940 when Hitler issued Directive No. 16 sketching out his strategy for a cross-Channel invasion, ordering his military planners to fill in the details for a full conquest. Just over a fortnight later he followed up with Directive No. 17 empowering the Luftwaffe and German navy to commence invasion operations against Britain any time after 5 August. Despite all the evidence that he was a dim narcissist with a Messiah complex, Hitler believed himself to be a rare genius, especially in military affairs. However, the planners he charged with the invasion quickly appreciated that they faced deep challenges. Britain's rugged island geography was daunting, and only three commanders had ever succeeded in a set-piece cross-Channel invasion: Claudius in AD 43, William of Normandy in 1066 and William of Orange in 1688. All sailed with vast invasion fleets, but none had to contend with the twentieth-century Royal Navy, which controlled the Channel and far outgunned the modest German Kriegsmarine. And, as Philip II of Spain had found in 1588, sending an armada against Britain's navy was not to be undertaken lightly.

The planners' first headache was that their invasion ships and beachheads would be destroyed by the RAF, so they first needed to launch Operation Eagle Attack (*Adlerangriff*) to cripple the RAF and put its airfields out of action. The

man put in charge of this key precondition to invasion was *Reichsmarschall* Hermann Göring, once a dashing World War One flying ace – commander of the Red Baron's legendary Flying Circus – but by 1940 a drug-addled klepto-crat. He rapidly assembled a force of 2,237 fighters and bombers, and assured Hitler he would cripple the RAF in just four days. He had every reason to be confident. The Luftwaffe's resources were formidable, as were its pilots, who had an average age of 26 and solid experience of combat. Against them, Britain's Fighter Command had 700 to 800 Spitfires and Hurricanes flown by relatively inexperienced pilots with an average age of 20.[20]

While Göring readied the Luftwaffe for the initial attack, the German army and navy were preparing Operation Sea Lion (*Seelöwe*) to land hundreds of thousands of assault troops along three wide fronts – from Ramsgate to Bexhill in the east, Brighton to the Isle of Wight in the south, and across the wide curve of Lyme Bay from Dorset to Devon in the west – while at the same time an additional two airborne divisions would drop at strategic loca-tions. Once the first wave of troops ashore had established secure beach-heads, the heavy armour of panzers and motorised divisions would follow in a second phase. Having learned from their easy defeat of the British Expeditionary Force in France earlier in the year, German planners counted on conquering the country and crushing all resistance within a month.

Military operations began on 13 August – 'Eagle Day' – with the Luftwaffe streaming across the Channel in a massed attack. However, they had not done their research, and failed to identify and destroy all the RAF's new coastal radar stations. As a result they met sustained resistance in the air from a forewarned Fighter Command. This continued day after day until, from 24 August, Göring was forced to go all in, sending 1,000 aircraft a day across the Channel. On the first day of these intense attacks, several German bombers – it is assumed in error – released payloads over central London. In swift reprisal, the following day RAF Bomber Command dropped bombs on Berlin. It was the first time the German capital had been hit from the air, and the bombardment enraged Hitler, who had assured the people of Berlin they were safe from attack.

In retaliation, Hitler ordered ferocious bombing of Britain's cities. Without knowing that Fighter Command was within days of collapse, Göring switched tactics on 7 September to concentrate on carpet bombing London by night, unwittingly giving the RAF breathing space to regroup and rearm. Confident that this Blitz on London and other cities was working and that the Luftwaffe had now made the necessary breakthrough in establishing air superiority over Britain, the following week Göring ordered a daylight raid

on London. When the bombers were mauled by a reinvigorated Fighter Command, Hitler concluded that the Luftwaffe was unable to deliver the clear skies essential for an invasion of Britain. In any event, his mind was already turning to the far more grandiose project of eviscerating Russia, and so, two days later, he disbanded the invasion fleet being assembled in northern France. The following month he formally confirmed that the invasion of Britain was postponed indefinitely, although he left the Blitz to run until May 1941 in the hope of forcing a British surrender.[21]

The Battle of Britain was over, and it had given Hitler the new experience of comprehensive defeat. After his Japanese allies bombed Hawaii's Pearl Harbor on 7 December 1941 – goading the United States into entering the war and deploying heavy military resources to Britain – the likelihood of Sea Lion ever being resuscitated dwindled to zero. Nazi planners, however, had been meticulous, and documents reveal this even extended to forcing their ideology onto a conquered Britain.

According to a directive signed in early September, once Britain had been taken, all able-bodied British men between the ages of 17 and 45 were to be interned and deported to the continent, where they would presumably have been deployed as slave labour. There were no similar orders for any other conquered country, and this measure suggests the Nazis were anticipating a high level of underground resistance in Britain.[22] This is also clear from the order that anyone found with an anti-German placard would be shot immediately, as would anyone who failed to surrender all firearms or radio sets within 24 hours.[23]

The spearhead of the Nazis' ideological war in Britain would be the SS, acting through its political police and military wings. In Europe its Special Task Forces (*Einsatzgruppen*) carried out mass liquidations, and detachments were ordered to accompany the invasion army to Britain and set up regional bases at Bristol, Birmingham, Liverpool, Manchester and Edinburgh or Glasgow, answering to a central command and control hub in London under Colonel Professor Doctor Franz Six, former dean of the Faculty of International Science – a front for national socialism – at Berlin University. In advance of Sea Lion he was formally appointed Chief of Security Police for Great Britain. When the invasion was subsequently abandoned, he was sent to Russia instead, where he actively deployed his murder squads in mass executions.[24]

Not all German officers and soldiers were familiar with Britain, so they were to be issued with the *Information Book G.B.* (*Informationsheft G.B.*)

compiled by the Reich Main Security Office, which managed the bewilder-
ing divisions of the SS. This specially prepared manual gave detailed descrip-
tions of Britain's topography, transport infrastructure, institutions, resources
for plundering, and dangerous organisations to be shut down, including the
Church of England, public schools, and the Boy Scouts, which was specifi-
cally identified as 'an excellent source of information for the British
Intelligence Service'.[25] The *Information Book G.B.* project was led by
SS-Sturmbannführer Walter Schellenberg, head of the SD (Sicherheitsdienst),
the SS Security Services, who was to be overall head of police in Britain. He
was a rising star in Himmler's world, not least for running Berlin's notorious
Salon Kitty, a society brothel he staffed with prostitutes trained to extract
secrets from senior Nazi politicians and military officers.[26]

Far more ominous than the *Information Book G.B.*, Schellenberg's office
compiled another book with a more lethal purpose. The 376-page *Specially
Wanted List G.B.* (*Sonderfahndungsliste G.B.*) was to be issued to the
Einsatzgruppen liquidation squads with orders to hunt down almost 3,000
named individuals. This is a selection of them.

77a. Astor, Lady, London, hostile to Germans, RSHA IV E 4.

6. Baden-Powell, Lord, RSHA IV E 4, founder of the Boy Scout
 movement.

96. Coward, Noel, probably. London, RSHA VI G 1.

52. Epstein, Jacob, 1880 New York, sculptor, London S.W.7, 18 Hyde-
 park Gate, RSHA II B 2.

114. Freud, Sigmund, Dr., Jew, 6.5.56 Freiburg (Mähren), London,
 RSHA II B 5.

13. de Gaulle, former French general, London RSHA VI G 1.

14. Pankhurst, Sylvia, secretary of the Women's International Matteotti
 League, Woodford Green/Essex, 3 Charteris Road, RSHA VI G 1.

118. Prevsner [sic], **Nikolaus, Dr.**, born. 1902, private lecturer,
 emigrant, London, RSHA III A l.

134. Russel [sic], **Bertrand**, RSHA VI G 1.

53. Weizmann, Chaim, 1870 or 1874 in Motyli at Pinks, chemistry
 professor, leader of all England's Jewish associations, London S.W.1,
 104 Pall Mall, Reform-Club, RSHA II B 2, VI G 1.

55. Wells, Herbert George, born 1866, writer, London N.W.1, Regents
 Park 13, Hanover Terrace, RSHA VI G 1, III A 5, II B 4.

116. Woolf, Virginia, writer, RSHA VI G.

Stanford University, Hoover Institution, Library and Archives | DA585.A1 G37 (V)/649516, p. 159

1. Packe, Edward H., Vertr. d. Brit. Regierung, London E.C. 2, Britannic House, Anglo-Iranian-Oil-Co., RSHA IV E 2.
2. Padding, A. H., zuletzt: Eindhoven, jetzt: vermutl. England (Täterkreis: Breijnen), RSHA IV E 4.
3. Paderewski, Ignacy, Musiker, Mitgl. d. poln. Nat.-Rates, RSHA IV D 2.
4. Padt, Ds., N., zuletzt: Zutfen/Holl., jetzt: vermutl. England (Täterkreis: Breijnen), RSHA IV E 4.
5. Paetel, Karl-Otto, 23.11.06 Berlin, Schriftsteller, vermutl. London, Deckname: Olaf Harrasin, Alex Afenda (Boy-Scout International-Büro/Bündische Jugend), RSHA IV B 1.
6. Pagel, Walter, Dr., Privatdozent am Papworth, Settlement, Cambridge, RSHA III A 1.
7. Pain, Peter, RSHA VI G 1.
8. Paish, George, 1867, Wirtschaftler, RSHA VI G 1.
9. Palacek, Karl, 28.1.18 Pilsen, ehem. tschech. Major, London, Kensington W. 8, 53. Lexham Gardens, RSHA IV E 4.
10. Palecek, Karel, 28.1.96 Pilsen, ehem. tschech. Major, London (Täterkreis: Moravec, Frantisek), RSHA IV E 6.
11. Palecek, 29.1.96 Pilsen, Major CSR., London, Deckname: Zimmer, RSHA IV E 3, Stapo Dortmund.
12. Palmer, R. A., Gen.-Sekr. d. Coop. Union Ltd., RSHA VI G 1.
13. Panelsky, Eugen (Jude), London (Täterkreis: Ignatz Petschek), RSHA III D 4.
14. Pankhurst, Sylvia, Sekret. Int. Frauenliga Matteotti, Woodford Green/Essex, 3 Charteris Road, RSHA VI G 1.
15. Pannes, Friedrich Gustav, 23.9.00 Essen, Hausmeister, zuletzt: Amsterdam, jetzt: vermutl. England, RSHA IV E 4.
16. Panski, zuletzt: Kowno, jetzt: vermutl. England, RSHA IV E 4, Stapo Tilsit.
17. van Panthaleon, J. H., Dr., Direktor, London E.O. 3, St. Helen's Court, The Asiatic Petroleum Co., RSHA IV E 2.
18. Pares, Bernhard, 1867, Prof. für Slawische Kultur an der Universität London, RSHA VI G 1.
19. Parigger, F. H., zuletzt: Holland, jetzt: vermutl. England, RSHA IV E 4.
20. Parker, John, geb. 1906, RSHA VI G 1.
21. Parker, S. J., Oberst, RSHA VI G 1.
22. Parmentier, ehem. Zivilflieger der KLM., Emigrant, England, RSHA III B.
23. Pasberg, Maximilian Max, 26.7.98 Ratibor, Student, Volkswirt, RSHA IV E 5, Stapo Oppeln.
24. Pascall, Sydney, RSHA VI G 1.
25. Passfield, Baron, RSHA VI G 1.
26. de Passen, holländ. Major, zuletzt: Wassenaar, vermutl. England, RSHA IV E 4, Stapoleit Düsseldorf.
27. Paterson, John, Leiter des Nachrichteninstitutes I.C.I., London S.W.1, Buckinghamgate (Täterkreis: s. Informationsheft I.C.I.), RSHA III D 5.
28. Paty, richtig: Kaspar, Jaroslav, RSHA IV E 4, Stapoleit Prag.
29. Paul, Ernst, 27.4.97 Steinsdorf/Tetschen, Generalsekretär, RSHA IV A 1.

Reich Main Security Office, Specially Wanted List G.B. (1940)

The code after each name and address is the specific department of the Reich Main Security Office that wanted to take custody of the individual, with some – like H. G. Wells – required by more than one. The Jewish desk wanted Epstein and Weizmann. The Marxist desk wanted Wells. The Liberals desk wanted Freud. The domestic intelligence service wanted

Pevsner and Wells, while its foreign counterpart wanted Coward, de Gaulle, Pankhurst, Russell, Weizmann, Wells and Woolf. Finally, the Secret State Police (Geheime Staatspolizei, or Gestapo) wanted Astor and Baden-Powell for its Scandinavian Counter Espionage desk, since it classified Britain as part of the Nordic world. There were many other well-known names on the list, including politicians like Churchill, Chamberlain, Attlee, Eden and the exiled Czech President Beneš; writers like Brittain, Forster, Huxley, Laski, Priestley, Spender and Strachey; singers and actresses like Paul Robeson and Sybil Thorndike; along with most of the country's leading publishers and newspaper owners.

At the back of the *Specially Wanted List G.B.* is a list of all the businesses and other organisations to be closed down. There is a strong showing of publishing companies, including Constable – publisher of this book – which it categorises as 'Marxist'. Curiously, the list also contains Thomas Cook & Sons, the travel agent, the Monotype Corporation which designed many of the age's most cherished typefaces, and Studd & Millington Ltd Sporting and Military Tailors of WC4, presumably for its order book. All of these were to be dragged before the Gestapo's Scandinavian Counter Espionage desk.

The SS was not only interested in rounding up people. Britain was also to be comprehensively asset-stripped of anything valuable. The British Museum, National Gallery, National Portrait Gallery, Wallace Collection, Ashmolean Museum and dozens of other homes to art, sculpture, valuable objects, manuscripts and books were to be systematically looted. To mark the country's humiliation, Nelson's Column was earmarked to be dismantled and set up in Berlin, and the headquarters of the Nazi government was to be triumphally established in Churchill's family home at Blenheim Palace.[27]

What would have happened if German troops had landed in 1940 is one of twentieth-century European history's great counterfactual questions. In 1974 a group of 30 representatives from the British and German armed forces met at the Royal Military Academy Sandhurst in Berkshire to conduct a computer-assisted wargame of Operation Sea Lion using all known plans and data. The participants divided up into land, air, sea and political commands, and played Sea Lion out over a vast board of northern France, the Channel and southern England. The simulation lasted two days and covered the first week of the invasion until a verdict was given by the seven observer umpires drawn from the senior ranks of the British and German

armies, navies and air forces. Their decision was, surprisingly, unanimous: the invasion was a catastrophe for Hitler. Although the initial landings were able to secure beachheads, the Royal Navy quickly took control of the Channel and prevented further landings, leaving the first 90,000 German troops ashore exposed with no supply lines or heavy armour rolling up the beaches to support them. The invaders therefore did not get beyond the GHQ Lines and their advance was crushed. Around 29 per cent of them were killed in combat, 17 per cent were drowned in the Channel, 37 per cent were taken prisoner, and just 17 per cent were successfully evacuated back to France.[28]

By Easter 1943 the threat of invasion was deemed remote, and church bells were again allowed to ring.[29] However much it felt like the return of a degree of normality, when the war ended in 1945 the reality was that an incomprehensible number of people had perished in the world's first 'total war' at the hands of all sides. World War One had killed 20 million people. But World War Two took around four times more, killing 70 to 85 million, of whom the vast majority were civilians. German bombing of Britain killed 61,000 people and, in response, the Allies had killed an estimated 600,000 Germans from the air, principally in firestorm bombings such as those carried out at Cologne, Dresden, Hamburg and Kassel.[30] The death toll from the nuclear bombs dropped by the United States on Hiroshima and Nagasaki is difficult to compute because of the nature of radiation poisoning, but in 1946 was estimated at around 200,000.[31]

The world's response to the numbing tally of dead was the Fourth Geneva Convention of 1949, strengthened by protocols in 1977 which brought a range of protections for civilians caught up in armed conflicts, safeguarding them and their property.[32] However, for all the intentions expressed in the treaties, the reality of subsequent conflicts around the globe is that World War Two set a precedent that has proved unbreakable, with civilians now routinely bearing the brunt of the violence of war.

39

Róisín Dubh – Ireland's Long Road to Independence

Winston Churchill
Telegram to Éamon de Valera
1941

By AD 1 Celtic culture in the British Isles had split into distinct families, with the Goidelic tribes of Ireland already practically and linguistically independent. Classical authors knew Ireland as Hibernia and, from around AD 350, Latin writers also called it Scotia.[1] Small Gaelic-speaking realms developed on the island and, in the north-east, the kingdom of Dál Riata spread across the 12-mile Straits of Moyle to the Mull of Kintyre, Argyll and the Inner Hebrides. When these Irish adventurers – the Scoti – eventually expanded farther into the land of the Picts, they gave their name to the country. Scotland.

Early Irish history is obscure as no travellers recorded their impressions and no literate armies invaded.[2] The centuries passed and Britain fell to the Romans, Anglo-Saxons, Vikings and Normans. Ireland meanwhile followed its own history, walled off by the Irish Sea. The earliest native inscriptions do not appear until the AD 400s, when the Romans were already leaving Britain. They are late compared to writing in the Classical world, but unique in being the earliest vernacular inscriptions in western Europe. The language is Primitive Irish, carved in the distinctive Ogham line-and-notch alphabet which is also found in West Wales, Scotland and the west of England. The

society that wrote them remains largely obscure, but it was organised into kin groups with a learned class – the *Aos Dána* – providing professionals like doctors, lawyers, craftsmen, the *filí* poets and the priestly druids.[3]

Like Britain, Ireland was maritime and had contact with the world around it. Tradition relates that the Romano-Briton St Patrick brought Christianity to Ireland in AD 432, but it had probably arrived with missionaries 200 years earlier. Being a religion of sacred texts, Christianity required a literate clergy, and there is indirect evidence that Latin was known from AD 431 as in that year the pope sent Bishop Palladius 'to the Christians in Ireland', where he 'left his books . . . and the board on which he used to write' at a church in the east of the island.[4]

The transition from old Celtic religion to Christianity was not clean. Pagan Bronze Age art flowed seamlessly into Irish Christianity along with sacred stones, trees and wells, which were all syncretically absorbed into the new religion. Other elements survived, too – although not without mystery – like the exuberant Sheela-na-gig (*Sile na gCíoch*) carvings on medieval churches depicting a nude woman drawing attention to her outsized genitals.[5]

The first real information about how the early medieval Irish lived emerges in the Brehon laws of the seventh to ninth centuries.[6] These collections of clan judges' decisions – 'brehon' is an anglicisation of *breitheamh*, judge – include a vast amount of colour and detail about daily life, conduct and relationships, including marriage – and tribal organisation.[7] Another important source is the *Book of Invasions* (*Lebor Gabála Érenn*), which – although from the mid-twelfth century – records old narratives of waves of invasions that culminated with the arrival of the Gaels. It is a mythological backstory for Ireland, but contains valuable details, especially of the Christianising of pagan culture.[8]

The earliest manuscripts of Ireland's great mythology story cycles and poetry – of Finn MacCool (Fionn mac Cumhaill), the *fianna*, Cuhullin (Cú Chulainn), the magical *Túatha Dé Danann* and *Aes Sidhe*, and the rest – date from the High Middle Ages. The oldest collection is the *Book of the Dun Cow* (*Lebor na hUidre*), probably written at Clonmacnoise Abbey in County Offaly around 1100.[9] Notwithstanding the late dates of these manuscripts, some of the content is far older, originating in the seventh century or earlier.

In time, provinces emerged. They were known as *cúige*, or fifths, but their borders moved and their number fluctuated until settling definitively at

four: Connacht and Leinster in the west and east, Ulster and Munster in the north and south. Each had a king with lesser kings beneath him, and eventually a High King at Leinster's fabled Hill of Tara ruled over all, but rarely effectively.[10] Although Ireland was largely ignored by the Romans and Anglo-Saxons, the island eventually hit the radar of land-hungry medieval raiders. The first conquerors were Vikings, who landed in AD 795, two years after sacking Lindisfarne in Northumberland. They put down roots, founding Dublin in AD 841 as a *longphort* ship camp, alongside other major maritime centres.[11] This Norse presence flourished across Ireland until Good Friday 1014, when High King Brian Boru (Brian Bóruma) defeated the Viking King Sihtric 'Silkenbeard' of Dublin at the Battle of Clontarf, beginning the demise of Viking influence over the island.[12]

The first significant military incursion from Britain came the following century during the reign of Henry II. England's territories extended from Scotland to Spain thanks to the dowry of Eleanor of Aquitaine, and an Anglo-Angevin identity had begun to emerge. It was confident, international, flushed with a sense of power, and had started asserting itself as superior to the older, Celtic cultures of Wales, Scotland and Ireland. This burgeoning sense of confidence coincided with Nicholas Breakspear's reign as Pope Adrian IV. He was the only British man ever to hold the office, and in 1155 he granted Ireland to Henry as a fief, partly in the hope that Henry would reform the Irish church which had been gradually developing a range of divergent local practices.[13] To seal the arrangement Adrian sent Henry a gold and emerald ring as a symbol that he had feudally invested him with the right to rule the island.[14] Henry's contemporaries believed the papacy had the power to give land because, centuries earlier, when the Roman Emperor Constantine moved his capital to Constantinople, he gave Pope Sylvester I all the lands of the western Roman Empire. Although the document in which he did this – the Donation of Constantine – was unveiled as a forgery in the Renaissance, for centuries it was the basis of much of the papacy's territorial power.[15]

Henry's conquest of Ireland did not start until 1169 when Anglo-Angevin knights crossed the Irish Sea as mercenaries in the pay of Dermot MacMurrough (Diarmait Mac Murchada), deposed king of Leinster. The knights acquired significant territory and were bolstered the following year by a larger force under Richard 'Strongbow' de Clare, Earl of Pembroke. Henry eventually landed in person in 1171 to legitimate the landgrab, but also to rein in Strongbow, who had succeeded MacMurrough as king of

Leinster.[16] The Anglo-Angevin invaders now held Dublin and much of surrounding Leinster and neighbouring Munster. As Henry processed around the conquered land, regional kings and the High King acknowledged him without a fight, and Pope Alexander III formally confirmed him as Lord of Ireland.[17] Once home, Henry invited High King Rory O'Conor (Ruaidrí Ua Conchobair) to Windsor, where the two signed a treaty declaring that O'Conor hold the unconquered parts of Ireland from Henry as overlord. Predictably, the arrangement broke down when Anglo-Angevin raiding parties invaded and seized ever more of O'Conor's territories, marking the start of centuries of shifting borders between the Angevin–Plantagenet and Irish regions of Ireland. For most of the period the heartland of the Anglo-Plantagenet settlement was the 'Pale' – the fortified lowlands around Dublin – first given the name in 1495 and one of the traditional etymologies of the expression 'beyond the pale'. Plantagenet control over medieval Ireland reached its zenith around 1300, waning after the devastation of the Black Death in the 1350s. In these centuries the cultures of conquerors, conquered and neighbours inevitably flowed into each other. This blending of the cultures is even evident from the language that evolved. For instance, the *Kildare Poems* from around this time – which include 'The Land of Cokaygne', with its bawdy nude swimming and sexual frolics between young nuns and monks – are in a uniquely Irish dialect of Middle English.[18] In the Statutes of Kilkenny of 1366 Edward III acknowledged that the English settlers in Ireland had gone native, and tried to legislate to preserve English culture, but the initiative failed.[19]

The next major development in Anglo-Irish relations came in the sixteenth century when Henry VIII broke from Rome, making the English monarch's feudal papal title 'Lord of Ireland' meaningless overnight. To fill the void, in 1541 he had the Irish parliament grant him the title 'King of Ireland' to underline that he was sovereign in his own right and not because he was the pope's vassal.[20] However, Henry struggled to assert his authority in Ireland, especially in his religious reforms. The people of Ireland – including the influential 'Old English' descendants of the Angevin and Plantagenet settlers – resolutely resisted the Reformation and remained firmly Catholic. A serious consequence of this was that when Spain and other continental powers began intriguing to bring England back to Catholicism, England's monarchs became increasingly anxious that Catholic Ireland offered a dangerous staging post for military invasions. To reduce the threat, Elizabeth I began a programme of ethnic engineering that would continue under the

Stuarts and shape Ireland's history to the present. Contemporaries used an agricultural metaphor to describe the process, of sowing 'plantations' to improve the 'soil' of Ireland by ripping out the Catholic 'weeds' and replacing them with 'good Protestant corn'.[21] In practical terms, the government confiscated land from the Irish, then private enterprise settled and developed it with English and Scottish colonists.

In the north of Ireland the province of Ulster was notably fervent in its hostility to Protestant England. After Hugh O'Neill and Rory O'Donnell – two of its most rebellious noblemen – left for the continent in the 1607 'Flight of the Earls', James VI and I confiscated their lands, seizing Armagh, Cavan, Coleraine, Donegal, Fermanagh and Tyrone. He then ordered the Plantation of Ulster from 1607 to 1610, which entailed the settlement of the expropriated lands by a large number of English and Scottish colonists 'planted' there with the help of private enterprise. For instance, in Derry, building and settling the plantation was entrusted to the livery companies of London, which were then honoured in James's 1613 royal charter renaming the city Londonderry.[22] Unsurprisingly, the indigenous Irish were resentful of the plantations, and the result was segregation. At Derry, aware of Irish hostility to their arrival, the planters built fortified walls around their new hilltop city of Londonderry, leaving the Irish down below, *extra muros*, in the Bogside, creating the geography of a divided community that would become all too familiar to the world in the twentieth century. The social tensions created by the plantations only deepened over time, fuelled by the settlers' investment with the principal positions of authority to engineer a Protestant ascendancy over the native Catholics. As a result, although the two communities were separated by theology, more meaningful and combustible divisions grew up around identity and culture, and two brutal wars soon polarised these differences even wider.

The first was Oliver Cromwell's 1649 to 1653 Irish expedition to exact revenge for a rebellion and break the island's support for the Royalist cause. The second was the 1688 to 1691 campaign of William of Orange – now king of England, Scotland and Ireland – to crush the deposed James II and prevent him rallying support in Ireland. William landed with Danish, Dutch, English, French, German and Scottish troops, and defeated James at the Boyne in 1690 and at Aughrim in 1691. The violence and social disruption of both wars seared itself into Irish memory. In Cromwell's war an estimated one-third of the island was killed, deported, or emigrated.[23] And after William's war the Treaty of Limerick guaranteed the freedoms of Ireland's

Catholics, but from 1695 to 1727 the Protestant Irish parliament passed a raft of penal laws that began systematically subjugating them. The provisions banished all Catholic bishops, forced Catholic priests to register and abjure or be castrated, forbade Catholic religious education, denied Catholics university education, prevented Catholics voting, buying land or bearing arms, and banned Catholics from overseas travel, intermarriage with Protestants, or earning a living as a soldier, sailor, lawyer or civil servant. These laws were erratically enforced, but the result was nevertheless the rapid creation of a destitute Catholic underclass simmering with resentment.[24]

Britain's empire was expanding at the time, and many of its settlements in the New World were based on the Irish plantation model. Running the empire involved participation by all the constituent parts of the British Isles, and Ireland notably contributed men, skills, and the majority of the butter, beef and pork that sustained those travelling to far-flung places. In terms of personnel, the Irish were disproportionately prominent. For instance, in 1780 one-third of the commissioned officers in the British Army were Irish.[25] The biggest constitutional change came in 1801, when Ireland – like Scotland in 1707 – was officially made part of the United Kingdom. Dublin's parliament was dissolved, and Westminster gained 100 Irish MPs, 28 representative peers and 4 Church of Ireland bishops.[26] The British Isles was now the United Kingdom of Great Britain and Ireland, all ruled under one amalgamated crown.

The 1700s and 1800s brought long periods of prosperity in Ireland, but disaster struck from 1845 to 1849 when the annual potato crop repeatedly failed, destroyed by a blight from across the Atlantic. Because so many in Ireland relied on potatoes as the mainstay of their diet, the effect was apocalyptic. Of the island's eight million people, over a million starved to death. Two million more were forced to flee, principally to the United States, but also to England – notably Liverpool – Wales, Scotland and Australia.[27] Given the island's small population and rural demographics, the long-term consequences were shattering. At the start of the twentieth century the population was still less than half pre-famine level. Today, at six and a half million, it remains unrecovered.

In the aftermath of the famine, the government focused on Ireland and prosperity returned, but an increasing number of voices had begun calling for self-determination. Some were angry at the government's negligent handling of the famine, while others were concerned that with the growing prosperity of the early 1900s, ever fewer people would have any appetite for

independence, and so action had to be taken swiftly. By 1905 they had gained a political voice in a new party: Sinn Féin.[28] Fearing that home rule would give Catholics in Dublin power over the whole island, in 1913 Sir Edward Carson – a Protestant Unionist from Dublin – formed the Ulster Volunteer Force, an armed militia pledged to fight for the status quo. Within 12 months it had around 110,000 members and, in response, those – mainly Catholics – wanting home rule and independence formed the Irish Volunteers the same year.[29]

Pressure to break from the United Kingdom grew steadily. On 18 September 1914 George v gave royal assent to the Government of Ireland Act which created the United Kingdom's first devolved parliament, in Dublin. However, Britain had declared war on Germany the previous month, so plans for Irish home rule were paused while the populations of Britain, Ireland and the empire poured their focus into defeating imperial Germany and the Central Powers. Some, however, were not prepared to wait until after the war for the home rule process to resume. And so, on 24 April 1916, Easter Monday, while the Battle of Verdun was raging in France, and two and a half months before the carnage at the Somme, disaffected elements in Ireland staged an armed rebellion in Dublin.

The organisers were the long-established Irish Republican Brotherhood, or Fenians, and the Irish Citizen Army, a recently formed trade union militia. Together they attacked government infrastructure in a full-scale armed uprising. Once they had seized the General Post Office, their leader, Patrick Pearse, stood outside on Sackville Street and proclaimed the Irish Republic.[30] 'In the name of God and of the dead generations from which she receives her old tradition of nationhood,' he declared, 'Ireland, through us, summons her children to her flag and strikes for her freedom.' He went on to announce a provisional government, while thanking 'gallant allies' in Europe. By 'allies' he meant imperial Germany, which the rebels openly supported because it was fighting Britain. In return, Germany was delighted to help the insurgents, smuggling them weapons and, just a few days before the Easter rebellion, dispatching SS *Libau*, laden with explosives, 20,000 rifles, 10 machine guns and a million rounds of ammunition.[31] Sailing under the false name SS *Aud*, the ship arrived off Tralee Bay in County Kerry where it was swiftly intercepted by the Royal Navy, prompting the captain to scuttle the vessel and sink its arsenal.

Despite initial success in Dublin, the rebellion collapsed outside the capital, failing to ignite public support, and the rebels surrendered within a

week. However, when British forces court-martialled Pearse and the ring-leaders and executed him and 14 others by firing squad at Kilmainham Gaol, public sympathy for the Nationalist movement surged and, as a direct result, in the 1918 general election Sinn Féin won 70 per cent of the vote in Ireland. But, instead of taking their seats at Westminster, the Irish MPs formed their own Irish parliament in Dublin, the Dáil Éireann, pledging allegiance to the republic proclaimed in the 1916 Easter Rebellion.

The Dáil met for the first time on 19 January 1919, and simultaneously in County Tipperary gunmen from the Irish Volunteers fired the opening shots of the War of Independence by murdering two members of the Royal Irish Constabulary (RIC). Things then escalated quickly. By the autumn the Irish Volunteers were swearing formal oaths to defend the Dáil against enemies foreign and domestic, and marching under the name of the Irish Republican Army (IRA). The rebels fought the war as an insurgency, and their campaign took a major step forward when Michael Collins ('the Big Fella') from County Cork – head of IRA intelligence and one of the Sinn Féin MPs who created the revolutionary Dáil – set up 'the Squad' to execute representatives of British power. It methodically assassinated those on its lists, the most notorious attack coming in the early hours of 21 November 1920, when Collins oversaw the murders of 14 men assumed to be connected with British intelligence. The killings – and the British reprisals that after-noon – were soon known as 'Bloody Sunday'.[32]

In London, the Secretary of State for War was Winston Churchill. As the insurgency escalated, he bolstered the RIC with an Auxiliary Division of former British Army officers, and a Special Reserve unit recruited largely in England but also in Ireland.[33] With their mixture of British Army and RIC uniforms the reserves were soon nicknamed the 'Black and Tans', and the brutal violence they and the IRA meted out to each other became a defining feature of the conflict. The memory persists today, with the rebel song 'Come out ye Black and Tans' still a staple in Republican circles.[34] The sense of grievance remains, too. In 2012, when Nike began marketing a 'Black and Tan' shoe for St Patrick's Day, hoping the name would conjure up mouth-watering images of the traditional pint of mixed stout and pale ale from which the phrase originated in the nineteenth century, a barrage of outrage forced it to apologise and withdraw the cele-bratory footwear.[35]

In an attempt to de-escalate the war, Westminster passed a fourth bill for Irish home rule. This resulted in the administrative partitioning of Ireland

in 1921. The six counties of Ulster were named Northern Ireland and given a devolved parliament in Belfast's City Hall. Simultaneously the southern 26 counties were named Southern Ireland, with a devolved parliament in Dublin's Royal College of Science. Meanwhile, on the streets, the tactics of irregular guerrilla warfare employed against Britain by Michael Collins and his IRA were proving effective. Although Westminster was winning the fight, the government concluded it would take a significant escalation in violence to secure absolute victory, a tactic for which it had little enthusiasm given some 2,000 were already dead. Michael Collins was equally aware that the government might launch such an escalation anytime, and so was open to a political solution. Accordingly, a truce was agreed on 11 July 1921, and Sinn Féin was invited to London to negotiate a political settlement.[36]

As the *de facto* head of the IRA and a prominent member of Sinn Féin, 30-year-old Collins, although not the most senior member of the delegation, acted as its leader, facing Winston Churchill who was now Secretary of State for the Colonies. Negotiations formally began on 11 October 1921, and – after significant concessions on all sides – ended two months later at 2.20 a.m. on 6 December with all parties signing the Anglo-Irish Treaty. It created the Irish Free State, granting it the status of a dominion in the Commonwealth like Canada, Australia and others. The Free State comprised the whole island of Ireland – all 32 counties north and south – and came into being on 6 December 1922. As anticipated, the next day the six Ulster counties of Northern Ireland opted to remain a constituent part of the United Kingdom and immediately seceded from the Free State.[37] The island of Ireland was now officially split into two countries, with a hard land border between them.

The Irish Free State's new status as a Commonwealth dominion proved controversial. Collins and his followers viewed it as a first step towards independence, but others were unwilling to continue owing allegiance to George v. Polarising over the issue, the IRA fractured into a pro-treaty wing under Collins, becoming the army of the Irish Free State, and an anti-treaty wing – 'the Irregulars' – commanded by the New York-born Éamon de Valera. The Irregulars immediately launched a campaign of guerrilla violence against the Free State's army just as the Old IRA had done against the government. The resulting descent into civil war across the 26 counties proved almost as costly as the preceding War of Independence, with the loss of around 1,500 lives. The most high-profile killing occurred on 22 August 1922, when Michael Collins was assassinated in his home region of West

Cork, most likely by a former British Army sniper turned Irregular.[38] Despite Collins's death, his national army eventually defeated de Valera's IRA Irregulars, and the Irish Free State settled down to life as a Commonwealth dominion.

Having lost the civil war, de Valera turned to mainstream politics in the hope of achieving a united Ireland democratically. He split from Sinn Féin and, in 1926, formed a new party, Fianna Fáil (Soldiers of Destiny), through which he eventually became Ireland's Taoiseach (Prime Minister) from 1932 to 1948, 1951 to 1954 and 1957 to 1959. When Westminster voted in 1931 to make all Commonwealth dominions sovereign nations in their own right, de Valera took the opportunity to create a firmer identity for Ireland and, in 1937, brought in a new constitution abandoning the name Irish Free State and renaming the country Éire in Irish, Ireland in English.

World War Two erupted two years later. Not wishing to ally with Britain, and conscious that Ireland was still recovering from its own vicious wars, de Valera chose to keep the country firmly neutral, thereby pitting himself against Churchill, who was now Prime Minister. The two men knew each other of old and, although they had never met, held no love for one another. Churchill had never accepted the way Irish independence had been achieved through rebellion, and resented de Valera's refusal to take a stand against Nazism. On the other hand, de Valera found Churchill's imperialism distasteful, and never accepted the partition of Ireland that Churchill had been instrumental in implementing.

Convinced that transatlantic shipping from the United States would be Britain's lifeline during the war, Churchill put pressure on de Valera to grant Britain access to three of Ireland's deep-water ports retained for Britain by Churchill himself under the 1921 Anglo-Irish Treaty, but returned to de Valera by Neville Chamberlain in 1938. At one stage Churchill even suggested that in return he would offer 'in principle' talks on Irish unification. However, de Valera doubted Churchill's sincerity and, unprepared to risk being sucked into the war, he refused.

The two men dug into their respective positions, but everything changed on 7 December 1941 when the Imperial Japanese Navy Air Service blitz-krieged Pearl Harbor in Hawaii. At Chequers, an exuberant Churchill immediately saw that the United States would now have to join the war, making Hitler's defeat far more likely. Within hours of hearing about the attack he dictated a late-night telegram to de Valera, sending it at 12.20 a.m. with orders for the Taoiseach to be woken.

Churchill Archives Centre, The Churchill Papers | Char 20/46/41

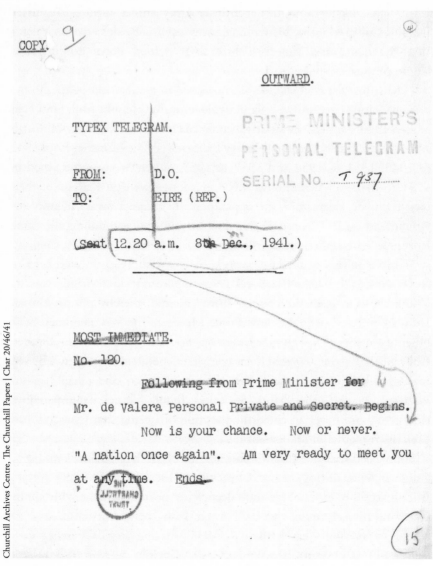

COPY.

OUTWARD.

TYPEX TELEGRAM.

PRIME MINISTER'S
PERSONAL TELEGRAM

FROM: D.O.
TO: EIRE (REP.)

SERIAL No. T 937

(Sent 12.20 a.m. 8th Dec., 1941.)

MOST IMMEDIATE.
NO. 120.
 Following from Prime Minister for
Mr. de Valera Personal Private and Secret. Begins.
 Now is your chance. Now or never.
"A nation once again". Am very ready to meet you
at any time. Ends.

Winston Churchill, Telegram to Éamon de Valera (1941)

The carefully crafted language was designed to leave de Valera in no doubt what Churchill was putting on the table. 'A Nation Once Again' was the title of an old Irish rebel song, popular since the 1840s, and in citing it Churchill was making a direct appeal to the Republican politics that had animated de Valera's life. And yet, after careful consideration, de Valera declined to meet Churchill for discussions.

Although laconic, the telegram is the most serious offer ever made by the

United Kingdom on Irish unification. Those seeking to explain de Valera's unwillingness to engage in the talks – including his son – have suggested that de Valera was told by the British official who delivered him the telegram that Churchill had dictated it drunk. However, de Valera was in no doubt Churchill was being serious: it was simply that the price Churchill was demanding was too high.[39] De Valera maintained Ireland's official neutrality throughout the war, although he was occasionally well-disposed to Britain, returning downed pilots and sending fire engines to the north during the Blitz. Others took a harder line. Elements in the IRA made clandestine overtures to the Abwehr – German military intelligence – hoping to build common cause against Britain. But despite IRA visits to Germany, and German agents parachuting into Ireland for clandestine meetings with the IRA, the collaboration failed to result in any significant military or intelligence dividends.[40]

After VE Day and VJ Day, Britain, the United States and the other Allies triumphantly celebrated the defeat of the Axis powers. Because of its neutrality, Ireland was left out of the euphoria. To compound its isolation, the day after Hitler's death was reported – when the world had already seen images from inside the extermination camps – de Valera visited the home of the German envoy to Ireland and expressed his condolences at Hitler's death. The visit, he later explained, was purely diplomatic *politesse*, but it led to widespread international condemnation and, as the Allies forged forward into the post-war world, Ireland found itself with no place at any major table.[41] De Valera's policy of neutrality had other serious consequences, too, contributing to a sense of separate histories in Ireland and Northern Ireland, hardening their different identities and making hopes for unification more distant.

In 1949 Ireland finally completed its journey to full independence by unilaterally renouncing its dominion status, exiting the Commonwealth, and severing its last constitutional ties with the United Kingdom. This act, though, did not break the links born of tradition, culture and geography. Some connections remained, like preserving the right of Irish citizens to serve in the British armed forces, police, and other public institutions. Economic ties also remained. In the 1950s and 1960s Ireland's agricultural economy struggled to cope with mass unemployment and economic emigration, and relied almost exclusively on trade with the United Kingdom. When Westminster began the process of applying for membership of the European Economic Community (EEC) – or Common Market as it was

known in Britain – Ireland became concerned that a trade border between Ireland and Britain would harm Ireland's economy. Accordingly, in 1963 and 1967 Britain and Ireland simultaneously applied for Common Market membership. They were met both times with President de Gaulle of France's resolute veto. But when Georges Pompidou finally replaced de Gaulle, France dropped its opposition and a referendum in Ireland saw 83 per cent of the vote support membership. Ireland and the United Kingdom accordingly joined the Common Market in 1973.

De Gaulle's reasons for rejecting Britain's membership were profoundly personal. As a career soldier he had long struggled with the perceived shame of France's liberation by Britain and the United States in World War Two, preferring to see them as imperialist invaders out to get what they could from his country. He also assessed that Britain's history and economy were unlike those of France and Germany, that Britain did not really understand Europe, and that Britain would always put the United States first. His rejection of Britain unfairly caught Ireland, leaving it marooned from its centuries-old political and religious links with the continent, caught in the crossfire of wider Euro-Anglo-American rivalries. Six decades on, as Brexit suggests that de Gaulle's anxieties were more perceptive than many at the time thought, large numbers of British journalists and voters are incredulous that the profoundly complex cultural and economic legacy of Ireland's partition in 1921 has proved to be the single most intractable element in the United Kingdom's discussions on leaving the European Union. Equally as thought-provoking is the idea that had the 26 counties of southern Ireland not gained their independence in the twentieth century, the 2016 Brexit referendum would have delivered an overall majority for Remain.[42]

40

Youth, Sex and Concrete – Britain Takes a Modern Turn

Mervyn Griffith-Jones QC
Opening Speech in Regina v. Penguin
Books Limited (Lady Chatterley's Lover)
1960

D. H. Lawrence's final novel, *Lady Chatterley's Lover*, did not break any new literary ground when it appeared in 1928, aside from a sustained use of heavily laboured country dialect. Everything about it was already passé. There was nothing new in printing vulgar words. 'Cunt' had been in steady use in manuscripts and books since first appearing in a Middle English poem in the 1250s. 'Fuck' had featured in books from the 1500s. By the time of Charles II's restoration, writers like John Wilmot Earl of Rochester were using them both liberally and graphically in describing sex. Pornographic novels were not new either since John Cleland's *Memoirs of a Woman of Pleasure* or *Fanny Hill* in 1748 to 1749, while a century later the Victorians were happy to churn out books like *The Romance of Lust* in 1873 to 1876, whose four volumes were filled with non-stop sex scenes dutifully choreographed with unremitting strings of four-letter words.[1]

Lawrence's story is an exploration of the tensions pulling at an antiquated class system grappling with intellectualism and industrial modernity. Sir Clifford Chatterley of Wragby is wheelchair-bound, paralysed from the waist down by a war injury. He neglects his wife, Constance Lady Chatterley, physically and emotionally, and she instead finds fulfilment in the arms of Oliver Mellors, their

taciturn gamekeeper. In the process she learns that real love cannot exist in the mind alone, but needs physical expression, blind to intellectualism or class. Regrettably, Lawrence tackles none of these themes convincingly. Instead, he offers up leaden characters who struggle to be credible in conveying his core message that machinery and overthinking things will destroy England unless gamekeepers are free to spout filth to sheltered women. It is far from a manifesto for emancipation. The title is resolutely not *Lady Chatterley*. Mellors is Lawrence's hero, and Constance's awakening is limited to feeling something approaching fulfilment only once she has come to terms with passively submitting to the urgent – but, she senses, noble – sexual demands of her employee.

Lady Chatterley's Lover is, on all counts, an improbable book to have held aloft the liberalising banner of the 1960s. The sexual themes offer women no new voice or insight, and the class motif ignores the reality that, throughout the ages, aristocratic and royal women have taken lovers from outside their circles. If anything the book reinforces a conservative worldview in which these are presented as radical. The significance of *Lady Chatterley's Lover* is, in fact, not in its humdrum contents, but in the paternalism that for three decades branded it unsuitable for the general public. No publisher in Britain dared produce an uncut version until 1960, when – in the wake of a new, more liberal law on obscenity – Penguin took the decision to release an unexpurgated edition.[2] Outraged, the Attorney General, Reginald Manningham-Buller, contacted the Director of Public Prosecutions to inform him that the government would not stand for it and someone needed to be made an example of.

The sensational case of *Regina v. Penguin Books Limited* duly opened on Thursday 20 October 1960 in the sombre grandeur of Court Room No. 1 at the Old Bailey. The formidable legal teams on both sides were ranged under the watchful eye of Mr Justice Byrne who, 15 years earlier, had prosecuted the traitor William Joyce – 'Lord Haw-Haw' – in the same courtroom for broadcasting pro-Nazi wartime propaganda from Germany.[3] Counsel for the Crown was Mervyn Griffith-Jones QC, who was educated at Eton and Cambridge, had served in the Coldstream Guards in the war, and had been a key member of the Allies' prosecuting team at the Nuremberg international war crimes tribunal.[4] Counsel for the defence was Gerald Gardiner QC, educated at Harrow and Oxford, and who had served in the Coldstream Guards in 1918 but opted to be a pacifist in World War Two. Just over three years after the *Lady Chatterley* trial he was appointed Lord Chancellor in Harold Wilson's Labour government. The trial was set to be a heady mix of top-grade advocacy and interwar smut.

when you have seen this book, making all such allowances in favour of it as you can, the Prosecution will invite you to say that it does tend, certainly that it may tend, to induce lustful thoughts in the minds of those who read it. It goes further, you may think. It sets upon a pedestal promiscuous and adulterous intercourse. It commends, and indeed it sets out to commend, sensuality almost as a virtue. It encourages, and indeed even advocates, coarseness and vulgarity of thought and of language. You may think that it must tend to deprave the minds certainly of some and you may think many of the persons who are likely to buy it at the price of 3s. 6d. and read it, with 200,000 copies already printed and ready for release.

'You may think that one of the ways in which you can test this book, and test it from the most liberal outlook, is to ask yourselves the question, when you have read it through, would you approve of your young sons, young daughters – because girls can read as well as boys – reading this book. Is it a book that you would have lying around in your own house? Is it a book that you would even wish your wife or your servants to read?' This last question had a visible – and risible – effect on the jury, and may well have been the first nail in the prosecution's coffin.

'Members of the Jury,' Mr Griffith-Jones continued, 'for what assistance it may be, those two words are defined in the dictionary in this way: "Deprave: to make morally bad, to pervert or corrupt morally." And Murray's Dictionary has an old quotation against the definition which is perhaps a little apt in the context of this book: "vicious indulgence depraves the inward constitution and character". When you read this book you may think that it is a book of little more than vicious indulgence in sex and sensuality.' This was a ready-made headline for the evening papers, which were not slow to seize upon it. It was also a phrase which defending Counsel put to nearly every expert witness, seeking their opinions as to its aptness. 'And for "corrupt" Murray's dictionary says this: "To render morally unsound or rotten, to destroy the moral purity or chastity, to pervert or ruin, to debase, defile."

'Members of the Jury, with regard to the second question

17

C. Rolph (ed), Harmondsworth, Penguin

Regina v. Penguin Books Limited (Lady Chatterley's Lover) (1960)

Despite his long experience with juries, Griffith-Jones did not make a good start for the Crown. He told the jury that Penguin was a venerable firm of publishers, but had crossed the line by printing 200,000 copies of *Lady Chatterley's Lover* to be sold at the knockdown price of three shillings and sixpence. This was a serious problem, he informed them, because the book was obscene, and publishing it was a criminal offence. To make matters worse, the cheap price meant the country would be flooded with copies of it. On the question of obscenity – which was for the jury to decide – he offered them a simple test.

> Does it suggest – or, to be more accurate, has it a tendency to suggest – to the minds of the young of either sex, or even to persons of more advanced years, thoughts of a most impure and lustful character.

To his mind the answer was plainly yes, and he invited the jury to stand back and see the book for what it really was.

> It sets upon a pedestal promiscuous and adulterous intercourse. It commends, and indeed it sets out to commend, sensuality almost as a virtue. It encourages, and indeed even advocates, coarseness of thought and of language.

Warming to his theme, he leaned in as if confiding in them by a fireside, and made the question personal, inviting each member of the jury to consider how he or she would feel if the book made its way into their home. The question he then posed them is one of the most famous in British legal history.

> You may . . . ask yourselves the question, when you have read it through, would you approve of your young sons, young daughters – because girls can read as well as boys – reading this book. Is it a book you would leave lying around in your own house? Is it a book that you would even wish your wife or your servants to read?

Rather than nodding solemnly, some in court struggled to suppress laughter. It was 1960. Elizabeth II was eight years into her reign. And yet a senior member of the legal profession was solemnly informing a jury – as if imparting a new and weighty secret – that girls could read. Equally

ridiculous, he clearly thought that husbands ought to have a say in which books their wives read. The deliberations of juries are confidential, so there is no record what the three women on the jury made of these bizarre observations, or of what any of the 12 thought of the idea they all had servants.

After this misjudged start, things did not improve for Griffith-Jones. The next six days in Court No. 1 proved unremitting, as it became clear that none of the 35 experts who gave evidence for the defence could be enticed to concede that Mellors's relentless use of four-letter words to evoke his innermost intimate feelings was the business of the criminal law. Some even thought it an important work of literature, although there were many not in court with the opposite view. Lawrence Durrell declined to attend as he found Mellors a 'complacent boor' full of 'half-baked twaddle', and Graham Greene likewise elected not to be a defence expert on the basis the book had no literary merit.[5] Nevertheless, the witnesses who did make it to court were largely enthusiastic. The bishop of Woolwich even gushed that Lawrence was portraying sex as a sacred act, like holy communion, and it was a book all Christians should read.[6] The newspapers wondered where all Griffith-Jones's Prosecution witnesses were – authors, academics and bishops, who would say the book was criminally obscene – but he called none to the witness box. When the jury finally brought the farce to an end, it unanimously acquitted Penguin.[7]

The jury was not asked to reach a conclusion on whether the book was worth three shillings and sixpence or a minute of anyone's time. They simply affirmed that they did not believe Mellors's graphic monologues were obscene within the meaning of the law. The case therefore highlighted, in bold headlines across the front pages, the extent of the gulf between patrician figures like Manningham-Buller – later Viscount Dilhorne, Lord Chancellor and a Law Lord – and 'the man on the Clapham omnibus', who acts as the lawyers' avatar of right-thinking public values.[8] Griffith-Jones, as prosecutor, may or may not have shared Manningham-Buller's belief in the obscenity of *Lady Chatterley's Lover*, but his views on girls, wives and servants were equally out of keeping with the age, and highlighted the extent to which the establishment lived in what seemed to many another world.

The decade would see many clashes of class and intergenerational values, and the public was soon to be presented with an even more stark example of the establishment's distance from most people's reality. The following summer, Secretary of State for War John Profumo, educated at Harrow and Oxford –where he had been a member of the Bullingdon Club – attended

a weekend house party at Cliveden, Lord Astor's country house. There, Profumo came across Christine Keeler – a 19-year-old dancer and occasional prostitute – naked, in a swimming pool. The two began an affair, but the situation was complicated by the fact that Keeler was also sleeping with a Soviet naval attaché, and it all spiralled out of control when a third paramour tried to shoot her in a London street, requiring her to provide the police with a list of all her lovers. News of his involvement filtered up into government circles, whereupon a shaken Profumo assured Conservative whips and the Prime Minister's office that he had not had sex with Keeler. Wanting all rumours scotched, No. 10 ordered Profumo to repeat the denial to the House of Commons. He did, but the gossip refused to die, and Manningham-Buller – now Lord Chancellor – was appointed to chair an inquiry into the scandal. Sensing that he was running out of road, Profumo admitted he had been lying.

The press and country were outraged that a senior cabinet minister – and by extension the government – had been so brazenly dishonest. Trust between Fleet Street and Westminster plummeted. It was immediately visible to close observers that this was a milestone in the public's growing disillusionment with the establishment. The Prime Minister, Harold Macmillan, was soon forced to resign, opening the way for Harold Wilson's Labour narrowly to win power and hold it for the following six years.

The 1950s had – in general – been an optimistic decade. But under the surface there had been an increasing sense of cynicism and scepticism towards authority, fuelled by memories of the futility and waste of the two world wars, and accelerated by the rapid social changes of the post-war period. The decade had opened to a fanfare of confidence in 1951 with the Festival of Britain marking the centenary of the Great Exhibition, but this time with exhibits showcasing the post-war rebuilding of the country, as well as science, technology and art. It captured the enthusiasm of the decade, which lived up to its promise and went on to deliver a sustained economic boom. Despite the international and military humiliation of losing the Suez Canal to Egypt in 1956, Macmillan was able to proclaim to the nation in 1957 that they had never had it so good.

Free of war and economic worries, the 1950s brought increasing optimism, boosted by the coronation of 25-year-old Elizabeth II in 1953. Other feelgood events included Edmund Hillary and Tenzing Norgay's conquest of Mount Everest – announced on the morning of the coronation – and Roger Bannister's sub-four-minute mile the following year. It felt that

Britain was emerging as a modern and successful country. However, society was still structurally conservative, which caused noticeable tensions, with these cross-currents even felt at the top. During Elizabeth's coronation ceremony, her younger sister, Margaret, absent-mindedly flicked fluff from the lapel of one of the queen's equerries, Group Captain Peter Townsend, only to find her love affair with him exposed and played out across the front pages in the first royal romance to be minutely commented on and photographed for the public's entertainment.[9] Despite the winds of change, Margaret learned that the Victorian values of her father and grandfather still prevailed in the royal family, and the relationship was unceremoniously killed off.

One of the most significant changes under way in the 1950s – and core to subsequent definitions of modernity – was the emergence of the leisured young. In the years immediately following 1945 the conscription brought in during the war was continued in the form of National Service for all 17- to 21-year-old men. When it was finally wound down, the change created the first generation of teenagers in decades who knew nothing of war or military service.[10] The freedom this gave them coincided with the fruits of the 1950s economic boom, combining to offer the young leisure time and the economic resources to enjoy themselves, which they did, expressing their baby-boomer identity with distinct tribal clothing, music and vehicles.

The older generations looked on nonplussed as a group of the young and prosperous working class began wearing sharply cut European fashions, riding Italian scooters, and popping amphetamines in all-night dance extravaganzas of soul, ska and jazz.[11] At the same time another working-class group donned jeans and badge-studded leather bomber jackets, and rode around on British motorbikes revelling in the rock and roll music of Eddie Cochran, Gene Vincent and Elvis Presley.[12] These groups of mods – short for moderns – and rockers increasingly polarised in tribal identity to the extent that when the Beatles broke into the mainstream in 1963 they were commercially astute enough to affirm that they were happy to be thought of as 'mockers'.[13]

As the 1960s dawned, Harold Wilson's Labour government promised that the decade would bring a New Britain bursting with innovation from the 'white heat' of the scientific revolution, offering fairness and equal opportunities for all. It was a stirring message, rooted in the technological advances visible all around. The first human had visited space in 1961 and,

before the decade was out, the Apollo mission would land two men on the moon then bring them safely home again. This space glamour reached Britain by the end of the decade with the launch of the Anglo-French Concorde. It was an eye-catching project – the only supersonic commercial passenger jet the western world put into the skies – but it eventually delivered little beyond good photo opportunities, and ended up a commercial failure. For all the hope, Wilson's Britain did not evolve in the ways he had desired. Compared with the United States, Britain's focus on electronics and technology was small scale and poorly funded, and it soon fell behind. Instead, a different kind of New Britain emerged as the 1960s began to implement the social changes that the 1950s had foreshadowed. London transformed into the world's centre of hip, becoming the cradle of the 'Swinging Sixties', powered by a cult of hedonism and the new looks of the day. Driving it were fashion designers like Mary Quant – who popularised the miniskirt and radical colours in lip and eye makeup – with the styles modelled by Jean Shrimpton, Twiggy, and the hundreds thronging trendy areas like Carnaby Street and the King's Road. This London fashion rapidly became international, carried over the Atlantic with the success of the 'British Invasion' of musicians like the Animals, the Beatles, the Kinks, the Rolling Stones and the Small Faces, who all stormed the American music scene.

Despite these 1960s youth innovations, the mods and rockers of the previous decade were still around. At Whitsun 1964 the press exuberantly splashed across its front pages stories of violent confrontations between them at Brighton, Margate and other seaside towns. The reality was less dramatic. The newspapers had largely egged the participants on after hyping a relative non-event at Clacton on Easter Monday into a mass riot, precipitating a moral panic. When prolonged countrywide violence between the groups failed to materialise, the media tired of the story. The mods then began to blend into the mainstream, bequeathing their look to the decade – including to the Beatles – while the rockers faded quietly into the shadows, eventually passing on their jeans, leather and motorbikes to the hard rock and heavy metal subculture of the 1970s.

It was not only youth culture that was modernising Britain. Profound changes were coming in dozens of areas. In 1961 the introduction of the contraceptive pill promised the most significant advance in the history of women's sexual and reproductive choices. Although it had limited initial impact, by the end of the decade and the start of the 1970s women's

contraception had revolutionised society. Simultaneously, in terms of equality, now the battle for suffrage was over a second wave of feminism began to examine women's overall experience in society. The rigid laws on marriage were relaxed, divorce and abortions were made simpler and more widely available, unmarried couples openly started to cohabit and, for the first time, sexual acts between men over the age of 21 in private were made legal. (Sexual acts between women have never been specifically criminalised, but acquired an age of consent in 2001.)[14] It was, in every way, a moral revolution.

Education was also radically overhauled with a move away from the tripartite system of secondary moderns, grammars and technical schools for advanced science and engineering, with a push instead towards all-encompassing comprehensives. Antony Crosland, Labour's Secretary of State for Education, famously remarked, 'I'm going to destroy every fucking grammar school in England and Wales and Northern Ireland,' and his sentiment became the main focus of the government's education policy.[15]

The criminal law saw dramatic changes, too. The appropriateness of capital punishment had begun to be questioned in 1955 when a 28-year-old Mayfair and Knightsbridge hostess, Ruth Ellis, was hanged at Holloway prison for having shot a former lover in a drink- and drug-fuelled *crime passionnel* outside the Magdala Tavern in Hampstead.[16] Many newspapers and members of the public expressed revulsion, and pressure for reform grew. This last hangings in England occurred in 1964, and the death penalty for murder was suspended the following year, then finally abolished in 1969.[17]

In the canon of the modern West, the 1960s are celebrated as the key decade of progress, modernisation and liberalisation. However, not all the changes were embraced or appreciated by everyone. Disposable, unskilled pop art – like the pieces coming out of Andy Warhol's Factory – began as satire, but were soon commercialised as valuable and noteworthy, posing challenging questions about the counterculture and capitalism, and ushering in what many would find to be an incomprehensible world of the avant-garde and the post-modern. In many cases the veneration of modernity came to be a virtue in itself, leading to the destruction of acres of historic buildings, especially in town centres, to be replaced by functionalist and brutalist concrete shopping centres and housing projects, few of which were loved by those who had to shop or live in them. Concrete tower blocks also became notably fashionable until, in 1968, the 22-floor Ronan Point tower

in Canning Town collapsed two months after completion, killing four people and calming the fever for replacing Victorian and Edwardian housing with vertical living.[18] The railways, too, were overhauled. They had been the artery of the Industrial Revolution, but the network was bulldozed. As a result of mass closures – including those carried out under the Beeching Axe – the number of stations fell from over 6,500 to just 2,355, while the country was directed onto the emerging network of concrete motorways and flyovers.[19]

There was, inevitably, a dark side to all the change. Although the United States successfully exported hippie culture to Britain, 1967's Summer of Love did not extend a blanket of peace and tolerance over all British society. The Notting Hill riots of 1958 had revealed a violent anger felt in some quarters towards British West Indians, and these tensions simmered on into the 1960s. As the hippies geared up for the summer of 1967, a motley assortment of far-right British groups formed the National Front to advocate the repatriation of all non-whites.[20] Their anti-immigration message broke into the mainstream the following spring when the shadow Secretary of State for Defence, Enoch Powell, delivered his 'Rivers of Blood' speech in Birmingham criticising the levels of immigration and predicting the end of traditional British culture.[21] The speech gave legitimacy to the National Front and secured Powell a moment in the spotlight, but it ended his political career, and he never held office again. The National Front and its successors remain.

Many of these changes in society were tangible and enduring. The old structures of deference were definitively junked by the mainstream, and the first blossoming of youth culture in the 1950s developed into a full-blown cult. Previously rigid moral and sexual restrictions were fundamentally overhauled, and the churches that had been their guardians lost influence, with congregations beginning to dwindle into the statistically almost negligible numbers of today.[22] Against this, perceptions of the decade are skewed by focusing on the big cities. Britain may now be remembered as the cradle of the Swinging Sixties but, outside a small slice of London's West End, parts of Liverpool and a few other areas, much of the rest of the country was largely unchanged from the 1950s. And although the 1960s is synonymous with counterculture, subversion and reinvention, the young – who were tuning in, turning on and dropping out – were still profoundly locked into twentieth-century economic models of consumerism. Clothing lines, bands, music festivals and pirate radio ships all required serious capital, and the

youth, who were undoubtedly sticking it to the man who had run their parents' generation, were simultaneously creating a new man getting rich off theirs. Harold Wilson's New Britain turned out not to be forged in the white heat of technology, but in the new economy of youth.

There is still debate whether the jury in the *Lady Chatterley's Lover* trial in 1960 was reflecting a society that was already liberal, or whether it fired the starting gun of the movement that would bring liberalisation. Some sections of the public were certainly profoundly angry with the verdict. What is clear, though, is that Britain in 1960 was quite different to the place it had been in 1928 when Lawrence completed the book. Then Lawrence used the story to set out his views of how society could be a better place. He voiced his thoughts through Mellors the gamekeeper, who summarises his vision for societal harmony in the book's final pages, as he signs off to Constance in an emotional letter from his genitals. He says in the world of the future he would wish 'men to wear different clothes: 'appen close red trousers, bright red, an' little short white jackets. Why, if men had red, fine legs, that alone would change them in a month. They'd begin to be men again, to be men! An' the women could dress as they liked. Because if once the men walked with legs close bright scarlet, and buttocks nice and showing scarlet under a little white jacket: then the women 'ud begin to be women.'[23]

Lawrence, regrettably, did not go on to develop quite how white jackets, red trousers and buttocks nice would resolve the individual and societal tensions of industrialisation and the class system, but it seems unlikely that Mellors – or Lawrence – would have been at ease with the solutions Britain found in the 1950s and 1960s.

41

Strikes, Grime and Safety Pins – The Decade of Discontent

Jamie Reid
Cover Art for Sex Pistols, God Save the Queen
1977

In the summer of 1970 the Isle of Wight's 100,000 inhabitants made space for 600,000 to 700,000 visitors, who descended on the sleepy island to hear an unparalleled line-up of musicians, from Jimi Hendrix and The Who to The Doors and Emerson, Lake & Palmer. It was the largest music festival of the age: almost twice the size of Woodstock which had been held 80 miles outside New York the previous summer.

The festival-goers on the Isle of Wight were probably fairly indifferent to the breakup of the Beatles that spring, but many will have taken note of the general election a few months earlier at which 18-year-olds had voted for the first time and Harold Wilson's Labour had been replaced by Ted Heath's Conservatives. As the crowds strutted to Free and swayed to Joan Baez, they probably anticipated that the new decade would continue to bring more of the prosperity that had powered Britain since the 1950s. In fact, the demise of the Fab Four and of Wilson's government were canaries in the coalmine indicating that Britain was changing again.

Six years later, when the American film director George Lucas landed in England to shoot a quirky new project at EMI-Elstree Studios, he found himself in a country that had long since ceased to swing. The crew at Elstree

remorselessly mocked his *Star Wars* space opera as a children's film but, when it opened in British cinemas the day after Boxing Day 1977, it delighted a tired and bruised country with its escapist intergalactic adventures, heroism, romance and comedy. However, a reminder of the real Britain arrived three days later with the launch of a new prime-time television series.

'Private Madness, Public Danger' was the first episode of an action drama whose two heroes were scowling hard men with chunky sideburns, flares, polo neck jumpers and soft leather jackets. As they tore around London's mean streets in a silver Ford Capri their pockets bulged with handguns and high-tech walkie-talkies resembling electric shavers, and in each episode they brought down a new group of terrorists or organised criminals plaguing the city and home counties. *The Professionals* ran for 57 episodes, showcasing a London in which the glamour of 1960s Carnaby Street and the King's Road was long gone, replaced by a menacing grey city in which violence, crime and a no-rules approach to law enforcement were the norm. Dubbed into an array of languages, it offered viewers around the world a gritty and hard-edged Britain,

The clothing and grubby street scenes in *The Professionals* did not lie. The 1970s is now a byword for economic disaster, with fashion to match. However, the malaise was episodic, and largely focused in the public sector. Underneath the grime, Britons were continuing to grow more affluent. There was social mobility, and almost all sections of society were living more comfortably, able to contemplate holidays abroad and other expenses that would have been impossible in previous generations. Millions of households now had everyday consumer goods including television sets, and could equip children with the fashionable luxuries of the day like the ubiquitous orange bouncy Spacehopper balls and the British Raleigh Chopper bicycles modelled on Peter Fonda's iconic Harley-Davidson in *Easy Rider*.

The prosperity of the 1950s and 1960s had been a result of the disruption of the 1930s and 1940s as the Great Depression and World War Two held back capital investment and the development of new technologies. When peace returned after the war, fresh opportunities to invest opened up and large sums were sunk into new ventures and technologies. Although Britain was at times inept at selecting the best technologies to focus on, many projects offered a strong return on investment and underpinned a booming economy.[1] As a direct result, from the late 1950s to the early 1970s the gross national product adjusted for inflation of the world's seven

largest industrial economies – Canada, France, Germany, Italy, Japan, the United Kingdom and the United States – grew at over 5 per cent per year. To many people it seemed as if the growth would continue for ever, so it came as a shock when, by the early 1970s, opportunities for new ventures began to dry up, and overall growth flagged.

On 6 October 1973 the gradual economic slowdown turned into an international crisis when, at dawn on Yom Kippur – the Jewish holy day of atonement – Egyptian and Syrian forces invaded the Sinai and Golan Heights, both of which had been occupied by Israel since the Six-Day War of 1967. A volatile situation became even more deadly when the United States and Russia opened up a proxy war by funnelling weaponry to the Israelis and Arabs respectively. To show solidarity, Arab leaders of the Organization of the Petroleum Exporting Countries, OPEC, signalled their displeasure with America by hiking prices. Oil shot from $3 to $12 a barrel, rapidly dragging up the price of all the modern world's industrially produced goods.[2] In Britain this was compounded by the change in 1971 from the traditional money system based on pounds, shillings, pence and the 12 times table to the new decimal system. With prices rising and decimal currency feeling unfamiliar, many struggled to maintain a sense of what goods were worth and suspected unscrupulous shopkeepers of hiking prices. Overall, the lethal combination of an inflationary pull colliding with a background slump in growth caused stagflation, which economists had theorised to be impossible. However, it was real, damaging, and brought complexities for which governments had no effective solutions. As a direct result, from 1973 to 1979, growth in the same seven largest industrial economies slumped to 2.5 per cent.[3]

In Britain, just over a month after the Yom Kippur invasion, Wednesday 14 November was a bank holiday. Bells rang out over Westminster, and crowds thronged the pavements as the archbishop of Canterbury married Princess Anne and Captain Mark Phillips inside the ancient abbey. But while the crowd's mood was exuberant, the newspapers were predicting dire days ahead. *The Times* pulled no punches: 'Lights go out as emergency powers bite'.[4] Everyone knew what this meant. The miners had voted to take industrial action again.

In the 1950s Britain's miners had earned significantly more than the average industrial worker, but 400 pits closed in the 1960s and miners' wages dropped below the average. There was unofficial industrial action with regional strikes in 1969 and 1970, but the first large-scale strike came

in January 1972. When the National Union of Mineworkers (NUM) demanded a 47 per cent pay increase, the Coal Board offered 7.9 per cent as Edward Heath's government had imposed an 8 per cent cap on any public sector pay increase. In response the NUM called its 280,000 miners out on strike and closed every pit in the country. At first the government was not overly concerned by the action, having already weathered strikes by dock workers and postal workers. But when a relatively unknown NUM official from Yorkshire named Arthur Scargill deployed a new tactic, the government took notice.

From his headquarters, Scargill arranged for busloads of miners to be transported around the country to block deliveries of fuel to power and energy plants. These 'flying pickets' successfully choked off the nation's power, rapidly bringing Britain to a standstill. Scargill explained that it was class war, and that war meant attacking the enemy's most vulnerable points.[5] Power cuts and blackouts followed, and the government imposed a three-day week on industry. No one had expected the strikers to succeed at the outset, but the strike ended after seven weeks with the miners awarded a 27 per cent pay rise, restoring their status as some of the highest paid manual workers in the country. Their action, though, was not without consequences. The wider economy had been damaged, with around 1.2 million workers laid off. Inspired by the miners, ambulance and engine drivers, firefighters, power workers, hospital staff and civil servants all then went on strike.

The dire portents in the newspapers the following year on the day of Princess Anne's wedding appeared because the NUM had placed a ban on miners doing any overtime as they wanted another wage increase to deal with depreciation in the value of wages from inflation. After the experience of the flying pickets the previous year, the government knew what to expect if the dispute deepened. It did, causing power cuts which became increasingly severe. Street lighting was turned off, schools were closed, and hospitals had to scale back their activities. In mid-December, Edward Heath appeared on television to announce that from New Year's Day 1974 the whole country would have to adopt a three-day week. With the relationship between the government and the miners growing more tense, in February the miners rejected the government's offer of a 16.4 per cent pay rise and went out on strike again.

Four thousand miles away in Kampala, Idi Amin Dada – the six-foot-four-inch veteran of the King's African Rifles turned butchering dictator of

Uganda – heard of the industrial dispute and offered to bail Britain out. He sent telegrams to London reporting that ordinary Ugandans were moved to help their 'former colonial masters' and had raised a substantial Save Britain Fund, as well as donating a plane load of vegetables and wheat which was ready for collection.[6] The Foreign Office politely declined, and Amin's mock munificence evaporated. By the mid-1970s he was back to his usual self and in talks with a small Scottish terrorist group – the Scottish National Liberation Army – in the hope of becoming king of Scotland.[7]

When the miners voted for a full strike in February 1974, Heath called a general election in which he asked the country for a mandate to clamp down hard on strikes. To his surprise the ballot box delivered a hung Parliament and, after he failed to agree a pact with the Liberals, he resigned. So, quite unexpectedly, Harold Wilson found himself back in No. 10 Downing Street leading a minority Labour government. He gave the miners a 35 per cent pay rise to end the strike, after which the miners achieved another 35 per cent rise from him the following year without any industrial action.

In October, Wilson called a fresh election to give him a firmer grip at Westminster, but the result was little better, yielding a majority of just three seats. The left of the Labour party – notably Tony Benn and Michael Foot – made his life a misery, and he had little room for manoeuvre with the unions. When he hit the age of 60 in March 1976 he dramatically resigned, handing over to his Foreign Secretary, James Callaghan, who lost the party's majority the day he took office, forcing him to rely on the support first of the Liberals and then the Scottish National Party. Meanwhile, the effect of stagflation had pushed unemployment – which had been at 600,000 in 1970 – to over 1.3 million.[8] With a large public sector pay bill to fund every month and the pound now sliding dangerously, the Chancellor, Denis Healey, faced a grim choice. The top rate of income tax was already 83 per cent, so the realistic options were to cut public sector wages or borrow.[9] He chose the latter, and in December 1976 approached the International Monetary Fund for a £2.3 billion rescue loan: the largest ever requested from the IMF.[10] In the event, he only drew down half the facility, but the affair was enough to destroy the government's financial credibility.[11]

The mods who, two decades earlier, had donned Italian and French suits in rebellion now had their own teenage children. But with rising unemployment and a country which at times seemed held together by sticky tape, the new generation was gravitating towards a far angrier rebellion. In America

the rock band the New York Dolls was delighting audiences with gender-bending shows of mayhem-infused exuberance. A London fashion entrepreneur, Malcolm McLaren, came across them, and tried to interest the band members in ideas for revamping their clothing and image, but they declined. On arriving back in London he learned that one of the shop assistants at SEX – the King's Road fetish-fashion boutique he ran with his former girlfriend Vivienne Westwood – was forming a band, and just needed a singer. McLaren offered his assistance, and held the auditions at SEX, with aspirants singing along to the shop's jukebox, at the end of which he convinced the band to choose an anarchic, feral-looking singer who took the stage name Johnny Rotten. The band was complete and, in honour of its origin at SEX, was named the Sex Pistols. McLaren continued to help here and there, but was not a manager in a traditional sense. His only musical advice was to be chaotic, as his principal interest in the group was for them to stir up trouble and get noticed, while he would dress them in artfully destroyed fashion that would lead fans to lines of clothing he and Westwood were selling at SEX.[12]

The Sex Pistols were soon signed by EMI and, on 26 November 1976 – a month before the IMF bailout – the band's debut single was released. The horror of 'Anarchy in the UK', as received by the mainstream, with its snarling nihilism and raucous, stomping rhythm – impeccably produced and delivered – came from a different planet to the gentle, crooning ballad by Chicago that was at the top of the charts. The band then shot to national attention when the guitarist called a TV presenter a 'fucker' during a live broadcast on Thames Television. It was not the first time the f-word had been uttered on television – that credit went to a railings painter, who told Ulster TV in 1959 that his job was 'fucking boring' – but it was the first time it had been used on screen as a term of abuse.[13] The newspapers went into meltdown, and EMI reluctantly gave in to pressure to fire the band just when it was getting noticed. After falling out with a second label, the Sex Pistols finally found a permanent home with Richard Branson's Virgin Records. However, by now they were notorious, inciting chaos and hooliganism wherever they went. Venues declined to book them for fear of the cost of the damage their fans would do, and radio stations refused to play their music. The publicity all this infamy brought transformed them into a household name.

It was now 1977, and Elizabeth II was celebrating her silver jubilee year on the throne. On 27 May the Sex Pistols released their own tribute for the

occasion: a brash and sneering track entitled 'God Save the Queen', with lyrics guaranteed to ensure the record would be banned instantly. 'God save the queen, the fascist regime, they made you a moron, a potential H-bomb. God save the queen, she ain't no human being, and there's no future in England's dreaming . . . When there's no future, how can there be sin, we're the flowers, they threw in the bin . . . No future, no future, no future for you'.[14] To ramp up the song's shock value, the artist Jamie Reid was commissioned to design a provocative record sleeve. He took one of Peter Grugeon's official jubilee portrait photographs of Elizabeth and cut out just the head. Then he tore a strip out over her eyes so it resembled a blindfold, and another off her mouth as if she was gagged. He then laid the words 'God Save The Queen' and 'Sex Pistols' onto the black strips over her eyes and mouth in letters cut out from newspapers as if it were a ransom note.

The record became instantly infamous. High street shops like W H Smith and Woolworths refused to stock it. To whip up more publicity, on 7 June, while the country was celebrating the jubilee, the band set off down the Thames on a boat and played its most aggressive songs at loud volume while drifting past the Houses of Parliament. There were fevered questions in the Commons, one MP quoting a newspaper's assessment of the punk movement: 'It is sick. It is dangerous. It is sinister.'[15] The tabloids foamed that the song and record sleeve were treasonous.[16] But none of this made any difference. 'God Save the Queen' was, inevitably, the best-selling record of the jubilee summer, and Reid's cover art was soon on thousands of walls and T-shirts, becoming an iconic and defining image of the decade. However, after such a promising start, it soon all went wrong for the Sex Pistols. They replaced the bass player with Sid Vicious, who had the look but no musical aptitude, recorded one album, attempted a chaotic tour of the United States, then split up on 14 January 1978. They had lasted almost a year and two months, leaving a legacy as the founders – and archetype – of British punk: a unique mix of art school rebellion, narcissism, shock and self-destruction.

By late 1978 the economy was again looking healthier, and there was an expectation that Callaghan would call an election to secure a majority. In the end he chose not to, and his attempts to urge public sector wage restraint and keep pay rises below 5 per cent led to a fresh wave of strikes. After he bowed to pressure from tanker drivers, awarding them a 15 per cent pay rise, ambulance drivers, dustbin men, grave diggers, nurses, sewage workers, water workers and a host of others all went on a series of over 2,000 strikes.

It was the coldest winter in over a decade, and soon dubbed the 'Winter of Discontent'.[17]

Callaghan's premiership effectively came to an end in March 1979 when he lost a confidence motion in Parliament by one vote. Aside from the four years 1970 to 1974, Labour had been in power for 15 years, and the strike-fatigued country wanted a change of direction, which it found in the revamped Conservatives. Heath had never really connected with the electorate and was widely viewed as cold and aloof. His replacement was in a thoroughly different mould. Most notably she was a woman and – after winning the general election in May – she became the country's first female Prime Minister. Like Heath, she did not come from a privileged background, but there the similarities ended. At the top of Margaret Thatcher's list was restoring the international prestige many felt Britain had lost, and controlling the unions so they could not subject the country to the strike misery that had blighted the decade. The expectations of her from all sides were high.

On 4 May Thatcher's government finished paying off Denis Healey's IMF loan.[18] Once clear of it, she was able to start focusing on her own economic strategy, which would mark a profound shift away from Keynesian spending programmes, corporatism and trade union power.[19] Society was already changing significantly from an economic perspective, with younger middle-class people able to borrow to fund house purchases, giving them a source of increasing wealth. Meanwhile, the working class and the older generations – who mainly rented their homes – were left increasingly vulnerable to rising prices. With Thatcher's election – and two subsequent re-elections – Britain was not only catching up with Argentina, the Central African Republic, China, India, Israel, Mongolia, Sri Lanka, the Tuvan People's Republic and Ukraine in having a woman as leader, but signalling that it wanted fundamental change in its economic and social structures.

42

The Armalite and Ballot Box – Northern Ireland's Troubles
The Provisional IRA
The Execution of Soldier Mountbatten
1979

Following Ireland's declaration of independent statehood in 1949, the Irish Republican Army (IRA) changed its goal from securing separation from the United Kingdom – which was now a reality – to the unification of the island's 32 counties. The single largest obstacle to this aspiration was that in December 1922 the six counties of Ulster making up Northern Ireland had chosen not to be part of the Irish Free State but instead to remain part of the United Kingdom. The IRA's objective was, therefore, to force the integration of the six counties into a unified Ireland against the democratic will of the northern population.

By the mid-twentieth century, Northern Ireland's two communities – Protestant and Catholic – were divided, although theology played little part. From the time of the Tudor and Stuart plantations, the two groups had developed separate political, social and cultural identities to the extent that a long history of violent rivalry divided them far more than doctrinal questions of Christianity. Of the main groups to emerge, Nationalists – predominantly Catholics – identified as Irish, promoted Irish culture and often wanted the island unified. Within their ranks, Republicans focused on the goal of unification. Opposing them, Unionists – predominantly Protestants

– identified as British, promoted British culture and wanted Northern Ireland to remain part of the United Kingdom. Those who focused specifically on Protestant identity and loyalty to Ulster were Loyalists.[1]

The IRA's policy of unification was aimed at the Nationalist population. It initially found little support, but that changed in the late 1960s when conditions in Northern Ireland sparked protests against social and political discrimination. In this climate of unrest, the IRA was able to capitalise on sectarian grievances to gather broader support. What had started as a non-sectarian civil rights movement fractured along Nationalist and Unionist lines, and the tipping point came dramatically in Londonderry on 12 August 1969. Despite a prohibition on Nationalist civil rights marches in the preceding 12 months, a 15,000-strong Unionist march was unexpectedly authorised in commemoration of 13 Apprentice Boys who, in 1689, had shut the city's gates on the recently deposed Catholic James II at the start of the war between James and William of Orange for the crowns of England, Ireland and Scotland. Once the commemorative parade was under way, some of the Unionists marching around the city's old walls began throwing coins and projectiles down into the Nationalist Bogside area. When the march then snaked down past the Bogside, scuffles broke out. Unionist marchers ran into the Bogside's densely packed streets, where a full-blown riot erupted with petrol bombs hurled in pitched battles.[2] News of the rioting spread, and similar sectarian disorder quickly erupted in Belfast's flashpoint zone around the Nationalist Falls Road and Unionist Shankill Road.

Northern Ireland's police force – the predominantly Protestant Royal Ulster Constabulary (RUC) – was inadequately resourced to respond to rioting on such a scale, and rapidly lost control of Londonderry. By now house burnings were in full swing, and of the estimated 1,800 houses burned down, 1,500 belonged to Catholics. To prevent the total breakdown of the city, just after 5 p.m. on 14 August 300 British soldiers of the 1st Battalion the Prince of Wales's Own Regiment of Yorkshire were sent to Londonderry in the opening phase of Operation Banner. Deploying the troops proved effective in preventing a major escalation in violence and, by 16 August, the riots had been quelled. However, in the fractious aftermath it became clear that tensions between the Nationalist and Unionist communities could reignite at any time into further rioting, so the government left the forces to patrol the city's streets, principally protecting the Catholic areas.

In some Republican circles there was disquiet that the IRA had been ineffective in protecting Nationalist areas from Loyalist attacks. As a result, towards the end of 1969, a splinter group committed to more aggressive action broke from the IRA under the name 'the Provisional IRA'. Known as the Provisionals or Provos – or PIRA in government, military and security circles – the group began recruiting and undertaking operations. Its aim was the island's unification by force of arms at any price, as it stated in the February 1970 edition of *An Phoblacht*, the magazine of Sinn Féin. 'We will erect the Irish Republic again in all its glory no matter what it costs and like Pearse "We know of no way by which freedom can be obtained and when obtained, maintained, except by armed men".'[3]

In furtherance of these aims, in 1971 it launched a campaign of violence directly against the British government, focusing particularly on killing members of the RUC and British Army. These murders caused such outrage that in August 1971 the British government introduced internment – imprisonment without trial – for suspected Provisional IRA activists, housing them at Long Kesh Detention Centre in Lisburn. In doing this it was following the actions of the Oireachtas – the Irish parliament – which had widely interned suspected IRA members in 1939, successfully breaking the group's operational abilities for a period.

As the sectarian violence intensified, separate groups of paramilitaries became more visible. On the Republican side the Provisional IRA had a virtual monopoly, although the Communist Irish National Liberation Army (INLA) also emerged. On the Unionist side the Loyalists had the Ulster Defence Association (UDA) – which conducted armed activities predominantly using the name the Ulster Freedom Fighters (UFF) – the Ulster Volunteer Force (UVF) and the Red Hand Commando (RHC), named after the heraldic red hand symbol of Ulster.[4] All across Northern Ireland, sightings of these openly armed paramilitaries became commonplace.

Violence on the streets escalated and, fearing civil war, in March 1972 the government suspended the Belfast parliament – which had been functioning since 1921 – and reimposed direct rule from Westminster. At the same time the British Army presence was ramped up to control the chaos, with the original 300 troops swelling to 28,000 by the summer.[5] The internments at Long Kesh grew increasingly divisive and inflammatory, with widespread resentment in Republican circles at the absence of trials prompting calls for the internees to be given prisoner-of-war status.[6] To calm the mood, in July 1972 the British government granted them Special Category

status, but not before, earlier that year, an illegal march in Londonderry had become one of the most publicised episodes in the Troubles.

On Sunday 30 January, around 10,000 to 15,000 Republican sympathisers gathered in the Bogside to protest against internment. As the crowd filed through the densely packed streets, some began throwing rocks and projectiles at British soldiers manning security barriers. Rioting soon broke out, and the Army responded with rubber bullets, water cannon and CS gas. For a short period the soldiers also used live ammunition. The first rioter to be shot was Damian Donaghey, who was throwing stones at soldiers. He was hit in the thigh and survived, but over the following 10 minutes 13 protestors were shot dead.

Within months the Widgery Report concluded that the crowd had fired on the soldiers first. Many wanted a more detailed inquiry, and in 1998 the Saville Enquiry was set up, reporting in 2010 that although some of the Republican marchers had been armed and fired their weapons, and at least one had hurled jars of acid at soldiers causing injuries, the Army had not been in an overall level of danger that warranted opening fire with live rounds.[7] Bloody Sunday, as the day became known, remains one of the most controversial and contentious incidents of the Troubles – although, confusingly, until then Bloody Sunday had meant 21 November 1920, when Michael Collins's IRA 'Squad' in Dublin had murdered 14 people allegedly connected with British intelligence.[8]

The year 1972 was one of the worst during the Troubles. On 7 July, 23-year-old Gerry Adams – released from internment specially for the occasion – and 21-year-old Martin McGuinness were flown along with other Republican leaders to a secret meeting with the Secretary of State for Northern Ireland in Chelsea's Cheyne Walk.[9] Both sides stated their positions. The Republican delegation demanded British withdrawal from Northern Ireland, while the British government reiterated that in 1922 the people of Northern Ireland had elected to remain part of the United Kingdom. The talks ended without resolution and, in response, a fortnight later on Bloody Friday, the Provisional IRA in Belfast detonated 19 devices – mostly car bombs – across the city in an hour and 20 minutes, killing and maiming scores of civilians, including 77 women and children. A further two bombs failed to detonate, and two more were successfully defused. The sheer number of explosions, compounded by a deliberate tactic of multiple simultaneous hoax bomb warnings, comprehensively overwhelmed the emergency response services, increasing the death toll. Despite the

involvement of around 150 Provisional IRA members in the carnage, only one person served prison time for the day's bloodbath.

The Provisional IRA was committed to bombing and shooting the British government out of Northern Ireland regardless of the democratic wishes of the people of Northern Ireland. In this cause, its 27-year war against the government resulted in a grisly tally of terrorist attacks. Atrocities became commonplace across Northern Ireland, and the campaign also spread to England, where bombs exploded in pubs, Hyde Park, The Regent's Park, the City of London and Harrods, at the Conservative Party conference and elsewhere. There was a mortar attack on No. 10 Downing Street, targeted shootings of military personnel, and even the murder in continental Europe of British soldiers and a range of civilians. In total, the Provisional IRA killed around 1,800 people and maimed thousands more.[10]

Throughout the Troubles the relationship between Sinn Féin and the Provisional IRA was carefully choreographed to give the impression that these were two separate organisations. Sinn Féin was thus enabled to present itself as a legitimate political party and the Provisional IRA as an unconnected paramilitary group. In reality there was only one organisation: the Provisional IRA, with Sinn Féin as its internal political and propaganda wing. Gerry Adams, President of Sinn Féin for much of the Troubles, has always denied having any involvement with the Provisional IRA. However, many observers and participants have stated that he and Martin McGuinness rose through the Provisional IRA's ranks to become leading members of its Army Council: the governing body which planned all strategy and terrorist actions, and directed Sinn Féin. They say that Adams sat on the Army Council from 1977, making him one of its longest-serving members. McGuinness rose to be chairman of the Army Council, and eventually admitted his Provisional IRA activity, which included having been its second-in-command in Londonderry during the 1972 Bloody Sunday march at which, according to the Saville Report, he was probably carrying a Thompson sub-machine gun and possibly fired it.[11] What observers note is that neither man ever admitted that they each served as Chief of Staff, the Provisional IRA's overall commander.[12]

Although the IRA saw itself as a people's army engaged in legitimate warfare against a hostile power, it was fighting for something that had been democratically rejected, so it had no legitimacy in many people's eyes. In 2006 a British Army assessment noted that it 'developed into what will probably be seen as one of the most effective terrorist organisations in

history. Professional, dedicated, highly skilled and resilient, it conducted a sustained and lethal campaign.'[13] Behind the scenes it raised money via donations, and from protection rackets, extortion, robbery, drugs, the sex trade and blackmail.[14] Unlike an official national army, its internal discipline and vendettas against outsiders were enforced with a steady diet of punishment beatings, kneecappings, and tarring-and-featherings, the latter notably in the 1970s for women it believed had relationships with British men.

On 27 August 1979 – when it is remarked that McGuinness was Chief of Staff of the Provisional IRA – it conducted one of its most high-profile terrorist attacks of the Troubles, detonating a 50-pound bomb in a small boat lobster-potting off the coast of County Sligo. The dead included two boys aged 14 and 15 and an 83-year-old woman. But the intended victim was Prince Louis of Battenberg, better known by his anglicised name: Louis Mountbatten. He was the queen's cousin, former Chief of the Defence Staff, Admiral of the Fleet, and last Viceroy of India.

As in previous years, Mountbatten had taken his family to holiday at Classiebawn Castle in Mullaghmore on the west coast of Ireland, 12 miles from the border with the North. He did not post any security on his nine-metre boat, *Shadow V*, enabling the Provisional IRA to plant a radio-controlled bomb on board. Afterwards, Sinn Féin issued a statement in *An Phoblacht*.

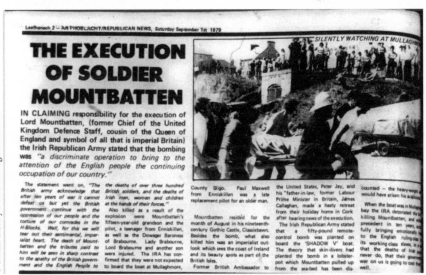

© British Library Board. All Rights Reserved

The Provisional IRA, The Execution of Soldier Mountbatten (1979)

IN CLAIMING responsibility for the execution of Lord Mountbatten, (former Chief of the United Kingdom Defence Staff, cousin of the Queen of England and symbol of all that is imperial Britain) the Irish Republican Army stated that the bombing was '*a discriminate operation to bring to the attention of the English people the continuing occupation of our country.*'

The statement went on, '*The British army acknowledge that after ten years of war it cannot defeat us but yet the British government continue with the oppression of our people and the torture of our comrades in the H-Blocks. Well, for this we will tear out their sentimental, imperialist heart. The death of Mountbatten and the tributes paid to him will be seen in contrast to the apathy of the British government and English people to the deaths of over three hundred British soldiers, and the deaths of Irish men, women and children at the hands of their forces.*'

The language of the statement was carefully chosen. 'Execution' implied lawful due process. 'Discriminate' deflected from the collateral deaths of two teenagers and an elderly woman. 'Occupation' was the narrative to distract from the democratic will of the people of Northern Ireland. The reference to torturing comrades in the H-blocks was an allusion to the cell blocks at the Maze prison, which had been built on the site of Long Kesh detention centre. In 1976 the government had removed Special Category status from paramilitary prisoners following a report concluding that it undermined prison discipline. In response, Republican prisoners began protests. Throughout the twentieth century IRA men and women had used hunger strikes in Ireland, Northern Ireland and England as a preferred means of protest, and they turned to them again, culminating in the suicide by starvation in 1981 of 10 members of the Provisional IRA. The deceased included Bobby Sands, leader of the Provisional IRA in the Maze, who was elected to Westminster as an MP for the last 26 days of his life. The strikers presented themselves as political victims, and the international media attention they achieved led directly to significant electoral successes for Sinn Féin, which emerged for the first time as a significant force in Northern Irish politics.

The Provisional IRA's assertion in the Mountbatten statement that the British government had not defeated them was true. But it was equally accurate that – despite the bombings and shootings – the Provisional IRA had not succeeded in its aspiration of driving the government out of

Northern Ireland, and was losing the conflict, with the government achieving significant intelligence coups against them.[15] By 1994 a quarter of a century of killing had achieved nothing except the toxic and almost total polarisation of Northern Ireland's Nationalist and Unionist communities.

Although it was presented as an Irish conflict, there were significant international angles to the Troubles. Arms dealers in the United States supplied most of the assault weaponry and other firearms, alongside Colonel Gaddafi's Libya. Funding came from multiple sources, but notably the Irish diaspora in the United States. Here the main coordinating body was the Bronx-based NORAID, whose fundraising letters in 1971 and 1972 stated clearly, 'our support goes exclusively to the Provisional IRA and those who are working with them'.[16] Although NORAID later explained that the money was for humanitarian relief, intelligence assessments concluded that it was used to acquire weapons. In May 1981 a United States District Court judge ruled that 'the uncontroverted evidence is that [NORAID] is an agent of the IRA, providing money and services for other than relief purposes'.[17]

The British authorities made efforts to prevent Gerry Adams entering the United States to raise funds from NORAID, but the value of the Irish vote in US elections was a complicating factor. When President Bill Clinton contemplated granting Adams a visa in 1994, John Major's Private Secretary wrote to Clinton's National Security Adviser in stark terms: 'The movement in which Gerry Adams has long been a leading figure has murdered not only thousands of its own countrymen, but also one member of our royal family, one cabinet minister's wife, two close advisers to Margaret Thatcher and members of parliament, two British ambassadors – and small children in our shopping centres.'[18] Clinton nevertheless issued Adams the visa.

To find a way out of the chronic bloodshed, political forces opened channels to allow the Provisional IRA/Sinn Féin into the mainstream democratic process on condition that they ceased terrorist activities. Aware that more death was unlikely to change anything, on 31 August 1994 the Provisional IRA implemented a ceasefire to allow Sinn Féin to attempt through politics what its gunmen had failed to deliver with blood. Seven weeks later, Loyalist paramilitaries also declared a ceasefire.

This newfound commitment to non-violence did not suit everyone, and the ceasefire was broken several times, notably on 9 February 1996 when the Provisional IRA detonated a truck bomb in London's Canary Wharf, killing two and causing £150 million of damage. However, compromise began to emerge from cross-party talks and, eventually, on 10 April 1998,

Good Friday, the governments of both the United Kingdom and Ireland, and the majority of Northern Island's political parties, signed the Belfast Agreement – or, colloquially, the Good Friday Agreement – bringing the Troubles to an end and committing all sides to peaceful and democratic collaboration.[19]

The agreement effectively airbrushed out the border between Northern Ireland and Ireland to allow the development of a closer cultural and economic relationship. Northern Ireland was given its own assembly to replace the one suspended in 1972, and the people of Northern Ireland were permitted to identify as British, Irish or both. The paramilitaries agreed to maintain their ceasefires and verifiably disarm. And – to many people perhaps most sensitively of all – the two governments agreed to release up to 500 convicted Republican and Loyalist prisoners serving sentences for terrorism and related offences. In the longer term, both governments committed to creating a united Ireland if the people of the North and South ever voted in favour of unification. These provisions were all profoundly contentious, and agreement was only possible by skilfully drafted language with artful 'constructive ambiguity' to allow all sides to sell it to their respective communities.[20]

The final step came 42 days later, on 22 May 1998, when referendums were held in both Ireland and Northern Ireland in the first all-island vote since 1918. When the results were in, the Good Friday Agreement was approved overwhelmingly, by 94 per cent in Ireland and 71 per cent in Northern Ireland. However, beneath these numbers the divisions of the past were still starkly visible in the North, where 96 per cent of Catholics voted in favour, compared to only 52 per cent of Protestants. The Reverend Ian Paisley's Democratic Unionist Party actively opposed the agreement, not least because of uncertainty around the pathway to decommissioning weapons.

After so much bloodshed, the Provisional IRA – which had been the *primum mobile* of the Troubles through its decades-long insurgency – had demonstrably opted for peaceful progress through Sinn Féin and the democratic process. But not all its members were ready to abandon violence. Two dissident groups – the Continuity IRA and the Real (later, the New) IRA – splintered off and rejected the peace process and Good Friday Agreement. Just four months after the agreement was signed, the Real IRA detonated a 500-pound bomb in the small, largely Catholic town of Omagh in County Tyrone, killing 29 people and injuring over 200.[21] The bombing did not,

though, succeed in derailing Ireland's commitment to transition from violence to democracy. Following the all-island referendums on peace, the Good Friday Agreement came into force. The United Kingdom repealed old legislation that claimed sovereignty over the southern 26 counties, and Ireland's constitution was amended to remove its claim to the six counties of Ulster. In the North, the Provisional IRA/Sinn Féin took its place in the new political assembly, with Gerry Adams and Martin McGuinness among its representatives. On the streets, the paramilitaries began dismantling their arsenals.

Inevitably, after so much violence, hostility and suspicion persisted between Nationalists and Unionists. The peace and decommissioning process took years longer than planned but, eventually, at 4 p.m. on 28 July 2005, the Provisional IRA formally announced that although the 'armed struggle was entirely legitimate', it was declaring an official end to its campaign and committing itself to exclusively peaceful means. Two years later, in July 2007, the British Army formally ended Operation Banner. Its patrols on the streets of Northern Ireland had lasted 37 years, making it the longest deployment in British military history. The Army's presence was the single largest factor in preventing the sectarian feud from spiralling into a Balkans-style all-out civil war.[22]

From 1969 to 1998 the Troubles claimed around 3,500 lives, but dissident violence since the Good Friday Agreement has continued to erupt, and the number of deaths has now edged closer to 4,000. Moreover, these figures take no account of the injured or maimed, of whom there have been many thousands. Overall, Republicans were responsible for 60 per cent of deaths, Loyalists for 30 per cent, the British Army 5 per cent and the RUC 5 per cent. Republicans lost 392 paramilitaries, of whom – surprisingly – 60 per cent were killed by fellow Republicans or by misadventure with explosives and weaponry. Loyalists lost 144 paramilitaries. Britain lost 1,441 soldiers and 509 police and local security forces. The Protestant civilian community lost 698 lives, while the Catholic community lost 1,232, the majority of both groups killed by Republicans.[23]

Twenty years on, the peace remains fragile. In early 2017 Martin McGuinness and Sinn Féin walked out of the power-sharing arrangement at the heart of the Northern Ireland Assembly and Executive, collapsing both, then, until January 2020, Northern Ireland was governed by civil servants. The main paramilitary groups remain committed to peace, but have not gone away. According to a 2015 joint report by MI5 and the Police

Service of Northern Ireland, the Provisional IRA, the INLA, the UDA/ UFF, the UVF and the RHC all continue to exist.[24] Although these groups are currently committed to peace, violence from smaller dissident groups is on the rise, with a recent increase in bombings, shootings, kneecappings and punishment beatings.

The most profound transformation, however, has not been political or paramilitary. It is demographic. The first census of Northern Ireland was conducted in 1926, and it disclosed a 66/33 ratio of Protestants to Catholics.[25] Over time this has changed. Eighty-five years later the 2011 census revealed that something dramatic had happened, with the ratio narrowing to 48/45 and, for those of school age, inverting with a Catholic majority of 51/37.[26] Demographers forecast that by the 2021 centenary celebrations of the creation of Northern Ireland, the overall population of the northern six counties would be majority Catholic.[27] If the time ever comes when this Catholic majority contains sufficient Republicans to trigger a vote on unification, the Good Friday Agreement will bring about the end of Northern Ireland if a similar vote is passed in the Irish Republic. Historical polling data consistently shows that a clear majority will vote in favour, although this is tempered by a rising awareness of the degree of poverty in Northern Ireland, which would become a significant drain on Ireland's resources.

The 2016 Brexit vote in the United Kingdom has also added a new dimension. Together with Scotland, Northern Ireland voted Remain, which means many in the North look more favourably on the direction of Ireland's future than the United Kingdom's, and this may prove a factor in any referendum in the North on unification with Ireland. More immediately, with Ireland in the European Union and the United Kingdom outside it, the question of where the Irish border should be is highly sensitive. There is no appetite in any camp for a border between Northern Ireland and Ireland, as this would undo the achievements of the Good Friday Agreement in eradicating the border and facilitating the prosperity of the two regions. The latest agreement between all parties puts the border down the Irish Sea, meaning Northern Ireland's status has definitively changed. It remains part of the United Kingdom, but is already, as regards European Union/United Kingdom border issues, part of Ireland.

43

Rule Britannia! Britannia's Making Waves – Shadows of Empire in the South Atlantic

The *Sun*
Gotcha
1982

On a warm July day in 1981 London hosted a fairy-tale pageant watched on television by a billion people. There was a festive atmosphere across the country, with street parties, bunting and Union Jacks. The nation was coming together to celebrate the wedding of the 32-year-old future king, Prince Charles, and the shy, 20-year-old Lady Diana Spencer, a nursery school teacher the world's media had already fallen for.[1] Britain was putting on its favourite show. The capital blazed with the colourful plumes and silver breastplates of the Household Cavalry and the scarlet tunics and black bearskins of the Foot Guards, who rode and marched through the city escorting the royal carriages to and from St Paul's Cathedral. Although retired from the armed forces, Prince Charles was in Royal Navy ceremonial day dress, and his father and brothers were similarly in formal military uniforms. The happiness of the occasion and the vibrant, carnival atmosphere meant that few onlookers connected the colourful choreography with the messy, bloody reality of war but, within a year, the country was to be reminded that the nation's armed forces were for more than royal pageantry.

A quarter of the distance between South America and South Africa, 1,000 miles off the east coast of Argentina, the isolated island of South

Georgia is steeply mountainous, permanently ice-clad, and unfit for settled human habitation. Once it was a stopping place for sealers and whalers, but since they abandoned it in the mid-twentieth century it has been home only to a solitary group of scientists of the British Antarctic Survey. On 18 March 1982 a large party of scrap metal merchants from Argentina landed there to begin dismantling an old whaling station. When members of the British Antarctic Survey investigated the sound of gunfire they found around 50 men milling about. A sign prohibiting unauthorised presence had been defaced, a recently shot reindeer was being roasted, and an Argentinian flag was fluttering in the breeze. On drawing closer they also noticed that some of the scrap metal men were in Argentinian military uniform.[2]

Anxious diplomacy followed between British and Argentinian authorities in Buenos Aires. The unauthorised flag was eventually lowered and some of the scrap dealers left, but a small unit of Argentinian naval commandos landed in their place. Not wishing to escalate tensions further, the Royal Navy ice patrol vessel HMS *Endurance* – whose operational instructions were to patrol the south Atlantic – quietly landed 22 Royal Marines on the island as a precaution, carefully avoiding the Argentinian warships that were simultaneously steaming to the area. There was no confrontation, but the incident was serious enough to hit the desk of the Prime Minister, Margaret Thatcher.

In Britain few people had heard of South Georgia, although it had been British for centuries. In the age of discovery a handful of explorers had sailed past it and inked its outline onto the map, but it remained largely unknown until Captain James Cook went ashore in 1775 and 'displayed our Colours and took possession of the Country in his Majestys name under a descharge of small Arms'.[3] After his departure the island fell back into obscurity, home to occasional sealers and whalers. The only notable event in its history occurred in 1922 when the polar explorer Ernest Shackleton died there of a heart attack and was buried in the island's frozen ground.[4] In 1843 British letters patent declared it to be a dependency of the Falkland Islands, a large archipelago 900 miles to the west and 300 miles off the coast of Argentina.

Britain had come into possession of the Falkland Islands in an altogether more complex way. A number of explorers claimed to have first discovered the islands, but the earliest recorded person ashore was the British sailor John Strong in 1690. Strong named the place the Falkland Islands after the

Admiralty grandee Viscount Falkland, whose title referenced Falkland in Fife.[5] For just over a century Britain, Spain, France and Argentina variously bought, sold, settled and controlled parts of the two principal islands – West Falkland and East Falkland – at times simultaneously, until Britain established definitive control in 1833 after expelling a penal colony of Argentines.[6] British settlers then began populating the islands, and its inhabitants have identified as British ever since.

In March 1982, when the scrap metal merchants landed on South Georgia, Argentina was ruled by a right-wing military junta under General Leopoldo Galtieri, a combat engineer and career soldier. The Falkland Islanders were entirely dependent on Galtieri's Argentina for supplies and transport, and it was well known that Argentinian public opinion was strongly in favour of Britain relinquishing all its south Atlantic possessions to Argentina, which led to a degree of good-humoured rivalry. When news of the scrap metal incident on South Georgia reached Port Stanley, the capital of the Falklands, islanders sneaked into the offices of LADE, the Argentinian airline, draped a Union Jack over the Argentinian flag, and squeezed out 'tit for tat you buggers' in toothpaste onto a desk.[7]

In London the mood was more serious. The Foreign Office was concerned that the mixed civilian–military landing on South Georgia could be a prelude to something more significant, as the junta in Buenos Aires was struggling politically, and it could not be ruled out that it was contemplating burnishing its reputation by military activity that would prove popular with its domestic audience. Although Argentina would be taking a risk, Britain was aware it had sent mixed signals in the course of building up good trading relationships with South America, and it was quite possible that Galtieri had interpreted them the wrong way.

First, Britain had not reacted in 1976 when Argentina had invaded and occupied South Thule, which comprised three of the British Sandwich Islands to the south of South Georgia. Argentina had noted Britain's lack of reaction and quietly established a permanent military base there. Second, in 1980 Nicholas Ridley, a Foreign Office minister, secretly met his Argentinian counterpart in Switzerland to agree the broad outline of a deal to sell the Falklands to Argentina then lease them back for 99 years, as had been done with China in respect of Hong Kong.[8] Since Britain respected the islanders' right to self-determination, Ridley flew to the Falklands after the meeting to put the idea to them, but to Ridley's disappointment the 1,800 islanders wanted nothing to do with the plan, and instead played

loud recordings of 'Rule Britannia' at him as he left.[9] Third, a year later Parliament passed the British Nationality Act 1981, which did not categorise Falkland Islanders as British citizens but instead gave them the lesser status of British Dependent Territory Citizens unless they could show they, their parents or grandparents were born in Britain.[10] And fourth, that same year, Britain announced it would no longer patrol the South Atlantic and that HMS *Endurance* would be withdrawn and decommissioned.[11] After pondering these four items of information, Galtieri had concluded that there was a chance Britain would not fight back if he seized Las Malvinas, as the Falklands were known in Argentina. With *Endurance* due to be withdrawn in April, he set an invasion date for later in the year. However, once things had started warming up on South Georgia in March, he seized the moment and brought *Operación Rosario* forward immediately, dispatching an invasion force to the Falklands.

London tracked the hostile fleet as it left Argentina and, at 3.30 p.m. on 1 April, the Foreign Office telegraphed Rex Hunt, British Governor of the Falkland Islands, to warn him that an invasion was imminent.[12] It did not take long, and at 4.30 p.m. the following morning 150 Argentinian special forces helicoptered into Mullet Creek, followed by over 1,000 more. The 80 British Royal Marines stationed in Port Stanley put up resistance, but they were soon overwhelmed. At 12.30 p.m. Hunt went to the town hall and surrendered the islands to prevent further bloodshed.

In London senior military figures informed a shaken Margaret Thatcher that it would be highly challenging for British forces to launch an amphibious invasion to retake islands 8,000 miles away, and that in any event it would take three weeks for British warships to reach the target. Further bad news arrived the following day when Thatcher learned that Argentina had landed a secondary invasion force on South Georgia and overpowered the 22 Royal Marines recently stationed there.

In New York the United Nations Security Council passed Resolution 502 condemning Argentina's illegal aggression and requiring it to withdraw all invasion forces immediately. In Britain the military was put on high alert, and the government launched Operation Corporate, which became visible to the world just two days later, on 5 April, when the aircraft carriers HMS *Hermes* and HMS *Invincible* left British ports together with an armada of Royal Navy and requisitioned civilian ships. This Task Force eventually comprised 147 vessels, including the repurposed ocean liners SS *Canberra* and RMS *Queen Elizabeth 2*.

The military plan to retake the Falklands was straightforward in concept. Royal Air Force Harrier jump jets would fly from the carriers to establish air superiority over the relevant parts of the Falklands, allowing ground troops from the Army and Royal Marines to establish one or more beachheads then break out and fight a land battle to reconquer the islands. What the world did not see was that the British government had no appetite for war, its primary hope being that the heavily publicised Task Force would convince Argentina to withdraw its forces and enter negotiations. The strategy was endorsed by Labour, whose leader Michael Foot – author of a book on the world's disastrous policy of appeasing Hitler – confirmed his party's support for the Task Force.[13]

Britain therefore began the diplomatic process to enter negotiations with the junta, making requests through the United Nations and agreeing to participate in talks hosted by other countries including the United States and Peru. Britain was willing not to demand that Argentina acknowledge British sovereignty, and supported a proposal to put the islands under United Nations control while talks on their future proceeded. However, Galtieri refused to participate in seven separate peace initiatives that were proposed to him, insisting that Britain recognise Argentinian sovereignty over the islands before any talks could begin. Thatcher was therefore left with an unpalatable choice. Giving in to Galtieri and walking away would be abandoning the Falkland Islanders to martial law under a dictator whose regime had an unsavoury record of torturing and murdering thousands of its opponents. It would also reward Galtieri's use of unlawful force, which would destabilise the order overseen by the United Nations. On the other hand, approving military action would mean deaths on both sides. Thatcher knew the first option would bring down her government, while the second had the potential to do so. In the end she chose the option which any other twentieth-century British government would have found itself compelled to take.

To minimise misunderstandings and unnecessary loss of life, Britain gave Argentina clear guidance on how it would proceed. Any Argentinian military asset anywhere in the South Atlantic would be attacked if it posed a threat to British personnel. In addition, a Total Exclusion Zone would be drawn 200 nautical miles around the Falklands, and any Argentinian military presence inside it would be deemed hostile and could be automatically attacked with no warning.[14]

The fightback began on 26 April, when a combined team of the Special Air Service, Special Boat Service and Royal Marines landed on South

Georgia and retook the island in two hours.[15] That evening Thatcher appeared outside No. 10 Downing Street to give the nation the news. When questioned by the media, she replied, 'Just rejoice at that news and congratulate our forces and the marines . . . rejoice.'[16] Four days later, on 30 April, the main Task Force arrived at the exclusion zone, and aerial operations began the following day. Argentinian aircraft attacked the Task Force in an effort to sink or disable the two aircraft carriers and British forces began bombing and shelling the airfield the Argentines were using at Port Stanley.

The day after, 2 May, the Churchill class hunter-killer nuclear submarine HMS *Conqueror* became aware of Argentinian Task Group 79.1 – an aircraft carrier and five warships – on the northern edge of the exclusion zone. *Conqueror* had been in the act of shadowing a different group – Task Group 79.3: a cruiser and two destroyers armed with Exocet missiles – which was zigzagging to the south-west of the Falklands on the edge of the exclusion zone. The cruiser was famous: in its former incarnation as USS *Phoenix* it had been one of the few survivors of the Japanese attack on the American navy at Pearl Harbor. By 1982 it was part of the Argentinian navy and sailing under the name ARA *General Belgrano*.

The captain of *Conqueror* was aware that the admiral in charge of *Operación Rosario* had ordered his navy to initiate a 'massive attack' on the Task Force, and concluded from the relative positions of Task Groups 79.1 and 79.3 that they were readying for a pincer assault with the assistance of a third Task Group also marking time on the edge of the exclusion zone. After lawyers were consulted, *Conqueror* received orders from the headquarters of the Commander-in-Chief Fleet at Northwood and the war cabinet at Chequers to attack *Belgrano*. At 3.57 p.m. *Conqueror* launched three torpedoes at *Belgrano* from a distance of around three miles. Two hit the target.

In London, when Fleet Street heard the news, Wendy Henry, features editor at the *Sun* newspaper, shouted a triumphant 'Gotcha!' The editor, Kelvin MacKenzie, heard her and set the word as the newspaper's front-page headline, rushed out in the early edition on Tuesday 4 May.[17] The word appeared as a stark black headline, plastered in capitals full width across the page above the emboldened, underlined caption 'Our lads sink gunboat and hole cruiser'. The accompanying article noted two British actions: British helicopters had sunk an Argentinian patrol boat, and 'wallop' *Conqueror* had holed *Belgrano* with hi-tech Tigerfish torpedoes, leaving the cruiser 'a useless wreck'.

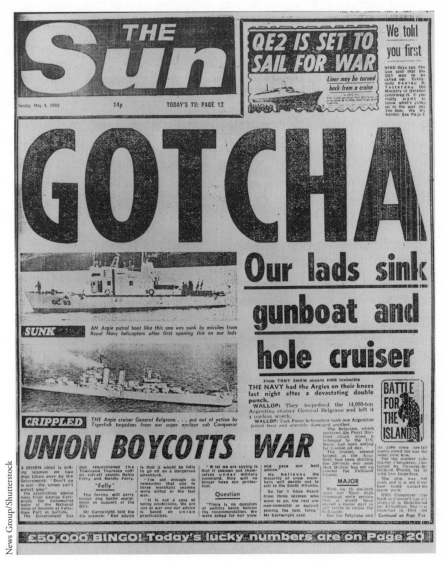

News Group/Shutterstock

The *Sun*, *Gotcha* (1982)

In fact the *Sun* had its facts wrong. *Conqueror* had not used the modern wire-guided Tigerfish homing torpedoes, but old 'point-and-shoot' Mark VIII** torpedoes, in service since World War Two and considered significantly more reliable.

Within 20 minutes of his vessel being struck, the captain of *Belgrano* ordered the ship abandoned, and by 5 p.m. it had disappeared under the waves, the only warship ever to have been sunk by a nuclear submarine.

Conqueror assumed the two destroyers of Task Group 79.3 accompanying *Belgrano* would rescue the stricken cruiser's crew, who had taken to life-boats. However, communications failures and poor visibility meant the destroyers were oblivious and initially headed for port, leaving *Belgrano*'s sailors to the freezing water, six- to seven-metre-high waves and 60-mile-per-hour winds, and only finding the first life rafts at lunchtime the follow-ing day.[18]

When news of the sinking reached London, the *Sun* changed its headline to 'Did 1,200 Argies drown?', making surviving originals of the 'Gotcha' front page – which only went to press in the first, northern edition – a rarity. Nevertheless, the 'Gotcha' headline was, and remains, one of the most controversial of the war. The *Sun* maintains it caught the national mood, while millions up and down the country – and in the Task Force – reacted with revulsion to its callous triumphalism. The eventual death tally from *Belgrano* was 323 sailors, prompting questions to be asked in Britain why the cruiser had been targeted when it was outside the exclusion zone and pointing away from it. However, the Argentinian Navy and Defence Ministry both confirmed that the entire South Atlantic was the agreed legit-imate battlefield, and the captain of *Belgrano*, who survived, was clear that *Belgrano* was an enemy warship engaged in hostile manoeuvres and a legiti-mate target. Although *Belgrano* had been temporarily pointing away from the exclusion zone, it was zigzagging around the perimeter, turning frequently, awaiting orders to advance into the zone to attack the British.[19] Its sinking proved a turning point with a major impact on the conflict as the Argentinian surface fleet moved back to port and did not emerge again during the hostilities. In retaliation, however, the Argentinian air force attacked HMS *Sheffield* with an Exocet two days later, making it the first Royal Navy ship to be sunk since World War Two.

The ground war began a fortnight later on 21 May with 5,000 soldiers from the Special Air Service, Special Boat Service, Royal Marines, Parachute Regiment, Blues and Royals, and Gurkhas landing at San Carlos on the north-west coast of East Falkland. The landing zone was on the other side of the island from Port Stanley and, as the Argentines had not expected any enemy presence there, the ground troops met with little resistance.[20] Instead, the Argentinian air force scrambled quickly to strafe them as they came ashore, earning the cove the nickname 'bomb alley'.

Once on the Falklands, the British forces split into three groups, each with orders to 'yomp' – Royal Marines' slang for marching with heavy

equipment – the 50 miles as the crow flies to Port Stanley, with each man carrying a 10-stone pack across the island's central mountain ranges. Before heading east, one detachment detoured south to neutralise an Argentinian garrison at Goose Green and Darwin, but – following a mix-up in government communications – the BBC announced the assault before it took place, inadvertently giving the Argentines warning. The attack nevertheless went ahead. The commanding officer of 2 Para, Colonel 'H' Jones, was killed while advancing on an Argentinian trench, and was posthumously awarded one of the two Victoria Crosses of the war. After 40 hours of fighting, the Argentines at Goose Green surrendered, leaving British forces unexpectedly needing to manage over 1,000 prisoners of war, many of whom were cold, frightened teenage conscripts.

Meanwhile, closer to Port Stanley there was fighting between British special forces and Argentinian troops around Mount Kent, before more troops – primarily of the Welsh and Scots Guards – were put ashore 20 miles south of Port Stanley at Fitzroy and Bluff Cove. However, the operation was mismanaged, and the landing craft were bombed by the Argentinian air force, resulting in heavy casualties. As the advancing groups neared Port Stanley, they ran into the final line of Argentinian defences in the mountains and hills around the capital. Battles were fought at Mount Harriet, Two Sisters, Wireless Ridge and Mount William, with notably fierce close-quarters and bayonet contact at Mount Longdon and Mount Tumbledown. The Argentinian defences fell one by one, and the British forces moved down into Port Stanley, expecting a final house-to-house street fight. Instead Argentinian General Mario Menéndez offered them the islands' surrender.

In Buenos Aires crowds demanded Galtieri's resignation, and he relinquished the presidency three days later. The day after that, a small contingent of Royal Marines landed on South Thule and accepted the surrender of the Argentinian forces which had been occupying it since 1976. And, with that, the Falklands conflict was over. In all, Britain had sent 25,000 service personnel to the South Atlantic, of whom 255 died alongside 650 Argentines and three Falkland Islanders. In addition to HMS *Sheffield*, Britain lost *Antelope*, *Ardent*, *Atlantic Conveyor*, *Coventry* and *Sir Galahad*, while *Glamorgan* was badly hit but not sunk.

The Task Force was met by euphoric crowds on its return and Thatcher's political opponents began portraying her as a warmonger, pointing to moments like her instruction to 'rejoice' on the retaking of South Georgia, although no lives had been lost in that operation. Commenting specifically

on Thatcher's mental state, the United Nations Secretary General Javier Pérez de Cuéllar, a Peruvian, noted in his diary, 'The Prime Minister appealed to me to keep "her boys" from being killed. I sensed this was the woman and the mother who was speaking to me – a very different person from the firm, seemingly belligerent leader of the British government. From this call I was certain that Margaret Thatcher was not, as so much of the press was reporting, hell-bent on war.'[21]

The British government set up an inquiry and, in January the following year, the Franks Report concluded that Britain was not to blame for the Argentinian invasion, and could neither have predicted it nor done anything to prevent it.[22] In March Parliament passed the British Nationality (Falkland Islands) Act 1983, making all Falkland Islanders full British citizens, and in June Thatcher went to the polls. The Conservatives had been polling well before the Argentinian invasion, and the electorate returned her to power with a strong majority at a ballot that was also significant for Labour. Among its first-time MPs arriving at Westminster were Tony Blair, Gordon Brown and Jeremy Corbyn, who would all go on to lead the party.

Most of Britain's wars since World War Two – including Korea, the first and second Iraq wars, and Afghanistan – have been rooted in ideological conflict. The Falklands, by contrast, was an old-fashioned colonial dispute which came, unexpectedly, towards the end of a century in which Britain had been dismantling its empire and turning it into the much looser and cheaper Commonwealth. In the 1930s when Noël Coward lampooned the British for striding and perspiring around the tropics in his cabaret song 'Mad Dogs and Englishmen', he gave the impression of a timeless empire as vibrant in the twentieth century as it had been in the nineteenth. Although British atlases still showed almost a quarter of the globe's landmass coloured in pink – and indeed the sun never set on the territory – in reality the empire had entered its twilight.

Before World War One, Canada, South Africa, Australia and New Zealand had all adopted dominion status. After the war Ireland followed in 1922, the same year Egypt declared independence. The fall of the German, Austro-Hungarian, Russian and Ottoman Empires in World War One had been evidence that imperialism was an anachronism, and another four countries left the British Empire in the 1940s. The most significant to go was India, which had been the heart of the empire for centuries. Its all-volunteer British Indian Army had sent 3.9 million men to fight in the two world wars – the largest volunteer army in history – and when India declared

independence in 1947 it was plain to even the non-astute observer that the empire was over.[23] Another four countries left in the 1950s, 23 in the 1960s and 13 in the 1970s. By the 1980s the empire had been reduced to a few scattered islands.

Coming at the end of this long process of decolonialisation, the Falklands conflict was a throwback to the days when Britannia ruled the waves. It was not a fight Britain wanted, and it has left long-term and difficult challenges. The Falkland Islands are now unambiguously British, as are its citizens, and Britain has no option but to foot the bill for maintaining a permanent military presence in the South Atlantic.

When the dust of the battle for the Falklands had settled, the Nobel prize-winning Argentine author and poet Jorge Luis Borges paraphrased the Roman writer Phaedrus, suggesting the conflict was rather like two bald men fighting over a comb.[24] It is a harsh judgement, but it contains a kernel of truth. The Falkland Islands were of little practical use to Argentina or Britain. They were a symbol to Argentina of her regional influence, and a reminder to Britain of its former power and ongoing responsibilities. Although there were abstract principles at play like sovereignty, international law and self-determination, Thatcher had little choice but to act when people who identified as British came under occupation by a hardline dictatorship. The surprising thing now, decades on, is that Borges's comb has turned out to be a potentially valuable one. From the 1970s it was known there was oil around the Falklands, but no one had a real sense of the quantity. Since 2010 advances in technology have revealed the oil fields to be extensive, and tools have been developed to exploit them.[25] It remains to be seen whether the twenty-first-century world continues to be as addicted to fossil fuels as the twentieth-century one and exploits these reserves, or whether they will lie – along with so many ships – forever deep in the South Atlantic.

44

Shaken and Stirred –
Treachery in the Intelligence Services
Peter Wright
Spycatcher
1988

In April 1953 a former naval intelligence officer named Ian Fleming hesi-
tantly published *Casino Royale*, his debut novel about a ruthless, hard-
drinking Secret Service spy with the most boring name he could think of:
James Bond. In hardboiled, fast-moving prose, he told how Bond takes on
Le Chiffre, paymaster of a Soviet-controlled French trade union, outsmart-
ing him at the smoky card table in Royale-les-Eaux, and in the process fall-
ing profoundly in love with Vesper Lynd, a young Secret Service employee.
After Le Chiffre takes his revenge by capturing and torturing Bond, the
lovers hole up in a seaside *auberge* so Bond can recuperate, until Lynd kills
herself, too ashamed to tell Bond she is an unwilling Soviet agent and
anxious her love for him will jeopardise his life. The book ends with Bond
telephoning headquarters in London. ' "This is 007 speaking. This is an
open line. It's an emergency. Can you hear me? . . . Pass this on at once.
3030 was a double, working for Redland . . . Yes, dammit, I said 'was'. The
bitch is dead now." '[1]

The book was a runaway success, and over the next 11 years Fleming
wrote another 21 novels and short stories featuring Bond. With their fast
pace, high-stakes adventure, glamour and violence, the public devoured

them and their vision of a Britain that was independent, confident and triumphant: a powerful escapist antidote to the reality of the loss of empire, dwindling international prestige and increasing reliance on the United States. Bond was who the public wanted to believe was nonchalantly and ruthlessly taking on those trying to harm Britain. But it was an illusion. The reality was that the reputation of Britain's intelligence agencies was at an all-time low, having been shredded by comprehensive Soviet penetration. Britain had proved its skills in the hidden arts of intelligence over the centuries, from Sir Francis Walsingham's protection of Elizabeth I's isolated England in the sixteenth century to the extraordinary success of the cryptographers at Bletchley Park who altered the course of World War Two. But in the early 1950s it all fell apart, dramatically and spectacularly.

Every ruler and government throughout history has relied on intelligence capabilities to defend and attack. The origins of Britain's modern intelligence infrastructure date to October 1909 when the War Office and the Admiralty joined forces to found the Secret Service Bureau. Its first office at 64 Victoria Street – appropriately opposite the Army and Navy Store – was staffed by just two men: Captain Vernon Kell of the South Staffordshire Regiment and Commander Mansfield Cumming of the Royal Navy. For convenience they split the work, Kell taking responsibility for domestic intelligence and Cumming focusing on foreign concerns. Before the year was out they had moved to separate offices and were operating independently. Kell's world eventually evolved into the Security Service, and Cumming's became the Secret Intelligence Service (SIS). From around 1921 they also acquired the designations MI5 and MI6 respectively.[2] On 1 November 1919, a third agency was founded – the Government Code and Cypher School (GC&CS) – which rose to prominence at Bletchley Park and eventually became the Government Communications Headquarters or GCHQ.

In their early years, Britain's intelligence agencies recruited heavily from public schools and the universities of Oxford and Cambridge. The people they brought in therefore moved in similar social circles, which bred trust through familiarity. However this proved to be a dangerous weakness. Any hostile group wishing to infiltrate British intelligence needed only to recruit a handful from this pool, and they would soon have access to the inner workings of the country's security apparatus. And that is exactly what the Soviet Union did.

The USSR's principal espionage organisation in the 1930s was the NKVD: the forerunner of the KGB, now the FSB. Its principal and most

brilliant recruiter in Britain was Dr Arnold Deutsch, an Austrian Jew who worked as a psychology researcher at University College London.[3] His simple plan was to find well-connected young men at top universities, recruit them as Soviet spies, then encourage them to enter jobs in government and intelligence. In early 1934 he focused on Cambridge, and at Trinity College found the flamboyant Guy Burgess. He was the son of a Royal Navy commander, a bright Etonian who had done a spell at the Royal Naval College Dartmouth before arriving in Cambridge a charming, homosexual bohemian.[4] He had recently graduated with an *aegrotat* in part two of the history tripos as he had fallen ill during the exams – having taken too many amphetamines according to some of his contemporaries – but was now back at Trinity for graduate study.

Like many in the early 1930s, Burgess was swept along on the tide of communism that flowed through Cambridge and easily made friends in the university's left-wing circles. The students watched the twin disasters of the Great Depression and the rise of European fascism, and put their hopes in communism as a bulwark against both. Burgess was outgoing and popular, and rapidly became one of the leading lights of the university's Socialist Society. A fellow member who impressed him was another student at Trinity, Kim Philby, and Burgess mentioned him to Deutsch. Philby had been born in the Punjab to an English civil servant, explorer, Arabist and Muslim convert who ended up as adviser to the al-Saud family. He attended school at Westminster before Trinity, where he graduated in history and economics. After leaving Cambridge, Deutsch met him in The Regent's Park in June 1934 and formally recruited him there as a Russian spy. Burgess and Philby then put Deutsch in touch with another of their friends, Donald Maclean, whose father had been Liberal leader of the opposition and a cabinet minister. Maclean was striking, athletic, six foot four inches tall, clever, and bisexual. He had been to Gresham's School before entering Trinity Hall to read modern languages. Deutsch recruited him immediately. Next it was Burgess's turn, as he had been instrumental in putting together the Deutsch–Philby–Maclean ring and so already knew too much. Philby and Maclean vouched to Deutsch that he would make an excellent spy, so Deutsch recruited him, too.

This group was not Deutsch's only focus. He was highly active, recruiting over 20 agents, most of whom were never uncovered. When he wanted still more names, Burgess and Philby suggested Anthony Blunt, a strait-laced vicar's son educated at Marlborough and Trinity, where he had graduated in

mathematics and modern languages. He was slightly older than the others, may have been Burgess's lover for a while, and was already a fellow at Trinity. Deutsch – or perhaps Teodor Maly, a former priest from Hungary who was one of Philby's controllers – duly recruited him as well.

The ring of the 'Magnificent Five', as they would eventually be known, was nearly complete. The fifth member was suggested by Burgess and Blunt, also from among their friends in the university's Socialist Society. John Cairncross did not share the privileged backgrounds of the other four, but had studied at university in Glasgow and the Sorbonne before gaining a place at Trinity. On leaving Cambridge he scored the top marks in the Civil Service's entrance exam that year, and – motivated by a visceral hatred of the establishment – willingly signed up to spy for Russia when Deutsch approached him.

The flamboyant Burgess was the centre of the ring, He had been the driving force that pulled the group together, and with his Etonian and Cambridge credentials he walked straight into a key role at the Talks Department of the BBC. There he arranged interviews and simultaneously built a rapport with the interviewees, many of whom were the most prominent figures of the day including Churchill, Chamberlain and Deladier. Shortly before the outbreak of war he was pulled into SIS to bring his knowledge of radio to the propaganda work of D Section, which specialised in sabotage behind enemy lines and would soon become one of the founding units of the Special Operations Executive. While working for SIS, Burgess also moonlighted for the Security Service, gaining them access into the closed world of London's interwar homosexual scene.

In 1940 Burgess took a step that would ultimately affect all the Cambridge spies' lives when he brought Philby into SIS. Deutsch had told Philby to socialise in right-wing groups to avoid any suspicion of communist leanings, so Philby had gone to cover the Spanish Civil War for *The Times* posing as a journalist with pro-Franco sympathies. While there, he may have been involved in a Communist plot to assassinate Franco, but the plan was dropped, and instead Philby ended up being decorated with a medal by the Spanish President.[5] After a spell in France, Philby leapt at Burgess's offer of joining SIS, where he started in Section 5, Counter-Intelligence, and was quickly identified as a rising star. Burgess, meanwhile, returned to the BBC, but left a year before the war ended to begin a career in the Foreign Office, where his expertise in communism secured him a job in the Information Research Department focusing on anti-communist propaganda. His talent

for spying was prodigious, and in 1944 to 1945 alone he sent the Soviets over 4,000 documents.

Back in Cambridge, Blunt had remained a fellow at Trinity, where he acted as an NKVD talent spotter. Keen to be in London, however, he left for the Warburg Institute in 1937 and within two years was Deputy Director of the Courtauld Institute. When war erupted the intelligence services needed to staff new sections quickly, and turned to prominent intellectuals. Blunt was pulled into the Security Service by Lord Rothschild – another friend from Trinity – where he began spying for the Soviet Union in earnest, handing over 1,000 documents to his handlers including ULTRA decrypts from Bletchley Park. But the strain of such intense espionage took a heavy toll, and he was hospitalised with exhaustion before leaving intelligence at the end of the war to take up an appointment as Surveyor of the King's Pictures. Within two years he was also made Director of the Courtauld and a professor of art history at the University of London.

The most productive of the Cambridge spies in the early days was the one who has remained the least well known. After stints at the Foreign Office and the Treasury, Cairncross was appointed Private Secretary to Lord Hankey, Chancellor of the Duchy of Lancaster, giving him access to atomic secrets that he sent straight to the Soviets. In 1942 he moved to the Government Code and Cypher School at Bletchley Park, where he was able to pass his handlers 5,832 top-secret ULTRA decrypts from Enigma. By informing the Soviets where all the German forward airbases were, he enabled the Soviets to bomb them and thereby decisively influence the Battle of Kursk. Before the end of the war, he returned to SIS and then to the Treasury.

When the five began spying for the Soviet Union in the 1930s the USSR had seemed to them the only credible force that could halt fascism. After Russia betrayed that belief by signing the Molotov–Ribbentrop non-aggression alliance with Nazi Germany in 1939, the scales fell from the eyes of many British communists, especially when the arrangement gave Hitler carte blanche to start World War Two by invading Poland while keeping Russia out of the first third of the war.[6] However, the communist–Nazi alliance did not unsettle the Cambridge five, and nor did the onset of the Cold War, when the Soviet Union ceased being the West's ally and became intensely hostile.

Now part of the furniture in SIS, Philby was awarded an OBE and placed in charge of the newly formed Section 9 overseeing Soviet Counter-Espionage. In this privileged role he was able to forewarn Russia of the

West's most secret Cold War plans and operations. When he notoriously informed Moscow of covert expatriate forces being infiltrated into Albania to take on the communists, his information enabled Moscow to have the men intercepted and murdered. Maclean meanwhile had started a career in the Diplomatic Service, being first posted to Paris, then in 1944 to Washington DC, where he remained after the war, with his wife's subsequent move to New York enabling him to use his regular trips to see her as opportunities to meet his Soviet handler and pass him the United States atomic secrets. The constant subterfuge, however, began to take a toll on him. As the 1950s approached, the strain of betraying both Britain and the United States became overwhelming, and he started drinking heavily.

Burgess and Blunt had lived together in London for most of the war. When it ended Burgess remained at the Foreign Office while Blunt, no longer part of the intelligence community and free to move about, acted as Burgess's courier, handing the Soviets documents Burgess had copied or photographed. Meanwhile, over at the Ministry of Supply, Cairncross again had access to atomic secrets and was handing them over to Moscow.

In Washington DC Maclean's superiors were now worried about his mental health and excessive drinking and, in 1948, posted him to Cairo in the hope a change of pace would help. The opposite happened and Maclean suffered a full breakdown, went on an alcohol-fuelled rampage and was sent back to London. After recuperating he was kept in London and appointed head of the Foreign Office's American Department. Over in the United States Philby's career was still in the ascendant, and in 1949 he was appointed SIS's representative in Washington DC. The following year Burgess joined him at the British Embassy, where he took up the post of Second Secretary. After eluding detection for so long, the two unwisely moved in together and redoubled their spying activities. Burgess handed the Soviets an estimated 4,000 diplomatic documents, while Philby gave them some of the most sensitive intelligence secrets of the Cold War.

The beginning of the end for them all came when American intelligence launched Operation Venona to scrutinise their large backlog of intercepted Russian signals. By chance they came across mention of a Soviet agent in the British Embassy in Washington DC who had permission to visit his wife regularly in New York. Aghast, Philby told Burgess, who was being sent back to London in disgrace after a spate of dissolute behaviour. On arrival in London Burgess immediately warned Maclean that he was in imminent danger of being uncovered. Aware that the penalty for treason was death,

Maclean decided it was over and chose to defect. For reasons that remain unclear – but possibly because Maclean's health was so severely impaired by drink and stress – Burgess decided to go with him. And so, on 25 May 1951 the two slipped aboard a ship to France, and disappeared.

British intelligence immediately searched Burgess's London flat, although not before Blunt had visited and removed incriminating evidence. However, he missed a handwritten note from an unidentified person giving details of a meeting with a civil servant. When the civil servant was questioned, it turned out that the writing belonged to Cairncross, who was duly hauled in and questioned. His interviewers came away convinced he was a spy, but without sufficient evidence to guarantee a conviction. Instead, Cairncross resigned from the Civil Service on the grounds of having been careless with paperwork, and the intelligence services secured him a job in Rome as a reporter for the *Observer* and *The Economist*.

The disappearance of Burgess and Maclean was widely covered in the press, but no one knew where they were until February 1956 when they participated in a news conference from Moscow in which they announced they had moved to Russia to work for peace. Meanwhile, in the United States, Philby was now under strong suspicion because of his closeness to Burgess and his student days with Maclean and Cairncross. He was interviewed multiple times, leaving the interviewing officers in no doubt he was also guilty. However, as with Cairncross, there was insufficient evidence to guarantee a conviction – or none that would not compromise other operations if revealed – and he left SIS under a cloud before being set up with a job as the Beirut correspondent of the *Observer* and *The Economist*.

The wobbly house of cards finally collapsed in 1962 when the KGB officer Anatoliy Golitsyn defected to the United States and informed on Philby. Officers from the Security Service and SIS immediately travelled to Beirut, where Philby finally confessed, but the next morning he was gone and not heard from again until he surfaced in Moscow in January 1963. Once Philby had confessed, the game was up and Cairncross did likewise.

The last of the five to fall was Blunt, who had been knighted in 1956. The year after Philby's defection a man named Michael Straight – a Cambridge undergraduate Blunt had talent spotted for the NKVD – gave Blunt's name to the FBI. The Security Service offered Blunt immunity from prosecution in return for a full confession, which he provided, including the fact he had helped arrange Burgess and Maclean's defection. The queen was informed, but no steps against Blunt were taken and he remained Surveyor of the

Queen's Pictures until his retirement in 1972, when he took on a role as an adviser until 1978. Around that time journalists and authors who had been tipped off by the intelligence community began naming Blunt openly, as a result of which Margaret Thatcher – who was outraged when told of his 1964 immunity deal – unveiled him in Parliament.[7] There was public uproar, and Blunt was stripped of his knighthood, turned to drink and was dead by 1983. Cairncross meanwhile retired first to France and then to England, where he took up writing, notably publishing a scholarly work in defence of Christian polygamy.[8]

Over in Russia, Burgess, Maclean and Philby had expected to be welcomed as heroes of the revolution, but were shocked to be met with indifference. Philby in particular was horrified to discover he was classified as a KGB agent rather than an officer, but nevertheless assumed the rank of a colonel in the KGB when dealing with journalists. All three found Moscow bleak and repressive, and not remotely the promised utopia they had been expecting. From positions of status in the West they found they had nothing in the Soviet Union as the KGB gave them no work, suspicious that their defections were a British trap. These doubts over integrity were not new. During the war the KGB had even considered assassinating Burgess, Philby and Blunt because it never knew whether or not they were trustworthy. In particular it worried about the lifestyle led by Burgess and Blunt, and the scandalous parties they threw at their flat. Now all three were in Moscow, boredom set in. Philby had an affair with Maclean's wife – who had joined them – but one by one they died in relative obscurity: Burgess of drink in 1963, seven months after Philby arrived, Maclean in 1983 and Philby in 1988. Cairncross, always doing things a little differently, died of natural causes in 1995.

The damage wrought by the five spies was enormous: not only to the officers, agents and others who lost their lives through being betrayed, but also in the world's distrust of British intelligence. The United States and Britain had enjoyed a 'special relationship' from the moment American intelligence officers were welcomed at Bletchley Park in World War Two as part of a charm offensive to bring the United States into the war. But the sheer quantity of sensitive information the Cambridge spies betrayed to the Soviets concerning American security interests profoundly damaged the special relationship. British intelligence had helped the United States set up the wartime Office of Strategic Services, which by 1945 had become the CIA, but by the 1950s and 1960s British intelligence was in disgrace, and

as far from the all-conquering force Fleming portrayed in his Bond books as it was possible to be.

And there the matter might have ended, with Britain slowly rebuilding its intelligence capabilities and earning back its former reputation, except that fear of Soviet penetration would not go away. The year after Philby defected a scientific officer in the Security Service named Peter Wright was tasked with heading up a joint Security Service–SIS project codenamed FLUENCY to identify any further Soviet moles, and Wright was soon convinced that the Cambridge spies were not the only ones to have penetrated British intelligence. After some preliminary research, he grew certain that none other than Sir Roger Hollis, former Director of the Security Service, was the KGB's top agent in Britain.

Not many people were convinced by Wright's theory, and he eventually retired in 1976. However, in 1980, Lord Rothschild – who had been at Cambridge with the five and pulled Blunt into the Security Service during the war – asked Wright to help him clear his name in yet another mole hunt. In the process Rothschild introduced Wright to Chapman Pincher, a veteran *Daily Express* investigative journalist who was pursuing the idea that there was another man in the Cambridge spy ring. Wright took the opportunity to share his theories about Hollis – who had actually been to Oxford – and they duly appeared in Pincher's 1981 book *Their Trade is Treachery*. Knowing the ropes, Pincher was careful not to accuse Hollis outright, but signposted prominently that some people thought he was guilty. This was a key element in Pincher's book, and Wright received a share of the royalties for his assistance with it. Inspired by the experience, Wright settled down to set out the case against Hollis at length in his own book. It was complete by 1985, and Wright entitled it *Spycatcher*. Aware that Wright was breaching his obligations under the Official Secrets Act, the publishers planned to bring it out first in Australia and the United States to avoid legal wrangles in Britain.

When Thatcher's government heard about the book, it moved swiftly to have it banned. The result was a series of bruising, highly public legal battles against Wright's publishers in England, Australia and New Zealand. These cases were eventually all defeated on the grounds Wright was saying nothing new in accusing Hollis – which Pincher had done – and once the book was available in some jurisdictions it made no sense maintaining the ban in others. When the sorry and very public legal soap opera finally came to an end in October 1988, the ban in England was lifted.[9]

Dell Publishing

⬩1

THE NEW YORK TIMES BEST SELLER
WEEK AFTER WEEK AFTER WEEK!

SPY
CATCHER

*THE SHOCKING BOOK
OF SECRETS
BRITAIN BANNED!*

by

PETER WRIGHT
Former Assistant Director of MI5
WITH PAUL GREENGRASS

2950E1 • $4.95 • A DELL INTERNATIONAL EDITION

Peter Wright, Spycatcher (1988)

Much to the public's disappointment, when they finally got hold of *Spycatcher*, what they got to read was nothing like an Ian Fleming novel. It had been ghost-written by Paul Greengrass – who would later direct three of the Hollywood *Bourne* films – and, although he turned Wright's ideas into a tale, what emerged most strongly was the account of an embittered man who resented that no one believed him, and who had turned against an organisation he had once loved, feeling it had changed beyond recognition. He especially lamented its modernisation, new approaches and accountability, and yearned for the good old days of freedom and flair, when:

> We did have fun. For five years we bugged and burgled our way across London at the State's behest, while pompous bowler-hatted civil servants in Whitehall pretended to look the other way.

The vast majority of the book deals in extensive detail with Wright's conviction that Hollis was a mole, inviting the reader into the conspiratorial world of mirrors inside Wright's head, and as the book progresses it becomes clear Wright accepts no other interpretation of events. Even when evidence points the other way, Wright concludes that Hollis was skilled at deflecting attention from himself. The catalogue of allegations against Hollis is far from riveting and, along with Stephen Hawking's *A Brief History of Time* published the same year, *Spycatcher* remains one of those books of the moment which fairly quickly loses all but the determined reader.

Spycatcher did, however, make some real trouble. One of its more lurid claims was that in the mid-1970s around 30 officers in the Security Service had been bent on bringing down Harold Wilson's Labour government.[10] This allegation caused such a furore that Thatcher instituted an inquiry and former Security Service officers were tracked down in their retirement and questioned about it at length. Four months later Thatcher reported back to Parliament that there was no evidence of any such plot.[11] Wright, it seemed, had made it up, and soon admitted in a television interview that it was all a fabrication. However, he knew how to get people's attention and had chosen the allegation astutely. Years earlier the Russian defector Anatoliy Golitsyn had accused Wilson of being a KGB informer, and in 1977 Wilson had complained that he felt he was being bugged by the Security Service, which he alleged was running a whispering campaign against him.[12] Wilson's successor as Labour Prime Minister, James Callaghan, conducted a review

and issued a statement expressing confidence in the service's impartiality and refuting claims it had bugged No. 10 Downing Street and the Prime Minister's office in the House of Commons.[13] Nevertheless, Wright's allegations caused a profound stir, especially among those who had always believed – or wanted to believe – Wilson.

Perhaps the best part of *Spycatcher* is the preface by the ghost writer, who conjures up something of the atmosphere the public hoped the book would deliver.

John le Carré once wrote that the British secret services have an image but no face. It is an image which has been carefully cultivated since they were founded in the first decade of the twentieth century. The CIA may have greater resources, the KGB greater machinations, Mossad the greater ruthlessness, but MI5 and MI6 were the first players in Kipling's Great Game; they are its master craftsmen. They invented the principles of tradecraft, broke the first codes, ran the best agents, bred the best spymasters, and taught the rest everything they know. Above all, they keep the secrets. In the intelligence world MI5 and MI6 are still *primus inter pares* . . . But in the end, of course, Spycatcher is just a book; an old man's recollections after a lifetime in secret intelligence. They are war stories from long ago, told by the fire, a drink in hand. Like all the best war stories, there are lessons for today. They tell of the days when espionage was still Kipling's Great Game, before the bureaucrats, the satellites, and the computers took over and squeezed the drama and excitement out of it all. These were the years when heroes strode the trenches of the Cold War. We shall not see their like again.

One major consequence of the *Spycatcher* affair was the government's attitude to the intelligence services. The World War Two intelligence officer turned black magic author Dennis Wheatley had mentioned 'MI5' in a novel in 1939, and it and MI6 had then become staples of spy-adventure stories.[14] Even the 1970s television show *The Professionals* used the organisational name 'CI5', which did not leave much to the imagination. Yet despite the public's love of spy dramas, at the time of *Spycatcher* the government had never officially set out what the British intelligence agencies did, preferring to keep their officers, agents, locations and operations in the shadows. After the *Spycatcher* publicity some of the secrecy seemed redundant, and Parliament introduced the Security Service Act 1989. 'There shall continue

to be a Security Service', it began, putting the service on a statutory basis for the first time, setting out its responsibilities and powers.[15] SIS and GCHQ managed to remain in the dark for another five years, but the Intelligence Services Act 1994 eventually did the same for them.

Ian Fleming was of the same generation as the Cambridge spies, with the same social background as all but Cairncross. Bond, too, moved in the same circles, having been expelled from Eton before attending university in Geneva then a skiing finishing school at Kitzbühel. But the similarities stop there. The Cambridge spies were not international playboys who slept with one eye open and a Walther PPK under the pillow, and who always brought down the villain. They were doctrinaire bureaucrats who engaged in the sordid business of betraying their friends, colleagues and country to an ideology that murdered an estimated 100 million civilians, more than any other in the twentieth century.[16] It was yet another nail in the coffin of the post-war establishment, with Philby arriving in Moscow just four months before the Profumo affair rocked the country. In the eyes of many in 1960s Britain, it was yet more proof that Westminster and Whitehall were dangerously out of touch.

45

Picket Lines and Parody –
The Lady Is Not for Turning
Spitting Image
The Last Prophecies of Spitting Image
1996

In Yorkshire, near the centre of a triangle formed by Barnsley in the west, Doncaster in the east and Rotherham in the south, lies Cortonwood Shopping Park. It is unexceptional, comprising all the usual supermarkets and warehouse outlets offering clothing, cosmetics, sports equipment, bicycles, car parts, DIY products and fast food. Nearby is a business park, lake and residential development. It could be any one of scores of similar places in Britain. Except that, for a moment in 1984, the nation's television cameras were excitedly rolling here, where the only visible structures were two tall headstocks – each with a pair of winding wheels – dominating the landscape. This was Cortonwood Colliery, whose miners had been bringing up coal from deep underground seams since 1873. By the start of 1984 the colliery was estimated to be good for another five years before exhausting the area's coal deposits.

At the high water mark of British mining before World War One, around a million miners worked in 3,000 collieries across the country. But, over time, against a background of rising costs and cheaper imports and alternatives, the mining industry had gradually become uneconomic and reliant on taxpayer subsidies to survive, posing complex issues for a succession of governments.

On the one hand mining was a historic industry that had powered the Industrial Revolution, provided employment in areas where there were limited opportunities, and forged tight-knit communities with strong traditions and attachments to their collieries. On the other it had become an unprofitable industry, was too big, and took up significant public resources, some of which could be used elsewhere. It was not an easy decision, but all British governments chose progressively to close the country's mines. Sometimes the process required a balance of measures. For instance, the Harold Wilson–James Callaghan Labour government of 1974 to 1979 reached a pay settlement with the miners to end the strike that had brought down Heath's Conservative government, but went on to shut down collieries. Both Labour and Conservative governments each closed hundreds of collieries in the twentieth century before Margaret Thatcher became Prime Minister.

When Thatcher came to power in 1979 it was on a manifesto that promised the country fundamental economic reform and modernisation, including a pledge to reduce the power of the unions in nationalised industries and prevent the strikes that had blighted the 1970s. A key element of this strategy was to make uneconomic industries profitable, so the National Coal Board – the government agency responsible for mining – set a target for the mining sector to break even by 1988. As part of this programme, and to address the national oversupply in coal, in March 1984 the NCB announced the closure of 20 collieries. Cortonwood was on the list and, when news of the planned closure leaked out ahead of the national announcement, its miners walked out in protest, as did many from collieries across Yorkshire in solidarity.[1]

Arthur Scargill had been voted President of the NUM in 1981 and, when news of the 20 colliery closures was announced, his instinct was to call all the country's miners out on strike. Legislation and NUM rules required a national ballot to sanction such a strike, but Scargill chose not to put the question to a vote, instead inviting the different regions to reach their own decisions. The result was fragmented industrial action with wide disparities across the country. For instance, in South Wales 99.6 per cent of miners stopped work, while in Nottinghamshire only 25 per cent responded to Scargill's call.

As in the 1970s, Scargill used the language of war and followed a strategy designed to cause a level of disruption that would compel the government to abandon its policy. As before, he dispatched flying pickets across the country with instructions to block any lorries trying to transport coal from

working pits to factories and power stations, and to set up picket lines to prevent 'scabs' – miners who wanted to work – from getting through their collieries' front gates. This strategy set miner against miner, dividing communities as the two groups polarised acrimoniously. To those who supported Scargill it was a critical strike sanctioned by the NUM leadership, and observing it was a question of honour, loyalty and tradition. To those who continued working it was an unofficial 'stoppage' outside the NUM's rules, leaving them free to continue earning if they chose.

With each camp believing its stance was correct, passions ran high and confrontations on picket lines soon flared into violence, sometimes fatally. In the first few days of the strike, David Jones, a 24-year-old miner who had travelled 50 miles south from Wakefield to Ollerton as a flying picket, died after being hit in the neck with a brick. In November, David Wilkie, a 35-year-old Welsh taxi driver, died near Merthyr Tydfil when two striking miners dropped a concrete block and post off a motorway footbridge onto his car as he was driving a working miner to his colliery. Across the country, the police intervened to keep order, but nightly television news programmes carried images of scuffles and pitched battles that were more reminiscent of scenes from Northern Ireland than England and Wales.

A key goal of the government's economic reforms was to curtail the power of the unions to bring the country to a standstill as they had in the 1978 to 1979 Winter of Discontent. It was a fight Thatcher was prepared and willing to have. Knowing that reform of the mining sector would spark strikes, she had made plans in advance, stockpiling large coal reserves to keep the country's power stations and industries working during any strike. In the event, she was helped by the fact that Scargill called the strike in March when the seasonal demand for coal was dropping as the weather warmed. The other key contingency she put in place in advance was to arrange for the police response to be coordinated centrally, enabling the police to deploy quickly and efficiently across county lines to ensure coal lorries could travel and working miners could get into their collieries.

As the dispute intensified it became clear for both Thatcher and Scargill that it was about more than pit closures, instead becoming an existential confrontation of their core ideologies. Thatcherism was staunchly rooted in free market economics and right-libertarian principles, and Thatcher made no secret of her total opposition to the hard left and its communist economics, which she saw as a threat to the country's prosperity.[2] Opposing her, Scargill was proud to advocate exactly those views, having joined the Young

Communist League as a teenager and quickly risen to its national executive. Notwithstanding the Cold War, he was a committed supporter of the Soviet regime, and advocated that no pit should ever be closed – even if it had exhausted its coal supply – firmly believing that governments had a duty to keep all miners permanently in work.[3]

The result was a year of bitter ideological confrontation: miners against miners, and miners against the police. Inevitably, with passions running so high, there were overreactions on both sides. Miners attacked the police with bricks and other missiles, while the police responded heavy-handedly with anti-riot equipment. The worst incident of the disruption occurred on 18 July, when around 10,000 miners picketed Orgreave Colliery near Cortonwood to prevent lorries laden with coke leaving the site. Some 5,000 to 8,000 police were deployed to safeguard the lorries, and the standoff erupted into violence. Projectiles were hurled at the police, who responded with batons, riot shields and mounted horseback charges. When the dust settled, 51 miners and 72 police had been injured.

To try and bring some resolution, in September working miners from Yorkshire and North Derbyshire took two cases to the High Court requesting a ruling on the legality of the strike. The judge declared it was unlawful as there had been no national ballot as required by the NUM's rules, and he fined the NUM £200,000. Scargill dismissed the judgement as an irrelevant attempt by an unelected judge to interfere in the NUM's affairs, and moved most of the NUM's £10.7 million offshore – some in suitcases on aeroplanes – to avoid paying the fine.[4] With the strike now officially unlawful, miners on the picket lines were no longer able to claim benefits, causing them and their families extreme economic hardship. Scargill appealed to Colonel Gaddafi in Libya for funds, and the Security Service uncovered Soviet channels trying to pass the NUM money, but none of these schemes resulted in the arrival of any financial support for the striking miners.[5] As winter came and went, the disruption did not bring the country to a standstill or cause a state of emergency. Without any serious pressure to capitulate, the government offered no concessions. Unlike in 1972 and 1974 the strike had failed. Accordingly, on 3 March 1985, 12 months after the miners first walked out of Cortonwood, and with many facing destitution, the NUM abandoned the strike and advised its members to return to work.

In all, 142,000 miners had taken part in the stoppage, and they had nothing to show for a year of protest except a deep sense of grievance against the government and 8,392 charges for public order offences.[6] Nationally,

the fallout changed the landscape. The failure of the strike fatally damaged the credibility of the NUM, and in the process weakened all other unions. The government therefore faced little opposition in passing legislation restricting union powers, effectively closing the door to future large-scale industrial action. As a direct result, unions shrank in size. In 1970 one in four workers in Britain belonged to a union. By 1990 the number had halved to one in eight, and the effect was felt immediately. Between 1979 and 1990 the working time lost in strikes fell from 900,000 days a month to 183,000.[7]

Cortonwood officially closed seven months after the end of the strike, and it was bulldozed the following year. Many of the country's 169 other collieries suffered a similar fate, prompting Scargill to call for another strike in 1986, but no action materialised. In 1994 the country's 15 remaining collieries were privatised, but they fared little better, and were shut one by one. The last in Britain, Kellingley Colliery in north Yorkshire, closed its doors in 2015, bringing deep-pit mining in Britain to an end.[8] Thatcher had played a leading role in the death of the mining industry, as had successive Labour and Conservative governments. So, too, had Scargill, as a less dogmatic leader of the NUM might have found acceptable compromises that impacted mining communities less harshly, and might also have held the national ballot required by law. Regardless of which way the vote may have gone, the result would have been less traumatic for the miners, their families and communities, who were as much victims of their own leadership as they were of the government.

Thatcher's unyielding determination to see her policies implemented made her a hate figure in many quarters, but it did not damage her popularity at the polls. She had made toughness the backbone of her political persona since a Soviet propagandist, Yuri Gavrilov, called her the 'Iron Lady' in a Russian army newspaper in 1976.[9] She embraced the image willingly, enjoying the reputation of being a hard negotiator, and it won her votes. When she came to power in 1979 it was with 339 seats and a majority of 44. In 1983, after the Falklands conflict, the electorate gave her 397 seats and an increased majority of 144. And in 1987, two years after the miners' strike, she won another landslide with 376 seats and a majority of 101.[10] The country's first-past-the-post voting system, it seemed, rewarded her determination. One group which did not appreciate her toughness, however, was the Provisional IRA. On 12 October 1984 – in a modern reworking of the Gunpowder Plot – they tried to murder her and her entire cabinet by

bombing the Conservative Party conference at the Grand Hotel in Brighton. Thatcher escaped unharmed, but the bomb murdered five and injured 31 more.[11]

Thatcher has a legacy unlike any other post-war Prime Minister, continuing to excite extremes of both admiration and revulsion. Her Britain, too, has its advocates and detractors. The miners' strike, the Brighton bomb, the Brixton riots and the poll tax riots all point to genuine problems, but the decade was also a period of increasing affluence. The weekly income of the median household grew from £270.74 to £341.58 a week, although care must be taken with these figures as this growth was not evenly spread across society, with a larger rise in incomes at the top of the economic ladder and a smaller increase at the bottom.[12]

Away from economics, Thatcher's Britain was a country in which creativity and expression flourished on a wider scale than ever before. From the time of the British Invasion of the mid-1960s, Britain's musicians had captivated audiences in the United States and globally. In the 1980s the British knack of combining fresh musical sounds with eye-catching fashions saw another explosion in British inventiveness, which the youth had unprecedented economic and social freedom to explore. New Romantics emerged, flamboyantly gender-bending with a nod to the eighteenth century in a way their 1970s glam rock forebears could only have dreamed of. Punks were still to be seen draped over the steps of the statue of Anteros in Piccadilly and in a hundred other places, but softer versions appeared too, like the moody goths who laid the foundation for emos, and quirky one-offs who effortlessly blended punk into New Romanticism to create sensations like the highway-robbery-themed Adam and the Ants. Other niches sprang up, too, like groups with explicitly political or gay rights messages. Few of these artists stayed in one genre for long, and neither did their fans, who – unlike their parents – found themselves free to experiment one by one with them all. Britain was the world leader in pop, and in 1985 the planet was treated to a showcase of all this musical creativity when Bob Geldof of the Boomtown Rats and Midge Ure of Ultravox staged a charity event to raise money for victims of the Ethiopian famine. Billed as the 'Global Jukebox', Live Aid was the largest live rock event in history, with British acts filling Wembley Stadium in London from midday to 10 p.m. and making up a third of the artist roster performing the same day at John F. Kennedy Stadium in Philadelphia.

Another notable area of popular culture in which 1980s Britain took centre stage was comedy. Monty Python had been entertaining global

audiences since the late 1960s, but reached a new generation with its films *Monty Python's Life of Brian*, released in Britain six months after Thatcher came to power, and *Monty Python's The Meaning of Life*, which appeared the year after the Falklands conflict and the year before the miners' strike. A new crop of comedians also emerged – Rowan Atkinson, Adrian Edmondson, Ben Elton, Dawn French, Stephen Fry, Lenny Henry, Hugh Laurie, Rik Mayall, Griff Rhys Jones, Jennifer Saunders, Alexei Sayle, Mel Smith and Victoria Wood – all of whom rejuvenated the tired spectacle of dinner jacket-clad music hall acts still filling the nation's Saturday evening television screens with jaded mother-in-law jokes. Much of the material in these new comedians' acts was directly or indirectly political, but television had yet to find a way to capture the British appetite for biting political satire the way *Punch* had done in print from the mid-nineteenth century to the mid-twentieth and *Private Eye* had since the 1960s. This was to change in February 1984 when ITV made a grab for the equivalent television market by broadcasting a show featuring life-size latex puppets shaped into grotesque caricatures of the people they represented. From the first, it was clear a boundary had been crossed and almost nothing was off limits. The puppets cruelly exaggerated the physical characteristics of those they lampooned, making fun of idiosyncrasies like the prominent port wine stain on Soviet President Mikhail Gorbachev's forehead, which was transformed into a hammer and sickle.

The programme was *Spitting Image*, and its raucous comedy delighted as many segments of the population as it appalled. Thatcher and the queen were the show's stars, alongside the cabinet, the royal family, and the people who filled the television and cinema screens daily, from news anchors to film, pop and sports stars. It took the programme's team a while to gain the confidence to parody the Queen Mother, but when eventually they did, they created one of their most-loved characters, portraying her as a tipsy, hard-gambling, northern granny. The humour was cutting and fearless, as in the much-rebroadcast sketch in which Thatcher takes her cabinet to a restaurant. 'Would you like to order, sir?' the waitress asks. 'Yes. I will have a steak,' Thatcher drawls. 'How do you like it?' the waitress enquires. 'Oh, raw please,' Thatcher answers languidly. 'And what about the vegetables?' the waitress concludes. 'Oh,' Thatcher replies, looking around at her cabinet, 'they'll have the same as me.'[13] When Thatcher resigned in 1990 the makers of *Spitting Image* feared her successor would not be as colourful, so they embraced the notion, spraying John Major grey from head to foot and

giving him a personality to match, creating a character whose exaggerated dullness became the voting public's perception of the real man.

At the general election in 1992 Labour was defeated for the fourth consecutive time. Aware it needed something fresh to offer, in 1994 it voted for a radical change of direction by putting its trust in 41-year-old Tony Blair, who rebranded the party 'New Labour' and positioned it as social democrat rather than socialist. To underscore this shift in values, he rewrote the official aims of the party – enshrined in Clause IV of its constitution – removing the original commitment 'to secure for the workers . . . the full fruits of their industry . . . upon the basis of the common ownership of the means of production' and replacing it with a statement that the party was one in which 'by the strength of our common endeavour we achieve more than we achieve alone . . . the means to realise our true potential . . . a community in which power, wealth and opportunity are in the hands of the many, not the few . . . where we live together, freely, in a spirit of solidarity, tolerance and respect'.[14] It was a decisive move away from those, like the larger unions, who came from a harder-left tradition.

Spitting Image chronicled Labour's transformation before coming to an end in February 1996, when it delivered final verdicts on how it perceived the state of British politics. In one sketch Blair confessed to his wife, Cherie, that a portrait of him in the attic was different every time he looked at it. His blue tie had turned red. His portrait was seen consulting a trade union leader while drinking bitter. And the image openly criticised Margaret Thatcher. A horrified Cherie offered a solution: 'Why don't you just bin it, like you binned everything else?' As the episode moved towards its close, it looked into the future, and showed Blair dragging Conservative cabinet members out of No. 10 Downing Street as his shadow cabinet arrived doing the conga, trampling the exiting Conservatives underfoot.

Nine days before the final episode aired, the Provisional IRA broke its 1994 ceasefire and detonated a half-tonne bomb in London's Docklands to protest at John Major's insistence they disarm before entering further talks.[15] As a result of the bomb, and an even more powerful one in Manchester in 1996 – the largest explosion in Britain since World War Two – the Provisional IRA got its way, and Major abandoned the precondition for disarmament. *Spitting Image*'s assessment was as caustic as ever, showing three IRA men in paramilitary clothing and balaclavas sitting in a dingy room around a small table drinking pints of stout and prodding the innards of a clumsily homemade bomb.

Cambridge University Library | MS-Spitting-Image-Series-00018-Episode-00006-18Feb1996-N-00478-00001 and 00002

SET: BLACKS:

TERRORIST 1 (DOUG) - MARK
TERRORIST 2 (LINTON) - KAEFEN/BRIAN
TERRORIST 3 (MILOW) - PHIL

(N478) DEMOCRACY NOT

(PARSONS/NAYLOR/TURNER)

TERRORIST ONE - Roger

TERRORIST TWO - Jon

TERRORIST THREE - Alistair

IRA COUNCIL MEETING. THREE GENERICS
IN BALACLAVAS.

TERRORIST 1:

We will not have any contact with
the British government until they
renounce the use of talks.

TERRORIST 2:

Aye we must never give in to the
demands of democracy.

TERRORIST 3:

If we give in to democracy now, it
will just open the floodgates to
reasoned negotiation.

TERRORIST 1:

So we're all agreed then?

2 AND 3 NOD VIGOROUSLY.

Or should we put it to the vote?

2 AND 3 TURN TO STARE AT 1.

TERRORIST 1:

Only kidding.

(ENDS)

Spitting Image, The Last Prophecies of Spitting Image (1996)

Fittingly, the show's curtain-closer – bringing 12 years of satirical chaos to an end – was introduced by the queen's puppet, complete with tiara, singing Lulu and the Luvvers' 1964 version of 'Shout'. With jazz hands flapping, she yells 'Weeeeeeeeeeeeell . . . you know we make you want to spit . . .', before dozens of puppets from down the years join in the anarchic singalong. The following year *Spitting Image*'s prophecy about Blair came true. On 1 May 1997 New Labour swept to power, winning 418 seats and a majority of 178, beating Thatcher's best result in 1983. It was the most seats a Labour government had ever won, although short of the 522 seats Stanley Baldwin achieved for the Conservatives in 1931.[16] *Spitting Image* came off air as the Thatcher–Major era closed, ending 18 years of rule in which Major continued the Thatcherite programme, while tempering it slightly with a softer element of One-Nation Conservatism.[17]

Even after the passage of several decades, the period's political legacy remains controversial. Steel, mining, and a host of other traditional industries were largely closed down, and Britain, no longer a country in which manufacturing was king, became one in which services were the main contributor to GDP. The 1986 Big Bang reforms of the stock exchange and City propelled finance into a newly prominent role, paving the way for London to become one of the world's leading financial centres. However, this all came at a social cost, with high levels of unemployment in predominantly Midland, northern and Welsh regions where the industries that had powered the Industrial Revolution were axed. While the south grew increasingly affluent, many former manufacturing areas became alienated, left out of the economic success.

The 1980s and early 1990s also left their mark on the DNA of the country's two political tribes. Many of today's cabinet ministers and MPs became politically aware in Thatcher's Britain. In the Conservative Party, Thatcher's ability to win elections is still regarded with envy, as is the way in which she projected a robust image of Britain on the international stage. More unexpectedly, Thatcher has also left a mark on the other side of the political divide. When asked to name her greatest achievement she answered, 'New Labour,' and not without some grain of truth.[18] New Labour shared her vision of a mixed public–private economy with strong roles for the private sector and a reduced role for the unions. Beyond this, as noted by Peter Mandelson – one of New Labour's architects – the most important lesson they took from Thatcher's success was that to win elections they had to listen to the public and not the party faithful. In particular, they had to

embrace the aspirational working class, which Thatcher had won over so convincingly.[19] This basic truth of modern British politics has remained decisive ever since. It sank Jeremy Corbyn in the general elections of 2017 and 2019, and played a material role in the country's Brexit convulsions. When New Labour came to an end in 2010, Ed Miliband ditched the 'New' and moved the party to the left before it then shifted to the hard left under Jeremy Corbyn. The electorate put neither of them into No. 10 Downing Street meaning, in effect, that Thatcher's legacy is a straight run through 18 years of Thatcher and Major, 13 years of New Labour, five of Conservative–Liberal coalition, and six – so far – of Conservative government under David Cameron, Theresa May and Boris Johnson. There have been no socialist governments since Thatcher won in 1979. More than any other politician in living memory – for better or worse – she shaped modern Britain.

46

Snail Porridge – A New Politics and Cool Britannia

The Fat Duck
Tasting Menu
1999

In the early 1990s, Upper Street in the London Borough of Islington was not the mecca of cool it is today. However, its bars and restaurants were beginning to become fashionable, and among them was the minimalist, Scandinavian-inspired eatery at number 127, whose name – Granita – has gone down in political history.

Granita is now no more, but it served trendy British-fusion food to a well-heeled crowd: a fresh clientele for an affluent new decade. In the 1970s and 1980s Islington had been one of the north London boroughs mocked by the tabloid press for its 'loony left' council implementing avant-garde social ideas. Memorably, a number of its schools encouraged pupils to devise their own curricula and manage discipline: an experiment which ended in gambling, weaponry and arson. A small legacy of the time survives in Pink Floyd's 1979 song 'Another Brick in the Wall', featuring Islington school-children joyfully chanting 'We don't need no education'.[1]

Accounts differ on the details, but on 31 May 1994 two men sitting around one of Granita's bare, square wooden tables concluded a pact that was to have far-reaching consequences across Britain, Europe, America and the Middle East. The more energetic of the two was the Shadow Home Secretary, Tony

Blair. The more ponderous was the Shadow Chancellor of the Exchequer, Gordon Brown. The two politicians were magnetic opposites. Blair, the public school- and Oxford-educated son of a would-be Conservative MP, was a clever, argumentative maverick with an intuitive understanding for the delicate alchemy of empathy and power. Across the table, Brown was the more doctrinaire of the two: the son of a Church of Scotland minister, steeped in politics from childhood, with a PhD in Labour history and a mission to transform society's economic strata. Their political credos barely intersected, but what they shared was an all-consuming ambition to be in government, and to lead it.

Their pact had been worked out a few weeks earlier, largely in Edinburgh, during a succession of hurried meetings following the sudden death of John Smith, the Labour Party leader.[2] Blair and Brown were both laser-focused on the party's impending leadership election, aware it was the opportunity they had been waiting for. Hence it was the moment to begin cutting deals. By the time they paid the bill and left the restaurant, Brown had agreed to step aside on two conditions. If Blair became leader, Brown would be given control of economic and social policy. And if Blair became Prime Minister and won a second term, he would hand the keys of No. 10 Downing Street to Brown.[3] It was the sort of horse-trading that political careers are made of, but was unique in the impact it was to have. The two were not close friends or ideological allies, but they had the insight to appreciate that – at least for the moment – they needed each other if they were to achieve power.

It is no accident that the Blair–Brown pact was usually presented by New Labour's publicists as having been sealed in a trendy restaurant. New Labour understood image and brand more than any government before or since, and London was becoming intensely fashionable. All political parties and politicians hoped some of the city's sparkle would rub off onto them, and this was especially true of Blair, who wanted his politics to be perceived as youthful and energetic.

In London, away from Westminster, magic was somehow in the air. The month Blair and Brown sat in Granita, the Channel Tunnel opened, bringing a new sense of connection to the glamour of Paris, where British designers like John Galliano and Alexander McQueen were in charge of French houses Dior and Givenchy. Capturing the mood, a short while later the American magazine *Newsweek* ran a cover featuring an outlandish Union Jack hat designed by Philip Treacy out of feathers with the headline 'London Rules. Inside the World's Coolest City'. Although the country was only half a decade on from the poll tax riots and the demise of Margaret Thatcher,

something transformational had happened. Her 1986 Big Bang had turned the City into a financial centre to rival New York, pulling hundreds of foreign banks and financial services companies to London, where they built a modern finance industry that was soon involved in everything from managing the nation's savings and pensions to facilitating global asset and liability management. The resulting wealth that flowed around the City inevitably found its way out of the Square Mile and into the wider economy, channelling money into entertainment, fashion, luxury goods, the arts and other sectors that flocked to serve wealthy patrons. The resulting boom in creative output, and the increasing visibility of international A-Listers in Britain's cities and country pubs, and coming and going from London's ultra-trendy Groucho Club and Soho House, soon gave the nation the confidence to brand itself 'Cool Britannia'.

A new wave of British art was in the vanguard of this renaissance, with Charles Saatchi's patronage of the Young British Artists funnelling unprecedented sums of money into their ultra avant-garde creations. Damien Hirst began the decade with a 4.3-metre tiger shark in a tank of formaldehyde, which left many people questioning what would, or could, come next.[4] The answer was a great deal more that was intended to shock and catch the eye. At the end of the decade Tracey Emin was shortlisted for the Turner Prize for a messy bed littered in everything from empty vodka bottles and discarded underwear to condoms and a pregnancy testing kit.[5]

Pop music also embraced Cool Britannia, with DVD players around the world spinning to indie Britpop. Forming as Oasis, brothers Noel and Liam Gallagher tried to recapture the success of the Beatles with a Mancunian twist and a creative–destructive rivalry that would come to mirror the dynamic of the Blair–Brown relationship. More light-heartedly, the Spice Girls offered a fresh take on feminism, selling 'girl power' to a fan base from the under-tens to college students. One review likened the front-row crush at one of their concerts to a cross between the opening day of the sales at ToysЯUs and the Nuremberg rallies. Both bands proudly and unmistakably flew the Union Jack, putting it centre stage on Noel Gallagher's Epiphone Sheraton guitar, and on a tea towel stitched to Geri Halliwell's black Gucci dress at the 1997 Brit Awards. After the international embarrassment of the three-day week and paralysing strikes of the 1970s, Britain had rediscovered its mojo.

The Prime Minister, John Major, tried to ride the wave, but *Spitting Image*'s final prediction came true in May 1997 when Tony Blair stormed into Downing Street. At 43 he was the youngest Prime Minister since the

Earl of Liverpool in 1812, and his use of D:Ream's catchy anthem 'Things Can Only Get Better' – sung by phalanxes of optimistic voters excited to wave goodbye to 18 years of Conservative rule – stitched New Labour seamlessly into the fabric of Cool Britannia, energising the nation with the sense that it had found a confident identity for the new millennium. Adept at image management, New Labour embraced this association and, a month after winning power, explicitly allied itself with youth culture by inviting a group of Britpop stars to a champagne reception at Downing Street where Blair and the glitterati were snapped chatting happily together, providing glamorous shots for the front pages. Eager to stay in the Cool Britannia slipstream, the government soon set up 'Panel 2000' as a forum for celebrities to advise on marketing British creativity abroad, like sending the Spice Girls to embassies while on foreign tours.

Artists and pop stars were obvious ambassadors for Cool Britannia, but they were soon joined by a far less likely group. In 1662 Samuel Pepys had written in his diary, 'So home and dined there with my wife upon a most excellent dish of tripes of my own directing.'[6] Thanks to chunks of eel in congealed vinegar stock, dripping smeared on bread, cheap minced-beef pies floating in parsley 'liquor', and tripe as enjoyed by Pepys, British cuisine had long had a reputation for inedible dishes. Two and a half centuries later, Virginia Woolf had been far less impressed than Pepys by the food on her plate. 'What passes for cookery in England is an abomination . . . It is putting cabbages in water. It is roasting meat till it is like leather. It is cutting off delicious skins of vegetables . . . A whole French family could live on what an English cook throws away.'[7] Woolf was saying nothing new. In 1771 Tobias Smollett had observed that London bread was 'a deleterious paste, mixed up with chalk, alum, and bone-ashes, insipid to the taste, and destructive to the constitution'.[8] In a nation famed for its lack of kitchen *savoir faire*, the 1990s suddenly and unexpectedly saw the arrival of celebrity British chefs.

There had been television cooks before. From the mid-1950s to the mid-1970s the larger-than-life Fanny Cradock – a former vacuum cleaner saleswoman, romantic novelist and double bigamist – gave on-air demonstrations of not very competent cookery while dressed in formal evening wear and ordering her subservient husband about.[9] She was followed by the complete contrast of Delia Smith: a no-nonsense games-teacher-style safe pair of hands, whose cookbooks filled kitchen shelves up and down the country. Then the 1980s brought Keith Floyd, a roguish charmer with a flair for tipsy culinary anarchy, whose 15-year television career saw him become

the country's first real television personality chef.[10] His chaotic cooking, trademark wine slurping, and chats with the cameraman gave the programmes an old-world dilettante feel. This would all culminate in the mid-1990s with the boy-next-door Jamie Oliver and the temperamental artiste Gordon Ramsay, who together began the era of the career celebrity chef.

Although the country's reputation for abysmal cuisine was well-established, it had not always been criticised. In 1782 a German visitor to England noted with delight: 'there is a way of roasting slices of buttered bread before the fire which is incomparable. One slice after another is taken and held to the fire with a fork until the butter is melted, then the following one will be always laid upon it so the butter soaks through the whole pile of slices. This is called "toast".'[11] But this mouth-watering fireside toast was part of the last hurrah of Britain's cookery before the decline set in, and a long tradition of good cooking was quietly obliterated.

Evidence from the Stone, Bronze and Iron Ages demonstrates a gradual evolution in British cuisine from large game to birds, cows, fish, goats, sheep, shellfish, acorns, barley, beans, chestnuts, spelt and wheat, invigorated with borage, burdock, celery, coriander, crab apples, clover, dandelions, garlic, mint and nettles. Blackberries, strawberries, raspberries and honey made things sweeter. Salt seasoned and preserved. Butter and cheeses enlivened. And ale, beer and mead helped pass the long evenings.[12] By AD 1 proximity to the Roman Empire even meant Britain was importing wine.

When Emperor Claudius's legions arrived in AD 43 they brought an entirely different tradition of cooking with wine and oil instead of milk and butter, and a large pantry of new ingredients including far stronger flavours like aniseed, asparagus, cabbages, carrots, cherries, chervil, cucumber, dill, endives, fennel, ginger, leeks, lettuce, marjoram, marrow, onions, parsley, parsnips, pepper, rocket, rosemary, sage, spearmint, thyme, turnips and watercress.[13] They also brought their legendary *garum* or *liquamen*, a fermented fish condiment without which no Roman meal was complete.[14]

In Rome food was taken seriously, and the Romans produced the world's oldest known cookbook: *On the Matter of Cooking* (*De re coquinaria*), attributed to Apicius. It contained everything from honey-spiced wine as a pick-me-up for the weary traveller to ways of cooking ostrich, flamingo and peacock.[15] Many of the instructions for preparing the individual dishes began with the Latin word *recipe*, meaning 'take', which English has kept unaltered in its culinary lexicon. The wealthy strove to outdo each other as *bons vivants*, with food elevated to an art form. Petronius's *Satyricon* famously

lists a succession of increasingly flamboyant and exotic dishes at Trimalchio's feast, starting with appetisers of dormice rolled in poppy seeds and culminating in a platter with a roast goose, fish and birds, all sculpted out of pork: a fish from tripe, a pigeon from bacon, a turtle from ham, and a chicken from pork-knuckle.[16] The evidence from grand Romano-British villas like the one at Fishbourne suggests that Roman gastronomy became an important part of life throughout the empire, even on its northern, Atlantic edge.

The collapse of Roman Britain and the arrival of the Anglo-Saxons saw all traces of Roman cookery disappear and a return to simpler, indigenous foods. Even the rabbits the legions had introduced to the country mysteriously left with them.[17] The Viking longships brought similar cuisine to that of the Anglo-Saxons, but also introduced their techniques of smoking food, especially fish, leaving a tradition that remains strong in Scotland.

The Bayeux Tapestry shows food being prepared, and the Norman conquest of 1066 had a profound impact on British cuisine, beginning a veneration of French food, cooks and kitchen vocabulary that has never disappeared. Every period of British history had seen its warlords feasting, but in the High Middle Ages this became a stylised ritual in the great castles and palaces, where monarchs, courtiers, barons and prelates hosted banquets to show off their wealth and status. Recipe books for these grand feasts began appearing, like the *Forme of Cury* – the earliest recipe book in English – prepared around 1377 by 'the chef Maister Cokes of king Richard the Secunde kyng of inglond'.[18] 'Cury' was the Middle English word for cookery, which was considered a branch of medicine, so Richard's master cooks compiled the recipes 'by aſſent and avyſement of Maiſters of phiſik and philoſophie þat dwellid in his court'.[19]

Medieval French recipe collections regularly made their way north of the Channel. The *Forme of Cury* was probably a response to the French compilation *Le Viandier*, which had been around since 1250 to 1300, but had recently reappeared under the guidance of Taillevent, 'master chef to the king', with such dramatic recipes as cooked animals that breathed fire like dragons.[20] The *Forme of Cury*'s recipes indicate few differences between British and French cuisine in this period, and some of the dishes are still recognisable today: 'blank mang', an early blancmange; 'toſtee', bread with spiced honey and wine sauce; 'coffins and chastletes', castle-shaped pastries filled with pork, almonds, saffron and sandalwood; 'pygg in ſawſe ſawge', pork in sage sauce; and 'porpeys in broth', porpoise in broth with wine and onions. Another cookbook from a few decades later even includes 'cuſtard',

which was then the whole ensemble of a marrow, date and prune pie covered in a sauce of spiced cream and eggs.[21]

A key feature of the dishes presented in the *Forme of Cury* is their use of a wide range of exotic spices including caraway, cardamom, ginger, nutmeg and pepper, and the first mentions of cloves, gourds, mace and olive oil in a British cookbook. The spice and flavour mix of the dishes has not survived into modern British cuisine, but the closest analogue is probably modern Moroccan cooking, like the *pastilla* pie of pigeon, scrambled egg, cloves, almonds, honey and sugar.[22] Medieval banqueting's formal rituals also became part of the overall display of fine dining, with the skill of good carving coming to be seen as a prized refinement. In around 1450 John Russell, Marshal-in-Hall and Usher-in-Chamber to Duke Humfrey of Gloucester, shared a hard-won piece of wisdom in his *Boke of Nurture*, noting that in his experience 'crabbe is a slutt to kerve'.[23]

Britain's tables continued to be well served throughout the Tudor and Stuart periods, with the decline not starting until the Industrial Revolution under the Hanoverians and Victorians. After the arrival of mechanisation, priorities began to shift towards the efficiency and convenience of manufacturing and transporting food rather than its quality. The death blow came during and after World War Two with the rationing that lasted into the 1950s. By this time many generations of Britons had forgotten the pleasures of the table and were largely accustomed to a mixture of bland or unappetising economy foods. There was, though, one exception to the general decline, as noted by the novelist Somerset Maugham – born in the British embassy in Paris to stop him being drafted into French military service – who mused that it was very simple to eat well in England: all one had to do was have three breakfasts a day.[24] This was the Victorians' single biggest positive contribution to Britain's culinary reputation, growing out of the leisured buffet breakfasts served in wealthy Victorian houses, which regularly included everything from lamb chops to kedgeree. Mrs Beeton's 1861 *Book of Household Management* included bacon, eggs, mushrooms, and a range of other familiar staples for the breakfast table, but the full cooked breakfast of bacon, eggs, sausage, beans, mushrooms, tomatoes, black pudding, toast, marmalade and tea only became available to the whole of society in the 1950s when the ingredients were cheap enough for mass consumption.[25]

By the 1990s restaurants were preparing bacon and eggs in myriad ways, but Cool Britannia brought one that had never entered the public consciousness before in the form of nitro-scrambled egg-and-bacon ice cream.[26] It

was the brainchild of the former photocopier salesman Heston Blumenthal, who opened his first restaurant in 1995 six miles west of Windsor Castle in a small village pub he renamed The Fat Duck. Blumenthal had taught himself traditional French cookery before talking his way into a job at Raymond Blanc's Le Manoir aux Quat'Saisons. After a week he decided he had no appetite to work his way up the kitchen food chain, but would instead do other jobs until he had saved enough money to start his own restaurant and cook the way he wanted.[27] Once open, The Fat Duck won a first Michelin star after three years, a second in 2001, a third in 2004, and was voted best restaurant in the world in 2005.

Blumenthal's astonishing success had not come from executing traditional French cookery in a way that delighted the critics, which was how a cook usually gained acclaim in Britain. Instead, inspired by Californian physicist and astronomer Harold McGee's 1984 book *On Food and Cooking. The Science and Lore of the Kitchen*, Blumenthal set about junking every shibboleth of traditional cookery he could identify and minutely re-examining exactly what was going on – in terms of physics and chemistry – on his stove.[28] He quickly demonstrated to himself that many accepted laws of cookery were wrong, and threw them out of the window. Browning meat does not seal in juices. Soaking mushrooms does not fill them with water. Adding salt to boiling vegetables does not keep them green. When he started reassembling dishes with science, the result of his new gastro-alchemy was unheard-of pairings that flabbergasted his diners' taste buds in ways that defied all accepted norms: sardine-on-toast sorbet, snail porridge, salmon poached in liquorice gel.[29] This food, though, was not only about taste. Sensory experience and showmanship were also important elements in Blumenthal's revolutionary cuisine, as he, McGee and two other chefs of the 'new cookery' noted in a joint 2006 statement. 'Preparing and serving food could therefore be the most complex and comprehensive of the performing arts,' they concluded.[30]

In Westminster, New Labour's politics were also a performing art. Thatcher had made herself available to television interviewers for hours at a time, during which she would open herself up to long questions and longer answers on her underlying beliefs. Blair was also a television politician, but he understood it in a more intuitive and personal way, focusing on message, soundbites, and mirroring his audience, even changing accent, which was another bedrock of British society that had transformed over the previous decades.

By kind permission of The Fat Duck

| LIME GROVE | ROAST SCALLOPS |
| Nitro poached green tea and lime mousse | Scallop tartare, caviar and white chocolate velouté |

ORANGE & BEETROOT JELLY

POACHED ANJOU PIGEON BREAST
A Pastilla of its leg with cherries, pistachio, cocoa and quatre epices

JELLY OF OYSTER
Passion fruit, lavender

PINE SHERBET
(Pre-hit)

RED CABBAGE GAZPACHO
Pommery grain mustard ice cream

MANGO AND DOUGLAS FIR PUREE
Bavarois of lychee and mango, blackcurrant sorbet, blackcurrant and green peppercorn jelly

JELLY OF QUAIL, CREAM OF LANGOUSTINE
(Homage to Alain Chapel)
Chicken Liver Parfait, Oak Moss and Truffle Toast

NITRO-SCRAMBLED EGG AND BACON ICE CREAM
Pain Perdu and Tea Jelly

SNAIL PORRIDGE
Joselito ham, shaved fennel

ROAST FOIE GRAS
Almond fluid gel, cherry and chamomille

PETITS FOURS
Carrot and Orange Lolly

The Fat Duck, Tasting Menu (1999)

By the 1990s the clipped, cut-glass speech of World War Two newsreels was long gone. Even the queen's accent had become less rigid, although it retained some antiquated pronunciations like 'orfen' for often and a hard 'r' in words like very and spirit. Blair, on the other hand, switched his accent from moment to moment depending on his audience, adopting Estuary English when he wanted to sound less privileged, like 'chews-dee' rather than 'Tews-day', 'Ga-wick' for Gatwick, and 'peepaw' for people. He was not alone in bending his normal accent to seem less distant. Princess Diana did it too, using glottal stops at the end of words. When picked up on it, she joked 'there's a lo' of i' abou' '.[31]

The optimism that carried New Labour into power lasted longer than for most new governments, but it eventually evaporated. The *Guardian* – the country's only left-leaning broadsheet – was already observing by 1999 that Blair had lost his common touch, and it dialled up Noel Gallagher to ask him how he felt about the famous Downing Street Cool Britannia drinks party two years earlier. It was a terrible mistake, the musician confessed, prompted by having consumed too many drugs. New Labour were just the Tories in disguise, he lamented. 'Nothing really changes does it? Same shit, different day.'[32]

Weapons of Mass Destruction – Wrecking Iraq and the Global Financial System

Tony Blair
Foreword to Iraq 'Dodgy Dossier'
2002

On Tuesday 11 September 2001 a hijacked commercial airliner flew directly into the north tower of New York's iconic World Trade Center. Seventeen minutes later a second ploughed into its south tower. A third crashed into the west side of the Pentagon in Virginia. A fourth – probably heading for the White House or the Capitol – crash-landed in a Pennsylvania field as passengers fought its hijackers.

George W. Bush had been inaugurated 43rd President of the United States in January that year. High on any United States President's list of responses to attacks like these was to declare war on the country responsible, but Bush faced a problem when the CIA informed him that they were the acts of a stateless Salafist named Osama bin Laden and his diffuse al-Qa'eda terror network. War was Bush's instinctive response, but with no country to strike in reprisal he instead declared a 'crusade . . . [a] war on terrorism', and began telephoning around for allies. The first person he called was Tony Blair, who promised him unwavering support in whatever he chose to do.[1]

United States intelligence assessments suggested that bin Laden was living in Afghanistan, where he was being sheltered by the Taliban regime whose strict Islamist ideology was sympathetic to al-Qa'eda. Bush therefore

immediately demanded that Afghanistan hand bin Laden over, but the Taliban requested proof of his involvement in the 9/11 attacks first. In response, Bush invoked article five of NATO's treaty – the first occasion in the alliance's 52-year history the clause had been triggered – requiring all NATO countries to recognise an attack on one as an attack on all. He then called for a joint invasion of Afghanistan, which he launched on 7 October 2001. In line with Blair's commitment, British forces were in the front line, and the Taliban was toppled by Christmas.

Once the Taliban was gone – at least for the moment – NATO forces searched Afghanistan as best they could but, finding no trace of bin Laden, concluded that he had slipped across the long, porous border into Pakistan. Bush had warned the world that his war on terrorism would not be over quickly, and he soon unveiled a wider international strategy to disable the ability of any Islamist terrorist to strike at United States' interests anywhere in the world.

Before the 9/11 attacks Bush's administration had been assessing the merits of military action against Saddam Hussein's Iraq, pondering whether a demonstration of strength there might help the United States' interests and relationships with other regimes in the region. After 9/11 his planners increased their focus on Iraq, and concluded that it should be next in the war on terrorism. In support of this, Bush and his senior team announced that Hussein had been illegally developing weapons of mass destruction (WMDs). At the same time, they began methodically insinuating that Hussein had links to bin Laden and al-Qa'eda and had been involved in 9/11. Nobody knew whether the WMD claim was accurate, but the accusation of involvement in 9/11 was widely known to be bogus. Hussein was, by any measure, a murderous despot who ran a notoriously brutal regime that tortured and slaughtered its citizens, but he was not an Islamist and had no common ground with bin Laden and al-Qa'eda, Nevertheless, Bush's message got through quickly. Sixty-nine per cent of Americans soon believed that Hussein had most likely been personally involved in the 9/11 attacks.[2]

In London, since coming to office Blair had looked back to the special relationship between Margaret Thatcher and Ronald Reagan and concluded that an adamantine bond between Britain and the United States was vital if Britain was to maintain a meaningful role in the post-World War Two, post-imperial world. He'd had a positive experience spearheading and championing NATO's 1999 military action against Slobodan Milošević in Serbia and, to an extent, supporting Bush's invasion of Afghanistan, as a result of which

Bush had repeatedly praised Blair for his steadfastness and resolve as an ally. Therefore, when Bush told Blair of his intention to invade Iraq, Blair was again unequivocal in his support.

Now on a war footing, from September 2002 until March 2003 both men worked hard to sell the case for military action to their respective audiences either side of the Atlantic. Blair avoided both the inaccurate bin Laden–Hussein angle and Bush's open call for regime change in Iraq, and focused instead on the WMD Bush said Hussein was developing. On 24 September Blair put his case for war to Parliament succinctly and clearly. 'Regime change in Iraq would be a wonderful thing,' he declared, but 'that is not the purpose of our action; our purpose is to disarm Iraq of weapons of mass destruction.'[3] To accompany the speech, he released a 55-page briefing document entitled *Iraq's Weapons of Mass Destruction: The Assessment of the British Government*. Always mindful of public opinion, he hoped it would demonstrate the thoroughness with which he had reached his decision. To underline his case he wrote a personal foreword to all readers.

FOREWORD BY THE PRIME MINISTER, THE RIGHT
HONOURABLE TONY BLAIR MP

The document published today is based, in large part, on the work of the Joint Intelligence Committee (JIC). The JIC is at the heart of the British intelligence machinery. It is chaired by the Cabinet Office and made up of the heads of the UK's three Intelligence and Security Agencies, the Chief of Defence Intelligence, and senior officials from key government departments. For over 60 years the JIC has provided regular assessments to successive Prime Ministers and senior colleagues on a wide range of foreign policy and international security issues.

Its work, like the material it analyses, is largely secret. It is unprecedented for the Government to publish this kind of document. But in light of the debate about Iraq and Weapons of Mass Destruction (WMD), I wanted to share with the British public the reasons why I believe this issue to be a current and serious threat to the UK national interest.

In recent months, I have been increasingly alarmed by the evidence from inside Iraq that despite sanctions, despite the damage done to his capability in the past, despite the UN Security Council Resolutions expressly outlawing it, and despite his denials, Saddam Hussein is continuing to develop WMD, and with them the ability to inflict real damage upon the region, and the stability of the world.

FOREWORD BY THE PRIME MINISTER, THE RIGHT HONOURABLE TONY BLAIR MP

The document published today is based, in large part, on the work of the Joint Intelligence Committee (JIC). The JIC is at the heart of the British intelligence machinery. It is chaired by the Cabinet Office and made up of the heads of the UK's three Intelligence and Security Agencies, the Chief of Defence Intelligence, and senior officials from key government departments. For over 60 years the JIC has provided regular assessments to successive Prime Ministers and senior colleagues on a wide range of foreign policy and international security issues.

Its work, like the material it analyses, is largely secret. It is unprecedented for the Government to publish this kind of document. But in light of the debate about Iraq and Weapons of Mass Destruction (WMD), I wanted to share with the British public the reasons why I believe this issue to be a current and serious threat to the UK national interest.

In recent months, I have been increasingly alarmed by the evidence from inside Iraq that despite sanctions, despite the damage done to his capability in the past, despite the UN Security Council Resolutions expressly outlawing it, and despite his denials, Saddam Hussein is continuing to develop WMD, and with them the ability to inflict real damage upon the region, and the stability of the world.

Gathering intelligence inside Iraq is not easy. Saddam's is one of the most secretive and dictatorial regimes in the world. So I believe people will understand why the Agencies cannot be specific about the sources, which have formed the judgements in this document, and why we cannot publish everything we know. We cannot, of course, publish the detailed raw intelligence. I and other Ministers have been briefed in detail on the intelligence and are satisfied as to its authority. I also want to pay tribute to our Intelligence and Security Services for the often extraordinary work that they do.

What I believe the assessed intelligence has established beyond doubt is that Saddam has continued to produce chemical and biological weapons, that he continues in his efforts to develop nuclear weapons, and that he has been able to extend the range of his ballistic missile programme. I also believe that, as stated in the document, Saddam will now do his utmost to try to conceal his weapons from UN inspectors.

The picture presented to me by the JIC in recent months has become more not less worrying. It is clear that, despite sanctions, the policy of containment has not worked sufficiently well to prevent Saddam from developing these weapons.

I am in no doubt that the threat is serious and current, that he has made progress on WMD, and that he has to be stopped.

Saddam has used chemical weapons, not only against an enemy state, but against his own people. Intelligence reports make clear that he sees the building up of his WMD capability, and the belief overseas that he would use these weapons, as vital to his

Joint Intelligence Committee, HMSO

3

Gathering intelligence inside Iraq is not easy. Saddam's is one of the most secretive and dictatorial regimes in the world. So I believe people will understand why the Agencies cannot be specific about the sources, which have formed the judgements in this document, and why we cannot publish everything we know. We cannot, of course, publish the detailed raw intelligence. I and other Ministers have been briefed in detail on the intelligence and are satisfied as to its authority. I also want to pay tribute to our Intelligence and Security Services for the often extraordinary work that they do.

What I believe the assessed intelligence has established beyond doubt is that Saddam has continued to produce chemical and biological weapons, that he continues in his efforts to develop nuclear weapons, and that he has been able to extend the range of his ballistic missile programme. I also believe that, as stated in the document, Saddam will now do his utmost to try to conceal his weapons from UN inspectors.

The picture presented to me by the JIC in recent months has become more not less worrying. It is clear that, despite sanctions, the policy of containment has not worked sufficiently well to prevent Saddam from developing these weapons.

I am in no doubt that the threat is serious and current, that he has made progress on WMD, and that he has to be stopped.

Saddam has used chemical weapons, not only against an enemy state, but against his own people. Intelligence reports make clear that he sees the building up of his WMD capability, and the belief overseas that he would use these weapons, as vital to his strategic interests, and in particular his goal of regional domination. And the document discloses that his military planning allows for some of the WMD to be ready within 45 minutes of an order to use them.

I am quite clear that Saddam will go to extreme lengths, indeed has already done so, to hide these weapons and avoid giving them up.

In today's inter-dependent world, a major regional conflict does not stay confined to the region in question. Faced with someone who has shown himself capable of using WMD, I believe the international community has to stand up for itself and ensure its authority is upheld.

The threat posed to international peace and security, when WMD are in the hands of a brutal and aggressive regime like Saddam's, is real. Unless we face up to the threat, not only do we risk undermining the authority of the UN, whose resolutions he defies, but more importantly and in the longer term, we place at risk the lives and prosperity of our own people.

The case I make is that the UN Resolutions demanding he stops his WMD programme are being flouted; that since the inspectors left four years ago he has continued with this programme; that the inspectors must be allowed back in to do their job properly; and that if he refuses, or if he makes it impossible for them to do their job, as he has done in the past, the international community will have to act.

I believe that faced with the information available to me, the UK Government has been right to support the demands that this issue be confronted and dealt with. We must ensure that he does not get to use the weapons he has, or get hold of the weapons he wants.

Blair's statements are assured and unambiguous in tone: 'established beyond doubt . . . continued to produce chemical and biological weapons . . . continues in his efforts to develop nuclear weapons.' There was nothing new in these specific assertions, as the government had been briefing them as part of its war strategy. But the revelation that 'his military planning allows for some of the WMD to be ready within 45 minutes of an order to use them' was new and alarming. As was a claim in the body of the dossier that Hussein's regime had been trying to source uranium in Africa, for which the only credible explanation was that he had a nuclear weapons programme. Britain's journalists joined the dots and the nation's news outlets ran the dramatic story that Hussein was a serious and current threat to the United Kingdom, who had developed nuclear weapons and could launch attacks on Britain in 45 minutes. It was a shocking revelation, and newspapers, television and radio programmes around the world repeated it endlessly. Not everyone, however, was convinced. On the day the briefing paper was released one British journalist dismissed it as a fabrication and described it as 'the dodgy dossier'.[4]

On 16 October Bush secured approval from Congress to go to war in Iraq, and in November he sought authority from the United Nations to use force to seize Hussein's WMD. It would later emerge that CIA and United States special forces units had, in fact, been on the ground in Iraq since July, but the United Nations Security Council rejected Bush's request to use force, instead adopting Resolution 1441 calling on Hussein to allow international weapons inspectors into Iraq or face 'serious consequences'.[5] The United States and Britain acknowledged that those words were insufficient to sanction military force, but Hussein – aware that the international spotlight was now shining directly on him and this was no longer a game of

brinkmanship – finally permitted weapons inspectors into Iraq to search for evidence of a WMD programme.

The task facing the inspectors was complex and challenging. Iraq is around 169,000 square miles in size – the same as Sweden – and everyone assumed that the facilities and traces of any WMD programme would be well concealed. At the end of January 2003, after several months on the ground, the inspectors reported back to the United Nations that, so far, they had found no evidence of anything indicating an Iraqi WMD programme. Bush meanwhile remained determined to use military force to find the WMD, and on 3 February Blair kept up the war momentum in Britain by issuing a second briefing document, a 19-page dossier entitled *Iraq – Its Infrastructure of Concealment, Deception and Intimidation.* The opening paragraph stated, 'This report draws upon a number of sources, including intelligence', and it went on to assert that Hussein's regime was carefully set up to be able to conceal its WMD programme.[6] However, Hans Blix, the United Nations' chief weapons inspector, soon reported back to the United Nations that his team of over 700 experts had conducted more than 300 surprise inspections of facilities across Iraq and found no evidence of a WMD programme.[7] Blix was, intentionally or not, causing people to question exactly what intelligence Bush and Blair were relying on.

By now it was clear to Bush that the United Nations would not deliver a route to military action without evidence from the weapons inspectors that WMD were present in Iraq, or serious obstruction by Hussein. But Bush was not prepared to wait, and therefore decided to try a different route, resuscitating two United Nations resolutions from the war his father, President George Bush Senior, had won against Hussein in 1990 to 1991. Taken together, Bush argued, Resolutions 678 and 687 authorised 'such further steps as may be required' to enforce the peace settlement, which included the destruction of all WMDs in Iraq.[8] These resolutions, he asserted, gave him all the authority for war he needed.

Bush's allies – including Britain – agreed with this reasoning, and decided that they could act independently of the United Nations inspection process. Accordingly, they met in the Azores on 16 March to coordinate strategy. The following day, in a televised ultimatum from the Cross Hall in the White House, Bush announced to the world that 'Intelligence gathered by this and other governments leaves no doubt that the Iraq regime continues to possess and conceal some of the most lethal weapons ever devised . . . The regime has a history of reckless aggression in the Middle East. It has a deep

hatred of America and our friends. And it has aided, trained and harbored terrorists, including operatives of al Qa'eda.' Bush gave Hussein and his sons 48 hours to leave Iraq, or face military action.[9]

In No. 10 Downing Street Blair knew he could take the country to war under the royal prerogative without approval from Parliament. But he was aware it was a controversial conflict, and chose to give Parliament a debate and a vote, saying he would resign if he lost. Relying on the assurances he had given to Parliament verbally and in the two dossiers that Hussein had WMDs, the vote passed by 412 votes to 149, the Liberal Democrats, Plaid Cymru, the Scottish National Party, a quarter of Labour and one Conservative voting against it.

The war officially began on 19 March 2003. Forty-six thousand British troops were deployed alongside United States and other forces in Operation Telic, and major combat activities ended just over a month later, on 1 May, with the complete collapse of the Iraqi regime. Hussein was captured, tried for crimes against humanity and hanged. The destruction of the country's infrastructure was so extensive that, when the dust settled, it became apparent coalition forces would need to stay in Iraq to stabilise the country and help to rebuild it. As a result, Britain only finally pulled out in 2011. In all, Telic claimed the lives of 179 British servicemen and women. Iraqi deaths are not known for certain, although one estimate puts the toll at 654,965 combatants and civilians in the initial period from 2003 to 2006.[10]

Once Hussein's regime was toppled, coalition forces conducted thorough search operations throughout Iraq, combing it for evidence of a WMD programme, but they found nothing. In Britain, an angry Parliament and public demanded explanations, particularly for how Blair's two dossiers could have been so wrong. This was not what Blair had been hoping for, and the mood became even more tense when BBC Radio 4's *Today* programme broadcast a piece by the journalist Andrew Gilligan in which he said he had information that No. 10 Downing Street had 'sexed up' the September dossier against the wishes of Britain's intelligence services, which did not support all the dossier's claims, including the one that Iraq had missiles capable of being loaded with WMD and airborne in 45 minutes. Gilligan's story caused a furore, as did his subsequent claim that Blair's Director of Communications and Strategy, Alastair Campbell, had inserted the 45-minute claim, along with others, to make the case for war more compelling from a PR perspective.[11]

To address the mounting accusations that Blair had misled Parliament and the country, the government launched a number of inquiries. They

reached a variety of conclusions, some of which exonerated Blair and Campbell. But the suicide of Gilligan's main source – Dr David Kelly, a Ministry of Defence weapons inspector – only increased a sense across the country that it had all been a murky affair; and this was not helped when Blair's former flatmate, Lord Falconer, the Lord Chancellor, intervened to stop the coroner's inquest into Kelly's death by putting it in the hands of a government inquiry.

When Blair first walked into Downing Street in 1997, millions of voters had seen him as a fresh hope for the new millennium. Just six years later, after Iraq and the dodgy dossiers, much of that hope had turned to anger. Blair noted candidly in his autobiography that 'politicians are obliged from time to time to conceal the full truth, to bend it and even distort it, where the interests of the bigger strategic goal demand that it be done'.[12] Whether or not his invasion of Iraq was one of these occasions is not spelled out, but his support for Bush's Iraq War – which destroyed the country and built a recruiting ground for Islamist extremism that would eventually give rise to Da'esh – would become his bitter, defining legacy. As early as June 2003, just three months after the war ended, *The Economist* ran a prescient article with the headline 'Bliar? Why the Row over Weapons of Mass Destruction is so Dangerous for Tony Blair', observing that his personal approval rating had fallen from plus 60 when he took office to minus 18.[13] It turned out to be right. Blair's premiership was wrecked and, even though he stayed on for another four years, his style of government transformed from open and engaging, youthful and energetic, to closed, brisk and defensive, as he tried semi-permanently to deflect allegations of dishonesty that simply refused to go away.

At the general election in 2005 Blair's majority was slashed to 65, down from the 178 he had gained in 1997 and the 166 in 2001.[14] Under the terms of the Blair–Brown Granita pact, he should have handed over the keys of No. 10 Downing Street to Brown in 2001 after winning his second term, in which case Britain might never have gone to war in Iraq. However, Blair maintained that the understanding with Brown was not clear cut and, in any event, a growing rift between the two had become public in 1997 almost as soon as they moved into No. 10 and No. 11 Downing Street, each camp briefing the media regularly and acrimoniously against the other. In the end, Blair stayed on as Prime Minister until June 2007, then resigned.

Alone among twentieth-century politicians, Margaret Thatcher and Tony Blair each won three general elections and were their parties' most successful leaders of the century. And yet both became liabilities, remembered less

than kindly by large swathes of the country and sections of their own parties. After Thatcher, few could have predicted that another Prime Minister would, so soon, leave an equally, or perhaps more, divisive legacy. Cool Britannia was definitely over. As a metaphor for the closing of the Blair chapter, a skull encrusted by Damien Hirst with £14 million worth of diamonds failed to find a buyer on the open market. The glamour and easy money of 1990s Britain was over, and barely had Brown got his feet under the desk in Number 10 before Hirst's diamond-studded white elephant was dwarfed by a financial crisis that threatened a global meltdown.

It began obscurely enough in August, when the Eurozone's second biggest bank, BNP Paribas, froze three investment funds holding $2.2 billion, closing them to any investments or redemptions. Its explanation was opaque and instantly forgettable: 'The complete evaporation of liquidity in certain market segments of the U.S. securitization market has made it impossible to value certain assets fairly, regardless of their quality or credit rating.' Translated into ordinary language, the meaning was ominous. BNP was saying that the funds had turned to junk, and the quality scores they carried from independent rating agencies were not worth the paper they were written on.[15] In effect, $2.2 billion had evaporated.

Although the closure of the funds was the first to be acted on by a central bank, BNP was not the first to experience the specific problem that destroyed their funds. The American investment bank Bear Stearns had $1.6 billion of its funds collapse in July.[16] The names of the two funds – High-Grade Structured Credit Fund and High-Grade Structured Credit Enhanced Leverage Fund – meant little to people outside the world of finance, although even non-specialists got the idea that a lot of financial engineering had gone into them. That engineering would turn out to be one half of the problem. The other was that they were based on United States mortgages that ranked 'subprime', less euphemistically called junk.

In the United States, eager lenders had offered mortgages to borrowers who would be unable to afford the repayments if the value of their homes and share portfolios did not continue to rise. As interest rates were low, sophisticated investors wanted opportunities that paid higher returns than cash, so mathematically minded bankers bundled large quantities of these subprime mortgages together to create pooled instruments called collateralised debt obligations, which paid a regular coupon higher than interest rates. Bankers then began slicing these mortgage-backed securities, combining them with others from different areas of the United States to diversify them, adding in small

amounts of better-quality debt, and reselling them in a variety of tranches with different yields and risk profiles, all of which could be made even more attractive to investors by taking out insurance against defaults by hedging them with credit default swaps. While the bankers claimed that all these measures meant they had structured out most of the subprime risk, the opposite was true: the investments were interlinked, toxically concentrated risk.

Banks trade with each other daily to manage liquidity and generate profits, and they sell each other, and their clients, vast numbers of highly complex structured products and derivatives like swaps, options and futures. This creates, in effect, a seamlessly interconnected system of instruments. It therefore did not take long for the entire financial system to be carrying exposure to subprime United States mortgage securities. When homeowners in the United States began defaulting on the mortgages in the slump of 2006, the global pyramid of debt started collapsing, and banks like Bear Stearns and BNP Paribas saw value evaporate from their mortgage-linked funds, some of which also used high leverage, borrowed capital, which fatally amplified the losses. Because the instruments are valued on a 'mark-to-market' basis – in other words, their most recent sale price – they had to record them as worthless, which immediately tore huge holes in the asset side of their balance sheets.

As news of the collapse of investments linked to subprime United States mortgages spread through the markets, banks and investors around the world examined their own portfolios critically, and realised that a significant number of them were ultimately linked, and also now junk. Confidence plummeted, money flows dwindled to a trickle, and the system of borrowing and lending began to seize up. What had started as a subprime mortgage crisis had become a banking crisis and, when the banks stopped lending to ordinary businesses, it became a general credit crisis that threatened to bring the world of money to a standstill.

In Britain the first serious casualty was Northern Rock, a small bank with its headquarters in Newcastle upon Tyne. It sold portfolios of its own mortgages abroad, but when the bottom fell out of the pooled mortgage market it ran out of money in September 2007, forcing the Bank of England to intervene and bail it out.[17] But it was too little too late. Now they knew the bank was vulnerable, Northern Rock's customers began queuing up to withdraw their money. Because the rules on fractional reserve banking mean that no modern bank holds anything like enough cash to repay all its savers at once, the government was forced to nationalise it in February 2008 to prevent it collapsing.

In the United States similar shock waves were spreading through the banking system, but on an altogether more dramatic scale. The government-backed mortgage pooling companies Fannie Mae and Freddie Mac had to be bailed out in early September 2008, before the world looked on, paralysed, as a Wall Street titan teetered towards the edge. Lehman Brothers was a shining incarnation of the American dream, having started in Montgomery, Alabama, as a dry goods store run by three brothers from Rimpar in Bavaria, before expanding its business activities into cotton trading, brokerage, and finally banking. In 2004 Gordon Brown had opened its London office in Canary Wharf noting that he 'would like to pay tribute to the contribution you and your company make to the prosperity of Britain'.[18] However, on 15 September 2008, the United States government resolutely stood aside while Lehman Brothers collapsed, to the horror of observers around the world who had assumed Washington would never let a linchpin of Wall Street fail.[19]

The collapse of Lehman Brothers instantly hit confidence in all banks worldwide, requiring governments to pump enormous sums of money in to recapitalise them. In doing this governments were not fixing the problem, merely keeping the system moving, like pouring water into a bucket with a hole to keep it full. The extra money was, though, too late to stop the contagion spreading throughout the global economy. Regional and sector crises erupted across the world, causing the most severe slump since the Great Depression. Few institutions remained untouched. In August 2009 even the United States government lost its triple-A credit rating.

The City of London was, along with New York, the centre of world finance, and Britain was hit hard, forcing Brown to announce a £500 billion bailout for the country's banks, £37 billion of it being pumped directly into the Royal Bank of Scotland and Halifax Bank of Scotland-Lloyds TSB to semi-nationalise them and stave off their imminent collapse.[20] Brown had always prided himself on his financial prudence, and the crisis gave him an opportunity to show international leadership, which he did by spearheading the call to recapitalise the world's banks. If he had not, another leader would have stepped up, but it was Brown, and he will go down in history for being the leader who acted decisively – with understanding of the complex problems – to prevent the crisis from becoming a total global meltdown. Ultimately, however, the disaster dominated his period in office and, when the general election came in May 2010, he lost power, resigned, and handed the government over to a Conservative–Liberal Democrat coalition.

It was the end of the longest period of non-Conservative rule since the defeat of the Whig Duke of Newcastle in 1762.

Blair watched Brown's tenure at No. 10 from the sidelines, and publicly declared that New Labour died when Brown took over.[21] That was not true. Despite their natural animosity – Blair and Brown were a partnership, and the achievements and failures of New Labour belonged to both, as did the legacy of spin and the wreckage of the Iraq War. Although Blair is pilloried as Bliar, the reputation for problems with integrity touched others in his administration. Along with Blair, Brown and Campbell, the fourth architect of New Labour was Peter Mandelson, whose grandfather had been a member of Ramsay Macdonald's Labour cabinet between the wars. Mandelson was Labour's first acknowledged spin doctor under Neil Kinnock – a role for which he was nicknamed 'the Prince of Darkness' – and he was instrumental in defining New Labour's brand and strategy. However, once in office, he was forced to resign from the cabinet twice: in 1998 for failing to declare a £373,000 loan he took from another cabinet member whose business affairs his department was investigating, and in 2001 for not being entirely candid during an inquiry into whether he had pulled strings to obtain a passport for a wealthy donor. For all its electoral success, the complex personalities at the heart of New Labour eventually brought it down.

When New Labour finally bowed out, Cool Britannia was in tatters, as was Labour's love affair with Blair's 'third way' politics, which had no historic roots in the party. Instead, Labour dropped the 'New' and moved to the left, losing another three straight elections. Not without irony, just as one of Thatcher's legacies had been to pull New Labour to the right of traditional Labour, one of New Labour's legacies was to see David Cameron's Conservatives adopt Blair's centrism, social agenda and slick PR. And, fundamentally, Cameron continued Blair's policy of positioning Britain as the United States' bridge into Europe, building a strong British brand in the European Union. Although this was not a controversial stance in the political centre ground, it was not widely supported by the Eurosceptics in either party, and Cameron was as aware as anyone that bitter divisions over Europe had been key to the downfall of both Margaret Thatcher and John Major. He was about to find out that they could claim yet more Prime Ministers.

Island Fever – The Perennial Europe Conundrum

HM Government
'Brexit' Referendum Ballot Paper
2016

'Take Back Control' was the punchy slogan of the cross-party group leading the official 2016 campaign for Britain to leave the European Union. The words were well chosen. Not only for their political immediacy and effectiveness, but also – probably unintentionally – as a meditation on Britain's historic links to Europe. The first word is Old Norse, the second Germanic and the third French. All three arrived with medieval invasion armies, and the fact the United Kingdom was to leave the EU on an etymologically euroglot slogan is a vibrant example of the depth of the intertwined ties between British and European culture. The pre-Anglo-Saxon version of the slogan might be '*Ail-hawlio ein tir*'. As with everything related to Brexit, this leads to yet another connection and conundrum, in that native Welsh speakers – whose forebears were the original victims of European invaders in the age of Arthur – voted Remain, while English settlers in Wales, largely retired and living in the marches, swung the country's overall vote to Leave.[1] As in all things Brexit, every issue seems to lead to another in a perpetual game of Whack-A-Mole.

It is too soon to write the history of Brexit. The effects are not yet visible, as the labyrinthine process of decoupling political, legal and institutional

ties with the EU will not be complete for years, and nor will the programme of creating uniquely British laws and structures to replace them. In addition, the spectrum of causes and motivations impelling both sides of the campaign has yet to be methodically mapped out to reach a more nuanced understanding than has so far been offered by political commentators feeding a 24-hour news cycle. In time, research will be done, and official papers, political memoirs and the reflections of voters will all provide more insights. Nevertheless, despite these limitations, it is possible to trace the history of how Britain came to be holding a referendum into its relationship with the EU, and which themes emerged.

The Prime Minister of the 2010 to 2015 Conservative–Liberal Democrat coalition, David Cameron, made a manifesto pledge that, if the Conservatives won the next election, he would renegotiate the terms of Britain's membership of the EU then hold an 'in/out' referendum. After securing a majority of just 11 seats in the 2015 general election, Cameron duly brought referendum legislation before Parliament, and it passed by 544 votes to 53 with the support of Labour and the Liberal Democrats.[2] Campaigning was passionate and at time aggressive on both sides, and feelings ran high across Britain. The vote was held on 23 June 2016 and, when the result came in, the final tally shocked all sides.[3]

During the campaign and its aftermath many were surprised by the strong polarity of views, especially since for the 43 years since Britain joined Europe there had been barely any coverage in the British media of the work of British MEPs or European Parliament debates in which they had participated. In Westminster, on the other hand, there had been well-publicised tensions from the start in 1946, when Winston Churchill – no longer in Downing Street and now leader of the Opposition – gave a speech at the University of Zurich. In it, he outlined his vision for preventing World War Three. 'I wish to speak about the tragedy of Europe,' he began, 'this noble continent, the home of all the great parent races of the western world, the foundation of Christian faith and ethics, the origin of most of the culture, arts, philosophy and science both of ancient and modern times. If Europe were once united in the sharing of its common inheritance there would be no limit to the happiness, prosperity and glory which its 300 million or 400 million people would enjoy.'

He went on to offer a remedy. Others had floated the idea, but Churchill was the first statesman to take it up and make it his own. The solution, he suggested, 'would as by a miracle transform the whole scene and would in a

few years make all Europe, or the greater part of it, as free and happy as Switzerland is today . . . We must build a kind of United States of Europe. In this way only will hundreds of millions of toilers be able to regain the simple joys and hopes which make life worth living.' However, to deliver this vision, other nations would have to assist. 'In this urgent work,' he continued, 'France and Germany must take the lead together. Great Britain, the British Commonwealth of Nations, mighty America – and, I trust, Soviet Russia, for then indeed all would be well – must be the friends and sponsors of the new Europe and must champion its right to live. Therefore I say to you "Let Europe arise!".'[4]

Churchill is widely honoured as the father of a united Europe. There are statues of him and buildings named after him in all the main cities of the EU's institutions. He argued that a United States of Europe was the surest route for the fractious continent to find peace after at least two millennia of war that had rarely paused. He was, though, explicitly clear that this new Europe would not include the United Kingdom, whose path he saw lying with America and its other present and former colonies. In this he was informed by a lifetime of imperialist views, and by being half-American. His was a Britain that was at the heart of an Anglo-Saxon sphere.

Europe did not take long to arise and unite in projects for peace, but the first stirrings were not what would become the EU, and Britain ignored Churchill by choosing to drive the initiative. In 1949 Britain and nine other European powers met at St James's Palace in London to found the Council of Europe for the protection of human rights. It went on to draw up the European Convention on Human Rights, with the British lawyer Sir David Maxwell-Fyfe MP – who had been a prosecutor at Nuremberg – overseeing the drafting. To enforce the convention, the Council created the European Court of Human Rights in Strasbourg, in which Britain has always been a leading light. The Council and the Court have no relationship to the EU, and Britain remains a member after Brexit, with convention laws directly enforceable in the courts of England and Wales since the Human Rights Act 1998.

What is today known as the EU has an entirely different pedigree. In 1952 six countries at the heart of western Europe – France, West Germany, Italy and the three Benelux nations – founded the European Coal and Steel Community to regulate heavy industry and prevent any country launching a major armaments programme. Six years later the same six countries founded a second community, the European Atomic Energy Community, to focus on creating a common market for nuclear power. And finally, that

same year, the six launched the European Economic Community, or EEC, whose remit was to deliver economic integration by building a customs union and a common market.

Britain initially chose not to be a member of these communities. But, by the turn of the decade, the Conservative Prime Minister, Harold Macmillan, was growing alarmed that Britain was missing out on Europe's increasing prosperity. Accordingly, in 1961 he lodged an application for Britain to join the EEC – which had emerged as the most important of the three communities – and the following year also requested to join the other two.[5] However, the application was rejected as President de Gaulle – ever hostile to Britain – exercised France's veto, as he did again in 1967 when Labour's Harold Wilson renewed the application. Once de Gaulle was gone, on 1 January 1973 Edward Heath's Conservative government finally signed Britain up to the three communities, or 'Common Market' as the British press dubbed them.

Although both Labour and Conservative governments had made applications to join the Common Market, not all MPs or voters were fans. Some had concerns over sovereignty and supranational obligations. On the left, there were also anxieties that the Common Market's economic rules would drive the price of food up for British workers, along with a general unease the scheme was a capitalist endeavour that would obstruct the road to socialism. Referendums were not part of British parliamentary tradition, and there had never been one as the Westminster system is built on representative democracy not direct democracy: voters elect MPs then leave decisions to Parliament. Heath therefore did not consult the voters directly on membership of the Common Market. Parliament was in favour 356 to 244, and that was sufficient.[6]

Harold Wilson's Labour was divided over the matter, and when he stood against Heath in the 1974 general election he hoped to hold his party together by pledging to renegotiate Britain's place in the Common Market and then put the matter to the voters in what would be the novelty of the country's first nationwide referendum. After defeating Heath, he set the referendum for 5 June 1975. Labour remained neutral with its MPs given a free vote. The Conservatives and Liberals campaigned to remain, as did both Wilson personally and the new leader of the Conservatives, Margaret Thatcher. When the result came in, 64.62 per cent of the electorate had turned out to vote, with a 67.23 per cent vote for Remain and a 32.77 per cent vote for Leave.[7] It was a two-to-one victory for Remain.

Thatcher came to power in 1979, and her combative approach to restoring Britain's international prestige after the decade of discontent soon

translated into robust dialogue with the Common Market. Thatcher became so known for her assertiveness at European summits that France's President François Mitterrand observed she had the mouth of Marilyn Monroe and the eyes of Caligula.[8] Her biggest achievement at these summits came in the summer of 1984, at the historic French royal chateau of Fontainebleau, where she negotiated a hefty rebate on the annual sums the United Kingdom paid the Common Market. Europe would, however, be her downfall. In the 1990s the European Commission's President, Jacques Delors, tabled proposals to give more power to the Common Market's political machinery. Thatcher summarised these proposals in the Commons, then ended with a flourish of 'No. No. No.' Her pro-European Deputy Prime Minister, Geoffrey Howe, resigned in protest several days later, prompting a crisis in which pro-Europeans in her party ousted her. The Conservatives were now openly at war over Europe, in a conflict that would lead to the 2016 Brexit referendum and ultimately take down more Prime Ministers.

Two years later, leading Common Market figures put forward a plan to create a limited but formal group of member states to be known as the European Union, with all their people becoming citizens of the European Union as well as of their own countries. It was the first major step towards a United States of Europe, and required member states to cooperate in numerous areas including defence and security. It also created a European central bank, and there were plans for a European currency. John Major signed up to these measures in the Maastricht Treaty, but with opt-outs for the United Kingdom on social policies and the proposed single currency.

Major's pro-EU stance antagonised his anti-European MPs – by now known as Eurosceptics – and, in a sign of their growing power, they toppled him. His replacement in 1997, William Hague, astutely saw the way the wind was blowing in his party. From 1997 to 2010, while the country was busy watching Blair, Brown and New Labour, Hague swung the Conservative Party firmly towards Euroscepticism in a bid to prevent the newly formed anti-EU party, the UK Independence Party (UKIP), from poaching Conservative voters. Meanwhile, the EU had been growing: from 6 countries in the 1950s to 9 in the 1970s, 12 in the 1980s, 15 in the 1990s, 27 in the noughties and 28 in the 2010s, changing the organisation's dynamics.

When the pro-European David Cameron became coalition Prime Minister in 2010, he avoided the Europe question, aware of its tendency to fracture his party's fragile unity. But as he looked forward to the 2015 election, he knew he needed to keep Conservative Eurosceptics onside. The

historic moment came after a NATO summit in May 2012 while Cameron was waiting for a flight home at Chicago's O'Hare airport with William Hague, the Foreign Secretary, and Ed Llewellyn, his Chief of Staff. Over slices of fast-food pizza, the three decided to buy the support of Eurosceptics and hopefully steal a march on UKIP by promising a referendum before the end of 2017.[9] The following year, on 23 January, Cameron announced this strategy in a speech at the London offices of financial media giant Bloomberg, pledging that if re-elected he would secure improved terms for Britain's membership of the EU, then offer the public an in/out referendum.[10] It was a carbon copy of Harold Wilson's election strategy for Labour in 1974 when he was facing similar rifts over Europe in his Party.

At the 2014 European Parliamentary elections UKIP beat the Conservatives into third place, making it even clearer to Cameron that he had to prioritise his referendum plan if he was to coax back UKIP voters.[11] He therefore included the referendum proposal in his 2015 general election manifesto, and won the election.[12] The referendum machinery was put in place, and the historic question for the electorate was published in the final section of the enabling legislation. With admirable brevity, the ballot paper simply asked voters to choose whether to remain a member of, or to leave, the European Union.

On 23 June 2016 voters up and down the country put a cross in one of the two boxes. When the results were in, they stunned poll predictors and much of the electorate. Exactly 72.21 per cent of those on the electoral roll had voted, some 25,903,194 people. Of them, 51.89 per cent had voted Leave, while 48.11 per cent had voted Remain. In national terms this equated to 26.5 and 24.7 per cent of the United Kingdom's overall population of 65,648,100 people, the difference between the two camps being a narrow 1.3 million.[13] As the unexpectedly close result sank in, commentators tried to understand what had happened. Whenever more voters were interviewed, it became clear that the idea of taking back control had resonated strongly in one or more of the three areas the Leave campaign had highlighted: sovereignty, money and immigration. Of these issues, the sovereignty question had been contentious from the start of Britain's membership of the Common Market.

Parliamentary sovereignty is a principle of constitutional law that says Parliament is supreme, can pass any law it wants, and can override any law it has previously passed. Because Parliament is all powerful, one of the things it can do is limit its powers for so long as it wants to. It has done this, for instance, in giving devolved powers to the Scottish, Welsh and Northern

SCHEDULE 4 Regulation 83

FORMS

Form 1 – Form of ballot paper
Front of ballot paper

Referendum on the United Kingdom's membership of the European Union
Vote only once by putting a cross ⊠ in the box next to your choice
Should the United Kingdom remain a member of the European Union or leave the European Union?
Remain a member of the European Union ▢
Leave the European Union ▢

Back of ballot paper

Number

[Other unique identifying mark]

Referendum on the United Kingdom's membership of the European Union

[insert voting area]

The European Union Referendum (Conduct) Regulations 2016

HM Government, 'Brexit' Referendum Ballot Paper (2016)

Irish assemblies, in subjecting itself to the European Convention on Human Rights, in giving away its powers as the highest court of appeal to the Supreme Court, and in a myriad other ways. However, it is always the case that, being all powerful, it can reverse any of these grants of power at any time, which is exactly what happened with Brexit. Parliament originally gave Europe powers in the European Communities Act 1972, then took them back again in the European Union (Withdrawal Agreement) Act 2020. Brexit has not therefore brought about the return of sovereignty. It has seen the recall of powers that successive governments had intentionally given to Europe for so long as it was Parliament's pleasure to do so. Technically, therefore, Parliament never

ceased being supreme or sovereign. It merely lent powers to Europe on a fully recallable and reversible basis.

The second major battleground in the Brexit campaign was over finance, and whether the cost of membership of the EU was a good use of British taxpayers' money. Accounting and statistics are a dark art. Political accounting and statistics even more so. The most recent available set of financial statements from the United Kingdom's Office for National Statistics and the European Commission are for 2018. They show that, for the year, the United Kingdom was required to pay the EU £20 billion. As in all years, this starting number was then discounted by the 'Fontainebleau abatement' negotiated by Thatcher, which brought the figure down to £15.5 billion. In addition, the EU owed the United Kingdom £4.5 billion for 'shared management programmes', £1.1 billion for the private sector, and other amounts for a variety of things. Once all these sums were netted off, in 2018 the United Kingdom paid the EU £7.8 billion.[14] Whether that is a big number is a matter of opinion. To give it context, overall government expenditure that year was £864.9 billion. The cost of EU membership was therefore 0.9 per cent of annual government spending. That year the government spent £145.8 billion on the National Health Service.[15] Had the £7.8 billion paid to the EU gone to the NHS, it would have increased the NHS's budget by 5 per cent.

The third and most complex of the referendum issues was immigration, which required responses from the electorate on the ways in which the population of Britain had changed. At the end of World War Two, the United Kingdom was a nation of what the census today categorises as White British. By the time of the Brexit referendum in 2016 Britain was a multicultural, multicoloured society. No one had ever really been asked in a vote how they felt about this, so the referendum offered an opportunity to explore the question.

As this book has shown, immigration into Britain is not a new phenomenon. In many ways it has defined Britain, from the original hominids who walked across Doggerland when Britain was still attached to the mainland, to the successive waves of continental hunter-gatherers and farmers, Romans, Anglo-Saxons, Vikings and Normans who settled. Many other groups have also arrived over the centuries. Among them, the Roma came in the 1500s, the East India Company brought Indians from the 1600s, and the Huguenots arrived later that century. Africans have made Britain their home since at least Roman times, and continued to do so in the Middle Ages. An African man is depicted in a row of thirteenth-century carved heads of the stonemasons who worked on Salisbury Cathedral. Some

Africans rose to positions of prestige and privilege. Henry VII and Henry VIII both paid John Blanke, an African trumpeter, for his services to the Crown, and he is depicted in Henry VIII's great Westminster Tournament Roll with his trumpet, from which are draped Henry's royal arms.[16]

What changed after World War Two was large-scale immigration from Africa, the Caribbean, Asia and elsewhere – primarily in the 14-year period from 1948 to 1962 – when Britain had one of the most relaxed immigration systems in the world. The process was not designed in recognition of the millions of colonial servicemen who had fought for Britain in the two wars, or even as a formal government policy for rebuilding Britain. In many ways it just happened.[17] By convention, everyone in the British Empire – and later the dominions and Commonwealth – was a direct subject of the British monarch with the right to settle anywhere in the monarch's realms. It was a classical empire model, inspired by the Roman Edict of Caracalla, which made anyone in the Roman Empire – including in Britain – a citizen of Rome. This was clearly articulated in 1954 by Henry Hopkinson, Conservative Minister for Colonial Affairs under Churchill, who announced in Parliament that 'any British subject from the Colonies is free to enter this country at any time as long as he can produce satisfactory evidence of his British status. That is not something we want to tamper with lightly. In a world in which restrictions on personal movement and immigration have increased we still take pride in the fact that a man can say *Civis Britannicus sum* [I am a British citizen] whatever his colour may be, and we take pride in the fact that he wants and can come to the Mother country.'[18]

The catalyst inspiring greater numbers to take up the offer to settle in Britain came in 1946 when, 3,500 miles from Westminster, the Canadian government passed a law that derailed the status quo, making Canadians British subjects by virtue of being Canadian citizens.[19] This change to the established convention was subtle, but raised a fear in London that other Commonwealth countries could adopt their own rules and definitions. Accordingly, Westminster passed the British Nationality Act 1948, which among other things reaffirmed the traditional right of all British subjects – around 700 million worldwide – to settle in Britain.[20] It was not thought it would affect immigration patterns, but it turned out to be the impetus for the arrival of hundreds of thousands from across the Commonwealth, notably Nigeria, Kenya, Ghana, South Africa, the Caribbean. India, Pakistan, Bangladesh and Hong Kong. Faced with these unexpected levels of immigration, successive Labour and Conservative governments became paralysed

with indecision. Many MPs were still wedded to the idea of free movement of people around the Commonwealth, especially the 'Old Commonwealth' of the United Kingdom, Australia, Canada and New Zealand, which were viewed in some circles as a type of Greater Britain.[21] While encouraging and supporting free movement around this Old Commonwealth, no government wanted to restrict immigration from other parts of the Commonwealth lest it be interpreted as racism.

Eventually, two acts of Parliament imposed tighter restrictions. In 1962 Harold Macmillan passed the Commonwealth Immigrants Act, requiring any new immigrant to show a government employment voucher at the border. Six years later, in Kenya, Jomo Kenyatta's 'Africanisation' policy that drove Asians out of the country led to a panic in Harold Wilson's Labour government that some 200,000 of them might head for Britain as they had already been granted British citizenship and promised they could come. In response Wilson rushed through legislation in three days to ban the Kenyan Asians from settling in Britain, and their aircraft were refused entry into British airspace. At the time Parliament and the country were split over whether it was a shameful and racist betrayal or a sensible response to a crisis.[22] Whatever the analysis, the period of large-scale immigration was over, and subsequent legislation in 1971 and 1981 imposed more stringent requirements of patriality on Commonwealth immigration.

As the 'asylum of nations', Britain has always let in migrants, and its membership of the EU in 1973 gave citizens of EU member states the right to work and settle in Britain too. The combination of this and Commonwealth immigration meant that, by the 2016 Brexit referendum, British society looked very different to the way it had in 1945. Figures from the time of the referendum show there were 3.5 million EU migrants in Britain along with 5.6 million non-EU migrants, together equalling 13.9 per cent of the population. In a far more unsavoury debate, the presence of these migrants also gave rise to questions about race and culture. The last nationwide census had been in 2011, and it revealed that 19.5 per cent of people in England and Wales identified as something other than White British.[23] The most mixed city of all was London, where White British made up 44.9 per cent, Asian 18 per cent, White Other 14.9 per cent, Black 13.3 per cent, Mixed 5 per cent and Other 3.4 per cent.[24] The fatal shooting and stabbing of Jo Cox MP by an extremist racist during the referendum campaign was a reminder of the ugliness of the racist passions that were being roused by aspects of the immigration, race and culture debate.

Away from the campaign issues, an unexpected aspect of the referendum was the role played by social media, which was deployed in ways that had never been seen before in national votes. Psychographic targeting firms Cambridge Analytica and AggregateIQ were engaged by the Leave campaign to identify the social media accounts of people thought potentially receptive to their messages. AggregateIQ was paid £3.5 million, almost half of Vote Leave's campaign budget, and in 2018 Vote Leave was fined £61,000 by the Electoral Commission for non-cooperation during an investigation into its dealings with BeLeave, an unregistered Leave campaign group that also funded AggregateIQ.[25] Separately, there may or may not additionally have been Russian social media involvement. In the United States the 2019 Mueller Report found that Russia had worked actively in the cyber sphere to promote Donald Trump's election in 2016.[26] In Britain, while Parliament's Intelligence and Security Committee has announced that Russia conducts sophisticated hostile cyber activities against and in the United Kingdom, its 2020 report on these activities noted that the government and intelligence agencies had not examined whether Russia played any cyber role in the Brexit referendum campaigns.[27]

The social and economic contours of post-Brexit Britain have yet to be defined, but the United Kingdom will have to find its place in a world that is very different to that of the 1970s when it joined the European project. Then there was consensus in the first world on the value of liberal democracy and international cooperation. By contrast, the post-Brexit world is increasingly one of nationalism, isolationism and populism, with Britain's oldest daughter across the Atlantic losing influence globally, and the age of China dawning. Assumptions about the global world order are changing fast.

In addition to the seismic geopolitical shifts now occurring, post-Brexit Britain will also have to see if it can address the plain fact that Britain – uniquely among its neighbours – has struggled since World War Two to develop a national understanding of its relationship to its continent. As the third most populous country in Europe after Russia and Germany, Britain is *de facto* a major component of Europe, but it has been divided and paralysed for seven decades over the role it wants to play on the continent and in the world. The nation has taken back control, but it remains to be seen whether it can develop a clear consensus on what to do with it.

Wunderkammern – Collecting Britain's Past

Pheidias
The Parthenon Sculptures
438 BC/2020

At 5 a.m. on Thursday 11 June 2020, a diver deep in the black waters of Bristol City Docks located a submerged bronze statue. He secured it with a strap before an overhead winch began the delicate process of raising it from the harbour floor. Once on dry land, the effigy was quietly loaded into a van and driven to an undisclosed location. There, conservators washed the mud off the figure of Edward Colston MP, 1636 to 1721, but left the blue and red graffiti daubed on the metal, along with the ropes binding the statue's ankles and body. Apart from a missing section of tailcoat, a lost walking stick, a hole in its side, and scuff marks where the monument had been rolled through the streets to the quayside at St Augustine's Reach, the statue was in remarkably good condition considering all that had happened.[1]

The story of how Colston's statue ended up in the River Avon reveals a number of things about Britishness today. One is that the anger of the protestors who heaved the statue into the harbour four days earlier – and the others who spray-painted Churchill's statue in Whitehall with 'RACIST' that same week – leaves no doubt that passion for the past is alive, and that some aspects of it evoke viscerally strong emotions. Another is that while some in the country regretted the vandalism to Colston's statue, there were

few who, on reflection, thought the effigy was appropriate in a twenty-first century public space. Britain no longer wants to identify with or celebrate racists and slave traders with civic honours.

Identity – the fact of being who or what a person or thing is – like history, has connections, shades and facets that are susceptible to multiple interpretations. In the case of a country's identity there is the additional complexity of change down the centuries and different understandings over time. Nowhere is this better seen than in a monumental 18.5-acre Greek temple in Bloomsbury, whose pediment high above the portico of double columns features a series of sculptures by Sir Richard Westmacott. They illustrate *The Progress of Civilisation*, depicting humanity being born of a rock, then greeted by the angel of religion before starting life as a hunter and farmer. A long process of education follows in the guise of allegorical figures of architecture, sculpture, painting, science-astronomy, mathematics-geometry, drama, music and poetry, before humanity is finally educated and rests, reclining in a garden with an elephant and lion, gazing at longevity in the form of a distant turtle.[2]

The institution's founder was Sir Hans Sloane, who also gave his name to nearby Sloane Square. His Ayrshire family had settled as planters in Ulster's County Down during the reign of King James i, where he was born in 1660, the year the monarchy was restored after Cromwell.[3] Aged 19 he made his way to London and, already captivated by the natural world, immersed himself in anatomy and chemistry, also spending long hours researching botany at the Chelsea Physic Garden and preparing medicines at the Apothecaries' Hall. After four years he moved to Paris for more studies, then took a doctorate at the University of Orange before heading to Montpellier for further research into anatomy, medicine and botany.

By May 1684 Sloane was back in London, where he set himself up as a doctor. His practice thrived and, after three years, he was engaged as personal physician to the Duke of Albemarle – son of General George Monck who had arranged the restoration of Charles ii – to accompany him to Jamaica, where Albemarle had been appointed Governor. Sloane sailed west with the duke, using his time on the voyage and once there to compile records and journals detailing the plants and animal life he found, but was unfortunately unable to save Albemarle from an early death brought on by stress and heavy drinking. Once back in England Sloane married a woman he had met in Jamaica – now a wealthy widow from her former husband's plantation revenues – and steadily grew in eminence, publishing books on the natural world whose subjects included the flora and fauna of Madeira, the Canary Islands,

Barbados, Jamaica and the other places he had visited. All the while he was becoming more eminent, eventually rising to be President of the College of Physicians, succeeding Sir Isaac Newton as President of the Royal Society, and receiving appointments as physician to Queen Anne and Kings George I and II. He was an early advocate of inoculations, developed his own range of remedies based on quinine, and devised a recipe for milk chocolate that Cadbury was still referring to in its marketing materials in the late 1800s. He was widely liked for his cheeriness and generosity with his time and money, offering a free clinic every morning for the poor, working at the Foundling Hospital, and refusing to take a salary for his appointment to Christ's Hospital in Newgate. Sloane was in every way an eminent scientist and successful physician. But his real passion lay elsewhere: in collecting.

The wealthy in Britain had always collected. In the thirteenth century Henry III even started a menagerie at the Tower of London with three lions, a polar bear and an African elephant. Private collections grew more systematic from the late 1500s, when natural philosophers began assembling *Wunderkammern*, wonder chambers, bringing together artworks, plants, animals and rarities. They became known in Britain as cabinets of curiosities – cabinets in the old sense of rooms – the largest and best-known being the Ark in Lambeth owned by the Tradescant family who had made their fortunes as gardeners to royalty and the aristocracy.[4] In 1659 they left the Ark to the experimental philosopher and antiquarian Elias Ashmole, who maintained and augmented it before donating the entire collection to the University of Oxford as the kernel of what would become the Ashmolean Museum.

Sloane began his own cabinet of curiosities with 800 largely unknown plant specimens he brought back from the West Indies, along with insects, corals, shells and minerals. He added to the collection enthusiastically all his life, expanding its range from natural history to a cornucopia of other areas, purchasing additional collections to extend it even further. After moving from Bloomsbury to the manor of Chelsea, his 'Museum', as he called it, grew so large that he had to acquire the property next door. Visitors flocked to it, including members of the royal family, philosophers, scientists, and well-known names of the age like Benjamin Franklin, Händel, Voltaire and a young Carl Linnaeus. Once inside they were awed by the treasure-trove of scientific and medical books and manuscripts, plants, shells, insects, fish, quadrupeds, precious stones, minerals, metals, and thousands of handmade objects including classical sculpture, watercolours by Dürer, Japanese prints, clothing and drums of the Iroquois and other American Indian peoples, and

precision scientific instruments like the oldest known English astrolabe, made around 1290 to 1300, engraved with the names of Saints Augustine, Dunstan and Edmund.[5]

When Sloane died in 1753 – just two years after Diderot's first Enlightenment encyclopaedia was published in France – his unparalleled collection amounted to over 80,000 'natural and artificial rarities', 40,000 books, and 32,000 coins and medals. He was keen it should all be preserved, so his will appointed 37 visitors to supervise 48 trustees to find a suitable home for the collection on condition the acquirer provide £20,000 to support his two daughters. The visitors and trustees were duly appointed and one of them, Horace Walpole, wrote to a friend to say how much fun it was looking after 'hippopotamuses, sharks with one ear, and spiders as big as geese! It is a rent charge to keep the foetuses in spirits!'[6] The trustees first offered the collection to the king, but George II had no inner life and waved it away. Undeterred, the trustees offered it to Parliament to acquire for the nation. After enquiries, MPs concluded that the collection was worth £80,000 to £100,000 – around £12 million in modern money – and purchased it, delighted with the bargain.

Parliament's decision was also influenced by the fact that acquiring Sloane's collection provided the opportunity to right a longstanding wrong. Half a century earlier MPs had acquired the most important library in the country – far more significant than the king's – which included *Beowulf*, the *Lindisfarne Gospels*, multiple versions of the *Anglo-Saxon Chronicle*, two of the four surviving copies of the 1215 Charter of Runnymede (Magna Carta), around 1,400 other manuscripts, and 500 charters, rolls and seals, many of which were among the country's most significant documents. They had been assembled by Sir Robert Cotton MP, a barrister and leading light of the Elizabethan Society of Antiquaries before James I shut it down. After acquiring Cotton's library and establishing a trust to make it available to the nation, Parliament had done little with it, leaving the archive to languish in a temporary home at Ashburnham House in Westminster, where a fire in 1731 completely destroyed some manuscripts and severely damaged others.[7] Now it had Sloane's collection as well, Parliament took the opportunity to combine the two into one 'great repository' that would form the basis of an Enlightenment house of knowledge. To complete the project, it simultaneously acquired the country's other key collection of over 7,000 British and European manuscripts, 14,000 charters and 500 rolls that had been assembled by Edward Harley, Earl of Oxford and Mortimer.

To bring these wonders together, in 1753 Parliament passed 'An Act for the

Purchase of the Museum, or Collection of Sir Hans Sloane, and of the Harleian Collection of Manuscripts; and for providing One General Repository for the better Reception and more convenient use of the Cottonian Library, and of the Additions thereto', stipulating that the new repository was to be made freely accessible 'to all studious and curious Persons', and that the trustees of this repository should forever bear the legal name 'The Trustees of the British Museum'.[8] To raise the funds to make the project a reality, Parliament organised a £300,000 national lottery, of which £200,000 was to go back to the public in prizes, £40,000 was to set up the museum, £30,000 was to be invested in public funds to provide staff salaries and related expenses, £20,000 was to be given to Sloane's two daughters, and the remaining £10,000 was to go to Harley's widow and daughter. To house it all, the trustees looked first at Buckingham House in Westminster, but instead chose Montagu House in Bloomsbury, which they purchased for £10,000. Two years later George III bought Buckingham House for Queen Charlotte, after which it became known as the Queen's House, and eventually Buckingham Palace.

The new national museum – the first of its kind in the world – grew quickly. The French writer François de la Rochefoucauld visited in 1784 and noted with admiration the civic spirit with which the public donated to it.[9] Sloane's collection had comprised objects from all over the world, and the museum continued to add items that enhanced visitors' understanding of the planet, its life and its people. The mid-1700s to early 1800s was still the age of the Grand Tour and veneration of the classical world, so many of the museum's earliest acquisitions were antiquities, with a particular focus on objects from ancient Greece, which was fêted as the cradle of liberty and inspiration for Britain's democratic tradition.

Over time the museum's collections swelled ever further through donations, bequests, purchases, commissions, excavations and treasure trove. By the 1840s it had comprehensively outgrown Montagu House, which was demolished to make way for the current neo-Greek temple. But even this eventually became too small, so in 1881 the museum moved its entire life and earth sciences collections out to what is now the Natural History Museum in South Kensington. In the late twentieth century it again became too small and, in 1997, the museum relocated its books and manuscripts to the new British Library building in St Pancras. In an admirable achievement of continuity and non-modernisation, the manuscripts and books originally from the Cotton, Sloane and Harley collections still show their provenance by carrying these historic names in today's computerised catalogues. The

Cotton collection even continues to be categorised by the Roman emperors whose busts adorned the top of each of his original book presses. The *Owl and the Nightingale*, for example, is 'Cotton MS Caligula A IX', *Beowulf* is 'Cotton MS Vitellius A XV', and the *Lindisfarne Gospels* is 'Cotton MS Nero D IV'.

From its foundation, the British Museum was in a position to chronicle the history of Britain's involvement with colonies. When Sloane died in 1753 Britain's possessions lay to the west, in the Americas and Caribbean, but this first empire broke apart 30 years later when the 13 colonies gained their independence. Britain's second empire, to the east and south, in Asia, India and Africa, only really began to be established when Britain gained Singapore in 1819, Hong Kong after the opium wars in 1842, India in 1858 and Africa from the 1880s. Given all these overseas connections, the British Museum had a keen interest in expanding its collections to educate visitors about every corner of the world. The museum was, though, a child of the Enlightenment from long before the empire, and its collections have never been dominated by artefacts from imperial contexts. Today, two-thirds of the galleries display objects from countries outside the empire, including China, Greece, Iran, Italy, Japan, Mexico and Turkey. Its North Korean collection, for example – one of the most substantial in the world – has largely been purchased in the last few decades.

From the second half of the twentieth century there has been increasing interest in understanding the effects and impact, at home and abroad, of Europe's colonies and empires. The resulting debates are often impassioned and the British Museum is occasionally caught in the crossfire, described with words like 'imperial', 'colonial', 'shame', 'stolen' and 'plunder', and at times treated as a national embarrassment.[10] In fact, although there are inevitably some contentious holdings among the museum's eight million objects and the library's 170 million books, manuscripts, recordings and other items, these can be numbered on the fingers of one hand.

As this book has shown, all objects – including documents – inevitably tell more than one story, and this is especially true of any museum's contentious artefacts, which reveal details of their origins but also their journeys. The statue of Edward Colston – beaten, trampled upon, and pitched into Bristol Harbour – will reappear in a museum complete with ropes and graffiti, allowing visitors to ponder Colston's Britain, a place in which a man could be a slaver, a respected MP and a noted philanthropist. They will also be able to muse on early twenty-first-century Britain, in which protestors

were furious enough to rip Colston's effigy from its plinth and hurl it into the same Atlantic that so many of his inhumane slave ships plied and foundered in.

A clear example of how objects have multiple histories can be seen in the Museum's selection of the Benin Bronzes, which were taken in an imperial conflict whose circumstances reveal important context about nineteenth-century British and African power, politics, trade and religion. In 1897 James Phillips, Acting Consul General of the Southern Protectorate of Nigeria, rejected trade terms proposed by the *Oba*, or king, of Benin, and led a party of eight Englishmen and around 200 African porters to Benin for trade discussions. The *Oba* asked Phillips to delay while he completed a religious ceremony worshipping the head of his dead father, but Phillips ignored him and continued on. A strike force set out from Benin to intercept him, and it massacred all but two of the 200-plus in Phillips's party. In retaliation, Britain dispatched an army to sack Benin. According to a civilian surgeon who accompanied the troops, on entering Benin they found staked down male and female slaves who had been ritually slaughtered and, in the *Oba*'s compound, long altars with, 'running the whole breadth of each, beautiful idols . . . All of them . . . caked over with human blood . . . Fresh blood was dripping off the figures and altars.'[11] The British forces occupied Benin, and took down the sacrificial idols to weaken the monarchy's power over its people, to discourage further human sacrifice, and to be sold to cover the costs of the expedition.[12] As a direct result, today, the bronzes – in fact, largely cast brass – are scattered in collections around the world. Their story definitively begins in Benin but it ends internationally, and their full tale is only complete with the account of their seizure and the role they have played in the modern debate around empire and cultural property in many countries. Wherever in the world they are housed or displayed – now or in the future – all these elements will forever be part of their story.

The controversies surrounding the Benin Bronzes are fuelled by the imperial context in which they were acquired, assumptions about race and culture, and questions of heritage and justice. Less socially and historically complex, but equally contentious, is the Museum's collection of ancient Greek sculpture that once adorned the ancient Parthenon temple in Athens. They were not seized in imperial violence, but purchased by one man in singular circumstances. In 1800 Athens had been under Ottoman control for almost three and a half centuries. The British ambassador to Istanbul, a

young Scottish peer, the seventh Earl of Elgin, was an enthusiast of the Enlightenment with a passion for the classical world. On discovering that the Parthenon had lost half its original sculptures to Athenian Christian iconoclasm, war and time, and that the Ottoman military was now using the remainder for rifle target practice, for grinding down, and for snapping bits off to sell to tourists, he decided to borrow money to save them. After acquiring formal written permission from the Sublime Porte of the Ottoman Empire in Istanbul to take them to Britain, he spent several years personally paying for teams of specialists, labourers and ships to package up half of the remaining sculptures and bring them to London. Saddled with the debts of the operation – which included raising a ship that sank in order to recover its sculpture – Parliament bought them from him for half of what he paid, then gave them to the British Museum.[13] Bankrupt, Elgin went into exile in France and died. No one at the time – including Greece when it regained its independence a few decades later with the help of British volunteer soldiers – claimed Elgin had committed a crime, but today it is a common assertion. For instance, in 2018 Jeremy Corbyn said, 'As with anything stolen or taken from occupied or colonial possession – including artefacts looted from other countries in the past – we should be engaged in constructive talks with the Greek government about returning the sculptures.'[14] Objects move around the world and, one day, the Parthenon Sculptures – today spread around the world's museums – may all again be in Athens, but their story will always involve their creation, destruction, rescue and role in introducing millions of people to Greek sculpture, and arise in modern debates around cultural heritage.[15]

Museum and library collections cost money, and Hans Sloane's wealth – much of which he poured into his 'museum' – came partly from his wife's one-third share in her former husband's Jamaican sugar plantations. The nation has long known this, alongside the fact that much of the wealth circulating in the country from the sixteenth to nineteenth centuries was, in one way or another, connected with the trading of slaves and the exploitation of slave labour on the plantations in the New World. Institutions like the Bank of England, Lloyds of London, several universities and the brewery Greene King have all acknowledged profiting from the slave economy, and there can be few major institutions of the period that did not have some connection with slave money. The same is true of some well-known families and personalities. The records of compensation paid to slave owners on abolition include ancestors of Elizabeth Barrett Browning, David and

Samantha Cameron, Benedict Cumberbatch, William Gladstone, Graham Greene, Ainsley Harriott, George Orwell and Sir George Gilbert Scott among its list of 3,000 slave owners. Slavery, in fact, has a long history in Britain, and it was known in the Celtic, Roman and medieval periods. So much so that over the centuries the histories of slavery and Britain have become deeply intertwined. Even twenty-first-century taxpayers have a connection, as the cost of the abolition compensation – equivalent to £1.8 billion today – was originally borrowed by the British government from Nathan Rothschild and Moses Montefiore, and taxpayers only finished paying off the loan's interest in 2015.[16]

The document in this chapter is a photograph of the Parthenon Sculptures on display in the British Museum in 2020. It has been chosen because it summarises two important themes in the history of the identity of modern Britain. The first is that Britain has a past as an international nation. From the 1500s to the mid-twentieth century Britons travelled the globe, involving themselves in the destinies of other nations and in turn being affected by them. Had Elgin been a diplomat for a country that minded its own affairs it is unlikely he would have been in a position to ask the Ottomans for the sculptures, or that they would have granted his request. The sculptures are now in London because, at the turn of the nineteenth century, Britain was a major world power which had international influence. Seeing a photograph of the sculptures in Bloomsbury in 2020 is a reminder of the globetrotting history of Britain as much as it is of the history of classical sculpture, Greece or Turkey.

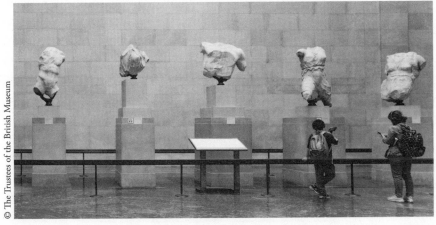

© The Trustees of the British Museum

Pheidias, The Parthenon Sculptures (438 BC/2020)

The second importance of the photograph is that it is a tangible illustration that identity – personal and national – operates on multiple levels. The breathtaking stone-made-flesh-and-fabric sculptures are not frozen in one time and place, but have had many lives. In Pheidias's workshop. On the Parthenon when it was a temple and a treasury. On the Church of the Parthenos Maria when Athens became Christian. On the mosque when the Ottomans made the Parthenon a place of Muslim worship. On a wrecked building inside a military base when the Ottomans used them for target practice. And finally in a room in Bloomsbury when Elgin brought some of them to Britain. They are simultaneously the Parthenon Sculptures and the Elgin Marbles and much else besides. These identities and pasts and present coexist in the sculptures, and their story is the aggregation of them all, as is the story of the nation's identity an aggregation of all that has gone before.

Britain inevitably has a history and identity that springs from its long and varied past, from the Celtic culture that Caesar found in the first century BC to the multiculturalism of the twenty-first century. Many cultures and influences have built Britain in every age and given it identity in each period. The British Museum and Library, and the other museums and libraries across England, Wales, Scotland and Ireland, are the time machines that reveal this complex web of connections within and beyond the islands' borders. These repositories hold items and writings related to every document and theme discussed in this book. Their collections touch each other and weave a lattice of connections that is replicated in wider society by the bonds between the nation's past and present. If anyone wants to understand British history and identity, the nation's great museums and libraries – with the Benin Bronzes and Elgin Marbles as much as the Wetwang woman charioteer's bones and jewellery, the Sutton Hoo warrior's lyre, the manuscript of *The Lark Ascending* and all the other treasures – are the places to start and finish the journey. More than cabinets of curiosities, they are the Wonder Chambers of the nation's past, present and future. And, when all is said and done, they are dazzling.

50

Sailing By! – The Waters of History BBC Radio 4

'The Ships'
2020

'. . . *Viking, North Utsire, South Utsire* . . .'

Anyone awake and tuned in to BBC Radio 4 in the still, small hours of the night will be familiar with the calm these words have the power to bring. The mind changes down a gear and pictures the waters off Norway, dotted with fishing boats bobbing on the black, moonlit swell as they chase shoals of herring and cod while the world sleeps. To listeners in a comfortable armchair or a warm bed it is the start of a mysterious, hypnotic and soothing liturgy, conjuring up a seascape of the ancient whale-road and dolphin-bath with shield-studded longships scudding through the stinging spray on their way to Britain to find glory or Valhalla.

For nearly a hundred years the BBC has broadcast 'the Ships', and it has become a national treasure. Its canon of lyrical place names is a poetic recitation, reminding those in the cities and villages, hills and forests, that the British Isles are girdled by seas. Its cadences verge on the liturgical and, in a sense, it is a liturgy. The repetitive words save souls with science, keeping seafarers from joining the 44,000 wrecks on the sea beds around Britain and Ireland.

As the broadcast continues, the mental longships arrive at the east coast of the British Isles – as they first did in the eighth century – in the waters off Scotland, Northumberland, Durham and Yorkshire.

'. . . *Forties, Cromarty, Forth, Tyne, Dogger . . .*'

The Ships is not only a hymn to the islands' seafaring heritage. It is also an immanation of the national cult of the weather. For a nation of farmers and sailors, Britain's mystifyingly unknowable weather that brings blight or blessing has always had the ability to focus the mind. This makes the Ships not only an internal meditation on island geography and maritime history, but also on what is happening in the clouds, providing a reassuring affirmation that fellow Britons, wherever they are on land or sea, have it somewhere both better and worse.

'. . . *Fisher, German Bight . . .*'

The voice of the continuity announcer then heads east to the Jutland Peninsula, where Denmark turns into Hanseatic Germany and, in World War One, Admiral Jellicoe pitted the Royal Navy's Grand Fleet against Admiral Scheer's Imperial High Seas Fleet in a clash of 250 battleships – many of them mighty dreadnoughts – in the largest naval encounter of the war, confirming Britain's domination of the North Sea.

'. . . *Humber, Thames, Dover, Wight, Portland, Plymouth . . .*'

The forecast then processes down the east coast of England, around the Isle of Thanet, and along the southern shores past Her Majesty's Naval Bases Portsmouth and Devonport. These are the historic home of the Royal Navy, the 'sons of the waves' in David Garrick's words from 1759: 'Heart of oak are our ships, heart of oak are our men'.[1] The waters here are a reminder that, for centuries, the Royal Navy was the world's foremost maritime force, projecting Britain's power across the globe from one side of the map to the other. 'Where wood floats,' Napoleon is reported to have reflected wistfully, 'there I find the English flag.'[2] From the time of the Cold War, historic Portsmouth and Devonport were supplemented by Gare Loch in western Scotland's Firth of Clyde as the home of Britain's nuclear submarine capability, but all that has changed. The Royal Navy has scaled back to suit a country which no longer has an empire. The principal vessels which now put to sea from Britain's shores are its fishing fleet – 6,036 vessels at the last count – commercial traffic, and pleasure craft.[3]

'. . . *Biscay, Trafalgar . . .*'

The voice in the warm, witching-hour Radio 4 studio now veers south into the vast Atlantic, across the rolling waters of the Bay of Biscay, down to Cape Trafalgar with the spice souks of Tangier on the horizon. These are the waters ruled by Spain and Portugal in Elizabeth I's day, where the great armada of 1588 was assembled to crush her and her fledgling Protestant

kingdom. Like the Greek sailor in the sixth century BC who first noted the existence of Albion in his periplus, the forecast then heads north from the Strait of Gibraltar, swinging wide into the Atlantic's open waters.

'. . . *FitzRoy* . . .'

The areas of water in the forecast have all, so far, been named after features: seas, sandbanks, islands, headlands, estuaries and towns. But now comes FitzRoy: the name of a sailor, scientist, father of the modern weather forecast and of the shipping forecast itself.

Vice-Admiral Robert FitzRoy was a direct male-line descendant of Charles II and Barbara Villiers. In 1828 he was given command of HMS *Beagle* in Montevideo when its captain shot himself, and he continued the ship's exploration of the coast of South America. Once home and ordered to undertake a second voyage, he suggested the expedition would benefit from a naturalist and geologist on board. His wish was granted, and when *Beagle* weighed anchor again it was with 22-year-old Charles Darwin among the ship's company, who used the voyage to conduct much of the research leading to *On the Origin of Species*.[4]

Once back in England FitzRoy was elected MP for County Durham, before being ordered to New Zealand as the colony's second Governor. There, he upset the establishment by supporting the Maoris' land rights against white settlers' territorial ambitions, and was dismissed after just two years. Returning home he was elected a fellow of the Royal Society, then appointed to the Board of Trade to head what would become the Meteorological Office. Keenly conscious of the weather's impact on mariners, he implemented a system for ships' captains to send him reports on meteorological conditions, which he used to compile detailed records of weather patterns in the world's waters.

Knowing that variations in atmospheric pressure and temperature could herald storms, FitzRoy designed and installed barometers at harbours around the country together with simple forecasting instructions. In the aftermath of a notably vicious storm in the North Sea which claimed 800 lives in 1859, he began transmitting explicit storm warnings to the Admiralty and to the country's ports.[5] For those already at sea, he instituted a system of drum and cone signals – lanterns at night – hoisted on headlands to give warning of impending treacherous weather.

FitzRoy was a weather evangelist and he sent his general predictions to *The Times*, which published them from 1 August 1861 replacing centuries of sham augury in almanacs with the first scientific weather forecasts.[6] The

debut read simply, 'General weather probably for the next two days in the – North – Moderate westerly wind; fine. West – Moderate south-westerly; fine. South – Fresh westerly; fine.'[7] FitzRoy even coined the term 'forecast' to describe his assessments, and their appearance in *The Times* became something of a sensation, eagerly pored over by everyone from day trippers to racecourse bookmakers. He entered gamely into correspondence in the letters page using the sobriquet 'the Clerk of the Weather' – a nickname *Punch* had given him – to explain that forecasts were 'expressions of probabilities – and not dogmatic predictions', apologising to 'those whose hats have been spoilt from umbrellas having been omitted'.[8] For serious students of meteorology he also set out his methods in a book, but the Board of Trade ordered him to stop forecasting and concentrate instead on collecting data.[9] Feeling that his work was misunderstood and unappreciated, he fell into a depression and slit his own throat.[10]

FitzRoy's forecasts were revived for shipping in 1867 and for the public in 1879. They were eventually transmitted as a radio broadcast by various authorities including the Air Ministry, before the BBC took them over in 1925. FitzRoy received little credit for any of it, until in 2002 Britain was asked to rename Finisterre – the area of water west of Biscay and north of Trafalgar – to avoid confusion with a different area of ocean the Spanish called by the same name. And so, 136 years after his death, FitzRoy, the father of the shipping forecast, became the only person named in it. There was, predictably, uproar in the British press at the change, but time has turned FitzRoy into a comfortably familiar name alongside all the others.

'. . . *Sole, Lundy, Fastnet, Irish Sea . . .*'

From the wide ocean of FitzRoy, the forecast heads back to Britain, to the waters of north Devon, Bristol and south Wales. Then to the southernmost point of Ireland at the wind-whipped Fastnet Rock eight miles off Country Cork where, until 1989, marooned lighthouse keepers kept a solitary vigil over the rough, featureless ocean. Then up the Irish Sea separating Ireland and England, notorious for its uncommonly rough waters. According to Irish legend, when Oliver Cromwell died, his body was found some distance from his grave three mornings in a row because the earth refused to take him, so his corpse was thrown into the Irish Sea, where the waters have been angry ever since.[11]

'. . . *Shannon, Rockall, Malin, South Hebrides, North Hebrides . . .*'

This leg of the forecast is the most scenic, up the wild and beautiful Atlantic west coast of Ireland and into the waters of the Hebrides. The haunting refrains of the Skye Boat Song can almost be heard through the

fog, immortalising Bonnie Prince Charlie's dash from Benbecula to Skye after the failed 1745 to 1746 Jacobite rising and the bloodbath at Culloden. As George II's net tightened, the young prince was put into the clothes of Bettie Burke, serving maid to Flora MacDonald, so he could slip unseen among the misty islands, then off to safety in France. The lexicographer and writer Samuel Johnson visited MacDonald on his 1773 trip to the Hebrides, and noted approvingly hers was 'a name that will be mentioned in history, and if courage and fidelity be virtues, mentioned with honour'.[12]

'. . . *Bailey, Fair Isle, Faeroes, Southeast Iceland . . .*'

Once north of Ireland and Britain, the forecast enters the North Sea again for the journey's final leg. First to the Orkneys – from the Old Norse *orkn*, seal – then to the distant Shetlands, whose annual Up Helly Aa fire festival is a reminder of neighbouring Viking, where the broadcast began. Finally, the journey swings westward, to the craggy, sheep- and puffin-covered Danish Faroe Islands, before coming to rest at the last port of call in Southeast Iceland. In a matter of minutes, the listener has been on a vivid tour of the British Isles, their geography, and their long and rich history.

The Ships is broadcast four times daily at 0048, 0520, 1201 and 1754, with the first including locations omitted from the shorter, daytime versions. For Friday 8 May 2020 the 0048 Ships was broadcast as follows.

And now here is the shipping forecast issued by the Met Office on behalf of the Maritime and Coastguard Agency at 0015 on Friday the eighth of May.

The first announcement after this introduction is always a warning of gales or storms. On some days they are blowing in a dozen or more places but, on 8 May, amazingly there were none. There is then a quick summary of pressure systems, their barometric reading, location and expected development.

The general synopsis at 1800. Low 350 miles west of South Shannon 998 expected 450 miles west of North Shannon 1006 by 1800 Friday.

After these preliminaries, the broadcast turns to the 31 area forecasts. For each it gives wind direction and speed, any expected changes, weather and visibility. The text is not permitted to be more than 350 words in length – or 380 for the 0048 broadcast – resulting in a hypnotic rhythm and mini-malist beauty.

The area forecast for the next 24 hours.

Viking – North Utsire – South Utsire
Westerly or southwesterly veering north westerly 3 to 5, becoming variable 2 to 4 later. Showers. Good.

Forties – Cromarty – Forth – Tyne – Dogger
West or southwest 2 to 4, occasionally 5 at first except in Cromarty, becoming variable later. Showers. Good, occasionally poor later.

Fisher – German Bight
West or southwest 3 to 5, becoming variable 2 to 4 later. Showers later. Good, occasionally poor later.

Humber – Thames
Variable 3 or less, increasing 4 at times. Fair. Moderate or good.

Dover – Wight – Portland – Plymouth
Variable 2 to 4, becoming east or northeast 3 to 5. Showers. Moderate or good, occasionally poor in Plymouth.

Biscay
Cyclonic 4 to 6, becoming variable 2 to 4. Thundery showers, fog patches. Moderate or good, occasionally very poor.

Trafalgar
Cyclonic 4 to 6 at first in east, and also later in west, otherwise northwesterly backing southwesterly 2 to 4. Thundery showers later. Good, occasionally poor later.

South East Fitzroy
Northerly or northeasterly 3 to 5, becoming variable 2 to 4. Thundery showers, fog patches. Moderate or good, occasionally very poor.

North West Fitzroy – Sole
Southerly backing easterly or south easterly 3 to 5. Rain or showers, fog patches. Moderate or good, occasionally very poor.

Lundy – Fastnet – Irish Sea
Variable 3 or less, increasing 4 at times but becoming southwesterly 5 for a time in northeast Irish Sea. Showers, fog patches. Moderate or good, occasionally very poor.

Shannon

South or southeast 3 to 5. Rain at times, fog patches. Moderate or good, occasionally very poor.

Rockall – Malin – South Hebrides

Variable mainly southerly 2 to 4. Rain at times, fog patches. Moderate or good, occasionally very poor.

North Hebrides – Bailey

Variable 2 to 4, becoming northeasterly 4 to 6 later. Occasional rain. Good, occasionally poor.

Fair Isle – Faeroes

West veering north west 3 to 5, becoming variable 2 for a time. Rain or showers. Moderate or good.

Southeast Iceland

Cyclonic 4 to 6, becoming northerly or northeasterly 5 to 7 later, perhaps gale 8 later. Rain then snow showers. Good, occasionally poor.

The descriptive terms used in the forecast have precise definitions, making decoding the broadcast an art form.

Wind	The compass point indicates where the wind is blowing from

The possible changes in direction are:

Veering	moving clockwise
Backing	moving anticlockwise
Cyclonic	change across the path of a depression

Wind speed is given on the Beaufort scale:

1–7	Given only as numbers
8	Gale 8
9	Severe gale 9
10	Storm 10
11	Violent storm 11
12	Hurricane force 12

Timings have precise meanings:

Imminent	within 6 hours
Soon	6–12 hours
Later	after 12 hours

Visibility There are four descriptions:

Very poor	less than 1,000 metres
Poor	1,000 metres to 2 nautical miles
Moderate	2 to 5 nautical miles
Good	5 or more nautical miles

The area forecasts are followed by reports from the coastal stations. These are anything from simple weather recording posts to light vessels or lighthouses.

Warning lights have been a feature of the British coastline for millennia. The oldest still standing is the East Pharos at Dover, originally erected by the Romans in their camp at Dubris, then converted into a belfry within medieval Dover Castle. The coastline has become no less treacherous over the centuries, and there are still over 350 working lighthouses and light-vessels around the British Isles warning sailors of danger.[13] The last keepers – at North Foreland in Kent – hung up their lanterns in 1998, and all light-houses are now automatic.

The coastal stations begin at Tiree Automatic, the most westerly point of the Inner Hebrides, and move clockwise around the British Isles, finishing back in Scotland with Machrihanish Automatic by the Mull of Kintyre overlooking the narrow waterway to Antrim in Ireland.

Tiree Automatic – Stornoway – Lerwick – Wick Automatic – Aberdeen – Leuchars – Boulmer – Bridlington – Sandettie Lightvessel Automatic – St Catherine's Point Automatic – Jersey – Channel Lightvessel Automatic – Milford Haven – Aberporth – Valley – Liverpool Crosby – Valentia – Ronaldsway – Malin Head – Machrihanish Automatic

As the continuity announcer reads the list, images come to mind of isolated communities like that living around Daphne du Maurier's Jamaica Inn in Cornwall, where wreckers lured ships onto lethal rocks to steal their

cargoes. Parliament passed a law against wrecking in 1737, decreeing that anyone who 'put out any false Light or Lights with Intention to bring any Ship or Vessel into Danger . . . shall be deemed guilty of Felony; and on being lawfully convicted thereof shall suffer Death'. There has only been one recorded conviction for wrecking – when the 80-ton *Charming Jenny* was driven aground in 1774 – but tales of wreckers luring shipments of tobacco and French brandy onto jagged rocks have remained a staple of coastal folklore, especially along the isolated shores of Devon and Cornwall.[14]

Finally, the shipping forecast reports on the weather for the inshore waters that wash the nation's beaches and coves. The list starts at Cape Wrath in Sutherland – the most northerly point on the mainland – and divides the coastline into 17 sections that journey gently clockwise around the British Isles:

Cape Wrath to Rattray Head including Orkney – Rattray Head to Berwick-upon-Tweed – Berwick-upon-Tweed to Whitby – Whitby to Gibraltar Point – Gibraltar Point to North Foreland – North Foreland to Selsey Bill – Selsey Bill to Lyme Regis – Lyme Regis to Land's End including the Isles of Scilly – Land's End to St David's Head including the Bristol Channel – St David's Head to Great Orme Head including St George's Channel – Great Orme Head to Mull of Galloway – Isle of Man – Lough Foyle to Carlingford Lough – Mull of Galloway to Mull of Kintyre including the Firth of Clyde and the North Channel – Mull of Kintyre to Ardnamurchan Point – Ardnamurchan Point to Cape Wrath – Shetland Isles

On 8 May 2020 the Ships closed with the following additional announcement:

And that completes the shipping bulletin.

We're reaching the end of our day's broadcasting here on BBC Radio 4. In a few moments we'll join the BBC World Service who will take us through the night before we return just after 5.30 in the morning with the shipping forecast and prayer for the day.

And then later in the morning at 11.00 to mark the 75th anniversary of the end of the Second World War in Europe we'll remember all those who gave their lives with a two-minute silence. And then at 9 o'clock in

the evening a special message to the nation from Her Majesty the Queen. It promises to be a day when we pause to remember the past.

Thank you very much for your company on Radio 4 through the evening. This is John Hammond in Broadcasting House in London wishing you, wherever you are, a safe and peaceful night.

Good night.

The National Anthem

And so, after 50 documents that tell the story of Britain's extraordinary history, the suggestion that the 75th anniversary of VE Day was a fitting time to reflect on the past is an ideal point at which to begin drawing the themes of this book together.

Afterword
Voices from the Future

Being an archipelago 20 miles off the coast of France, the British Isles are – as a statement of physical geography – part of the continent of Europe. They are also historically part of the family of European nations that inherited the cultures of Greece and Rome, transmitting them through the Middle Ages and Enlightenment to the modern world. Britain is, on both these measures, European. Yet even centuries before Brexit, there would have been those who disagreed. And that is the first point to note about British identity. It is complex, and excites strong opinions.

Britain's ambiguity on the question of its relationship with Europe has a long history. On the breakup of the Roman Empire, Britain retained the same *romanitas* as the rest of former Roman Europe, bound together by the rites of imperial Christianity. The two events that fundamentally changed this were the start of the Age of Discovery in 1492, and the arrival of the Protestant Reformation in 1517. These altered Britain's outlook profoundly, turning it away from Catholic Europe and towards its new, English-speaking, Protestant family, causing the Channel to grow into a cultural barrier far wider than its mere physical dimensions. In the wake of these events at the start of the Early Modern Age, Britain began to assume the imperial and maritime identity that is still at the heart of its perception of itself.

A nation is not, though, merely its political history. It is made up of people, and their achievements are also what give it identity. In Britain the

achievement that shines through almost every page of this book is that of sustained creativity. Other nations, of course, are creative. Britain is not unique. But it ranks among the countries whose people have been responsible for some of the most influential creativity of all time, in literature, poetry, art, music, philosophy, intellectual pursuits, technology, engineering, science, industry, and many other endeavours, with leading figures often household names worldwide.

One notable feature of this creativity is the degree to which it has come from the British being a nation of hobbyists. Numerous of the country's creative titans have spent their lives doing something else, with the skill they are remembered for being an activity they took up on the side, or stumbled across as a happy accident. Chaucer was a public official and diplomat. Caxton was a merchant. Baskerville was a japanner. Sloane was a physician. Ada Byron was a socialite. The writers of the *Wipers Times* were soldiers, Harry Beck was an electrical draughtsman, Berners-Lee was designing a telephone directory. There is a streak of the dilettante and amateur in many great British creations, which feeds into a more general British aversion to the earnest and the intellectual. Britain likes the accidental genius. For instance, it has had many philosophers – Bacon, Locke and Newton started the Enlightenment – but would never have a grand body of them in the way the French have the heavyweight eighteenth-century *philosophes*. Creativity permeates Britain's history, but it is often with a lightness and a quiet industriousness rather than a bold fanfare.

The next aspect of Britain that emerges in stark relief from the pages of this book is conflict. Ask people throughout history what their experience of the British is, and a substantial number will say that they met them at the point of a sword or the end of the barrel of a gun. As many chapters have shown, Britain has demonstrated an extraordinary capacity for conflict down the ages. When the Britons first emerge into history, it is with Caesar noting how warlike they are as they fight each other, and Rome, for power and territory. The Anglo-Saxon kingdoms of the Early Middle Ages did the same. The High and Late Middle Ages were similarly warrior cultures, with interminable warfare like the Anarchy, Hundred Years War and Wars of the Roses running almost seamlessly through the period. The wars of religion, the Thirty Years War, and civil and Cromwellian wars after the Reformation saw more hostilities, as did the Anglo-Dutch Wars, the campaigns of William of Orange, the Jacobites, Marlborough, the Seven Years War, the American Revolutionary War, Wellington, the empire, the two world wars, Korea, Ireland, Iraq One and Two, Afghanistan, and the others. British children

have long complained of all the dates and battles they are given in history lessons, but the reality is that down the centuries the British have done an immense amount of fighting. In telling the story of Britain in this book, it has been a surprise how many significant battles there simply was not space to include. And riding above it all, the nation's heroes – Arthur the unofficial patron saint of Britain, Ælfred the Great, Richard the Lionheart, Henry v, Drake, Cromwell, Wellington, Churchill – have all been military leaders.

It may not be a welcome thought, but behind all the conflict in Britain's history is an infrastructure of tribalism and antagonism that feeds it. Britain has always had tribes, and the need to belong to them seems sewn into many aspects of British life. All groups and societies function on those who are in and those who are out but, in Britain, this is institutionally ingrained and ritualised in the nation's core institutions to an unusual extent. Most parliaments and government chambers around the world make an architectural plea for unity with amphitheatres, but Britain still revels in its two neo-Gothic chambers of confrontation, with the political armies opposing each other, shouting and jabbing fingers. The law is equally adversarial, with hearings arranged as combats not inquiries. This culture of conflict is in fact ubiquitous. There are few countries where national sport is not a colourful and vibrant part of life but, in Britain, competitiveness and tribalism become so antagonistic that they periodically but predictably descend into an outlet for hardcore violence.

As much as many Britons like to see the nation as a place of the gentle countryside of Wordsworth and Vaughan Williams, the mother of parliaments, and a bastion of civilised values, Britain undoubtedly has another, more aggressive side. The Cromwell whose statue stands outside Parliament is the same who said he came to give the Irish 'blood to drink . . . even the dregs of the cup of the fury and the wrath of God, which will be poured out unto you'.[1] This book has steered a middle course through the culture wars, arguing for reasoned engagement with all history – accepting, acknowledging, confronting and challenging – but it cannot be too shocking to say that the time has come for Cromwell to be removed. He does not represent the values of modern Westminster democracy or the United Kingdom.

Happily, Cromwell's failed experiment with military dictatorship has not been repeated, and these days the military has no meaningful connections to Parliament. It guards neither Westminster nor No. 10 Downing Street, but its allegiance is sworn directly to the reigning monarch and her or his successors with no mention of Parliament in the military oath. It is the royal family – not politicians – who have military escorts and are the showcase

for, and the safeguarders of, the nation's deep military traditions. It is a very British separation of powers, and an ongoing demonstration that the lessons of Cromwell have been well learnt.

This survey of 50 documents has simultaneously traced the history of every age and, from the reign of Æthelstan in AD 927, also gives an account of the reign of every monarch. In the 950,000 years covered, Britain emerges from the shadows of the Stone, Bronze and Iron Ages, becoming a little more illuminated under the Romans, and then erupting in ever-brighter technicolour across the Early, High and Late Middle Ages, before it is in full 3D by the Early Modern Age, and HD by the dawn of the Modern Age. One of the most striking conclusions to emerge in hard relief after immersion in all these periods is that Britain has manifestly been many countries, peoples and ideas. And it has endlessly reinvented itself and stood for different things. It has comprehensively demonstrated that the Whig notion of linear progress from savagery to civilisation and ignorance to knowledge is palpable fiction. These characteristics all dance together down the centuries, leading each other in turn to the particular music of the age.

The book began with Churchill's funeral because it came at the start of Britain's modern identity crisis. In the decades since, Britain has lost touch with who and what it was, is, could or should be. The end of empire and rise of the United States as a superpower has led to a crisis of purpose, with Britain no longer the undisputed leader of the English-speaking world. As this reality set in during the 1960s and 1970s, the nation tried to build a future as part of the European project, but found itself something of a stranger: a family member who has been away too long and lost the bond of intimacy and the shared, familial language.

To fill the void, Britain has become accustomed to look back to the last moment it knew who it was, in World War Two, when it stood for freedom – alone in 1940 and 1941 – and young pilots of Fighter Command fought the nation's most glorious hours over the fields of England. This World War Two nostalgia has now become an identity industry. The 1939 'Keep Calm and Carry On' poster is more ubiquitous than red post boxes, and the Dunkirk and Blitz spirits are invoked by journalists daily for any act of stoicism. Striding across it all is Churchill, whose face is scattered across every gift shop and airport, and who is still strong enough electoral catnip for Boris Johnson to knock out a Churchill biography as part of his strategy to become leader of the Conservative Party.[2] But this obsession with World War Two brings serious problems.

The first is that, the way it is usually told, it airbrushes out the fact Britain was

not alone. The young heroes who wheeled around the blazing blue summer skies in Spitfires and Hurricanes during the Battle of Britain included 145 experienced Polish pilots, over 100 from each of Canada and New Zealand, over 80 Czechs, and a range of others from Ireland, India, Belgium and elsewhere. Our simplistic modern narratives readily obliterate the memory of the many contributions from other countries. Millions of men and women from all over the empire and dominions – white, brown and black – all fought and died for Britain in both world wars, and the price of empire for them was high. The second is that the country's World War Two fetish has become an albatross to progress, leaving the nation uncertain who it is now that Nazi boots are no longer thundering through Berlin, and Germany is a modern, liberal democracy with a larger GDP and fewer nationalist politicians than Britain.

Memories of empire are equally problematic, as evidenced by the current culture wars and the struggle for the way the centuries of colonialism are remembered. The often rancorous debate is, in effect, a part of reassessing the empire's role and relevance to modern Britain's identity. In stark terms, the argument pits those who advocate for the empire having had some positive effects against those who deem it an innately immoral and racist enterprise. It is sometimes not a subtle debate, but it is one that was always inevitable as Britain comes to terms with the tensions and inequalities developing in its modern multiculturalism. However, a major challenge with the way the sides are often positioned is that they can both lose sight of the individual experiences of empire, which differed profoundly across the centuries and the globe, from the savannahs of Africa to the financial skyscrapers of Hong Kong, and the royal pavilions of the Middle East to the salt- and spray-battered sheep stations of the South Atlantic. In these places, people lived very different empires. The realities and prospects for a black plantation slave in the eighteenth century West Indies compared to an Indian teenager at Eton in the dying days of the Raj were qualitatively different, although both would have been intimately familiar with the fact they were not white, not in their own country, and not able to determine their own destinies. The task of understanding empire and its impact on all the people it affected is only just beginning. But what is indisputable is that it continues to cast its shadow over modern Britain's perception of itself.

The defining moment of the last few years was undoubtedly the morning of 24 June 2016 when the country woke to the news that it was going to join Andorra, Iceland, Liechtenstein, Monaco, Norway, Russia, San Marino, Switzerland, Vatican City and a clutch of former Eastern bloc nations as the

only European countries not in the European Union. Although it was not articulated by the principal campaigners, what was visible to all observers was that, underneath the froth, the vote was pitting ideas of Britain's past identities against each other as much as visions of its future.

In whatever direction Brexit unfolds, it will not solve Britain's post-imperial identity crisis. The country's future will only come into clear focus once it stops searching for answers in the limited historical pool of the last 200 years, and broadens its vision to embrace the fact that Britain, over the millennia, has been many things, built by many peoples. As well as its modern 'British' culture, it has also had Celtic, Germanic, Scandinavian and Norman identities, and these have always been supplemented by sub-groups from all over the world. Britain has been endlessly reinvented, and history never repeats itself exactly, so the two things that can be said with absolute certainty are that white Britain and the empire, in its historic form, will not be coming back, and that until a clear, consensual vision for the future emerges, Britain will remain in a no-man's-land of identity uncertainty. Ultimately, to reconcile itself to a new identity, it will need to look all the way back into its past, then right the way up to the modern globalised world, and try afresh to understand its extraordinary history and the future it could build. This might lie in many directions. Britain has profound connections with the Celtic, Germanic, Scandinavian and French traditions in Europe, and – with the current move away from the EU and the decline in global influence of the United States, and Britain's special relationship with it in question – it is interesting to ponder whether the country might turn once more towards Scandinavia. But wherever it looks, Britain needs to recapture the passion it once felt for so many different ventures, systems and faiths, and channel that energy into a modern sense of itself, capitalising on its unique gift of the extraordinarily rich, mongrel English language to the planet as its *lingua franca*. If the country can wean itself off the morphine of empire and World War Two, adopt a realistic and honest view of its long past, take inspiration from its outstanding heritage of all those who have called the British Isles home, then a twenty-first century identity will emerge. It will, as it has done in the past, welcome a plurality of beliefs, be multicultural, multiracial, the asylum of nations, and focus on revelling in its unique history to again offer the world the extraordinary, fizzing creativity it has found in every century in so many fields. And then the forecast for Britain will be:

THE BRITISH ISLES
Variable 1 to 12. Rain at times, mainly sunny. Good becoming excellent later.

Appendix 1

The Many Names of Britain

The British Isles is an archipelago. The Ordnance Survey estimates the number of its islands at 5,000, of which around 200 are inhabited. The largest is Great Britain, home to the three countries of England, Wales and Scotland. Immediately west of Great Britain is Ireland, which is also one of the British Isles. The narrowest point between the two is just 12 miles of ocean separating Scotland's Mull of Kintyre and Ireland's County Antrim.

Until early last century all but one or two of the islands in this archipelago formed a conglomerate: the United Kingdom of Great Britain and Ireland, commonly abbreviated to the United Kingdom or the UK. Following the independence of the southern 26 counties of Ireland in 1922, the full name was altered to the United Kingdom of Great Britain and Northern Ireland. In ordinary speech the UK is, a little confusingly, also called Great Britain, or just Britain. To avoid being pedantic I follow the custom and use the terms interchangeably, with the context indicating whether I mean the British Isles, the UK or the geographic island of Great Britain.

Over the millennia Britain's countries, regions, counties and settlements have had a colourful variety of names in different languages. Using historically accurate names in a book like this would be distracting. So, despite raising complex issues of culture and identity, I mostly use modern place names for all periods of history. For instance, Ireland in the Roman period is Ireland not Hibernia. Cornwall in Anglo-Saxon times is Cornwall not Dumnonia. The same is true for the rest of the world. Istanbul in 1800 is Istanbul not Constantinople. This is technically nonsensical: 'Ireland', 'Cornwall' and 'Istanbul' did not exist at these dates, nor were there people who identified as Irish, Cornish or *Istanbullu*. However, it is a simple and clear system, and I hope readers will forgive these anachronisms for the sake of readability.

Appendix 2

A Note on the Changing English Alphabet

In the past, English was spelled with a few wonderful extra letters that are now obsolete. For quotations from original writings from around 1450 onwards this book uses the original letters to bring you closer to the way in which the people of Britain expressed themselves.

The changes in the English alphabet over time are explained throughout the book. However, if you need a quick reference, you can turn back to this page.

Letter	Sound	Old		Modern
Æ æ	a	Ælfred	=	Alfred
ſ	s	ſtone	=	stone
Ð ð	th	ðat	=	that
Þ þ	th	þe	=	the
Ƿ ƿ	w	ƿaſ	=	was
Ȝ ȝ	y or gh	ȝour	=	your
		knyȝt	=	knight

Spelling and punctuation were also more erratic in the past. Macbeth's famous speech from Act 5 Scene 5 of the first edition of Shakespeare's *The Tragedie of Macbeth* actually looks like this:

> Life's but a walking Shadow, a poore Player,
> That ſtruts and frets his houre vpon the Stage,
> And then is heard no more. It is a Tale
> Told by an Ideot, full of ſound and fury
> Signfying nothing.

As with the alphabet, all documents in this book from around 1450 onwards use the original spelling and punctuation to give an authentic sense of what it was like to read these texts at the time.

Ages

Stone Age	
– Palaeolithic	950,000–10,000 BC
– Mesolithic	10,000–4000 BC
– Neolithic	4000–2500 BC
Bronze Age	2500–800 BC
Iron Age	800 BC–AD 43
Roman Age	43–410
Middle Ages	
– Early Middle Ages	410–1066
– High Middle Ages	1066–1272
– Late Middle Ages	1272–1485
Early Modern Age	1485–1750
Modern Age	1750–present

Kings and Queens

THE KINGDOM OF ENGLAND

House of Wessex	927–1013
Æthelstan	927–939
Edmund I	939–946
Eadred	946–955
Eadwig 'the All-Fair'	955–959
Edgar 'the Peaceful'	959–975
Edward 'the Martyr'	975–978
Æthelred II 'the *Unræd*'	978–1013

House of Denmark	1013–1014
Swein Haraldsson 'Forkbeard'	1013–1014

House of Wessex	1014–1016
Æthelred II 'the *Unræd*'	1014–1016
Edmund II 'Ironside'	1016

House of Denmark	1016–1042
Cnut 'the Great'	1016–1035
Harold I 'Harefoot'	1035–1040
Harthacnut	1040–1042

House of Wessex	1042–1066
Edward 'the Confessor'	1042–1066

House of Godwin	1066
Harold II	1066

House of Normandy	1066–1135
William I 'the Conqueror'	1066–1087
William II 'Rufus'	1087–1100
Henry I 'Beauclerc'	1100–1135

House of Blois	1135–1154
Stephen	1135–1154

House of Plantagenet–Anjou	1154–1216
*Henry II 'FitzEmpress' or 'Curtmantle'	1154–1189
**Henry 'the Young King'	1170–1183
Richard I 'the Lionheart'	1189–1199
John 'Lackland'	1199–1216

* The monarch of England was also 'Lord of Ireland' from 1171 to 1541
** Crowned in his father's lifetime, but never ruled independently

House of Plantagenet	1216–1399
Henry III	1216–1272
Edward I 'Longshanks'	1272–1307
Edward II	1307–1327
Edward III	1327–1377
Richard II	1377–1399

House of Plantagenet–Lancaster	1399–1461
Henry IV	1399–1413
Henry V	1413–1422
*Henry VI	1422–1461

* Also disputed King of France from 1422–1453

House of Plantagenet–York	1461–1470
Edward IV	1461–1470

House of Plantagenet–Lancaster	1470–1471
Henry VI	1470–1471

House of Plantagenet–York	1471–1485
Edward IV	1471–1483
Edward V	1483
Richard III	1483–1485

House of Tudor	1485–1542
Henry VII	1485–1509
Henry VIII	1509–1542

THE KINGDOM OF ENGLAND
 and
THE KINGDOM OF IRELAND

House of Tudor	1542–1603
Henry VIII	1542–1547
Edward VI	1547–1553
Mary I	1553–1558
Elizabeth I	1558–1603

THE KINGDOM OF ENGLAND
 and
THE KINGDOM OF IRELAND
 and
THE KINGDOM OF SCOTLAND

House of Stuart	1603–1649
James I (VI of Scotland)	1603–1625
Charles I	1625–1649

Interregnum	1649–1660

* On the Restoration Charles II was retrospectively declared to have been king during the interregnum

House of Stuart	1660–1688
Charles II	1660–1685
James II (VII of Scotland)	1685–1688

House of Stuart and Orange-Nassau	1689–1694
Mary II and William III	1689–1694

House of Orange-Nassau	1694–1702
William III	1694–1702

House of Stuart	1702–1707
Anne	1702–1707

THE KINGDOM OF GREAT BRITAIN
 and
THE KINGDOM OF IRELAND

House of Stuart	1707–1714
Anne	1707–1714

House of Hanover	1714–1800
George I	1714–1727
George II	1727–1760
George III	1760–1800

THE UNITED KINGDOM OF GREAT BRITAIN AND IRELAND

House of Hanover	1801–1901
George III	1801–1820
George IV	1820–1830
William IV	1830–1837
Victoria	1837–1901

House of Saxe-Coburg and Gotha	1901–1917
Edward VII	1901–1910
George V	1910–1917

House of Windsor	1917–1922
George V	1917–1922

THE UNITED KINGDOM OF GREAT BRITAIN AND NORTHERN IRELAND
and
THE IRISH FREE STATE

House of Windsor	1922–1937
George V	1922–1936
Edward VIII	1936
George VI	1936–1937

THE UNITED KINGDOM OF GREAT BRITAIN AND NORTHERN IRELAND

House of Windsor	1937–
George VI	1937–1952
Elizabeth II	1952–

Prime Ministers

George I		**1714–1727**
Robert Walpole	Whig	1721–

George II		**1727–1760**
Robert Walpole	Whig	–1742
The Earl of Wilmington	Whig	1742–1743
Henry Pelham	Whig	1743–1754
The Duke of Newcastle	Whig	1754–1756
The Duke of Devonshire	Whig	1756–1757
The Duke of Newcastle	Whig	1757–

George III		**1760–1820**
The Duke of Newcastle	Whig	–1762
The Earl of Bute	Tory	1762–1763
George Grenville	Whig	1763–1765
The Marquess of Rockingham	Whig	1765–1766
*William Pitt 'the Elder'	Whig	1766–1768
The Duke of Grafton	Whig	1768–1770
Lord North	Tory	1770–1782
The Marquess of Rockingham	Whig	1782
The Earl of Shelburne	Whig	1782–1783
The Duke of Portland	Whig	1783
William Pitt 'the Younger'	Tory	1783–1801
Henry Addington	Tory	1801–1804
William Pitt 'the Younger'	Tory	1804–1806
Lord Grenville	Whig	1806–1807
The Duke of Portland	Tory	1807–1809
Spencer Perceval	Tory	1809–1812
The Earl of Liverpool	Tory	1812–

* Created Earl of Chatham at the start of his administration

George IV		1820–30
The Earl of Liverpool	Tory	–1827
George Canning	Tory	1827
Viscount Goderich	Tory	1827–1828
The Duke of Wellington	Tory	1828–

William IV		1830–1837
The Duke of Wellington	Tory	–1830
The Earl Grey	Whig	1830–1834
Viscount Melbourne	Whig	1834
The Duke of Wellington	Tory	1834
Robert Peel	Conservative	1834–1835
Viscount Melbourne	Whig	1835–

Victoria		1837–1901
Viscount Melbourne	Whig	–1841
Robert Peel	Conservative	1841–1846
*Lord John Russell	Whig	1846–1852
The Earl of Derby	Conservative	1852
The Earl of Aberdeen	Conservative	1852–1855
Viscount Palmerston	Whig	1855–1858
The Earl of Derby	Conservative	1858–1859
Viscount Palmerston	Liberal	1859–1865
*Earl Russell	Liberal	1865–1866
The Earl of Derby	Conservative	1866–1868
Benjamin Disraeli	Conservative	1868
William Ewart Gladstone	Liberal	1868–1874
**Benjamin Disraeli	Conservative	1874–1880
William Ewart Gladstone	Liberal	1880–1885
The Marquess of Salisbury	Conservative	1885–1886
William Ewart Gladstone	Liberal	1886
The Marquess of Salisbury	Conservative	1886–1892
William Ewart Gladstone	Liberal	1892–1894
The Earl of Rosebery	Liberal	1894–1895
The Marquess of Salisbury	Conservative	1895–

* Lord John Russell (PM 1846–52) was created Earl Russell in 1861
** Created the Earl of Beaconsfield during his second administration

Edward VII		1901–1910
The Marquess of Salisbury	Conservative	–1902
Arthur Balfour	Conservative	1902–1905
Henry Campbell-Bannerman	Liberal	1905–1908
Herbert Asquith	Liberal	1908–

George V		1910–1936
Herbert Asquith	Liberal	–1916
David Lloyd George	Liberal	1916–1922
Andrew Bonar Law	Conservative	1922–1923
Stanley Baldwin	Conservative	1923–1924
James Ramsay MacDonald	Labour	1924
Stanley Baldwin	Conservative	1924–1929
James Ramsay MacDonald	Labour/Nat. Lab.	1929–1935
Stanley Baldwin	Conservative	1935–

Edward VIII		1936
Stanley Baldwin	Conservative	

George VI		1936–1952
Stanley Baldwin	Conservative	–1937
Neville Chamberlain	Conservative	1937–1940
Winston Churchill	Conservative	1940–1945
Clement Attlee	Labour	1945–1951
Winston Churchill	Conservative	1951–

Elizabeth II		1952–
Winston Churchill	Conservative	–1955
Anthony Eden	Conservative	1955–1957
Harold Macmillan	Conservative	1957–1963
Alec Douglas-Home	Conservative	1963–1964
Harold Wilson	Labour	1964–1970
Edward Heath	Conservative	1970–1974
Harold Wilson	Labour	1974–1976
James Callaghan	Labour	1976–1979
Margaret Thatcher	Conservative	1979–1990
John Major	Conservative	1990–1997
Tony Blair	Labour	1997–2007
Gordon Brown	Labour	2007–2010
David Cameron	Conservative	2010–2016
Theresa May	Conservative	2016–2019
Boris Johnson	Conservative	2019–

Original Texts

Prelude. William the Conqueror, *Charter to Lundenburgh* (1067)
- Original charter: London, London Metropolitan Archives, COL/CH/01/001/A
- Original text and translation: D Selwood
- William kyng gret William biſceop 7 goffregð portirefan 7 ealle þa burhþaru binnan londone frenciſce 7 engliſce freondlice. 7 ic kyðe eop þæt ic þylle þæt getbeon eallra þæra laga þeorðe þe gyt þæran on eadperdeſ dæge kynges. 7 ic þylle þæt ælc cyld beo hiſ fæder yrfnume æfter hiſ fæder dæge. 7 ic nelle geþolian þæt ænig man eop ænig þrang beode. god eop gehealde.

1. Stonehenge, *Carvings of Axe Heads and Daggers* (1750–1500 BC)
- Original object: Salisbury Plain, Stonehenge, carvings

2. Julius Caesar, *The Gallic War* (*c*. 50 BC)
- Original manuscript: Paris, Bibliothèque Nationale, MS Lat 5763, fols 1r–12v (AD 800–25) and multiple other copies
- Original text: Julius Caesar (1917), 72, book 5, chapter 12, pp. 248–51 | book 5, chapter 14, pp. 252–3 | book 5, chapter 14, pp. 252–3 | book 5, chapter 14, pp. 252–3 | book 4, chapter 33, pp. 222–3 | book 4, chapter 33, pp. 222–3 | book 6, chapter 13, p. 336–7 | book 6, chapter 16, pp. 340–1 | book 5, chapters 12, 14, pp. 250–1, 252–3 | book 5, chapter 12, pp. 250–1 | book 5, chapter 12, pp. 250–1
- Translation: D Selwood
- Britanniae pars interior ab eis incolitur quos natos in insula ipsi memoria proditum dicunt, maritima pars ab eis, qui praedae ac belli inferendi causa ex Belgio transierunt (qui omnes fere eis nominibus civitatum appellantur, quibus orti ex civitatibus eo pervenerunt) et bello illato ibi permanserunt atque agros colere coeperunt. Hominum est infinita multitudo creberrimaque aedificia fere Gallicis consimilia. | Omnes vero se Britanni vitro inficiunt, quod caeruleum efficit colorem, atque hoc horridiores sunt in pugna aspectu. | Capilloque sunt promisso atque omni parte corporis rasa praeter caput et labrum superius. | Vxores habent deni duodenique inter se communes et maxime fratres cum fratribus parentesque cum liberis; sed qui sunt ex his nati, eorum habentur liberi, quo primum virgo quaeque deducta est. | Genus hoc est ex essedis pugnae. Primo per omnes partes perequitant et tela coniciunt atque ipso terrore equorum et strepitu rotarum ordines plerumque perturbant, et cum se inter equitum turmas insinuaverunt, ex essedis desiliunt et pedibus proeliantur. | Ac tantum usu cotidiano et exercitatione efficiunt uti in declivi ac praecipiti loco incitatos equos sustinere et brevi moderari ac flectere et per temonem percurrere et in iugo insistere et se inde in currus citissime recipere consuerint. | Disciplina

in Britannia reperta atque inde in Galliam translata esse existimatur, et nunc, qui diligentius eam rem cognoscere volunt, plerumque illo discendi causa proficiscuntur. | Alii immani magnitudine simulacra habent, quorum contexta viminibus membra vivis hominibus complent; quibus succensis circumventi flamma exanimantur homines. Supplicia eorum qui in furto aut in latrocinio aut aliqua noxia sint comprehensi gratiora dis immortalibus esse arbitrantur; sed, cum eius generis copia defecit, etiam ad innocentium supplicia descendunt. | Pecorum magnus numerus . . . Interiores plerique frumenta non serunt, sed lacte et carne vivunt pellibusque sunt vestiti. | Leporem et gallinam et anserem gustare fas non putant; haec tamen alunt animi voluptatisque causa. | Vtuntur aut aere aut nummo aureo aut taleis ferreis ad certum pondus examinatis pro nummo.

3. Claudia Severa, *Birthday Invitation to Sulpicia Lepidina* (*c.* AD 100)
– Original object: London, British Museum, 1986,1001.64, on display as G49/dc2
– Original text and translation: D Selwood
– claudia seuera lepidinae [suae] salutem. iii idus septembres soror ad diem sollemnem natalem meum rogo libenter facias ut uenias ad nos iucundiorem mihi [diem] interuentu tuo factura si . . . cerialem tuum salute. aelius meus et filiolus salutant . . . sperabo te soror. uale soror anima mea ita ualeam karissima et haue. || sulpiciae lepidinae cerialis a seuera

4. Anonymous, *The History of the Britons* (AD 829/830)
– Original manuscript: Chartres, Bibliothèque municipal, MS 98 (AD 900–1100) and multiple other copies
– Original text: *Historia Brittonum* (1898), pp. 199–200, 217–8
– Translation: D Selwood
– Tunc Arthur pugnabat contra illos in illis diebus cum regibus Brittonum, sed ipse dux erat bellorum. Primum bellum fuit in ostium fluminis quod dicitur Glein. Secundum et tertium et quartum et quintum super aliud flumen, quod dicitur Dubglas et est in regione Linnuis. Sextum bellum super flumen, quod vocatur Bassas. Septimum fuit bellum in silva Celidonis, id est Cat Coit Celidon. Octavum fuit bellum in castello Guinnion, in quo Arthur portavit imaginem sanctae Mariae perpetuae virginis super humeros suos et pagani versi sunt in fugam in illo die et caedes magna fuit super illos per virtutem domini nostri Iesu Christi et per virtutem sanctae Mariae virginis genetricis eius. Nonum bellum gestum est in urbe Legionis. Decimum gessit bellum in litore fluminis, quod vocature Tribruit. Undecimum factum est bellum in monte, qui dicitur Agned. Duodecimum fuit bellum in monte Badonis, in quo corruerunt in uno die nongenti sexaginta viri de uno impetu Arthur; et nemo prostravit eos nisi ipse solus, et in omnibus bellis victor extitit. | Est aliud mirabile in regione quae dicitur Buelt. Est ibi cumulus lapidum et unus lapis superpositus super congestum cum vestigio canis in eo. Quando venatus est porcum Troynt, impressit Cabal, qui erat canis Arthuri militis, vestigium in lapide et Arthur postea congregavit congestum lapidum sub lapide in quo erat vestigium canis sui et vocatur Carn Cabal. Et veniunt homines et tollunt lapidem in manibus suis per spatium diei et noctis, et in crastino die invenitur super congestum suum. | Est aliud miraculum in regione quae dicitur Ercing. Habetur ibi sepulchrum iuxta fontem, qui cogniminatur Licat Anir, et viri nomen, qui sepultus est in tumulo, sic vocabatur Anir, filius Arthuri militis erat et ipse occidit eum ibidem et sepelivit. Et veniunt homines ad mensurandum tumulum in longitudine aliquando sex pedes, aliquando novem, aliquando duodecim, aliquando quindecim. In qua mensura metieris eum in ista vice, iterum non invenies eum in una mensura, et ego solus probavi.

5. Anonymous, *The Seafarer* (AD 650–950)
– Original manuscript: Exeter, Cathedral Library MS 3501, fols 81v–83r (AD 950–1000)
– Original text: D Selwood
– Translation: *Beowulf* (2011), pp. 150–4; reprinted with permission of the University of Pennsylvania Press
– Mæg ic beme sylfum soð gied þrecan siþas secgan huic gefþinc dagum earfoð hþile oft þropade bitre breoft ceare gebiden hæbbe gecunnad inceole cear selda fela atol yþa geþealc . . . þonne hebe clifum cnossað calde geþrungen þæron mine fet forfte gebunden caldum clommum þærþa ceare seofedun hat ymb heortan hungor innan slat mere perges mod þæt se mon neþat þehim onfoldan fægrost limþeð huic earm cearig isce, aldne sæ þinter þunade præccan laftum þinemægum bidroren bihongen hrim gicelum hægl scurum fleag þær ic nege hyrde butan hlimman sæ iscaldne þæg hþilum ylfete song. dyde icme to gomene ganetes hleoþor 7 huilpan fþeg fore hleahtor þera mæþ fingende fore medo drince . . . forþon nu min hyge hþeorfeð ofer hreþer locan min mod sefa mid mere flode ofer hþæles eþel hþeorfeð þide eorþan sceatas cymeð eft tome gifre 7 grædig gielleð anfloga hþeteð onþæl þeg hreþer unþernum ofer holma gelagu forþon me hatran sind dryhtnes dreamas þoon þis deade lif læne onlonde icgelyfe no þæt him eorð þelan ece ftondeð simle þreora sum þinga gehþylce. ær his tiddege geto

tƿeon þeorþeð adl oþþe yldo oþþe ecg hete . . . þe þonne eac tilien þæt þe tomoten in þa ecan eadignesse þær is lif gelong inlufan dryhtnes hyht inheofonum þæs sy þam halgan þonc þæt heus ic geþeorþade þuldres ealdor ece dryhtenin ealle tid Amen.

6. Anonymous, *The Sayings of the High One* (c. AD 900)

- Original manuscript: Reykjavik, Árni Magnússon Institute for Icelandic Studies, *Codex regius*, GKS 2365 4o (1250–1300)
- Original text and translation: *The Hávamál* (1923), verses 12, 16, 23, 27, 35, 40, 41, 42, 57, 77, 81, 119, pp. 44-87
- Era svá gott, sem gott kveða, öl alda sona; þvíat færa veit, er fleira drekkr, síns til geðs gumi. | Ósnjallr maðr hyggz muno ey lifa, ef hann við víg varaz; en elli gefr hánom engi frið, þótt hánom geirar gefi. | Ósviðr maðr vakir um allar nætr ok hyggr at hvívetna; þá er móðr er at morni kømr: alt er vil sem var. | Ósnotr maðr er með aldir kømr, þat er batst at hann þegi; engi þat veit at hann ekki kann, nema hann mæli til mart veita maðr hinn er vetki veit, þótt hann mæli til mart. | Ganga skal, skala gestr vera ey í einom stað; ljúfr verðr leiðr ef lengi sitr annars fletjom á. | Fjár síns, er fengit hefr, skylit maðr þörf þola; opt sparir leiðom þats hefir ljúfom hugat; mart gengr verr, en varir. | Vápnom ok váðom skolo vinir gleðjaz — þat er á sjálfom sýnst; viðrgefendr ok endrgefendr erosk lengst vinir,ef þat bíðr at verða vel. | Vin sínom skal maðr vinr vera ok gjalda gjöf við gjöf; hlátr við hlátri skyli hölðar taka, en lausung við lygi. | Brandr af brandi brenn unz brunninn er, funi kveykiz af funa: maðr af manni verðr at máli kuðr, en til dœlskr af dul. | Deyr fé, deyja frændr, deyr sjálfr it sama; ek veit einn, at aldri deyr, dómr um dauðan hvern. | At kveldi skal dag leyfa, konu er brennd er, mæki er reyndr er, mey er gefin er, ís er yfir kømr, öl er drukkit er. | Ráðomk þér, Loddfáfnir, en þú ráð nemir — njóta mundo, ef þú nemr, þér munu góð, ef þú getr —: veitsu, ef þú vin átt þannz þú vel trúir, farðu at finna opt; þvíat hrísi vex ok hávo grasi vegr er vetki trøðr.

7. *The Bayeux Tapestry* (1066–77)

- Original object: Bayeux, Musée de la Tapisserie de Bayeux
- Original text and translation: D Selwood
- Edward[us] rex | Ubi Harold dux anglorum et sui milites equitant ad Bosham ecclesia[m] | Hic Harold mare navigavit | Et velis vento plenis venit in terra Widonis comitis | Harold | Hic apprehendit Wido Haroldu[m] | Et duxit eum ad Belrem et ibi eum tenuit | Ubi Harold Wido parabolant | Ubi nuntii Willelmi ducis venerunt ad Widone[m] | Turold | Nuntii Willelmi | Hic venit nuntius ad Wilgelmum ducem | Hic Wido adduxit Haroldum ad Wilgelmum normannorum ducem | Hic dux Wilgelm[us] cum Haroldo venit ad palatiu[m] suu[m] | Ubi unus clericus et Ælfgyva | Hic Willem[us] dux et exercitus eius venerunt ad monte[m] Michaelis | Et hic transierunt flumen Cosnonis | Hic Harold dux trahebat eos de arena | Et venerunt ad Dol et Conan fuga vertit | Rednes | Hic milites Willelmi ducis pugnant contra Dinantes | Et Cunan claves porrexit | Hic Willelm[us] dedit arma Haroldo | Hic Willelm[us] venit Bagias | Ubi Harold sacramentum fecit Willelmo duci | Hic Harold dux reversus est ad Anglicam terram | Et venit ad Edwardu[m] regem | Hic portatur corpus Eadwardi regis ad ecclesiam S[an]c[t]i Petri ap[osto]li | Hic Eadwardus rex in lecto alloquit[ur] fideles | Et hic defunctus est | Hic dederunt Haroldo corona[m] regis | Hic residet Harold rex Anglorum | Stigant archiep[iscopu]s | Isti mirant[ur] stella[m] | Harold | Hic navis Anglica venit in terram Willelmi ducis | Hic Willelm[us] dux jussit naves [a]edificare | Hic trahunt naves ad mare | Isti portant armas ad naves et hic trahunt carrum cum vino et armis | Hic Willelm[us] dux in magno navigio mare transivit et venit ad Pevenesæ | Hic exeunt caballi de navibus | Et hic milites festinaverunt Hestinga ut cibum raperentur | Hic est Wadard | Hic coquitur caro et hic ministraverunt ministri | Hic fecerun[t] prandium | Hic episcopus cibu[m] et potu[m] benedicit | Odo ep[iscopu]s Willem[us] Rotbert | Iste jussit ut foderetur castellum at Hestenga ceastra | Hic nuntiatum est Willelm[o] de Harold[o] | Hic domus incenditur | Hic milites exierunt de Hestenga et venerunt ad pr[o]elium contra Haroldum rege[m] | Hic Willelm[us] dux interrogat Vital[em] si vidisset Haroldi exercitu[m] | Iste nuntiat Haroldum rege[m] de exercitu Willelmi ducis | Hic Willelm[us] dux alloquitur suis militibus ut preparen[t] se viriliter et sapienter ad pr[o]elium contra Anglorum exercitu[m] | Hic ceciderunt Lewine et Gyrð fratres Haroldi regis | Hic ceciderunt simul Angli et Franci in pr[o]elio | Hic Odo ep[iscopu]s baculu[m] tenens confortat pueros | Hic est Willel[mus] dux| E[usta]tius | Hic Franci pugnant et ceciderunt qui erant cum Haroldo | Hic Haroldus rex interfectus est | Et fuga verterunt Angli.

8. Anonymous, *Beowulf* (c. AD 700–1000)

- Original manuscript: London, British Museum, Cotton MS Vitellius A XV, fols 132r–201v (AD 975–1000)

– Original text and translation: D Selwood

9. Anonymous, *The Anglo-Saxon Chronicle* (*E, Peterborough*) (1137)
– Original manuscript: Oxford, Bodleian, MS Laud Misc. 636, fol. 89v (1120–1300)
– Original text and translation: D Selwood
– Hi fuencten fuyðe þe uureccemen of þe land mid caftel peorcef, þa þe caftlef uuaren maked þa fylden hi mid deoulef 7 yuelemen, þa namen hi þa men þe hi penden ðat ani god hefden, bathe be nihtef 7 be dæief, carlmen 7 þimmen, 7 diden heom in prifun efter gold 7 fyluer 7 pined heom, untellendlice pining, for ne uuæren næure nan martyrf fpa pined alfe hi pæron, | mani þufen hi drapen mid hungær, I ne can ne i ne mai tellen alle þe þunder ne alle þe pinef ðat hi diden precce men on þis land, 7 ðat lastede þa xix pintre pile Stephne paf king, 7 æure it paf uuerfe 7 uuerfe, hi læiden gæildef on the tunep æure um pile, 7 clepeden it tenferie. þa þe uureccemen ne hadden nammore to gyuen, þa pæueden hi 7 brendon alle the tunef, ðat þel þu myhtef faren al a dæif fare fculdeft thu neure finden man in tune fittende ne land tiled, þa paf corn dære, 7 flec 7 cæfe 7 butere, for nan ne þæf o þe land, precce men fturuen of hungær, fume ieden on ælmef þe paren fum pile rice men, fume flugen ut of lande, paf næure gæt mare preccehed on land, ne næure hethen men perfe ne diden þan hi diden, | þar fæ me tilede, þe erthe ne bar nan corn, for þe land paf al fordon mid fuilce dædes. 7 hi fæden openlice ðat xpift flep, 7 hif halechen.

10. *The Charter of Runnymede* (*Magna Carta*) (1215)
– Original manuscript: London, British Library, Cotton MS Augustus II 106
– Original text and translation: D Selwood
– Johannes Dei gracia rex Anglie, dominus Hibernie, dux Normannie, Aquitannie et comes Andegavie, archiepiscopis, episcopis, abbatibus, comitibus, baronibus, justiciariis, forestariis, vicecomitibus, prepositis, ministris et omnibus ballivis et fidelibus suis salutem. | (1) In primis concessisse Deo et hac presenti carta nostra confirmasse, pro nobis et heredibus nostris in perpetuum quod Anglicana ecclesie libera sit, et habeat jura sua integra, et libertates suas illesas. | (51) Et statim post pacis reformacionem amovebimus de regno omnes alienigenas milites, balistarios, servientes, stipendiarios, qui venerint cum equis et armis ad nocumentum regni. | (10) Si quis mutuo ceperit aliquid a iudeis, plus vel minus, et moriatur antequam debitum illud solvatur, debitum non usuret quamdiu heres fuerit infra etatem. | (35) Una mensura vini sit per totum regnum nostrum, et una mensura cervisie, et una mensura bladi, scilicet quarterium Londoniense, et una latitudo pannorum tinctorum et russetorum et halbergettorum, scilicet due ulne infra listas; de ponderibus autem sit ut de mensuris. | (33) Omnes kidelli de cetero deponantur penitus de Tamisia, et de Medewaye, et per totam Angliam, nisi per costeram maris. | (13) Et civitas Londoniarum habeat omnes antiquas libertates et liberas consuetudines suas, tam per terras quam per aquas. Preterea volumus et concedimus quod omnes alie civitates, et burgi, et ville, et portus, habeant omnes libertates et liberas consuetudines suas. | (8) Nulla vidua distringatur ad se maritandum, dum voluerit vivere sine marito. | (54) Nullus capiatur nec imprisonetur propter appellum femine de morte alterius quam viri sui. | (21) Comites et barones non amercientur nisi per pares suos, et non nisi secundum modum delicti. | (39) Nullus liber homo capiatur, vel imprisonetur, aut disseisiatur, aut utlagetur, aut exuletur, aut aliquo modo destruatur, nec super eum ibimus, nec super eum mittemus, nisi per legale judicium parium suorum vel per legem terre. | (40) Nulli vendemus, nulli negabimus aut differemus rectum aut justiciam | (49) Omnes obsides et cartas statim reddemus que liberate fuerunt, nobis ab Anglicis in securitatem pacis vel fidelis servicii.

11. Anonymous, *The Owl and the Nightingale* (1189–1216)
– Original manuscripts London, British Library, Cotton MS Caligula A IX, fols 233r–246r (1250–1300) and one other copy in Oxford, Jesus College, MS 29/2 (1300–1400)
– Original text and translation: D Selwood.
– Ich pas in one fumere dale. In one fuþe diȝele hale. Iherde ich holde grete tale. An hule and one niȝtingale. Þat plait paf ftif 7 ftarc 7 ftrong. Sum pile fofte 7 lud among. An aiþer aȝen oþer sval. 7 let þat vvole mod ut al. 7 eiþer feide of operes cufte. Þat alere porfte þat hi pufte. 7 hure 7 hure of opere fonge. Hi holde plaiding fuþe ftronge. Þe Niȝtingale bigon þe fpeche. In one hurne of one breche. 7 sat upone vaire boȝe. Þar pere abute blofme inoȝe. In ore pafte þicke hegge. Imeind mid fpire 7 grene fegge. Ho pas þe gladur uor þe rife. 7 fong auele cunne pife. Het þuȝte þe dreim þat he pere. Of harpe 7 pipe þan he nere. Bet þuȝte þat he pere ifhote. Of harpe 7 pipe þan of þrote. O ftod on old ftoc þarbifide. Þar þo vle fong hire tide. 7 pas mid iui al bigrope. Hit pas þare hule eardingftope (1–28) . . . Vnpiȝt ho fede apei þu flo. Me if þe vvrs þat ich þe fo. Ipif for þine vvle lete. Þel oft ich mine fong forlete (33–6) . . . Þos hule abod fort hit paf eve (41) . . . Hu þincþe nu bi mine fonge. Þeft þu þat ich ne cunne finge. Þeȝ ich ne cunne of pritelinge. Ilome

þu dest me grame. 7 feiſt me boþe tone 7 fchame (46–50) . . . þu atteſt Niȝtingale. Þu miȝteſt bet hoten galegale. Vor þu haueſt to monie tale. Lat þine tunge habbe ſpale (255–8) . . . Ȝet þu me feiſt of oþer þinge. 7 telſt þat ich ne can noȝt ſinge. Ac al mi rorde is poning. 7 to ihire griſlich þing. Þat nis noȝt ſoþ ich ſinge efne. Mid fulle dreme 7 lude ſtefne. Þu peniſt þat ech ſong bo griſlich. Þat þine pipinge nif ilich. Mi ſtefne is bold 7 noȝt unorne. Ho is ilich one grete horne. 7 þin is ilich one pipe. Of one ſmale pode unripe. Ich ſinge bet þan þu deſt. Þu chatereſt so doþ on irish proſt (309–22) . . . Betere is min on þan alle þine. Betere is o ſong of mine muþe. Þan al þat eure þi kun kuþe. An luſt ich telle þe pareuore. Poſtu to pan man paſ ibore. To þare bliſſe of houene riche (712–17) . . . Ich parni men to here gode. Þat hi bon bliþe on hore mode. An bidde þat hi moten iſeche. Þan ilke ſong þat euer if eche . . . (739–42) Þu nart noȝt to non oþer þinge. Bute þu canſt of chateringe. Vor þu art lutel an unſtrong. An nif þi reȝel no þing long (559–62) . . . Ȝet ich can do þel gode þike. Vor ich can loki manne þike. An mine þike boþ þel gode. Vor ich helpe to manne uode. Ich can nimen muſ at berne. An ek at chirche ine þe derne. Vor me is lof to criſteſ huſe. To clanſi hit þiþ fule muſe. Ne fchal þar neure come to. Ful piȝt ȝif ich hit mai de iuo (603–12) . . . Hule ho fede feie me ſoþ. Þi doſtu þat unpiȝtiſ doþ. Þu ſingiſf a niȝt 7 noȝt a dai. 7 al þi Vong is þailaþai (217–20) . . . Hit þinckeſt boþe piſe 7 ſnepe. Noȝt þat þu ſinge ac þat þu þepe. Þu fliȝſt a niȝt 7 noȝt a dai. Þarof ich vvndri 7 þel mai. Vor eurich þing þat fchuniet riȝt. Hit luueþ þuſter 7 hatiet liȝt. 7 eurich þing þat is lof miſdede. Hit luueþ þuſter to hif dede (225–32) . . . Vor þane þu ſitteſt on þine rife. Þu draȝſt men to fleſeſ luſte. Þat plleþ þine ſongeſ luſte (892–4) . . . Al þat þu ſingſt if of golneſſe (897) . . . Þummon mai pleie under cloþe. Þeþer heo þile þel þe proþe. 7 heo mai do bi mine ſonge. Hpaþer heo þule þel þe pronge (1357–60) . . . For gold 7 feoluer god hit is. An noþeles þarmid þu miȝt. Spusbruche buggen 7 unriȝt. Þepne beoþ gode griþ to halde. Ah neoþeleſ þarmide beoþ men acþalde. Aȝeines riht 7 fale londe. Þar þeoueſ hi bereð an honde. Alſpa hit if bi mine ſonge. Þah heo beo god me hine mai miſſonge (1364–72) . . . Ne fchal non mon vvimman bigrade. An fleſcheſ luſteſ hire upbreide. Spuch he may telen of golneſſe. Þat funegeþ þurſe imodineſſe (1411–14) . . . Ich teache heom bi mine ſonge. Þat ſpucch luue ne leſt noȝt longe. For mi ſong lutle hþile ileſt (1447–9) . . . Þat maide pot hþanne ich ſpike. Þat luue is mine ſonges iliche. For hit nis bute a lutel breþ. Þat ſone kumeþ 7 ſone geþ (1457–60) . . . Ȝif þu art iporþe oþer iſhote. Þanne þu miȝt ereſt to note. Vor me þe hoþ in one rodde. An þu mid þine fule codde. An mid þine ateliche ſþore. Biþereſt manne corn urom dore (1119–24) . . . Ich do heom god mid mine deaþe (1615) . . . Me mai upone ſmale ſticke. Me ſette a þude ine þe þicke. An ſpa mai mon tolli him to. Lutle briddes 7 iuo. An ſpa me mai mid me biȝete. Þel gode brede to hiſ mete. Ah þu neure mon to gode. Liues ne deaþeſ ſtal ne ſtode (1627–30) . . . Hwat canſtu þrecche þing of ſtorre. Bute þat þu bihaltſt hi feorre (1319–20) . . . On ape mai a boc bihalde. An leues þenden 7 eft folde. Ah he ne con þe bet þaruore. Of clerkes lore top ne more (1323–6) . . . Þat Maiſter Nichole þat is þis. Bituxen vs deme fchulde (1744–5) . . . Ah ute þe þah to him fare. For þar is unker dom al ȝare (1777–8) . . . Mid þiſſe þorde forþ hi ferden. Al bute here 7 bute uerde. To Porteſham þat heo bicome. Ah hu heo fpedde of heore dome. Ne chan ich eu na more telle. Her nis na more of þis fpelle (1789–94).

12. Anonymous, *Sumer Is Icumen In* (1240)
– Original manuscript: London, British Library, Harley MS 978, fol. 11v (1261–5)
– Original text and translation: D Selwood
– Hanc rotam cantare poſſunt quatuor focij. A paucioribus autem quam a tribus uel faltem duobus non debet dici preter eoſ qui dicunt pedem. Cantatu autem ſic. Tacentibus ceteriſ unus inchoat cum hiiſ qui tenent pedem. Et cum uenerit ad primam notam poſt crucem, inchoat aliuſ 7 ſic de ceteris. Singuli uero repauſent ad pauſaciones ſcriptaſ 7 non alibi, ſpacio uniuſ longe note. | Hoc repetit unus quocienſ opus eſt facienſ pauſacionem in fine. | Hoc dicit alius, pauſanſ in medio et non in fine sed immediate repetens principium.

13. Anonymous, *Plague Graffiti* (1350/1361)
– Original graffiti: Ashwell, Church of St Mary the Virgin
– Original text and translation: D Selwood
– pestilēcia | m c t⁹ x penta miserāda ferox violēta | suþest plebs pessima testis in fine qᵉ vēt⁹ valid⁹ | oc anno maurus in orbe tonat m ccc lxi | primula pestis ī m t⁹ ccc fuit l minus uno

14. Joan of Arc, *Letter to King Henry VI of England* (1429)
– Original manuscript: Paris, Bibliothèque de l'Assemblée Nationale, MS 1119, fols 51v–52r
– Original text and translation: D Selwood
– Roy d'Angleterre, et vous, duc de Bedford, qui vous dictes regent le royaume de France; vous, Guillaume de la Poule, conte de Sudford; Jehan, sire de Talebot; et vous, Thomas, sire d'Escales, qui vous dictes lieutenans dudit duc de Bedford, faictes raison au Roy du ciel; rendez a la Pucelle, qui est cy envoiee de

par Dieu, le Roy du ciel, les clefs de toutes les bonnes villes que vous avez prises et violees en France. Elle est cy venue de par Dieu pour reclamer le sanc royal. Elle est toute preste de faire paix, se vous lui voulez faire raison, par ainsi que France vous mectrés jus et paierez ce que vous l'avez tenu. Et entre vous, archiers, compaignons de guerre, gentilz et autres qui estes devant la ville d'Orleans, alez vous ent en vostre païs, de par Dieu; et se ainsi ne le faictes, actendez les nouvelles de la Pucelle qui vous ira voir briefment, a voz bien grans dommaiges. Roy d'Angleterre, se ainsi ne le faictes, je sui chief de guerre, et en quelque lieu que je actaindray voz gens en France, je les en feray aler, vueillent ou non vueillent. Et si ne veullent obeir, je les feray tous occire; je sui cy envoiee de par Dieu, le Roy du ciel, corps pour corps, pour vous bouter hors de toute France. Et si veullent obeir, je les prandray a mercy. Et n'aiez point en vostre oppinión, quar vous ne tendrez point le royaume de France de Dieu, le Roy du ciel, fils saincte Marie; ains le tendrá le roy Charles, vray heritier; car Dieu, le Roy du ciel, le veult, et lui est revelé par la Pucelle; lequel entrera a Paris a bonne compagnie. Se ne voulez croire les nouvelles de par Dieu et la Pucelle, en quelque lieu que vous trouverons, nous ferrons dedens et y ferons ung si grant hahay que encore a il mil ans que en France ne fu si grant, se vous ne faictes raison. Et croyez fermement que le Roy du ciel envoiera plus de force a la Pucelle que vous ne lui sariez mener de tous assaulx, a elle et a ses bonnes gens d'armes; et aux horions verra on qui ara meilleur droit de Dieu du ciel. Vous, duc de Bedford, la Pucelle vous pries et vous requiert que vous ne vous faictes mie destruire. Si vous lui faictes raison, encore pourrez venir en sa compaignie, l'ou que les Franchois feront le plus bel fait que onques fu fait pour la chrestienté. Et faictes response se vous voulez faire paix en la cité d'Orleans; et se ainsi ne le faictes, de vos bien grans dommages vous souviengne briefment. Escript ce mardi sepmaine saincte.

15. Margery Brews, *Valentine's Letter* (1477)
– Original letter: London, British Library, Add MS 43490, fol. 23r

16. Thomas Malory, *Le Morte Darthur* (1485)
– Original book: Thomas Malory (1485), book 1, chapters 5–6, leaves 46–8

17. Thomas Cromwell, *Summary of an Execution* (1539)
– Original manuscript: London, British Library. Cotton MS Titus B I, fol. 441rv

18. Edmund Campion, *To the Right Honourable Lords of Her Majesties Privy Council* (1580)
– Original manuscript: London, British Library. Harley MS 422, fols 134r–135r, another copy at 132r–133r (1580–1)

19. Thomas Potts, *The Wonderfull Discoverie of Witches in the Countie of Lancaster* (1613)
– Original book: Potts (1613)

20. Gunpowder Plotter, *Letter to Lord Monteagle* (1605)
– Original letter: London, The National Archives, SP 14/216/2

21. The High Court of Parliament, *Death Warrant of King Charles I* (1649)
– Original warrant: London, Parliamentary Archives, HL/PO/JO/10/1/297A

22. Margaret Cavendish Lady Newcastle, *A Lady Drest by Youth* (1653)
– Original book: Newcastle (1653), p. 158

23. Richard Head, *The Canting Academy, or the Devils Cabinet Opened* (1673)
– Original book: Head (1673)

24. Isaac Newton, *The Emerald Tablet* (1685–95)
– Original manuscript: Cambridge, King's College Library, Keynes MS 28/ALCH00017, fol. 2rv

25. Anonymous, *The Forme of Giveing the Mason Word* (1696)
– Original manuscript: Edinburgh, National Records of Scotland, RH9/17/14

26. Admiral Sir John Norris, *The Hunt for Pirate Blackbeard* (1718)
– Original manuscript: London, The National Archives, Adm 1/2/1826

27. Robert Clive, *Letter to William Pitt on Opportunities in India* (1759)

– Original text: Malcolm (1836), II, p. 119

28. William Blake, *And Did Those Feet in Ancient Time* (1804–11)
– Original manuscript: London, British Museum, 1859,0625

29. John Constable, *Salisbury Cathedral from the Meadows* (1831)
– Original painting: London, Tate Britain, T13896

30. Ada Byron, *Code for Charles Babbage's Analytical Engine* (1843)
– Original article: *Scientific Memoirs* (1843)

31. Sergeant W. Reinners, *Rejection of Karl Marx's Application for Naturalisation* (1874)
– Original report: London, The National Archives, PRO HO 45/9366/36228

32. Lieutenant (Brevet Major) John Chard VC, *Sketches of Rorke's Drift for Queen Victoria* (1880)
– Original sketches: Windsor, Royal Archives, VIC/MAIN/O/46, sketch no. 4

33. 'Jack the Ripper', *Letter from Hell* (1888)
– Original photograph: London, Barts Health NHS Trust Archives and Museums, RLHMC/PM/5/2/2/1

34. 12th Battalion Sherwood Foresters, *The Wipers Times* (1916–18)
– Text: *The Wipers Times* (2018), no. 1, vol. 1 (12 February 1916), no. 3, vol. 1 (22 May 1916), no. 2, vol. 1 (25 December 1916), no. 1, vol. 1 (17 April 1916), no. 1, vol. 1 (12 February 1916), no. 4, vol. 2 (20 March, 1916), no. 2, vol. 1 (26 February 1916), no. 4, vol. 2 (25 December 1917), no. 1, vol. 1 (12 February 1916), no. 1, vol. 1 (12 February 1916), no. 2, vol. 1 (26 February 1916), no. 2, vol. 1 (December 1918), pp. 3, 77, 138, 50, 5, 41, 14, 249, 6, 7, 18, 319.

35. Arthur Balfour, *The Balfour Declaration* (1917)
– Original manuscript: London, British Library, Add MS 41178 A, fol. 3

36. Ralph Vaughan Williams, *The Lark Ascending* (1914/1920)
– Original manuscript: London, British Library, Add MS 52385

37. Harry Beck and Edward Johnston, *Map of London's Underground Railways* (1933)
– Original map: London, Underground Electric Railway Company, 1933

38. Reich Main Security Office, *Specially Wanted List G.B.* (1940)
– Original book: California, Stanford University, Hoover Institution, Library and Archives, DA585.A1 G37 (V)/649516, pp. 7, 15, 34. 52, 62, 71, 159, 162, 175, 220, 220, 222
– Translation: D Selwood
– 77a. Astor, Lady, London, deutschfeindlich, RSHA IV E 4. | 6. Baden-Powell, Lord, RSHA IV E 4, Gründer der Boy-Scout-Bewegung. | 96. Coward, Noel, vermutl. London, RSHA VI G 1. | 52. Epstein, Jacob, 1880 New York, Bildhauer, London S. W. 7, 18 Hyde-park Gate, RSHA II B 2. | 114. Freud, Sigmund, Dr., Jude, 6.5.56 Freiburg (Mähren), London, RSHA II B 5. | 13. de Gaulle, ehemaliger französischer General, London RSHA VI G 1 | 14. Pankhurst, Sylvia, Sekret. Int. Frauentfiga Matteotti, Woodford Green/Essex, 3 Charteris Road, RSHA VI G 1. | 118. Prevsner, Nikolaus, Dr., geb. 1902, Priv.-Dozent, Emigrant, London, RSHA III A l. | 134. Russel [sic], Bertrand, RSHA VI G 1. | 53. Weizmann, Chaim, 1870 oder 1874 in Motyli bei Pinks, Professor der Chemie, Führer der gesamten Judenvereine Englands, London S. W. l, 104 Pall Mall, Reform-Club, RSHA II B 2, VI G l. | 55. Wells, Herbert George, 1866 geb., Schriftsteller, Lonaon N. W. 1, Regents Park 13, Hanover Terrace, RSHA VI G l, III A 5, II B 4. | 116. Woolf, Virginia, Schriftstellerin, RSHA VI G.

39. Winston Churchill, *Telegram to Éamon de Valera* (1941)
– Original manuscript: Cambridge, Churchill Archive Centre, CHAR 20/46/41

40. Mervyn-Griffiths QC, *Opening Speech in Regina v. Penguin Books Limited* (*Lady Chatterley's Lover*) (1960)
– Original book: *The Trial of Lady Chatterley* (1961), p. 17

41. Jamie Reid, *Cover Art for Sex Pistols, God Save the Queen* **(1977)**
– Original image: National Portrait Gallery, NPG D448055 and multiple other copies

42. The Provisional IRA, *The Execution of Soldier Mountbatten* **(1979)**
– Original newspaper: *An Phoblacht*, 1 September 1979, p. 2

43. The Sun, *Gotcha* **(1982)**
– Original newspaper: *The Sun*, 4 May 1982, p. 1

44. Peter Wright, *Spycatcher* **(1988)**
– Original, first English edition: Wright (1988), pp. 68, vii–xv

45. Spitting Image, *The Last Prophecies of Spitting Image* **(1996)**
– Original manuscript: Cambridge, University Library, Spitting-Image-Series-00018-Episode-00006-18Feb1996-N-00478

46. The Fat Duck, *Tasting Menu* **(1999)**
– Original menu: Bray, The Fat Duck

47. Tony Blair, *Foreword to Iraq 'Dodgy Dossier'* **(2002)**
– Original document: *Iraq's Weapons of Mass Destruction: The Assessment of the British Government* (2002) Joint Intelligence Committee, HMSO, ID 114567 9/2002 776073

48. HM Government, *'Brexit' Referendum Ballot Paper* **(2016)**
– Original text: The European Union Referendum (Conduct) Regulations 2016, schedule 4, Form 1, p. 104

49. Pheidias, *The Parthenon Sculptures* **(438 BC/2020)**
– Original image: British Museum (2020)

50. BBC Radio 4, *'The Ships'* **(2020)**
– Original image: D Selwood

Bibliography

ABBREVIATIONS

Hansard	*The Official Report* (1802–). London, various printers, multiple vols
LCL	*Loeb Classical Library* (1913–). Various editors, London, Heinemann, then Cambridge, Harvard University Press, 542 vols
ODNB Online	*Oxford Dictionary of National Biography* (2004). H Matthew and B Harrison (eds), Oxford, Oxford University Press, 60 vols, online version with updated articles https://bit.ly/36AGGCj
Rolls Series	*Rerum britannicarum medii aevi scriptores*, or *The Chronicles and Memorials of Great Britain and Ireland during the Middle Ages* (1858–1911). Various editors, London, Longman & Co, 253 vols

MANUSCRIPTS AND ARTEFACTS

ABERYSTWYTH
National Library of Wales
 MS 2.81 — *Llyfr Aneirin* containing *Y Gododdin*
 MSS 3054D and 5276D — Elis Gruffudd, *Cronicl o Wech Oesoedd*
 MS 23849D — *Beunans Ke*
 Peniarth MS 2 — *Llyfr Taliesin* and *Armes Prydain Fawr*
 Peniarth MSS 4 and 5 — *Llyfr Gwyn Rhydderch*
 Peniarth MS 105B — *Beunans Meriasek*

ALDERSHOT
The Museum of Military Medicine
 RAMC/801/14/9 — John Reynolds, account of the Battle of Rorke's Drift

AMSTERDAM
University Library
 Amsterdam MS XV G 1 (Amstelodamensis 73) — Julius Caesar, *Commentarii de bello gallico*

BAYEUX
Musée de la Tapisserie de Bayeux
 Bayeux Tapestry

BERLIN
Bundesarchiv
 A/100/07 — Heinrich Himmler, letter to Walther Wüst and Wolfram Sievers
 NS 6/334 — Martin Bormann, edict on typography

CALIFORNIA
Stanford University, Hoover Institution, Library and Archives
 DA585.A1 G37 (V)/649516 — RSHA, *Sonderfahndungsliste G.B.*

CAMBRIDGE
Churchill Archive Centre
 CHAR 20/46/41 — Winston Churchill, telegram to Éamon de Valera

Corpus Christi College
 MS 173 — *Anglo-Saxon Chronicle* (A, Winchester)
 MS 383 — King Alfred and King Guthrum, treaty
 MS 473 — *Winchester Troper*

King's College Library, Archive Centre
 CB/V/1 — Rupert Brooke, 'The Soldier'
 Keynes MS 28/ALCH00017 — Isaac Newton, *Emerald Tablet*

Magdalene College, Pepys Library
 State Papers PL 2503 — Thomas Blount, account of the death of Amy Robsart

Trinity College
 E. 17. 1, James 987 — Eadwine, *Psalterium triplex*

University Library
 MS Add 3995 — Isaac Newton, notebook
 Spitting Image-Series-00018-Episode-00006 — Spitting Image, *The Last Prophecies of Spitting Image*
CHARTRES
Bibliothèque Nationale
 MS 98 — *Historia brittonum*

DUBLIN
Royal Irish Academy
 MS 23 E 25 — *Lebor na hUidhre*

Trinity College Dublin
 MS 58 — *Book of Kells*
 MS 1339 — *Book of Leinster*

EDINBURGH
National Museum of Scotland
 IL.2011.1.1 — Deskford carnyx

National Records of Scotland
 RH9/17/14 — *The Forme of Giveing the Mason Word*

ETON
Eton College
 MS 178 — *Eton Choirbook*

EXETER
Cathedral Library
 MS 3501 — *Exeter Book*

FLORENCE
Biblioteca Medicea Laurenziana
 MS Amiatino 1 — *Codex amiatinus*

HATFIELD
Hatfield House Library and Archives
 CP 150/86 — Katharine Ashley, confession
 Salisbury MS 112/91 — Thomas Winter, confession 2
 Salisbury MS 113/54 — Thomas Winter, confession 1

LONDON
Barts Health NHS Trust Archives and Museums
 RLHMC/PM/5/2/2/1 — 'Jack the Ripper', letter from Hell (photograph)

British Library
 Add MS 4848 — Articles of the Barons
 Add MS 17451 — Glastonbury register
 Add MS 27446, 43488, 43490 — Paston letters
 Add MS 41178 A — Balfour Declaration
 Add MS 45025 — Ceolfrith, Bible fragments
 Add MS 52385 — Ralph Vaughan Williams, *The Lark Ascending*
 Add MS 59678 — Thomas Malory, *Le Morte Darthur* (Winchester MS)
 Add MS 89000 — *St Cuthbert Gospel*
 Cotton Charter VI 2 — Edward the Confessor, charter to Westminster Abbey
 Cotton Charter VIII 24 — Innocent III, *Rex regum et*
 Cotton MS Augustus II 106 — Charter of Runnymede (Magna Carta)
 Cotton MS Caligula A IX — *Owl and the Nightingale*
 Cotton MS Caligula A XV — Christ Church Canterbury, *Annals* and Easter computational tables
 Cotton MS Cleopatra E I — Innocent III, *Etsi karissimus*
 Cotton MS Domitian A VIII —*Anglo-Saxon Chronicle* (F, Canterbury)
 Cotton MS Galba E VI — Elizabeth I, letter to Catherine de' Medici
 Cotton MS Julius B XIII — Gerald of Wales, *De principis instructione*
 Cotton MS Nero D IV — *Lindisfarne Gospels*
 Cotton MS Nero D VIII — Geoffrey of Monmouth, *Historia regum britannie*
 Cotton MS Otho B X and B XI — *Anglo-Saxon Chronicle* (G, Winchester)
 Cotton MS Otho C I/1 — Gospels in Old English
 Cotton MS Tiberius A VI — *Anglo-Saxon Chronicle* (B, Abingdon I)
 Cotton MS Tiberius B I — *Anglo-Saxon Chronicle* (C, Abingdon II)
 Cotton MS Tiberius B IV — *Anglo-Saxon Chronicle* (D, Worcester)
 Cotton MS Tiberius B XIII — Gerald of Wales, *Speculum ecclesiae*
 Cotton MS Titus B I — Thomas Cromwell, *Rememberances*
 Cotton MS Titus D XXVI–XXVII — Ælfwine, prayer book
 Cotton MS Vitellius A VI — Gildas, *De excidio et conquestu britanniae*
 Cotton MS Vitellius A XV — *Beowulf* (*Nowell Codex*)
 Harley MS 422 — Edmund Campion, letter to the Privy Council
 Harley MS 913 — *Kildare Poems*
 Harley MS 978 — *Sumer Is Icumen In*
 Harley MS 4011 — John Russell, *Boke of Nurture*
 Harley MS 4016 — *Boke of Kokery*
 Harley MS 6798 — Elizabeth I, Tilbury speech
 Royal MS 17 A.1. — *Regius Poem*

British Museum
 1859,0625 — William Blake, *And Did Those Feet in Ancient Time*
 1939,1010.93 — Sutton Hoo, grimhelm

1939,1010.203 — Sutton Hoo, lyre
1986,1001.64 — Claudia Severa, birthday invitation to Sulpicia Lepidina
2001,0401.20 — Wetwang, woman charioteer's skeleton
CM 1913,1213.1 — King Offa, gold dinar
OA.10262 — rune ring
SLMathInstr.54 — Sloane astrolabe

College of Arms
Westminster Tournament Roll

Lambeth Palace Library
MS 603 — Statutes of Kilkenny

London Transport Museum
1999/321 — Harry Beck and Edward Johnston, *Map of London's Underground Railways*

National Archives
Adm 1/2/1826 — Admiral Sir John Norris, The hunt for pirate Blackbeard
MEPO 3/142 (original lost) — 'Jack the Ripper', letter from Hell
PRO HO 45/9366/36228 — Sergeant W. Reinners, on Karl Marx
PRO HO 144/221/A49301C — Charles Warren, letter to Godfrey Lushington
PRO SP 10/6/21 — Katherine Aschyly, deposition
PRO SP 14/2/51 — Anthony Copley, declaration
PRO SP 14/4/85 — Earl of Northumberland, letter to James VI and I
PRO SP 14/216/2 — Gunpowder plotter, letter to Lord Monteagle
PRO SP 14/216/54 — Guy Fawkes, confession 1
PRO SP 14/216/101 — Guy Fawkes, confession 2
PRO SP 14/216/126 — Robert Keyes, examination
PRO SP 14/216/225 — Earl of Northumberland, papers

National Portrait Gallery
NPG 1727 — Holbein, *Thomas Cromwell*, oil on panel, 78.1 x 61.9 cm
NPG D448055 — Jamie Reid, cover art for the Sex Pistols, *God Save the Queen*

Parliamentary Archives
HL/PO/JO/10/1/297A — Parliament, death warrant of King Charles I
HL/PO/PU/1/1688/1W&Ms2n2 — Bill of Rights 1689

Sir John Soane Museum
45/1/13 — John Soane, *Design for a British Senate House*, drawing

Tate Britain
N05058/B306 — William Blake *Newton*, colour print finished in ink and watercolour, 46×60 cm
T13896 — John Constable, *Salisbury Cathedral from the Meadows*, oil on canvas, 153.7x192 cm

Victoria and Albert Museum
E.365–1956 — William Blake, *There is No Natural Religion*, colour relief etching, 5.08 x 4.13 cm
FA.33[O] — John Constable, *Salisbury Cathedral from the Bishop's Ground*, oil on canvas, 87.6 x 111.8 cm

MANCHESTER
John Rylands Library
MS 7 — *Forme of Cury*

NEW HAVEN
Yale Centre for British Art
B1992.8.1 — William Blake, *Jerusalem: The Emanation of the Giant Albion*, plate 77, relief etching printed in orange with pen and black ink and watercolour, 34.3 x 26.4 cm

PRIVATE COLLECTIONS
Stephen A. Cohen Collection
 Damien Hirst, *The Physical Impossibility of Death in the Mind of Someone Living*

The Duerckheim Collection
 Tracey Emin, *My Bed*

OXFORD
Bodleian
 Bodley 791 — *Origo mundi, Passio christi, Resurrexio domini*
 MS Junius 1 — *Ormulum*
 MS Junius 11 — *Junius Manuscript*
 MS Laud Misc 610 — *Macgnímartha Finn*
 MS Laud Misc. 636 — *Anglo-Saxon Chronicle* (E, Peterborough)

Jesus College
 MS 111 — *Llyfr Coch Hergest*
 MS E 29/2 — *Owl and the Nightingale*

New College
 NCA 5367 — William of Wykeham, foundation charter

Worcester College
 MS 65 — Sir William Clarke, shorthand notes of the Putney debates

PARIS
Bibliothèque de l'Assemblée Nationale
 MS 1119 — Joan of Arc, trial records

Bibliothèque Nationale
 MS Lat 5763 — Julius Caesar, *Commentarii de bello gallico*

REYKJAVIK
Árni Magnússon Institute for Icelandic Studies
 GKS 2365 4° — *Codex regius*

ROCHESTER
Cathedral Library
 MS A.3.5 — *Textus roffensis*

SAN MARINO
The Huntingdon Library
 MS EL 26 C 9 — *Ellesmere Chaucer*

SIMANCAS
Archivo General
 Secreteria de Estado 814 — Spanish ambassador, report

STRATFORD-UPON-AVON
Shakespeare Birthplace Trust
 ER 93/2 — Sir Francis Fane, *Commonplace Book*

WASHINGTON D.C.
National Archives
 No. 1419123 — The Declaration of Independence

WINCHESTER
Winchester College
 Muniments 697 — William of Wykeham, foundation charter

Muniments 22097 — Account roll for 1415/1416

WINDSOR
Royal Archives
VIC/MAIN/O/46 — Lieutenant (Brevet Major) John Chard VC, letter report to Queen Victoria

WORCESTER
Archive
S 207 — King Burgred of Mercia, charter

VERCELLI
Biblioteca Capitolare,
MS CXVII — *Vercelli Book*

PRINTED SOURCES
Authors born before 1500 are listed by first name.

(1) Incunabula

al-Mubashshir ibn Fatik (1477). *The Dictes or Sayengis of the Philosophhres*, A Woodville (tr), Westminster, W Caxton

Alphonso de Espina (*c.* 1470). *Fortalitium fidei*, Strasbourg, Johann Mentelin

Catherine of Siena (1500). *Epistole devotissime*, Venice, Aldus Manutius

Geoffrey Chaucer (*c.* 1476). *The Canterbury Tales*, Westminster, W Caxton

Heinrich Kramer and Jakob Sprenger (1497). *Malleus maleficarum*, Speyer, Peter Drach

James of Cessolis (1474). *The Game and Playe of the Chesse*, W Caxton (tr), Bruges, W Caxton

Johannes Nider (*c.* 1470). *Formicarius*, Cologne, Duldenschaff

Julius Caesar (1469). *Commentarii de bello gallico*, Rome, Conradus Sweynheym and Arnoldus Pannartz

Raoul Lefèvre (1473). *The Recuyell of the Historyes of Troye*. W Caxton (tr), Bruges, W Caxton

Thomas Malory (1485). *Le Morte Darthur*, Westminster, W Caxton

(2) Primary Sources: Individual Authors – Chronicles, Novels

Adamson H (1638). *The Muses Threnodie, Or, Mirthfull Mournings, on the Death of Mr Gall*, Edinburgh, George Adamson

Ælfred, King (1899). *King Alfred's Old English Version of Boethius De consolatione philosophiae*, W Sedgefield (ed), Oxford, Oxford University Press

Alanbrooke, Field Marshal Lord (2001). *War Diaries 1939–1945*, Berkeley, University of California Press

Amatus of Monte Cassino (1935). *L'Ystoire de' li Normant*, B Bartholomaeis (ed), *Storia de' Normanni*, in *Fonti de la storia d'Italia*, Rome, Istituto storico italiano per il medio evo

Ammianus Marcellinus (1940–50). *History*, LCL 300, 315, 331, 3 vols

Apicius (1977). *Cookery and Dining in Imperial Rome*, J Vehling (ed and tr), London, Constable

Ashmole E (1927). *The Diary and Will of Elias Ashmole*, R Gunther (ed), Oxford, Butler and Tanner

Asser (1904). *Asser's Life of King Alfred Together with the Annals of St Neots*, W Stevenson (ed), Oxford, Clarendon Press

Aubrey J (1898). *'Brief Lives' Chiefly of Contemporaries, Set Down by John Aubrey, between the Years 1669 and 1696*, A Clark (ed), Oxford, Clarendon Press, 2 vols

Avienus (1968). *Rufus festus avienus ora maritima, lateinisch und deutsch*, D Stichtenoth (ed and tr), Darmstadt, Wissenschaftliche Buchgesellschaft

Baldassarre Bonaiuti (1903). *Cronaca Fiorentina di Marchionne di Coppo Stefani*, N Rodolico (ed), *Rerum italicarum scriptores* 30, Florence, S Lapi

Bale J and J Leland (1549). *The Laboryouse Journey & Serche of Iohan Leylande, for Englandes Antiquitees, Geuen of Hym as a Newe Yeares Gyfte to Kynge Henry the viij, in the xxxvij. Yeare of his Reygne, with Declaracyons Enlarged*, London, S Mierdman

Bede (1896). *Venerabilis baedae historiam ecclesiasticam gentis anglorum*, C Plummer (ed), Oxford, Clarendon Press

—— (1950). *De ratione temporum*, in *Venerabilis bedæ anglosaxonis presbyteri opera omnia*, in *Patrologiæ cursus completes*, series Latina 90, J-P Migne (ed), Paris, Migne, part 1, cols 293–578

Beeton I (1861). *The Book of Household Management*, London, S O Beeton

Blair C (2009). *Speaking for Myself: My Life from Liverpool to Downing Street*, London, Sphere

Blair T (2011). *A Journey*, London, Arrow

Blake W (1862a). 'Couplets and Fragments', in Gilchrist (1862), II

—— (1862b) 'The Woman Taken in Adultery (Extracted from a Fragmentary Poem, entitled 'The Everlasting Gospel'), in Gilchrist (1862), II

Blumenthal H (2009). *The Fat Duck Cook Book*, London, Bloomsbury

Borges J L (1967). *The Witness*, in *A Personal Anthology*, A Kerrigan (tr), New York, Grove Press, p. 178

Boyle R (1772). *The Works of the Honourable Robert Boyle*, T Birch (ed), London, 6 vols

Brooke R (1915a). 'The Dead', in *New Numbers*, 1:1

—— (1915b). 'The Soldier', in *New Numbers*, 1:1

Brown G (2018). *My Life, Our Times*, London, The Bodley Head

Burnet G (1681). *The History of the Reformation of the Church of England*, London, T H for Richard Chiswell

—— (1833). *Bishop Burnet's History of His Own Time*, Oxford, Oxford University Press, 6 vols

Burns R (1859). 'Such a Parcel of Rogues in a Nation', in *The Complete Works of Robert Burns: Containing his Poems, Songs, and Correspondence*, Boston, Phillips, Sampson and Co

Cassius Dio (1914–27). *Roman History*, LCL 32, 37, 53, 66, 82, 83, 175, 176, 177, 9 vols

Christine of Pisa (1977). *Ditié de Jehanne d'Arc*, A Kennedy and K Varty (eds), Oxford, Society for the Study of Mediæval Languages and Literature

Chrysogonus Polydorus (1541). *De alchimia*, Nuremberg, Johann Petreius

Churchill W (1988). 'Zurich Speech, 19 September 1946', in *Documents on the History of European Integration* (1988), III, pp. 663–6

Cicero (1999). *Letters to Atticus*, LCL 7, 8, 97, 491, 4 vols

Clarke W (1992). *The Clarke Papers: Selections from the Papers of William Clarke: Secretary to the Council of the Army, 1647–49, and to General Monck and the Commanders of the Army in Scotland, 1651–60*, C Firth (ed), London, Royal Historical Society

Cleland J (1748–9). *Memoirs of a Woman of Pleasure*, or *Fanny Hill*, London, G Fenton, 2 vols

Conan Doyle A (1887). 'A Study in Scarlet', *Beeton's Christmas Annual*, London, Ward Lock

Cook J (1974). *The Journals of Captain James Cook on His Voyages of Discovery*, J Beaglehole (ed), London, The Hakluyt Society, 4 vols

Cromwell O (1857). *Oliver Cromwell's Letters and Speeches*, T Carlyle (ed), London, Chapman and Hall, 3 vols

Curling H (2001). *The Curling Letters of the Zulu War. 'There Was an Awful Slaughter'*, B Best and A Greaves (eds), London, Leo Cooper

Darwin C (1859). *On the Origin of Species*, London, John Murray

de la Rochefoucauld F (1933). *A Frenchman in England in 1784: Being the Mélanges sur l'Angleterre of François de la Rochefoucauld*, J Marchand (ed), S Roberts (tr), Cambridge, Cambridge University Press

de Viau T (1981). *The Cabaret Poetry of Théophile de Viau. Texts and Traditions*, C Gaudiani (ed), Paris, Jean-Michel Place

Dickens C (1894). *The Uncommercial Traveller*, Boston and New York, Houghton and Mifflin

Diodorus of Sicily (1933–67). *The Library of History*, LCL 279, 303, 340, 375, 377, 384, 389, 390, 399, 409, 422, 423, 12 vols

Disraeli B (1847). *Tancred*. London, H Colburn

Eliot G (1876). *Daniel Deronda*, London, William Blackwood & Sons

Elizabeth I, Queen (2002). *Elizabeth I: Collected Works*, L Marcus et al (eds), Chicago, University of Chicago Press

Flavius Josephus (1905). *The Antiquities of the Jews*, in W Whiston (tr), *The Works of Flavius Josephus*, Hartford, The S S Scranton Co, pp. 37–618

Fleming I (2012). *Casino Royale*, London, Vintage Books

Florence of Worcester (1854). *The Chronicle of Florence of Worcester*, T Forester (ed), London, Bohn's Antiquarian Library

Foxe J (1563). *Actes and Monuments*, London, John Day

Gabriel of Mussis (1994). *Historia de morbo*, in *The Black Death* (1994)

Gelasius (1959). *Adversus andromachum contra lupercalia*, in *Gélase Ier. Lettre contre les Lupercales et dix-huit messes du Sacrementaire léonien*, G Pomarès (ed), Sources Chrétiennes 65, Paris, pp. 161–89

Geoffrey Chaucer (1988). *The Riverside Chaucer*, L Benson (ed), Oxford, Oxford University Press

Geoffrey le Baker (1889). *Chronicon galfridi le baker de swynebroke*, E Thompson (ed), Oxford, Clarendon Press

Geoffrey of Monmouth (1854). *Gottfried's von Monmouth Historia Regum Britannie*, A Schulz (ed), Halle, Eduard Anton

Gerald of Wales (1873). *De vita galfridi archiepiscopi eboracensis*, in *Giraldi cambrensis opera*, J Brewer (ed), *Rolls Series* 21, IV

—— (1891). *De principis instructione liber*, in *Giraldi cambrensis opera*, G Warner (ed), *Rolls Series* 21, VIII

Gerard J (1872). *Father Gerard's Narrative of the Gunpowder Plot*, J Morris (ed), London, [n.p.]

Gervase of Canterbury (1879–80). *Gesta regum*, W Stubbs (ed), *Rolls Series* 73, 2 vols

Gildas (1838). *De excidio britanniæ*, J Stevenson (ed), London, English Historical Society

Gregg V (2013). *Dresden. A Survivor's Story*, London, Bloomsbury

Guest, Lady Charlotte (1849). *The Mabinogion: From the Llyfr Coch o Hergest, and Other Ancient Welsh Manuscripts: With an English Translation and Notes*, London and Llandovery, Longman, Brown, Green, and Longmans, 3 vols

Guy of Amiens (1999). *The Carmen de Hastingae proelio of Guy, Bishop of Amiens*, New York, Oxford University Press

Head R (1675). *The English Rogue Described, in the Life of Meriton Latroon . . . Being a Compleat History of the Most Eminent Cheats, etc.*, London, Richard Head

—— (1673). *The Canting Academy, or, the Devils Cabinet Opened Wherein Is Shewn the Mysterious and Villanous Practices of that Wicked Crew, Commonly Known by the Names of Hectors, Trapanners, Gilts, &c. : to Which Is Added a Compleat Canting-dictionary, Both of Old Words, and Such as Are Now Most in Use : with Several New Catches and Songs, Compos'd by the Choisest Wits of the Age*, London, F Leach for M Drew

Healey D (1989). *The Time of My Life*, London, Michael Joseph

Heloise (1855). *Petri abelardi abbatis rugensis opera omnia*, in *Patrologiæ cursus completes series latina* 178, J-P Migne (ed), Paris, Migne, cols 181–8

Henry VIII, King (1521). *Assertio septem sacramentorum*, London, Richard Pynson

—— (1543). *A Necessary Doctrine and Erudition for any Christen Man, Sette Furthe by the Kynges Maiestie of Englande*, London, Thomas Berthelet

Henry of Huntingdon (1879). *Henrici archidiaconi huntendunensis historia anglorum*, T Arnold (ed) London, Longman & Co

Hermann Gigas (1750). *Hermanni gygantis ordinis fratrum minorum, flores temporum, seu chronicon universal, ab orbe condito ad annum christi MCCCXLIX*, M Eysenhart (ed), Leiden, Philip Bonk

Hero of Alexandria (1851). *The Pneumatics of Hero of Alexandria*, B Woodcroft (ed), London, Taylor Walton and Maberly

Hess M (1841). *Die europäische Triarchie*, Leipzig, Otto Wigand

Hopkins G M (1918). 'The Windhover' in *Poems of Gerard Manley Hopkins*, R Bridges (ed), London, Humphrey Milford, p. 29

Houghton, Lord, R Milnes (1890). *The Life, Letters, and Friendships of Richard Monckton Milnes, First Lord Houghton*, T Reid (ed), London, Cassell & Co, 2 vols

James VI and I, King (1597). *Dæmonologie, In Forme of a Dialogue, Diuided into Three Bookes*, Edinburgh, Robert Walde-Grave

—— (1604). *A Counterblaste to Tobacco*, London, R Barker

Jean Bodel (1989). *La Chanson des Siasnes de Jehan Bodel*, A Brasseur (ed), Geneva, Droz, 2 vols

John of Salisbury (1929). *Ioannis saresberiensis episcopi carnotensis metalogicon*, C Webb (ed), Oxford, Clarendon Press

John Philoponus (1867). *Ioannis philoponi in aristotelis de anima libros commentaria*, M Hayduck (ed), Berlin, Georg Reimer

John Rous (1745). *Historia regum angliae*, Oxford, J Fletcher & J Pote

Johnson S (1775). *A Journey to the Western Islands of Scotland*, London, W Strahan and T Cadell

Julius Caesar (1917). *The Gallic War*, LCL 72

Kant I (1996). 'An Answer to the Question: What is Enlightenment?', in *The Cambridge Edition of the Works of Immanuel Kant*, M Gregor (ed and tr), Cambridge. Cambridge University Press, pp. 17–22

Lawrence D H (2005). *Lady Chatterley's Lover*, London, C R W Publishing

Leake J (1666). *An Exact Svrveigh or the Streets Lanes and Chvrches Contained within the Rvines of the City of London, December 1666*, London, Nathanaell Brooke Stationer

Livy (1919–51). *History of Rome*, LCL 114, 133, 172, 191, 233, 295, 301, 313, 332, 355, 367, 381, 396, 13 vols

Locke J (1690a). *An Essay Concerning Humane Understanding*, London, Tho. Basset

—— (1690b). *Two Treatises of Government*, London, Awnsham Churchill

London J (1903). *The People of the Abyss*, New York, Grosset & Dunlap

Mantel H (2009). *Wolf Hall*, London, Fourth Estate

—— (2012). *Bring Up The Bodies*, London, Fourth Estate

—— (2020). *The Mirror & The Light*, London, Fourth Estate

Manuele Fieschi (1881). 'Lettre de Manuel Fiesque concernant les dernières années du roi d'Angleterre Edouard II', *Mémoires de la Société Archéologique de Montpellier*, 7, pp. 109–27

Martin Luther (1525). *Wider die Mordischen und Reubischen Rotten der Bawren*, Wittemberg

Matthew Paris (1872–84). *Chronica majora*, H Luard (ed), *Rolls Series* 57, 7 vols

Meredith G (May 1881). 'The Lark Ascending', *The Fortnightly Review*, pp. 588–91

Milton J (1667). *Paradise Lost*, London, Peter Parker

—— (1758a). *Paradise Lost*, Birmingham, J Baskerville for J and R Tonson

—— (1758b). *Paradise Regained*, Birmingham, J Baskerville for J and R Tonson

Newcastle, the Lady, M Cavendish, (1653). *Poems and Fancies*, London, T R

—— (1666). *The Description of a New World, Called the Blazing World*, England, A Maxwell

Newton I (1687). *Philosophiæ naturalis principia mathematica*, London, the Royal Society

—— (1728). *The Chronology of Ancient Kingdoms Amended*, London, J Tonson

Nietzsche F (1954). *Werke in drei Bänden*, Munich, Carl Hanser

Noyes A (1906). 'The Highwayman', *Blackwood's Magazine*, 180, pp. 244–7

Orderic Vitalis (1969–80). *The Ecclesiastical History*, M Chibnall (ed and tr), Oxford, Oxford University Press, 6 vols

Owen W (1920). *Poems*, London, Chatto & Windus

Paine T (1776). *Common Sense; Addressed to the Inhabitants of America*, Philadelphia, R Bell

Pepys S (1983). *The Diary of Samuel Pepys*, R Latham and W Matthews (eds), London, Bell and Hyman, 11 vols

—— (2001). *The Diary of Samuel Pepys*, R Le Gallienne (ed), New York, Modern Library

Peter Lombard (1971–81). *Sententiae in IV libris distinctae*, Rome, Editiones Collegii S. Bonaventurae ad Claras Aquas, 2 vols

Petronius (2020). *Satyricon*, LCL 15

Phillips J (1566). *The Examination and Confession of Certaine Wytches at Chensforde in the Countie of Essex: Before the Quenes Maiesties Judges, the XXVI Daye of July, Anno 1566, at the Assise Holden There as Then, and one of Them put to Death for the Same Offence, as Their Examination Declareth More at Large*, London, Willyam Powell for Wyllyam Pickeringe

Pitt W (1838–40). *Correspondence of William Pitt, Earl of Chatham*, London, John Murray, 4 vols

Pliny (1938–62). *Natural History*, LCL 330, 352, 353, 370, 371, 392, 393, 394, 418, 419, 10 vols

Plutarch (1914–26). *Parallel Lives*, LCL 46, 47, 65, 80, 87, 98, 99, 100, 101, 102, 103, 11 vols

Polybius (2010–12). *The Histories*, LCL 128, 137, 138, 159, 160, 161, 6 vols

Polydore Vergil (1844). *Three Books of Polydore Vergil's English History, Comprising the Reigns of Henry VI, Edward IV, and Richard III*, H Ellis (ed), London, Camden Society

Potter W (1873–6). *The Romance of Lust; or, Early Experiences*, London, W Lazenby, 4 vols

Potts T (1613). *The Wonderfull Discoverie of Witches in the Countie of Lancaster*. London, W Stansby for J Barnes

Ptolemy of Alexandria (1883–1901). *Κλαυδίου Πτολεμαίου Γεωγραφικὴ ὑφήγησις / Claudii ptolemæi geographia*, K Müller (ed), Paris, Alfredo Firmin-Didot, 2 vols

Ptolemy of Lucca (2009). *Historia ecclesiastica nova*, O Clavuout (ed), *Monumenta germaniae historica, scriptores* 39, Hannover, Hahnsche Buchhandlung

Ralph Higden (1865–86). *Polychronicon*, C Babington and J Lumby (eds), *Rolls Series* 41, 9 vols

Ralph of Coggeshall (1875). *Chronicon anglicanum*, J Stevenson (ed), *Rolls Series* 66

Regino of Prüm (1853). *De ecclesiasticis disciplinis*, in *Opera omnia*, in *Patrologiæ cursus completes, series latina* 132, J-P Migne (ed), Paris, Migne, cols 176–370

Richard of Holy Trinity (1854). *Itinerarium peregrinorum et gesta regis ricardi*, W Stubbs (ed), *Rolls Series* 38, I

Robert of Avesbury (1889). *De gestis mirabilibus regis edwardi tertii*. E Thompson (ed), *Rolls Series* 93

Robert of Boron (1995). *Joseph d'Arimathie*, R O'Gorman (ed), Toronto, Pontifical Institute of Medieval Studies

Rochester, Earl of, J Wilmot (2013). *Selected Poems*, P Davis (ed), Oxford, Oxford University Press

Roger Bacon (1900). *The Opus Majus of Roger Bacon*, J Bridges (ed), Oxford, Clarendon Press, 2 vols

Roger of Howden (1868–71). *Chronica magistri rogeri de houedene*, W Stubbs (ed), *Rolls Series* 51, 4 vols

Roger of Wendover (1890). *Flores historiarum*, H Luard (ed), *Rolls Series* 95, 3 vols

Rowling J K (1997). *Harry Potter and the Philosopher's Stone*, London, Bloomsbury

—— (1998). *Harry Potter and the Chamber of Secrets*, London, Bloomsbury

—— (1999). *Harry Potter and the Prisoner of Azkaban*, London, Bloomsbury

—— (2000). *Harry Potter and the Goblet of Fire*, London, Bloomsbury

—— (2003). *Harry Potter and the Order of the Phoenix*, London, Bloomsbury

Sassoon S (1918). 'Dreamers', in *Counter-Attack and Other Poems*, New York, E P Dutton & Company, p. 19

Saxo Grammaticus (1931). *Gesta danorum*, J Olrik and H Ræder (eds), [n.pl.], Hauniæ, Levin & Munksgaard

Scargill A (1975). 'The New Unionism', *New Left Review*, 92, pp. 3–33

Scott W (1829). *Anne of Geierstein, or The Maiden in the Mist*, Edinburgh, Cadell & Co, 3 vols

Shakespeare W (1623). *Mr. William Shakespeares Comedies, Histories, & Tragedies. : Published According to the True Originall Copies*, London, Isaac Iaggard and Ed Blount

Shelley M (1818). *Frankenstein; Or, The Modern Prometheus*, London, Lackington, Hughes, Harding, Mavor & Jones, 3 vols

Simeon of Durham (1855). *The Historical Works of Simeon of Durham*, J Stevenson (tr), The Church Historians of England, London, Seelays

Smith A (2002). *A Complete History of the Lives and Robberies of the Most Notorious Highwaymen, Footpads, Shoplift and Cheats of Both Sexes*, London, Routledge

Smollett T (1859). *The Expedition of Humphry Clinker*, New York, Derby & Jackson

Spenser E (1579). *The Shepheardes Calender*, London, H Singleton

Stendhal (1831). *Le Rouge et le Noir*, Paris, Bibliothèque Larousse, 2 vols

Stevenson R L (1886). *Strange Case of Dr Jekyll and Mr Hyde*, London, Longmans, Green & Co.

Stoker B (1897). *Dracula*, London, Archibald Constable and Company

Strabo (1917–32). *Geography*, LCL 49, 50, 182, 196, 211, 223, 241, 267, 8 vols

Stubbes J (1579). *The Discoverie of a Gaping Gulf Whereunto England Is Like To Be Swallowed by Another French Marriage, If the Lord Forbid Not the Banes, by Letting Her Majestie See the Sin and Punishment Therof*, London, H Singleton for W Page

Tacitus (1914). *The Life of Julius Agricola*, LCL 35

—— (1937). *Annals*, LCL 312, 322, 2 vols

Taillevent (1988). *The Viandier of Taillevent. An Edition of All Extant Manuscripts*, T Scully (ed), Ottawa, University of Ottawa Press

Templar of Tyre, The (1887). *The Chronicle of the Templar of Tyre*, in *Les Gestes des chiprois*, G Raynaud (ed), Geneva, Jules-Guillaume Fick

Tennyson, Lord A (1857). *Enid and Nimuë*, London, E. Moxon

—— (1869). *Idylls of the King*, London, Strahan and Co

Tesimond O (1973). *The Gunpowder Plot: The Narrative of Oswald Tesimond alias Greenway*, F Edwards (ed and tr), London, Folio Society

Thomas Malory (1889–91). *Le Morte Darthur by Syr Thomas Malory. The Original Edition of William Caxton*, H Sommer (ed), London, David Nutt, 3 vols

—— (1976). *The Winchester Malory: A Facsimile*, N Ker (ed), London, Oxford University Press

Thomas of Malmesbury (1858–63). *Eulogium historiarum sive temporis*, F Haydon (ed), *Rolls Series* 9, 3 vols

Thomas of Monmouth (1896). *The Life and Miracles of St William of Norwich*, A Jessop and M James (eds), Cambridge, Cambridge University Press

Thomas Walsingham (2005). *The Chronica Maiora of Thomas Walsingham, 1376–1422*, D Preest (ed), Woodbridge, The Boydell Press

Tolkien J R R (1937). *The Hobbit or There and Back Again*, London, Allen & Unwin

—— (1954a). *The Fellowship of the Ring*, London, Allen & Unwin

—— (1954b). *The Two Towers*, London, Allen & Unwin

—— (1955). *The Return of the King*, London, Allen & Unwin

Thatcher M (1993). *The Downing Street Years*, London, HarperCollins

Ussher J (1650). *Annales veteris testamenti, a prima mundi origine deducti: una cum rerum asiaticarum et aegyptiacarum chronico, a temporis historici principio usque ad Maccabaicorum initia producto*, London, J Crook and J Baker

Victoria, Queen (1984). *Queen Victoria in Her Letters and Journals*, C Hibbert (ed), London, Murray

Virgil (1757). *Publii virgilii maronis bucolica, georgica, et aeneis*, Birmingham, J Baskerville

Voltaire (1769). *Épître à l'auteur du nouveau livre des trois imposteurs*, [n.pl.], [n.p]

— (1994). *Dictionnaire de la pensée de Voltaire, par lui-même*, A Versaille (ed), Paris, Editions Complexe

Walpole H (1765). *The Castle of Otranto*, London, Thomas Lownds

—— (1820). *Private Correspondence of Horace Walpole, Earl of Oxford*, London, Rodwell and Martin, 4 vols

—— (1903–25). *The Letters of Horace Walpole, Earl of Oxford*, Oxford, Clarendon Press, 16 vols

Walter of Coventry (1872–3). *Memoriale fratris walteri de coventria*, W Stubbs (ed), *Rolls Series* 58, 2 vols

Waugh E (1935). *Edmund Campion*, London, Longmans & Co

Weldon A (1650). *The Court and Character of King James*, London, R.I

Wellington, the Duke of, A Wellesley (1965). *Wellington and His Friends. Letters of the First Duke of Wellington*, G Wellesley (ed), London, Macmillan & Co

Wheatley D (1939). *Sixty Days to Live*, London, Hutchinson & Co

Whitelock B (1682). *Memorials of the English Affairs*, London, Nathaniel Ponder

William le Breton (1882). *Œuvres de Rigord et de Guillaume le Breton, historiens de Philippe-Auguste*, F Delaborde (ed), Paris, Librarie Renouard

William of Jumièges (1995). *The Gesta Normannorum Ducum of William of Jumièges, Orderic Vitalis and Robert of Torigni*, E Van Houts (ed and tr), Oxford, Clarendon Press, 2 vols

William of Malmesbury (1887–9). *Willelmi malmesbriensis monachi de gestis regum anglorum*, W Stubbs (ed), Rolls Series 90, 2 vols

—— (2012). *De gestis regum anglorum*, W Stubbs (ed), Cambridge, Cambridge University Press, 2 vols

William of Newburgh (1884–5). *Historia rerum anglicarum*, R Howlett (ed), *Rolls Series* 82, 2 vols

William of Poitiers (1844). *Gesta guillelmi ducis normannorum et regis anglorum*, London, Caxton Society

William Rishanger (1865). *Willelmi rishanger quondam monachi s albani chronica et annales*, H Riley (ed), *Rolls Series* 28, II

Wollstonecraft M (1791). *Original Stories from Real Life*, London, J Johnson

Woolf V (1992). *To the Lighthouse*, in *Collected Works of Virginia Woolf: Mrs. Dalloway, To the Lighthouse, The Waves*, S McNichol (ed), London, Macmillan

Wright P (1988). *Spycatcher*, New York, Dell

Wulfstan of Winchester (2003). *Narratio metrica sancti swithuno*, in *The Cult of Saint Swithun*, M Lapidge (ed), Oxford, Clarendon Press, pp. 372–551

Wulfstan of York (1959). *Institutes of Polity, Civil and Ecclesiastical*, K Jost (ed), Bern, Schweizer anglistische Arbeiten 47

—— *Sermo lupi ad anglos* (1976). D Whitelock (ed), Exeter, University of Exeter

Yeats W B (1986–2018). *The Collected Letters of William Butler Yeats*, J Kelly (ed), Oxford, Clarendon Press, 5 vols

Zosimus (1982). *New History: A Translation with Commentary*, R Ridley (tr), Canberra, Australian Association for Byzantine Studies

(3) Primary Sources: Anonymous, Collections

A Choice of Anglo-Saxon Verse (2015). R Hamer (ed), London, Faber & Faber

'A Fourteenth-Century Chronicle from the Grey Friars at Lynn' (1957). A Gransden (ed), *English Historical Review*. 72, pp. 270–8

Anglo-Saxon Charters: An Annotated List and Bibliography (1968). P Sawyer (ed), London, Royal Historical Society

Annales cambriae. The A Text from London, British Library, Harley MS 3859 (2015a). H Gough-Cooper (ed), Welsh Chronicles Research Group

Annales cambriae. The B Text from London, National Archives, MS E164/1 (2015b). H Gough-Cooper (ed), Welsh Chronicles Research Group

Annales de margan (1864). H Luard (ed), *Rolls Series* 36, I

Annales paulini (1882). W Stubbs (ed), *Rolls Series* 76, I

Annalium hibernae chronicon (1849). R Butler (ed), Dublin, Irish Archaeological Society

Anonimalle Chronicle, 1333–1381 (1927). V Galbraith (ed), Manchester, Manchester University Press

Anonymous of Béthune (1840). *Histoire des ducs de Normandie et des rois d'Angleterre*, F Michel (ed), Paris, Jules Renouard

Beowulf and Other Old English Poems (2011). C Williamson (ed and tr), Philadelphia, University of Pennsylvania Press

Celebrating the Saints (2016). R Atwell (ed), Norwich, Canterbury Press

Croniques de London (1844). G Aungier (ed), London, Camden Society

Chymische Hochzeit Christiani Rosencreutz Anno 1459 (1616). Strasbourg, Lazarus Zetzner

'City Records Relative to the Monument: Court of Common Council, 17 June 1681' (1831). *The Gentleman's Magazine*, p. 150

Confessio fraternitatis (1615). Kassel, Wilhelm Wessel

Correspondance politique de MM. de Castillon et de Marillac, ambassadeurs de France en Angleterre (1537–1542) (1885). J Kaulek (ed), Paris, Félix Alcan

Councils and Synods with Other Documents Relating to the English Church (1981). D Whitelock et al (eds), Oxford, Oxford University Press, 2 vols

Crime and Punishment in England: A Sourcebook (1999). A Barrett and C Harrison (eds), London, UCL Press

Curia Regis Rolls (1922–91). London, HMSO, 17 vols

Decrees of the Ecumenical Councils (1990). N Tanner (ed), London, Sheed & Ward, 2 vols

Depositions Taken the 22nd of October 1688. Before the Privy Council and Peers of England Relating to the Birth of the (Then) Prince of Wales (n.d.). [Npl.], His Majesty's Special Command

Dialogus de Scaccario, and Constitutio Domus Regis/The Dialogue of the Exchequer, and The Establishment of the Royal Household (2007). E Amt and S Church (eds), Oxford, Oxford University Press

Documents on German Foreign Policy, 1918–1945. Series D (1937–1945) (1949–64). London, HMSO. 13 vols

Documents on the History of European Integration (1985–8). W Lipgens and W Loth (eds), Berlin, de Gruyter, 3 vols

Documents Relating to Law and Custom of the Sea (1999). R Marsden (ed), New Jersey, The Lawbook Exchange, 2 vols

Elizabethan Recusant Prose, 1559–1582 (1950). A Southern (ed), London, Sands and Co

Fama fraternitatis (1614). Kassel, Wilhelm Wessel

Gesta stephani regis anglorum (1886). R Howlett (ed), *Rolls Series* 82, 4 vols

Harlequin's Invasion (1781). In *The Vocal Magazine*, p. 141

Historia brittonum (1898). In *Monumenta germaniae historica, auctores antiquissimi*, T Mommsen (ed), Berlin, Weidmann, XIII. 13, pp. 111–222

La Notitia Dignitatum: Nueva Edición Crítica y Comentario Histórico (2005). C Faleiro (ed), Madrid, Consejo Superior de Investigaciones Científica

Le Procès de condamnation de Jeanne d'Arc (1955). J Marchand (ed), Paris, Plon

Le Procès de Jeanne d'Arc (1995). Jean Ratteaud (ed), Paris, Editions du Cadran

Letters and Papers, Foreign and Domestic, of the Reign of Henry VIII (1862–1932). J Brewer et al (eds), London, HMSO, 23 vols

Literature of the Women's Suffrage Campaign in England (2004). C Nelwon (ed), Plymouth, Broadview Press

Memorials of London and London Life in the XIIIth XIVth and XVth Centuries (1868). H Riley (ed), London, Longmans & Co

Original Letters, Illustrative of English History (1969). H Ellis (ed), London, Dawsons, 4 vols

Paston Letters and Papers of the Fifteenth Century (2004). N Davis (ed), Oxford, Oxford University Press, 2 vols

Procès de condamnation et de réhabilitation de Jeanne d'Arc, dite la Pucelle, (1841–9). J Quicherat (ed), Paris, Renquard

Quellen und Untersuchungen zur Geschichte des Hexenwahns und der Hexenverfolgung im Mittelalter (1901). J Hansen (ed), Bonn, Carl Georgi

Readings in European History (1908–9). J Robinson (ed), Boston, Ginn & Company, 2 vols

Select Historical Documents of the Middle Ages (1896). E Henderson (ed), London, George Bell and Sons

Speeches and Documents on Indian Policy 1750–1921 (1922). A Keith (ed), London, Oxford University Press, 2 vols

Statutes and Customs of the Cathedral Church of the Blessed Virgin Mary of Salisbury (1915). C Wordsworth and D Macleane (eds), London, W Clowes

The Anglo-Saxon Chronicle: A Revised Translation (1961). D Whitelock et al (trs), London, Eyre and Spottiswoode

The Babees Book, Aristotle's A B C, Urbanitatis, Stans puer ad mensam, etc. The Bokes of Nurture of H. Rhodes and J. Russell. W. de Worde's Boke of Keruynge, the Booke of Demeanor, the Boke of Curtasye, Seager's Schoole of Vertue, etc. (1868). F Furnivall (ed), London, Early English Text Society

The Battle of Maldon (2015). In *A Choice of Anglo-Saxon Verse* (2015), pp. 48–67

The Black Death (1994). R Horrox (ed and tr), Manchester, Manchester University Press

The Book of Common Prayer: The Texts of 1549, 1599, 1662 (2011). B Cummings (ed), Oxford, Oxford University Press

The Cartulary of the Monastery of St Frideswide at Oxford (1895). S Wigram (ed), Oxford, Clarendon Press, 2 vols

The Communist Manifesto (1976). In Marx and Engels (1976), VI, pp. 477–519

The Constitutional Documents of the Puritan Revolution 1625–1660 (1979). S Gardiner (ed), Oxford, Clarendon Press

The Earliest Life of Gregory the Great (1968). B Colgrave (ed), Cambridge, Cambridge University Press

The Earliest Welsh Poetry (1970). J Clancy (ed and tr), London, Macmillan

The Empire of the Bretaignes', 1175–1688: The Foundations of a Colonial System of Government (1985). F Madden and D Fieldhouse (eds), London, Greenwood

The English Civil War and Revolution: A Sourcebook (1998). K Lindlay (ed), Oxford, Routledge

The Forme of Cury. A Roll of Ancient English Cookery (1780). S Pegge (ed), London, J Nichols

The Hávamál: With Selections from Other Poems of the Edda, Illustrating the Wisdom of the North in Heathen Times (1923). D Martin Clarke (ed), Cambridge, Cambridge University Press

The Holy Bible (1611). London, Robert Barker

The Ledger-Book of Vale Royal Abbey, (1914). J Brownbill (ed), London, Lancashire and Cheshire Record Society

The Letters of Abelard and Heloise (1974). B Radice (ed), New York, Penguin

The Owl and the Nightingale (1972). E Stanley (ed), Manchester, Manchester University Press

The Pontifical of Egbert, Archbishop of York, AD 732–766 (1853). Durham, George Andrews

The Publications of the Pipe Roll Society (1884–). London, Pipe Roll Society

The Seafarer (2015). In *A Choice of Anglo-Saxon Verse* (2015), pp. 188–97

The Spirit of Man. An Anthology in English & French from the Philosophers and Poets (1915). R Bridges (ed), London, Longmans Green

The Trial of Joan of Arc (2005). D Hobbins (ed), London, Harvard University Press

The Trial of Lady Chatterley. Regina v. Penguin Books Limited. The Transcript of the Trial (1961). C Rolph (ed), Harmondsworth, Penguin

The Verona List (1982). In T Barnes, *The New Empire of Diocletian and Constantine*. Cambridge, Harvard University Press. pp. 201–8

The Vindolanda Writing-Tablets (Tabulae Vindolandenses II) (1994). A Bowman and D Thomas (eds and trs), London, British Museum Press

The World War I Reader (2007). M Neiberg (ed), New York, New York University Press

Three Chapters of Letters Relating to the Suppression of Monasteries (1843). T Wright (ed) London, Camden Society

Trattato dei tre impostori: la vita e lo spirito del signore Benedetto de Spinoza (1994). S Berti (ed and tr), Turin, G Einaudi

Writings of the Luddites (2004). K Binfield (ed), Baltimore, Johns Hopkins University Press

Y Gododdin (1970). In *The Earliest Welsh Poetry*, J Clancy (ed and tr), London, Macmillan, pp. 33–64

(4) Primary Sources: Official – Laws, Governmental Publications, Reports, Enquiries, Party Political Materials

Corpus iuris hibernici (1978). D Binchy (ed), Dublin, Dublin Institute for Advanced Studies, 6 vols

Die Gesetze der Angelsachsen (1858). R Schmid (ed), Leipzig, F A Brockhaus

Domesday Book (1976). *Liber de wintonia: Warwickshire*, J Morris et al (eds), Chichester, Phillimore & Co Ltd, XXIII

——— (1978). *Liber de wintonia: Derbyshire*, J Morris et al (eds), Chichester, Phillimore & Co Ltd, XXVII

——— (1986). *Liber de wintonia: Yorkshire*, J Morris et al (eds), Chichester, Phillimore, XXX

Edictus langobardorum, edictus rothari (1868). In *Monumenta germaniae historica, legum*, G Pertz (ed), Hannover, Hahn, IV

Edward VI, King (1547). *Inivnctions Geuen by the Moste Excellente Prince Edwarde the VI.*, London, Richard Grafton

Falkland Islands Review. Report of a Committee of Privy Counsellors. Chairman: the Rt Hon the Lord Franks (1983). London, HMSO

First Report of the Commissioners for the Exhibition of 1851 to the Right Hon. Spencer Horatio Walpole (1852). London, W Clowes and Sons

Geneva Convention Relative to the Protection of Civilian Persons in Time of War (12 August 1949)

If the Invader Comes. What To Do – And How To Do It (1940). Ministry of Information, London

India and the Commonwealth War Graves Commission (2002). Commonwealth War Graves Commission, Maidenhead, 04/02

Iraq – Its Infrastructure of Concealment, Deception and Intimidation (2003). Coalition Information Centre

Iraq's Weapons of Mass Destruction: The Assessment of the British Government (2002). Joint Intelligence Committee, HMSO, ID 114567 9/2002 776073

Liquidity Support Facility for Northern Rock Plc (4 September 2007). Tripartite Statement by HM Treasury, Bank of England and Financial Services Authority

Operation Banner: An Analysis of Military Operations in Northern Ireland (2006). British Army, Prepared under the Direction of the Chief of the General Staff, Army Code 71842, July 2006

Paramilitary Groups in Northern Ireland: An Assessment Commissioned by the Secretary of State for Northern Ireland on the Structure, Role, and Purpose of Paramilitary Groups Focusing on Those Which Declared Ceasefires in Order to Support and Facilitate the Political Process (19 October 2015). MI5 and PSNI

Public Expenditure Statistical Analysis 2018 (July 2018). HMSO, Cm 9648

Public Papers of the Presidents of the United States. George Bush, 2001 (2001). Washington, United States Government Printing Office, 2 vols

Report and Accounts for the Year Ended 31 December 2019 (2020). Communist Party of Britain

Report of the Inquiry into the Collapse of Flats at Ronan Point, Canning Town (1968). H Griffiths et al, London, HMSO

Russia (21 July 2020). Intelligence and Security Committee of Parliament, HC 632, HMSO

Saville, Lord (2010). *Report of the Bloody Sunday Inquiry.* London, TSO, 11 vols

Statutes of the Realm 1101–1713 (1810–28). London, Britain Record Commission, 11 vols

Strong Leadership. A Clear Economic Plan. A Brighter, More Secure Future (2015). Conservatives, London, St Ives PLC

The Atomic Bombings of Hiroshima and Nagasaki (1946). United States Army/The Manhattan Engineer District

The Dooms of the City of London (1849). In J Kemble, *The Saxons in England: A History of the English Commonwealth till the Period of the Norman Conquest*, London, Longman, Brown, Green, and Longmans, ii, app. A, pp. 521–7

The IRA: Finance and Weapons: Fund-Raising (26 May 1983). Public Record Office of Northern Ireland, NIO/12/525A

The Jewish National Home in Palestine: Hearings Before the Committee on Foreign Affairs (1944). Washington, Government Printing Office

Tudor Constitutional Documents AD 1485–1603 with an Historical Commentary (1930). J Tanner (ed), Cambridge, Cambridge University Press

UK Armed Forces Operational Deaths Post World War II (26 March 2015). Ministry of Defence, Defence Statistics (Health), Bristol

UK Election Statistics: 1918–2019: A Century of Elections (2020). L Audickas et al (2020), House of Commons Library: Briefing Paper CBP7529

United Nations Security Council (1990). S/RES/678, 29 November 1990

—— (1991). S/RES/687, 6 April 1991

—— (2002). S/RES/1441, 8 November 2002

White Paper. Palestine. Statement of Policy (1939). London, HMSO, cmd 6019

Widgery, Lord (1972). *Report of the Tribunal Appointed to Inquire into the Events on Sunday, 30 January 1972, Which Led to Loss of Life in Connection with the Procession in Londonderry on That Day*, London, HMSO

Wild Bird Populations in the UK, 1970 to 2018 (2020). Department for Environment, Food and Rural Affairs, York, Biodiversity Statistics Team

(5) Secondary Sources: Reference –
Dictionaries, Encyclopaedias, Catalogues

A Dictionary of Greek and Roman Antiquities (1875). W Smith (ed), London, John Murray

Damon S (1979). *A Blake Dictionary: The Ideas and Symbols of William Blake*, London, Thames and Hudson

Dictionary of Greek and Roman Geography (1856–7). W Smith (ed), London, Walton and Maberly, John Murray, 2 vols

Dictionary of National Biography (1908–). L Stephen and S Lee (eds), London, Smith, Elder & Co, 63 vols

Duffy S (2005). *Medieval Ireland: An Encyclopedia*, Oxford, Routledge

Eddleston J (2001). *Jack the Ripper. An Encyclopedia*, Oxford, ABC-Clio

Encyclopedia of Romanticism (Routledge Revivals): Culture in Britain, 1780s–1830s (1992). L Dabundo (ed), Oxford, Routledge

Encyclopedia of the Age of Political Revolutions and New Ideologies, 1760–1815 (2007). G Fremont-Barnes (ed), Westport, Greenwood Press

Encyclopedia of the Black Death (2012). J Byrne (ed), Oxford, ABC-Clio

Faiths and Folklore. A Dictionary of National Beliefs, Superstitions and Popular Customs, Past and Current, with Their Classical amd Foreign Analogues Described and Illustrated (1905). C Hazlitt (ed), London, Reeves and Turner, 2 vols

Oxford Dictionary of Modern Quotations (2007). E Knowles (ed), Oxford, Oxford University Press

Safire W (2008). *Safire's Political Dictionary*, Oxford, Oxford University Press

The Encyclopedia of Medieval Literature in Britain (2017). S Echard et al (eds), Oxford, Wiley Blackwell

The European Powers in the First World War: An Encyclopedia (1996). S Tucker (ed), Abingdon, Routledge

The Historical Encyclopedia of World Slavery (1997). J Rodriguez (ed), Oxford, ABC-CLIO, 2 vols

The London Encyclopaedia (2008). B Weinreb et al (eds), London, Macmillan

The Official Descriptive and Illustrated Catalogue of the Great Exhibition of the Works of Industry of all Nations (1851). London, Spicer Brothers

The Victoria History of the County of Somerset (1911). W Page et al (eds), London, Archibald Constable

Wagner J (1999). *Historical Dictionary of the Elizabethan World*, Oxford, Routledge

Women and Gender in Medieval Europe: An Encyclopedia (2006). M Schaus (ed), London, Routledge

(6) Secondary Sources: Studies – Books and Articles

Abbott M and H Anderson-Whymark (2012). *Stonehenge Laser Scan: Archaeological Analysis Report*, English Heritage Research Department Report Series 32, Portsmouth, English Heritage

Adams I (1988). *Ideology and Politics in Britain Today*, Manchester, Manchester University Press

Adlam R (2020). *Brexit: Causes and Consequences*, Prien, Springer

Aldrich R (2010). *GCHQ*, London, HarperPress

Alex-Tweedie E (1908). *Hyde Park*, London, Eveleigh Nash

Alibek K et al (1999). *Biohazard: The Chilling True Story of the Largest Covert Biological Weapons Program in the World – Told from the Inside by the Man Who Ran It*, New York, Random House

Allawi A (2014). *Faisal I of Iraq*, London, Yale University Press

Anderson A (1997). *The Treatise of the Three Impostors and the Problem of Enlightenment*, Oxford, Bowman and Littlefield

Andrew C (2009). *The Defence of the Realm: The Authorized History of MI5*, London, Allen Lane

Andrew C and V Mitrokhin (1999). *The Mitrokhin Archive: The KGB in Europe and the West*, London, Allen Lane

Andrew J and J Allen (2009). 'A Confirmation of the Location of the 1712 'Dudley Castle' Newcomen Engine at Coneygree, Tipton', *The International Journal for the History of Engineering and Technology*, 79:2, pp. 174–82

Apel W (1990). *Gregorian Chant*, Bloomington, Indiana University Press

Arnold C (2017). *Edward VII: The Prince of Wales and the Women He Loved*, London, St Martin's Press

Ash P and Robinson D (2010). *The Emergence of Humans: An Exploration of the Evolutionary Timeline*, Chichester, Wiley-Blackwell

Ashdown P (2010). *The Lord Was at Glastonbury: Somerset and the Jesus Voyage Story*, Glastonbury, Squeeze Press

Ashton N et al (2014). *Hominin Footprints from Early Pleistocene Deposits at Happisburgh, UK. PLoS One* 9(2): e8832

Atkin M (2015). *Fighting Nazi Occupation: British Resistance 1939–1945*, Barnsley, Pen and Sword

Aughey A (2005). *The Politics of Northern Ireland: Beyond the Belfast Agreement*, Oxford, Routledge

Aughey A and J Oakland (2013). *Irish Civilization: An Introduction*, Oxford, Routledge

Ayers T (2000). *Salisbury Cathedral: The West Front: A History and Study in Conservation*, Chichester, Phillimore

Babbage C (1830). *Reflections on the Decline of Science in England, and on Some of Its Causes*, London, B Fellowes & J Booth

—— (1851). *The Exposition of 1851: Or, Views of the Industry, the Science and the Government of England*, London, John Murray

Bacon E (1897). *Benin: The City of Blood*, London, Edward Arnold

Baggott J (2015). *Origins: The Scientific Story of Creation*, Oxford, Oxford University Press

Bagnell A (1829). *Antiquated Scrupulosity Contrasted with Modern Liberality*, London, C & J Rivington

Bahn P (2005). 'Creswell Crags. Discovering Cave Art in Britain', *Current Archaeology*, 197, pp. 217–26

Bailey M (2007). *Magic and Superstition in Europe: A Concise History from Antiquity to the Present*, Plymouth, Bowman and Littlefield

Baker P (2002). *Polari: The Lost Language of Gay Men*, London, Routledge

Balfour A (2019). *The Walls of Jerusalem: Preserving the Past, Controlling the Future*, Hoboken, Wiley Blackwell

Baltzer R (1987). 'Notre Dame Manuscripts and Their Owners: Lost and Found', *The Journal of Musicology*, 5:3, pp. 380–99

Banfield S (1988). *Sensibility and English Song: Critical Studies of the Early 20th Century*, Cambridge, Cambridge University Press

Barber M (1993). *The Trial of the Templars*, Cambridge, Cambridge University Press

Barker N (1992). *Aldus Manutius and the Development of Greek Script & Type in the Fifteenth Century*, New York, Fordham University Press

Barry J (2012). *Witchcraft and Demonology in South-West England, 1640–1789*, Basingstoke, Palgrave Macmillan

Bartlett T and K Jeffrey (eds) (1997). *A Military History of Ireland*, Cambridge, Cambridge University Press

Bar-Yosef C (1994). 'The Lower Paleolithic of the Near East', *Journal of World Prehistory*, 8, pp. 211–65

Baskin J et al (1997). *A History of Corporate Finance*, Cambridge, Cambridge University Press

Bates D (2016). *William the Conqueror*, New Haven and London, Yale University Press

Bauer A (2003). *Runengedichte. Texte, Untersuchungen und Kommentare zur gesamten Überlieferung*, Studia Medievalia Septentrionalia 9, Vienna, Fassbaender

Beck P (2014). *The Falkland Islands as an International Problem*, Abingdon, Routledge

Beckett I (2019). *Rorke's Drift and Isandlwana*, Oxford, Oxford University Press

Beckett I and K Simpson (eds) (2004). *A Nation in Arms: The British Army in the First World War*, Barnsley, Pen and Sword Select

Beer B (1982). *Rebellion and Riot: Popular Disorder in England During the Reign of Edward VI*, Kent, Kent State University Press

Beer J (2005). *William Blake: A Literary Life*, Basingstoke, Palgrave Macmillan

Begg P and J Bennett (2013). *The Complete and Essential Jack the Ripper*, London, Penguin

Bell W (2008). 'Arab Revolt of 1936–1939', in *The Encyclopedia of the Arab–Israeli Conflict: A Political, Social, and Military History*, S Tucker (ed), I, Oxford, ABC-Clio, pp. 135–7

Bennett M (2006). *Oliver Cromwell*, Abingdon, Routledge

Benton J (2014). *John Baskerville, Type-Founder and Printer, 1706–1775*, Cambridge, Cambridge University Press

Bettey J (1989). *The Suppression of the Monasteries in the West Country*, Gloucester, Alan Sutton

Bew P (2016). *Churchill and Ireland*, Oxford, Oxford University Press

Bieler L (1948). 'The Mission of Palladius: A Comparative Study of Sources', *Traditio*, 6, pp. 1–32

Bitel L (2009). *Landscape with Two Saints. How Genovefa of Paris and Brigit of Kildare Built Christianity in Barbarian Europe*, Oxford, Oxford University Press

Blake N (1991). *William Caxton and English Literary Culture*. London, The Hambledon Press

Blumenberg W (1972). *Karl Marx: An Illustrated Biography*, D Scott (tr), London, NLB

Boardman A (2009). *Towton: The Bloodiest Battle*, Stroud, Sutton

Boatwright M (2000). *Hadrian and the Cities of the Roman Empire*, Oxford, Princeton

Bogdan H (2007). *Western Esotericism and Rituals of Initiation*, Albany, State University of New York Press

Borman T (2013). *Witches: A Tale of Sorcery, Scandal and Seduction*, London, Jonathan Cape

Borneman W (2006). *The French and Indian War: Deciding the Fate of North America*, New York, Harper Collins

Bos B and E (eds) (2007). *AGI: Graphic Design Since 1950*, London, Thames & Hudson

Bowden B (ed) (1953). *Faster Than Thought: A Symposium of Digital Computing Machines*, London, Sir Isaac Pitman & Sons

Bowie K (2003). 'Public Opinion, Popular Politics and the Union of 1707', *The Scottish Historical Review*, 82:214:2, pp. 226–60

Bowman M (2014). *Battlefield Bombers: Deep Sea Attack*, Barnsley, Pen and Sword

Bowman T (2007). *Carson's Army: The Ulster Volunteer Force, 1910–22*, Manchester, Manchester University Press

Breay C (2015). *The St Cuthbert Gospel. Studies on the Insular Manuscript of the Gospel of John*, London, British Library

Breay C and J Story (eds) (2018). *Anglo-Saxon Kingdoms. Art, Word, War*, London, British Library

Brent Dalrymple G (1991). *The Age of the Earth*, Stanford, Stanford University Press

Brock D et al (2019). *Power and Everyday Practices*, London, University of Toronto Press

Brody A and R King (2013). 'Genetics and the Archaeology of Ancient Israel', *Human Biology Open Access Pre-Prints*, 44, pp. 1–31

Brooks N (2000). 'The English Origin Myth', in N Brooks (ed), *Anglo-Saxon Myths, State and Church, 400–1066*, London, Hambledon Press, pp. 79–89

Brooks S (2008). 'Deir Yassin Massacre', in *The Encyclopedia of the Arab-Israeli Conflict: A Political, Social, and Military History*, S Tucker (ed), Oxford, ABC-CLIO, I, p. 297

Bround D (2011). *The Reality Behind Charter Diplomatic in Anglo-Norman Britain*. Glasgow, University of Glasgow

Bruce-Mitford R (1975). *The Sutton Hoo Ship-Burial, Volume 1: Excavations, Background, the Ship, Dating and Inventory*, London, British Museum Publications

Brundage J (1987). *Law, Sex and Christian Society in Medieval Europe*, London, University of Chicago Press

Bruni D (2018). *The British Political Parties and the Falklands War*, London, Palgrave Macmillan

Bryant M (2016). '"The Progress of Civilization": The Pedimental Sculpture of the British Museum by Richard Westmacott', *Sculpture Journal*, 25:3, pp. 315–27

Bucholz R and N Key (2009). *Early Modern England 1485–1714: A Narrative History*, Oxford, Wiley-Blackwell

Bullock S (1996). *Revolutionary Brotherhood: Freemasonry and the Transformation of the American Social Order 1730–1840*, Chapel Hill, University of North Carolina Press

Bullock-Davies C (1978). *Menestrellorum Multitudo: Minstrels at a Royal Feast*, Cardiff, University of Wales Press

Burl A (2000). *The Stone Circles of Britain, Ireland and Brittany*, New Haven, Yale University Press

Burnham G et al (2006). 'Mortality After the 2003 Invasion of Iraq: A Cross-sectional Cluster Sample Survey', *The Lancet*, 368:9545, pp. 421–8

Bushnell Jr D (1906). 'The Sloane Collection in the British Museum', *American Anthropologist*, New Series 8:4, pp. 671–85

Byron A (1863). 'Sketch of the Analytical Engine Invented by Charles Babbage Esq. By L F Menabrea, of Turin, Officer of the Military Engineers [From the Bibliothèque Universelle de Génève, No, 82, October 1842]', *Scientific Memoirs, Selected from The Transactions of Foreign Academies of Science and Learned Societies and from Foreign Journals*, R Taylor (ed), London, Richard and John E Taylor, vol. 3, article 29, pp. 666–731, Notes by the Translator, pp. 691–731

Cairncross J (1974). *After Polygamy Was Made a Sin: The Social History of Christian Polygamy*, London, Routledge & Kegan Paul

Camp J (1988). *In Praise of Bells: The Folklore and Traditions of British Bells*, London, Hale

Campbell J (2000). *The Anglo-Saxon State*, London, Hambledon and London

Campbell J (2012). 'Was Sir Christopher Wren a Freemason?', *Freemasonry Today*, 18, Summer, pp. 36–8

Campos M (2007). 'Remembering Jewish-Arab Contact and Conflict', in S Sufian and M LeVine (eds) *Reapproaching Borders: New Perspectives on the Study of Israel-Palestine*, Plymouth, Rowman & Littlefield, pp. 41–65

Capp B (2012). *England's Culture Wars, Puritan Reformation and its Enemies in the Interregnum, 1649–1660*, Oxford, Oxford University Press

Carley J (2001). *Glastonbury Abbey and the Arthurian Tradition*, Cambridge, D S Brewer

Carpenter D (1990). *The Minority of Henry III*, London, Methuen

—— (2015). *Magna Carta*, London, Penguin Classics

—— (2020). *Henry III: The Rise to Power and Personal Rule, 1207–1258*, London, Yale University Press

Carpenter W (1831). *The People's Book Comprising Their Chartered Rights*, London, W Strange

Carter M (2001). *Anthony Blunt: His Lives*, London, Macmillan

Cartlidge N (2010). 'Nicholas of Guildford and The Owl and the Nightingale', *Medium Ævum*, 79:1, pp. 14–24

Castillejo D (1981). *The Expanding Force in Newton's Cosmos*, Madrid, Ediciones de arte y bibliofilia

Caygill M (1992). *The Story of the British Museum*, London, British Museum Press

Chandler D and Beckett I (eds) (1994). *The Oxford History of the British Army*, Oxford, Oxford University Press

Chaplais P (2003). *English Diplomatic Practice in the Middle Ages*, London, Hambledon and London

Charles-Edwards T (1978). 'The Authenticity of the Gododdin, the Historian's View', *Astudiaethau ar yr Hengerdd / Studies in Old Welsh Poetry*, R Bromwich and R Jones (eds), Cardiff, University of Wales Press, pp. 44–71

—— (1991). 'The Arthur of History', *The Arthur of the Welsh: The Arthurian Legend in Medieval Welsh Literature*, Cardiff, University of Wales Press, pp. 15–32

—— (2013). *Wales and the Britons, 350–1064*, Oxford, Oxford University Press

—— (2017). 'Annales cambriae', in *The Encyclopedia of Medieval Literature in Britain* (2017)

Cheshire E (1854). 'The Results of the Census of Great Britain in 1851, with a Description of the Machinery and Processes Employed to Obtain the Returns; also an Appendix of Tables of Reference', *Journal of the Statistical Society of London*, 17:1, pp. 45–72

Chetwode Crawley W (1895). 'Notes on Irish Freemasonry', *Ars Quatuor Coronatorum*, 8, pp. 53–7

Childs J (2007). *The Williamite Wars in Ireland, 1688–1691*, London, Hambledon Continuum

Christianson G (1996). *Isaac Newton and the Scientific Revolution*, Oxford, Oxford University Press

Clark G (1956). *The Later Stuarts, 1660–1714*. Oxford, Oxford University Press

Clark J (1978). *Excavations at Star Carr: An Early Mesolithic Site at Seamer Near Scarborough, Yorkshire*, Cambridge, Cambridge University Press

Clarke H (2015). 'Planning and Regulation in the Formation of New Towns and New Quarters in Ireland, 1170–1641', in *Lords and Towns in Medieval Europe: The European Historic Towns Atlas Project*, H Clarke and A Simms (eds), Oxford, Routledge, pp. 321–53

Clarke H et al (2017). *Brexit. Why Britain Voted to Leave the European Union*, Cambridge, Cambridge University Press

Clarke P (2007). *The Interdict in the Thirteenth Century: A Question of Collective Guilt*, Oxford, Oxford University Press

Cleveland H and T Huertas (1979). 'Stagflation: How We Got into It, How to Get Out', *Foreign Affairs*, 58:1, pp. 103–20

Cobbett W (1852). *A History of the Reformation in England and Ireland in a Series of Letters*, Baltimore. J Murphy & Co

Cohen K (1973). *Metamorphosis of a Death Symbol. The Transi Tomb in the Late Middle Ages and the Renaissance*, London, University of California Press

Cohen M (2014). *Britain's Moment in Palestine: Retrospect and Perspectives, 1917–1948*, Abingdon, Routledge

Cole J (1965). *Lord Haw-Haw – and William Joyce: The Full Story*, London, Farrar, Straus and Giroux

Colquhoun K (2007). *Taste: The Story of Britain through Its Cooking*, London, Bloomsbury

Colton L (2017). *Angel Song: Medieval English Music in History*, London, Routledge

Conder E (1895). 'The Hon. Miss St. Leger and Freemasonry', *Ars Quatuor Coronatorum*, 8, pp. 16–23

Connor P (1986). 'The Structure of the Exeter Book Codex (Exeter, Cathedral Library, MS 3501)', *Scriptorium*, 40:2, pp. 233–42

Constable G (1998). 'The Orders of Society', in *Three Studies in Medieval Religious and Social Thought*, Cambridge, Cambridge University Press, pp. 249–360

Copeland J (2006). 'Machine Against Machine', in B Copeland (ed), *Colossus: The Secrets of Bletchley Park's Codebreaking Computers*, Oxford, Oxford University Press, pp. 64–77

Cordingly D (1995). *Life Among the Pirates: The Romance and the Reality*, London, Little, Brown

Corthorn P (2019). *Enoch Powell: Politics and Ideas in Modern Britain*, Oxford, Oxford University Press

Cottesloe, The Lord (1930). 'The Earliest "Establishment" – 1661 – of the British Standing Army', *Journal of the Society for Army Historical Research*, 9:37, pp. 147–61

Courtois S et al (1999). *The Black Book of Communism. Crimes, Terror, Repression*, J Murphy and M Kramer (trs), Cambridge, Harvard University Press

Cowdrey H (1969). 'Bishop Ermenfrid of Sion and the Penitential Ordinance Following the Battle of Hastings', *The Journal of Ecclesiastical History*, 20:2, pp. 225–42

Cox R (1982). *Operation Sealion*, London, Arrow

Coyle G (2010). *The Riches Beneath Our Feet. How Mining Shaped Britain*, Oxford, Oxford University Press

Cranbrook, Lord, G Hardy (1981). *The Diary of Gathorne Hardy, Later Lord Cranbrook, 1866–1892: Political Selections*, N Johnson (ed), Oxford, Clarendon Press

Cressy D (2018). *Gypsies: An English History*, Oxford, Oxford University Press

Crosland S (1982). *Tony Crosland*, London, Jonathan Cape

Cunliffe B (1966). 'The Temple of Sulis Minerva at Bath', *Antiquity*, 40:159, pp. 199–204

Curtis R (1983). 'In Defense of Garum', *The Classical Journal*, 78:3, pp. 232–40

Cusack C (2007). 'Brigit: Goddess, Saint, "Holy Woman", and Bone of Contention', in *On a Panegyrical Note: Studies in Honour of Garry W Trompf*, V Barker and F Di Lauro (eds), Sydney, University of Sydney, pp. 75–97

David S (2004). *Zulu: The Heroism and Tragedy of the Zulu War of 1879*, London, Viking

Davies F and G Maddocks (2014). *Bloody Red Tabs: General Officer Casualties of the Great War 1914–1918*, Barnsley, Pen & Sword Military

Davis M (1977). *William Blake: A New Kind of Man*, Berkeley, University of California Press

Davis P (1992). 'William Blake', in *Encyclopedia of Romanticism* (1992), pp. 44–51

de Beer G (1953). *Sir Hans Sloane and the British Museum*, Oxford, Oxford University Press

Deliyannis D (2010). *Ravenna in Late Antiquity*, Cambridge, Cambridge University Press

DellaPergola, S (2003). 'Demographic Trends in Israel and Palestine: Prospects and Policy Implications', *The American Jewish Year Book*, 103, pp. 3–68

Derry C (2020). *Lesbianism and the Criminal Law. Three Centuries of Legal Regulation in England and Wales*, Cham, Palgrave Macmillan

Derwent S (2006). *Kwazulu-Natal Heritage Sites*, Claremont, David Philip

Dibble J and C Hubert (1992). *Parry: His Life and Music*, Oxford, Oxford University Press

Dickon C (2014). *Americans at War in Foreign Forces: A History, 1914–1945*, Jefferson, McFarland & Company

Dobbs B (1988). *The Foundations of Newton's Alchemy. Or "The Hunting of the Greene Lyon"*, Cambridge, Cambridge University Press

Dolan A (2006). 'Killing and Bloody Sunday, November 1920', *The Historical Journal*, 49:3, pp. 789–810

Dolan T (1999). 'Writing in Ireland', in D Wallace (ed), *The Cambridge History of Medieval English Literature*, Cambridge, Cambridge University Press, pp. 208–28

Donagan B (1994). 'Did Ministers Matter? War and Religion in England, 1642–1649', *Journal of British Studies*, 33:2, pp. 119–56

Doran S (1994). *Elizabeth I and Religion 1558–1603*, London, Routledge

—— (1996). *Monarchy and Matrimony: The Courtships of Elizabeth I*, London, Routledge

Downham C (2004). 'Vikings' Settlements in Ireland Before 1014', in J Viðar Sigurðsson and T Bolton (eds), *Celtic-Norse Relationships in the Irish Sea in the Middle Ages 800–1200*, Leiden, Brill, pp. 1–22

Draper A (1979). *Operation Fish: The Race to Save Europe's Wealth, 1939–1945*, London, Cassell

Duffy E (2005). *The Stripping of the Altars: Traditional Religion in England c. 1400–c. 1580*, New Haven and London, Yale University Press

—— (2018). 'The Rise of Sacred Song', in *Royal Books and Holy Bones*, London, Bloomsbury, pp. 87–96

Duffy S (2013). *Brian Boru and the Battle of Clontarf*, Dublin, Gill & Macmillan

Duggan A (2016). '*Sicut ex scriptis vestris accepimus*: Innocent II and the *insulae britanniae et hiberniae*', in *Pope Innocent II (1130–43): The World vs the City*, J Doran and D Smith (eds), London and New York, Routledge, pp. 69–106

Durant W (1961). *The Story of Philosophy*, London, Simon and Schuster

Edwardes S and S Garrett (1995). *Mughal Rule in India*, New Delhi, Atlantic

Ellis S (1998). *Ireland in the Age of the Tudors, 1447–1603: English Expansion and the End of Gaelic Rule*, London, Longman

Engels F (1845). *Die Lage der arbeitenden Klasse in England*, Leipzig, Otto Wigand

—— (1888). *Ludwig Feuerbach und der Ausgang der Klassischen deutschen Philosophie . . . Mit Anhang Karl Marx über Feuerbach von Jahre 1845*. Berlin, J Dietz

English R (2004). *Armed Struggle: The History of the IRA*, London, Pan

Epstein S (1991). *Wage Labor and Guilds in Medieval Europe*, London, The University of North Carolina Press

Erikson E (2014). *Between Monopoly and Free Trade: The English East India Company, 1600–1757*, Oxford, Princeton University Press

Essick R (1991). 'William Blake, Thomas Paine, and Biblical Revolution', *Studies in Romanticism*, 30:2, pp. 189–212

Evans A (1986). *The Sutton Hoo Ship Burial*, London, British Museum Publications

Evans M (2004). *Invasion! Operation Sealion 1940*. London, Pearson Longman

Ezra K (1992). *Royal Art of Benin*, New York, The Metropolitan Museum of Art

Fairbanks White D (2006). *Bitter Ocean: The Battle of the Atlantic, 1939–1945*, New York, Simon & Schuster

Fairchild H (1940). 'The Romantic Movement in England', *PMLA*, 55:1, pp. 20–6

Faletra M (2012). 'Merlin in Cornwall: The Source and Contexts of John of Cornwall's Prophetia Merlini'. *The Journal of English and Germanic Philology*, 3:3, pp. 304–38

Farran C (1951). 'The Royal Marriages Act, 1772', *The Modern Law Review*, 14, pp. 53–63

Fay C (1951). *Palaces of Industry, 1851: A Study of the Great Exhibition and its Fruits*, Cambridge, Cambridge University Press

Fido M (1987). *The Crimes, Detection and Death of Jack the Ripper*, London, Weidenfeld & Nicolson

Field C (2008). 'A Shilling for Queen Elizabeth: The Era of State Regulation of Church Attendance in England, 1552–1969', *Journal of Church and State*, 50:2, pp. 213–53

Fielding N (2016). *The National Front*, Abingdon, Routledge

Fishman N (1994). *The British Communist Party and the Trade Unions, 1933–45*, Aldershot, Scolar Press

Fitton R (1989). *The Arkwrights: Spinner of Fortune*, Manchester, Manchester University Press

Fitzpatrick A (2011). *The Amesbury Archer and the Boscombe Bowmen, Bell Beaker Burials at Boscombe Down, Amesbury, Wiltshire*, Salisbury, Wessex Archaeology

FitzRoy R (1863). *The Weather Book. A Manual of Practical Meteorology*, London, Longman, Green, Longman, Roberts, & Green

Fletcher A (1999). 'The Genesis of "The Owl and the Nightingale": A New Hypothesis', *The Chaucer Review*, 34:1, pp. 1–17

Flierman R (2017). *Saxon Identities, AD 150–900*, London, Bloomsbury

Florato V et al (2000). *Blood Red Roses*. Oxford, Oxbow Books

Foster R (1988). *Modern Ireland 1600–1972*, London. Allen Lane

Fournier P-S (1764–6). *Manuel typographique*, Paris, J Barbou, 2 vols

Fowler H (1885). 'Ashwell, and its Parish Church of S. Mary', *Transactions of the S. Albans Architectural & Archaeological Society*, pp. 14–24

Fowler P (1983). *The Farming of Prehistoric Britain*, Cambridge, Cambridge University Press

Fowler W (1899). *The Roman Festivals of the Period of the Republic. An Introduction to the Study of the Religion of the Romans*, London, Macmillan and Co

Fradin D (1998). *Samuel Adams: the Father of American Independence*, New York, Clarion

Frank R (1984). 'Viking Atrocity and Skaldic Verse: The Rite of the Blood-Eagle', *English Historical Review*, 99:391, pp. 332–43

Fredette R (2007). *The Sky on Fire: The First Battle of Britain, 1917–1918*, Tuscaloosa, University of Alabama Press

Freedman L (2005). *The Official History of the Falklands Campaign*, London, Routledge, 2 vols

Freitag B (2004). *Sheela-na-gigs: Unravelling an Enigma*, Oxford, Routledge

French C et al (2012). 'Durrington Walls to West Amesbury by Way of Stonehenge: A Major Transformation of the Holocene landscape', *Antiquaries Journal* 92, pp. 1–36

Frere S (1967). *Britannia. A History of Roman Britain*, London, Routledge & Kegan Paul

Frogley A and A Thomson (2013). *The Cambridge Companion to Vaughan Williams*, Cambridge, Cambridge University Press

Frye S (1992). 'The Myth of Elizabeth at Tilbury', *The Sixteenth Century Journal*, 23:1, pp. 95–114

Gabriel M (2011). *Love and Capital: Karl and Jenny Marx and the Birth of a Revolution*, London, Little, Brown

Gasquet F (1895). *The Last Abbot of Glastonbury and his Companions: A Historical Sketch*, London, Simpkin Marshall, Hamilton, Kent & Co

Gamberini A (2014). 'Milan and Lombardy in the Era of the Visconti and the Sforza', in *A Companion to Late Medieval and Early Modern Milan, The Distinctive Features of an Italian State*, A Gamberini (ed), Leiden, Boston, Brill

Gentles I (1992). *The New Model Army in England, Ireland, and Scotland, 1645–1653*, Oxford, Blackwell

—— (2007). *The English Revolution and the Wars in the Three Kingdoms, 1638–1652*, Abingdon, Routledge

Gibson M (1999). *Reading Witchcraft*, London, Routledge

—— (ed) (2003). *Witchcraft and Society in England and America, 1550–1750*, London, Continuum

Gibson M et al (eds) (1992). *The Eadwine Psalter: Text, Image, and Monastic Culture in Twelfth-Century Canterbury*, The Modern Humanities Research Association, London

Gilbert M (2000). *Churchill: A Life*, London, Pimlico

Gilchrist A (1862). *Life of William Blake: 'Pictor Ignotus'*, London, Macmillan and Co, 2 vols

Giles M (2012). *A Forged Glamour: Landscape, Identity and Material Culture in the Iron Age*, Oxford, Windgather Press

Gillies J and R Cailliau (2002). *How the Web was Born: The Story of the World Wide Web*, Oxford, Oxford University Press

Gillingham J (1993). 'The English Invasion of Ireland', in *Representing Ireland: Literature and the Origins of Conflict, 1534–1660*, B Bradshaw et al (eds), Cambridge, Cambridge University Press, pp. 24–42

—— (1999). *Richard I*, New Haven and London, Yale University Press

Gittos H (2013). *Liturgy, Architecture, and Sacred Places in Anglo-Saxon England*, Oxford, Oxford University Press

Gnuse R (1997). *No Other Gods: Emergent Monotheism in Israel*, Sheffield, Sheffield Academic Press

Godfrey J (1979). 'The Defeated Anglo-Saxons Take Service with the Eastern Emperor', *Proceedings of the Battle Conference 1978*, R Allen-Brown (ed), Woodbridge, Ipswich, The Boydell Press, pp. 63–74

Goff P et al (2014). *The Bible in American Life*, Indiana University and Purdue University Indianapolis, The Center for the Study of Religion and American Culture

Gold C (2012). *The King's Mistress*, London, Quercus

—— (2018). *King of the North Wind: The Life of Henry II in Five Acts*, London, William Collins

Golden C (2009). *Posting It. The Victorian Revolution in Letter Writing*, Gainesville, University Press of Florida

Goldsworthy A (1996). *The Roman Army at War, 100 BC–AD 200*, Oxford, Clarendon Press

Gómez de la Serna R (1929). 'Completa y verídica historia de Picasso y el cubismo', *Revista de Occidente*, 73, pp. 63–102

Goodacre J (2013a). 'Witchcraft in Scotland', in *The Oxford Handbook of Witchcraft in Early Modern Europe and Colonial America*, B Levack (ed), Oxford, Oxford University Press, pp. 300–17

—— (2013b). *Scottish Witches and Witch-Hunters*, Basingstoke, Palgrave Macmillan

Goodwin G (2011). 'The Battle of Towton', *History Today*, 61:5, pp. 37–41

Goold Walker G (1986). *The Honourable Artillery Company, 1537–1947*. London, The Honourable Artillery Company

Goos G and J Hartmanis (1981). *The Programming Language Ada: Reference Manual*, New York, United States Department of Defence

Gottfried R (1983). *The Black Death: Natural and Human Disaster in Medieval Europe*, London, The Free Press

Gotti M (1999). *The Language of Thieves and Vagabonds: 17th and 18th Century Canting Lexicography in England*, Tübingen, Max Niemeyer

Gould T (1999). *Imperial Warriors: Britain and the Gurkhas*, London, Granta

Graham J (1965). 'The Slave Trade, Depopulation and Human Sacrifice in Benin History', *Cahiers d'Études Africaines*, 18, pp. 317–34

Graham-Campbell J (2001). 'The Northern Hoards: From Cuerdale to Bossall/Flaxton', in *Edward the Elder, 899–924*, N Higham and D Hill (eds), Oxford, Routledge

Grainger J (2005). *The Battle of Yorktown, 1781: A Reassessment*, Woodbridge, The Boydell Press

Grainger S (2018). 'Garum and Liquamen, What's in a Name?', *Journal of Maritime Archaeology*, 13, pp. 247–61

Green J (1997). '"I My Self": Queen Elizabeth I's Oration at Tilbury Camp', *Sixteenth Century Journal*, 28:2, pp. 421–45

Green J (2006). *Henry I, King of England and Duke of Normandy*, Cambridge, Cambridge University Press

Green W (1931). 'The Lupercalia in the Fifth Century', *Classical Philology*, 26:1, pp. 60–9

Gray E (1994). *The U-Boat War 1914–1918*, London, Leo Cooper

Griffiths P (2009). *Sprawling Wargames Multiplayer Wargaming*, [n.pl.], Lulu

Gristwood S (2016). *Game of Queens: The Women who Made Sixteenth-Century Europe*, London, Oneworld

Gupta B (1962). *Sirajuddaullah and the East India Company, 1756–1757: Background to the Foundation of British Power in India*, Leiden, Brill

Gustafson L (1988). *The Sovereignty Dispute Over the Falkland (Malvinas) Islands*. New York: Oxford University Press

Guy B (2015). 'The Origins of the Compilation of Welsh Historical Texts in Harley 3859', *Studia Celtica*, 49, pp. 21–56

Hadfield C (1984). *British Canals: An Illustrated History*, Newton Abbot, David & Charles

Haines R (2003). *King Edward II: His Life, His Reign, and Its Aftermath, 1284–1330*, London, McGill-Queen's University Press

Haley A (1992). *Typographic Milestones*, Hoboken, John Wiley & Sons Inc

Halgron D (2009). '"Caring" John Major: Portrait of a Thatcherite As One-Nation Tory', *Observatoire de la société britannique*, 7, pp. 177–96

Hallahan W (1999). *The Day the American Revolution Began: 19 April 1775*, New York, Avon Books

Halliwell J (1840). *The Early History of Freemasonry in England*, London, Thomas Rodd

Hallmann C et al (2017). 'More than 75 Percent Decline over 27 Years in Total Flying Insect Biomass in Protected Areas', *PloS ONE*, 12(10): e0185809.

Hanford J (1913). 'The Mediæval Debate between Wine and Water', *Publications of the Modern Language Association of America*, 28:3, pp. 315–67

Hanks D and J Brogdon (2000). *The Social and Literary Contexts of Malory's Morte Darthur*, Woodbridge, D S Brewer

Hansen R (1999). 'The Kenyan Asians, British Politics, and the Commonwealth Immigrants Act, 1968', *The Historical Journal*, 42:3, pp. 809–34

—— (2000). *Citizenship and Immigration in Post-war Britain. The Institutional Origins of a Multicultural Nation*, Oxford, Oxford University Press

Harding, A (2000). *European Societies in the Bronze Age*, Cambridge World Archaeology, Cambridge, Cambridge University Press

Hargrave O (1982). 'Bloody Mary's Victims: The Iconography of John Foxe's Book of Martyrs', *Historical Magazine of the Protestant Episcopal Church*. 51:1, pp. 7–21

Harris M (2011). *Sacred Folly: A New History of the Feast of the Fools*, London, Cornell University Press

Harris P (1998). *A History of the British Museum Library, 1753–1973*, London, British Library

Harris S (1994). *Factories of Death: Japanese Biological Warfare 1932–45 and the American Cover-Up*, New York, Routledge

Harris S (2002). 'Bede and Gregory's Allusive Angles', *Criticism*, 44:3, pp. 271–89

Harris T (1986). 'The Bawdy House Riots of 1668', *The Historical Journal*, 29:3, pp. 537–56

Hartwell R (1961). 'The Rising Standard of Living in England, 1800–1850', *The Economic History Review*, New Series, 13:3, pp. 397–416

—— (2017). *The Industrial Revolution and Economic Growth*, Abingdon, Routledge

Harvey M et al (2014a). *The Miners' Strike*, Barnsley, Pen and Sword History

Harvey S (2014b). *Domesday: Book of Judgement*, Oxford, Oxford University Press

Hazlitt Q (1905). 'St Valentine's Day', in *Faiths and Folklore* (1905)

Headland R (1992). *The Island of South Georgia*, Cambridge, Cambridge University Press

Heaney M (2004). 'The Earliest Reference to the Morris Dance?', *Folk Music Journal*, 8:4, pp. 513–5

Heathcote T (1995). *The Military in British India: The Development of British Land Forces in South Asia, 1600–1947*, Manchester, Manchester University Press

Hechter M (1975). *Internal Colonialism: The Celtic Fringe in British National Development, 1536–1966*, Berkeley, University of California Press

Hedenstierna-Jonson C et al (2017). 'A Female Viking Warrior Confirmed by Genomics', *American Journal of Physical Anthropology*, 164:4, pp. 853–60

Hellinga L and Kelliher H (1977). 'The Malory Manuscript', *The British Library Journal*, 3:2, pp. 91–113

Henderson J (1992). 'The Black Death in Florentine Medical and Communal Responses', in S Bassett (ed), *Death in Towns. Urban Responses to the Dying and the Dead, 100–1600*, Leicester, Leicester University Press, pp. 136–50

Henderson L (2016). *Witchcraft and Folk Belief in the Age of Enlightenment Scotland, 1670–1740*, Basingstoke, Palgrave Macmillan

Hewitt R (1958). *The Black Prince's Expedition of 1355–1357*, Manchester, Manchester University Press

Hickey R (2007). *Irish English: History and Present-Day Forms*. Cambridge, Cambridge University Press

Hicks C (2007). *The Bayeux Tapestry: The Life Story of a Masterpiece*, London, Vintage

Hieatt C (1988). 'Further Notes on the "Forme of Cury" et al.: Additions and Corrections, *Bulletin of the John Rylands Library*. 70:1, pp. 45–52

Higham T et al (2011). 'The Earliest Evidence for Anatomically Modern Humans in Northwestern Europe', *Nature*, 479, pp. 521–4

Hiley D (2009). *Gregorian Chant*, Cambridge, Cambridge University Press

Hill D and A Rumble (eds) (1996). *The Defence of Wessex: The Burghal Hideage and Anglo-Saxon Fortifications*, Manchester, Manchester University Press

Hill J (2002). 'Wetwang Chariot Burial', *Current Archaeology* 15:178, pp. 410–12

Hills R (1970). *Power in the Industrial Revolution*, Manchester, Manchester University Press

Himmelfarb G (1983). 'Engels in Manchester: Inventing the Proletariat', *The American Scholar*, 52:4, pp. 479–96

Hinsley F and A Stripp (eds) (1993). *Codebreakers: The Inside Story of Bletchley Park*, Oxford, Oxford University Press

Hobsbawm E (1963). 'The Standard of Living during the Industrial Revolution: A Discussion', *The Economic History Review*, New Series, 16:1, pp. 119–34

Hogan D and W Osborough (eds) (1990). *Brehons, Serjeants and Attorneys: Studies in the History of the Irish Legal Profession*, Dublin, Irish Academic Press

Hollister C (1961). 'King John and the Historians', *Journal of British Studies*, 1:1

Holman K (2016). 'Defining the Danelaw', in *Vikings and the Danelaw, Select Papers from the Proceedings of the Thirteenth Viking Congress*, J Graham-Campbell et al (eds), Oxford, Oxbow Books, pp. 1–11

Holt J (1992). *Magna Carta*, Cambridge, Cambridge University Press

Home M (2015). *The Peterborough Version of the Anglo-Saxon Chronicle: Rewriting Post-Conquest History*, Woodbridge, The Boydell Press

Hopkins K (2018). *Sociological Studies in Roman History*, Cambridge, Cambridge University Press

Hoppit J (ed) (2003). *Parliaments, Nations and Identities in Britain and Ireland, 1660–1850*, Manchester, Manchester University Press

Hornblower S et al (eds) (2014). *The Oxford Companion to Classical Civilization*, Oxford, Oxford University Press

Horrox R (2020). *Richard III: A Failed King?* London, Penguin Books

Hosler J (2007). *Henry II: A Medieval Soldier at War, 1147–1189*, Leiden, Brill

Houston S (1995). *James I*, London, Routledge

Hubard M (2013). *Trading Secrets: Spies and Intelligence in an Age of Terror*, London, I B Taurus

Hudson R (2002). 'The Changing Geography of the British Coal Industry: Nationalisation, Privatisation and the Political Economy of Energy Supply, 1947–1997', *Mining Technology*, 111:3

Huggett F (1978). *Victorian England as Seen by 'Punch'*, London, Sidgwick and Jackson

Hulme E (1896). 'The History of the Patent System under the Prerogative and at Common Law', *Law Quarterly Review*, 12, pp. 141–54

—— (1900). 'The History of the Patent System under the Prerogative and at Common Law. A Sequel', *Law Quarterly Review*, 16, pp. 44–56

Hunt R (1899). 'Mr Blake's Exhibition', *Examiner*, 17 September 1899, pp. 605–6

Hunt R (1992). *My Falkland Days*, Newton Abbot, David & Charles

Hutton R (2009). *Blood and Mistletoe: The History of the Druids in Britain*, New Haven and London, Yale University Press

—— (2010). 'Writing the History of Witchcraft: A Personal View', *The Pomegranate*, 12:2, pp. 239–62

Hyman L (1976). 'The Greek Slave by Hiram Powers: High Art as Popular Culture', *Art Journal*, 35:3, pp. 216–23

Idelsohn A (1914–32). *Thesaurus of Hebrew Oriental Melodies*, Berlin, B Harz, 10 vols

Ingram D (1972). *The Palestine Papers: 1917–1922: Seeds of Conflict*, London, J Murray

Innes J (2003). 'Legislating for Three Kingdoms: How the Westminster Parliament Legislated for England, Scotland and Ireland, 1707–1830', in Hoppit (2003)

Israel J (ed) (2003). *The Anglo-Dutch Moment: Essays on the Glorious Revolution and Its World Impact*, Cambridge, Cambridge University Press

Izbicki T (2015). *The Eucharist in Medieval Canon Law*, Cambridge, Cambridge University Press

Jackson K (1945). 'Once Again Arthur's Battles', *Modern Philology*, 43:1, pp. 44–57

Jacques D et al (2014). 'Mesolithic Settlement Near Stonehenge: Excavations at Blick Mead, Vespasian's Camp, Amesbury', *Wiltshire Archaeological and Natural History Magazine* 107, pp. 7–27

Jayne A (1998). *Jefferson's Declaration of Independence: Origins, Philosophy, and Theology*, Lexington, The University Press of Kentucky

Jefferies J (2005). 'The UK Population: Past, Present and Future', in R Chappell (ed), *Focus on People and Migration*, London, Palgrave Macmillan

Jensen M (1968). *The Founding of a Nation: A History of the American Revolution, 1763–1776*, Indianapolis, Hackett

Jesch J (2005). *Women in the Viking Age*, Woodbridge, The Boydell Press

—— (2015). *The Viking Diaspora*, Oxford, Routledge

Johansen S (1996). 'The Great Exhibition of 1851: A Precipice in Time?', *Victorian Review*, 22:1, pp. 59–64

Johnson A (1934). *Type Designs: Their History and Development*, London, Grafton & Co

Johnson B (2014). *The Churchill Factor*, London, Hodder and Stoughton

Johnson C (2002). *A General History of the Robberies and Murders of the Most Notorious Pyrates*, Oxford, Routledge

Johnson J (2004). *A Profane Wit: The Life of John Wilmot, Earl of Rochester*, Rochester, The University of Rochester Press

Johnson R (2018). 'The de Bunsen Committee and a Revision of the 'Conspiracy' of Sykes–Picot', *Middle Eastern Studies*, 54:4, no pagination

Jones C (1966). 'John Locke and Masonry: A Document', *Neuphilologische Mitteilungen*, 67:1 pp. 72–81

Josten C (1960). 'Elias Ashmole, F.R.S. (1617–1692)', *Notes and Records of the Royal Society of London*, 15, pp. 221–30

Jouanna A (2007). *The Saint Bartholomew's Day Massacre: The Mysteries of a Crime of State (24 August 1572)*, J Bergin (tr), Manchester, Manchester University Press

Joyce P (2016). *The Policing of Protest, Disorder and International Terrorism in the UK Since 1945*, London, Palgrave Macmillan

Kane B (2014). 'Elizabeth on Rebellion in Ireland and England: *semper eadem*?' in *Elizabeth I and Ireland*, B Kane and V McGowan-Doyle V (eds). Cambridge, Cambridge University Press

Kapp Y (1994). 'Frederick Demuth: New Evidence from Old Sources', *Socialist History*, 6, pp. 17–27

Kara S (2012). *Bonded Labor: Tackling the System of Slavery in South Asia*, New York, Columbia University Press

Kasapis A (2008). *Mastering Credit Derivatives: A Step-by-Step Guide to Credit Derivatives and Structured Credit*, London, FT Prentice Hall

Keats-Rohan K (1999–2002). *Domesday People: A Prosopography of Persons Occurring in English Documents 1066–1166*, Woodbridge, The Boydell Press, 2 vols

Kelly H (1986). *Chaucer and the Cult of Saint Valentine*, Leiden, Brill

Kennedy M (1980). *The Works of Ralph Vaughan Williams*, Oxford, Oxford University Press

Kesselring K (2007). *The Northern Rebellion of 1569. Faith, Politics, and Protest in Elizabethan England*, Basingstoke, Palgrave Macmillan

Keynes J (1947). 'Newton, the Man', *Newton Tercentenary Celebrations, 15–19 July 1946*, Cambridge, Cambridge University Press

Kilroy G (2015). *Edmund Campion: A Scholarly Life*, Farnham, Ashgate

Kinnard J (2007). *Artillery. An Illustrated History of its Impact*, Oxford, ABC Clio

Knight I (2011). *Voices from the Zulu War: Campaigning through the Eyes of the British Soldier, 1879*, Barnsley, Frontline

—— (2019). *Zulu Rising: The Epic Story of Isandlwana and Rorke's Drift*, Oxford, Oxford University Press

Knowles D (1948–59). *The Religious Orders in England*, Cambridge, Cambridge University Press, 3 vols

Koch J (1997). *The Gododdin of Aneirin*, Cardiff, University of Wales Press

Kochavi A (1998). 'The Struggle against Jewish Immigration to Palestine', *Middle Eastern Studies*, 34:3, pp. 146–67

Kozaczuk W (1984). *Enigma: How the German Machine Cipher Was Broken, and How It Was Read by The Allies in World War Two*, University Publications of America

Kristiansen L (2018). 'Not My President', in *You Shook Me All Campaign Long: Music in the 2016 Presidential Election and Beyond*, E Kasper and B Schoening (eds), Denton, University of North Texas Press, pp. 51–88

Kynaston D (2017). *Till Time's Last Sand: A History of the Bank of England 1694–2013*, London, Bloomsbury

Labaree B (1964). *The Boston Tea Party*, New York, Oxford University Press

—— (1973). *The Boston Tea Party, 1773: Catalyst for Revolution*, Boston, Massachusetts Bicentennial Commission Historic Series

Lahue C (2007). 'Tea Act (1773)', in *Encyclopedia of the Age of Political Revolutions and New Ideologies, 1760–1815* (2007), pp. 711–12

Lane P (1988). *Prince Charles: A Study in Development*, London, Hale

Lapham E (1901). 'The Industrial Status of Women in Elizabethan England', *Journal of Political Economy*, 9:4, pp. 562–99

Larrington C et al (eds) (2016). *A Handbook to Eddic Poetry: Myths and Legends of Early Scandinavia*, Cambridge, Cambridge University Press

Lea H (1957). *Materials Toward a History of Witchcraft*, London, Thomas Yoseloff, 3 vols

Leapman M (2011). *The World for a Shilling: How the Great Exhibition of 1851 Shaped a Nation*, London, Faber and Faber

Lee C and J Lee (2010). *The Churchills – A Family Portrait*, Basingstoke, Palgrave Macmillan

Leeson P and Russ J (2018). 'Witch Trials', *The Economic Journal*, 128:613, pp. 2066–105

Le Goff J (1981). *La Naissance du purgatoire*, Paris, Gallimard

Leins I (2007). 'Coins in Context and Votive Deposition in Iron Age Southeast Leicestershire', *The British Numismatic Journal*, 77, pp. 22–48

Leslie C (1845). *Memoirs of the Life of John Constable, Esq., R.A.: Composed Chiefly of His Letters*, London, Longman, Brown, Green, and Longmans

Levack B (1995). *The Witch-hunt in Early Modern Europe*, London, Longman, pp. 21–6

—— (1996). 'State-building and Witch Hunting in Early Modern Europe', in *Witchcraft in Early Modern Europe. Studies in Culture and Belief*, J Barry et al (eds), Cambridge, Cambridge University Press, pp. 96–115

Lightbody B (2004). *The Second World War: Ambitions to Nemesis*, London, Routledge

Little A (1917). 'The Franciscan School at Oxford', *Studies in English Franciscan History*, Manchester, Manchester University Press, pp. 193–222

Loach J (1999). *Edward VI*, London, Yale University Press

Loades D (1992). *Mary Tudor: A Life*, Oxford, Oxford University Press

Lock R and P Quantrill (2002). *Zulu Victory. The End of Isandlwana and the Cover Up*, London, Greenhill

Loe L (2015). 'Death on Ridgeway Hill', *Current Archaeology*, 229, pp. 38–41

Loft C (2013). *Last Trains: Dr Beeching and the Death of Rural England*, London, Biteback

Longmate N (2012). *If Britain Had Fallen: The Real Nazi Occupation Plans*, Barnsley, Frontline

Loomie A (1971). 'King James I's Catholic Consort', *Huntington Library Quarterly*, 34, pp. 303–16

López T (2014). *The Winter of Discontent: Myth, Memory, and History*, Liverpool, Liverpool University Press

Lovell J (2011). *The Opium War: Drugs, Dreams and the Making of China*, London, Picador

Lowe N (2009). *Mastering Modern British History*, Basingstoke, Palgrave Macmillan

Lownie A (2015). *Stalin's Englishman: The Lives of Guy Burgess*, London, Hodder & Stoughton

Lowry M and M (1979). *The World of Aldus Manutius: Business and Scholarship in Renaissance Venice*, New York, Cornell University Press

Lowry S (1973). 'Lord Mansfield and the Law Merchant: Law and Economics in the Eighteenth Century', *Journal of Economic Issues*, 7:4, pp. 605–22

Lloyd I (2019). *An Audience with Queen Victoria: The Royal Opinion on 30 Famous Victorians*, Stroud, The History Press

MacCulloch D (2018). *Thomas Cromwell: A Life*, London, Penguin

Mackie E (2009). *Rakes, Highwaymen, and Pirates: The Making of the Modern Gentleman in the Eighteenth Century*, Baltimore, The Johns Hopkins University Press

Makubuya A (2018). *Protection, Patronage, or Plunder? British Machinations and (B)uganda's Struggle for Independence*, Newcastle, Cambridge Scholars Publishing

Malcolm J (1802–7). *Londinium Redivivum, or, An Ancient History and Modern Description of London*, London, J Nichols and Son, 4 vols

Malcolm J (1836). *The Life of Robert, Lord Clive*, London, John Murray, 3 vols

Malys S et al (2015). 'Why the Greenwich Meridian Moved', *Journal of Geodesy*, 89:12, pp. 1263–72

Manchester W and P Reid (2012). *The Last Lion: Winston Spencer Churchill / Defender of the Realm: 1940–1965*, Little, Brown and Company

Mann S (2007). *Supremacy and Survival, How Catholics Endured the English Reformation*, New York, Scepter

Manuel F (1997). *A Requiem for Karl Marx*, London, Harvard University Press

Manning S (2013). *The Martini-Henry Rifle*, Botley, Osprey

Marcus S (2017). *Engels, Manchester, and the Working Class*, Abingdon, Routledge

Mark-FitzGerald E (2013). *Commemorating the Irish Famine: Memory and the Monument*, Liverpool, Liverpool University Press

Markham C (1893). 'Pytheas, the Discoverer of Britain', *The Geographical Journal*, 1:6, pp. 504–24

—— (2014). *Richard III. His Life and Character Reviewed in the Light of Recent Research*, Cambridge, Cambridge University Press

Marshall P (1965). *The Impeachment of Warren Hastings*, London, Oxford University Press

Martin F (ed) (2013). *The Irish Volunteers 1913–1915: Recollections and Documents*, Sallins, Irish Academic Press

Martin T (2009). 'The Beginning of Labor's End? Britain's "Winter of Discontent" and Working-Class Women's Activism', *International Labor and Working-Class History*, 75, pp. 49–67

Marx K (1887). *Capital*, F Engels (ed), S Moore and E Aveling (trs), London, Swan Sonnenschein

—— (1973). *The Revolutions of 1848*. D Fernbach (tr), New York: Random House

Marx K and F Engels (1975–2004). *Collected Works*, R Dixon et al (trs), London, Lawrence and Wishart, 50 vols

Marzinzik S (2007). *The Sutton Hoo Helmet*, London, British Museum Press

Massie R (2007). *Dreadnought: Britain, Germany and the Coming of the Great War*, London, Vintage

Matchett W (2016). *Secret Victory: The Intelligence War that Beat the IRA*, Northern Ireland, Matchett

Mate M (1998). *Daughters, Wives and Widows after the Black Death*, Woodbridge, The Boydell Press

Matras Y (2010). *Romani in Britain: The Afterlife of a Language*, Edinburgh, Edinburgh University Press

Mauriès P (2001). *Cabinets of Curiosities*, London, Thames & Hudson

Mavor W (1787). *Blenheim, a Poem. To Which is Added, a Blenheim Guide*, London, T Cadell

Mayr-Harting H (1991). *The Coming of Christianity to Anglo-Saxon England*, London, Batsford

McCarthy C (2004). *Marriage in Medieval England. Law, Literature, and Practice*, Woodbridge, The Boydell Press

McCulloch J (1997). 'Jewish Ritual Murder: William of Norwich, Thomas of Monmouth, and the Early Dissemination of the Myth', *Speculum*, 72:3, pp. 698–740

McEvoy K (2001). *Paramilitary Imprisonment in Northern Ireland: Resistance, Management and Release*, Oxford, Oxford University Press

McGee H (1984). *On Food and Cooking. The Science and Lore of the Kitchen*, New York, Scribner's

McKay C (1993). *The Great Salisbury Clock Trial: How Old Is the Clock?*, Wadhurst, Antiquarian Horological Society

McKenna J (2017). *Voices from the Easter Rising: First Hand Accounts of Ireland's 1916 Rebellion*, Jefferson, McFarland & Company

McKie D (1960). 'The Origins and Foundation of the Royal Society of London', *Notes and Records of the Royal Society of London*, 15, pp. 1–37

McKittrick D (1999). *Lost Lives: The Stories of the Men, Women and Children who Died as a Result of the Northern Ireland Troubles*, Edinburgh, Mainstream

McLynn F (2002). *Crime and Punishment in Eighteenth-century England*, Oxford, Routledge

McNamara M and P Mooney (2000). *Women in Parliament: Ireland, 1918–2000*, Dublin, Wolfhound Press

McNeil P (2019). *The Visual History of Type*, London, Laurence King Publishing

McSheffrey S (2006). *Marriage, Sex, and Civic Culture in Late Medieval London*, Philadelphia, University of Pennsylvania Press

Mehring F (1936). *Karl Marx: The Story of His Life*, E Fitzgerald (tr), London, John Lane

Mellersh H (1968). *FitzRoy of the Beagle*, New York, Mason and Lipscomb

Menotti F and A O'Sullivan (2013). *The Oxford Handbook of Wetland Archaeology*, Oxford, Oxford University Press

Mews C (2005). *Abelard and Heloise*, Oxford, Oxford University Press

Middlebrook M (2009). *The Argentine Fight for the Falklands*, Barnsley, Pen & Sword

Miles D et al (2003). *Uffington White Horse and its Landscape: Investigations at White Horse Hill, Uffington, 1989–95, and Tower Hill, Ashbury, 1993–4*, Oxford, Oxford Archaeology Unit

Millett M (1990). *The Romanization of Britain*, Cambridge, Cambridge University Press

Milne N (2014). *Libertines and Harlots: From 1600 to 1836*, London, Paragon Publishing

Minois G (2012). *The Atheist's Bible: The Most Dangerous Book That Never Existed*, Chicago, The University of Chicago Press

Mitchell T (2015). *Likud Leaders. The Lives and Careers of Menahem Begin, Yitzhak Shamir, Benjamin Netanyahu and Ariel Sharon*, Jefferson, McFarland & Company

Moloney E (2007). *A Secret History of the IRA*, Harmondsworth, Penguin

Molyneaux G (2011). 'Why Were Some Tenth-Century English Kings Presented as Rulers of Britain?', *Transactions of the Royal Historical Society*, 21, pp. 59–91

—— (2015). *The Formation of the English Kingdom in the Tenth Century*, Oxford, Oxford University Press

Mommsen T (1942). 'Petrarch's Conception of the "Dark Ages"', *Speculum*, 17:2, pp. 226–42

Montaño J (2011). *The Roots of English Colonialism in Ireland*, Cambridge, Cambridge University Press

Moore P (2015). *The Weather Experiment: The Pioneers who Sought to see the Future*, London, Vintage

Moorhouse R (2014). *The Devils' Alliance: Hitler's Pact with Stalin, 1939–1941*, London, The Bodley Head

Moote A and D Moote (2004). *The Great Plague: The Story of London's Most Deadly Year*, London, The Johns Hopkins University Press

Moran J (1976). *Wynkyn de Worde, Father of Fleet Street*, London, Wynkyn de Worde Society

Morand P (1972). *The Captive Princess: Sophia Dorothea of Celle*, New York, American Heritage Press

More C (1940). *The Road to Dunkirk: The British Expeditionary Force and the Battle of the Ypres-Comines Canal*, Barnsley, Frontline

Morgan K (2001). *Britain Since 1945: The People's Peace*, Oxford, Oxford University Press

Morris M (2021). *The Anglo-Saxons. A History of the Beginnings of England*, London, Hutchinson

Mortimer I (2005). 'The Death of Edward II in Berkeley Castle', *The English Historical Review*, 120:489, pp. 1175–1214

Mosely J (1999). *The Nymph and the Grot*, London, Friends of St Bride Printing Library

Moynahan B (2002). *If God Spare My Life: William Tyndale, the English Bible and Sir Thomas More – A Story of Martyrdom and Betrayal*, London, Little, Brown

Mulsow M (2004). 'Ambiguities of the *Prisca Sapientia* in Late Renaissance Humanism', *Journal of the History of Ideas*, 65:1, pp. 1–13

Musset L (2005). *The Bayeux Tapestry*, R Rex (tr), Woodbridge, The Boydell Press

Neidorf L (ed) (2014). *The Dating of Beowulf: A Reassessment*, Cambridge, D S Brewer

Newman W (2019). *Newton the Alchemist: Science, Enigma, and the Quest for Nature's 'Secret Fire'*, Princeton, Princeton University Press

Newman W and L Principe (2002). *Alchemy Tried in the Fire: Starkey, Boyle, and the Fate of Helmontian Chymistry*, Chicago, University of Chicago Press

Nicholls M (1991). *Investigating Gunpowder Plot*, Manchester, Manchester University Press

—— (2007a). 'Discovering Gunpowder Plot: The *King's Book* and the Dissemination of News', *British Catholic History*, 28:3, pp. 397–415

Nielson J and R Skousen (1998). 'How Much of the King James Bible Is William Tyndale's?', *Reformation*, 3:1, pp. 49–74

Nijenhuis W (2001). 'In a Class of their Own, Anglo-Saxon Female Saints', *Mediaevistik*, 14, pp. 125–48

Norton D (2011). *The King James Bible: A Short History from Tyndale to Today*, Cambridge, Cambridge University Press

O'Brien B (1999). *Long War: The IRA and Sinn Féin*, New York, Syracuse University Press

O'Cathasaigh D (1982). 'The Cult of Brigid: A Study of Pagan-Christian Syncretism in Ireland', in *Mother Worship: Theme and Variations*. J Presaton (ed), Chapel Hill, University of North Carolina Press

O'Connor F (1937). *The Big Fellow*, London, T Nelson & Sons

Ó Corráin D (1989). 'Prehistoric and Early Christian Ireland', in *The Oxford Illustrated History of Ireland*, R Foster (ed), Oxford, Oxford University Press, pp. 1–52

Oles T (2015). *Walls: Enclosure and Ethics in the Modern Landscape*, London, Chicago University Press

Olin L (2000). *Across the Open Field: Essays Drawn from English Landscapes*, Philadelphia, University of Pennsylvania Press

Oosthuizen S (2019). *The Emergence of the English*, Leeds, Arc Humanities Press

Omrani B (2017). *Caesar's Footprints: A Cultural Excursion to Ancient France: Journeys Through Roman Gaul*, London, Head of Zeus

Orchard P (2014). *A Right to Flee: Refugees, States, and the Construction of International Cooperation*, Cambridge, Cambridge University Press

O'Reilly T (2008). *Hitler's Irishmen*, Cork, Mercier Press

Ormrod W (2001). 'A Problem of Precedence: Edward III, the Double Monarchy, and the Royal Style', in *The Age of Edward III*, J Bothwell (ed), Woodbridge, York Medieval Press, pp. 133–54

Ó Siochrú M (2008). *God's Executioner: Oliver Cromwell and the Conquest of Ireland*, London, Faber & Faber

Ovenden M (2005). *Metro Maps of the World*, Harrow, Capital Transport

Ovrut B (1977). 'Edward I and the Expulsion of the Jews', *The Jewish Quarterly Review*, 67:4, pp. 224–35

Padel O (1994). 'The Nature of Arthur', *Cambrian Medieval Celtic Studies*, 27, pp. 1–31

Page C (2012). *The Christian West and its Singers: The First Thousand Years*, London, Yale University Press

Page R (1987). *Runes. Reading the Past*, London, British Museum Press

—— (1995). *Runes and Runic Inscriptions: Collected Essays on Anglo-Saxon and Viking Runes*, Woodbridge, The Boydell Press

Pakenham F and T O'Neill (1970). *Eamon De Valera*, London, Hutchinson

Palmer J (1999). 'The Wealth of the Secular Aristocracy in 1086', in *Anglo-Norman Studies: XXII Proceedings of the Battle Conference 1999*, C Harper-Bill (ed), Woodbridge, The Boydell Press, pp. 279–91

Parfitt K (1993). 'The Dover Boat', *Current Archaeology* 133, pp. 4–8

Parker Pearson M (2012). *Stonehenge: Exploring the Greatest Stone Age Mystery*, London, Simon & Schuster

—— (2018). *Science and Stonehenge. Recent Investigations of the World's Most Famous Stone Circle*, Amsterdam, Joh. Enschedé Amsterdam

Parks W (1990). 'Air War and the Law of War', *The Air Force Law Review*, 32:1, pp. 1–225

Parrish C (1978). *The Notation of Medieval Music*, New York, Pendragon Press

Parry J and R Caldwell (1959). 'Geoffrey of Monmouth', in *Arthurian Literature in the Middle Ages*, R Loomis (ed), Oxford, Clarendon Press

Patterson L (1996). 'Experience Woot Well It Is Noght So': Marriage and the Pursuit of Happiness in the Wife of Bath's Prologue and Tale', in *Geoffrey Chaucer. The Wife of Bath*, Boston, P Beidler (ed), St Martin's Press, pp. 133 –54

Paz E et al (2010). *A Brief Illustrated History of Machines and Mechanisms*, London, Springer

Pearce C (2010). *Cornish Wrecking, 1700–1860. Reality and Popular Myth*, Woodbridge, The Boydell Press

Pereira M (2000). 'Heavens on Earth. From the Tabula Smaragdina to the Alchemical Fifth Essence', *Early Science and Medicine*, 5:2, pp. 131–44

Pernoud R (1953). *Vie et mort de Jeanne d'Arc. Les témoignages du procès de réhabilitation, 1450–1456*, Paris, Hachette

Perone J (2009). *Mods, Rockers, and the Music of the British Invasion*, London, Greenwood

Pestana C (2017). *The English Conquest of Jamaica. Oliver Cromwell's Bid for Empire*, Cambridge, Harvard University Press

Peters T and A Beveridge (2010). 'The Blindness, Deafness and Madness of King George III: Psychiatric Interactions', *Journal of the Royal College of Physicians of Edinburgh*, 40, pp. 81–5

Pettitt P et al (2007). *Palaeolithic Cave Art at Creswell Crags in European Context*, Oxford, Oxford University Press

Philpot C (2018). *Secret Wartime Britain: Hidden Places that Helped Win the Second World War*, Barnsley, Pen and Sword

Phinney E (1875). *History of the Battle of Lexington: On the Morning of the 19th April, 1775*, Boston, Franklin Press

Picton H (2015). *A Short History of the Church of England: From the Reformation to the Present Day*, Newcastle Upon Tyne, Cambridge Scholars Publishing

Platt C (1996). *King Death: The Black Death and its Aftermath in Late-Medieval England*, London, UCL Press

Plowden A (2016). *Lady Jane Grey*, Stroud, The History Press

Pocock N (ed) (1884). *Troubles Connected with the Prayer Book of 1549*, London, Camden Series

Poole A (1951). *From Domesday Book to Magna Carta, 1087–1216*, Oxford, Clarendon Press

Popova I and B Simkins (2013). 'Introduction to Energy Risk Management', in *Energy Finance and Economics: Analysis and Valuation, Risk Management, and the Future of Energy*, B Simkins and R Simkins (eds), Hoboken, Wiley, pp. 379–410

Porterfield J (2016). *Tim Berners-Lee*, New York, Rosen Publishing

Pound J (1971). *Poverty and Vagrancy in Tudor England*, Abingdon, Routledge

Prescott A (2014). 'The Old Charges', in *Handbook of Freemasonry*, Bogdan and Snoek (eds), Leiden, Brill, pp. 33–49

Prestwich M (1988). *Edward I*, London, Methuen

Principe L (2013). *The Secrets of Alchemy*, Chicago, University of Chicago Press

Pritchard A (1979). *Catholic Loyalism in Elizabethan England*, London, Scolar Press, 2 vols

Prüfer K et al (2017). 'A High-Coverage Neandertal Genome from Vindija Cave in Croatia', *Science*, 358:6363, pp. 655–8

Putnam B (1908). *The Enforcement of the Statute of Labourers During the First Decade After the Black Death, 1349–1359*, New York, Columbia University

Rackham O (1986). *The History of the Countryside*, London, Dent

Radin M (1918). 'The Date of Composition of Caesar's Gallic War', *Classical Philology*, 13:3, pp. 283–300

Raithby J (1823). *The Statutes Relating to the Admiralty, Navy, Shipping, and Navigation of the United Kingdom*, London, George Eyre and A Strahan

Ramsey J (1925). *A History of the Revenues of the Kings of England, 1066–1399*, Oxford, Oxford University Press, 2 vols

Rascovan N et al (2018). 'Emergence and Spread of Basal Lineages of Yersinia Pestis During the Neolithic Decline', *Cell*, 10;176 (1–2): pp. 295–305

Rattray D (2013). *Guidebook to the Anglo-Zulu War*, Barnsley, Pen & Sword

Redmond G et al (1998). *The Arithmetic of Tax and Social Security Reform: A User's Guide to Microsimulation Methods and Analysis*, Cambridge, Cambridge University Press

Reeves R (2019). *Women of Westminster: The MPs who Changed Politics*, London, I B Tauris

Reinharz J (1984). 'Chaim Weizmann and the Elusive Manchester Professorship', *AJS Review*, 9:2, pp. 215–46

Rentoumi V et al (2017). 'The Acute Mania of King George III: A Computational Linguistic Analysis', *PLoS ONE*, 12(3): e0171626.

Reynolds P (1994). *Fiefs and Vassals, The Medieval Evidence Reinterpreted*, Oxford, Oxford University Press

—— (2016). *How Marriage Became One of the Sacraments: The Sacramental Theology of Marriage from its Medieval Origins to the Council of Trent*, Cambridge, Cambridge University Press

Rhys J (2014). *Celtic Britain*, Cambridge Library Collection, Cambridge, Cambridge University Press

Richardson R (1972). *Puritanism in North-West England: A Regional Study of the Diocese of Chester to 1642*, Manchester, Manchester University Press

Richter M (1988). *Medieval Ireland: The Enduring Tradition*, London, Macmillan Education

Risebero B (2002). *Modern Architecture and Design: An Alternative History*, Cambridge, The MIT Press

Roach L (2016). *Æthelred: The Unready*, New Haven and London, Yale University Press

Roberts A (2018). *Churchill: Walking with Destiny*, London, Allen Lane

Roberts H (2011). 'The 150th Anniversary of the First Public Weather Forecast', *Weather*, 66:8, pp. 221–2

Robertson J and W Funnell (2014). *Accounting by the First Public Company. The Pursuit of Supremacy*, Abingdon, Routledge

Rocco M (2010). 'The Reasons Behind *Constitutio antoniniana* and its Effects on the Roman Military', *Acta Classica Universitatis Scientiarum Debreceniensis*, 46, pp. 131–56

Rodger N (1997). *The Safeguard of the Sea: A Naval History of Britain, Vol. 1, 660–1649*, London, Harper Collins

Rogers C (1999). *The Wars of Edward III. Sources and Interpretations*, Woodbridge, The Boydell Press

Roland P (2014). *Nazi Women: The Attraction of Evil*, London, Arcturus Publishing

Roll S (1995). *Towards the Origin of Christmas*, Kampen, Kok Pharos Publishing

Rose N (1992). 'Weizmann, Ben-Gurion and the 1946 Crisis in the Zionist Movement', in *Power, Personalities, and Policies: Essays in Honour of Donald Cameron Watt*, M Fry (ed), London, Frank Cass, pp. 258–277

Rossiter M (2007). *Sink the Belgrano*, London, Random House

Roth F (1903). 'Diary of a Surgeon with the Benin Punitive Expedition', in H Roth, *Great Benin: Its Customs, Art and Horrors*, Halifax, E King & Sons, Appendix 2, pp. ii–xii

Rothchild D (1970). 'Kenya's Africanization Program: Priorities of Development and Equity', *The American Political Science Review*, 64:3, pp. 737–53

Rosewarne D (1994). 'Estuary English: Tomorrow's RP?', *English Today*, 10:1, pp. 3–8

Round J (1892). *Geoffrey de Mandeville: A Study of the Anarchy*, London, Longmans & Co

Roy T (2012). *The East India Company: The World's Most Powerful Corporation*, New Delhi, Allen Lane

Rubenberg C (1986). *Israel and the American National Interest: A Critical Examination*, Chicago, University of Illinois Press

Rubenhold H (2019). *The Five: The Untold Lives of the Women Killed by Jack the Ripper*, Boston, Houghton Mifflin Harcourt

Rubin M (1991). *Corpus Christi. The Eucharist in Late Medieval Culture*, Cambridge, Cambridge University Press

—— (2020). *Cities of Strangers*, Cambridge, Cambridge University Press

Rumbelow D (1990). *Jack the Ripper. The Complete Casebook*, New York, Berkley Books

Sachse W (1973). 'England's "Black Tribunal": An Analysis of the Regicide Court', *The Journal of British Studies*, 12, pp. 69–85

Salway P (1993). *A History of Roman Britain*, Oxford, Oxford University Press

Saunders N and P Cornish (2017). *Modern Conflict and the Senses*, London, Routledge

Schmitz L (1875). 'Lupercalia', in *A Dictionary of Greek and Roman Antiquities* (1975)

Schmitz O (1914). *Das Land ohne Musik: englische Gesellschaftsprobleme*, Munich, G Müller

Schmuhl R (2016). *Ireland's Exiled Children: America and the Easter Rising*, Oxford, Oxford University Press

Scobie-Youngs K (2018). 'Salisbury, Wells and Rye – The Great Clocks Revisited', *Antiquarian Horology*, 39:3, pp. 327–41

Scully D (2006). 'Ireland and the Irish in Bernard of Clairvaux's Life of Malachy: Representation and Context', in *Ireland and Europe in the Twelfth Century: Reform and Renewal*, D Bracken and D Ó Riain-Raedel (eds), Dublin, Four Courts Press, pp. 239–56

Seear M (2017). *With the Gurkhas in the Falklands*, Barnsley, Pen & Sword Military

Seel G (1999). *The English Wars and Republic, 1637–1660*, Abingdon, Routledge

Selwood D (2015). *Spies, Sadists, and Sorcerers. The History You Weren't Taught in School*, London, Crux

Sharp D (2000). *The Coming of the Civil War*, Oxford, Heinemann

Sharpe J (2005). *Remember, Remember: A Cultural History of Guy Fawkes Day*, Cambridge, Harvard University Press

Shaw P (2011). *Pagan Goddesses in the Early Germanic World: Eostre, Hreda and the Cult of Matrons*. London, Bristol Classical Press

Sheehan W (2017). *A Hard Local War: The British Army and the Guerrilla War in Cork 1919–1921*, Dublin, The History Press Ireland

Shelby L (1964). 'The Role of the Master Mason in Mediaeval English Building', *Speculum*, 39:3, pp. 387–403

Shirer W (1991). *The Rise and Fall of the Third Reich*, London, Arrow

Shoard M (1980). *The Theft of the Countryside*, London, Temple Smith

Skawran P (1970). *Ikaros. Personlichkeit und Wesen des deutschen Jagdflieger im Zweiten Weltkrieg*, Steinebach am Wörthsee, Luftfahrt-Verlag Walter Zuerl

Sklar S (2011). *Blake's Jerusalem as Visionary Theatre: Entering the Divine Body*, Oxford, Oxford University Press

Simpson R (2010). *Edmund Campion*, Leominster, Gracewing

Singer P (1983). *Hegel. A Very Short Introduction*, Oxford, Oxford University Press

Smith A (1776). *Inquiry into the Nature and Causes of the Wealth of Nations*, London, W Strahan and T Cadell, 2 vols

Smith A (1989). ' "And Did Those Feet . . .?" ' The 'Legend' of Christ's Visit to Britain', *Folklore*, 100:1, pp. 63–83

Smith E (1999). *George IV*, London, Yale University Press

Smith H (1910). *From Constable to Commissioner: The Story of Sixty Years, Most of Them Misspent*. London, Chatto & Windus

Smout T (1964). 'The Anglo-Scottish Union of 1707. I. The Economic Background', *The Economic History Review*, New Series 16:3, pp. 455–67

Snoeck C et al (2018). 'Strontium Isotope Analysis on Cremated Human Remains from Stonehenge Support Links with West Wales', *Scientific Reports*, 8:10790

Sofer S (1998). *Zionism and the Foundations of Israeli Diplomacy*, D Shefet-Vanson (tr), Cambridge. Cambridge University Press

Southern N (2018). *Policing and Combating Terrorism in Northern Ireland: The Royal Ulster Constabulary GC*, Basingstoke, Palgrave Macmillan

Speirs E (2004). *The Victorian Soldier in Africa*, Manchester, Manchester University Press

Spence C (2016). *Accidents and Violent Death in Early Modern London, 1650–1750*, Woodbridge, The Boydell Press

Springer M (2003). 'Location in Space and Time', in *The Continental Saxons from the Migration Period to the Tenth Century: An Ethnographic Perspective*, D Green and F Siegmund (eds), Woodbridge, The Boydell Press

Stanford J et al (2011). 'Sea-level Probability for the Last Deglaciation: A Statistical Analysis of Far-Field Records', *Global and Planetary Change* 79, pp. 193–203

Staniforth A (2013). *Routledge Companion to UK Counter Terrorism*, Oxford, Routledge

Steinnes K (1998). 'The European Challenge: Britain's EEC Application in 1961', *Contemporary European History*, 7:1, pp. 61–79

Stephens W (2002). *Demon Lovers: Witchcraft, Sex, and the Crisis of Belief*, London, University of Chicago Press

Stokoe W (1915). *Flags of the World, Past and Present: Their Story and Associations*, revised by W Gordon, London, F Warne and Co

Stowers R (2005). *Bloody Gallipoli: The New Zealanders' Story*, Auckland, D Bateman

Stoyle M (1999). 'The Dissidence of Despair: Rebellion and Identity in Early Modern Cornwall', *Journal of British Studies*, 38, pp. 423–44

—— (2004). 'Remembering the English Civil Wars', in *The Memory of Catastrophe*, P Gray and K Oliver (eds), Manchester, Manchester University Press, pp. 19–30

—— (2017). *Witchcraft in Exeter 1558–1660*, Exeter, The Mint Press

Stubbs W (1988). 'The Organs of Winchester Cathedral', *The Musical Times*, 129:1745, pp. 371–2

Stubbs W (1874–8). *The Constitutional History of England in Its Origin and Development*. Oxford, Oxford University Press, 3 vols

Stukeley W (1740). *Stonehenge, A Temple Restor'd to the British Druids*, W Innys and R Manby, London

Sugden P (2002). *The Complete History of Jack the Ripper*, London, Constable & Robinson

Szporluk R (1988). *Communism and Nationalism. Karl Marx Versus Friedrich List*, Oxford, Oxford University Press

Taylor A (2002). *Textual Situations. Three Medieval Manuscripts and Their Readers*, Philadelphia, University of Pennsylvania Press

—— (2016). *American Revolutions: A Continental History, 1750–1804*, New York, W W Norton & Co

Taylor P (1998). *Provos The IRA and Sinn Féin*. London, Bloomsbury

Taylor T (1992). *The Anatomy of the Nuremberg Trials: A Personal Memoir*, New York, Alfred A Knopf

Tetsch J (1926). *Short Readings in Masonic History: A Concise Account of the Rise and Development of Ancient Craft Masonry; Prepared from Authentic Sources for the Use of Masonic Study Groups and Individual Brethren*, Cedar Rapids, The Torch Press

Thibodeaux J (2015). *The Manly Priest: Clerical Celibacy, Masculinity, and Reform in England and Normandy, 1066–1300*, Philadelphia, University of Pennsylvania Press

Thorpe A (2000). *The British Communist Party and Moscow, 1920–43*, Manchester, Manchester University Press

Tilford E (1996). 'Air Warfare: Strategic Bombing' in *The European Powers in the First World War: An Encyclopedia* (1996). pp. 13–15

Tinniswood A (2016). *The Long Weekend: Life in the English Country House between the Wars*, London, Jonathan Cape

Todman D (2016). *Britain's War: Into Battle, 1937–1941*, New York, Oxford University Press

Tomlin R (1974). 'The Date of the "Barbarian Conspiracy",' *Britannia*, 5, pp. 303–9

—— (2016). *Roman London's First Voices: Writing Tablets from the Bloomberg Excavations, 2010–14*, London, Museum of London Archaeology

Toole B (1992). *Ada: The Enchantress of Numbers*, Mill Valley, Strawberry Press

Toynbee A (1884). *Lectures on the Industrial Revolution in England*, London, Rivingtons

Trowell B (1957). 'A Fourteenth-Century Ceremonial Motet and its Composer', *Acta Musicologica* 29:2/3, pp. 65–75

Turing A (1936 and 1937). 'On Computable Numbers with an Application to the *Entscheidungsproblem*', *Proceedings of the London Mathematical Society*, 42, pp. 230–65, 43, P. 544–6

Turner M (1980). *English Parliamentary Enclosure: Its Historical Geography and Economic History*, Hamden, Archon

Usher R (1910). *The Reconstruction of the English Church*, London, D Appleton & Co, 2 vols

von Clausewitz C (1832–3). *Vom Kriege*, Berlin, Ferdinand Dümmler, 3 vols

van der Bijl N (1999). *Nine Battles to Stanley*, London, Leo Cooper

van der Velden S et al (2007). *Strikes Around the World, 1968–2005: Case-studies of 15 Countries*, Amsterdam, Aksant

Vârlan P-C (2015). 'Typical and Atypical Aspects in The Lark Ascending by Ralph Vaughan Williams', *Bulletin of the Transilvania University of Brașov*, Series 8, 8:57:2, pp. 123–38

Vervliet H (2008). *The Palaeotypography of the French Renaissance: Selected Papers on Sixteenth-Century Typefaces*, Leiden, Brill, 2 vols

Vielliard F (1989). 'Sur la tradition manuscrite des *Fables* de Marie de France', *Bibliothèque de l'École des Chartes*, 147, pp. 371–97

Villmoare B et al (2015). 'Early Homo at 2.8 Ma from Ledi-Geraru, Afar, Ethiopia', *Science*, 347:6228, pp. 1352–8

Vinen R (2014). *National Service: A Generation in Uniform 1945–1963*, London, Allen Lane

Volo J (2012). *The Boston Tea Party. The Foundations of Revolution*, Oxford, Praeger

von Krafft-Ebing R (1886). *Psychopathia sexualis. Eine klinische-forensische studie*. Stuttgart, Enke

W L (1874). *English Pottery and Porcelain: Being a Concise Account of the Development of the Potter's Art in England*, London, F Phillips

Wacher J (1974). *The Towns of Roman Britain*, Berkeley and Los Angeles, University of California Press

Wall M (1961). *The Penal Laws, 1681–1760: Church and State from the Treaty of Limerick to the Accession of George III*, Dundalk, W Tempest

Watt J (1970). *The Church and the Two Nations in Medieval Ireland*, Cambridge, Cambridge University Press

Webster C (1974). 'New Light on the Invisible College: the Social Relations of English Science in the Mid-Seventeenth Century', *Transactions of the Royal Historical Society*, 24, pp. 19–42

Weiser B (2003). *Charles II and the Politics of Access*, Woodbridge, The Boydell Press

Welchman G (1982). *The Hut Six Story*, New York, McGraw Hill

Welshman J (2010). *Churchill's Children: The Evacuee Experience in Wartime Britain*, Oxford, Oxford University Press

Whalen B (2014). *The Medieval Papacy*, Basingstoke, Palgrave Macmillan

Wheelis M (2002). 'Biological Warfare at the 1346 Siege of Caffa', *Historical Review*, 8:9, pp. 971–5

White D (2019). *Cold Warriors: Writers Who Waged the Literary Cold War*, London, Little, Brown

White M and Pettitt P (2012). 'Ancient Digs and Modern Myths: The Age and Context of the Kent's Cavern 4 Maxilla and the Earliest Homo Sapiens Specimens in Europe', *European Journal of Archaeology*, 15(3), pp. 392–420

White R (2017). *Out of the Ashes: An Oral History of the Provisional Irish Republican Movement*, Newbridge, Merrion Press

—— (2020). *Ruairí Ó Brádaigh. The Life and Politics of an Irish Revolutionary*, Bloomington, Indiana University Press

Whitelock D (1950). 'The Interpretation of the Seafarer', in *Early Cultures of Northwest Europe, H M Chadwick Memorial Studies*, C Fox and B Dickins (eds), Cambridge, Cambridge University Press, pp. 261–72

Williams A (2002). *The Battle of the Atlantic*, London, BBC Worldwide

Williams J (2007). 'New Light on Latin in Pre-Conquest Britain', *Britannia*, 38, pp. 1–11

Williams J (2013). 'Parliaments, Museums, Trustees, and the Provision of Public Benefit in the Eighteenth-Century British Atlantic World', *Huntington Library Quarterly*, 76:2, pp. 195–214

Williams M (2010). *Uncontrolled Risk: Lessons of Lehman Brothers and How Systemic Risk Can Still Bring Down the World Financial System*, New York, McGraw-Hill

Williams P (2015). *Custer and the Sioux, Durnford and the Zulus: Parallels in the American and British Defeats at the Little Bighorn (1876) and Isandlwana (1879)*, Jefferson, McFarland & Company

Williams T (2017). *Viking Britain: A History*, London, William Collins

Wills C (2007). *That Neutral Island: A Cultural History of Ireland During the Second World War*, Cambridge, Harvard University Press

Wilson D (2002). *The British Museum. A History*, London, The British Museum Press

Wilson E and J Whittaker (2013). *William Blake and the Digital Humanities: Collaboration, Participation, and Social Media*, Abingdon, Routledge

Wilson J (1952). *Nell Gwyn: Royal Mistress*, London, Frederick Muller

Winter J (1977). 'Britain's 'Lost Generation' of the First World War', *Population Studies*, 31:3, pp. 449–66

Winterton J and R Winterton (1989). *Coal, Crisis, and Conflict: The 1984–85 Miners' Strike in Yorkshire*, Manchester, Manchester University Press

Wolf G (2008). 'A Kidney from Hell? A Nephrological View of the Whitechapel Murders in 1888', *Nephrology Dialysis Transplantation*, 23, pp. 3343–9

Wolfe P (1972). *Linguistic Change and the Great Vowel Shift in English*, London, University of California Press

Wood A (2007). *The 1549 Rebellions and the Making of Early Modern England*, Cambridge, Cambridge University Press

Wood D (1989). *Clement VI, The Pontificate and Ideas of an Avignon Pope*, Cambridge, Cambridge University Press

Woodard C (2007). *The Republic of Pirates*, Orlando, Harcourt

Woodward S (2012). *One Hundred Days: The Memoirs of the Falklands Battle Group Commander*, London, HarperCollins

Woolf E (1972). *The English Mystery Plays*, Berkeley, University of California Press
Zirpolo L (2020). *Michelangelo. A Reference Guide to His Life and Works*, Lanham, Rowman & Littlefield
Zuckerman L (2004). *The Rape of Belgium: The Untold Story of World War I*, New York, New York University Press

(7) Secondary Sources: Doctoral Theses

Franklin A (1921). *The Lupercalia*, Columbia University
Oosterwijk S (2009). '*Fro Paris to Inglond*'? *The Danse Macabre in Text and Image in Late-Medieval England*, Leiden University
Pilcher-Dayton A (2011). *Women Freemasons and Feminist Causes 1908–1935: The Case of the Honourable Fraternity of Antient Masonry*, University of Sheffield

(8) Secondary Sources: Newspapers, Magazines, Pamphlets

Alberge D (4 November 2019). 'British Museum Is World's Largest Receiver of Stolen Goods, Says QC', the *Guardian*
Asthana A (10 August 2017). 'Blair Reveals He "Toyed with Marxism" after Reading Book on Trotsky', the *Guardian*
Baddiel D (21 February 2021). 'Talking Is the Only Way Through the Culture Wars', the *Sunday Times*
Bajaj V and J Creswell (21 June 2007). 'Bear Stearns Staves off Collapse of 2 Hedge Funds', the *New York Times*
Ball J (12 April 2013). 'The Thatcher Effect: What Changed and What Stayed the Same', the *Guardian*
Barrett D (15 May 2011). 'Scotland Yard Fights to Keep Jack the Ripper Files Secret', the *Telegraph*
Bennett C (28 October 2004). 'All Aboard with Satan's Sailor', the *Guardian*
Biggar N (22 February 2021). 'Universities Are Not Systematically Racist', *Sp!ked*
'Bliar? Why the Row over Weapons of Mass Destruction is so Dangerous for Tony Blair' (5 June 2003). *The Economist*.
Blumenthal H et al (10 December 2006). 'Statement on the New Cookery', the *Guardian*
Borges J L (14 February 1983). 'On the Falklands War', *Time*
Bowcott O (14 November 2001). 'Stalin "Picked Philby for Plot to Kill Franco"', the *Guardian*
Carrington D (18 October 2017). 'Warning of 'Ecological Armageddon' after Dramatic Plunge in Insect Numbers', the *Guardian*
Churchill W (26 April 1915). 'Death of Mr. Rupert Brooke. Sunstroke at Lemnos', *The Times*, p. 5
Connolly C (4 May 2019). 'Turbulent Water: A Cultural History of the Irish Sea', the *Irish Times*
Copping J (28 May 2011). 'Blackbeard's Queen Anne's Revenge Wreck Reveals Secrets of the Real Pirate of the Caribbean', the *Telegraph*
Critchlow A (28 May 2015). 'Falklands Oil Discovery Could Stir Trouble with Argentina', the *Telegraph*
Curtis P (8 July 2011). 'Tony Blair: New Labour Died When I Handed over to Gordon Brown', the *Guardian*
Dalton, J (3 June 2018). 'Corbyn Vows to Return Elgin Marbles to Greece If He Becomes Prime Minister', the *Independent*
Daley P (9 April 2015). 'Preservation or Plunder? The Battle over the British Museum's Indigenous Australian Show', the *Guardian*
Elliott L (13 December 2015). 'Coalmining Has Breathed Its Last but Working Life Can Still Be the Pits', the *Guardian*
Evans M (7 June 2020). 'Statue of Slave Trader Edward Colston Pulled Down and Thrown into Harbour by Bristol Protesters', the *Telegraph*
Fairhall D and A Graham-Yooll (26 April 1982). 'South Georgia Seized', the *Guardian*
'Fifty Years of Type-Cutting: 1900–1950' (1950). The *Monotype Recorder*, 39:2
Foster P and M Evans (24 February 2017). 'Exclusive: How a Tiny Canadian IT Company Helped Swing the Brexit Vote for Leave', the *Telegraph*
'Full Text: Bush's Speech. A Transcript of George Bush's War Ultimatum Speech from the Cross Hall in the White House' (18 March 2003), the *Guardian*
'Full Text of Cameron's Speech' (23 January 2013). The *Financial Times*
Gavrilov Y (24 January 1976). 'Zheleznaya Dama Ugrozhayet', *Krasnaya Zvezda*
Gillan A (8 May 2000). 'Ex-Solider Admits Defacing Statue of Churchill', the *Guardian*
Gilligan A (21 July 2003). 'The Betrayal of Dr David Kelly, 10 Years on', the *Telegraph*
'Gotcha' (4 May 1982). The *Sun*, p. 1
Greenslade R (25 February 2002). 'A New Britain, A New Kind of Newspaper', the *Guardian*
Griffin A (2 December 2014). 'Stephen Hawking: AI Could Be the End of Humanity', the *Independent*

'Hans Blix's Briefing to the Security Council' (14 February 2003). The *Guardian*

Harding T (26 December 2011). 'Belgrano Was Heading to the Falklands, Secret Papers Reveal', the *Telegraph*

Heffer S (4 March 2016). 'Jerusalem is an Ideal Song for England's Pleasant Land', the *Telegraph*

Hern A (30 July 2019). 'Cambridge Analytica Did Work for Leave.EU, Emails Confirm', the *Guardian*

Hornall T and L Roberts (28 December 2018). 'John Major Government Sent Blistering Notes to Clinton Administration after Gerry Adams Got US Visa, Cabinet Papers Show', the *Independent*

Houlihan J (15 March 2012). 'Nike Forced to Run Like Hell Away over Black and Tan Trainer Branding', The *Irish Examiner*

Jones J (4 November 2014). 'The Art World's Shame: Why Britain Must Give Its Colonial Booty Back', the *Guardian*

Jones T (22 March 1987). 'Irish Troubles. American Money', the *Washington Post*

Kar-Gupta S and Y Le Guernigou (9 August 2007). 'BNP Freezes $2.2 bln of Funds over Subprime', *Reuters*

Kirkup J (16 September 2008). 'As If He Did Not Have Enough Troubles, Gordon Brown Is Now Being Accused of Killing off Lehman Bros', the *Telegraph*

Kuttler H (23 March 2019). '75 Years after His Death, Why Orde Wingate Remains a Hero in Israel', the *Times of Israel*

Leake J and I Horton (22 September 2019). 'Wealthy English Blow-ins "Swung Welsh Brexit Vote"', the *Sunday Times*

London Plagues, 1348–1665 (2011). Pocket Histories: Exploring History Through Objects, London, Museum of London

Malik N (22 February 2021). 'The Culture War Isn't Harmless Rhetoric, It's Having a Chilling Effect on Equality', the *Guardian*

Manjapra K (29 March 2018). 'When Will Britain Face up to Its Crimes against Humanity?', the *Guardian*

'Martin McGuinness: Past and Presidency' (24 September 2011). The *Irish Times*

McDermott J and T Harnden (15 August 2001). 'The IRA and the Colombian Connection', The *Telegraph*

McGreevy R and S Collins (3 October 2013). 'Gunman Believed to Have Killed Michael Collins Was Granted Military Pension', the *Irish Times*

McSmith A (8 April 2013). 'Margaret Thatcher's Legacy: Spilt Milk, New Labour, and the Big Bang – She Changed Everything', the *Independent*

—— (4 July 2016). 'Chilcot Report: The Inside Story of How Tony Blair Led Britain to War in Iraq', the *Independent*

Moran J (16 August 2013). 'Television's Magic Moments', the *Guardian*

'Mueller Report: Here Are the Key Revelations' (19 April 2019). The *Financial Times*

Nelsson R (10 March 2016). 'Jerusalem: Centenary of an Anthem', the *Guardian*

Newman C and C Giles (2 December 2005). '1976 Sterling Crisis Details Made Public', the *Financial Times*

Nolan P (19 June 2018). 'United Ireland May Be in the Gift of "Others",' the *Irish Times*

Norton-Taylor R and R Evans (28 June 2005). 'UK Held Secret Talks to Cede Sovereignty', the *Guardian*

'Old Antiquity' (1879). The *Masonic Magazine*, 74:8, pp. 49–55

O'Neill B (24 September 2002). 'Blair's Dodgy Dossier', *Sp!ked*

Olusoga D (12 February 2018). 'The Treasury's Tweet Shows Slavery Is Still Misunderstood', the *Guardian*

'On This We Stand: The Rock of the Republic' (February 1970). *An Phoblacht*, pp. 1 and 8

Parker G and A Barker (24 January 2016). 'How Brexit Spelled the End to Cameron's Career', the *Financial Times*

Parker G et al (26 May 2014). 'Ukip and Front National Lead Populist Earthquake', the *Financial Times*

—— (24 June 2016). 'Britain Turns its Back on Europe', the *Financial Times*

Paton Walsh N (31 October 1999). 'Noel Looks Back in Anger at Drinks Party with Blair', *The Observer*

Pickard J and C Hodgson (17 July 2018). 'Vote Leave Fined and Referred to Police', the *Financial Times*

Porter A et al (13 October 2008). 'Financial Crisis: Banks nationalised by Government', the *Telegraph*

Procter A (23 April 2018). 'Museums Are Hiding Their Imperial Pasts – Which Is Why My Tours Are Needed', the *Guardian*

Ram A and C Rutter Pooley (27 March 2018). 'Cambridge Analytica Whistleblower Claims Link to Vote Leave', the *Financial Times*

Roberts Y (25 November 1990). '. . . And the One I Didn't', the *Observer*, p. 15

Roche B (11 August 2019). 'Academic Says Republicans Responsible for 60% of Troubles Deaths', the *Irish Times*

Rogers S (8 April 2013). 'How Britain Changed under Margaret Thatcher. In 15 Charts', the *Guardian*

Ross T et al (26 April 2014). 'Former Archbishop of Canterbury: We Are a Post-Christian Nation', the *Telegraph*

Sawer P (10 March 2013). 'Iraq War: The Key Players in the March to War'. the *Telegraph*

Selwood D (27 August 2015). 'What English Catholicism Will Look Like in 2115', the *Catholic Herald*

Shariatmadari D (30 April 2015). 'Why Have We Got It in for the Glottal Stop?', the *Guardian*

Simms B (18 September 2019). 'From Backdoor to Backstop: Ireland's Shifting Relationship with Britain and Europe', *New Statesman*

Smith C and A Wilson (17 July 1977). 'Why I Lost My Faith in MI5', the *Observer*, p. 1

'Special Issue Describing the Times New Roman Type, The Times Old Roman Type' (1933). The *Monotype Recorder*, London, The Monotype Corporation Ltd

Swaine J (8 October 2008). 'Bank Bailout: Alistair Darling Unveils £500 Billion Rescue Package', the *Telegraph*

The Aldine Press (2001). The Regents of the University of California, Berkeley, University of California Press

'The Execution of Soldier Mountbatten' (1 September 1979). *An Phoblacht*, p. 2

'The Fritz Times. With Which Are Incorporated The Wipers Times, The New Church Times, The Kemmel Times. The Somme Times, The B.E.F. Times. & The Better Times', no. 1, vol 24, *Die Welt*, 12 February 2016

'The Nation Pays Its Last Tribute' (1 February 1965). *The Times*, pp. 5–6

The Times (29 June 1830). Obituary of King George IV

The Times (28 February 1853). 'Asylum of Nations', p. 4

The Times (19 January 1858). 'Refuge of Nations', p. 8

The Times (14 November 1974). 'Lights Go Out As Emergency Powers Bite'

The Wipers Times: The Famous First World War Trench Newspaper (2018). C Westhorp (ed), Oxford, Osprey Publishing

Tombs R (20 February 2021). 'The Distortion of British History', the *Spectator*

Travis A (3 January 2014). 'National Archives: Thatcher Demanded Action to Stop Soviets Funding Miners', the *Guardian*

Union Flag or Union Jack (2014). The Flag Institute, London.

'US Public Thinks Saddam Had Role in 9/11' (7 September 2002). the *Guardian*

Weinraub B (16 December 1975). 'I.R.A. Aid Unit in the Bronx Linked to Flow of Arms', the *New York Times*

Wilford J (24 June 2009). 'Flutes Offer Clues to Stone-Age Music', the *New York Times*

Wilson M (13 June 2014). 'Why Britain's Historic Hedgerows Should Be Conserved and Cherished', the *Financial Times*

Wright M (14 November 2018). 'Church of England Sees Regular Attendance Rise but Churchgoers Struggle to Make Traditional Sunday Services,' the *Telegraph*

OTHER

(1) Internet Resources

Adams S (24 May 2008). 'Dudley, Robert, Earl of Leicester', *ODNB Online*

Age Groups (31 July 2019). Gov.uk, https://bit.ly/2A6e9b7

Barlow D (23 September 2004). 'Turpin, Richard [Dick]', *ODNB Online*

Bayeux Museum (2020). *Explore the Bayeux Tapestry Online,* https://bit.ly/37zo6et

Beare T (23 September 2004). 'Symington, William', *ODNB Online*

Benyon J (23 September 2004). 'Frere, Sir (Henry) Bartle Edward, First Baronet', *ODNB Online*

Birley A (27 May 2010). 'Roman Officers and Their Wives at Vindolanda', *ODNB Online*

Blake N (3 January 2008a). 'Caxton, William', *ODNB Online*

——— (3 January 2008b). 'Worde, Wynkyn de', *ODNB Online*

Bogdanor V (2012). 'Aneurin Bevan and the Socialist Ideal', Lecture delivered to Gresham College, 16 October 2012, https://bit.ly/3vJ7TxL

Bowen H (3 January 2008). 'Clive, Robert, First Baron Clive of Plassey', *ODNB Online*

Bradford S (3 October 2013). 'Margaret Rose, Princess, Countess of Snowdon', *ODNB Online*

Broadberry S et al (2010). 'English Medieval Population: Reconciling Time Series and Cross Sectional Evidence', *Reconstructing the National Income of Britain and Holland, c.1270/1500 to 1850*, Leverhulme Trust, F/00215AR, https://bit.ly/3eEE3Uz

Bullough D (7 May 2010). 'Alcuin [Albinus, Flaccus]', *ODNB Online*

Callahan R (6 January 2011). 'Wingate, Orde Charles', *ODNB Online*

Capturing the Changing Face of Great Britain (13 February 2020). Ordnance Survey, Press Office, https://bit.ly/3ddKNoy

Carter N (3 January 2008). 'Morison, Stanley Arthur', *ODNB Online*

Carter P (23 September 2010). 'Lady Chatterley's Lover Trial', *ODNB* Online

Cecil R (6 January 2011). 'Maclean, Donald Duart', *ODNB Online*

'Census 2011: Key Statistics for Northern Ireland' (2012). NISRA, https://bit.ly/314qwON

Clive N (1 September 2017). 'Philby, Harold Adrian Russell [Kim]', *ODNB Online*

Collinson P (5 January 2012). 'Elizabeth I', *ODNB Online*

Cordingly D (3 January 2008a). 'Bonny, Anne', *ODNB Online*

—— (3 January 2008b). 'Read, Mary', *ODNB Online*

Davenport-Hines R (8 October 2009). 'Cairncross, John', *ODNB Online*

De-la-Noy M (24 May 2008). 'Townsend, Peter Woolridge', *ODNB Online*

Di Campli San Vito V (1 September 2017). 'Davison, Emily Wilding', *ODNB Online*

Doggett N (23 September 2004). 'Whiting, Richard', *ODNB Online*

Dunn J (3 January 2008). 'Ellis [née Neilson], Ruth', *ODNB Online*

Ellis F (3 January 2008). 'Wilmot, John, Second Earl of Rochester', *ODNB Online*

Essick R (22 September 2005). 'Blake, William', *ODNB Online*

Ethnicity and National Identity in England and Wales: 2011 (2012). Office for National Statistics, 11 December 2012 https://bit.ly/2UHVM3a

Falkner J (3 January 2008). 'Churchill [née Jenyns], Sarah, Duchess of Marlborough', *ODNB Online*

Fitzmaurice J (23 September 2008). 'Cavendish [née Lucas], Margaret, Duchess of Newcastle upon Tyne', *ODNB Online*

Frogley A (6 October 2009). 'Williams, Ralph Vaughan', *ODNB Online*

Gaffney V et al (2020). 'A Massive, Late Neolithic Pit Structure Associated with Durrington Walls Henge', *Internet Archaeology* 55, https://doi.org/10.11141/ia.55.4

Gibbs G (21 May 2009). 'George I', *ODNB Online*

Gilbum et al, (2015). 'Are Neonicotinoid Insecticides Driving Declines of Widespread Butterflies?', PeerJ, 3:e1402, https://bit.ly/2V2h1No

Gordon G (19 April 2018). ' "Catholic majority possible" in NI by 2021', BBC, https://bbc.in/3cVzwLF

Gregg E (24 May 2012). 'James Francis Edward [James Francis Edward Stuart; Styled James; Known as Chevalier de St George, the Pretender, the Old Pretender]', *ODNB Online*

Griffiths P (1 September 2017). 'Frith [married name Markham], Mary [known as Moll Cutpurse]', *ODNB Online*

Halkon P (4 February 2021). 'Chariots in the Landscape of East Yorkshire', public lecture at the Society of Antiquaries of London, https://bit.ly/3ak9vp5

Haycock M (23 September 2004). 'Merlin [Myrddin]', *ODNB Online*

Hobsbawm E (22 May 2015). 'Marx, Karl Heinrich', *ODNB Online*

Hunter M (25 May 2006). 'Ashmole, Elias', *ODNB Online*

Kerr S (25 September 2014). 'Burgess, Guy Francis de Moncy', *ODNB Online*

Kitson M and M Carter (1 September 2017). 'Blunt, Anthony Frederick, *ODNB Online*

Larminie V (3 January 2008). 'Fell, John', *ODNB Online*

Levy P (1 September 2017). 'Cradock, Phyllis Nan Sortain [Fanny]', *ODNB Online*

—— (10 January 2013). 'Floyd, Keith', *ODNB Online*

Lewis J (11 June 2020). 'Charlotte Augusta, Princess [Princess Charlotte Augusta of Wales]', *ODNB Online*

Macgregor A (23 September 2004). 'Sloane, Sir Hans, Baronet', *ODNB Online*

Matthew H (23 September 2004). 'George V', *ODNB Online*

McConnell A (8 January 2015). 'FitzRoy [Fitzroy, Fitz-Roy], Robert', *ODNB Online*

Mid-1851 to Mid-2014 Population Estimates for United Kingdom (2016). Office for National Statistics, https://bit.ly/310AQbJ

Moore J (3 January 2008). 'Thomson, Richard', *ODNB Online*

Morrill J (17 September 2015). 'Cromwell, Oliver', *ODNB Online*

Mosely J (3 January 2013a) 'Baskerville, John', *ODNB Online*

—— (3 October 2013b) 'Caslon, William, the Elder', *ODNB Online*

Nenner H (23 September 2004). 'Regicides', *ODNB Online*

Nicholls M (24 May 2008a). 'Catesby, Robert', *ODNB Online*

—— (3 January 2008a). 'Percy, Thomas', *ODNB Online*

—— (3 January 2008b). 'Winter [Wintour], Thomas', *ODNB Online*
Owen M (23 September 2004). 'Aneirin [Aneurin, Neirin]', *ODNB Online*
Payton P (4 October 2007). 'Trevithick, Richard', *ODNB Online*
Pirouet N (6 January 2011). 'Amin, Idi', *ODNB Online*
Porter S (1 September 2017). 'Farriner, Thomas', *ODNB Online*
Regional Ethnic Diversity (1 August 2018). Gov.uk, https://bit.ly/2ZMhLYU
Religion in Northern Ireland (24 March 2015), NISRA, Census 2011, https://bit.ly/30YS08v
Roberts B (23 September 2004). 'Gruffudd, Elis', *ODNB Online*
Roberts S (21 May 2009). 'Sealed Knot', *ODNB Online*
Rogers P (23 September 2004). 'Smith, Alexander', *ODNB Online*
Rollason D (23 September 2004). 'Ælle [Ælla]', *ODNB Online*
Roy I (19 May 2011). 'Rupert, Prince and Count Palatine of the Rhine and Duke of Cumberland', *ODNB Online*
Selwood D (1 May 2017). 'The Case for Lord Elgin', Classics For All, *Ad Familiares*, https://bit.ly/3pMO2cP
Sharpe J (23 September 2004). 'Hopkins, Matthew', *ODNB Online*
Stedman Jones G (4 October 2012). 'Engels, Friedrich [Frederick]', *ODNB Online*
The UK Contribution to the EU Budget (2019). Office for National Statistics, 30 September 2019, https://bit.ly/30EbNuL,
Thornhill M (25 September 2014). 'McLaren, Malcolm Robert Andrew', *ODNB Online*
Thornton D (23 September 2004). 'Nennius [Ninnius, Nemniuus]', *ODNB Online*
Tomes J (23 September 2004). 'Tegart, Sir Charles Augustus', *ODNB Online*
Uboat.net (2021). https://bit.ly/3flvr62
UK Sea Fisheries Statistics 2018 (2019). M Elliott and J Holden (eds), London, Marine Management Organization, https://bit.ly/3f26VEe
University College London, *Legacies of British Slave Ownership*, https://bit.ly/2VlacGH
Vetch R (3 January 2008). 'Chard, John Rouse Merriott', *ODNB Online*
Victoria, Queen (1832–1901). *Queen Victoria's Journals: Princess Beatrice's Transcript*, Windsor Castle, Royal Archives, 141 volumes, https://bit.ly/2LMxZ0N
Watt D (3 January 2008). 'Barton, Elizabeth [called the Holy Maid of Kent, the Nun of Kent]', *ODNB Online*
Weikel A (3 January 2008). 'Mary I', *ODNB Online*
Weizmann C (10 December 1946). *Full Text of Dr. Weizmann's Keynote Address at 22nd World Zionist Congress*, Jewish Telegraphic Agency, https://bit.ly/3e1Hz94
White B (1 September 2017). 'Ferrers [married name Fanshawe], Catherine', *ODNB Online*
Wood P (23 September 2004). 'Teach [Thatch], Edward [known as Blackbeard]', *ODNB Online*
Wynne S (1 September 2017). 'Eleanor [Nell] Gwyn', *ODNB Online*

(2) Television and Music

BBC Timewatch (2003). *Zulu: The True Story*
Pink Floyd (1979). 'Another Brick in the Wall', *The Wall*, Pink Floyd Music Publishers
Sex Pistols (1977). 'God Save the Queen', A&M Records/Virgin Records
The Wolfe Tones (1972). 'Come Out Ye Black and Tans', *Let the People Sing*, Dolphin Records

Bibliographical Note

The bibliography only includes works cited in the endnotes. The general closure of libraries and archives during the COVID-19 pandemic has meant I have not always been able to find the very best edition of some works. For the same reason, a few entries lack specific page numbers, and in rare cases I have relied on page numbers supplied in other works.

Notes

PRELUDE: VOICES FROM THE PAST

1 'William, king, greets William, bishop, and Gosfrith, portreeve, and all the burghers in London, French and English, friendlily. And I inform you that I will that you be worthy of all the laws you were worthy of in Edward the king's day. And I will that every child is his father's heir after his father's days. And I will not suffer that any man offer any wrong to you. God keep you.' London, London Metropolitan Archives, COL/CH/01/001/A, William I, Charter to Lundenburgh (1067); Broun (2011).
2 Borges (1967).
3 *The Times* (1 February 1965), pp. 5–6.
4 Ibid.
5 Gillan (8 May 2000).
6 Roberts (2018), pp. cvi, ccclxxx; Cohen (2014), p. 311.
7 *Age Groups* (31 July 2019).
8 Tombs (20 February 2021); Biggar (22 February 2021); Baddiel (21 February 2021); Malik (22 February 2021).

1. HUNTERS AND HENGES – NOMADS ARRIVE

1 Cassius Dio (1924), 175:VII, book 60, chapter 19, pp. 414–22.
2 Williams (2007).
3 Sections of the periplus are thought to survive in Avienus's *The Sea Shore* (*Ora maritima*) of *c.* AD 350, which includes the phrase, 'situated nearby is the island of the Albions' (*insula albionum*), Avienus (1968), p. 20.
4 Pliny (1942), 352:II, book 4, pp. 196–7.
5 The scientific dating puts the footprints at 0.78 to 1 million years ago, Ashton et al (2014).
6 Villmoare et al (2015), pp. 1352–8. The first hominins (humans or close human ancestors) were the Australopithecines, who appeared around 4 million BC.
7 Ashton et al (2014); Ash and Robinson (2010), p. 196.
8 Prüfer et al (2017), pp. 655–8.
9 Higham et al (2011), but see White and Pettitt (2012) urging caution with this date.

10 The world's sea levels rose by around 120 metres between 19,000 BC and 6,000 BC, Stanford et al (2011), pp. 193–203.
11 Bahn (2005); Pettitt et al (2007).
12 Nietzsche (1954), III, pp. 830–8.
13 A total of 21 deer headdresses dating from around 10,000 BC were found in 1949–51, with further similar finds uncovered later, Clark (1978).
14 Miles et al (2003).
15 Parker-Pearson (2018), p. 33.
16 Jacques et al (2014).
17 Despite the name, Stonehenge is not technically a henge as it has a bank inside a circular ditch rather than the other way around.
18 Scotland 508, England 316, Ireland 187, Northern Ireland 156, Wales 81, Burl (2000), p. 395.
19 French et al (2012).
20 (1) 3000 to 2920 BC, (2) 2620 to 2480 BC, (3) 2480 to 2280 BC, (4) 2280 to 2020 BC, and (5) 1600 BC. The vast bluestones were set up in Stage 1, then in Stage 2 a double arc of even more massive sarsen stones was erected around a horseshoe of equally huge sarsen trilithons. In Stages 3 and 4 the bluestones were moved multiple times, first into two concentric circles, then into a horseshoe inside a circle. Stage 5 saw a circle of pits dug, and was perhaps unfinished. Parker-Pearson (2018), pp. 9–10.
21 Ibid., p. 12.
22 Ibid., pp. 12, 38.
23 Ibid., pp. 29, 33.
24 Ibid., p. 15.
25 The remains of 63 individuals have been found, with estimates suggesting up to 150 may be buried at the site, Parker-Pearson (2012), p. 193, (2018), p. 15. For the Welsh connection, Snoeck et al (2018).
26 Parker-Pearson (2018).
27 Stukeley (1740).
28 Parker-Pearson (2018), pp. 25, 28.
29 Fitzpatrick (2011).
30 Gaffney et al (2020).
31 Parker-Pearson (2018), pp. 7, 44–9.
32 Ibid., pp. 43–4.
33 Abbott and Anderson-Whymark (2012), pp. 26–37.

2. CHARIOTS AND WOAD – A PATCHWORK OF CELTIC TRIBES

1 *Domesday Book* (1986), 1:2B:10, p. 302.
2 London, British Museum, 2001,0401.20, Wetwang, woman charioteer's skeleton (*c.* 250–200 BC). The charioteer was 35–45 years old, Giles (2012), pp. 245–9. There are 27 known chariot burials in east Yorkshire, and another three elsewhere in the UK. Of them four have so far been identified as women, Halkon (4 February 2021). Generally, Hill (2002).
3 Julius Caesar (1986, 1917), 72, book 4, chapter 33, pp. 222–3.
4 The Parisi are mentioned in Ptolemy of Alexandria (1883), I, book 2, chapter 3, p. 98.
5 Harding (2000).
6 Diviciacus belonged to the Suessiones, Julius Caesar (1917), 72, book 2, chapter 4, pp. 94–5.
7 Most experts place Homer in the ninth or eighth century BC.
8 Plutarch (1919), 99:VII, book 15, pp. 478–9.
9 Ibid., book 23, p. 499; Strabo (1917), I, book 2, chapter 4:1–2, pp. 398–401, who also discusses Polybius's views.
10 On the first visit he brought two legions (*VII Claudia* and *X Equestris*), skirmished around his beachhead, lost ships in storms, then returned to France. On the second he brought five legions, pushed inland and crossed the Thames, placed a friendly tribal leader named Mandubracius on the throne of the Trinovantes (who controlled parts of Essex and Suffolk), lost more ships to storms, and returned to France.
11 It was in circulation before 46 BC, Radin (1918).
12 The first to mention Britain was Pytheas of Marseilles, who travelled to Britain around 330 BC. His book, *On the Ocean*, is lost and only known in fragments, principally via Timaeus (*c.* 350–after 264 BC), Eratosthenes (*c.* 276–*c.* 194 BC), Polybius (*c.* 200–*c.* 118 BC), Diodorus of Sicily (first century BC),

Pliny the Elder (AD 23–79) and Strabo (c. 64 BC–after AD 21). Ancient writers who mentioned Britain include Diodorus of Sicily, Strabo, Livy (64/59 BC–AD 17), Fabius Rusticus (first century AD), Pliny the Elder, Pomponius Mela (fl. AD 43), Juvenal (AD 55/60–c.127), Tacitus (AD 56–c. 120), Suetonius (AD 69–after 122) and Cassius Dio (c. AD 150–235). See Markham (1893).

13 Among the oldest manuscripts are Paris, Bibliothèque Nationale MS Lat. 5763 (AD 800–25) and Amsterdam, University Library MS XV G 1 (AD 825–50). The earliest printed version is Julius Caesar (1469).

14 The Romans called the people of France 'Gauls', but the people called themselves 'Celts'. Caesar makes no similar distinction for Britons, implying there was only the one name, Julius Caesar (1917), 72, book 1, chapter 1, pp. 2–3.

15 The Greek word is Πρεττανική or Βρεττανική, Strabo (1917), I, book 2, chapter 4:1–2, pp. 398–401 and Diodorus of Sicily (1939), 340:III, book 5, chapter 21, pp. 150–1.

16 Ibid., book 5, chapter 21, pp. 152–5.

17 Tacitus (1914), 35, chapter 11, pp. 46–7.

18 The (multiple) invasion theory became popular in the eighteenth century as an explanation for why England and Wales spoke Brythonic Celtic while Ireland, the Isle of Man and west Scotland spoke Goidelic Celtic. In the late twentieth century alternative theories around a gradual and voluntary Celticisation began to appear. None of the theories is conclusive.

19 Parfitt (1993).

20 Julius Caesar (1917), 72, book 5, chapter 14, pp. 252–3.

21 Ibid., book 6, chapter 19, pp. 342–5.

22 Diodorus of Sicily (1939), 340:III, book 5, chapter 26, pp. 166–7.

23 Livy (1924), 172:III, book 5, chapter 48, pp. 164–5; Plutarch (1914), 47:II, chapter 28, pp. 164–5.

24 Flavius Josephus (1905), book 15, chapter 7, p. 467.

25 Polybius (2010), 128:I, book 2, chapter 28, pp. 340–1.

26 Tacitus (1914), 35, chapter 11, pp. 46–7.

27 Julius Caesar (1917), 72, book 4, chapter 24, pp. 212–3.

28 Ibid., book 5, chapter 19, pp. 258–9.

29 Ibid., book 5, chapter 16, pp. 254–5.

30 Ibid., book 6, chapters 13–14, pp. 334–9; Tacitus (1914), 35, chapter 11, pp. 46–7. For British druids, Hutton (2009).

31 Julius Caesar (1917), 72, book 6, chapter 14, pp. 338–9.

32 Ibid., book 6, chapter 14, pp. 338–9.

33 Ibid., book 5, chapter 12, pp. 250–1.

34 Leins (2007), pp. 22–48.

35 Tacitus (1914), 35, chapter 30, pp. 80–1.

3. TOGAS AND TRADE – THE EDGE OF EMPIRE

1 Cassius Dio (1927), 177:IX, book 77, chapter 16, pp. 274–5.

2 Ibid., book 77, chapter 12, pp. 262–3.

3 Claudius did not personally use the title *Britannicus*, but gave it to his son.

4 Millett (1990).

5 For Roman Gaul, Omrani (2017).

6 Augustus (27 BC–AD 14), Tiberius (AD 14–37) and Claudius (AD 41–54) all suppressed druidry in Gaul.

7 Tacitus (1937), 322:II, book 14, chapter 30, pp. 154–7.

8 Some translators say the daughters were 'outraged' but the Latin is unambiguously clear that they were raped ('et filiae stupro violatae sunt'), Tacitus (1937), 322:II, book 14, chapter 31, pp. 156–7.

9 Cassius Dio (1925), 176:VIII, book 62, chapter 2, pp. 84–5. The traditional name Boadicea is an invention. Her name was Boudicca or something similar. Bodicca appears in a Roman inscription in Africa. Boudica or Boudicas appears in a Roman inscription in Spain. Budic is known from Brittany. All are assumed to be allied to the Celtic (especially Welsh) word *budd*, 'victory' or *buddugol*, 'victorious', Rhys (2014), p. 278.

10 Tacitus (1937), 322:II, book 14, chapter 33, pp. 162–3.

11 In imperial times a legion was around 6,000 men, built up of 10 heavy infantry cohorts of 360 men armed with spear (*pilum*) and sword (*gladius*), plus light infantry armed with bows, javelins and slings, and cavalry. As the legions became more defensive, the cohorts increased to 500–600 men, and each legion could also have up to 10 catapults and 60 *ballistae*.

12 Tacitus (1937), 322:II, book 14, chapter 35, pp. 164–5.

13 Ibid., book 14, chapter 37, p. 168.

14 Ibid., book 14, ch 37, p. 168 says she took poison. Cassius Dio says she sickened and died (1925), 176:VIII, book 62, chapter 12, pp. 102–5.

15 Ibid., book 62, chapter 12, pp. 104–5 says her burial was lavish.

16 The principal legions and their bases in Britain were: *Legio II Adiutrix* (2nd Legion, Assistant) – Chester, Lincoln; *Legio II Augusta* (2nd Legion, Augustan) – invasion of AD 43, Antonine Wall, Caerleon, Carpow, Chichester, Corbridge, Corfe Mullen, Gloucester, Hadrian's Wall; *Legio VI Victrix* (6th Legion, Victorious) – Antonine Wall, Carpow, Corbridge, Hadrian's Wall; *Legio VIII Augusta* (8th legion, Augustan) – invasion of AD 43; Tyne; *Legio IX Hispana* (9th Legion, Spanish) – invasion of AD 43; Lincoln, Longthorpe, Malton, Newton-on-Trent, York; *Legio XIIII Gemina Martia Victrix* (14th Legion, Twin, added 'Martia Victrix' (Martial and Victorious) after crushing Boudicca along with *Legio XX Valeria*) – invasion of AD 43, Mancetter, Wroxeter; *Legio XX Valeria Victrix* (20th Legion, Valiant, added 'Victrix' (Victorious) after crushing Boudicca along with *Legio XIIII Gemina*) – invasion of AD 43, Antonine Wall, Carlisle, Chester, Colchester, Inchtuthil, Kingsholm, Wroxeter; *Legio XXII Deiotariana* (22nd Legion, Deiotarian) – possibly in Britain; *Legio XXII Primigenia* (22nd Legion, Firstborn) – possibly in Britain.

17 Experts differ on the date. Goldsworthy (1996), p. 134 has AD 84.

18 Tacitus (1914), 35, chapter 30, pp. 80–1.

19 For a period from AD 142–c. 163 the border was pushed further north, up to the Antonine Wall between the Clyde and the Firth of Forth, but this northernmost boundary was eventually abandoned and the line was pulled back to Hadrian's Wall.

20 Atrectus is *cervesarius* (tablet 182, sheet 2, line 5); Tagomas is *vexillarius* (tablet 01-39); Vitalis is *seplesarius* (tablet 586, line 7); Virilis is *veterinaries* (tablet 310, sheet 1, lines 10 and 11). Tablet 301 shows slaves discussing the *Saturnalia*, when slaves and masters switched places. The Vindolanda Writing-Tablets (1994).

21 Birley (27 May 2010).

22 'Ne tu turpis appare', Tomlin (2016), WT 30, pp. 120–3.

23 Wacher (1974), p. 84.

24 Rocco (2010), pp. 131–56.

25 Ammianus Marcellinus (1940), 331:III, book 27, chapter 8.7, pp. 54–5; *Dictionary of Greek and Roman Geography* (1857), II, p. 203. The undated Register of Dignitaries (perhaps c. AD 400) mentions a 'praepositus thesaurorum augustensium in britanniis', *La Notitia Dignitatum* (2005), p. 365.

26 Clodius Albinus (AD 196) was a usurper. Caracella and Geta (AD 211) were the sons of Emperor Septimus Severus who died at York. Postumus (AD 260) was emperor of the breakaway 'Gallic Empire' of Britannia, Gaul, Germania and Hispania. Carausius (AD 286) and Allectus (AD 293) were emperors of breakaway Britannia and northern Gaul. Magnus Maximus (AD 383) was a legitimate emperor. Marcus (AD 406), Gratian (AD 407) and Constantine III (AD 407) were all usurpers, although Constantine was legitimised by Honorius.

27 A medieval tradition, first mentioned by Henry of Huntingdon, maintains that Constantine's mother, Helena, was from England, but there is no evidence for it, Henry of Huntingdon (1879), book 1, chapter 38, p. 30. The Edict of Milan promoting religious tolerance was issued in AD 312. Constantine held the Council of Nicaea in AD 325 and founded Constantinople in AD 330. Constantine was only baptised on his deathbed, and hovered between Christianity and paganism even after his conversion.

28 The names western Roman empire and eastern Roman Empire are modern. The Romans saw only one empire with two capitals.

29 Gamberini (2014), p. 20; Deliyannis (2010), p. 46.

30 According to the Verona List compiled around AD 297, Britain was split into four provinces: Maxima Caesariensis (capital at London), Flavio Caesariensis (capital at Lincoln), Britannia Prima (capital at Cirencester) and Britannia Secunda (capital at York), *The Verona List* (1982), pp. 201–8. For the capitals, Hornblower et al (2014), p. 138.

31 The Vandal-born Roman commander Stilicho pulled legionaries from Britain to fight the Visigoths in Italy. The precise date is unclear, but probably in waves from around AD 398–402, Salway (1993), pp. 312–15. The withdrawals in AD 407 were by order of Emperor Constantine III.

32 Ammianus Marcellinus (1940), 331:III, book 27, chapter 8.1, pp. 50–1; Tomlin (1974).

33 The Rescript of Honorius is only known from a short entry composed c. AD 498–518. It reads simply 'Honorius sent letters to the cities in Britain, urging them to fend for themselves', Zosimus (1982), p. 130.

4. WARRIORS IN THE MIST – THE AGE OF ARTHUR

1 Menotti and O'Sullivan (2013), p. 376.
2 The legends of Joseph of Arimathea are part of the Arthurian cycle. The first author to connect Joseph with Britain was Robert of Boron, who wrote around 1200 that Joseph sent the Holy Grail and the Grail Fellowship to Avalon, Robert of Boron (1995). The thorn was cut down by Puritans in the Civil War, but regrown from clippings saved by locals, a sprig of which is still sent to the queen every Christmas.
3 Gerald of Wales (1891), chapter 20, pp. 126–8. Gerald also told the story of the excavation, idem (1873), chapters 8–9, pp. 47–50. Each of these works now exists in only one manuscript, British Library, Cotton MS Julius B XIII, Gerald of Wales, *De principis instructione* (1174–1325) and British Library, Cotton MS Tiberius B XIII, Gerald of Wales, *Speculum ecclesiae* (1200–99).
4 Gerald of Wales (1891), p. 127. Generally, Carley (2001).
5 London, British Library, Cotton MS Nero D VIII, Geoffrey of Monmouth, *Historia regum britannie* (1175–1200). For the Leir story, Geoffrey of Monmouth (1854), book 2, chapter 11, pp. 24–6.
6 'Quendam Britannici sermonis librum vetustissimum', ibid., book 1, chapter 1, pp. 3–4.
7 The three great medieval literary cycles were: (1) The Matter of Britain, involving the kings of Britain (mainly Arthur), (2) The Matter of France, dealing with Charlemagne, and (3) The Matter of Rome, covering classical mythology. They were first identified by the twelfth-century French poet Jean Bodel, see Jean Bodel (1989).
8 This is complex, see Charles-Edwards (2013).
9 The office of 'comes litoris saxonici per britanniam' appears in the Register of Dignitaries, *La Notitia Dignitatum* (2005), pp. 140, 413.
10 Charles-Edwards (2013), pp. 202–19.
11 For the date, ibid., p. 217.
12 Using mercenaries was a model the Romans had employed, bringing in barbarian *foederati* (federates) to help with defence. Gildas used the name Gurthrigern ('superbo tyranno Gurthrigerno Britannorum duce'), but it is a form of Vortigern, as is Gwrtheyrn in the Welsh texts, see Gildas (1838), p. 30.
13 Bede (1896), chapter 15, pp. 30–3; *The Anglo-Saxon Chronicle* (1961), p. 10 (entries for AD 449–73).
14 Brooks (2000).
15 The exceptions were Christians, Jews and druids, with whom the Romans had friction.
16 Cunliffe (1966).
17 Brythonic Celtic was spoken in England (including Cornwall) and Wales. Emigrants later took it to Brittany. Goidelic Celtic was spoken in Ireland, the west of Scotland and the Isle of Man. Together, Brythonic and Goidelic Celtic are known as the 'insular' Celtic languages to indicate they came from the British Isles.
18 Owen (23 September 2004).
19 *Y Gododdin* has an A and older B version. The references to Catraeth are largely in the B version, Charles-Edwards (2013), pp. 373–6, 385–7.
20 *Y Gododdin* (1970), p. 64.
21 The earliest surviving manuscript of *Y Gododdin* is Aberystwyth, National Library of Wales, Cardiff MS 2.81 (*c.* 1275). It was probably copied at the Cistercian monastery of Aberconwy. Aneirin is believed to have flourished alongside Taliesin *c.* AD 575–600. The poem begins, 'This is the Gododdin, Aneirin sang it' and in verse 48 Aneirin refers to himself. The attribution to Aneirin of the original version is supported by Charles-Edwards (1978), pp. 44–71. Generally, Koch (1997).
22 Views are divided on whether Nennius was the author, Thornton (23 September 2004), pp. 423–4, Charles-Edwards (2013), 438.
23 The 'Glein' is the river Glen in Lincolnshire or Northumberland. 'Linnuis' is Lindsay, the area around Lincoln. 'Cat Coit Celidon' (The Wood of Celyddon) is around the upper Clyde and Tweed valleys. The 'city of the legion' is Chester, or perhaps Caerleon. 'Tribruit' is probably in Scotland. 'Mount Badon' is probably in the south of England, Jackson (1945).
24 The Battle of Badon is usually dated to *c.* AD 500. Bede says AD 493. The *Annales cambriae* say AD 516.
25 Guy (2015); Charles-Edwards (2017), pp. 124–6.
26 *Annales cambriae* (2015a), p. 3.
27 Geoffrey of Monmouth hedged his bets by stating that Arthur carried 'on his shoulders a shield named Pridwen, on which was painted an image of Saint Mary' ('Humeris quoque suis clypeum vocabulo Priwen: in quo imago sanctae Mariae dei genitricis impicta') Geoffrey of Monmouth (1854) book 9, chapter 4, pp. 124–5.

28 'Gueith cam lann inqua arthur & medraut corruerunt', *Annales cambriae,* (2015a), p. 4.

29 A later manuscript of *The Annals of Wales* from AD 1250–1300 expanded both sections. For AD 516 it added that Arthur was 'king' and that 'Congrinus and Radulphus, dukes of the English died in this battle'. For AD 537 it added that Arthur was 'renowned king of the Britons' and Mordred was 'his betrayer', *Annales cambriae* (2015b), p. 23.

30 Padel (1994).

31 Generally, Charles-Edwards (1991).

5. GAME OF THEGNS – ANGLE-LAND EMERGES

1 Bruce-Mitford (1975); Evans (1986); Marzinzik (2007).

2 London, British Museum, 1939,1010.93, Sutton Hoo, *grimhelm* (AD 550–650).

3 Campbell (2000), pp. 55–84.

4 For *saxones* as pirates, Springer (2003) 16; Flierman (2017).

5 *Anglo-Saxon Charters* (1968) S 348, 354, 355, 356, pp. 156–7, 158.

6 For the emergence/creation of ideas of England, Molyneaux (2011 and 2015).

7 'Non solum domina vel regina, sed etiam rex vocaretur', Henry of Huntingdon (1879) book 5, chapter 17, p. 158. This is, of course, a post-Conquest chronicle.

8 'Ferocissimi illi nefandi nominis saxones deo hominibusque inuisi', Gildas (1838), chapter 23, p. 30.

9 Bede (1896), book 2, chapter 1, pp. 79–81; *The Earliest Life of Gregory the Great* (1968); Harris (2002).

10 Rochester, Cathedral Library, MS A.3.5, *Textus roffensis* (1122–4).

11 Other kings have been bibliophiles, like Æthelstan, Henry VIII and George III.

12 London, British Library Cotton MS Nero D IV, the *Lindisfarne Gospels* (*c.* AD 700); London, British Library, Cotton MS Otho C I/1, the *Gospels in Old English* (1000–50).

13 Nijenhuis (2001), p. 125.

14 'Wodensleie' (Wensley), *Domesday Book* (1978), 1, 12m, 272 b,c; 'Tiheshoche' (Tysoe), *Domesday Book* (1976), 22, 4, 242 c; 'Thunresfeld' (Thunderfield), *The Dooms of the City of London* (1849), p. 521.

15 Bede (1850), p. 357; Shaw (2011).

16 London, British Museum, OA.10262, rune ring (AD 700–1000). Transcribed into Roman letters the inscription reads 'ÆRKRIUFLTKRIURITHONGLÆSTÆPON TOL'. The last three letters are inside the ring.

17 Such charms appear elsewhere, including in Anglo-Saxon Christian texts, so may have sat alongside more traditional Christian beliefs. London, British Library, Cotton MS Caligula A XV, Christ Church Canterbury, *Annals* and Easter computational tables (775–1075) and Cotton MS Titus D XXVI–XXVII, Ælfwine, prayer book (1075–1100) both feature Old Norse charms alongside Christian materials.

18 The only manuscript of the Anglo-Saxon rune poem, once in London, British Library Cotton MS Otho B X (AD 875–925), was destroyed in the 1731 Ashburnham House fire. For the Norwegian and Old Icelandic rune poems, Bauer (2003), pp. 113–62, 163–208.

19 Page (1987, 1995).

20 St Cuthbert's Coffin dates from AD 698. The Franks Casket is from the early AD 700s.

21 London, British Museum, CM 1913,1213.1, King Offa, gold dinar (AD 774–96). The text is misspelled and upside down, suggesting a lack of familiarity with Arabic.

22 King Harald Hardrada of Norway, killed by King Harold II of England at Stamford Bridge in 1066, served in the Varangian Guard for 10 years, Godfrey (1979), pp. 63–74.

23 Vercelli, Biblioteca Capitolare, MS CXVII, the *Vercelli Book* (AD 950–1000); Exeter, Cathedral Library, MS 3501, the *Exeter Book* (AD 950–1000); London, British Library, Cotton MS Vitellius A XV, the *Nowell Codex* (AD 975–1000); Oxford, Bodleian Library, MS Junius 11, the *Junius Manuscript* (1000–25).

24 Exeter, Cathedral Library, MS 3501, the *Exeter Book* (AD 950–1000).

25 It is at fols 81v–83r; Connor (1986), pp. 233–42.

26 The classic interpretation is Whitelock (1950).

27 Some, like Oosthuizen (2019), argue for an evolution rather than an invasion model.

28 'Pan uyd kechmyn Danet an teyrned', Aberystwyth, National Library of Wales, Peniarth MS 2, *Armes Prydain Fawr* (1300–50). *Kechmyn* translates literally as 'shit-men'.

29 William of Malmesbury (1887), I, book 2, chapter 134, pp. 148–9. For Cornwall, Charles-Edwards (2013), p. 22.

30 The phrase originated with Renaissance humanists keen to show they had rediscovered the light of Greece and Rome, Mommsen (1942), pp. 226–42. It was popularised in Britain by a Scottish Whig, Bishop Gilbert Burnet of Salisbury, Burnet (1681).

6. *RANNSAKA AND SLAHTR* – VIKINGS TAKE THE THRONE

1 Sighvar the Skald, *Knútsdrápa* (*c.* 1038), stanza 1, in Frank (1984), pp. 332–43. Not all scholars accept this account, Rollason (23 September 2004).

2 *Orkneyinga Saga* (*c.* 1200), chapter 8, in Frank (1984), p. 333.

3 *The Anglo-Saxon Chronicle* (1961), p. 35 (entry for AD 787, although it means 789). *The Annals of St Neots* located it at the Isle of Portland, Asser (1904), p. 128.

4 *The Anglo-Saxon Chronicle* (1961), p. 36 (entry for AD 793).

5 Ibid., p. 36 (entry for AD 793).

6 Alcuin of York's letter to Higbald, *Celebrating the Saints* (2016), p. 177.

7 Simeon of Durham (1855), p. 457 (entry for AD 793).

8 Although the memories were not entirely lost. There is an Anglo-Saxon copy of Gildas, London, British Library, Cotton MS Vitellius A VI (mid-AD 900s) and Archbishop Wulfstan Lupus of York's *Sermon of the Wolf to the English* (1014) reminds listeners of Gildas's warnings, Wulfstan of York (1976).

9 Loe (2015), pp. 38–41.

10 Asser (1904), chapter 55, p. 45.

11 Asser (1904), chapter 56, p. 45.

12 'Ealles Angelcynnes Þitan', Cambridge, Corpus Christi College, MS 383, fols 57r–57v (*c.* AD 1100). There is another copy in the same manuscript, fol. 12v. *Die Gesetze der Angelsachsen* (1858), p. 106.

13 There is one older instance in a charter given by King Burgred of Mercia to the bishop of Worcester in which he mentions 'English persons' ('angelcynnes monna'), Worcester Archive, S 207 (AD 855).

14 The first two references to the Danelaw are in the *Laws of Edward and Guthrum* (1002–8) and the *VI Alfred* (1008) in Holman (2016), p. 2.

15 Jesch (2015).

16 Graham-Campbell (2001), p. 220.

17 Generally, Larrington et al (2016).

18 It is variously dated to pre-AD 900 or AD 900–25, *The Hávamál* (1923), pp. 12–13.

19 Saxo Grammaticus (1931), book 9, chapter 4, pp. 251–2.

20 Hedenstierna-Jonson et al (2017).

21 Jesch (2005).

22 Hill and Rumble (1996).

23 *The Battle of Maldon* (2015), p. 50.

24 *Wælwulf* is not to be confused with the Old English *werewulf* (man-wolf), mentioned in the *Laws of Cnut I*, Law 26 (*c.* AD 1000), *Die Gesetze der Angelsachsen* (1858), p. 270.

25 S 909 (1004), *The Cartulary of the Monastery of St Frideswide at Oxford* (1895), I, pp. 2–7. For Æthelred's reign, Roach (2016).

26 *The Anglo-Saxon Chronicle* (1961), p. 92 (entry for 1013).

27 Generally, Williams (2017).

7. A ROYAL STITCH-UP – THE BASTARD'S CROSS-CHANNEL EMPIRE

1 Berlin Bundesarchiv A/100/07, Himmler, letter to Walther Wüst and Wolfram Sievers (7 January 1943); Hicks (2007), pp. 226–7.

2 Hicks (2007), pp. 226–7.

3 Prestwich (1988).

4 For a full colour reproduction, Mussett (2005). Online zoomable version Bayeux Museum (2020).

5 Anglo-Saxon embroiderers had an international reputation for *opus anglicanum* (English Work), while the Normans had no known expertise in embroidery. The tapestry's imagery has similarities with the illuminated manuscripts produced at Canterbury, which was Odo's base in England. Other reasons for seeing an English origin are that certain spellings are English (*ceastra*, *Eadward*), and two proper names have specifically English letters (*æ* and *ð*). The case for Odo is that apart from Harold and William, he is the most important person in the tapestry, appearing numerous times in key roles, and three of his knights are mentioned by name.

6 Æthelred the *Unræd*'s first wife was Ælfgyfu of York (died *c.* 1002). His second wife, Emma of Normandy (died 1052) – Edward the Confessor's mother – took Ælfgyfu as her adopted English

name. Cnut married Ælfgyfu of Northampton (died after 1036), before marrying Æthelred's widow, Emma of Normandy/Ælfgifu.

7 Orderic Vitalis (1969), II, book 3, p. 144.
8 William of Jumièges (1995), II, book 7, chapter 2, p. 94.
9 Generally, Bates (2016).
10 Orderic Vitalis (1969), II, book 3, p. 172.
11 The chronicles are Guy of Amiens (1999) 1066–7; William of Jumièges (1995) 1070; William of Poitiers (1844) 1071–7; *The Anglo-Saxon Chronicle* (1961), pp. 140–5 (entry for 1066).
12 Amatus of Monte Cassino (1935), book 1, chapter 3, p. 11. The chronicle of Amatus only exists in a late medieval French copy which may have been interpolated. The biblical allusion to blinding for perjury occurs in the story of King Zedekiah (2 Kings 25:7 and Jeremiah 52:11).
13 The list was drawn up by the Norman bishops perhaps as early as 1066, and approved in 1070 by the papal legate, Ermenfrid of Sion, so is usually known as The Ermenfrid Penitential. Penances include one year for each man killed, 40 days for wounding, three days for having thought about wounding. Anyone guilty of adultery, rape or fornication was to do the penance normally in their own country, Cowdrey (1969), pp. 225–42.
14 Florence of Worcester (1854), p. 174. Nowadays called John.
15 Orderic Vitalis (1969), II, book 4, p. 232.
16 *The Anglo-Saxon Chronicle* (1961), pp. 161–2 (entry for 1085).
17 Salisbury was then a Norman settlement on the Iron Age hillfort at Old Sarum. It was called Salisbury (*Sarisbirie*). The name Old Sarum is likely a later error from a scribe misreading the Latin abbreviation *Sār̄as Sar*[*um*] rather than *Sar*[*isbirie*].
18 Generally, Harvey (2014b).
19 Broadberry et al (2010), p. 22.
20 'Roger Deus Salvæt Dominas' and 'Humfrid Aurei Testiculi', Keats-Rohan (1999), pp. 272, 407.
21 William of Malmesbury (1889), II, book 3, chapter 282, pp. 336–7.
22 Generally, Green (2006).
23 Henry of Huntingdon (1879), book 7, chapter 43, p. 254.
24 British Library, Cotton MS Caligula A XV, *Annals of Christ Church Canterbury*, fol. 135r (late eleventh century); Morris (2021), pp. 403–8.
25 Edward the Confessor's Romanesque abbey was largely pulled down by Henry III starting in 1245 and replaced with the current Gothic building. The Pyx Chamber and the undercroft remain from Edward's building.

8. *HPÆT!* – THE CREATION OF A JEWELLED LANGUAGE

1 Genesis 1: 1–3, *The Holy Bible* (1611), p. 77.
2 Goff et al (2014).
3 Cambridge, Trinity College E. 17. 1, James 987, Eadwine's *Psalterium triplex* (*c.* 1150); Gibson et al (1992).
4 London, British Library, Cotton Vitellius A XV, the *Nowell Codex* (*c.* 975–1000). *Beowulf* is at fols 132r–201v.
5 *Cædmon's Hymn* (Chapter 12) dates from the seventh century, but it is short. Cynewulf's longer poems are from the ninth-century. No one knows the date of *Beowulf*, Neidorf (2014).
6 Anglo-Saxon scribes used eth and thorn interchangeably, even for the same word in the same manuscript. Some linguists suggest that originally thorn may have been for the voiceless 'th' in 'think' while eth may have been for the voiced 'th' in 'then', but there is no hard evidence.
7 Parliament passed the Pleading in English Act 1362 because, it stated, French was 'trop desconue' (too unknown); Stubbs (1875), II, p. 414.
8 Wolfe (1972).

9. WHEN CHRIST AND HIS SAINTS SLEPT – THE EMPRESS, THE USURPER AND THE ANARCHY

1 Charlemagne and Pope Leo III refounded the Roman Empire on Christmas Day AD 800 with a ceremony in Old St Peter's Basilica, Rome.
2 Orderic Vitalis (1978), VI, book 12, chapter 26, pp. 294–307; William of Malmesbury (1889), II, book 5, chapter 419, pp. 496–7. There are also accounts in Eadmer, Henry of Huntingdon, Hugh the

Chanter, Robert of Torigni, Simeon of Durham and Wace.

3 Duggan (2016), p. 77.

4 *Gesta stephani* (1886), III, p. 76.

5 For a recent biography, Gold (2018).

6 The term was coined in Round (1892).

7 The manuscripts are: Cambridge, Corpus Christi College, MS 173, 'A, Winchester' (*c.* 1099); British Library, Cotton MS Tiberius A VI, 'B, Abingdon I' (AD 975–1400); British Library, Cotton MS Tiberius B I, 'C, Abingdon II' (1000–1200); British Library, Cotton MS Tiberius B IV. 'D, Worcester' (1050–1600); Oxford, Bodleian, MS Laud Misc. 636, 'E, Peterborough' (1121–1300); British Library, Cotton MS Domitian A VIII, 'F, Canterbury' (1075–1650); British Library, Cotton MS Otho B XI, 'G, Winchester' (AD 950–1050).

8 Home (2015).

9 The *Dialogue of the Exchequer* (*Dialogus de scaccario*) was written in the late 1100s by Richard FitzNeal to explain its workings, *Dialogus de Scaccario* (2007).

10 The number 8,000 comes from Palmer (1999), pp. 286–7.

11 Ramsey (1925), I, pp, 190–1.

10. A HOUSE OF DEVILS – ANGEVIN LORDS OF RULE AND MISRULE

1 Gerald of Wales (1891), VIII, book 3, chapter 27, p. 301.

2 The name comes from Empress Matilda's husband, Geoffrey of Anjou, who was nicknamed 'Plantagenet', possibly because he wore a sprig of wild broom (*planta genista*) in his helmet.

3 Roger of Howden (1869), II, p. 277.

4 'Alii filii mei se revera bastardos, iste vero solus se legitimum et verum esse probavit', Gerald of Wales (1873), book 1, chapter 3, p. 368.

5 William of Newburgh (1884), I, book 4, chapter 5, p. 306.

6 Richard of Holy Trinity (1854), pp. xvii–xviii. For an opposing view, Gillingham (1999).

7 'Anglia sicut adhuc sordet fœtore Johannis, Sordida fœdatur fœdante Johanne Gehenna', Matthew Paris (1874), II, p. 669.

8 *Annales de margan* (1874), I, p. 27; Hollister (1961), pp. 1–19.

9 Attested by all chroniclers, Hollister (1961), p. 14.

10 Anonymous of Béthune (1840), p. 105.

11 William le Breton (1882); Carpenter (1990), p. 30.

12 Gervase of Canterbury (1880), II, pp. 92–3.

13 London, British Library, Cotton Charter VIII 24, Innocent III, *Rex regum et* (1214). The last payment under the vassalage was paid by Edward III in 1333. In 1365 Parliament declared that John's original act had been invalid because it had not been sanctioned by England's bishops, Reynolds (1994), p. 389.

14 Matthew Paris (1874), II, pp. 587–8; Ralph of Coggeshall (1875), pp. 171–2; Roger of Wendover (1890), II, p. 154; Walter of Coventry (1873), II, p. 221.

15 London, British Library, Add MS 4848, The Articles of the Barons (1215). The name was coined based on the opening words, 'Ista sunt capitula que barones petunt et dominus rex concedit'. The Articles are undated, but 10 June is widely accepted, Holt (1992) p. 431.

16 Broadberry et al (2010).

17 Matthew Paris (1874), II, p. 534; Roger of Wendover (1890), II, entry for 1212.

18 Holt (1992), p. 454.

19 London, British Library, Cotton MS Cleopatra E I, fols 155–6, Innocent III, *Etsi karissimus* (1215).

20 Of these, one charter survives from 1216, and four from 1217.

11. BORN IN BLODD – FORGING A UNITED KINGDOM

1 Carpenter (2020).

2 Kings began increasingly to understand English from the fourteenth century, Chaplais (2003), pp. 127–33.

3 The reference in it to King Henry is usually taken to be Henry II, Fletcher (1999), pp. 1–17.

4 'Altercacio inter filomenam et bubonem', Oxford, Jesus College, MS E 29/2, fols 156r–168v (1300–1400).

5 Hanford (1913), pp. 315–67.
6 Cartlidge (2010), pp. 14–24.
7 Her name is based on a line in the epilogue to her *Fables*, 'Marie ai num, si sui de France', Vielliard (1989), pp. 371–97.
8 Oxford, Bodleian Library, MS Junius 1, the *Ormulum* (*c.* 1170–85).
9 San Marino, The Huntington Library, MS EL 26 C 9, *The Ellesmere Chaucer* (1400–10).
10 *The Owl and the Nightingale*, lines 513–16, p. 64.
11 The Templar of Tyre (1887), chapter 382, p. 201.
12 Ptolemy of Lucca (2009), book 23, chapter 6, p. 587.
13 King Alfred (1899), chapter 17, 40; letter of 1002–5 from Ælfric to Wulfstan, *Councils and Synods* (1981), 1, no. 45, chapter 14, p. 252; Wulfstan of York (1959) pp. 55–6; Constable (1998), pp. 249–360.
14 McCulloch (1997), pp. 698–740. For the initial account, Thomas of Monmouth (1896).
15 Ovrut (1977).
16 William Rishanger (1865), p. 373.
17 In 1236 Henry III adjourned a legal case 'to the Parliament' ('ad parliamentum') the following January, *Curia Regis Rolls* (1972) vol. 15, no. 2047, p. 522.
18 *Annales paulini* (1882), pp. 260–2; *Chroniques de London* (1844), p. 34; Haines (2003), p. 55.
19 Manuele Fieschi (1881), pp. 109–27.
20 But see Mortimer (2005) for an argument Edward II survived.

12. NEUMES AND TUNES – THE GLORY OF MEDIEVAL MUSIC

1 Schmitz (1914).
2 Stubbs (1988), p. 369.
3 Wulfstan of Winchester (2003), p. 384.
4 Wilford (24 June 2009).
5 Edinburgh, National Museums Scotland, IL.2011.1.1, the Deskford carnyx (*c.* AD 80–100).
6 Cicero (1999), 7:1, letter 89, pp. 340–1.
7 'Hwn yw e Gododin: Aneirin ae cant', Aberystwyth, National Library of Wales, MS 2.81, *Y Gododdin* (*c.* 1275).
8 Bede (1896), book 4, chapter 24, pp. 258–62.
9 1 Samuel 16:23. London, British Museum, 1939,1010.203, Sutton Hoo, lyre (early seventh century).
10 Page (2012).
11 Lord (2008), pp. 23–8; Apel (1990), p. 5; Idelsohn (1914–32).
12 Hiley (2009), p. 1.
13 When neumes were first written above the words with no staff they were called *in campo aperto* (in an open field), Parrish (1978), pp. 4–12.
14 Duffy (2018).
15 Apel (1990), p. 13.
16 Cambridge, Corpus Christi College, MS 473, the *Winchester Troper* (*c.* 1020).
17 The *Magnus liber organi* no longer survives, but is referred to in other works, Baltzer (1987).
18 The author was previously thought to be the Franciscan Simon Tunsted, but is now deemed to be an anonymous author writing while Tunsted was Regent Master of Oxford's Franciscans.
19 Generally on English medieval music, Colton (2017).
20 Trowell (1957), pp. 65–75.
21 Eton College, MS 178, the *Eton Choirbook* (*c.* 1500–04).
22 Mayr-Harting (1991), p. 215.
23 Taylor (2002), pp. 110–11.
24 For the *festum fatuorum*, Harris (2011).
25 Woolf (1972), pp. 3–104.
26 For Corpus Christi generally, Rubin (1991).
27 Oxford, Bodleian Library, Bodley 791, *Origo mundi*, *Passio christi*, and *Resurrexio domini* (1400–50); Aberystwyth, National Library of Wales, Peniarth MS 105B (1504) and MS 23849D, *Beunans Meriasek* and *Beunans Ke* (1550–1600).
28 The earliest mentions are moryssh daunsers (1488), morysk daunce (1448), morysch daunce (*c.* 1448), moreys daunce (1458), moresk (1458), morys daunse (1462), moruske (1466), morisse daunce (1477), mourice dance (1494), Heaney (2004), pp. 513–5.

29 Matilda Makejoy was a *saltatrix*, attached to the royal household for at least 14 years, Bullock-Davies (1978); *Women and Gender in Medieval Europe* (2006), p. 233.

13. KING DEATH – PESTILENCE, APOCALYPSE AND REBIRTH

1 London, British Library, Cotton Charter VI 2, Edward the Confessor, charter to Westminster Abbey (1066).
2 Gift made in 1211, *The Publications of the Pipe Roll Society* (1952), LXVI, p. xxix.
3 Fowler (1885), pp. 14–24.
4 Gabriel of Mussis (1994), p. 17.
5 'Archidiaconus asemnes' and 'Ebrietas frangit quicquid sapienta tangit', Ashwell, St Mary the Virgin, on a pillar dividing the nave from the south aisle. *Asemnes* is almost certainly from the Greek ασεμνος, unholy or ignoble.
6 Rascovan et al (2018).
7 Wheelis (2002).
8 Harris (1994); Alibek et al (1999).
9 Two factors have caused some to consider that the disease was not bubonic plague: its virulence in winter and the speed of its transmission. However, the medieval strain of *Yersinia pestis* appears to have been more virulent and aggressive than the modern counterpart, Horrox (1994), pp. 7–8.
10 Exodus 7.14–12.30.
11 Baldassarre Bonaiuti (1903); Henderson (1992), p. 145.
12 *Encyclopedia of the Black Death* (2012), pp. 71–2.
13 Petrarch, letter to a Friend, *Readings in European History* (1908), I, p. 502 (1340–53).
14 Hermann Gigas (1750), p. 138.
15 Wood (1989), p. 197.
16 Gottfried (1983), pp. 72–3.
17 *The Anonimalle Chronicle* (1927), p. 30; Ralph Higden (1882) p. 355; 'A Fourteenth-Century Chronicle' (1957), p. 274.
18 *Annalium hibernae chronicon* (1849), pp. 35–7.
19 Robert of Avesbury (1889), pp. 407–8.
20 Thomas of Malmesbury (1863), pp. 230–1.
21 *The Black Death* (1994), pp. 118–9.
22 Between 40–55 per cent, Horrox (1994), p. 3.
23 'A Fourteenth-Century Chronicle' (1957), p. 275.
24 Ibid., p. 275.
25 45 Edward III 1371, *Memorials of London* (1868), pp. 356–8.
26 Broadberry et al (2010).
27 *The Ordinance of Labourers* 1349 (1810); Putnam (1908); Epstein (1991).
28 Rubin (2020), pp. 71–90.
29 Mate (1998).
30 *Statutes of the Realm*, I, pp. 378–88.
31 William of Wykeham's foundation charters: Oxford, New College, NCA 5367 (1379); Winchester, Winchester College, Muniments 697 (1382).
32 Oosterwijk (2009).
33 Cohen (1973).

14. THREE LIONS AND THE *FLEUR-DE-LYS* – COVETING THE FRENCH CROWN

1 Geoffrey le Baker (1889), p. 46.
2 Rogers (1999).
3 Rodger (1997), pp. 91–108.
4 Edward's English royal arms were 'gules, three lions passant guardant in pale or': three golden lions, walking with faces turned to the viewer, arranged one above the other on a red background. The royal arms of France were 'azure, semé-de-lis or': a scattering of golden fleurs-de-lys on a blue background'; Ormrod (2001), pp. 133–54.
5 Kinnard (2007), pp. 56–7.
6 Geoffrey of Monmouth (1854).

7 Shakespeare (1623), *Henry v*, act 4, scene 3, p. 87.
8 Winchester College, Muniments 22097, Account Roll for 1415/1416.
9 *The Trial of Joan of Arc* (2005), pp. 193–4.
10 *Procès de condemnation* (1841–9).
11 Pernoud (1953), passim.
12 Christine of Pisa (1977), verse 34, p. 34.
13 Sir John Wingfield, letter to the bishop of Winchester, Robert of Avesbury (1889), pp. 439–443; Hewitt (1058), pp. 43–77.
14 von Clausewitz (1832–3).
15 Thomas Walsingham (2005), pp. 97–102.

15. MY WELEBELOUED VOLUNTYNE – MEDIEVAL ROMANCE

1 Plutarch (1919), 99:vii, chapter 61, pp. 584–5; Fowler (1899), pp. 299–302; Franklin (1921); Schmitz (1875).
2 Green (1931); Hopkins (2018), pp. 313–45.
3 Gelasius (1959).
4 Hazlitt (1905), pp. 608–11; Kelly (1986).
5 Geoffrey Chaucer (1988), *The Parlement of Foules*, pp. 385–94, lines 309–10, p. 389.
6 There is a third Saint Valentine, but he was martyred in Africa and nothing is known of him.
7 Kelly (1986), p. 61.
8 For Brigit, O'Cathasaigh (1982), Cusack (2007), Bitel (2009). The earliest reference to Christmas falling on 25 December is AD 354 in the *Chronograph* of Furius Dionysius Philocallus, Roll (1995).
9 London, British Library, Add MS 43490, fol. 22r; *Paston Letters* (2004), ii, no. 791, pp. 435–6 (*c.* 9 February 1477).
10 Most of the Paston Letters are in the British Library, but some are in Oxford, Bodleian Library and the Norfolk Record Office.
11 British Library, Add MS 43490, fol. 24r; *Paston Letters* (2004), ii, no. 416, p. 663 (Febnruary 1477).
12 *Paston Letters* (2004), vol. i, pp. 216–7 (14 December 1441).
13 Peter Lombard (1971), ii, pp. 422–3; McCarthy (2004), pp. 19–50.
14 Pope Alexander iii clarified that if the consent was expressed in the future tense, subsequent consummation would act as consent, Brundage (1987), p. 334.
15 *The Pontifical of Egbert* (1853), pp. 125–6, 132–3; Gittos (2013), pp. 270–2.
16 Izbicki (2015); Le Goff (1981); Reynolds (2016); Thibodeaux (2015).
17 Some of the earliest were the 1217/19 Statutes of Salisbury, *Statutes and Customs* (1915). Some rules applied across the Church, like those of the Fourth Lateran Council of 1215, which provided that marriage was prohibited if the couple was related in the fourth degree (canon 50), if the marriage was clandestine (canon 51), and that hearsay would not be admissible in marriage trials (canon 52), *Decrees of the Ecumenical Councils* (1990), i.
18 Clarke (2007), pp. 152–3; McSheffrey (2006).
19 Geoffrey Chaucer (1988), *The Canterbury Tales, The Wife of Bath's Prologue*, pp. 105–116, lines 54–8, pp. 105–6; Patterson (1996).
20 As a young woman, Heloise was celebrated for her skill in Latin, Greek and Hebrew. She was sent to Paris, where her uncle Fulbert entrusted her education to one of the most famous philosophers of the day, Peter Abelard. She was probably in her early twenties. The two became lovers and had a child they called Astrolabe, before Abelard forced her into marriage to placate her uncle. Abelard wished to keep the marriage secret so as not to damage his career, but Fulbert began spreading rumours of it. Abelard decided that, for her safety, Heloise should move to the convent at Argenteuil. Fulbert thought Abelard had got rid of her by making her a nun, and sent men to castrate Abelard. Broken, Abelard became a monk at Saint-Denis. At Argenteuil, Heloise professed as a nun against her wishes, and after around 20 years rose to be abbess of a new nunnery at the Paraclete, and as abbess she sent Abelard three love letters in which she set out her deep anger at his treatment of her, of forcing her to marry him, at her life without religious vocation or earthly love, and at her burning memories of their intellectual and sexual union. The quality of her Latin is exceptional, and she is today regarded as having been a principal influence on many of Abelard's philosophical ideas. They were buried together, and their tomb

later moved to Paris's Père-la-Chaise cemetery. See especially, Mews (2005). For their correspondence, *The Letters of Abelard and Heloise* (1974).

21 'Et si uxoris nomen sanctius ac validius videtur, dulcius mihi semper exstitit amicæ vocabulum; aut, si non indigneris, concubinæ vel scorti.' Heloise, 'Quæ est heloissæ ad petrum deprecatoria', Heloise (1855), col. 184.

22 London, British Library, Additional MS 43488, fol. 4r; *Paston Letters* (2004), i, no. 13, p. 26 (probably 20 April 1440).

23 London, British Library, Add MS 27446, fol. 52rv; *Paston Letters* (2004), i, pp. 664–5 (*c.* 4 November 1481).

16. SWORDS AND SORCERY – THE ONCE AND FUTURE KING

1 'The wars of the White and Red Roses', Scott (1829), i, p. 168. Others had used the rose imagery earlier. Thomas Smith wrote in a pamphlet of 1561 of 'the striving of the two roses'. Shakespeare (1623), *Henry VI*, act 2, scene 4, p. 104 had the rose scene in Old Temple Gardens.

2 Shakespeare (1623), *Henry V*, act 3, scene 1, p. 77, and act 4, scene 3, p. 87.

3 *Paston Letters* (2004), i, no. 90, 268, pp. 165–6 (4 April 1461) gives 28,000. Prospero di Camulio, Milanese ambassador, mentions 20,000 Lancastrians and 8,000 Yorkists in a letter to the Duke of Milan. The *Croyland Chronicle* gives 38,000. Hanks and Brogdon (2000), p. 70; Boardman (2009), p. 148; Goodwin (2011), pp. 37–41.

4 Florato et al (2000).

5 London, British Library, Add MS 59678, *Le Morte Darthur* (1471–83); facsimile, Malory (1976); Hellinga and Kelliher (1977). For the incunable, Thomas Malory (1485); facsimile Malory (1889–91).

6 Thomas Malory (1485), book 1, chapter 25, pp. 77–9.

7 For the battle of Arfderydd, *Annales cambriae* (2015a), p. 6; Haycock (23 September 2004).

8 Parry and Caldwel (1959); Faletra (2012).

9 Geoffrey of Monmouth (1854), book 6, chapters 17–19, pp. 89–91, book 7, chapters 1–4, pp. 92–101, book 8, chapter 1, pp. 101–2. He notes that Merlin was also called Ambrose, book 6, chapter 19, p. 91; *Historia brittonum* (1898), pp. 111–222 mentions the Vortigern/dragon story, but calls the boy Ambrosius (Emrys in Welsh).

10 Geoffrey of Monmouth (1854), book 8, chapters 10–12, pp. 108–11.

11 Ibid., book 8, chapter 19, pp. 115–17.

12 Tennyson (1857, 1859); Tolkien (1937, 1954a, 1954b, 1955); Rowling (1997, 1998, 1999, 2000, 2003).

13 The others were Aneirin, Bluchbard, Cian (also called Gueinth Guaut) and Talhaern, *Historia brittonum* (1898), chap. 62, p. 205.

14 Aberystwyth, National Library of Wales, Peniarth MS 2, *Llyfr Taliesin* (1300–50). The manuscript contains around 60 poems by the historical and mythical Taliesins.

15 Aberystwyth, National Library of Wales, MSS 5276D and MS 3054D, Elis Gruffudd, *Cronicl o Wech Oesoedd* (1529–52); Roberts (23 September 2004).

16 The Fenian Cycle takes its name from Fionn, the leader of the Fianna Éireann. For the tale of Fionn and the salmon, Oxford, Bodleian Library, MS Laud Misc 610, *Macgnímartha Finn* (1453–6); Dolan (1999).

17 Guest (1849).

18 Oxford, Jesus College, MS 111, *Llyfr Coch Hergest* (1400–1500); Aberystwyth, National Library of Wales, Peniarth MS 4 and 5, *Llyfr Gwyn Rhydderch* (*c.* 1350).

17. SEVERING TIES – HENRY VIII AND THE DREAM OF DYNASTY

1 In 1484 the French Estates General accused Richard of the murder. The Italian chronicler Dominic Mancini was in London, and recorded it was common talk that Richard had murdered the children even before he usurped the throne. In 1674 two children's skeletons were found buried behind a staircase at the Tower under 10 feet of rubbish. They were reburied at Westminster Abbey in a tomb designed by Christopher Wren and have never been tested. Horrox (2020).

2 Polydore Vergil (1844), p. 224.

3 Shakespeare (1623), *Richard III*, act 5, scene 4, p. 204.

4 Richard died in 1485, but two carbon dating tests on the skeleton gave ranges of 1412–49 and 1430–60, before they were retrospectively manually adjusted to take into account a fish-rich diet, which then produced a range of 1475–1530. The mitochondrial (female line) DNA in the skeleton is from the correct group, but it is a very large group, as every mother passes it to her sons and daughters, and her daughters pass it on. The Y-chromosome (male line) DNA is wrong for Richard unless the Plantagenet line had been broken. Further, the DNA codes in the skeleton are for blond hair and blue eyes, while Richard almost certainly had black hair and brown eyes. Although the skeleton does have spinal deformities, it does not show any healed injuries that would be expected from a soldier. Together, this cumulatively falls short of the 99.999 per cent certainty announced by the Leicester University team managing the excavation, Selwood (2015), pp. 120–1.

5 Zirpolo (2020), p. 189.

6 Rous (1745), p. 214; Markham (2014), p. 184.

7 King Henry VIII (1521).

8 Currently D G REG F D (*Dei gratia regina fidei defensatrix*).

9 Act in Restraint of Appeals 1533 and Act of Supremacy 1534, *Tudor Constitutional Documents* (1930), pp. 40–8.

10 Suppression of Religious Houses Acts 1535 and 1539, *Tudor Constitutional Documents* (1930), pp. 50–92.

11 Bale and Leland (1549), preface, p. B1r.

12 Mantel (2009, 2012, 2020); MacCulloch (2018). Holbein produced a number of Cromwell portraits, of which the best known is in London, National Portrait Gallery NPG 1727 (1532–3).

13 London, British Library, Cotton MS Titus B 1, Thomas Cromwell, *Rememberances* (1500–1600). Others at the National Archives. The Cromwell archive consists mainly of his notes and correspondence he received. The file copies of letters he sent are missing, perhaps destroyed by his household when he was arrested.

14 *The Victoria History of the County of Somerset* (1911), pp. 94–82; Gasquet (1895); Bettey (1989).

15 Doggett (23 September 2004); Gasquet (1895).

16 Knowles (1959), III, p. 380.

17 London, British Library, Add MS 17451, Glastonbury register (1544–8).

18 Wright (1843), letter 24, pp. 58–9.

19 *Letters and Papers* (1892), XIII, no. 573, pp. 211–2; Doggett (23 September 2004).

20 *Original Letters* (1969), III, p. 247.

21 Gasquest (1895), p. 88.

22 *Three Chapters of Letters* (1843), no. 126, pp. 255–6.

23 Gasquet (1895), p. 93.

24 *Correspondance politique de MM. de Castillon* (1885), no. 170, pp. 144–5 (30 November 1539).

25 'Item the abbot Redyng to be sent down to be tried and executyd at Redyng with his complycys', London, British Library, Cotton MS Titus B 1, fol. 441, Thomas Cromwell, *Rememberances* (1500–1600).

26 Watt (3 Janaury 2008).

27 Stoyle (1999).

28 Beer (1982), pp. 38–81; Pocock (1884); Wood (2007).

29 Ross et al (26 April 2014); Wright (14 November 2018).

30 Duffy (2005) p. 256.

18. SMASHING THE ALTARS – BLOODY TUDORS

1 Statute of Six Articles 1539, *Tudor Constitutional Documents* (1930), pp. 95–8; King Henry VIII (1543).

2 Act of Uniformity 1552, *Tudor Constitutional Documents* (1930), pp. 119–120.

3 Edward VI (1547), fol. 10v.

4 Duffy (2005).

5 The Prosecutor v. Ahmad al-Faqi al-Mahdi (27 September 2016). The prosecution was brought under article 8(2)(e)(iv) of the Rome Statute of the International Criminal Court 1998.

6 Loach (1999); Plowden (2016); Loades (1992).

7 Duffy (2005).

8 Field (2008).

9 Gristwood (2016).

10 Kane (2014), p. 279.

11 Wagner (1999), p. 258.

12 'Man soll sie zerschmeißen, würgen, stechen, heimlich und öffentlich, wer da kann, wie man einen tollen Hund erschlagen muss', Luther (1525).

13 Jouanna (2007).

14 Ibid., p. 3.

15 Kilroy (2015); Simpson (2010). For a dramatised life, Waugh (1935).

16 *Elizabethan Recusant Prose* (1950), pp. 153–5.

17 In total 803 priests were trained abroad, of whom 649 were sent into England, Pritchard (1979), I, pp. 7–8; Bucholz and Key (2009), p. 135.

18 London, British Library, Harley MS 6798, art 18, fol. 87v Elizabeth I, Tilbury speech (early seventeenth century); Queen Elizabeth I (2002), no. 19, pp. 325–6.

19 Frye (1992). But see also Green (1997).

20 'She wold blush when he were spoken of', Hatfield, Hatfield House Library and Archives, CP 150/86, fol. 86r; 'Cut hyr gowne yn a c peces', London, National Archives, PRO SP 10/6/21, fol. 55r, Katherine Aschyly, deposition.

21 Adams (24 May 2008).

22 The only reliable account of the death is by Thomas Blount of Kidderminster, who investigated the event, Cambridge, Magdalene College, Pepys Library, State Papers PL 2503, pp. 717–24. For Cecil's suspicions, Simancas, Archivo General, Secreteria de Estado 814, fol. 24 (11 September 1560); Collinson (5 January 2012).

23 Stubbe (1579).

24 Doran (1996), p. 187.

25 The original is in French, London, British Library, Cotton MS Galba E VI, fol, 255r, Elizabeth I, letter to Catherine de' Medici (1584); Elizabeth I (2002), pp. 260–1.

26 Notably plays and masques by Thomas Churchyard; Spenser (1579); Collinson (2004).

27 Lapham (1901), p. 589.

28 Weikel (3 January 2004).

29 Foxe (1563), actually titled *Actes and Monuments*; Hargrave (1982). Elizabeth executed 700 after the rising in the north, along with 133 priests and 63 laypeople.

19. THE DEVIL'S VOTARIES – WITCHES IN THE AIR

1 Gibson (1999). Maud Park and Alice Mead were convicted earlier in Exeter, but their fate is not known, Stoyle (2017).

2 Phillips (1566), unpaginated.

3 Regino of Prüm (1853), no. 345, cols 352–3; Bailey (2007), pp. 70–2; Stephens (2002), pp. 125–44.

4 *Edictus langobardorum* (1868), cap. 376, p. 67.

5 Lea (1957), p. 143.

6 References to non-divine magic in the Bible include: Genesis 41:8, 41:24, Exodus 7:11, 7:22. 8:7, 8:18, 8:19, 9:11, Deuteronomy 18:10–12, 18:14, Samuel 28:3–24, 2 Kings 9:22, 2 Chronicles 33:6, Isaiah 47:12, Jeremiah 27:9, Ezekiel 13:18, 13:20, Daniel 1:20, 2:2, 2:10, 2:27, 4:7, 4:9, 5:11, Micah 5:12, Nahum 3:4, Malachi 3:5, Acts 8:9, 8:11, 13:6, 13:8, 19:19, Galatians 5:20, Revelation 9:21, 18:23, 21:8, 22:15.

7 This was also stated clearly by Pope Alexander IV in *Quod super nonullis* (1258), *Quellen und Untersuchungen* (1901), no. 1, pp. 1–2.

8 Barber (1993), pp. 193–204.

9 Johannes Nider (*c.* 1470); Alphonso de Espina, *Fortalitium fidei* (*c.* 1470).

10 *Quellen und Untersuchungen* (1901), no. 36, pp. 24–7.

11 Exodus 22:18.

12 One other pope at the time, Alexander VI, endorsed witch-hunting, *Cum acceperimus* (1501) to Angelo of Verona, *Quellen und Untersuchungen* (1901), no. 42, p. 31.

13 Heinrich Kramer and Jakob Sprenger (1497); Bailey (2007), p. 139.

14 Leeson and Russ (2018).

15 Gibson (2003), pp. 1–2.

16 Ibid., pp. 3–4.

17 Borman (2013), pp. 28–46; Goodacre (2013a).

18 King James VI and I (1597).

19 Gibson (2003), pp. 5–6.
20 Kesselring (2007), p. 68.
21 King James vi and i (1597), book 3, chapter 6, p.78.
22 Sharpe (23 September 2004).
23 Berry (2012), p. 58.
24 The facts are confused, Henderson (2016), p. 238. A woman was executed for murder later, in 1738, with a popular tradition of magical elements, ibid., p. 240.
25 Gibson (2003), pp. 7–8.
26 Yeats (1997), ii, no. 514 (25 April 1900) and no. 518 (28 April 1900).
27 Bennett (28 October 2004).
28 Hutton (2010), p. 247; Levack (1995).
29 Levack (1996), p. 99.
30 Goodacre (2013b), p. 302.

20. BOMBING PARLIAMENT – HOMEGROWN TERRORISM

1 The National Archives, PRO SP 14/4/85, Earl of Northumberland, letter to James i.
2 Loomie (1971), pp. 303–16.
3 Picton (2015), p. 37.
4 The National Archives, PRO SP 14/2/51, Anthony Copley, declaration.
5 Hatfield, Hatfield House Library and Archives, Salisbury MS 112/91, Thomas Winter, confession 2 (26 November 1605).
6 Generally, Nicholls (24 May 2008).
7 Nicholls (1991, 3 January 2008a, b, 24 May 2008); Gerard (1972). Tesimond (1973).
8 Nicholls (3 January 2008b).
9 The National Archives: PRO SP 14/216/126, Robert Keyes, examination.
10 Hatfield, Hatfield House Library and Archives, Salisbury MS 113/54, Thomas Winter, confession 1 (23 November 1605).
11 London, The National Archives, PRO SP 14/216/126, Robert Keyes, examination.
12 Cobbett (1852), p. 237.
13 Nicholls (3 January 2008a).
14 Guy Fawkes's confessions: London The National Archives, PRO, SP 14/216/54, Guy Fawkes, confession 1 (9 November 1605) and PRO SP 14/216/101 Guy Fawkes, confession 2 (17 November 1605).
15 Hatfield, Hatfield House Library and Archives, Salisbury MS 113/54, Thomas Winter, confession 1 (23 November 1605).
16 London, The National Archives: PRO SP 14/216/225.
17 Sharpe (2005), pp. 76–7.
18 Nicholls (2007a).
19 Richardson (1972), p. 156.

21. MONARCHISTS AND REGICIDES – THE UNCIVIL WAR

1 Weldon (1650), p. 179.
2 'Tandis qu'Elizabeth fut roi, | L'Anglois fut d'Espagne l'effroy. | Maintenant devise, et coquette, | Regi par la reine Jaquette,' Bagnell (1829), p. 35.
3 'Et ce savant roy d'Angleterre | Foutoit-il pas le Boukinquan', in 'Au marquis de Boukinquan', de Viau (1981), pp. 103–4.
4 Houston (1995), p. 58.
5 Usher (1910), ii, p. 342.
6 *Book of Common Prayer* (2011), pp. 786–7.
7 Norton (2011), p. 54.
8 The Puritan William Prynne described Thomson as 'dissolute, ebrious, prophane, luxurious . . . deboist drunken English-Dutchman, who seldome went one night to bed sober', Moore (3 January 2008).
9 Nielson and Skousen (1998), pp. 49–74; Moynahan (2002), p. 1.
10 King James vi and i (1604), unpaginated, final page.
11 Stokoe (1915), p. 57. The earliest definitive use of the term 'jack' for a flag on the bowspit jackstaff is 1633, *Union Flag or Union Jack* (2014), p. 4.
12 Ibid., p. 3.

13 For the Militia Ordinance, *The English Civil War and Revolution* (1998), pp. 98–100; for the Commission of Array, ibid., pp. 100–1.
14 Seel (1999), p. 44.
15 Roy (19 May 2011).
16 Oxford, Worcester College, MS 65, Sir William Clarke, shorthand notes of the Putney debates (1647).
17 *The Constitutional Documents of the Puritan Revolution* (1979), no. 82, pp. 371–4.
18 Sachse (1973), p. 73.
19 Bennett (2006), p. 155.

22. RELIGIOUS DICTATORSHIP – KING CROMWELL AND HIS SAINTS

1 Capp (2012), p. 27.
2 Roberts (21 May 2009).
3 Cromwell (1857), letter to Colonel Valentine Walton, I, no. 21, pp. 151–4 (5 July 1644).
4 Cromwell (1857), Declaration to the Lord Lieutenant of Ireland, II, pp. 99–119 (1649).
5 Cromwell (1857), letter to the Speaker of Parliament, II, no. 105, pp. 50–6 (17 September 1649).
6 Morrill (17 September 2015).
7 *The Historical Encyclopedia of World Slavery* (1997), 1, pp. 369–70.
8 Donagan (1994), p. 137.
9 Gentles (1992), pp. 440–2; Chandler and Beckett (1994), p. 43.
10 Whitelocke (1682), p. 529.
11 Fitzmaurice (23 September 2008).
12 Ibid.
13 Milton (1667).
14 Stoyle (2004), p. 26.
15 The Lord Cottesloe (1930).
16 Goold Walker (1986), pp. 1–5. The company may have been in existence prior to that date, as there are medieval accounts of similar activity.
17 Nenner (23 September 2004).
18 Scotland 60,000, England 180,000, Ireland 300,000, Gentles (2007), p. 436.
19 Massie (2007), p. 781.
20 Newcastle (1666).

23. PRIGNAPPERS IN RUMVILE – THE RESTORATION'S DARK UNDERBELLY

1 *London Plagues, 1348–1665* (2011), p. 3.
2 Total deaths for the year were 100,000, of which 69,000 were registered plague burials, but the plague number was almost certainly over 100,000, Moote and Moote (2004), p. 10.
3 Malcolm (1807), II, p. 74.
4 Gregg (2013).
5 Pepys (1983), VII, p. 274 (4 September 1666).
6 Leake (1666).
7 Spence (2016), p. 72.
8 Porter (1 September 2017).
9 'City Records' (1831), p. 314.
10 Pepys (1983), VIII, p. 503 (26 October 1667).
11 Ibid., VI, p. 73 (3 April 1665); VIII, p. 193 (1 May 1667); VIII, p. 594 (28 December 1667).
12 Ibid., IX, p. 19 (11 January 1668).
13 Stratford-Upon-Avon, Shakespeare Birthplace Trust, ER 93/2 (1672).
14 Ibid., fol. 182v.
15 Wilson (1952), p. 197.
16 Burnet (1833), VI, p. 473.
17 Wynne (1 September 2017).
18 Mackie (2009).
19 Pepys (1983), IV, p. 209 (1 July 1663); Milne (2014), pp. 59–60.

20 Weiser (2003), p, 23.
21 Ellis (3 January 2008); Wilmot (2013).
22 Harris (1986), p. 537.
23 Ibid., p. 538.
24 Pepys (1983), ix, p. 132 (25 March 1668).
25 *Crime and Punishment* (1999), no. 3.1, p. 58.
26 Gotti (1999), p. 6.
27 Head (1675).
28 Head (1673), unpaginated.
29 'The wretched, wily, wandering, vagabonds calling and naming themselves Egyptians', Thomas Harman in 1597, in Cressy (2018), p. 38.
30 Pound (1971).
31 Matras (2010), p. 91.
32 Gotti (1999), p. 2.
33 Baker (2002), pp. 19–38.
34 Johnson (2004), p. 250.

24. A VERY BRITISH ALCHEMY – THE EMERGENCE OF SCIENCE

1 Roger Bacon (1900), ii, part 6, chapter 12:3, pp. 217–8; Little (1917), p. 206.
2 McKie (1960), p. 32.
3 Boyle (1772), letter to Marcombes, i, p. xxxiv (22 October 1646); letter to Tallents, p. xxxiv (20 February 1647); letter to Hartlib, p. xl (8 May 1647). Some scholars have questioned whether the name properly referred to this group.
4 McKie (1960), p. 31.
5 On 22 April 1663 Charles issued a second charter changing the name to The Royal Society of London, ibid., p. 36.
6 Generally, Christianson (1996).
7 Newton (1687).
8 Castillejo (1981), p. 55.
9 For Philalethes, Newman and Principe (2002).
10 Dobbs (1988), p. 12.
11 Principe (2013).
12 Newman (2019), p. 36, although he transcribed it incorrectly as *Jeova Sanctus Unus*.
13 Mulsow (2004), p. 1.
14 The classic formulation of the Latin text is in Chrysogonus Polydorus (1541).
15 Newton's Latin text had a few variations from the canonical text, Keynes MS 28/ALCH00017, fol. 6r (1685–95).
16 Pereira (2000), p. 144.
17 Keynes (1947), p. 27.
18 Newton (1728) was his last major work, published just after his death. The whole of its Chapter 5, with fold-out plans, is an analysis of King Solomon's Temple, pp. 332–46; McKie (1960), p. 32.
19 Malys (2015).
20 The First Anglo-Dutch War (1652–4) ended with the Treaty of Westminster. The Second Anglo-Dutch War (1665–7) ended with the Treaty of Breda. The Third Anglo-Dutch War (1672–4) ended with the Treaty of Westminster.
21 *Depositions Taken the 22nd of October 1688* (n.d.).
22 Gregg (24 May 2012).
23 The Immortal Seven were William Cavendish Duke of Devonshire, Henry Compton Bishop of London, Richard Lumley Earl of Scarbrough, Thomas Osborne Earl of Danby, Edward Russell Earl of Oxford, Henry Sidney Earl of Romney and Charles Talbot Earl of Shrewsbury.
24 Israel (2003), pp. 1–3.
25 London, Parliamentary Archives, HL/PO/PU/1/1688/1W&Ms2n2, The Bill of Rights (1689).

25. *SAPERE AUDE*! – THE BRITISH ROOTS OF THE ENLIGHTENMENT

1 The events took place in 1710–12, Conder (1895); Chetwode Crawley (1895).
2 Shelby (1964).
3 'Sculptores lapidum liberorum' appear in the Assize of Wages 1212, and 'Nicholas le Freemason' is named in the 1325 London Coroner's Rolls, Prescott (2014), p. 33.
4 *The Ledger-Book of Vale Royal Abbey* (1914).
5 London, British Library, Royal MS 17 A.1, the *Regius Poem* (*c.* 1390); Halliwell (1840), pp. 11–38.
6 Ibid., p. 31.
7 John Philoponus (1897), p. 117.
8 Durant (1961), pp. 26–7.
9 Tetsch (1926).
10 Josten (1960), pp. 221–30; Hunter (25 May 2006).
11 Ashmole (1927), pp. 26–7.
12 *Fama fraternitatis* (1614); *Confessio fraternitatis* (1615); *Chymische Hochzeit Christiani Rosencreutz Anno 1459* (1616).
13 Adamson (1638), p. 32.
14 *Poor Robin's Intelligence* of 10 October 1676, in Bogdan (2007), p. 71.
15 Kant (1996), pp. 17–22.
16 Aubrey (1898), 1, p. 75.
17 Cambridge, University Library, MS Add 3995, Isaac Newton, notebook (*c.* 1670).
18 Locke (1690).
19 Smith (1776).
20 *Trattato dei tre impostori* (1994); Anderson (1997); Minois (2012).
21 Voltaire (1769), p. 2.
22 Jones (1966).
23 'Old Antiquity' (1879); Campbell (2012).
24 Bullock (1996), p. 17.
25 Pilcher-Dayton (2011).
26 Locke (1690b), book 2, chapter 2, section 6, p. 222 appeared in 1689 but is dated 1690; Washington DC, National Archives, No. 1419123, Engrossed Declaration of Independence (1776).
27 Voltaire (1994), p. xxxvii.

26. FORTUNES FOR THE TAKING – ROBBERY ON THE HIGHWAYS AND HIGH SEAS

1 The first British Letter of Marque was granted by Edward I in 1293. By the 1600s they were issued by the High Court of Admiralty. *Documents Relating to Law and Custom of the Sea*, I, p. 19.
2 Pestana (2017).
3 Woodard (2007).
4 Israel (2003).
5 Bowie (2003); Smout (1964).
6 Burns (1859), no. 135, pp. 258–9.
7 Falkner (3 January 2008).
8 Gibbs (21 May 2009).
9 Morand (1972), p. 27.
10 Gold (2012).
11 Smith (2002).
12 Rogers (23 September 2004).
13 Noyes (1906).
14 He is mentioned in *Henry V* and he also appears in *The Merry Wives of Windsor*, but as a somewhat different character, Shakespeare (1623), pp. 69–95, 39–60.
15 Griffiths (1 September 2017).
16 White (1 September 2017).

17 Barlow (23 September 2004).
18 *The London Encyclopaedia* (2008), p. 424.
19 Alex-Tweedie (1908), p. 227.
20 Walpole (1903), letter to Sir Horace Mann, III, no. 344, p. 88 (23 March 1752).
21 Johnson (2002), pp. 133–4.
22 Cordingly (1995, 3 January 2008a, b).
23 Wood (23 September 2004).
24 Johnson (2002), pp. 53–5.
25 Copping (28 May 2011).
26 Clark (1956), p. 259; McLynn (2002).

27. THE SUN NEVER SETS – LOSING THE COLONIES AND GAINING AN EMPIRE

1 Labaree (1964, 1973); Lahue (2007).
2 Volo (2012), pp. 156–80.
3 Walpole (1820), letter to George Montagu, II, p. 119 (21 October 1759).
4 Borneman (2006).
5 Taylor (2016).
6 Fradin (1998), p. 84.
7 Jensen (1968), pp. 483– 507.
8 Phinney (1875); Hallahan (1999).
9 Paine (1776); Jensen (1968), p. 669.
10 Jayne (1998).
11 Washington DC, National Archives, No. 1419123, Engrossed Declaration of Independence (1776).
12 Grainger (2005).
13 Roy (2012).
14 Elizabeth I, Charter for an East India Company of 31 December 1600, in '*The Empire of the Bretaignes*' (1985), no. 158, pp. 234–7.
15 Baskin et al (1997), pp. 58–63.
16 Erikson (2014), p. 3.
17 Baskin et al (1997), p. 72.
18 Ibid., pp. 73–7.
19 Robertson and Funnell (2014).
20 Lovell (2011), pp. 2, 6, 24–5.
21 Gould (1999), pp. 58–9 and passim.
22 Edwardes and Garret (1995).
23 Bowen (3 January 2008).
24 'Colonel Clive to the Secret Committee of the Directors, 26 July 1757', *Speeches and Documents* (1922), I, pp. 6–13.
25 Gupta (1962), pp. 126–35.
26 'Firman from Shah Alam Granting the Diwani of Bengal, Behar, and Orissa to the East India Company, 12 August 1765', *Speeches and Documents* (1922), I, pp. 20–2.
27 Bowen (3 January 2008).
28 Marshall (1965).
29 *India and the Commonwealth War Graves Commission* (2002); Heathcote (1995), pp. 21–38, 253–4.

28. ENGLAND'S GREEN AND PLEASANT LAND – THE BIRTH OF THE ROMANTICS

1 London, Tate Britain, N05058/B306, Blake, *Newton* (1795–c.1805).
2 London, Victoria & Albert Museum, E.365–1956, Blake, *There is No Natural Religion* (1788–94).
3 Generally, Essick (22 September 2005).
4 Gilchrist (1892), I, p. 7.
5 Houghton (1890), letter, II, pp. 222–3 (25 March 1879).
6 Damon (1979), pp. 255–7, 399–401, 419–26, 426–7, 458; Davis (1992), p. 49.

7 Hunt (1809), p. 605.

8 Fairchild (1940), pp. 20–6.

9 Harris (1998).

10 Smith (1999), p. 58.

11 Farran (1951).

12 *Dictionary of National Biography* (1908), VII, p. 1066.

13 Peters and Beveridge (2010); Rentoumi et al (2017).

14 *The Times* (29 June 1830).

15 Wollstonecraft (1791).

16 Essick (1991); Gilchrist (1862), I, pp. 95–6.

17 Beer (2005), p. 94.

18 Sklar (2011), p. 110.

19 Davis (1977), p. 41.

20 Blake (1862b), pp. 84–5.

21 Blake (1862a), p. 113.

22 Essick (22 September 2005).

23 There are only four known copies. The British Library has a hand-coloured copy in which the original etchings have been embellished with watercolour, ink, and wash. London, British Museum, 1859,0625 (1804–11).

24 Smith (1989); Ashdown (2010).

25 Revelation 21:2.

26 Damon (1979), pp. 273–4, 444–6.

27 *The Spirit of Man* (1915).

28 Banfield (1988), p. 137.

29 Dibble and Hubert (1992).

30 Wilson and Whittaker (2013), p. 78; Nelsson (10 March 2016); Heffer (4 March 2016).

31 New Haven, Yale Center for British Art, B1992.8.1, plate 77, Blake, *Jerusalem: The Emanation of the Giant Albion* (1804–20).

29. FULL STEAM AHEAD – THE AGE OF THE MACHINES

1 The cloister is from 1240, the chapter house 1263, the tower and spire 1310.

2 McKay (1993); Scobie-Youngs (2018).

3 Paz et al (2010).

4 Toynbee (1884).

5 London, Victoria and Albert Museum, FA.33, Constable, *Salisbury Cathedral from the Bishop's Ground* (1823).

6 London, Tate Britain, T13896, Constable, *Salisbury Cathedral from the Meadows* (exhibited 1831).

7 Leslie (1845).

8 Walpole (1765); Shelley (1818); Stoker (1897).

9 *Hansard*, HC Deb, 15 March 1838, vol. 41, col. 940.

10 Hero of Alexandria (1851), section 50, p. 72.

11 Andrew and Allen (2009).

12 Hills (1970), pp. 134–64.

13 Hartwell (2017), pp. 123–4.

14 Beare (23 September 2004).

15 Payton (4 October 2007).

16 Fitton (1989).

17 WL (1874), p. 127.

18 Hadfield (1984), p. 30; Hartwell (2017), p. 123.

19 Risebero (2002), p. 76.

20 *First Report of the Commissioners for the Exhibition of 1851* (1852), p. 70.

21 Huggett (1978), p. 56.

22 *The Official Descriptive and Illustrated Catalogue* (1851).

23 Fay (1951), p. 75.

24 Hyman (1976).

25 *First Report of the Commissioners for the Exhibition of 1851* (1852), p. xxxvi.

26 Leapman (2011).

27 Fay (1951), p. 71.

28 Ibid., p. 76.
29 Queen Victoria (1851), xxxi, p. 300 (Saturday 14 June 1851).
30 Hess (1841); Marcus (2017), p. 66.
31 Engels (1845).
32 Himmelfarb (1983).
33 Hartwell (1961); Hobsbawm (1963).
34 *Writings of the Luddites* (2004), document M5, pp. 78–9 (16 December 1811).
35 Hulme (1896, 1900).
36 Lowry (1973).
37 Cheshire (1854), p. 46.
38 Ayers (2000).

30. VICTORIAN SALONS TO BLETCHLEY PARK – THE RISE OF BRITISH PROGRAMMERS

1 Fairbanks White (2006), p. 2; Williams (2002), p. 287; Uboat.net (2021).
2 Kozaczuk (1984).
3 Lightbody (2004), p. 103.
4 Copeland (2006), p. 74.
5 Turing (1936, 1937).
6 Babbage (1830).
7 Babbage, letter (9 September 1843), facsimile in Toole (1992), p. 236.
8 Byron (1863).
9 Ibid., Note A, p. 696.
10 Ibid., Note A, p. 694.
11 Ibid., Note A, p. 694.
12 Ibid., Note A, p. 694, Note G, p. 722.
13 Turing, in Bowden (1953), chapter 25, pp. 286–310.
14 Goos and Hartmanis (1981).
15 Gillies and Cailliau (2002), p. 11.
16 Porterfield (2016), pp. 8–12; Gillies and Cailliau (2002), p. 132.
17 Griffin (2 December 2014).
18 Babbage (1851).
19 Hinsley and Stripp (1993), p. v; Aldrich (2010).
20 Welchman (1982).

31. IMMIGRANTS OF THE WORLD UNITE! – MARX'S LONDON CAPITAL

1 *The Times* (28 February 1853), p. 4.
2 *The Times* (19 January 1858), p. 8.
3 *The Communist Manifesto* (1976), pp. 477–519.
4 Singer (1983).
5 Engels (1888).
6 Marx (1973).
7 Stedman Jones (4 October 2012).
8 Marx and Engels (1982), letter to Engels, xxxviii, p. 398 (31 July 1851).
9 Gabriel (2011). Some historians do not accept that Marx was the father, citing lack of evidence and the possibility that the letter recording that Engels confessed on his deathbed that Marx was the father was a forgery.
10 Hobsbawm (22 May 2015); Kapp (1994), pp, 18–19, 26–7.
11 Blumenberg (1972), p. 55.
12 Marx and Engels (1982), xxxviii, p. 325.
13 Manuel (1997), pp. 79–82.
14 Mehring (1936), p. 531.
15 Marx (1887).
16 Marx, *Neue Rheinissche Zeitung* (1 January 1849), in Szporluk (1988), p. 48.

17 Bogdanor (2012).
18 Fishman (1994); Thorpe (2000), p. 2; *Report and Accounts for the Year Ended 31 December 2019* (2020), section 3.
19 Lowe (2009).
20 Adams (1998), p. 144.
21 The Labour Prime Ministers were Ramsay MacDonald 1924, 1929–35; Clement Attlee 1945–51; Harold Wilson 1964–70, 1974–6; James Callaghan 1976–9; Tony Blair 1997–2007; Gordon Brown 2007–10. The numbers six and 30 refer to the number of individuals who held the office, not terms in office.
22 Golden (2009), p. 129; Johansen (1996), p. 62.

32. MEN OF HARLECH – WEAVING A TALE IN ZULULAND

1 Generally, Benyon (23 September 2004).
2 Of the 17,929, over 9,000 were natives and 1,000 were mounted colonial volunteers, Speirs (2004).
3 Manning (2013), p. 40; Curling (2001), pp. 89–90.
4 David (2004).
5 Williams (2015), p. 70.
6 David (2004).
7 Williams (2015), p. 70.
8 Manning (2013), pp. 38–41; Rattray (2013), appendix A.
9 Beckett (2019); Knight (2019), p. 49.
10 Queen Victoria (1879), LXX, pp. 28–9 (11 February 1879).
11 Ibid., LXX, p. 43 (1 March 1879).
12 Vetch (3 January 2008).
13 Derwent (2006), p. 15.
14 Windsor, Royal Archives, VIC/MAIN/O/46, Lieutenant (Brevet Major) John Chard VC, letter report to Queen Victoria on the Battle of Rorke's Drift (January 1880) gives the number 4,000.
15 Beckett (2019); Knight (2018).
16 Queen Victoria (1879), LXXI, pp. 62–5 (11–13 October 1879).
17 Beckett (2019), p. 79.
18 For the written report, Knight (2011), p. 90 et seq. See also the account by Surgeon John Reynolds VC, Aldershot, The Museum of Military Medicine, RAMC/801/14/9 (1879).
19 For Isandlwana and Rorke's Drift, Knight (2019).
20 The numbers come from the private journal of Lieutenant Colonel John North, Lock and Quantrill (2002).
21 Caygill (1992), p. 44.
22 BBC Timewatch (2003).

33. SLAUGHTER IN THE SLUMS – POVERTY AND TERROR IN WHITECHAPEL

1 Wellington (1965), p. 90.
2 Lewis (11 June 2020).
3 Carpenter (1831), p. 406.
4 Kara (2012), p. 22.
5 London (1903), chapter 19, page 212.
6 London, National Archives, HO 144/221/A49301C, Charles Warren, letter to Godfrey Lushington, Permanent Under-Secretary of State for the Home Department (6 November 1888).
7 The ages of the victims are from Rubenhold (2015), pp. 15, 75, 135, 185, 253.
8 Fido (1987).
9 Rubenhold (2015), pp. 10–12.
10 Kelly earned money as a prostitute around the time of her murder. Stride had been arrested for prostitution in the past but was not involved in sex work at the time of her murder, Rubenhold (2015).
11 Cranbrook (1981), p. 716.
12 Wolf (2008), p. 3346.
13 Ibid., p. 3346.

14 Sugden (2002).
15 Smith (1910), pp. 154–5.
16 PRO HO 144/221/A49301C, Charles Warren, letter to Godfrey Lushington, Permanent Under-Secretary of State for the Home Department (6 November 1888).
17 Conan Doyle (1887).
18 Queen Victoria (1879), LXXXVIII, p. 85 (Thursday 4 October 1888).
19 Eddleston (2001), pp. 4–6 for Smith and pp. 6–12 for Tabram.
20 Lloyd (2019), chapter 13.
21 Queen Victoria, cipher telegram, from Balmoral to London (10 November 1888), Begg and Bennett (2013), chapter 8.
22 Queen Victoria (1984), p. 314.
23 Dickens (1894), p. 236.
24 Rumbelow (1990), p. 86.
25 Barrett (15 May 2011).
26 Stevenson (1886).
27 von Krafft-Ebing (1886).

34. CHEWING BARBED WIRE – THE END OF EMPIRE

1 Mavor (1787), p. 14.
2 *Hansard*, HC Deb, 16 March 1939, vol. 345, col. 708.
3 Zuckerman (2004), p. 1.
4 Gilbert (2000), pp. 277–308.
5 Allies: 130,842 dead, 262,014 wounded, total 392,856. Ottomans: 250,000 dead and wounded. Total on all sides: 642,856, Stowers (2005).
6 Gilbert (2000), pp. 328–74.
7 Cambridge, King's College, Archive Centre, CB/V/1, fols 15–17, Rupert Brooke, 'The Soldier' (1914); Brooke (1915b).
8 Churchill (26 April 1915).
9 Brooke (1915a).
10 Owen (1920), p. 15.
11 Gray (1994), pp. 13–23.
12 Saunders and Cornish (2017), p. 35.
13 Beckett and Simpson (2004), p. 14.
14 Sassoon (1918).
15 'The Fritz Times' (12 February 2016), p. 6.
16 Ibid., p. 1.
17 Safire (2008), p. 799.
18 *Literature of the Women's Suffrage Campaign* (2004), p. xv.
19 Gilbert (2000), p. 70.
20 Marx and Engels (1980), XIV, p. 542. Davies and Maddocks (2014), p. 22. Cambridge lost 18 and Oxford lost 19 per cent of their students that served, and other universities fared similarly. Oxford lost 24 per cent of those under 20, 27 per cent aged 20–4, 21 per cent aged 25–9, 18 per cent aged 30–4, 13 per cent aged 35–9, and 8 per cent aged 40–4, Winter (1977), pp. 458, 462, 464.
21 Arnold (2017); Lee and Lee (2010); Manchester (1983).
22 Winter (1997), pp. 350, 449–66.
23 Tinniswood (2016).

35. THE UNHOLY LAND – BRITAIN'S PALESTINE DILEMMA

1 Reinharz (1984).
2 Johnson (2018), p. 3.
3 Disraeli (1847); Eliot (1876).
4 Johnson (2018), p. 13.
5 Figures for 1914: 525,000 Muslim Arabs, 70,000 Christian Arabs, and 94,000 Jews, totalling 689,000. Figures for 1922: 589,000 Muslim Arabs, 71,000 Christian Arabs, 84,000 Jews, and 8,000 others, totalling 752,000, DellaPergola (2003), p. 11.
6 Bar-Yosef (1994), pp. 211–65; Oles (2015), p. 22.

7 Gnuse (1997); Brody and King (2013), p. 6.
8 Boatwright (2000), pp. 196–203.
9 Johnson (2018), pp. 3–11.
10 *The World War I Reader* (2007), pp. 335–6.
11 Johnson (2018), p. 4.
12 Ibid., pp. 2, 21.
13 Tomes (23 September 2004).
14 *The Jewish National Home* (1944), p. 37.
15 Allawi (2014), p. 189.
16 Campos (2007), pp. 41–2.
17 Bell (2008).
18 Tomes (23 September 2004).
19 Callahan (6 January 2011).
20 Kuttler (23 March 2019).
21 *White Paper* (1939).
22 Sofer (1998), p. 254.
23 *Documents on German Foreign Policy* (1964), xiii, pp. 881–5.
24 Kochavi (1998), p. 146.
25 Mitchell (2015), p. 87.
26 Kochavi (1998), p. 146.
27 Weizmann (10 December 1946).
28 Rubenberg (1986), p. 46; Brooks (2008), p. 297.
29 Rubenberg (1986), p. 46; Balfour (2019), p. 123.
30 Johnson (2018).
31 Ingram (1972), p. 73.
32 Johnson (2018), p. 19.

36. FLIGHTS OF FANCY – THE IDYLL OF THE ENGLISH COUNTRYSIDE

1 Stendhal (1831), ii. 2, p. 46.
2 *Beowulf* (2011), pp. 150–4.
3 Shakespeare (1623), *A Midsummer Night's Dream*, act 2, scene 1, p. 150.
4 Gómez de la Serna (1929).
5 Turner (1980); Brock et al (2019), p. 222; Olin (2000), p. 155; Wilson (13 June 2014).
6 Rackham (1986).
7 Fowler (1983), p. 35; Frere (1967), p. 311; Broadberry et al (2010), p. 22; Sharp (2000), p. 5; Jefferies (2005), p. 3; *Mid-1851 to Mid-2014 Population Estimates* (2016).
8 *Capturing the Changing Face of Great Britain* (13 February 2020).
9 Shoard (1980).
10 Hallmann et al (2017); Carrington (18 October 2017).
11 Gilbum et al (2015).
12 *Wild Bird Populations in the UK, 1970 to 2018* (2020).
13 Kennedy (1980), p. 13.
14 Frogley and Thomson (2013), p. 40.
15 Frogley (6 October 2009).
16 Meredith (May 1881).
17 Hopkins (1918).
18 Brooke (1915b).
19 Vârlan (2015), pp. 123–38.

37. A NATION OF BOOKS AND LETTERS – THE BRITISH TYPE

1 Florence, Biblioteca Medicea Laurenziana, MS Amiatino 1, *Codex amiatinus* (before AD 716).
2 Fragments of one survive in London, British Library, Additional MS 45025 Bible fragments (before AD 716); Breay and Story (2018), pp. 124–7.

3 London, British Library, Cotton MS Nero D IV, the *Lindisfarne Gospels* (*c*. AD 700).

4 Dublin, Trinity College, TCD MS 58, the *Book of Kells* (*c*. AD 800).

5 London, British Library, Add MS 89000, *St Cuthbert Gospel* (AD 700–25); Breay (2015).

6 Raoul Lefèvre (1473); James of Cessolis (1474).

7 Johnson (1934), pp. 9–10.

8 Geoffrey Chaucer (*c*. 1476); al-Mubashshir ibn Fatik (1477); Blake (1991), p. 99.

9 Moran (1976); Blake (23 January 2008a, b).

10 Berlin, Bundesarchiv, NS 6/334, Bormann, edict on typography (3 January 1941).

11 Bullough (7 May 2010).

12 Catherine of Siena (1500), letter 368; Barker (1992), p. 59; *The Aldine Press* (2001), p. 23.

13 Lowry (1979).

14 Larminie (3 January 2008); McNei (2019), pp. 66–7.

15 Mosely (3 October 2013b).

16 McNeil (2019), pp. 76–7.

17 Mosely (2004a).

18 Virgil (1757); McNeil (2019), pp. 80–1.

19 Milton (1758a, 1758b).

20 Benton (2014), p. 28.

21 Fournier (1766), II, p. xxxviii.

22 London, Sir John Soane Museum, 45/1/13, Design for a British Senate House (10 August 1778).

23 Mosely (1999).

24 McNeil (2019).

25 Ovenden (2005).

26 McNeil (2019), pp. 152–3, 266–7, 354–5; Calvert, in Bos (2007).

27 Carter (3 January 2008).

28 'Fifty Years of Type-Cutting' (1950), pp. 8–14.

29 Haley (1992), p. 103.

30 McNeil (2019), pp. 30–1, 48–9.

31 Ibid., pp. 244–5.

32 Ibid., pp. 20–1, 196–7.

33 Ibid., pp. 82–3, 218–9.

34 Ibid., pp. 262–3.

35 Vervliet (2008), I, p. 242; McNeil (2019), pp. 194–5.

36 'Special Issue Describing the Times New Roman Type' (1933).

37 McNeil (2019), pp. 280–1.

38. SS-GB – HITLER'S TARGETS IN BRITAIN

1 Matthew (23 September 2004).

2 Di Campli San Vito (1 September 2017).

3 McNamara and Mooney (2000), p. 73; Reeves (2019), chapter 1.

4 More (1940), pp. 33–4.

5 Along with some other countries, Britain had reserved its position on chemical weapons when ratifying the prohibition treaty, permitting itself to use chemical weapons in retaliation if they were used on Britain first. Regarding the mustard gas, Alanbrooke (2001), p. 94 (22 July 1940).

6 Todman (2016), p. 405.

7 Kynaston (2017), pp. 376–7; Draper (1979).

8 Philpot (2018).

9 Camp (1988), pp. 81–2.

10 *If the Invader Comes* (1940), p. 2.

11 Atkin (2015).

12 Manchester and Reid (2012).

13 Shirer (1991), p. 785.

14 Tilford (1996); Fredette (2007), p. 262.

15 Parks (1990), p. 154.

16 Welshman (2010), p. 5.

17 Ibid., p. 6.

18 Evans (2004), p. 64.

19 Bowman (2014), p. 20.

20 Göring's forces comprised 923 fighters, 998 bombers and 316 dive bombers, Shirer (1991), p. 775. For ages, Skawran (1970); Dickon (2014), p. 173.

21 For the Battle of Britain and the invasion plans, Shirer (1991), pp. 758–82.

22 Ibid., p. 782.

23 Ibid., p. 782.

24 Longmate (2012), pp. 125–8.

25 Shirer (1991), p. 784.

26 Roland (2014), pp. 126–31.

27 Longmate (2012), pp. 135–7.

28 Cox (1982); Griffiths (2009).

29 *Hansard*, HL Deb, 20 April 1943, vol. 127, col. 295.

30 The number for British dead from German bombs, excluding service people, is 60,595. The number of German dead is harder to gauge, with *c*. 600,000 being a not uncommon estimate, Parks (1990), p. 1.

31 *The Atomic Bombings of Hiroshima and Nagasaki* (1946), p. 18.

32 Geneva Convention Relative to the Protection of Civilian Persons in Time of War (12 August 1949).

39. *RÓISÍN DUBH* – IRELAND'S LONG ROAD TO INDEPENDENCE

1 Scully (2006).

2 Ó Corráin (1989).

3 Aughey and Oakland (2013), p. 65.

4 Ibid., p. 3; Bieler (1948), pp. 2–3; Richter (1988), p. 43.

5 There are many theories on the origin and meaning of Sheela-na-gig carvings. The most recent concludes they are a remnant of pre-Christian folk religion, Freitag (2004).

6 Hogan and Osborough (1990).

7 *Corpus iuris hibernici* (1978).

8 Dublin, Trinity College, MS 1339, the *Book of Leinster* (*c*. 1150–1200).

9 Royal Irish Academy, MS 23 E 25, *Lebor na hUidhre* (before 1106); Duffy (2005), p. 86.

10 Aughey and Oakland (2013), pp. 3–4.

11 Downham (2014), p. 4.

12 Duffy (2013).

13 Gillingham (1993), p. 24; *Select Historical Documents* (1896), no. 2, pp. 10–11.

14 John of Salisbury (1929), book 4, pp. 217–8; Watt (1970), pp. 35–8.

15 Whalen (2014), pp. 1–2.

16 Hosler (2007), pp, 70–2.

17 Poole (1951), p. 309.

18 British Library, Harley MS 913, the *Kildare Poems* (*c*. 1330); Hickey (2007), pp. 54–66.

19 London, Lambeth Palace Library, MS 603, Statutes of Kilkenny (1366).

20 Ellis (1998), p. 151.

21 Montaño (2011), p. 103.

22 Clarke (2015), p. 343.

23 Ó Siochrú (2008); Childs (2007), p, 265.

24 Hechter (1975), pp. 76–7; Wall (1961); Aughey and Oakland (2013), p. 9.

25 Bartlett and Jeffrey (1997), p. 7.

26 Innes (2003), p. 15.

27 Numbers are inevitably imprecise. The pre-famine 1840s population was 8.2 million, which by 1911 was 4.4 million, Foster (1988), pp. 323–4; Mark-FitzGerald (2013), p. 1.

28 Sinn Féin was founded by Arthur Griffith in Dublin on 28 November 1905, Schmuhl (2016), p. xii.

29 Bowman (2007), p. 1; Martin (2013).

30 The Irish Republican Brotherhood was founded by James Stephens in Dublin on 17 March 1858 as the Irish Revolutionary Brotherhood, soon followed by a sister organisation in the United States called the Fenian Brotherhood, Schmuhl (2016), p. xi.

31 McKenna (2017), p. 49.

32 Dolan (2006).

33 Bew (2016), p. 95.

34 For example, The Wolfe Tones (1972).

35 Houlihan (15 March 2012).
36 Sheehan (2017).
37 Six of Ulster's counties are in Northern Ireland: Antrim, Armagh, Down, Fermanagh, Londonderry, Tyrone. Three are in Ireland: Cavan, Donegal, Monaghan.
38 McGreevy and Collins (3 October 2013); for a life of Collins, O'Connor (1937).
39 Pakenham and O'Neill (1970), pp. 392–4.
40 O'Reilly (2008), pp. 42–7.
41 Wills (2007), pp. 389–90.
42 Simms (18 September 2019).

40. YOUTH, SEX AND CONCRETE – BRITAIN TAKES A MODERN TURN

1 Cleland (1748–9); Potter (1873–6).
2 The unexpurgated book was first published in Florence in 1928, then Paris in 1929. British readers had a censored version by Heinemann. In 1960 the trial was brought under section 2 of the Obscene Publications Act 1959, which made it an offence to publish an obscene article.
3 Cole (1965), p. 253.
4 Taylor (1992).
5 Carter (23 September 2010).
6 *The Trial of Lady Chatterley* (1961), pp. 68–73.
7 Carter (23 September 2010).
8 The man on the Clapham omnibus first appears in a judicial decision in 1903 by Lord Collins MR in McQuire v. Western Morning News [1903] 2 KB 100 at 109 CA.
9 Bradford (3 October 2013); De-la-Noy (24 May 2008).
10 Vinen (2014).
11 Perone (2009), p. 1.
12 Ibid., p. 3.
13 Ibid., p. 1.
14 Derry (2020), pp. 1–2.
15 Crosland (1982), p. 148.
16 Dunn (3 January 2004).
17 The Murder (Abolition of Death Penalty) Act 1965 suspended the death penalty until 31 July 1970. In 1969 Parliament voted to make it permanent.
18 *Report of the Inquiry into the Collapse of Flats at Ronan Point* (1968).
19 Loft (2013).
20 Fielding (2016), p. 19.
21 Corthorn (2019), pp. 83–6, passim.
22 Selwood (27 August 2015).
23 Lawrence (2005), p. 304.

41. STRIKES, GRIME AND SAFETY PINS – THE DECADE OF DISCONTENT

1 Cleveland and Huertas (1979), p. 104.
2 Popova and Simkins (2013), p. 382.
3 Cleveland and Huertas (1979), p. 103.
4 *The Times* (14 November 1974).
5 Scargill (1975), pp. 3–33.
6 Makubuya (2018), p. 355.
7 Pirouet (6 January 2011).
8 Newman and Giles (2 December 2005).
9 Redmond et al (1998), pp. 20, 31.
10 Newman and Giles (2 December 2005).
11 Healey (1989), p. 432.
12 Thornhill (25 September 2014).
13 Moran (16 August 2013).

14 Sex Pistols (1977).

15 *Hansard*, HC Deb, 14 June 1977, vol. 993, col. 338.

16 Kristiansen (2018), p. 54.

17 Martin (2009), p. 49; López (2014).

18 Healey (1989), p. 432.

19 Morgan (2001), p. 437.

42. THE ARMALITE AND BALLOT BOX –
NORTHERN IRELAND'S TROUBLES

1 The terminology of Nationalist, Republic, Unionist and Loyalist is still current.

2 Staniforth (2013), p. 52.

3 'On This We Stand' (February 1970), pp. 1, 8.

4 The years of formation were: UVF 1966, UDA/UFF 1971, RHC 1972, INLA 1974.

5 *Operation Banner* (2006), section 105.

6 Generally, McEvoy (2001).

7 Lord Widgery (1972).

8 Dolan (2006).

9 Hubard (2013), p. 45.

10 White (2017), p. 346.

11 Lord Saville (2010), xi, para. 3.119, p. 46.

12 In 2005 Michael McDowell, then Irish Minister for Justice, Equality and Law Reform, openly denounced Gerry Adams, Martin McGuinness and Martin Ferris as members of the Provisional IRA's Army Council. Those who have made similar written claims include Moloney (2007), pp. 163–8, 688, 697 and passim and O'Brien (1999), p. 343. In 1973 McGuinness was arrested in a car with 113 kilograms of explosives and 5,000 rounds of ammunition. In court he said, 'I am a member of the Derry brigade of *Óglaigh na hÉireann* and am very, very proud of it', White (2020), p. 208; 'Martin McGuinness: Past and Presidency' (24 September 2011). For the Army Council directing Sinn Féin, see MI5 and PSNI (19 October 2015), section 13.

13 *Operation Banner* (2006), section 106.c.

14 RUC Chief Constable Sir John Hermon characterised the activities as 'mafia-like gangsterism', *The IRA: Finance and Weapons* (26 May 1983); McDermott and Harnden (15 August 2001).

15 Maloney (2007); English (2004).

16 Jones (22 March 1987).

17 Officials from the governments of the US, Britain and Ireland all assert that NORAID money was used for purchasing thousands of weapons, Weinraub (16 December 1975), p. 1; Southern (2018), p. 25.

18 Hornall and Roberts (28 December 2018).

19 The two agreements were: (1) a short intergovernmental agreement between the UK and Ireland that incorporated (2) a more detailed second multi-party agreement between the governments of the UK and Ireland and the Alliance Party, Labour, the Northern Ireland Women's Coalition, Sinn Féin, the Social Democratic and Labour Party, the Progressive Unionist Party, the Ulster Democratic Party and the Ulster Unionist Party.

20 Aughey (2005), pp. 148–55.

21 The Continuity IRA was formed in 1986, and the Real IRA was formed in 1997.

22 Matchett (2016).

23 McKittrick (1999), p. 1477; the Army figure is from *UK Armed Forces Operational Deaths Post World War II* (26 March 2015); Roche (11 August 2019).

24 *Paramilitary Groups in Northern Ireland* (19 October 2015), sections 2.i, 2.ii, 18.

25 *Religion in Northern Ireland* (24 March 2015). The 66 per cent Protestant was made up of Protestants and other Christians (non-Catholics).

26 'Census 2011: Key Statistics for Northern Ireland' (2012), pp. 3, 19; Gordon (19 April 2018).

27 Nolan (19 June 2018).

43. RULE BRITANNIA! BRITANNIA'S MAKING WAVES – SHADOWS OF EMPIRE IN THE SOUTH ATLANTIC

1 Lane (1988), p. 128.
2 *Falkland Islands Review* (1983), para. 169. Freedman (2005), I, pp. 145–50; van der Bijl (1999), p. 8.
3 Cook (1974), II (17 January 1775).
4 Headland (1992), pp. 26, 78.
5 Gustafson (1988), p. xii.
6 Ibid., p. 5.
7 *Falkland Islands Review* (1983), para. 174; Freedman (2005), I, p. 152.
8 Norton-Taylor and Evans (28 June 2005).
9 Gustafson (1988), p. 111.
10 Bruni (2018), p. 27.
11 Beck (2014), p. 124.
12 Hunt (1992).
13 *Hansard*, HC Deb, 14 April 1982, vol. 21, cols. 1150–4.
14 Middlebrook (2009), pp. 74–5.
15 Fairhall and Graham-Yooll (26 April 1982).
16 Ibid.
17 Greenslade (25 February 2002).
18 Middlebrook (2009), pp. 113–4.
19 Harding (26 December 2011); Woodward (2012); Rossiter (2007).
20 Seear (2017).
21 Freedman (2005), I, p. 311.
22 *Falkland Islands Review* (1983), para. 339.
23 *India and the Commonwealth War Graves Commission* (2002); Heathcote, (1995), pp. 21–38, 253–4.
24 Borges (14 February 1983).
25 Critchlow (28 May 2015).

44. SHAKEN AND STIRRED – TREACHERY IN THE INTELLIGENCE SERVICES

1 Fleming (2012), p. 228.
2 Andrew (2009).
3 Andrew and Mitrokhin (1999), p. 56.
4 The exact history of the Cambridge spies – how they were recruited, how they spied, why and when they did specific things – will probably never be fully known. They have given various accounts, but it is quite probable that significant elements are untrue. Furthermore, not all information regarding their activities has yet been declassified. Generally, Cecil (6 January 2011), Clive (1 September 2017), Davenport-Hines (8 October 2009), Kerr (25 September 2014), Kitson M and M Carter (1 September 2017), Lownie (2015).
5 White (2019); Bowcott (14 November 2001).
6 Moorhouse (2014).
7 *Hansard*, HC Deb, 15 November 1979, vol. 973, cols 679–81; Carter (2001), p. 472.
8 Cairncross (1974).
9 Attorney General for the United Kingdom v. Heinemann Publishers Australia Pty Ltd and Another [1987] 10 NSWLR 86; Attorney General for the United Kingdom v. Wellington Newspapers Ltd. [1988] 1 NZLR 129; Attorney General (UK) v. Wellington Newspapers Ltd. [1988] 1 NZLR 163.
10 Wright (1988), pp. 463–8.
11 *Hansard*, HC PQ, 6 May 1987, vol. 115, cols. 723–8.
12 Andrew (2009); Smith and Wilson (17 July 1977), p. 1.
13 *Hansard*, HC PQ, 6 May 1987, vol. 115, col. 723.
14 Wheatley (1939), p. 58.
15 Section 1(1) Security Service Act 1989.
16 Including China 65 million, USSR 20 million, North Korea and Cambodia 2 million each, Africa 1.7 million, Afghanistan 1.5 million, Eastern Europe and Vietnam 1 million, Latin America 150,000, others 10,000, Courtois et al (1999), p. 4.

45. PICKET LINES AND PARODY – THE LADY IS NOT FOR TURNING

1 Winterton and Winterton (1989), pp. 65, 66–8.
2 Thatcher (1993), passim.
3 Scargill (1975), pp. 3–33.
4 Coyle (2010); Harvey et al (2014a), pp. 144–5; Winterton (1989), p. 156.
5 Travis (3 January 2014).
6 van der Velden et al (2007), p. 353.
7 Rogers (8 April 2013).
8 Elliott (13 December 2015); Hudson (2002).
9 Gavrilov (24 January 1976). The headline translates as 'The Iron Lady Wields Threats'.
10 General election results: 1979 Con 339 (maj. 44), Lab 269; 1983 Con 397 (maj. 144), Lab 209; 1987 Con 376 (maj. 101), Lab 229; 1992 Con 336 (maj. 21), Lab 271; 1997 Lab 418 (maj. 178), Con 165, *UK Election Statistics: 1918–2019* (2020), pp. 10, 13.
11 Joyce (2016), p. 257.
12 Ball (12 April 2013).
13 *Spitting Image*, Spitting Image Productions for ITV.
14 Adams (1998), pp. 144–6.
15 Staniforth (2013), p. 83.
16 *UK Election Statistics: 1918–2019* (2020), p. 7.
17 Halgron (2009), pp. 177–96.
18 McSmith (8 April 2013).
19 Ibid.

46. SNAIL PORRIDGE – A NEW POLITICS AND COOL BRITANNIA

1 Pink Floyd (1979).
2 Brown (2018); Blair (2009); Asthana (10 August 2017).
3 Brown (2018).
4 Stephen A. Cohen Collection, Damien Hirst, *The Physical Impossibility of Death in the Mind of Someone Living* (1991).
5 The Duerckheim Collection, Tracey Emin, *My Bed* (1998).
6 Pepys (2001), p. 76 (24 October 1662).
7 Woolf (1992), p. 253.
8 Smollett (1859), p. 157.
9 Levy (1 September 2017).
10 Idem (10 January 2013).
11 Colquhoun (2007), p. 3.
12 Ibid., pp. 7–13.
13 Ibid., pp. 17–31.
14 Curtis (2018).
15 Apicius (1977).
16 Petronius (2020), 15, chapters 26–78, pp. 108–231.
17 Colquhoun (2007), p. 40.
18 Manchester, Rylands English Ms 7, the *Forme of Cury* (1377); *The Forme of Cury* (1780). For its date, folio 4r of the manuscript has '1377' in a seventeenth-century hand, C Hieatt (1988), p. 47.
19 *The Forme of Cury* (1780), pp. 1–2.
20 Taillevent (1988), pp. 28, 35, 271.
21 London, British Library, Harley MS 4016, the *Boke of Kokery* (c. 1440).
22 Colquhoun (2007), p. 55.
23 London, British Library, Harley MS 4011, John Russell, the *Boke of Nurture* (c. 1450); *The Babees Book*, p. 158.
24 *Oxford Dictionary of Modern Quotations* (2007), p. 217.
25 Beeton (1861), paras 2144–6, p. 959 and passim.

26 Blumenthal (2009), pp. 256–63.
27 Ibid., pp. 17–51.
28 McGee (1984).
29 Blumenthal (2009), pp. 162–9, 188–96, 216–21.
30 Blumenthal et al (10 December 2006).
31 Rosewarne (1994), pp. 3–8; Shariatmadari (30 April 2015).
32 Paton Walsh (31 October 1999).

47. WEAPONS OF MASS DESTRUCTION – WRECKING IRAQ AND THE GLOBAL FINANCIAL SYSTEM

1 *Public Papers of the Presidents of the United States* (2001), II, p. 1116; McSmith (4 July 2016).
2 'US Public Thinks Saddam Had Role in 9/11' (7 September 2002).
3 *Hansard*, HC Deb, 24 September 2002, vol. 390, col. 17.
4 O'Neill (24 September 2002).
5 United Nations Security Council (2002).
6 *Iraq – Its Infrastructure of Concealment, Deception and Intimidation* (2003), p. 1.
7 'Hans Blix's Briefing to the Security Council' (14 February 2003); Sawer (10 March 2013).
8 United Nations Security Council (1990, 1991).
9 'Full Text: Bush's Speech' (18 March 2003).
10 Burnham et al (2006), pp. 421–8.
11 Gilligan (21 July 2013).
12 Blair (2011), p. 186.
13 'Bliar? Why the Row over Weapons of Mass Destruction is so Dangerous for Tony Blair' (5 June 2003).
14 *UK Election Statistics: 1918–2019* (2020), p. 10.
15 Kar-Gupta and Le Guernigou (9 August 2007).
16 Bajaj and Creswell (21 June 2007); Kasapis (2008), p. 237.
17 *Liquidity Support Facility for Northern Rock Plc* (4 September 2007).
18 Kirkup (16 September 2008).
19 Williams (2010).
20 Swaine (8 October 2008); Porter et al (13 October 2008).
21 Curtis (8 July 2011).

48. ISLAND FEVER – THE PERENNIAL EUROPE CONUNDRUM

1 Leake and Horton (22 September 2019).
2 *UK Election Statistics: 1918–2019* (2020), p. 10; *Hansard*, HC Division 6, 9 June 2015, vol. 596, cols. 1157–60.
3 Parker et al (24 June 2016).
4 Churchill (1988).
5 Steinnes (1998), pp. 61–79.
6 *Hansard*, HC Deb, 28 October 1971, vol. 823, col. 2217.
7 Adlam (2020), p. 24.
8 Roberts (25 November 1990), p. 15.
9 Parker and Barker (24 January 2016).
10 'Full Text of Cameron's Speech' (23 January 2013).
11 Parker et al (26 May 2014).
12 *Strong Leadership* (2015), p. 30.
13 Clarke et al (2017), p. 209.
14 *The UK Contribution to the EU Budget* (2019).
15 *Public Expenditure Statistical Analysis 2018* (July 2018), table 4.1, p. 66.
16 London, College of Arms, *Westminster Tournament Roll* (1511).
17 Hansen (2000), p. 35.
18 *Hansard*, HC Deb, 5 November 1954, vol. 532, col. 827.
19 Section 26, Canadian Citizenship Act, S.C. 1946, c. 15.
20 Orchard (2014), p. 222.

21 Hansen (2000), p. 18.
22 Hansen (1999); Rothchild (1970), pp. 737–53.
23 *Ethnicity and National Identity in England and Wales: 2011* (2012).
24 *Regional Ethnic Diversity* (1 August 2018).
25 Ram and Rutter Pooley (27 March 2018); Foster and Evans (24 February 2017); Hern (30 July 2019); Pickard and Hodgson (17 July 2018).
26 'Mueller Report: Here Are the Key Revelations' (19 April 2019).
27 *Russia* (21 July 2020).

49. *WUNDERKAMMERN* – COLLECTING BRITAIN'S PAST

1 Evans (7 June 2020).
2 Bryant (2016).
3 de Beer (1953); Macgregor (23 September 2004); Wilson (2002), pp. 11–21.
4 Mauriès (2001).
5 Bushnell (1906); London, British Museum, SLMathInstr.54, Sloane astrolabe (1290–1300).
6 Walpole (1903), letter to Sir Horace Mann, III, no. 360, p. 142 (14 February 1753).
7 Williams (2013), p. 203.
8 An Act for the Purchase of the Museum 1753.
9 de la Rochefoucauld (1933), pp. 16–17.
10 Procter (23 April 2018); Jones (4 November 2014); Alberge (4 November 2019); Daley (9 April 2015).
11 Roth (1903), pp. x–xi; Bacon (1897), pp. 88–9; Graham (1965).
12 Ezra (1991), pp. 16–17.
13 Selwood (1 May 2017).
14 Dalton (3 June 2018).
15 Elgin was not the only person to export Greek sculpture. Others did, to other countries.
16 Olusoga (12 February 2018); Manjapra (29 March 2018); University College London, *Legacies of British Slave Ownership*.

50. SAILING BY! – THE WATERS OF HISTORY

1 *Harlequin's Invasion* (1781), p. 141.
2 This quotation has many variations.
3 *UK Sea Fisheries Statistics 2018* (2019).
4 Darwin (1859).
5 Barrow and Hulme (2007), p. 145.
6 Roberts (2011).
7 Moore (2015), p. 271.
8 Ibid., p. 286.
9 FitzRoy (1963), p. 171; Mellersh (1968), pp. 10, 263.
10 McConnell (8 January 2015).
11 Connolly (4 May 2019).
12 Johnson (1775), p. 150.
13 The main authorities are: Northern Lighthouse Board (Scotland) 206, Commissioners of Irish Lights (Ireland) 90, Trinity House (England) 66. There are others.
14 Section 2, An Act for Enforcing the Laws against Persons who Shall Steal or Detain Shipwrecked Goods, in Raithby (1823), pp. 251–4; Pearce (2010),p. 69.

AFTERWORD: VOICES OF THE FUTURE

1 Cromwell (1857), Declaration to the Lord Lieutenant of Ireland, II, pp. 99–119 (1649).
2 Johnson (2014).

Acknowledgements

A book as wide-ranging as this incurs many debts of gratitude to those who have ensured it does not go too far off the rails. I especially need to thank Adrian Adlam, Professor David Bates, Professor Thomas Charles-Edwards, Dr Jim Daniel, Steffen Deutschenbauer, Nikki Elvin, John Hammond, Professor John Harper, Dr Alison Hudson, Dr Mike Ibeji, Dr Ian Jenkins, Dr Robert Johnson, Dr Simon Kingston, Victoria Kingston, James Long, Dr George Molyneaux, Rhian Morris, Dr Timothy Morris, Professor Michael Parker-Pearson, Professor Paul Pettitt, David Riley, Professor Levi Roach, Claire Rostron, James Sanders, Andreas Selwood, Professor Richard Sharpe, Dr Giles Shilson, Professor Mark Shuttleworth, Dr Greg Sullivan and James Winter. All have been supremely generous with their expertise.

I have inevitably taken up space in many libraries and archives, and corresponded with their unfailingly helpful staff since the onset of the Covid-19 pandemic. My sincerest gratitude to the wonderful people of the Bodleian Library, British Library, British Museum, Cambridge University Library, College of Arms, King's College Library Cambridge, Morgan Library and Museum, National Archives, National Records of Scotland, Parliamentary Archives, New College Archives, Pepys Library Cambridge, Royal Collection, St Bride's Foundation Library, Society of Antiquaries and Winchester College Archives.

I thank my children, Inigo and Arminel, for their boundless patience with my interrogations. I am likewise very grateful to my agent Matthew Hamilton and the amazing team at Constable – Andreas Campomar, Nithya Rae and Linda Silverman – for making this book such fun to work on. But, most of all, I must thank Delia, who has lived this book daily, offered unfailingly astute suggestions, and whose inexhaustible support in countless ways has made it far better than it would otherwise have been.

All errors are mine alone.

Index

Index entries in **bold** indicate central documents.